DATE DUE

GAYLORD			PRINTED IN U.S.A.

THE BURLINGTON MAGAZINE

A Centenary Anthology

THE BVRLINGTON MAGAZINE

A Centenary Anthology

❧

selected and introduced by

Michael Levey

❧

YALE UNIVERSITY PRESS
NEW HAVEN & LONDON

This publication has been supported
by generous funding from
the Michael Marks Charitable Trust

Designed by Sally Salvesen
Set in Monotype Baskerville
Printed in Italy

LIBRARY OF CONGRESS CATALOGING-IN-PUBLICATION DATA

Levey, Michael.
The Burlington Magazine : a centenary anthology /
selected and introduced by Sir Michael Levey.
p. cm.
Includes bibliographical references.
ISBN 0-300-09911-8
1. Art. I. Burlington magazine for connoisseurs. II. Title.
N7443.2 .L48 2003
701´.18--DC21
2002013295

CONTENTS

PREFACE

Caroline Elam

Volume I, no.1 of The Burlington Magazine appeared in March 1903, produced from offices in New Burlington Street around the corner from Burlington House, then as now the seat of the Royal Academy and the Society of Antiquaries. It was published by the Savile Publishing Co., especially created for the occasion and presumably named after nearby Savile Row, the headquarters of the Burlington Fine Arts Club, whose exhibitions of Old Master Paintings from British private collections had long attracted the admiring attention of international connoisseurs. The aims of the new Magazine were to set the study of art history in Britain on an entirely new footing, based on internationalism of outlook, catholicity of coverage – including art of all periods and places, 'decorative' as well as 'fine' – scholarly seriousness of treatment, high standards of typographical design and illustration, and, above all, readability. Informed Editorials – perhaps the most unusual feature of the Burlington among existing art periodicals in any country at the time – were to deal with important political issues related to museums, monuments and the art world in general.

These aims have not essentially changed over the hundred years of the Burlington's existence. It remains in many ways a hybrid publication, a scholarly journal masquerading as a monthly magazine, balancing short critical reviews with weighty products of academic research, freighted with footnotes and documentary evidence. It is the Magazine's variety of content and approach, rather than some canonical 'contribution to the subject' that Michael Levey conveys in his inspired choice of pieces for this centenary anthology.

The idea for the anthology came from the Magazine's Board of Directors, and we are particularly grateful for the inspiration and guidance of Christopher White, the then Chairman of the Board, who has followed the project closely throughout. The publication would not have been possible without an extremely generous grant from one of the Magazine's most loyal benefactors, the Michael Marks Charitable Trust. Warm thanks are due to John Nicoll at Yale University Press for taking on the publication, and to Sally Salvesen, our editor there (and herself an alumna of the Burlington editorial office) for her skill, calmness and tact in seeing it through. Annette Bradshaw serenely took on the formidable task of assembling an incredibly heterogeneous and widely scattered array of photographs, ably supported by the research skills of Virginia Thomas. Among the many people who have helped us to locate and secure images, we would especially like to thank David Chambers, Keith Christiansen, Howard Coutts, Simon Dickinson, Ingeborg Krüger, Timothy Llewellyn, Jan Marsh, Carol Plazzotta, Michael Rogers, Francis Russell, Paul Taylor,

Gary Tinterow, Jeremy Warren, and the Photographic Department of the Warburg Institute. Mary Pixley mended lacunae in the page proofs with speed and skill. Last but by no means least, warmest thanks are due to the authors of the articles and reviews, especially those who have generously supplied photographs and given us permission to republish their pieces.

A NOTE TO THE READER

Minor interventions have been made here and there to give overall consistency to the house style of text and footnotes, and to provide current locations of works of art where possible. Caroline Elam has made minimal additions, which appear at the beginning of each section of the notes, to supply some context for the article in question or an updating of its bibliography. She is entirely responsible for any deficiencies or errors that remain.

INTRODUCTION

Michael Levey

As a celebration of the periodical's centenary, the Directors of the Burlington Magazine decided to commission an anthology of writings which had been published in it over that impressive period of time.

I felt greatly honoured by the invitation to compile such an anthology. My task of reading or re-reading for that purpose every number of the Magazine during the last ninety-nine years was largely agreeable, occasionally amusing and always enlightening. Any sense of burden has been mitigated by the kind assistance and advice I have received from those acknowledged at the end of this Introduction.

Nevertheless, the ultimate choice of material was mine alone. And in that connection I have frequently recalled a remark of Sargent's, based on bitter experience, that a portrait can be defined as a likeness in which there is something wrong with the mouth. Similarly, an anthology may be defined as a collection of writings from which some favourite item is unaccountably missing.

No anthology can act adequately as a history, but in what follows I have attempted to sketch – very briefly – the context in which the Magazine was founded, mentioning some of the personalities involved.

A single anthology could not possibly cover every decade of the Burlington's existence, any more than it could represent every country, period, artistic category and style, with which the Magazine has dealt. Given the length of its history, and the increasingly wide range of articles published, a token representation was all that could be achieved, touching on only a few areas. If ultimate selection has proved a difficult process, and it has, that serves to indicate how much comparable material exists for compilation in potential further volumes.

For this particular volume I confess that selection has been based on pragmatism rather than on established principles of art-historical importance, if such really exist. I did not think it necessary to aim at any inclusive goal, whether of subjects or of authors. However, while recognising the eternal elusiveness of the concept, I have sought to convey some sense of artistic 'balance', within a Burlington context. Yet this is, after all, an anthology – not a primer of world art. There can be no necessity to labour the fact that culling of the flowers has been undertaken by one person, and thus the result is inevitably personal. Where I have – to continue the flowery metaphor – plucked a lily, somebody else might have chosen a rose. Any obvious weeds, I hope to have avoided.

My main hope is more positive: I should like to think that what is collected here illustrates and constitutes – in essence – the true character of the Burlington Magazine.

* * *

Several significant though unrelated cultural initiatives marked the opening years of the twentieth century in Britain. Since they were cultural, they will have passed unperceived by the majority of the population. Nevertheless, in their way, they can be seen as manifestations of a new, livelier, more sophisticated age, ushered in under the ægis of a new, livelier, far from uncultivated monarch.

In 1902, in the second year of his reign, Edward VII granted a royal charter to the British Academy, a newly-constituted body whose object was defined as 'promotion of the study of the moral and political sciences, including history, philosophy, law, politics, archaeology and philology'. To that list would gradually be added other sciences, among them the science of art history.

In 1903 the initiative of a group of public-spirited private individuals brought into existence the National Art-Collections Fund. It began 'with little but faith and enthusiasm', its subsequent Chairman, Sir Robert Witt, recalled. Its purpose (at a period when no system of export control existed) was to raise funds to ensure that important items under threat of being sold abroad should be purchased and presented to the national museums and galleries. Its first royal patron was King Edward VII.

In the same year, thanks to another group of private individuals, the Burlington Magazine was launched. Although the King is unlikely ever to have perused it, his Surveyor of Pictures and Works of Art, Sir Lionel Cust, was to contribute to the Magazine several informative articles about the Royal Collection.

And there was – at least for a period – some inevitable overlap of individuals between the Burlington and the other two new bodies. Thus, serving on its Consulative Committee was Viscount Dillon, one of the Founding Fellows of the British Academy, while members of the original Executive Committee of the National Art-Collections Fund included Roger Fry. Like the NACF, the Burlington might be described as beginning 'with little but faith and enthusiasm', but those qualities were accompanied, from the very first, by notable scholarly expertise. The Magazine was conceived as a new kind of periodical in Britain, providing something felt to be long overdue: a professional English equivalent to those magazines on the Continent seriously and chiefly devoted to study of 'ancient art', as the editorial put it in the first number of March 1903.

Abroad, the position was indeed different. Merely in passing, one may note that in Germany, for example, *Zeitschrift für bildende Kunst* had begun as a monthly publication in 1866. In Italy, *Archivio Storico dell'Arte* (subsequently *L'Arte*) was published monthly from 1888. And the 'doyenne des revues d'art', as it still proudly proclaims itself, the *Gazette des Beaux-Arts*, has been published monthly in France since 1859.

Unable at the time to invoke any more satisfactory term to indicate its serious nature, and that of its intended readership, the Burlington Magazine declared on its first cover that it was 'for Connoisseurs'. Rather surprisingly, the words continued to appear on the Magazine until as late as 1948. Only then were they suppressed, by the new editor, Benedict Nicolson. He robustly defended his decision in an editorial, making witty play with the old-fashioned, cigar-smoking, as it were Edwardian, image of the 'connoisseur'.

Can there have been a hint of rivalry, or even a grain of malice, in the choice of that noun for the Burlington's readership in 1903? Another monthly art magazine had been launched in England two years before, *The Connoisseur*, declaring on its cover that it was intended 'for Collectors'. Some of its staff immediately defected to the Burlington, and they included Robert Dell, an experienced journalist who became the first editor. His is

now an almost forgotten name, but it should not be omitted from the Magazine's roll of honour.

Much detail about the actual founding of the Burlington is undocumented or anyway unrecoverable. Benedict Nicolson pondered on what had led to that name, possibly the Magazine's original premises in New Burlington Street, or proximity to Burlington House, or the man Lord Burlington – or a natural combination of all three. A fourth, related possibility would be the existence of the Burlington Fine Arts Club, founded as far back as 1866 but by the late nineteenth century attracting scholarly attention by the calibre of its old master exhibitions.

In any event, Richard Boyle, Third Earl of Burlington, has received a posthumous commemoration he could hardly have expected. It must have seemed ironic at the time of the Magazine's very early, acute financial crisis, as on occasion later, that he was the addressee of Pope's epistle, 'On the Use of Riches'.

Enough is established about the founding of the Burlington to credit chiefly a trio of scholars, ostensibly on friendly terms and at that date united by a mutual interest in Italian Renaissance painting: Bernard Berenson, Herbert Horne and Roger Fry. Remarkably – and fortunately – the Magazine was not launched to deal exclusively with painting of that period. After publishing one or two important articles in it, Berenson in any case soon detached himself from concern with or support for it. In the days of Benedict Nicolson's editorship, he would complain that it had become contaminated with the 'craze' for the Baroque. Even allowing for an element of tease, the comment seems that of some sad Rip Van Winkle rather than of a person who piqued himself on being a great aesthete. A more alert and regular reader would have noticed that contamination had begun already in 1915, when Martin Briggs published two articles entitled 'The Genius of Bernini'.

Horne is mainly remembered today as the author of a fundamental monograph on Botticelli. He was active, however, in a number of other directions, as architect and as editor, for example, as well as being a collector and, indeed, a connoisseur. In his short-lived, cumbersomely-named magazine, *Century Guild Hobby Horse* (1886–91), he had written an article on Inigo Jones, politely praised by Pater. It was Horne who made the most immediately visible contribution to the Burlington Magazine by designing its cover and its typography; neither changed greatly until after the Second World War.

Yet there can be no doubt that the most committed of the three, and the real hero of the Burlington's earliest, sometimes desperate struggles, was Roger Fry. He and Horne were friends and close contemporaries, but Horne died in Florence in 1916. Fry continued to be on the Consultative Committee until his own death in 1934. If not precisely the founder of the Burlington, he can be seen as effectively its patron saint, little though he would probably have cared for that designation. He valiantly championed it, intellectually watched over it, practically raised funds for it and took a part in editing it. Most relevantly, he wrote constantly for it.

The Magazine has always paid due tribute to Fry, and the Roger Fry who emerges from its pages provides a useful corrective to the still widely diffused notion of him as primarily concerned with advancing the cause of Post-Impressionism in England and as interpreting all works of art through a narrow concept of 'significant form'. Certainly, to Fry's initiative is owed the appearance of Maurice Denis in the Magazine, writing on Cézanne in 1909 (see p.12). But it was also Fry, in Berensonian guise, who published in 1911 an attribution to Baldovinetti of the profile portrait of a woman in yellow, in the National Gallery, now universally accepted. In 1905 he had published an

essay on Mantegna, a painter notoriously resistant to verbal analysis, 'Mantegna as a Mystic', which remains a suitably subtle and rigorous exploration of a stony, enigmatic artist. And as late in his career as 1933, he published a major painting, the 'Banquet of Cleopatra' (Melbourne), by Giambattista Tiepolo, a painter to whom he might be supposed antipathetic.

Exhibitions stimulated some of Fry's best writing. In 1910 he wrote two long articles reviewing the major exhibition of Mohammedan art held in Munich, and one of those I have preferred for inclusion here (p.20), although they are reprinted in *Vision and Design*, whereas the Mantegna article is still unreprinted. In any anthology painful choices of that kind are inevitable. My eventual preference was governed by a desire to show the Burlington prepared – from early on – to deal with the arts beyond conventional, European borders.

By the 1920s, the Burlington could reflect on having successfully survived a cataclysm of world dimensions, the 'Great War', an event fraught with danger to works of art and to the bonds of scholarship, quite apart from all its other horrors. The Magazine's respected international status was consolidated, and one testimony to that lies in the list of distinguished foreign contributors. The period from 1920 to 1933, the year in which Herbert Read became editor, has sometimes been assessed as a comparatively low point in the Burlington's scholarly prestige, but there were exceptions – such as Paul Jamot's article in 1922, publishing Poussin's two pictures of the story of Phocion. Other contributions in the period came from Reinach, Marcel Aubert, Hulin de Loo, Kingsley Porter and Max J. Friedländer. And in 1930 Campbell Dodgson published Dürer's 'Una Vilana Windish' (p.40). Terse the article may be by today's standards, but scrupulous in its scholarship and sensible in allowing a masterpiece of drawing to speak for itself.

During the 1920s, and for a time afterwards, the Burlington certainly tended to be over-receptive to dubious little articles asserting the attribution of some murky-looking picture, in an anonymous collection, to artists as great as Titian and Velázquez. And, notoriously, it published in 1937 an article by the aged Bredius, 'A New Vermeer', the *Supper at Emmaus*, which proved to be indeed 'new', a forgery by Van Meegeren.

But by the 1930s the Burlington was publishing major contributions from a fresh generation of gifted scholars in this country. Among them was Martin Davies, whose article on Ingres's second portrait of Madame Moitessier (p.53) has gained classic status. The young Douglas Cooper then chose to write under the pseudonym of 'Douglas Lord' (apparently a joky homage to Lord Alfred Douglas), but there is no mistaking the acuity of his review of a landmark exhibition in Paris in 1935 (p.51).

More intriguing than the case of Bredius's article is that of the article by Panofsky on the Arnolfini double portrait (in the National Gallery), published in 1934. That the Burlington welcomed so erudite and so convincing an interpretation is entirely comprehensible. The author became one of the most admired and influential of art historians, and his article seemed to have earned its own classic status. Only recently has its theory about depiction of a marriage ceremony been subjected to detailed, devastating analysis and rejection, and its erudition impugned. Panofsky himself never reprinted it, but it has often been in demand. While murmuring 'caveat lector', I have decided to include it here (p.42).

When Herbert Read signed the editorial in the issue of September 1939, he took the opportunity to re-assert the Burlington's policy of internationalism in its coverage of the arts and in its contributors, declaring his belief that the Magazine which had survived one war would survive another.

He was to be justified. There is something gallant and brave about the issues of the Burlington which appeared unfailingly throughout the Second World War. They seem a defiant proclamation of ultimate, civilised values, with editorials calmly discussing the inauguration of the National Gallery of Art in Washington or the restoration of Goya's frescoes in San Antonio de la Florida in Madrid. In 1943 an editorial was able to celebrate 'Number Five Hundred'. Unexpected artist contributors during the war years were Oskar Kokoschka, on baroque art in Czechoslovakia, and Augustus John, paying such eloquent tribute to the genius of his sister that it cried out for inclusion here (p. 72). A false report, as it happened, of the death of Ensor prompted Brinsley Ford's brilliantly entertaining obituary in 1942 (p.76). And in 1944 Ernst Gombrich published his magisterial elucidation of the previously puzzling subject of Poussin's 'Orion' (p.77).

The unprecedently long reign of Benedict Nicolson – for reign it was, despite his modest, un-regal demeanour – must be saluted as outstanding in the Magazine's history. Francis Haskell's obituary (p.146) says almost all that needs to be said, and says it shrewdly, affectionately and with splendid frankness, not overlooking idiosyncrasies that could occasionally be maddening. It should be read in combination with the generous but equally frank editorial of April 1977, probably by the same author, which had celebrated a thirty-year achievement.

Ben's intense, unwavering attachment to the Magazine took a variety of forms, including honest assessment of individual issues. I treasure the occasion when he told me gloomily, 'The June number is very dull'. Then, typically continuing his thought aloud, he added, 'It will interest you, Michael'. My laughter seemed to surprise him.

No other editor of the Burlington can have written so much and so frequently in it – and not just editorials but articles and exhibition reviews, long and short. And of course his own books were reviewed too. He wrote with great style as well as with scholarly authority, and to represent him by a single item has not been easy. But the subject of Caravaggio and the Netherlands was certainly one which engaged him passionately and knowledgeably (p.98).

A further aspect of his editorial activity is relevant here. With an innate, arguably over-developed bump of respect for older personalities in the international art-historical world, he yet had a keen eye for younger, sometimes unknown talent. Possibly without their friendship, Kenneth Clark would have published Piero della Francesca's St Augustine Altarpiece in the Burlington (p.81), but it was a real coup to get the great Giovanni Bellini exhibition in Venice reviewed in 1949 by Roberto Longhi. A coup of a different kind had occurred in the previous year when he published a first article on the sculpture of Henry Moore (p.87), by 'an impoverished youth' (in his own words) met by chance in Paris, one A.D.B. Sylvester.

In the aftermath of Ben's shockingly sudden death in 1978, the Magazine was fortunate to find in Terence Hodgkinson an ideal new editor, clear-headed, tactful, fastidious, and himself a distinguished scholar in the field of sculpture. Although he was editor for only a few years, until 1981, an unobtrusive widening of the Burlington's scope may be detected in that period, and I regret being unable, in the end, to represent it here. Perhaps his two twentieth-century successors, first Neil MacGregor and then Caroline Elam, professionally trained and profoundly versed in traditional art history but alive also to new attitudes, new emphases, new topics, would agree that their own conduct of the Magazine was partly inspired by his example and that of Benedict Nicolson.

* * *

Aside from all personalities, there remains the Burlington as a magazine. Having perused it for the purposes of this anthology, I was left with the strongest impression of its character as fixed, and fixed wisely, from the first. Even the nature and arrangement of the contents have remained remarkably the same: from editorial to articles separated by length (sensibly permitting the 'Shorter Notice'), followed by extensive book reviews and exhibition reviews.

What has changed since 1903 – and changed dramatically – is, of course, art history. Paragraphs if not pages would be needed to define all that the term now embraces, and to list all the institutions where it is now taught. But within a Burlington-British perspective, two events should, however briefly, be noted.

In 1930 the Courtauld Institute of Art was established in London, putting the history of art on a professional academic basis, with implications which Roger Fry immediately recognised, declaring in a letter to the Burlington: 'this scheme gives us a new hope for the future of art in England'. Three years later, the Warburg Institute transferred from Hamburg to London. The forced exodus of scholars from Germany and Austria was one of the most shameful episodes even in twentieth-century history, but paradoxically its effect was beneficial for the Anglo-Saxon world. England in particular gained from an institute where the visual arts were studied in a wide cultural context.

Together, the two events worked to remove from art history any taint of amateurism and to distance it from connoisseurship. Benedict Nicolson had recognised the position and in effect brought the magazine up to date when he banished 'connoisseurs' from its cover. But I do not believe that he meant to banish connoisseurship from its contents.

That hints at the challenging, complex, position today. 'History', in the sense of cultural study of an artefact, still needs 'art' in the sense of knowing at least when an artefact was made, even if indifferent to its aesthetic quality or any individual maker of it. And 'art'. especially as traditionally interpreted by scholars in British galleries and museums, can only be enriched by seeing dimensions beyond the object itself. To remain open to the divergent aspects – if in reality they *are* divergent – is perhaps what the Burlington's own history has fitted it ideally to do.

The secret of the Burlington's success, I conclude, the chief reason why it stands so high in international repute, lies – and has always lain – in its pragmatic approach. It has responded to the various forms and the ever-increasing professionalism of the discipline, but it has never been the organ for any particular theory of art history, never been dominated by a single narrow viewpoint of any kind. That pragmatism is what I have tried to reflect. Those who know it have probably a very good idea of what continues to constitute a 'Burlington' article, cogent, not diffuse, scholarly yet readable – or at least jargon-free – and often with a factual basis. In a word, something that can truly be said to make a contribution to knowledge.

The Magazine started as it was to go on. Speedily, pragmatically, its editorials took an authoritative tone upon general artistic affairs, whether the acquisitions policy of the National Gallery (a favourite theme down the years) or the protection of buildings in London (p.10). Today's professional art historians would be wrong to assume superiority over the 'connoisseurs' who launched it and were to write for it. If this anthology does nothing else, it may help to drive home the point. How striking, even perhaps humbling, to find in the first issue of March 1903, for example, William Michael Rossetti discussing the work of Elizabeth Siddal (p.1), and with the unique advantage of having known her.

I began by declaring that my task in compiling this anthology had been largely agreeable, occasionally amusing and always enlightening. If readers of the result share

a tithe of those feelings, I shall think myself rewarded in the nicest way possible: beyond my deserts.

However, if only in fairness to the other people involved, I must make clear the limits of my responsibility for this publication. The attractive design, clear typography and spacious lay-out were planned by Sally Salvesen of the Yale University Press, to whom I feel grateful – as will indeed all readers. Apart from once or twice correcting extremely minor and obvious factual slips, I have not attempted to alter or update any of the articles selected. Editorial notes have been supplied by Caroline Elam, and in her hands have been such editorial matters as curtailment of texts and the choice of illustrations reproduced in the volume.

ACKNOWLEDGEMENTS

My prime debt of gratitude is to Sir Christopher White who, when Chairman of the Board of Directors of The Burlington Magazine, kindly invited me to compile this anthology; he has always been available to advise and support, and has throughout been both patient and encouraging.

To Caroline Elam, editor of the Magazine during the period of my involvement, I am indebted in numerous ways, starting with the practical, arduous matter of ferrying batches of it to me, with great goodwill. She generously provided information and references to the benefit of my Introduction, and I want to express my particular indebtedness to her important essay, 'Roger Fry and Early Italian Painting' in the catalogue of the exhibition, *Art Made Modern, Roger Fry's Vision of Art*, edited by Christopher Green, Courtauld Gallery, London, 1999–2000, pp. 87–106, while thanking her also for much stimulating conversation upon Fry and other topics.

Some of my references to the early years of the Burlington, and to Benedict Nicolson, derive from his article, 'The Burlington Magazine', published in *The Connoisseur*, March 1976, pp. 177–83.

For knowledgeable comment about the early years of the National Art-Collections Fund, and for providing me with detailed information about foreign periodicals, I am warmly grateful to Alyson Wilson, whose kind interest in the whole project I have much appreciated.

Finally, I must thank Caryl Yendell of Louth Secretarial Services for once again coping efficiently and speedily with an untidy typescript, and also for saving me from at least one slip in spelling.

M.L.
September 2002

NOTES ON THE CONTRIBUTORS

compiled by Caroline Elam

JEAN ADHÉMAR (1908–87) was a distinguished art historian who became Director of the Cabinet des Estampes at the Bibliothèque Nationale, Paris (1961–77), and wrote on the art of the French renaissance and on nineteenth-century prints and drawings and art criticism, editing Diderot's *Salons* with Jean Seznec. Earlier in his career he was the Paris correspondent for the Warburg Institute in London and he wrote a book on antique influences on medieval French art. An occasional contributor to the Burlington, he was editor of the *Gazette des Beaux-Arts* from 1956 and founder of the *Nouvelles de l'estampe* in 1965.

DAVID BOMFORD (1946–) is Senior Restorer in the Department of Conservation, National Gallery, London. He has co-authored many National Gallery publications, including *Rembrandt* (1988), *Italian painting before 1400* (1989), *Impressionism* (1990) and *Underdrawings in Renaissance Paintings* (2002) in the 'Art in the Making' series. He was Slade Professor of Fine Art in Oxford University 1996–97 and has been Secretary-General of the International Institute for Conservation since 1993.

J.B. BULLEN (1942–) is Professor of English Literature at the University of Reading. He has a long-standing interest in the relationship between literature and the visual arts and has published, *inter alia*, books on *Post-Impressionists in England: The Critical Reception* (1988), *The Myth of the Italian Renaissance in Nineteenth Century Writing* (1994) and *The Pre-Raphaelite Body: Fear and Desire in Painting, Poetry and Criticism*. He has contributed several articles to the Burlington, and has just published a book on the Byzantine Revival in Europe and America.

ANDREW BUTTERFIELD (1959–) is a Director of Salander O'Reilly Galleries, New York. He is the author of *The Sculptures of Andrea del Verrocchio* (1997), and has written many articles for scholarly journals including the Burlington, as well as being a contributor to *New Criterion* and the *New York Review of Books*.

LORNE CAMPBELL (1946–) is Research Curator at the National Gallery, London. He is a specialist on early Netherlandish painting and has written catalogues of these holdings in the Royal Collections (1985) and the National Gallery (1998), as well as a book on *Renaissance Portraits* (1990). He has published many articles and reviews in the Burlington, and is a member of the Consultative Committee.

KENNETH CLARK (1903–83). Sir Kenneth Clark, in addition to his importance as an art historian and museum director, was a collector and supporter of living artists and a great populariser of art through the media of lecturing and television as well as print (publishing such influential books as *Landscape into Art* and *The Nude*). He was Director of the Ashmolean Museum, Oxford (1931–34) and of the National Gallery, London (1934–45, also serving as Surveyor of the King's Pictures (1934–44). His catalogue of the Leonardo drawings at Windsor (with Carlo Pedretti), along with his monographs on Leonardo and Piero della Francesca, are among his outstanding contributions to art history. A friend and great admirer of Roger Fry, he encouraged the early career of Benedict Nicolson, and so connects two eras of the Burlington, to which he contributed a number of articles, as well as serving on the Editorial Board.

DOUGLAS COOPER ('Douglas Lord') (1911–84), a major collector of Cubist paintings, drawings and sculptures, wrote widely on nineteenth- and twentieth-century art and artists and was a lifelong polemicist, in particular a relentless critic of the acquisition policies of the Tate Gallery. His association with the Burlington was long but stormy, involving much ferocious correspondence with the editor, Benedict Nicolson. He wrote nearly two dozen articles for the Magazine under his own name, in addition to many pseudonymous reviews one of which is reprinted here.

MARTIN DAVIES (1908–75). Sir Martin Davies devoted his entire career to the National Gallery, London, becoming Keeper in 1960 and Director in 1968. The series of revised catalogues of the gallery's collection arranged under national schools, which he instituted in 1937, himself contributing volumes on the Early Netherlandish, French, British and Early Italian schools, have remained models of scrupulous erudition and concision. He contributed around a dozen articles to the Burlington.

MAURICE DENIS (1870–1943), a member of the Nabi group of artists who exhibited with the symbolists and Neo-Impressionists, was also an important theorist of formalism whose ideas profoundly influenced Roger Fry. Fry hoped that his essay on Cézanne, reprinted here, would help to make the Burlington 'a real power' among those 'who are keen about the future of modern art'.

ALAN DERBYSHIRE (1954–) is a Senior Paper Conservator at the Victoria and Albert Museum. He has written numerous articles, and taught and lectured extensively on paper conservation and on the conservation of portrait miniatures.

CAMPBELL DODGSON (1867–1948), an international authority on German prints and drawings, was Keeper of the Department of Prints and Drawings at the British Museum from 1912 until his retirement in 1932. A member of the Consultative Committee of the Burlington from its foundation in 1903, Dodgson was already by then a contributor to French, Italian and German art history periodicals and went on to edit *Print Collector's Quarterly* and to found *Old Master Drawings*. He contributed over fifty articles to the Burlington.

C.R. DODWELL (1922–94). Reginald Dodwell was a distinguished historian of medieval art, making significant contributions to the study of English manuscript illumination and of all types of medieval artefact in books such as *Anglo-Saxon Art: a New Perspective* (1982) and *The Pictorial Arts of the West 800–1200* (1993). As Professor of the History of Art at the University of Manchester for over twenty years (1966–89), he was also Director of the Whitworth Art Gallery, where he mounted ambitious international loan exhibitions.

ROBERT ENGGASS (1921–) is Professor Emeritus of Art at the University of Georgia. He has published a monograph on the paintings of Giovanni Battisti Gaulli, il Baciccio (1964) and a catalogue raisonné of early eighteenth-century sculpture in Rome (1976). He has been a regular contributor to the Burlington.

SVEND ERIKSEN (1923–) is the leading Danish authority on the history of the decorative arts, specialising in French eighteenth-century furniture and porcelain. He contributed several pioneering articles in the Burlington on the birth of Neo-classicism, subject of his book *Early Neo-Classicism in France* (1974), and is the author, with Geoffrey de Bellaigue, of *Sèvres Porcelain: Vincenne and Sèvres 1740–1800* (1987).

SHARON FERMOR (1956–) is Senior Lecturer at the History of Art Department, University of Warwick, and before that was Curator of Paintings at the Victoria and Albert Museum. She is the author of *Piero di Cosimo, fiction, invention and fantasia* (1993) and *The Raphael Tapestry Cartoons* (1996)

BRINSLEY FORD (1908–99). Sir Brinsley Ford was the last of the great collector-*dilettanti* and an authority on his spiritual forebears, the British collectors and artists who made the Grand Tour to Italy. He was Chairman of the National Art

Collections Fund (1975–80) and an unflagging patron of young artists. A contributor to the Burlington from 1939 onwards, he was a member of the Editorial Board from 1952 and later a Director and a Trustee. He personally negotiated the Magazine's survival on at least two occasions.

ROGER FRY (1868–1934), painter and writer on art, was closely associated with the Burlington from before its first issue in March 1903 to the end of his life, and co-editor from 1909 to 1919. Initially his writing focused primarily on early Italian painting, but from c.1908 his (and the Magazine's) interests broadened to encompass, *inter alia*, Post-impressionism and contemporary French painting, Asian, Islamic and African art as well as all aspects of aesthetics.

E.H. GOMBRICH (1909–2002). Sir Ernst Gombrich was one of the greatest art historians of the twentieth century, celebrated for his *Story of Art*, for his innovatory work on art and the psychology of perception, and for his studies of iconography. Born and trained in Vienna, he emigrated to England in 1936 to work at the Warburg Insitute of which he was Director from 1959 to 1976. He was a member of the Consultative Committee of the Burlington and contributed many articles to it, engaging vigorously in the 'cleaning controversy' of the 1950s.

ENRIQUETA HARRIS (1910–). Enriqueta Harris Frankfort is the leading authority outside Spain on Spanish painting from El Greco to Goya and his followers. An Honorary Fellow of the Warburg Institute, she was the Curator of the Photographic Collection there from 1949 to 1970. Author of an outstanding monograph on Velázquez (1982), she has been a constant contributor to the Burlington since 1938.

FRANCIS HASKELL (1928–2000), one of the greatest and most influential art historians of the twentieth century, was from 1967 to 1995 Professor of the History of Art at Oxford University. He wrote pioneering studies of patronage and the history of collecting and taste (*Patrons and Painters*, 1963, *Rediscoveries in Art*, 1976) and on the uses made by historians of visual sources (*History and its Images*, 1997). A member of the Consultative Committee of the Burlington since 1968, he joined the Editorial Board in 1972 and was Chairman from 1978–89, seeing the Magazine through to its independent charitable status in 1986.

HUGH HONOUR (1927–) is a polymathic historian of all aspects of the visual arts of all periods, the author of major specialist studies of Canova and Neo-classicism as well as of indispensable dictionaries, works of reference and general surveys (*A World History of Art*, 1982 and subsequent eds.), written in collaboration with the late John Fleming, with whom he founded the influential *Style and Civilisation* series for Penguin Books.

IAN JENKINS (1953–) is Keeper of Presentation at the British Museum, where until recently he was Senior Curator

in the Department of Greek and Roman Antiquities. His books include *Vases and Volcanoes, Sir William Hamilton and his Collection* (1996 with Kim Sloan), *The Parthenon Frieze* (1994) and *Archaeologists and Aesthetes in the Sculpture Galleries of the British Museum* (1992). He has a long-standing interest in the after-life of Greek and Roman art in recent centuries.

AUGUSTUS JOHN (1878–1961), the painter and accomplished draughtsman and printmaker, studied under Henry Tonks (q.v.) at the Slade School, and had a long and prolific career, achieving particular success as a portrait painter. He himself felt he would be remembered only as the brother of the painter Gwen John. His appreciative note about her work, reprinted here, was followed by a couple of other contributions to the Magazine, on Rembrandt and Holbein.

OTTO KURZ (1908–75) was a prodigiously erudite and wide-ranging Austrian art historian who, through both the Courtauld Institute, where he taught during the Second World War, and the Warburg Institute, where he became Librarian in 1949 and Professor of the History of the Classical Tradition in 1965, had a profound influence on the development of art history in Britain, not least through his interest in Bolognese Seicento art (he wrote his doctoral thesis on Guido Reni, 'then at the nadir of his reputation' – Gombrich). Always eschewing narrow specialism, he espoused subjects as diverse as fakes and forgeries, oriental Christian manuscripts, European clocks and watches, and the history of food. He was a member of the Consultative Committee of the Burlington, to which he made frequent contributions from 1937.

JAMES MANN (1897–1962). Sir James Gow Mann, an outstanding figure in the study of arms and armour, was Keeper of the Wallace Collection (1936–62), Master of the Armouries at the Tower of London (1939–62), Surveyor of the King's (and later Queen's) Works of Art (1946–62), as well as being briefly Deputy Director of the newly founded Courtauld Institute of Art (1932–36). His scholarly involvement with arms and armour dated from his early childhood and he retained 'a deep, almost boyish streak of romanticism'. His catalogue of the arms and armour at the Wallace Collection remains a standard work.

NEIL MACLAREN (1909–1988) joined the staff of the National Gallery in 1934 as Assistant Keeper with responsibility for the Spanish, Dutch and Flemish schools. He supervised the evacuation of the collection in 1939 and had responsibility for the building during the war, sleeping in the basement. In 1949 he was appointed Deputy Keeper and took charge of the Conservation Department. His publications included catalogues of the National Gallery Spanish paintings (1952) and Dutch paintings (1960). In 1961 he joined Sotheby's as Assistant Director.

OLIVER MILLAR (1923–). Sir Oliver Millar, a leading authority on British art from the sixteenth to the nineteenth centuries, was Surveyor of the Queen's Pictures from 1972 to 1988 and the first Director of the Royal Collection (1987–88). He is the co-author of *English Art 1625–1714* (1957) and has catalogued the Tudor, Stuart, Georgian and Victorian paintings in the Royal Collection, as well as organising and writing the catalogues of a series of major exhibitions. He is a Trustee of the Burlington Magazine Foundation and has contributed many articles and reviews to the Magazine.

BENEDICT NICOLSON (1914–78) was a distinguished and pioneering historian of the international phenomenon of Caravaggism, who also wrote important monographs on Georges de la Tour and Joseph Wright of Derby. Editor of the Burlington from 1947 to 1978, he left an indelible stamp on the Magazine, making it, *inter alia*, a major forum for discoveries in the field of seventeenth-century painting. For his career and character, see Francis Haskell's obituary, reprinted here, pp.146–49.

ERWIN PANOFSKY (1892–1968) was one of the most important art historians of the twentieth century concerned with interpreting the meanings of works of art. Associated with the Bibliothek Warburg in Hamburg, he was professor of art history at the university there from 1926 to 1934, when he emigrated to the USA, holding professorships at Princeton, New York and Harvard. The article on Van Eyck's *Arnolfini* portrait is one of three he contributed to the Burlington, a tiny fraction of his huge and influential art-historical output.

ROLAND PENROSE (1900–84), the founder of the British Surrealist Group and organiser of the first International Surrealist Exhibition in London (1936), was an artist and poet, collector and patron, husband of the photographer Lee Miller. He founded and sponsored the Institute of Contemporary Arts and played a major role in organizing its exhibitions. He was a friend (and biographer) of Picasso, whose portrait of Kahnweiler is the subject of his essay reprinted here.

JOHN POPE-HENNESSY (1913–94), a major authority on Italian renaissance painting and sculpture, was Keeper of the Department of Sculpture at the Victoria and Albert Museum from 1954, becoming Director of the museum in 1967. After two years as Director of the British Museum (1974–76) he moved to New York as chairman of the Department of European Paintings at the Metropolitan Museum. He wrote, *inter alia*, pioneering books on Sienese Quattrocento artists and an important survey of Italian gothic, renaissance and baroque sculpture. While not always seeing eye to eye with the editorial direction of the Burlington, he contributed nearly thirty articles to the Magazine, as well as numerous reviews, and was a member of the Editorial Board as well as of the Consultative Committee.

BERNARD RACKHAM (1876–1964), brother of the book-illustrator Arthur Rackham, spent his entire career at the Victoria and Albert Museum, where he was Keeper of Ceramics for nearly twenty-five years. In his obituary in the Burlington (CVI [1964], pp.424–25) he is described as 'the creator of ceramic studies in this country as we know them today'. Best known for his pioneering research on Italian maiolica, he had very wide interests in both ceramics and glass, and contributed over fifty articles to the Burlington.

HERBERT READ (1893–1968). Sir Herbert Read, as well as being a poet and autobiographer, was an important critic and theorist of modern art, who also espoused an idiosyncratic form of anarchism. His extraordinarily many-sided life involved the Civil Service, the Victoria and Albert Museum where he worked in the Department of Ceramics, the professorship of art history at Edinburgh University, advice to Peggy Guggenheim on her collection, presidency of the Institute of Contemporary Arts, and war-time educational research for London University, as well as a stream of influential books on modern art. From 1933 to 1939 he was Editor of the Burlington, to which he had earlier contributed articles on ceramics and glass, and he remained loyal to what his biographers call this 'stuffy' Magazine, serving as Chairman of the Board until his death.

DAVID RODGERS (1942–99) was director of the Wolverhampton Art Gallery from 1969 to 1981 where he built up an important collection of British and American Pop Art and published the catalogue of its paintings (1976). He moved to the Exeter Museum and then to the Geffrye Museum, London, where he was director from 1986 to 1990. He was also the author of books on *Rossetti* (1996) and *William Morris at Home* (1996) and a contributor to *The Oxford Companion to Western Art* (2001).

J.M. ROGERS (1935–) a leading scholar of Islamic art, has been Deputy Keeper in the Department of Oriental Antiquities of the British Museum and Professor of Islamic Art at the School of Oriental and African Studies, London University (1991–2000). He is now Honorary Curator of the Nasser D. Khalili Collections. He is the author of many studies of Islamic art, including *The Spread of Islam* (1976), *Islamic Art and Design 1500–1700* (1983) and *Empire of the Sultans: Ottoman art from the collection of Nasser D. Khalili* (1995). He is a member of the Consultative Committee of the Burlington, to which he is a regular contributor.

WILLIAM MICHAEL ROSSETTI (1829–1919), younger brother of Dante Gabriel Rossetti, was secretary of the Pre-Raphaelite Brotherhood and editor of *The Germ*. A poet and critic, he published many studies of the work of his brother, and also wrote on Blake and Whistler. The article reprinted here was his only contribution to the Burlington.

ANDRÉ SALMON (1881–1969), poet and critic, was a friend of Picasso and Apollinaire and an early chronicler of Cubism. He wrote regular art criticism for foreign as well as French periodicals and in addition to the article on Negro art reprinted here, contributed a piece on Seurat in 1937 to the Burlington.

ALEXANDRA SHATSKIKH is a leading authority on the Russian avant-garde, suprematism and the art of Kasimir Malevich. A researcher at the State Institute of Art Studies in Moscow, she is the author of, *inter alia*, the *Collected Works of Kasimir Malevich* in five volumes, of which vols 1–3 have been published and vol. 4 is forthcoming, spring 2003.

A.D.B. SYLVESTER (1924–2001). David Sylvester was one of the best-known critics of twentieth-century art in the post-War period, and an outstanding curator of exhibitions. Remembered especially for his writings on Giacometti and Francis Bacon, and for his monumental catalogue raisonné of the paintings of Magritte, he first established his reputation with the article on the sculpture of Henry Moore reprinted here

HENRY TONKS (1862–1937) was a painter, lifelong supporter of the New English Art Club and Professor at the Slade School of Art, University College, London, where he taught several generations of outstanding British artists including Augustus John (q.v.), Stanley Spencer, Wyndham Lewis and Mark Gertler. On the whole, he deplored the influence of Roger Fry. The obituary of Sir Hugh Lane reprinted here was his only contribution to the Burlington.

E.K. WATERHOUSE (1905–85). Sir Ellis Waterhouse was a distinguished museum director and art historian who made major contributions to the study of Italian baroque painting and British eighteenth-century art and had an unrivalled knowledge of the provenance of works of art. The last eighteen years of his official career (1952–70) were spent as Director of the Barber Institute at the University of Birmingham for which he made discerning acquisitions. He wrote dozens of articles and reviews for the Burlington, and from the mid-1940s until 1947 was effectively Editor, while refusing to be named on the masthead.

RUDOLF WITTKOWER (1901–71), the great historian of Italian renaissance and baroque sculpture and architecture, was trained in Munich and Berlin and emigrated first to London in 1934 where he worked at the Warburg Institute and was Professor of the History of Art at University College, then to the U.S.A where he spent the last sixteen years of his career at Columbia University. A founding co-editor of the Warburg Institute *Journal*, he published several articles in the Burlington.

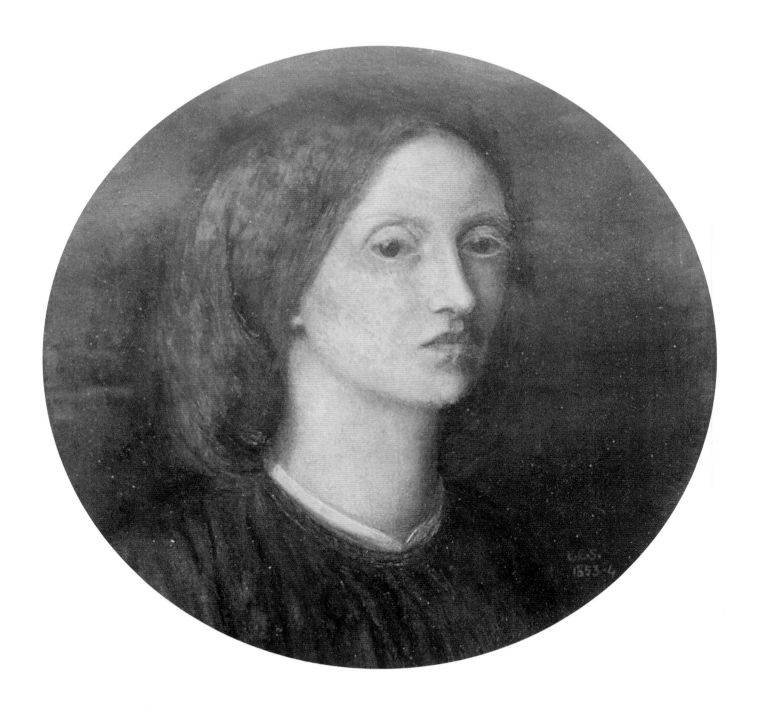

1. *Self-portrait*, by Elizabeth Siddal. 1853–54. Diameter 22.86 cm.
(Private Collection).

W. M. ROSSETTI

Dante Rossetti and Elizabeth Siddal

Having been invited to say something about the designs of Miss Siddal by Rossetti, here reproduced (by kind permission of their present owner, Mr Harold Hartley), I make this the opportunity for writing a brief monograph of the woman who bore so large a part in the painter's earlier life. I have before now written and edited various details concerning her, and shall have to repeat myself to some extent; but those details did not form a consecutive unity, and I think she is well entitled to something in the nature of express biographic record. Her life was short, and her performances restricted in both quantity and development; but they were far from undeserving of notice, even apart from that relation which she bore to Dante Rossetti, and in a very minor degree to other leaders in the 'Præraphaelite' movement. I need hardly say that I myself knew her and remember her very well.

I may begin by mentioning that the correct spelling of the surname appears to be Siddall: but Dante Rossetti constantly wrote Siddal, and I follow his practice. Elizabeth Eleanor Siddal was the daughter of a Sheffield cutler, and was born in or about 1834; as my brother was born in May 1828, she was some six years his junior. The family came to London – Newington Butts or its neighbourhood; this, I take it, was before the birth of Elizabeth. I do not know when the father died; it must have been prior to the time when Elizabeth was known in any artistic circle. The mother survived, along with three sons and three daughters; one or more of the sons continued the cutlery business. Elizabeth received an ordinary education, conformable to her condition in life; she became an assistant or apprentice in a bonnet shop in Cranbourne Alley, then a very well-known line of shops close to Leicester Square.

In Elizabeth Siddal's constitution there was a consumptive taint. This may, I suppose, have come from the father; for the mother was a healthy woman, living on till past ninety. Two sons and two daughters are still alive, or were so very recently. Almost the only anecdote that I have heard of Elizabeth's early life, before she came into my circle, is that 'she had read Tennyson, having first come to know something about him by finding one or two of his poems on a piece of paper which she brought home to her mother, wrapped round a pat of butter'.

Elizabeth was truly a beautiful girl; tall, with a stately throat and fine carriage, pink and white complexion, and massive straight coppery-golden hair. Her large greenish-blue eyes, large-lidded, were peculiarly noticeable. I need not, however, here say much about her appearance, as the designs of Dante Rossetti speak for it better than I could do. One could not have seen a woman in whose whole demeanour maidenly and feminine purity was more markedly apparent. She maintained an attitude of reserve, self-controlling and alien from approach. Without being prudish, and along with a decided inclination to order her mode of life according to her own liking, whether conformable or not to the views of the British matron, she was certainly distant. Her talk was, in my experience, scanty; slight and scattered, with some amusing turns, and little to seize hold upon – little clue to her real self or to anything determinate. I never perceived her to have any religion; but a perusal of some of her few poems may fairly lead to the inference that she was not wanting in a devotional habit of feeling.

The Præraphaelite Brotherhood, or P.R.B., was formed towards September 1848 – the principal painter-members being William Holman-Hunt, John Everett Millais, and Dante Gabriel Rossetti. A leading doctrine with the Præraphaelites (and I think a very sound one) was that it is highly inexpedient for a

painter, occupied with an ideal or poetical subject, to portray his personages from the ordinary hired models; and that on the contrary he ought to look out for living people who, by refinement of character and aspect, may be supposed to have some affinity with those personages – and, when he has found such people to paint from, he ought, with substantial though not slavish fidelity, to represent them as they are. This plan would secure (1) some general conformity between the painter's idea of his personages and the individuals from whom he pictures them; and (2) a lifelike treatment of a living countenance, with its precious personal vitality, and *nuances* of mould and character – things which it is difficult or impossible to obtain from 'inner consciousness', but which nature supplies in lavish superabundance. In other words, the artist had to furnish the conception; nature had to furnish the model; but this must not be a model obviously unresembling.

Walter Howell Deverell was a young painter of promising gifts, and a very handsome one: he was not a P.R.B., but was much associated with the members of the Brotherhood, and with none of them more than with Rossetti. He was a son of the secretary to the Government School of Design at Somerset House, which in the course of years developed into the Department of Science and Art. One day, which may have been in the latter part of 1849, he accompanied his mother to a bonnet-shop in Cranbourne Alley. Looking from the shop through an open door into a back room, he saw a very young woman working with the needle: it was Elizabeth Siddal. Deverell was at this time beginning a well-sized picture from Shakespeare's *Twelfth Night* – the scene where the Duke Orsino, along with Viola habited as a page, and the Jester, is listening to some music. Deverell wanted to get a model for Viola, and it struck him that here was a very suitable damsel for his purpose – and, indeed, he could not have chosen better. So he asked his mother to obtain from the shop-mistress permission for her assistant to sit to him. The permission was granted, and the Viola was painted, and is a very fair likeness of Miss Siddal at that early date. Soon afterwards Deverell drew another Viola from her, in an etching for *The Germ*. Rossetti sat to his friend for the head of the Jester in the oil picture, and it was probably in the studio of Deverell that he first met his future wife. The picture was exhibited in 1850. It belonged at one time to William Bell Scott, the painter and poet; afterwards to a lady in Wales, who, dying, left it under trusteeship.

Rossetti saw that Deverell had secured a very eligible model for his Viola, and that the same model would suit himself extremely well for a Dante's Beatrice or something else. She consented to sit to him, and he painted from her a number of times; the first coloured example seems to have been his little water-colour named *Rossovestita* (1850). I shall not here dwell upon other instances, but leave this over for a list before I conclude. To fall in love with Elizabeth Siddal was a very easy performance, and Dante Gabriel transacted it at an early date – I suppose before 1850 was far advanced. She sat also to Holman-Hunt and to Millais – not I think to anyone else. Her head appears in Holman-Hunt's pictures of the *Christian Missionary persecuted by the Druids* (1850) and of *Valentine rescuing Sylvia from Proteus* (1851); and in Millais's *Ophelia* (1852). Of these three versions of her face, the Ophelia is the truest likeness, and is indeed a close one, only that the peculiar poise of the head thwarts the resemblance to some extent.

At what precise date Dante and Elizabeth were definitely engaged I am not able to say: it may probably have been before the end of 1851, and I presume that about the same time she finally gave up any attendance in the bonnet-shop. The name Elizabeth was never on Dante's lips, but Lizzie or Liz; or fully as often Guggums, Guggum, or Gug. Mrs Hueffer, the younger daughter of Ford Madox Brown, tells an amusing anecdote how, when she was a small child in 1854, she saw Rossetti at his easel in her father's house, uttering momently, in the absence of the beloved one, 'Guggum, Guggum'. Lizzie was continually in Rossetti's studio, 14, Chatham Place, Blackfriars, *tête-à-tête*. Sometimes she was sitting to him, but they were often together without any intention or pretence of a sitting; as time advanced she was frequently also drawing or painting there for her own behoof. This may have begun some considerable while before July 1854; but it seems to have been only about that date that Rossetti thought expressly that she would do well to turn to professional account the gifts for art which, though not cultivated up to the regulated standard, she manifestly possessed and clearly exemplified. After a while 'Guggum' became so much of a settled institution in the Chatham Place chambers that other people understood that they were not wanted there in and out – and I may include myself in this category. The reader will understand that this continual association of an engaged couple, while it may have gone beyond the conventional fence-line, had nothing in it suspicious or ambiguous, or conjectured by any one to be so. They chose to be together because of mutual attachment, and because

Dante was constantly drawing from Guggum, and she designing under his tuition. He was an unconventional man, and she, if not so originally, became an unconventional woman. As Algernon Swinburne, who knew her well in after years, once said in print, but with a different reference: 'It is impossible that even the reptile rancour, the omnivorous malignity, of Iago himself, could have dreamed of trying to cast a slur on the memory of that incomparable lady whose maiden name was Siddal and whose married name was Rossetti.' Dante was also occasionally, but I think seldom, in the house where Lizzie lived: 'her native crib, which I was glad to find comfortable', as he termed it, with his usual proclivity towards the slangy in diction.

Nothing, I suppose, was more distant from Miss Siddal's ideas in her earlier girlhood than the notion of drawing or painting; but, under incitement from Rossetti, she began towards the close of 1852. The first design of hers which I find mentioned was from Wordsworth's *We are Seven*, January 1853. In 1853–54 she painted a portrait of herself – the most competent piece of execution that she ever produced, an excellent and graceful likeness, and truly good: it is her very self. This work (Fig. 1) remains in my possession, and there are few things I should be sorrier to lose. Other early designs are – a pen-and-ink drawing of *Pippa and the Women of Loose Life*, from Browning's drama; a water-colour of the *Ladies' Lament*, from the ballad of Sir Patrick Spens; two water-colours from Tennyson, *St Agnes' Eve* and *Lady Clare*; a spectral subject, water-colour, *The Haunted Tree*. All these are in my hands, except the *Patrick Spens*, which belongs to Mr Watts-Dunton. There was an idea that she, along with Rossetti, would illustrate a ballad-book compiled by William Allingham. This project lapsed; but she produced (May 1854) a design of *Clerk Saunders*, which afterwards she developed into a water-colour, about her completest thing except the portrait. It was purchased by the American scholar Professor Eliot Norton; later on in 1869 Rossetti got it back, and it is now in the fine collection of Mr Fairfax Murray. 'It even surprised me', Rossetti wrote to Professor Norton, 'by its great merit of feeling and execution'. By 1854 she had also produced designs of Rossetti's *Sister Helen*, *The Nativity*, *The Lass of Lochroyan*, and *The Gay Gos-hawk* – the latter two for the Ballad-book. Two water-colours, *La Belle Dame Sans Merci*, and the old design of *We are Seven*, were in hand at the beginning of 1855. There was also a design, pen-and-ink, of *Two Lovers* seated *al fresco*, and singing to the music of two dark Malay-looking women, while a little girl listens. This properly belonged by gift to Allingham, but got sold inadvertently to Ruskin. She made some designs to be executed in carving in Trinity College, Dublin, a building carried out by Benjamin Woodward (the architect of the Oxford Museum). One of the designs represented 'an angel with some children and all manner of other things', and it was supposed to be *in situ* in 1855, but I see it stated that no such work is now traceable there. She began late in 1856 an oil-picture from one of the ballad-subjects, probably *The Lass of Lochroyan*. This I think is not now extant, but there is a water-colour of it.

The total of designs made by Lizzie, coloured and uncoloured, was somewhat considerable, allowing for the short duration of her artistic activity. I question whether she produced much at a date later than 1857; but she certainly produced something after as well as before her marriage – she was at work at the end of November 1860, and probably later. In January 1862 the drawing-room at 14 Chatham Place was entirely hung round with her water-colours of poetic subjects; and there must at that time have been several others in the possession of Ruskin, and not of him alone. This drawing-room was papered from a design made by Rossetti; trees standing the whole height of the wall, conventionally treated, with stems and fruit of Venetian red, and leaves black, and with yellow stars within a white ring: 'the effect of the whole', he said, 'will be rather sombre, but I think rich also'. As to the quality of her work, it may be admitted at once that she never attained to anything like masterliness – her portrait shows more competence than other productions; and in the present day, when vigorous brush-work and calculated 'values' are more thought of than inventiveness or sentiment, her performances would secure little beyond a sneer first, a glance afterwards, and a silent passing by. But in those early 'Præraphaelite' days, and in the Præraphaelite environment, which was small, and ringed round by hostile forces, things were estimated differently. The first question which my brother would have put to an aspirant is, 'Have you an idea in your head?' This would have been followed by other questions, such as: 'Is it an idea which can be expressed in the shape of a design? Can you express it with refinement, and with a sentiment of nature, even if not with searching realism?' He must have put these queries to Miss Siddal practically, if not *viva voce*; and he found the response on her part such as to qualify her to begin, with a good prospect of her progressing. She had much facility of invention and composition, with eminent

purity of feeling, dignified simplicity, and grace; little mastery of form, whether in the human figure or in drapery and other materials; a right intention in colouring, though neither rich nor deep. Her designs resembled those of Dante Rossetti at the same date: he had his defects, and she had the deficiencies of those defects. He guided her with the utmost attention, but I doubt whether he ever required her to study drawing with rigorous patience and apply herself to the realizing of realities. It should be added that her health was so constantly shaky, and often so extremely bad, that she was really not well capable of going through the toils of a thorough artist-student.

Ruskin made himself personally known to Rossetti in April 1854, by calling at his studio: he had some little while before seen and praised some of the painter's works. He struck up a close friendship with my brother, and undertook to buy, in a general way, whatever the latter might have to offer him from time to time: the prices to be paid were not lavish, but they were such as Rossetti, at that stage of his practice and repute, was highly pleased to accept. Through Rossetti, Ruskin knew Miss Siddal before the end of 1854. He took the greatest pleasure in her art-work, present and prospective. She visited at his house, with Rossetti, in April 1855. He 'said she was a noble, glorious creature, and his father said that by her look and manner she might have been a countess'. In March of this year John Ruskin (as Rossetti wrote) 'saw and bought on the spot every scrap of design hitherto produced by Miss Siddal. He declared that they were far better than mine, or almost than anyone's, and seemed quite wild with delight at getting them. He is going to have them splendidly mounted, and bound together in gold.' The price which Dante Gabriel named for the lot was certainly modest, £25: Ruskin made it £30. In May of this same year Ruskin settled £150 per annum on Miss Siddal, taking, up to that value, any works which she might produce. This arrangement held good, if I am not mistaken, up to 1857, but was then allowed to lapse, with reluctance on the generous writer's part, upon the ground that the state of her health did not admit of her meeting her share in the engagement in a continuous and adequate manner. Ruskin called Miss Siddal Ida (from Tennyson's 'Princess'), and befriended her to the utmost of his power in various ways – getting her to visit Oxford, and place herself under the advice of Dr Acland who pronounced (and I fancy with a good deal of truth) that the essence of her malady was 'mental power long pent up and lately overtaxed.' It is too clear,

however, that the germs of consumption were present, with neuralgia, and (according to one opinion) curvature of the spine. One result of Ruskin's admiration of Miss Siddal's designs was that Tennyson and his wife heard of the matter at the time when the well-known 'Illustrated Tennyson' was in preparation; and they both 'wished her exceedingly to join' in the work: 'Mrs Tennyson wrote immediately to Moxon about it, declaring that she had rather pay for Miss Siddal's designs herself than not have them in the book.' Her drawings, reasonably controlled by Rossetti, would really have been a credit to the undertaking; but, whatever the reason, she was not enlisted by Moxon. Perhaps he thought the fastidiousness of Rossetti over his wood-blocks was quite enough without being reinforced by that of an unknown female ally.

I hardly think that Miss Siddal ever exhibited any of her paintings or drawings, except in the summer of 1857, when a small semi-public collection was got together by various artists in Russell Place, Fitzroy Square. People came to call this 'the Præraphaelite Exhibition', although no such name was put forward by the exhibiting artists. Miss Siddal sent *Clerk Saunders*, *Sketches from Browning and Tennyson*, *We are Seven*, *The Haunted Tree*, and a *Study of a Head* (I think her own portrait). Madox Brown, Holman-Hunt, Millais, Rossetti, C. Allston Collins, William Davis, Arthur Hughes, Windus, Joseph Wolf, Boyce, and some others, were contributors. *Clerk Saunders* was also included in an American Exhibition of British Art, New York, in the same year, 1857.

Rossetti made Miss Siddal known to several friends of his, all of whom treated her with the utmost cordiality or even affection: William and Mary Howitt, and their daughter Anna Mary (then a painter of whom high hopes were entertained); Miss Barbara Leigh Smith (Mrs Bodichon); Miss Bessie Parkes (Madame Belloc); William Allingham; the sculptor, Alexander Munro; Madox Brown and his family. Mrs Brown, who had previously had some knowledge of Mrs Siddal, naturally became very intimate with Lizzie. At a later date there were Burne-Jones, William Morris, and Alexander Gilchrist, and their respective wives. In Paris, in the autumn of 1855, she met for a few minutes Robert Browning: and Rossetti showed him the design from *Pippa Passes*, with which the poet 'was delighted beyond measure'. My mother did not meet Lizzie in person until April 1855: between that date and the time when my brother's marriage took place, they encountered from time to time, not frequently. Dante Gabriel

had at one period a fancy that Christina was not well affected to the unparagoned Guggum: in this there was in fact next to nothing, or indeed nothing.

All this while Miss Siddal's health was extremely delicate – at times wofully bad. One recurring symptom was want of appetite and inability to retain food on the stomach. She went to a number of health resorts: Hastings, Bath, Matlock, Clevedon. The most important expedition was in the autumn of 1855, when she journeyed to Nice, passing through Paris: this last was the place that seemed to suit her the best of all. At Nice in December she had weather 'as warm as the best English May', but the improvement to her health, after a somewhat prolonged sojourn, did not turn out to be considerable. She was accompanied in this instance by a Mrs Kincaid, a married lady related to my mother, but of whom we did not know very much; but they had, I think, separated before the experiment at Nice came to a conclusion. Between Ruskin's subvention and funds supplied by my brother Miss Siddal was kept while abroad free from money straits: a sum of £80 was in her hands, partly at the date of starting and partly soon afterwards.

Rossetti made a rather long stay with Miss Siddal at Matlock, where she tried the hydropathic cure: this may, I think, have been in the later months of 1857 and the earlier of 1858. It appears to me – but I speak with uncertainty – that during the rest of 1858 and the whole of 1859 he did not see her so constantly as in preceding years. For this, apart from anything savouring of neglectfulness on his part, there may have been various causes, dubious for me to estimate at the present distance of time. Her own ill-health would have been partly accountable for such a result; and, again, the fact that Rossetti, increasingly employed as a painter, had by this time some other sitters for his pictures – Miss Burden (Mrs Morris), Mrs Crabb (stage name Miss Herbert), and, two whose heads appear respectively in the *Mary Magdalene at the Door of Simon* the *Pharisee* and in *Bocca Baciata*. In April 1860 Miss Siddal was staying at Hastings, and was desperately ill. She may possibly in some previous instances have been equally brought down: more so she cannot have been, for she seemed now at the very gates of the tomb. Dante Rossetti joined her at this place; and some expressions in his letters may be worth quoting (I condense *ad libitum*):–

To his mother, 13th April 1860: 'I write you this word to say that Lizzie and I are going to be married at last, in as few days as possible. Like all the important things I ever meant to do – to fulfil duty or secure happiness – this one has been deferred almost beyond possibility. I have hardly deserved that Lizzie should still consent to it, but she has done so, and I trust I may still have time to prove my thankfulness to her. The constantly failing state of her health is a terrible anxiety indeed.' To myself, 17th April: 'You will be grieved to hear that poor dear Lizzie's health has been in such a broken and failing state for the last few days as to render me more miserable than I can possibly say. She gets no nourishment, and what can be reasonably hoped when this is added to her dreadful state of health in other respects? If I were to lose her now, I do not know what effect it might have on my mind, added to the responsibility of much work, commissioned and already paid for, which still has to be done. The ordinary licence we already have, and I still trust to God we may be enabled to use it. If not, I should have so much to grieve for, and (what is worse) so much to reproach myself with, that I do not know how it might end for me.' To Madox Brown, 22nd April: 'I have been, almost without respite, since I saw you, in the most agonizing anxiety about poor dear Lizzie's health. Indeed, it has been that kind of pain which one can never remember at its full, as she has seemed ready to die daily and more than once a day. Since yesterday there has certainly been a reaction for the better. It makes me feel as if I had been dug out of a vault, so many times lately has it seemed to me that she could never lift her head again.'

Black as things had been looking, Miss Siddal did so far revive as to be able, on 23rd May 1860, to attend at St Clement's Church, Hastings, where the marriage rites were performed by the Rev. T. Nightingale. The bride and bridegroom went off at once to Folkestone, and thence to Boulogne and Paris. At Boulogne she made acquaintance with a married couple advancing in years, Signor C. P. Maenza and his wife, who had been very attentive and affectionate to Dante Gabriel in 1843 and 1844, when he was received into their house to keep his health and stamina up to the mark. Maenza was known to my father, being, like himself, one of the numerous refugees from governmental tyranny in Italy: he subsisted in Boulogne chiefly by teaching drawing. He was a rapid and telling sketcher of all sorts of bits of landscape and seascape, with fisher-folk, boats, and so on. I still possess several of his drawings of this class, which, without showing artistic faculty of any exalted order, are cleverly dashed or touched off: I have more than once heard my brother say, and truly say, 'I know *I* couldn't have done them.' Lizzie took a warm liking to this most worthy Italian, and Rossetti made a pencil study of his head, now in the Art Gallery of Cardiff.

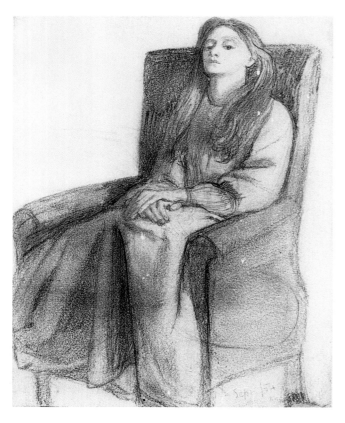

2. *Elizabeth Siddal seated*, by Dante Gabriel Rossetti. 1854. Graphite, 19 by 15.2 cm. (Private Collection).

Rossetti and his bride spent most of their honeymoon in Paris: one thing that he did there in part was the design named *How They Met Themselves* – two mediaeval lovers in a forest meeting their own wraiths; another was *the Dr Johnson and the Methodistical Young Ladies at the Mitre Tavern*. Pretty soon they were back in London, staying on in the chambers at Chatham Place, considerably enlarged by opening a communication into the adjoining house, and they also occupied for a while part of a house in Downshire Hill, Hampstead.

Lizzie did not attain to anything approaching tolerable health during her wedded life, although it may be that illness did not assail her again in quite so fierce a form as had been the case just before her marriage. She continued designing and painting to some extent at intervals, and of course she sat at times to her husband for his works. The last instance, only a few days before her death, was for a head of the Princess in the subject called St George and the Princess Sabra. Ill-health did not induce her to seclude herself beyond what was actually necessary: every now and then she stayed on a visit in the house of the Madox Browns near Highgate

Rise, or in that which the Morrises had been building at Upton, near Bexley. In May 1861 she was confined, of a stillborn female infant; her recovery was rapid enough. In all cases she was, as her husband wrote; 'obstinately plucky in illness'. The then very youthful poet, Algernon Swinburne, just at the very beginning of his shining career, was often in her company: he delighted in her society, and she in his. I have already quoted some words of his, a tribute to her memory: he went on to speak 'of all her marvellous charms of mind and person – her matchless grace, loveliness, courage, endurance, wit, humour, heroism, and sweetness'. Mr Swinburne also once wrote something to me, expressing a wish that it might be published at some opportunity. I will here only cite one sentence, in which he says that, with a single exception, 'I never knew so brilliant and appreciative a woman – so quick to see and so keen to enjoy that rare and delightful fusion of wit, humour, character-painting, and dramatic poetry – poetry subdued to dramatic effect – which is only less wonderful and delightful than the highest works of genius. She was a wonderful as well as a most lovable creature.' Mr Swinburne is very well known to be a munificent praiser: but it would be childish to imagine that, when an intellect such as his discerns certain intellectual and personal merits in another person, nothing of the sort was really there. Lizzie Rossetti has more claims than one to sympathetic and respectful memory: no testimony to them tells out so impressively as the record of her from the hand of Algernon Swinburne.

Of her life there is little more for me to say – only of her death. Her consumptive malady, accompanied by wearing neuralgia, continued its fatal course, and her days could at best, to all appearance, have only been prolonged for some very few years. For the neuralgia she took, under medical authority, frequent doses of laudanum – sometimes as much as 100 drops at a time; she could not sleep nor take food without it; stimulants were also in requisition. On 10th February 1862, she dined at the Sablonière Hotel, Leicester Square, with her husband and Mr Swinburne; it was no uncommon thing for her to go out thus, as a variation from dining at home. The Rossettis returned to Chatham Place about eight o'clock; she was about to go to bed at nine, when Dante Gabriel went out again. He did not re-enter till half-past eleven, when the room was in darkness, and, calling to his wife, he received no reply. He found her in bed, utterly unconscious; there was a phial on the table by the bedside – it had contained laudanum, but was now empty. Dr Hutchinson (who had

attended her in her confinement) was called in, and three other medical men, one of them the eminent surgeon John Marshall, well known to Madox Brown and to Rossetti. The stomach-pump and other remedies were tried – all without avail. Lizzie Rossetti expired about a quarter past seven in the morning of 11th February. An inquest was held on the 12th at Bridewell Hospital; I was present, but had no evidence to give. The witnesses, besides Dr Hutchinson, were Dante Rossetti, Swinburne, and Mrs Birrell, the housekeeper for the various Chambers at 14, Chatham Place. She testified, among other things, to uniformly affectionate relations between the husband and wife. There was but one inference to be formed from the evidence, namely, that Mrs Rossetti had, by, misadventure, taken an overdose of laudanum, and the jury at once returned a verdict of accidental death.

She lies buried in Highgate Cemetery, in the grave where my father had already been interred; my mother and my sister Christina have joined them there. Dante Rossetti, as it has often been recorded, buried in her coffin the mass of his poems, which had then recently been announced for publication. He chose to make this sacrifice to her memory, and for more than seven years thereafter he was unable to bring out the intended volume. At last, in October 1869, the manuscript was uncoffined, and the publication ensued.

With the aim of throwing a little light on Lizzie's character and demeanour, I will extract here a few sentences from letters written by Ruskin to Rossetti, and by Rossetti to Allingham.

Ruskin. – 30th April 1855:– 'My feeling at the first reading is that it would be best for you to marry, for the sake of giving Miss Siddal complete protection and care, and putting an end to the peculiar sadness, and want of you hardly know what, that there is in both of you.' 1860.– 'It is not possible you should care much for me, seeing me so seldom. I wish Lizzie and you liked me enough to – say – put on a dressing-gown and run in for a minute rather than not see me. Perhaps you both like me better than I suppose you do; but I have no power in general of believing much in people's caring for me. I've a little more faith in Lizzie than in you – because, though she don't see me, her bride's kiss was so full and queenly-kind.' *Rossetti.*– 24th July 1854:– 'I wish, and she wishes, that something should be done by her to make a beginning, and set her mind a little at ease about her pursuit of art; and we both think that this, more than anything, would be likely to have a good effect on her health. It seems hard to me when I

3. *Elizabeth Siddal seated*, by Dante Gabriel Rossetti. Graphite, 17.1 by 13.3 cm. (Private Collection).

look at her sometimes, working or too ill to work; and think how many, without one tithe of her genius or greatness of spirit, have granted them abundant health and opportunity to labour through the little they can or will do, while perhaps her soul is never to bloom nor her bright hair to fade; but, after hardly escaping from degradation and corruption, all she might have been must sink out again unprofitably in that dark house where she was born. How truly she may say, "No man cared for my soul.' I do not mean to make myself an exception; for how long I have known her, and not thought of this till so late – perhaps too late!" 29th November 1860. – 'Indeed, and of course, my wife does draw still. Her last designs would, I am sure, surprise and delight you, and I hope she is going to do better than ever now. I feel surer every time she works that she has real genius – none of your make-believe – in conception and colour; and, if she can only add a little more of the precision in carrying-out which it so much needs health and strength to attain, she will, I am sure, paint such pictures as no woman has painted yet. But it is no use hoping for too much.'

Elizabeth Siddal developed a genuine faculty for verse as well as for painting – both assuredly under the stress of Rossetti's prompting. Mr Swinburne, in writing to me, expressed the quality of her verse with equal intuition and precision. 'Watts [Theodore Watts-Dunton] greatly admires her poem [*A Year and a Day*], which is as new to me as to him; I need not add that I agree with him. There is the same note of originality in discipleship which distinguishes her work in art – Gabriel's influence and example not more perceptible than her own independence and freshness of inspiration.' The amount of verse which she produced was, I take it, very small; certainly what remains in my hands is scanty. In two of my publications I have printed nine specimens. Since then I have deciphered six others scrappily jotted down, and I may one of these days publish all the six. I here extract one of them:–

A SILENT WOOD.
O silent wood, I enter thee
With a heart so full of misery,
For all the voices from the trees
And the ferns that cling about my knees.
In thy darkest shadow let me sit,
When the grey owls about thee flit;
There I will ask of thee a boon,
That I may not faint, or die, or swoon.
Gazing through the gloom like one
Whose life and hopes are also done,
Frozen like a thing of stone,
I sit in thy shadow – but not alone.
Can God bring back the day when we two stood
Beneath the clinging trees in that dark wood?

I will now come to the drawings by Dante Rossetti which form our illustrations. For a series of years, of which 1854 may be taken as the centre, he made a more than copious set of drawings of Miss Siddal; very generally representing her as she actually was and looked, only occasionally treating her figure as a study of action antecedent to some painting. When those sketches had become numerous, and no doubt littery (for Dante Gabriel's studio was not a model of orderly neatness), a friend of his, Lady Dalrymple, presented him with a large handsome volume into which they could be collected; and collected they were, and formed for years a great attraction to visitors in his studio. Some of them were given away or otherwise dispersed from time to time; a considerable number still remained at the date of my brother's death in 1882. Here is the testimony which Madox Brown, in his diary of 6th October 1854,

bore to the quality of these drawings:– 'Called on Dante Rossetti. Saw Miss Siddal, looking thinner and more deathlike and more beautiful and more ragged than ever; a real artist, a woman without parallel for many a long year. Gabriel, as usual, diffuse and inconsequent in his work. Drawing wonderful and lovely Guggums one after another, each one a fresh charm, each one stamped with immortality.' Here also is the testimony of Ruskin, in a letter addressed to my brother, 4th September 1860: he appears to have called in Chatham Place without finding any one at home. 'I looked over all the book of sketches at Chatham Place yesterday. I think Ida should be very happy to see how much more beautifully, perfectly, and tenderly you draw when you are drawing her than when you draw anybody else. She cures you of all your worst faults when you only look at her.'

I will take in order the illustrations here supplied. The first (Fig. 2) I consider to be the best of all, both as a drawing and as a likeness; it strongly confirms the accuracy of the portrait already mentioned, which Miss Siddal painted of herself. In the pencil design the expression is more than commonly grave, and seems to give evidence of ill-health; the date is September 1854, nearly the same date as our extract from Brown's diary. She is seated 'in that armchair which suits your size', as Rossetti phrased it in a valentine of about this period. The second (Fig. 3) and third in order are fair likenesses, but in the latter there is a certain *petitesse* about the lower part of the face which detracts from the resemblance. The fourth drawing (Fig. 4) gives the face truly, yet not very characteristically; the pose is a pretty one, and counts for more than the visage. Of the last (Fig. 5) nearly the same may be said, but the face here, in its reposeful quiet, presents more of the aspect which prevailed in Miss Siddal, or even predominated. These five designs, taken collectively, may be regarded as marking a very fair average of the series eulogised by Brown and by Ruskin. Some were still better than these; some others slighter or less observable. It may be remarked that in all the five the dress is full and loose, without any trimming or ornament. Two or three of the other sketches were sent to Professor Norton at the time when he returned to Rossetti the water-colour of Clerk Saunders. There were, I think, at least three careful and very successful drawings done of Lizzie in her married days: not many more than that, if we except heads introduced into subject-paintings.

The best list extant of paintings and drawings by my

4. *Elizabeth Siddal standing*, by Dante Gabriel Rossetti. Graphite, 21.6 by 17.1 cm. (Private Collection).

5. *Elizabeth Siddal seated*, by Dante Gabriel Rossetti. Graphite, 17 by 17 cm. (Private Collection).

brother is, it is well known, that given by Mr H. C. Marillier in his sumptuous volume *Dante Gabriel Rossetti* (1899). I will extract from it the more important works in which Elizabeth Siddal's face appears:– 1850, *Rossovestita*; 1851, *Beatrice at a Marriage Feast denying her Salutation to Dante*; 1852, *The Meeting of Dante and Beatrice in Eden*; 1853, *Dante drawing an Angel in Memory of Beatrice*; 1855, *The Annunciation* (Mary washing clothes in a rivulet), *Paolo and Francesca da Rimini*, *Dante's Vision of Rachel and Leah*, *The Maids of Elfen-Mere*; 1856, *Passover in the Holy Family*; 1857, *Designs for the Illustrated Tennyson*, *The Tune of Seven Towers*, *The Blue Closet*, *Wedding of St George*; 1858, *A Christmas Carol*, *Hamlet and Ophelia*; 1860, *Bonifazio's Mistress*, *How they met Themselves*; 1861, *The Rose Garden*, *Regina Cordium*; 1862, *St George and the Princess Sabra*; 1863, *Beata Beatrix*. Of portraits of Lizzie, Mr Marillier catalogues eleven, but this is a mere trifle as compared with the actual total.

As to Miss Siddal's own designs, I may mention, besides those already specified, *Jephthah's Daughter*, *The Deposition from the Cross*, *The Maries at the Sepulchre*, *The Madonna and Child with an Angel*, *Macbeth taking the Dagger from his Wife who meditates Suicide*, *The Lady of Shalott*, *St Cecilia*, *The Woeful Victory*. The *St Cecilia* was evidently intended to illustrate Tennyson's poem *The Palace of Art*. It is a different composition from the same subject as treated by Dante Rossetti, but, like that, it certainly indicates the death of the saint (a point which does not

appertain to the poem), and I have no doubt it preceded Rossetti's design, and therefore this detail of invention properly belongs to Miss Siddal. *The Woeful Victory* is an incident which was to be introduced into Rossetti's poem The Bride's Prelude; that work, however, was not brought to completion, and the incident was never put into verse, but it appears in the published prose argument of the poem. I must not beguile the reader into supposing that these designs by Miss Siddal are works of any developed execution: some of them are extremely, and all comparatively, slight. But there is right thought in all of them, and a right intention as to how the thought should be conveyed in the structure of the composition.

Specimens of Elizabeth Siddal's art are to be found in four books known to me – perhaps not in any others. These are *Tennyson and his Preraphaelite Illustrators*, by G. Somes Layard (1894); *Dante Rossetti's Letters to William Allingham*, edited by Dr Birkbeck Hill (1897); *The English Preraphaelite Painters*, by Percy H. Bate (1899); and Marillier's book previously named, *Dante Gabriel Rossetti* (1899). There is likewise her portrait of herself in *my Memoir of Dante Rossetti published along with his Family letters* (1895).

I will conclude this brief account of Elizabeth Eleanor Siddal by saying that, without overrating her actual performances in either painting or poetry, one must fairly pronounce her to have been a woman of unusual capacities, and worthy of being espoused to a painter and poet.

Clifford's Inn
and the protection of ancient buildings

We must confess that when we published Mr Philip Norman's appeal to the Government to save Clifford's Inn, we had little hope that the appeal would be listened to; it is too much to expect an English Government to take any interest in a question of an artistic nature; in agreeing to ignore such questions the unanimity of political parties is wonderful. Nor does the English public really care about such matters. The appeal received considerable support in the press, but it was a support given by men who, whatever they themselves think, know well enough that an agitation for the preservation of an ancient building would only bore most of their readers.

So Clifford's Inn has been sold, and sold at a ridiculously low price. It is some satisfaction to know that legal education, which condemned it to destruction, will profit little if at all by its sale, for the income derived from the purchase money can be no larger than could have been derived from the rents of the Inn under proper management. The end, however, is not yet, for the gentleman who now owns Clifford's Inn is happily not without appreciation of its artistic and historical interest; for the present, at any rate, he will leave matters *in statu quo*, and all the tenants have been informed that they need not fear early ejection. Moreover we have every reason to believe that, if there were any movement to preserve the Inn, the present owner would be willing to part with his property at a very moderate premium on the sum of £100,000 that he paid for it.

The London County Council – the only public authority in London that cares about such matters – has had its eye on Clifford's Inn, and a committee of the Council only refrained from recommending its purchase from fear of the ratepayers. We would, however, appeal to the County Council to cast aside fear of the Philistines and reconsider the matter. Expert opinion in such matters holds that Clifford's Inn could be made, as it stands, to return £3,000 a year; its purchase,

therefore, at a little more than £100,000 would involve little or no loss to the ratepayers. The County Council has done and is doing admirable work for the preservation of ancient buildings; it might well add to its laurels by acquiring Clifford's Inn for the citizens of London.

The case of Clifford's Inn raises the larger question of the preservation of ancient buildings generally. We in England pretend to be an artistic nation; we talk and write very much about art, and we all collect more or less works of art or imitations thereof; most of us try to paint pictures, and the world will soon be unable to contain the pictures that are painted. But there is one fact that brands us as hypocrites, the fact that Great Britain shares with Russia and Turkey the odious peculiarity of being without legislation of any kind for the protection of ancient buildings and other works of art such as is possessed to some degree by every other country in Europe, and by almost every State of the American Union. We have calmly looked on while amiable clergymen, restoring architects, and legal peers with a mania for bricks and mortar and more money than taste, have hacked, hewn, scraped and pulled to pieces the greatest architectural works of our forefathers; too many modern architects, when they are not engaged in copying the work of their predecessors, are engaged in destroying it. Though the legend of 'Cromwell's soldiers' still on the lips of the intelligent pew-opener accounts for the havoc wrought in many an ancient church, the historian and the antiquary know that to the sixteenth and not the seventeenth century must that havoc be in the first place attributed, and the observer of recent history knows that the mischief worked by the iconoclast of the sixteenth century has been far exceeded by that worked by the restorer and the Gothic revivalist of the nineteenth. And if this has been done by persons who imagined themselves to be artistic and were actuated by the best possible motives, what has been the destruction wrought by those who made no profession of any motive but that of

commercial advantage? Within the memory of the youngest among us, buildings of great artistic and historical interest have been ruthlessly swept away in London and in every other town in the kingdom, and the few that have been left are rapidly disappearing.

There is no way of saving the remnant of our heritage but that of legislation; but we cannot honestly recommend the advocacy of such legislation to a minister or a party in need of an electioneering cry, and we are not sanguine as to the prospects of anything being done. Still, it may be interesting to some to learn what the despised foreigner has done in this respect; we take the information from a Parliamentary paper presented to the House of Commons on 30th July 1897.[1]

We will briefly summarise the facts given in this paper, referring those of our readers who wish for further information to the paper itself. In Austria there has existed for many years a permanent 'Imperial and Royal Commission for the investigation and preservation of artistic and historical monuments.' This Commission had, in 1897, direct rights only over monuments belonging to the State (in which churches are included); but it acted in concert with municipalities and learned societies, and promoted the formation of local societies to carry out its objects. No ancient monument coming within its scope can be touched without the sanction of the Commission. Since 1897 its powers have, we believe, been extended. Not only buildings, but objects of art and handicraft of every kind as well as manuscripts and archives, of any date up to the end of the eighteenth century, come within the scope of activity of the Commission, which is a consultative body advising the Minister of Public Worship and Education, who is the executive authority for these purposes.

In Bavaria, alterations to all monuments or buildings of historical or artistic importance (including churches) belonging to the State, municipality, or any endowed institution, have, since 1872, required the sanction of the Sovereign, who is advised by the Royal Commissioners of Public Buildings. The ecclesiastical authorities and even religious communities are prohibited from altering a church or dealing with its furniture without the consent of the Commissioners.

In Denmark there has been a Royal Commission with similar objects since 1807; ancient monuments are scheduled, and since 1873 the Royal Commission has had power to acquire them compulsorily if their owners will not take proper measures for their preservation.

In France the Minister of Public Instruction and Fine Arts, who is advised by a Commission of Histori-

cal Monuments, has as drastic powers as the Danish Royal Commission; some 1,700 churches, castles, and other buildings (including buildings in private ownership) have been scheduled and classified, and cannot be destroyed, restored, repaired, or altered except with the approval of the Minister, who has power to expropriate private owners under certain circumstances.

Belgium has statutory provisions of a similar character; there a Royal Commission on Monuments was constituted so long ago as 1835, so that Belgium is second only to Denmark in this matter. The Commission may schedule any building or ancient monument, and the scheduled building not be touched without the consent of the Commission, even if it is in private ownership. In Belgium, as in France and Denmark, grants of public money are given for the purchase and preservation of ancient monuments, and the Belgian municipalities are very zealous in the same direction. In Bruges, we understand, the façades of all the houses belong to the municipality, so that their preservation is secured, and also congruity in the case of new buildings. No object of art may legally be alienated or removed from a Belgian church; this law, however, is unfortunately still evaded to some extent.

In Italy several laws have been passed, beginning with an edict of Cardinal Pacca for the old Papal States in 1820. The Minister of Public Instruction may, by a decree, declare any building a national monument, and the municipalities have large powers; works of art, as is well known, cannot legally be taken out of Italy, but this law is often evaded.

In Greece the powers of the State are perhaps more drastic than anywhere else. Even antique works of art in private collections are considered as national property in a sense and their owner can be punished for injuring them; if the owner of an ancient building attempts to demolish it or refuses to keep it in repair, the State may expropriate him.

Holland, Prussia, Saxony, Spain, Sweden and Norway, Switzerland, and many American States have provisions of a more or less stringent character with the same purpose. But we need not now go further into details; the whole of the facts will be found in the Parliamentary paper, and we have given enough of them to show how far behind every other civilised country England is in this matter. The protection of monuments of the past which Denmark has had for nearly a century and Belgium for nearly seventy years we have not yet thought of. Surely the time has come to wipe out this reproach; until it is wiped out let us have done with the hypocritical claim that we are an artistic people.

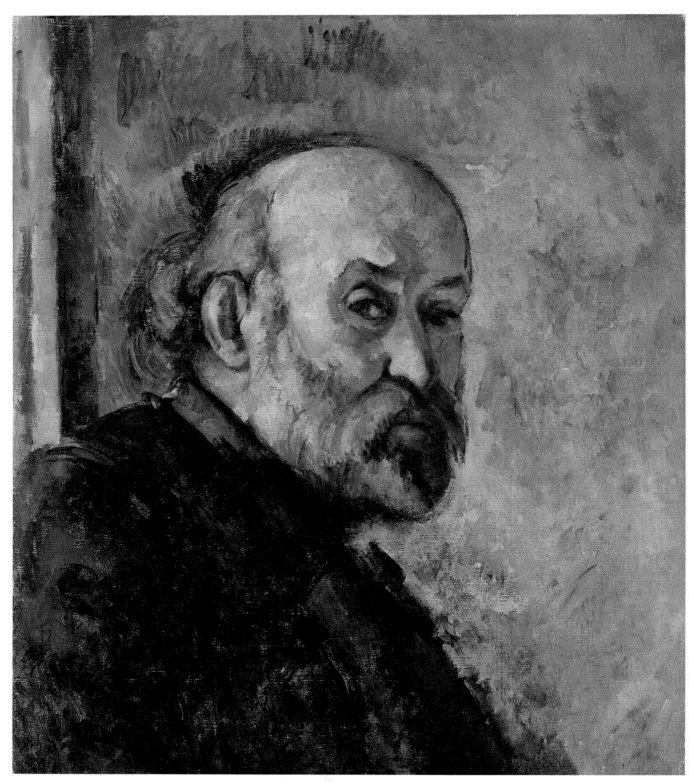

6. *Portrait of the artist*, by Paul Cézanne. c.1895. 55 by 46 cm. (Private Collection).

MAURICE DENIS

Cézanne – I[1]

INTRODUCTORY NOTE

Anyone who has had the opportunity of observing modern French art cannot fail to be struck by the new tendencies that have become manifest in the last few years. A new ambition, a new conception of the purpose and methods of painting, are gradually emerging; a new hope too, and a new courage to attempt in painting that direct expression of imagined states of consciousness which has for long been relegated to music and poetry. This new conception of art, in which the decorative elements preponderate at the expense of the representative, is not the outcome of any conscious archaistic endeavour, such as made, and perhaps inevitably marred, our own pre-Raphaelite movement. It has in it therefore the promise of a larger and a fuller life. It is, I believe, the direct outcome of the Impressionist movement. It was among Impressionists that it took its rise, and yet it implies the direct contrary of the Impressionist conception of art.

It is generally admitted that the great and original genius, – for recent criticism has the courage to acclaim him as such – who really started this movement, the most promising and fruitful of modern times, was Cézanne. Readers of THE BURLINGTON MAGAZINE may therefore be interested to hear what one of the ablest exponents in design of the new idea has to say upon the subject. M. Maurice Denis has kindly consented to allow his masterly and judicious appreciation of Cézanne which appeared in *L'Occident*, September 1907, to be translated for the benefit of a wider circle of English readers than has been reached by that paper. Feeling, as he did, that he had expressed himself therein once and for all, he preferred this to treating the subject afresh for THE BURLINGTON MAGAZINE.

The original article was unillustrated, but seeing how few opportunities English readers have for the study of Cézanne's works, especially of his figure pieces, it has been thought well to include here some typical examples, excluding the better known landscapes and fruit pieces. It is possible that some who have seen only examples of Cézanne's landscapes may have been misled by the extreme brevity of his synthesis into mistrusting his powers of realising a complete impression; they will be convinced, I believe, even in the reproduction by Cézanne's amazing portrait of himself (Fig. 6). Before this supremely synthetic statement of the essentials of character one inevitably turns for comparison to Rembrandt. In Fig. 7, the *Portrait of a Woman*, we get an interesting light upon the sources of Cézanne's inspiration. One version of the El Greco which inspired this will be familiar to our readers from its appearance at the National Loan Exhibition. M. Maurice Denis discusses at length the position of El Greco in the composition of Cézanne's art. One point of interest, however, seems to have escaped him. Was it not rather El Greco's earliest training in the lingering Byzantine tradition that suggested to him his mode of escape into an art of direct decorative expression? and is not Cézanne after all these centuries the first to take up the hint El Greco threw out? The 'robust art of a Zurbarán and a Velázquez' really passed over this hint. The time had not come to re-establish a system of purely decorative expression; the alternative representational idea of art was not yet worked out, though Velázquez perhaps was destined more than any other to show its ultimate range.

Fig. 8, *L'enfant au foulard blanc*, is another example of Cézanne's astonishing power of synthetic statement. The remaining illustrations, *The Bathers* and *The Satyrs* (Figs. 9 and 10) show Cézanne in his more lyrical and romantic mood. He here takes the old traditional material of the nude related to landscape, the material which it might seem that Titian had exhausted, if Rubens had not found a fresh possibility therein.

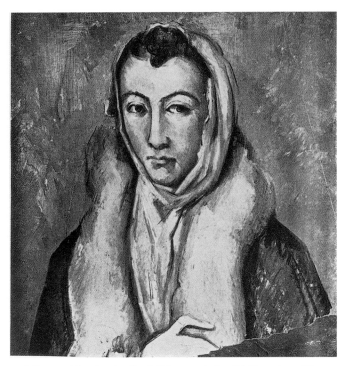

7. *Woman with a boa*, by Paul Cézanne (after El Greco). c.1885. 53.3 by 48.8 cm. (Private Collection, Lausanne).

Rubens at all events seemed to have done all that was conceivable, so that Manet only saw his way to using the theme by a complete change of the emotional pitch. But here Cézanne, keeping quite closely within the limits established by the older masters, gives it an altogether new and effective value. He builds up a more compact unity by his calculated emphasis on rhythmic balance of directions.

ROGER E. FRY

There is something paradoxical in Cézanne's celebrity; and it is scarcely easier to explain than to explain Cézanne himself. The Cézanne question divides inseparably into two camps those who love painting and those who prefer to painting itself the literary and other interests accessory to it. I know indeed that it is the fashion to like painting. The discussions on this question are no longer serious and impassioned. Too many admirations lend themselves to suspicion. 'Snobbism' and speculation have dragged the public into painters' quarrels, and it takes sides according to fashion or interest. Thus it has come about that a public naturally hostile, but well primed by critics and dealers, has conspired to the apotheosis of a great artist, who remains nevertheless a difficult master even for those who love him best.

I have never heard an admirer of Cézanne give me a clear and precise reason for his admiration; and this is true even among those artists who feel most directly the appeal of Cézanne's art. I have heard the words – quality, flavour, importance, interest, classicism, beauty, style . . . Now of Delacroix or Monet one could briefly formulate a reasoned appreciation which would be clearly intelligible. But how hard it is to be precise about Cézanne!

The mystery with which the Master of Aix-en-Provence surrounded his life has contributed not a little to the obscurity of the explanations, though his reputation has benefited thereby. He was shy, independent, solitary. Exclusively occupied with his art, he was always restless and usually ill satisfied with himself. He evaded up to his last years the curiosity of the public. Even those who professed his methods remained for the most part ignorant of him. The present writer admits that about 1890, at the period of his first visit to Tanguy's shop, he thought that Cézanne was a myth, perhaps the pseudonym of some artist well known for other efforts, and that he disbelieved in his existence. Since then he has had the honour of seeing him at Aix; and the remarks which he there gathered, collated with those of M. E. Bernard,[2] may help to throw some light upon Cézanne's aesthetics.

At the moment of his death, the articles in the press were unanimous upon two points; and, wherever their inspiration was derived from, they may fairly be considered to reflect the average opinion. The obituaries, then, admitted first of all that Cézanne influenced a large section of the younger artists; and secondly that he made an effort towards style. We may gather, then, that Cézanne was a sort of classic, and that the younger generation regards him as a representative of classicism.

Unfortunately it is hard to say without too much obscurity what classicism is.

Suppose that after a long sojourn in the country one enters one of those dreary provincial museums, one of those cemeteries abandoned to decay, where the silence and the musty smell denote the lapse of time; one immediately classifies the works exhibited into two groups: in one group the remains of the old collections of amateurs, and in the other the modern galleries, where the commissions given by the State have piled together the pitiful novelties bought in the annual

8. *Young man with a white scarf (Portrait of Louis Guillaume)*, by Paul Cézanne. 1879–80. 55.9 by 46.7 cm. (National Gallery of Art, Washington, Chester Dale Collection).

salons according as studio intrigues or ministerial favour decides. It is in such circumstances that one becomes really and ingenuously sensitive to the contrast between ancient and modern art; and that an old canvas by some Bolognese or from Lebrun's atelier, at once vigorous and synthetic in design, asserts its superiority to the dry analyses and thin coloured photographs of our gold-medallists!

Imagine, quite hypothetically, that a Cézanne is there. So we shall understand him better. First of all, we know we cannot place him in the modern galleries, so completely would he be out of key among the anecdotes and the fatuities. One must of sheer necessity place him among the old masters, to whom he is seen at a glance to be akin by his nobility of style. Gauguin used to say, thinking of Cézanne: 'Nothing is so much

9. *The Bathers*, by Paul Cézanne. 1876–77. 35 by 45.5 cm. (Musée d'art et d'histoire, Geneva, Prévost Foundation).

like a *croûte* as a real masterpiece.' *Croûte* or masterpiece, one can only understand it in opposition to the mediocrity of modern painting. And already we grasp one of the certain characteristics of the classic, namely, *style*, that is to say synthetic order. In opposition to modern pictures, a Cézanne inspires by itself, by its qualities of unity in composition and colour, in short by its painting. The actualities, the illustrations to popular novels or historical events, with which the walls of our supposed museum are lined, seek to interest us only by means of the subject represented. Others perhaps establish the virtuosity of their authors. Good or bad, Cézanne's canvas is truly a *picture*.

Suppose now that for another experiment, and this time a less chimerical one, we put together three works of the same family, three *natures-mortes*, one by Manet, one by Gauguin, one by Cézanne. We shall distinguish at once the objectivity of Manet; that he imitates nature 'as seen through his temperament,' that he translates an artistic sensation. Gauguin is more subjective. His is a decorative, even a hieratic interpretation of nature. Before the Cézanne we think only of the picture; neither the object represented nor the artist's personality holds our attention. We cannot decide so

quickly whether it is an imitation or an interpretation of nature. We feel that such an art is nearer to Chardin than to Manet and Gauguin. And if at once we say: this is a picture and a classic picture, the word begins to take on a precise meaning, that, namely, of an equilibrium, a reconciliation of the objective and subjective.

In the Berlin Museum, for instance, the effect produced by Cézanne is significant. However much one admires Manet's *La Serre* or Renoir's *Enfants Bérard* or the admirable landscapes of Monet and Sisley, the presence of Cézanne makes one assimilate them (unjustly, it is true, but by the force of contrast) to the generality of modern productions: on the contrary the pictures of Cézanne seem like works of another period, no less refined but more robust than the most vigorous efforts of the Impressionists.

Thus we arrive at our first estimate of Cézanne as reacting against modern painting and against Impressionism.

When he was first feeling his way out of the tradition of Delacroix, Daumier and Courbet, it was already the old masters of the museums that guided his steps. The revolutionaries of his day never came under the attraction of the old masters. He copied them, and one sees

10. *La Lutte d'amour*, by Paul Cézanne. c.1880. 45 by 56 cm. (Private Collection).

with surprise in his father's house at the Jas de Bouffan a large interpretation of a Lancret and a *Christ in Hades* after Navarete. We must, however, distinguish between this first manner, inspired by the Spanish and Bolognese, and his second fresh and delicately accented manner.

In the first period one sees what Courbet, Delacroix, Daumier and Manet became for him, and by what spontaneous power of assimilation he transmuted in the direction of style certain of their classic tendencies. No doubt he does not arrive at such realisations of placid beauty and plenitude as Titian's; but it is through El Greco that he touches Venice. 'You are the first in the decadence of your art,' wrote Beaudelaire [*sic*] to Manet; and such is the debility of modern art that Cézanne seems to bring us health and promise us a ren-aissance by bringing before us an ideal akin to that of the Venetian decadence.

It is an instructive comparison, and one to which I would call attention, between Cézanne and the neu-rotic, somewhat deranged Greco, who, by an opposite effort, introduced into the triumphant maturity of Venetian art the system of discords and expressive deformations which gave its origins to Spanish painting. Out of this feverish decrepitude of a great epoch was born in turn the sane robust method of a Zurbarán and a Velázquez. But whilst El Greco indulged in refine-ments of naturalism and imagination out of lassitude with the perfection of a Titian, Cézanne transcribed his sensibility in bold and reasoned syntheses out of reaction against expiring naturalism and romanticism.

The same interesting conflict, this combination of style and sensibility, meets us again in Cézanne's second period, only it is the Impressionism of Monet and Pis-sarro that provides the elements, provokes the reaction to them and causes the transmutation into classicism. With the same vigour with which in his previous period he organised the oppositions of black and white, he now disciplines the contrasts of colour introduced by the study of open air light, and the rainbow irides-cences of the new palette. At the same time he substi-tutes for the summary modelling of his earlier figures the reasoned colour-system found in the figure-pieces and *natures-mortes* of this second period, which one may call his 'brilliant' manner.

Impressionism – and by that I mean much more the general movement, which has changed during the last twenty years the aspect of modern painting, than the special art of a Monet or a Renoir – Impressionism was

synthetic in its tendencies, since its aim was to translate a sensation, to realise a mood; but its methods were analytic, since colour for it resulted from an infinity of contrasts. For it was by means of the decomposition of the prism that the Impressionists reconstituted light, divided colour and multiplied reflected lights and gradations; in fact, they substituted for varying greys as many different positive colours. Therein lies the fundamental error of Impressionism. The *Fifre* of Manet in four tones is necessarily more synthetic than the most delicious Renoir, where the play of sunlight and shadow creates the widest range of varied half-tones. Now there is in a fine Cézanne as much simplicity, austerity and grandeur as in Manet, and the gradations retain the freshness and lustre which give their flower-like brilliance to the canvases of Renoir. Some months before his death Cézanne said: 'What I wanted was to make of Impressionism something solid and durable, like the art of the museums.' It was for this reason also that he so much admired the early Pissarros, and still more the early Monets. Monet was, indeed, the only one of his contemporaries for whom he expressed great admiration.

Thus at first guided by his Latin instinct and his natural inclination, and later with full consciousness of his purpose and his own nature, he set to work to create out of Impressionism a certain classic conception.

In constant reaction against the art of his time, his powerful individuality drew from it none the less the material and pretext for his researches in style; he drew from it the sustaining elements of his work. At a period when the artist's sensibility was considered almost universally to be the sole motive of a work of art, and when improvisation – 'the spiritual excitement provoked by exaltation of the senses' – tended to destroy at one blow both the superannuated conventions of the academies and the necessity for method, it happened that the art of Cézanne showed the way to substitute reflexion for empiricism without sacrificing the essential *rôle* of sensibility. Thus, for instance, instead of the chronometric notation of appearances, he was able to hold the emotion of the moment even while he elaborated almost to excess, in a calculated and intentional effort, his studies after nature. He *composed* his *natures-mortes*, varying intentionally the lines and the masses, disposing his draperies according to premeditated rhythms, avoiding the accidents of chance, seeking for plastic beauty; and all this without losing anything of the essential *motive* – that initial motive which is realised in its essentials in his sketches and water colours. I

allude to the delicate symphony of juxtaposed gradations, which his eye discovered at once, but for which at the same moment his reason spontaneously demanded the logical support of composition, of plan and of architecture.

There was nothing less artificial, let us note, than this effort towards a just combination of style and sensibility. That which others have sought, and sometimes found, in the imitation of the old masters, the discipline that he himself in his earlier works sought from the great artists of his time or of the past, he discovered finally in himself. And this is the essential characteristic of Cézanne. His spiritual conformation, his *genius*, did not allow him to profit directly from the old masters: he finds himself in a situation towards them similar to that which he occupied towards his contemporaries. His originality grows in his contact with those whom he imitates or is impressed by; thence comes his persistent *gaucherie*, his happy *naïveté*, and thence also the incredible clumsiness into which his sincerity forced him. For him it is not a question of imposing style upon a study as, after all, Puvis de Chavannes did. He is so naturally a painter, so spontaneously classic. If I were to venture a comparison with another art, I should say that there is the same relation between Cézanne and Veronese as between Mallarmé of the 'Hérodiade' and Racine of the 'Bérénice.' With the same elements – new or at all events refreshed, without anything borrowed from the past, except the necessary forms (on the one hand the mould of the Alexandrine and of tragedy, on the other the traditional conception of the composed picture) – they find, both poet and painter, the language of the Masters. Both observed the same scrupulous conformity to the necessities of their art; both refused to overstep its limits. Just as the writer determined to owe the whole expression of his poem to what is, except for idea and subject, the pure domain of literature – sonority of words, rhythm of phrase, elasticity of syntax – the painter has been a painter before everything. Painting oscillates perpetually between invention and imitation: sometimes it copies and sometimes it imagines. These are its variations. But whether it reproduces objective nature or translates more specifically the artist's emotion, it is bound to be an art of concrete beauty, and our senses must discover in the work of art itself – abstraction made of the subject represented – an immediate satisfaction, a pure aesthetic pleasure. The painting of Cézanne is literally the essential art, the definition of which is so refractory to criticism, the realization of which seems impossible. It imitates objects

without any exactitude and without any accessory interest of sentiment or thought. When he imagines a sketch, he assembles colours and forms without any literary preoccupation; his aim is nearer to that of a Persian carpet weaver than of a Delacroix, transforming into coloured harmony, but with dramatic or lyric intention, a scene of the Bible or of Shakespeare. A negative effort, if you will, but one which declares an unheard of instinct for painting.

He is the man who paints. Renoir said to me one day: 'How on earth does he do it? He cannot put two touches of colour on to a canvas without its being already an achievement.'

It is of little moment what the pretext is for this sampling of colour: nudes improbably grouped in a non-existent landscape, apples in a plate placed awry upon some commonplace material – there is always a beautiful line, a beautiful balance, a sumptuous sequence of resounding harmonies. The gift of freshness, the spontaneity and novelty of his discoveries, add still more to the interest of his slightest sketches.

'He is' said Sérusier, 'the pure painter. His style is a pure style; his poetry is a painter's poetry. The purpose, even the concept of the object represented, disappears before the charm of his coloured forms. Of an apple by some commonplace painter one says: I should like to eat it. Of an apple by Cézanne one says: How beautiful! One would not peel it; one would like to copy it. It is in that that the spiritual power of Cézanne consists. I purposely do not say idealism, because the ideal apple would be the one that stimulated most the mucous membrane, and Cézanne's apple speaks to the spirit by means of the eyes.'

'One thing must be noted,' Sérusier continues: 'that is the absence of subject. In his first manner the subject was sometimes childish: after his evolution the subject disappears, there is only the *motive*.' (It is the word that Cézanne was in the habit of using.)

That is surely an important lesson. Have we not confused all the methods of art – mixed together music, literature, painting? In this, too, Cézanne is in reaction. He is a simple artisan, a primitive who returns to the sources of his art, respects its first postulates and necessities, limits himself by its essential elements, by what constitutes exclusively the art of painting. He determines to ignore everything else, both equivocal refinements and deceptive methods. In front of the *motive* he rejects everything that might distract him from painting, might compromise his *petite sensation* as he used to say, making use of the phraseology of the aesthetic philosophy of his youth: he avoids at once deceptive representation and literature.

ROGER FRY

The Munich exhibition of Mohammedan art – I

It would be hard to exaggerate the importance of this exhibition for those who are interested in the history not alone of Oriental but of European art. Perhaps the most fascinating problem that presents itself to the art historian is that of the origins of mediaeval art. Until we understand more or less completely how in the dim centuries of the later Empire and early middle age the great transformation of Græco-Roman into mediaeval art was accomplished, we cannot quite understand the renaissance itself, nor even the form which the whole modern art of Europe has come in the course of centuries to assume. And on this problem the Munich exhibition throws many illuminating sidelights. Early Mohammedan art is seen here to be a meeting point of many influences. There are still traces of the once widespread Hellenistic tradition, though this is seen to be retreating before the refluent wave of aboriginal ideas. Sassanid art had already been the outcome of these contending forces, and the pre-eminence of Sassanid art in forming early Mohammedan styles is clearly brought out in this exhibition. Then there is a constant exchange with Byzantium and finally continual waves of influence, sometimes fertilising, sometimes destructive, from that great reservoir of Central Asian civilization, the importance of which is now at last being gradually revealed to us by the discoveries of Dr Stein, Drs Lecoq and Grunwedel, and M. Pelliot.

And through this great clearing-house of early Mohammedan art there are signs of influences passing from West to East. The most striking example is that of the plate in cloisonnée enamel from the Landes Museum at Innsbruck, shown in Room 18. Here we have the one certain example of Mohammedan cloisonnée enamel established by its dedication to a prince of the Orthokid dynasty of the twelfth century. It is extraordinary that this solitary example should alone have survived from what must, judging from the technical excellence of this specimen, have once been a flourishing craft. The general effect of the intricate pattern of animal forms upon a whiteish ground suggests on the one hand the earliest examples of Limoges enamels and on the other the early Chinese, and there can be little doubt that the Chinese did in fact derive their knowledge of cloisonnée, which they themselves called 'Western ware,' from these early Mohammedan craftsmen, who had themselves learned the technique from Byzantium.

But on the whole the stream of influence is in the opposite direction, from East to West, and one realises at Munich that in the great period of artistic discovery and formation of styles the near East and the West were developing in closest contact and harmony. Indeed the most fertile, if not actually the most resplendent, period of both arts, was attained whilst they were almost indistinguishable. If it were not for the habit of these early Mohammedan craftsmen of interweaving inscriptions into their designs, a habit which endears them quite especially to art-historians, how many works of Oriental manufacture would have been ascribed to Europe? In spite of these inscriptions, indeed, such an authority as M. Babelon has sought to place to the account of Western artists the superb cut crystal vessels of which the noblest example is the inscribed ewer of the tenth century in the treasury of St Mark's. Or take again the textiles. In Room 17 of the exhibition there are a number of fragments of textiles of the tenth to the twelfth centuries, in which the general principle of design is the same; for the most part the surface is covered by circular reserves in which severely conventionalised figures of hunters, lions, or monsters are placed in pairs symmetrically confronted. Only minute study has enabled specialists to say that some were made in Sassanid Persia, some in Byzantium, some in Sicily and some in Western Europe. The dominant style in all

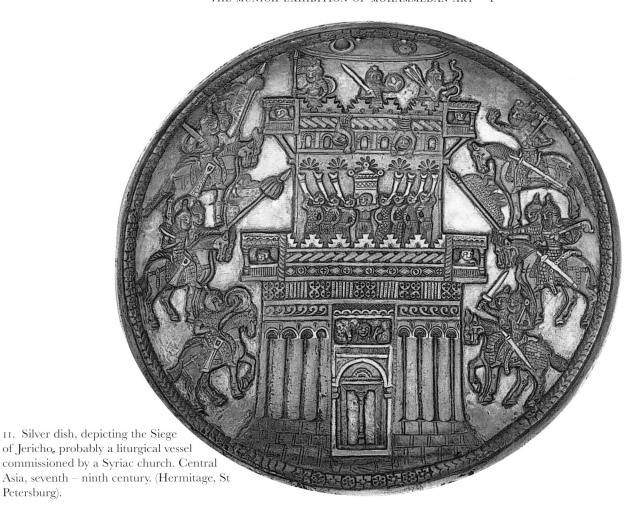

11. Silver dish, depicting the Siege of Jericho, probably a liturgical vessel commissioned by a Syriac church. Central Asia, seventh – ninth century. (Hermitage, St Petersburg).

these is again derived from Sassanid art. And here once more one must note the strange recrudescence after so long of Assyrian types and motives, and its invasion of Western Europe, through Byzantium, Sicily and Spain.

What strikes us most in comparing Græco-Roman art with the new art which gradually emerges in the middle ages is that on the one hand we have a series of decorative designs never so remarkable for vitality as for their elegance, and become by the time of the Roman Empire only less perfunctory and mechanical than the patterns of modern times; and on the other hand an art in which the smallest piece of pattern-making shows a tense vitality even in its most purely geometrical manifestations, and the figure is used with a new dramatic expressiveness unhindered by the artists' ignorance of actual form. Now in the splendid photographs of the Sassanid rock carvings which Dr Sarre has taken and which are exposed at Munich, we can see something of this process of the creation of the new vital system of

design. In the earlier reliefs, those of the time of Sapor, we have, it is true, a certain theatrical splendour of pose and setting, but in the actual forms some flaccidity and inflation. The artists who wrought them show still the predominance of the worn-out Hellenistic tradition which spread in Alexander's wake over Asia. In the stupendous relief of Chosroes at Tak-i-Bostan, on the other hand, we have all the dramatic energy, the heraldic splendour of the finest mediaeval art, and the source of this new inspiration is seen to be the welling up once more of the old indigenous Mesopotamian art. We have once more that singular feeling for stress, for muscular tension, and for dramatic oppositions, which distinguish the bas-reliefs of Babylon and Nineveh from all other artistic expressions of the antique world. It would be possible by the help of exhibits at Munich to trace certain Assyrian forms right through to Mediaeval European art. Take, for instance, the lion heads on the pre-Babylonian mace from Goudea in the Louvre; one

12. Silver dish with mounted horsemen. Sogdian, Central Asia, sixth – seventh century. (Hermitage, St Petersburg).

finds a precisely similar convention for the lion head on the Sassanid repoussé metalwork found in Russia (Fig. 12), once again it recurs in the superb carved rock crystal waterspout lent by the Karlsruhe Museum (Room 54), and one finds it again on the font of Lincoln Cathedral, or in the lions that support the doorway columns of Italian cathedrals. In all these there is a certain community of style, a certain way of symbolising the leonine nature which one may look for in vain in Greek and Græco-Roman art.

Even if this seem too forced an interpretation of facts, it is nonetheless clear that everywhere in early Mohammedan art this recrudescence of Assyrian forms may be traced, and that their influence was scarcely less upon Europe than upon the near East. Dr Sarre has taken a tracing of the pattern which is represented in low relief upon the robes of Chosroes in the Tak-i-Bostan relief. In South Kensington Museum [the Victoria and Albert Museum, London] there is an almost identical piece of silk brocade which actually comes from the ruins of Khorsabad, and in the same museum one may find more than one Byzantine imitation of this design and closely similar ones made in Sicily; and the conventional winged monster which forms the basis of these designs has a purely Assyrian air.

In Egypt too it would seem that there was before the Arab invasion a marked recrudescence of indigenous native design which enabled the Coptic craftsmen gradually to transform the motives given to them by Roman conquerors into something entirely non-Hellenistic. And the incredible beauty of the Fatimite textiles of the tenth, eleventh, and twelfth centuries, of which a few precious relics are shown in Room 17, preserve something, especially in the bird forms, of this antique derivation.

But to return once more to Sassanid art. By the kindness of Dr Kühnel, whose courtesy to those making use of the exhibition for the purposes of study is unfailing, I have been enabled to reproduce here some of the most remarkable specimens from the Hermitage and Prince Bobrinsky's collections. These form an object lesson of extraordinary interest in the development of early Mohammedan art. They have inherited and still retain that extreme realisation of massive splendour, that fierce assertion of form and positive statement of relief which belongs to the art of the great primitive Empires, and most of all to the art of Mesopotamia, and yet they already adumbrate the forms of Mohammedan art into which they pass by insensible degrees. Here, too, we find vestiges of the dying Hellenistic tradition. One of Prince Bobrinsky's bronzes, a great plate, has, for instance, a design composed of classic vases, from which spring stems which bend round into a series of circles, a design which might almost be matched as regards form, though not as regards spirit, in the wall decorations of Pompeii. Or take again the superb repoussé silver plate (Fig. 12), representing a Sassanid king spearing a lion. Here the floating drapery of the king and the edge of his tunic show a deliberately schematised rendering of the traditional folds of the Greek peplos. But how much more Assyrian than Greek is the whole effect – the dramatic tension of the figures expressed by an emphasis on all the lines of muscular effort, as in the legs of the horse and the lions. How Assyrian, too, is the feeling for relief, and the predilection for imbricated or closely set parallel lines as in the lions' manes. In the conventional rock under one of the lions one seems to see also a hint of Chinese forms.

Still more Assyrian is the other plate reproduced (Fig. 11). Here the whole arrangement recalls the reliefs of Assurbanipal or Sennacherib, and yet already there are forms which anticipate Mohammedan art; the gate of the city, its crenellations, and the forms of the helmets of the soldiers, all have an air of similarity with far

13. Aquamanile in the form of a goose. South Indian, seventeenth century. Bronze. (Hermitage, St Petersburg).

later Mohammedan types. Another plate, not reproduced here, shows a Sassanid king regaling himself with wine and music, and gives already more than a hint of the favourite designs of the Rhages potters or the bronze workers of Mossoul.

Reproduced here are some of Prince Bobrinsky's bronzes which were found in the Caucasus. Fig. 13 is a late Sassanid aquamanile in the form of a bird.¹ It is already almost Mohammedan, though retaining something of the extreme solidity and weight of earlier art. Once more in the aggressive schematization of the form of the tail and the suggestion of feathers by a series of deeply marked parallel lines we get a reminiscence of Assyrian art, while in the treatment of the crest there is the more florid interweaving of curves which adumbrate not only Mohammedan but Indian forms.

In the aquamanile in the form of a horse (Fig. 15), the Sassanid influence is still predominant, but there can be no doubt that this is already Mohammedan, probably of the eighth or ninth century. We have already here the characteristics of Fatimite bronzes, of which a few specimens are shown at Munich. The great griffin of Pisa could not, of course, be moved from the Campo Santo nor are the two specimens in the Louvre shown, but the stag from the Bavarian National Museum is there and affords a most interesting

14. Incense burner or aquamanile in the form of a cockerel. Iran, eleventh century. Bronze. (Hermitage, St Petersburg).

15. Horse figurine. Iran, tenth century. Brass, ht 36 cm. (Hermitage, St Petersburg).

comparison with Prince Bobrinsky's horse. Both have the same large generalisation of form, and in both we have the curious effect of solidity and mass produced by the shortened hind legs, with the half-squatting movement which that suggests.

The Bobrinsky horse is obviously more primitive, and probably indicates the beginnings of a school of bronze *plastik* in Mesopotamia nearly parallel to that of Egypt. This school, however, never developed as fully along sculptural lines, and at a comparatively early date abandoned sculpture for the art of bronze inlay, of which Mossoul was the great centre in the twelfth and thirteenth centuries. In the incised designs on the horse we have an example of the early forms of the palmette ornament and of the interlacing curves which form the basis of most subsequent Mohammedan patterns. Within the reserves formed by the *intreccie* are small figures, of which one – that of a man seated and playing the lute – can just be made out in the reproduction. It is already typical of the figure design which the Mohammedan artists developed in the twelfth and thirteenth centuries.

By way of comparison with this Mesopotamian example, Fig. 16 shows a supreme example of Fatimite sculpture of the twelfth century. It is, indeed, a matter for regret that Mohammedan artists so soon abandoned an art for which they showed such extraordinary aptitude. The lion which comes from the Kassel Museum has already been published by M. Migeon,[2] but is of such rare beauty and interest in relation to the Sassanid works here described that it seemed desirable to reproduce it again. It shows the peculiar characteristics of all the art produced for the Fatimite court, its exquisite perfection and refinement of taste, its minuteness of detail and finish together with a large co-ordination of parts, a rhythmic feeling for contour and the sequence of planes which have scarcely ever been equalled. And all these qualities of refinement, almost of sophistication, which Fatimite art possesses, do not, as we see here, destroy the elementary imaginative feeling for the vitality of the animal forms. In the case in which this masterpiece of Mohammedan sculpture is shown there is also seen the celebrated lion which once belonged to the painter Fortuny. Noble though this is in general conception, the coarseness of its workmanship and the want of subtlety in its proportions, in comparison with the Kassel lion, makes it evident that it is not from the same school of Egyptian craftsmen, but probably of Spanish origin.

Fig. 14 shows yet another of the Bobrinsky bronzes

16. Aquamanile or perhaps a fountain-head in the form of a Lion. Sicily or Fatimite Egypt, tenth – eleventh century. (Staatliche Kunstsammlungen, Kassel).

of about the same date as the horse. It is already typically Mohammedan as may be seen by the leaf forms and the *intreccie* of the crest, but how much of the antique Sassanid proportions and sense of relief is still retained! It is believed to be from Western Turkestan and, of the eighth or ninth century. One must suppose that Sassanid forms travelled North and East as well as South and West, and helped in the formation of that Central Asian art which becomes the dominant factor in the later centuries of Mohammedan, more especially of Persian, art.

Before leaving the question of Sassanid influences I must mention the series of bronze jugs in the Bobrinsky and Sarre collections. The general form is obviously derived from classic originals, but they have a peculiar spout of a rectangular shape placed at right angles on the top of the main opening. The effect of this is to give two openings, one for pouring the water in, the other for pouring it out at right angles. Now in the early Mossoul water jugs we see 'numerous examples of what are clearly derivations of this form passing by gradual degrees into the familiar neck with spout attached but not separated, which is typical of later Mohammedan water jugs. This evolution can be traced step by step in the Munich Exhibition, and leaves no doubt of the perfect continuity of Sassanid and Mohammedan forms.[3]

HENRY TONKS

Sir Hugh Lane

On Friday 7th May, Sir Hugh Lane lost his life by the sinking of the 'Lusitania'. In his short life he influenced by his singular gifts the tastes and perceptions of people in many parts of the world. Though naturally of a weak constitution, his boundless will-power enabled him to overcome these physical disadvantages and with surprising energy to carry out his plans. As has been happily said of him, he brought imagination into the dull life of a picture dealer. A picture dealer he certainly was, but never in romance or real life has there been such a dealer before. Sometimes he sold pictures and sometimes he gave them away, and it seemed as if he was as ready to do one as the other, and it was exactly the readiness to give away which was least understood, the reason of his action being sought in every direction but the right one, his extreme generosity. If he had ambitions it would be very difficult to say what they were; at least they were not those of a dealer. His tastes in everything, except in that of an almost morbid desire to surround himself with the most beautiful objects possible, were exceedingly simple. He would pay seventy pounds for a box at a charity ball, and have his meal at a coffee stall on the way. He had an intense desire to possess any beautiful work that he saw, and would express a kind of humorous grief, which was certainly genuine, when he found in the collection of a friend something he felt he ought to have. An ideal host, his first hope was that everyone was happy, and then displaying all their best qualities, and there could not be found in the world quite such a house as his to spend an evening in. Other people have fine collections, but no one else had such a constant variety of masterpieces. Balzac would have delighted in making the catalogue of his house.

He certainly had an extraordinary power, which seemed like a natural gift, of detecting a good picture. No doubt his unusual memory helped him largely in this, and, having made up his mind, the opinion of another person had no influence upon him. Re-painting he seemed to be always able to see through, and the happiest moments of his life were when he was superintending or actually doing himself the removal of repaint. Old pictures interested him more than new, but nevertheless he entered with zest into the most difficult of all searches, that of the living genius, and artists will miss him more than anybody.

It was unfortunate that Ireland so little understood his intentions that they refused his magnificent offer of a modern picture gallery; it would have made of Dublin a place of pilgrimage for the man of taste, the more so as the offered collection was of a kind not to be seen in London. His freedom in expressing his opinion was apt to give offence, though the peculiar way in which it was done, with a sort of nervous, apologetic laugh, very often took away the offence. His death has ended many a splendid enterprise; we can only talk of these, and he would have seen them done.

BERNARD RACKHAM

The literature of Chinese pottery: a brief survey and review

Mr Hobson's great work on Chinese porcelain,[1] published during the early months of the war, which has hitherto been denied by the circumstances of the time any detailed notice in these columns, must be counted amongst books fortunate in the moment of their appearance. Had it been longer delayed, the difficulties of its production might have been found insurmountable, not only because the cost of production would have been enormously increased, but chiefly because reference to and reproduction of specimens scattered in collections in various countries of both hemispheres would have become in many cases well-nigh impossible. On the other hand the time was fully ripe for an exhaustive treatise on the subject for the English reader. The material available for study had increased vastly in scope since the century began, and at the same time the admirers of the art of the Chinese potter had become so great a multitude that the need of a trustworthy and readable handbook was widely felt.

To make this claim is no disparagement to the work of earlier writers, amongst whom Sir Augustus Wollaston Franks and Dr S. W. Bushell will always take foremost rank. The advance in our knowledge of the subject which the present work makes possible may perhaps best be appreciated by a brief survey of its more important predecessors.

Apart from isolated references the first serious and detailed notice of Chinese porcelain in European literature is that contained in the *Lettres Edifiantes* of the Jesuit missionary Père d'Entrecolles, under the dates 1712 and 1722, with which all students of the subject are familiar. These letters are devoted exclusively to an account of industry and its methods as practised by the potters of the time, and are devoid of any reference to its origin or its history in earlier ages. Even if the Father had interested himself in the archæological side of the subject, it is doubtful whether searches would have led

to very satisfactory results. An investigation of the ceramic industry of the Staffordshire potteries (a locality which provides the nearest parallel to Ching-tê Chên of a large and populous district occupied almost entirely in this craft), conducted by oral enquiry on the spot amongst the managers and workmen, would be productive of much valuable information as to the technical methods of the present day, but would be disappointing in its results if directed towards a reconstruction of past history.

The earliest European work dealing with the history of the subject is the *Histoire et Fabrication de la Porcelaine Chinoise* of Stanislas Julien, published in 1856, which consists of a translation from the Chinese, with notes by the translator and a technical commentary by Alphonse Salvétat of the Sèvres factory, of the Ceramic Records of Ching-tê Chên, by Lan P'u, written in 1815. This book has been the basis upon which subsequent studies have been elaborated, and we find in it a brief classification of all the various fabriques from the time of the Sung dynasty onwards, with chronological details and descriptions of the characteristic features of the wares. Though of absorbing interest at the present time, when it first appeared this elaborate marshalling of facts as to types of ware of which actual specimens were quite beyond their reach must have provided somewhat arid reading to the collectors of the day.

Interest in the porcelain of the later dynasties received a great impetus from the writings of Albert Jacquemart, whose *Histoire de la Porcelaine*, produced in collaboration with E. le Blant, appeared in 1862. This somewhat verbose treatise retarded almost as much as it advanced the progress of the study by its confusion of Chinese and Japanese porcelains, and its fantastic attribution of certain types to Persia, India and Korea. Jacquemart invented a Korean provenance for what he termed 'porcelaine archaique' (ware of the Kakiemon

school), though he admitted that in old catalogues it was '*invariablement attribuée au Japon*'; he also claimed as Chinese certain wares the true origin of which was well understood for instance by the painters of 'Japan patterns' in many an English pottery. Two of Jacquemart's classifications, however, have secured general acceptance in ceramic terminology, and are likely to continue in currency; the terms '*famille verte*' and '*famille rose*' are convenient class-labels which there seems no reason to discard.

The pretentious volume of Octave Du Sartel, dated 1881, still further confounded the confusion begun by Jacquemart, and appears not to have been found worthy of a place in Mr Hobson's bibliography. Its only distinction is that it was the first book, save for a few plates in Alexandre Brongniart's catalogue of the Sèvres museum and a single example in Marryat's *History of Pottery and Porcelain*, in which Chinese porcelain was reproduced in coloured illustrations.

Meanwhile the catalogue by Sir A. Wollaston Franks of his collection, now in the British Museum, made its first appearance in 1876. Though limited as regards history to a summary of Stanislas Julien, this catalogue is of great value as a basis of technical classification, and at the same time went far to restore order in the matter of differentiating Chinese wares from those of Japan.

In 1886 a second Chinese work was made available to Western readers by the translation of the sixteenth-century album of Hsiang Yüan-p'ien, the first publication of the late Dr Bushell, reprinted in 1908; the illustrations of the album, not reproduced in the first edition, are so unconvincing in their colouring that they have caused some bewilderment and discussion as to the true nature of the objects they represent.

A considerable advance in the application of Julien's history to the chronological classification of the specimens in European collections was marked by the publication in 1894 of Monsieur E. Grandidier's *Céramique Chinoise*. This author perceived clearly the true nature of many wares of the earlier dynasties, but with few exceptions he admitted that the specimens in his own and other collections which he identified with the various types were in reality reproductions of these types made in later periods. His work is indeed excellent within the limitations imposed by the restricted material available for study; it is chiefly open to criticism in the attempted differentiation between polychromes of the late Ming and K'ang Hsi periods.

Five years later appeared the great work of Dr Bushell, upon the Walters Collection at Baltimore, enti-

17. Chia Ching bowl, with enamel painting. Diameter 18 cm. (Formerly Cumberbatch Collection).

18. Chia Ching bowl, with enamel painting. Diameter 19 cm. (Formerly Alexander Collection).

tled *Oriental Ceramic Art*, proving the truth of the assertion made by Sir A. W. Franks, in the preface of his catalogue, that 'until some European residing in China, well versed in the subject, and well acquainted with the Chinese language, has obtained access to the stores of native collectors, we shall be to a certain extent working in the dark'. The new book, with its copious citations

19. T'ang dynasty ewer. Ht. 26.7 cm. (Victoria and Albert Museum, formerly Eumorfopoulos Collection).

of the early wares as being accessible to Western students, and in a book published in the same year *Porcelain, Oriental, Continental and British*, we find Mr Hobson himself declaring that 'with very few exceptions the porcelains of this time are only known outside China by written descriptions, and even within the Celestial Empire they are excessively rare'. In another handbook entitled *Porcelain*, also published in 1906, we find Mr William Burton writing that 'the Sung productions have become so scarce that they are hardly to be procured by the most princely purse, even in China itself'; amongst distinguishing features of Sung porcelain he mentions that 'the pieces are simple, often clumsy in shape', and that 'the colour effects are always obtained by the use of simple coloured glazes and never by the use of painted colour under the glaze'.

When we think of the multitude of specimens dating not only from the Sung dynasty but also from still earlier times which have in late years been exhibited for all to see, either permanently or on loan, in our public museums and galleries, it is difficult to realise that the lapse of little more than a decade has so vastly widened our knowledge. An unsuspected wealth of artistic achievement has been brought before our eyes, whilst much that was already familiar has been endowed with new meaning and interest.

This change in the state of affairs has come about, as Mr Hobson explains in the preface of his new work, as the result of several causes. In the first place, political changes and disturbances have compelled many Chinese connoisseurs to part with their jealously guarded treasures, thus for the first time bringing the works of the Sung dynasty, which were their chiefest pride, within the reach of Western collectors. Hitherto there were very few pieces indeed amongst the collections of the latter which could confidently be assigned to that Golden Age of Chinese art, and even these stray specimens were so far misunderstood, in times when the finished and dainty workmanship of the eighteenth century was regarded as the acme of attainment, that they had even to be sought out, in at least one museum, amongst the stores of objects deemed unworthy of exhibition.

The Sung wares however were known to survive by the few who had been allowed the privilege of access to native collections. Even for these favoured few, unexpected surprises were in store. The operations of railway engineers, seconded, it would seem, in one district by a series of inundations, have brought to the light of day great quantities of pottery which had been left

from Chinese authorities and references to pieces in Chinese collections, threw a flood of new light upon the study, and must always remain a classic, even though for the collector it is superseded by the work now under review. Dr Bushell's volumes include critical discussions of the wares of the earlier dynasties, and, in addition to detailed descriptions of individual pieces, presented for the first time what was of even greater value – illustrations of several authentic specimens in the Walters Collection. Conspicuous amongst them is a superb vase of Chün yao of the Sung dynasty, reproduced in colours, giving an adequate idea of the beauty of the transmutation glazes which T'ang Ying sought to imitate in the reign of Ch'ien Lung. The splendid chromolithographs by which this work is adorned have never been surpassed amongst coloured illustrations of pottery.

The chapter on pottery in Dr Bushell's Victoria and Albert Museum handbook of Chinese Art, issued in 1906, provides a very useful summary of the subject, both historical and technical. Even so recently as this, however, it was possible to cite only very few examples

20. T'ang dynasty dish. Diameter 20.75 cm. (Victoria and Albert Museum, London, formerly Eumorfopoulos Collection).

undisturbed since remote ages to furnish the tombs of the departed. It is to be feared also that the desecration of graves has been found a profitable employment by native Chinese whose religious scruples have abandoned them under the influence of the general demoralisation and the sense of insecurity which often accompany political upheavals. In this manner the rare specimens previously known of tomb wares of the Han dynasty and the still earlier archaic period were supplemented by great accessions, whilst the T'ang dynasty, preceding that of the Sung, was revealed as an age which produced pottery in some respects little inferior in beauty to that of later and more accomplished ages. The wonders of the T'ang dynasty are indeed, as Mr Hobson claims, the most striking revelation of recent discoveries. We need no longer regret, with Dr Bushell, in his museum handbook, that the delicate T'ang wares 'have all probably long since disappeared', so that 'we must be content with literary evidence of their existence'.

The new knowledge, so far as it concerns the Han

21. Celadon bowl. Diameter 22.5 cm. (Victoria and Albert Museum, London, formerly Eumorfopoulos Collection).

published by Dr Bushell, and in a great number of cases he has endowed this literary material with a new interest by applying it to the wares themselves as we know them from specimens in museums and private cabinets. The service thus rendered is greatly enhanced in value by copious and excellent illustrations, many of them in colours. The colour-plates are naturally most successful in the case of monochrome pieces; those of the enamelled porcelains would stand less satisfactorily the severe test of comparing them side by side with the objects themselves, although, as Dr Bushell said of the plates in Mr Cosmo Monkhouse's monograph (and the admission is far better deserved in the present instance), they appeal to one 'as sufficient *memoria technica* of the originals'.

It remains very briefly to survey the scope of Mr Hobson's book and to mention a few points of especial interest. A discussion of the nature of the archaic tomb pottery is followed by an account of the immense variety of pottery models and other objects which give such precious evidence as to Chinese social life under the Han dynasty. To this succeeds a very careful examination of the evidence which justifies the dating of the tomb wares generally accepted as belonging to the T'ang dynasty; perhaps of chief importance is the fact that towards the end of that period wood superseded earthenware as the material for tomb furniture.

The traces of Sassanian and Græco-Roman influences in the art of the T'ang dynasty are now familiar to all students of the subject. An instance is provided by the form of the ewer (Fig. 19), whilst the remarkable dish with mottled glaze and decoration in the manner of the *cuenca* tiles of Southern Spain (Fig. 20) proves what a degree of refinement the T'ang potters were capable of attaining. Mr Hobson shows that painting in the strict sense of the term was almost certainly practised in this period; a fine example is that of a shallow bowl with a water-lily and dragon-flies painted in bright green and orange-yellow which was illustrated in the Victoria and Albert Museum Review for 1914. The colours upon this bowl are similar to those of the celebrated statues of Arhats, of which one, fittingly chosen for the frontispiece of the first volume, will figure henceforward amongst the great treasures of the British Museum.

We now pass to the highly interesting chapter on the beginnings of true porcelain, providing one of several cases in which the author has found it necessary to modify Dr Bushell's renderings of Chinese terms. The latter writer's assignment of the earliest porcelain to the Han Dynasty is shown to be the result of an

period, was set forth with great thoroughness by Dr Berthold Laufer in his *Chinese Pottery of the Han Dynasty* (1909), but the time had come for a complete survey of the history of Chinese ceramics as revealed by the new light. The positions recovered from the forces of oblivion needed to be consolidated against the time of another forward move, lest the episode of Jacquemart and his misleading conjectures should be repeated for the confusion of a new generation.

We may notice here the essay made with this aim by Professor Ernst Zimmermann in his *Chinesisches Porzellan* (1913), which was reviewed in these columns at the time of its appearance. Though an advance upon earlier works, it can only be regarded as moderately successful, suffering as it does from the lack of first-hand reference to Chinese texts, and it is unnecessary now to discuss afresh its merits or its shortcomings.[2] It has fallen to the lot of Mr Hobson to achieve with entire success the task attempted by Prof. Zimmermann, in a work which must long remain the supreme authority on Chinese ceramics.

In this book, which it would be difficult to praise too highly, we have no longer to be satisfied with literary references leaving us vainly attempting to visualise the wonders which they describe. Assisted by Prof. Giles, Mr Hobson has collected with infinite pains much new evidence from Chinese sources, he has verified and corrected in many vital points the versions previously

22. Stoneware vase, with milky grey glaze. ?Sung dynasty or later. Ht. 17.8 cm. (Freer Gallery, Washington).

anachronism in the rendering of the character 'tz'ǔ'. The question is complicated by the extraordinary fact that there is no word in the Chinese language to distinguish porcelain from other types of pottery, and Mr Hobson reasonably complains of the mischief that has been caused by lack of caution on the part of translators. Another mis-translation is shown to be responsible for the assumption that green porcelain, in other words celadon ware, was made by one Ho Ch'ou during the period of the Sung dynasty (Fig. 21). On the other hand it seems to be established that white kaolinic ware was already known about the middle of the seventh century, that is, early in the T'ang dynasty.[3] It would appear to be proved also that certain jars of grey kaolinic

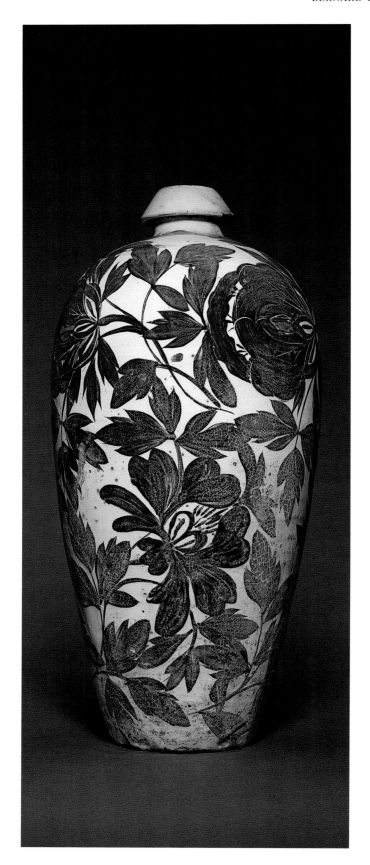

stoneware, showing reddish-brown on the surface where it was not protected during the firing by a translucent greenish-grey glaze, may be referred to a much earlier date, having been found with other objects belonging approximately to the end of the Han dynasty (220 A.D.) (Fig. 22); one of these jars, given to the Victoria and Albert Museum by Mr Robert Mond, is figured in the Review of that museum for 1915.

The classification of the Sung dynasty porcelains was first made known to the Western world by Stanislas Julien, but the identification of many at least of the types has now for the first time been accomplished with reasonable certainty.

The Ju and Kuan wares are still the subject of speculation. With regard to the former, Mr Hobson gives an illuminating reference, dated 1125, from which it may be inferred that they resembled the Korean porcelain with a pale bluish-toned glaze of which numerous specimens are extant; he also clears up a strange misconception of Dr Bushell, who identified as Ju Yao one of the numerous slender 'funeral vases' of coarse grey-glazed stoneware with applied reliefs. The Ko, Ting, Chün, Chien and Lung-ch'üan porcelains are fully described, and represented in the illustrations by many beautiful specimens; these wares for the most part owe their survival, often in perfect condition, to the massive build and satisfying solidity of material which are so characteristic of their period. The skill of the Sung potters in the art of painting with the brush is proved by the wonderful productions of the Tz'ŭ Chou kilns (Fig. 23). The early use of enamel colours at Tz'ŭ Chou is another interesting point which Mr Hobson discusses.

The second volume, devoted to the Ming and Ch'ing dynasties, is scarcely less interesting than the first, in spite of our greater familiarity with its subject. Space does not permit us to deal with it here in detail, but it will be found to throw fresh light on many obscure and difficult points. Everywhere we meet with the same searching examination of the evidence, the same austere restraint in the deductions drawn from it, as for instance when the author points to a dated K'ang Hsi ink-palette in the British Museum, with enamel decoration *sur biscuit* in the late Ming style, as a warning against too early attributions, for wares of this character;[4] or again, when he explains that the signature

23. Tz'ŭ Chou painted vase. Ht. 38 cm (Musée du Louvre, Paris).

'Pai-shih' and date (corresponding to 1724) on a *famille rose* eggshell cup and saucer are those of the design and not of the piece upon which it is copied – a case parallel to that of the erroneous deductions drawn from the celebrated majolica service of Nicola Pellipario in the Correr Museum at Venice, with its copies of woodcuts of the year 1482. Only in one instance does Mr Hobson seem to have departed from this admirable attitude of caution, namely, in attributing to the seventeenth century a vase in the Salting Collection shown in his Plate 84. This piece, reproduced from the early Ming type with designs in raised outline filled in with coloured glazes, shows a close affinity, in the quality and colour of the glazes, with the well-known imperial dragon bowls painted in green and purple or yellow *sur biscuit* of the reign of Yung Chêng.

A few suggestions may be made for the improvement of reprints which are certain to be found necessary in the future. A modern map would be of value on the lines of that in Julien's history, showing the sites of the various pottery centres, and the illustrations would be more useful if their titles included a reference to the pages of the text. Lastly, the curious half-Scandinavian form assumed by the name of the Kaiser Friedrich-Museum, '*Acthlohanberg*' on p. 35 and 'Ching-tê Chen' on p. 38, vol. I, are misprints needing corrections.

ANDRÉ SALMON

Negro art

An exhibition of negro art held in a Parisian gallery at the beginning of last winter served to render familiar to the public, and to some extent popular, the interest of modern artists in the productions of African and Oceanic sculptors. Those of us who have studied the manifestations of contemporary art know what patience is necessary before the public can accept in its integrity and purity a disinterested aesthetic conception. Disinterestedness lies in the moral attitude which teaches us to despise the advantages of a fashion. A *fête nègre*, as delightful as a charming Russian ballet, which was held on the occasion of this exhibition, seems to have greatly favoured the fashion but to have been of little service to the pure idea. And so although many amateurs of negro art, knowing the poverty of the French national collections in this respect, will have taken the trouble to revisit the incomparable collection at the British Museum, we cannot feel sure that each of them will see it with regenerated eyes. That is to say, with eyes completely purified from a love of the curious and picturesque. This it was precisely which rendered vain their first visit, because it prevented them from seeing in these wooden sculptures and rare bronzes the only thing which matters – the element of essential beauty. We cannot feel this beauty until we have discarded the vulgar sentiment – in itself a civilised barbarism – which causes us to be astonished when we find sculptures worthy of a place in our museums to be the work of savages. It might be better before seeing the collections at the British Museum or the Trocadero again, to study the creations of the modern artists who were the first to place negro art on a plane not inferior to that of Grecian, mediaeval, or Ancient Egyptian art. It was the study of the latter which inevitably led the artists I have mentioned to the discovery of the statuary of the African deserts and Polynesian Isles.

Before the awakening of the interest which led to these discoveries the known examples of the art of primitive peoples were only looked at from the academic point of view, so to speak. They were nothing but illustrations to various branches of ethnography; the playthings of explorers, lecturers, and professors of anthropology and geography. They were not even considered from the unsatisfactory standpoint of the picturesque. They had no such 'decorative poet' as the natives of the Dark Continent and of the Pacific Isles found in Pierre Loti. The first statuettes and masks from Dahomey, Nigeria, Senegal, or the Polynesian archipelagos were eagerly sought for by the painters Henri Matisse, Picasso, André Derain, Maurice de Vlaminck, and M. de Goloubew. They were found in curiosity shops mixed with shields, clubs, spears, arrows and assegais. Such trinkets as these were usually preferred by collectors, who found the masks, for instance, too tragic in conception to suit their European taste – a taste which they considered refined when it was only excessively limited.

Nor was this all. The only contemporary artist who was fired with a passion for virgin lands, who was essentially a revolutionary painter, impatient for absolute novelty, and whose thirst for the unfamiliar justified the exile which it ordained – even he remained prodigiously indifferent to the masterpieces of Maori sculpture. When towards the end of the nineteenth century Paul Gauguin, tired of his royalty at Pont-Aven, left Brittany for Tahiti, he had already carved out of the wood of the forests of Finistère some of the rude but expressive figures which rank among the best of his work. This apprenticeship in rustic imagery, this re-invention of the art of sculpture, should have helped him, if not to any immense revelation through which modern art might find its renewal, at least to some understanding of the austere masters of savage

24. Wooden ceremonial mask of the Baoulis (Côte d'Ivoire). Ht. 38 cm. (Formerly Collection Paul Guillaume).

25. Wooden head, used in ritual of Gabou district. (Formerly Collection Paul Guillaume).

26. Large wooden mask used in the *Gouli* dances of the Baoulis. Ht. 91 cm. (Musée d'art moderne, Troyes; formerly Collection Paul Guillaume).

antiquity. Paul Gauguin saw nothing, at home or abroad, except from the angle of the picturesque. As a poet in Tahiti he sang *Noa-Noa* in verses which are nothing but Pierre Loti revised and corrected by the symbolists. Gauguin could not have enriched us with negro art such as it appears to us to-day. Our concern with order, with constructive values, the desire for form and harmony which have since come to govern our aesthetics, were totally lacking in the undisciplined and irritable impressionist. After that there is little need for me to speak of academic artists incapable of suspecting the existence of a negro art, except when they become indignant because other people are moved by it. An American sculptor built himself an African studio next door to the hut of a carver of idols – a humble copyist of the images of the best period. Without ever realising that this artist, fallen to the rank of artisan, might still be his master, the American serenely modelled a naturalistic study of the black sculptor at work on his fetish. But how can we wonder at this when the whole of Europe has for so long regarded black statuary from the point of view of the American who found the negro

interesting. Interesting! Picturesque! Good taste! Who can tell what harm these words have done with their suggestion of half-heartedness and feeble faith. Their maleficent power over the human spirit has not yet been destroyed.

A public convinced of the excellence of its own culture is at a loss to understand the anguish which drove modern artists to seek lessons from barbarian image-makers. When they had completed their tour of the world and their tour through the ages, the most thoughtful of our contemporary artists went back to the negro village, which remains unchanged from century to century. They did not do so, however, in order that they might wallow naively in some shameful cannibalism. Impressionism and symbolism yielded in Europe enough material for savagery. They were, on the contrary, irresistibly drawn towards an art, primitive indeed in a sense, but already highly developed, unshadowed by any Academy, or by any renaissance. Such an art, if its logic were studied, was capable of reviving the dried-up sources of the classic.

Picasso – an enthusiastic collector of negro masks in

27. Wooden Mask with four faces, used in the lunar dances of Gabou. 10th century. Ht. 36 cm. (Formerly Collection Paul Guillaume).

28. Wooden charm against sickness, Kilamantan tribes, Borneo. (British Museum, London).

1906 – was about to discover that cubism which was defined by an anarchist friend of Bonnard as '*un retour offensif de l'Ecole*'. At the shops of the dealers Picasso found himself in competition with the 'Fauves', who like himself loved and defended that admirable *ingénu* le Douanier Rousseau. Now we do not cherish Rousseau for his barbarism, but for his science. There is nothing accidental in his work; there are no marvellous successes. He is a painter who never owes anything to the miraculous. For this reason the Douanier sometimes reminds us of the great masters, and when he does so he makes us more appreciative of Giotto and Paolo Uccello. The Douanier painted his ambitious compositions in the same way that the black sculptor carved his sacred images. The latter had begun to awaken our interest about the same time that the former was enjoying his innocent triumphs. Rousseau was in fact ignorant of nothing but Academism. He did not feel

obliged to waste his time, and to spoil his freshness in such reactionary tasks as were, after all, those of the impressionists. It was not the African negroes and the Polynesians who taught us the monstrosities with which some erring Europeans proved the truth of the paradox that there is a 'science of ignorance'. The artists of the twentieth century were faithful to the museums, which they visited with a passion which was governed by their reason and critical faculties. They were impatient to set their art in harmony with new life. To them the savage sculptors yielded plastic examples of the ambition of the primitive to found a style, a culture, on the most profound human emotion. And this emotion is already purified by a noble sentiment which, while limiting the emotion, is capable of turning it into a conception. This sentiment in the race was the religious faith which preceded revelation. There is no reason to lay stress on the allegories, the symbols, which contain such an affir-

mation. They will be apparent to all to whom art is anything more than a recreation.

The carver of idols is, without doubt, the most scrupulous of realists. He works with almost the same delicious naivety as Rousseau, who, before painting a full-length of the poet Alfred Jarry, carefully measured him with a pocket rule, after the fashion of a tailor. But we must not forget that the Douanier chose his models, that he only treated them thus through a kind of scruple, and that before setting to work he had a complete conception of his subject. The black sculptor was also scrupulous and believed that he ought not to neglect any detail. It is because of this virtuous application, devoid of any mischievous intent, or any violent sensuality, that the wooden sculpture of savages – especially those of Western Africa – is occasionally indecent. In our climate the indecent pieces are deliberately suppressed even by the most inclusive of collectors, and by those with the greatest sensibility and respect for negro art. These pieces can be omitted without the unity of the whole work suffering. This is because such pieces are accidental, not essential in the art. The negro sculptor conceived his theme as did after him the great masters of our civilisation. His diligence and fidelity in the study of human perfection do not arise from the base fetishism of imitation which leads the academic European to rejoice when he can confound the picture with the mirror. The negro, and his rival the Polynesian, drew all their inspiration from human perfection without ever subordinating the work of art to it. As realists, their scrupulous attention is directed to the construction of a harmonious whole. All that which is accessory to these works may disappear, devoured by time or sacrificed to the good taste, the prudery, or indeed the barbarism of the European. The premeditated harmony of the whole is not thereby diminished.

29. Wooden figure, Trobriand Islands, New Guinea. (British Museum, London).

30. Wooden mask, Tami Island, New Guinea. (British Museum, London).

31. Wooden figure, Baluba people. S.E. Central Africa. Ht. 46 cm. (British Museum, London).

Besides the sacrifice I have referred to, it often happens that masks of feast and mourning, weddings and funerals, only reach us deprived of their beards and fleeces of wool, tow, hair or raffia. Very often also the more or less brilliant colouring has been seriously damaged. But our aesthetic joy in the genius of barbarism does not suffer in consequence. The value of these ornaments is sometimes purely symbolic, more religious than æsthetic; or else (since even among primitive peoples artists are not exempt from preciosity) they are elements of the superfluous, which warn us of the time when over-refinement and false civilisation will ruin the whole. Negro sculpture is admirable through its balance, its nobility of form, its sum of naked beauty.

We may smile at the disgust and scepticism of the collectors who are convinced that they are the vigilant guardians of the classic, who despise negro statuettes, or noisily mock at them, while at the same time they fill their houses, galleries, and museums with gothic images. Is the distortion which offends them in the powerful works of African and Polynesian sculptors less marked in the pieces which have come down to us from mediaeval Europe? I do not think so. M. Camille Enlard, a prudent thinker and a jealous defender of tradition, an erudite compiler and a learned commentator on mediaeval art, has unwittingly furnished me with the materials for a seductive thesis as to the distortion proper to all peoples and every period. It was in the marvel of an equilibrium firm yet graceful that the Egyptians discovered the secret of Karnak and Medinet-Habu. Modern artists, dissatisfied with the Greeks, who by an accumulation of parts tended to destroy the balance of the whole, would be logical if in their preoccupation with constructive principles they went beyond the art of the Egyptians to that of the negroes.

Although the subject is worthy of a more extensive study, I should like at least to touch upon one of the essential features of the beauty which is peculiar to African and Oceanic sculpture. This feature is only possible in the complete absence of futile naturalistic imitation. Man taking man for his model, to represent his gods it may be, is not satisfied only by imitating man. Herein lies that which separates the healthy realist from the naturalist who is entangled in a hampering dogma. That which allows the black sculptor to achieve the divine in his interpretations of the human face is his plastic translation of emotion, preferably at its most intense instant. From this we are entitled to claim that even psychology is not lacking in negro art.

People are now beginning to weigh the value of that which drew the artists mentioned above towards these hitherto unknown sources. To the names already given we must add those of Othon Friesz, a companion of Henri Matisse, and their comrade Franck Burty, grandson of Philippe Burty. Their fraternal union was the foundation of the Céret group, in which André Derain at last found himself, and Cubism rose to the dignity of a school. There were Luc-Albert Moreau, André Lhote, Dunoyer de Segonzac, Marie Laurencin and writers such as the late Guillaume Apollinaire and Jean Paulhan, psychologist and logician, a fervent commentator on the genius of East African languages. For myself, Picasso revealed to me pieces of Dahomean sculpture, of whose purity I had had no conception, although I had an idea of their savage beauty, still spoilt for me by the travellers' notion of the picturesque. I kept a very coarse coloured illustration out of the *Petit Journal*, the sort of thing that humble folk in France cut out, to brighten their walls with crimes, catastrophes, or military or civilian feats of prowess. My picture showed the first of Colonel Doods's soldiers to enter Abomey, smiling at the Dahomian idols with the heads of jackals, buffaloes or imaginary monsters. I always hoped that some lettered soldier would write the poignant story of the encounter of civilised prejudice with these monuments of a new beauty, so much older than that which is familiar to us. But the glamour of the picturesque was too blinding, and the book was never written.

What was necessary to lead up to the discovery of Negro art? It needed the desperate patience of Cézanne to yield us, after his death at the end of a life of sublime dissatisfaction, the constructive elements whose deliberate acceptance gave the strict and lucid lesson of Ingres its full value. From Ingres we had to turn to Cézanne, building with difficulty among the ruins, and so to rediscover Greco, in whose work M. Maurice Barrès could see nothing but the pathetic. It was necessary for new works to throw light on the subtle and rigorous intention of Seurat, the most unpopular of impressionists, and the only one of them who illustrates in each of his works the pregnant affirmation of the moderns that 'conception is more important than vision'. In the service of pure painting as such, we had to visit the Louvre and to imagine its contents arranged in the proper order, with the Venetians and the Florentines freed from the tyranny of the Dutch.[1] We had to compare Delacroix with Courbet without evading any of the exercises in criticism which this entailed, and finally, as I have said before, we had to do homage to Rousseau.

Living artists dislike the haphazard, which is never to be reconciled with durable work. They no longer recognise signs of purity in the fugitive products of impressionism, which leaves even the best, those most completely freed from the constraint of a sterile anarchism, and the freest of its adherents, timid in front of that high summit – patience. Purity? Since 1906 purity has been visible in the black statuary of the Ivory Coast, Dahomey, Senegal and the Pacific Isles. The lesson was one which was aspired to by young men not anxious to steep themselves in barbarism, when they fled from something worse, but desirous of a method, properly speaking of a method of decomposition, tending to a renaissance of composition. Composition was a thing unknown in Europe since the triumph of the charming but perfectly anarchic talent of Bonnard, Vuillard, most of the Pont-Aven school, and even of Gauguin himself, though no one has yet dared to say so.

In one of the note books which are still being published (pleasant reading, and in spite of everything worthy of the greatest respect) that constant witness of the flower of Polynesian art, Paul Gauguin, has quietly written this which his faithful historiographer, Mr Charles Morice, coolly reports in the thought no doubt of serving his memory: '*On ne semble pas se douter en Europe qu'il y a eu, soit chez les Maoris de la Nouvelle Zélande, soit chez les Marquisiens, un art très avancé de décoration.*' He may well say '*de décoration*'. So Gauguin allowed himself to be dazzled, but in the wrong way. He was charmed, but without being able to understand. He shows us here where to strike if we wish to discredit his own work, in spite of the richness of its superficial seductions.

There was great trouble in the minds of those who had been nourished in the symbolist doctrine (so inferior to that of the impressionists). Charles Morice, commenting on Gauguin, discovered confusedly that the art of the Maoris – negro art – was 'l'art vrai' – that which links Mexico to Egypt, the Greek to the Italian, the Flemish and French primitives to the Japanese, and to the Chinese, and 'Giotto to Puvis de Chavannes'. Leaving Puvis de Chavannes to rest in peace, let us notice in passing the error of placing Japanese and Chinese art upon the same plane of achievement, and above all the disorder which must have reigned in the minds of the symbolists if in savage art they could see nothing but 'decoration'. The 'Fauves' of 1905, and

following them the Cubists, expressed the need of something besides decorative teaching. It is not to the negroes in any case that they would have gone for such lessons. In a recent study M. Paul Guillaume has given a valuable indication of the real feeling of those of our contemporary artists, who are under the influence of negro art. He writes '*Chez Derain, un masque, étonnante évocation des mystères pahouins, un tabou émouvant comme une hallucination. Chez ce peintre, le plus disintéressé qui soit, aucun souci de collectioner, mais le simple plaisir, la simple nécessité de cette compagnie âpre et rassérénante. Picasso possède un certain nombre de pièces des origines les plus variées; il fait coquetterie de n'attacher aucune importance aux époques.*'

These '*époques*' are numerous and go back so far in point of time that the actual documentation does not prevent us from asserting that in studying these marvels European painters and sculptors are only rediscovering the source of perfect classicism. Not only are some of the finest pieces that have come down to us far anterior in date to the Christian era, but we are justified in discussing the influence of the carver of fetishes on the style of the ancient Egyptians. That the Greeks were greatly influenced by Egyptian example is no longer a matter for dispute; artists, aesthetes and scientists being agreed on this point.

The revolutionary artists of our time are so fundamentally constructive in their aims that anarchist critics of post-impressionism try to insult them by labelling them reactionaries. Passionately careful weighers of form and measurers of space, they hold to be of value only that vision which is under the control of thought. They did not build up a museum of Negro art, whose rooms are some Parisian studios, and at whose doors the best students of our time have come to knock, merely by the sacrifice of their hankering after the picturesque which they had repudiated. Nor was it in the miserable quest of a poverty of style calculated to content a romantic cabinet-maker, an upholsterer who subscribes to the *Journal des Voyages*. Nor, as I have said before, did they try to find rejuvenation by plunging into the black lake of a terrible naiveté – salvation through cannibalism! No. But we are justified in claiming that the logic of the noblest artists' life that has been led since the golden age in Italy should lead them to recognise in the grandiose and savage fragments of antique negro sculpture the very principles of art.

1930

CAMPBELL DODGSON

Una Vilana Windisch

The magnificent drawing (Fig. 32) which the British Museum has recently acquired through the prompt support given by the National Art Collections Fund to the effort of the Keeper of Prints and Drawings to secure it, is comparatively unfamiliar even to students of Dürer's work. To those who see it for the first time, it gives a shock, pleasurable or otherwise, according to the temperament of the beholder; it possesses the vitality of a great work of art, and the artist has endowed it with an energy which can never perish and can never cease to surprise. This strange sly woman with half-closed eyes and widely-opened mouth is the Mona Lisa of German art. With her delicately modelled face, supported by a straight neck and massive bosom, she gazes directly to the front, amused perhaps by one of the not very delicate jests which Dürer shortly after this was putting into his letters home from Venice. The drapery wound about the hair is drawn with Dürer's utmost skill. The lines of the dress are very slightly indicated, and beneath the upper edge of the bodice Dürer has written a date, a signature, and a title, so complete, large and emphatic, with the characteristic open figures and '*Schnörkel*' of this period, as to suggest that he was specially proud of his work.

'*Una vilana Windisch*' should be interpreted 'a Slavonic peasant woman'. Lippmann called her 'South Tyrolese', and this put into my head the suggestion, which I now know to be etymologically false, that she was a native of the Vintschgau, the Upper Adige Valley, above Meran. I realised, of course, that this lay off Dürer's route to Venice by the Brenner road, but there would be nothing improbable in his drawing, say at Botzen or Trent, a woman who came from the Vintschgau.

'*Windisch*', however, as I have been reminded by Austrian friends, is simply the equivalent of the modern 'Slovene'. Applied in early times to the Slav race in general, 'Windisch' came to denote the Southern Slavs inhabiting various parts of what till recently was the Austrian Empire, and not to be confused with the Wends of a more northerly region. The word occurs in several Austrian family and place-names, such as Windisch-Grätz, Windischgratz, and Windisch-Matrei. The 'Windische Mark' was a district in the Carolingian Empire, which became merged in Carniola (Krain), but survived till the end as part of the titles of the Emperors of Austria. Slovenes are to be found in various parts of Styria, Carinthia, Carniola, etc.

Whether Dürer drew this woman on his road to Venice or after his arrival, we do not know for certain. It is more probable, however, that other writers like Thausing and Ephrussi are correct in saying that the sitter was a Slavonic woman whom Dürer drew at Venice. The inscription, at any rate, was written when he had acquired some familiarity with Italian speech, and probably he wrote it when the drawing was fresh.[1]

The pen work was done in bistre, and the wash is of a brown colour, rich and warm, not so cool and greyish as Lippmann's collotype suggests. The dimensions are 39 by 27 centimetres, and as the drawing has been backed with old paper, no water-mark is visible. Not much is known of its history. The mark of the Lagoy Collection (d. 1829, Lugt 1710), is indistinctly stamped in the right lower corner, while in the left is the large mark (also in a triangle) of Alfred Seymour. Neither mark can be discerned in Lippmann's reproduction. As related by Mr Frits Lugt (No. 176), the collection marked with the A.S. stamp formerly belonged to Henry Danby Seymour, M.P. (1820–77), and then passed to his brother Alfred (1824–88), also a Member of Parliament, of Knoyle, Wilts. When Lippmann published the drawing in 1896 it belonged to his widow (according to Lippmann, 'Mrs Seymour, London'). In 1906, when

40

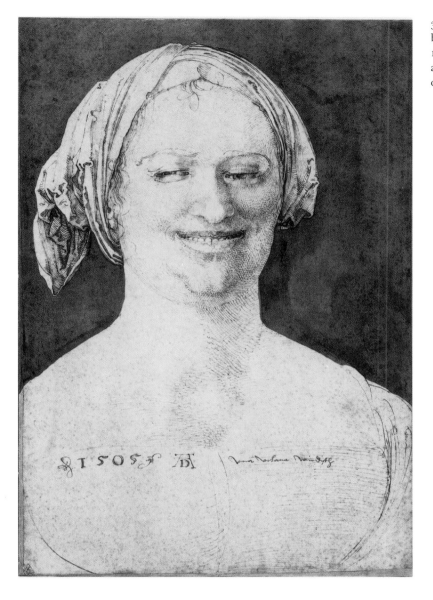

32. *Una Vilana Windisch*, by Dürer. Inscribed 1505. Pen and brown ink and wash, 41.6 by 28.1 cm. (British Museum).

I was collecting Dürer drawings for the exhibition of Early German Art at the Burlington Fine Arts Club, I tried in vain to discover the whereabouts of L.408. Parts of the Seymour collection had already been sold in 1875 and 1878; but a remainder of the drawings and engravings, including this and another Dürer (L.711), were sold at Sotheby's by the Trustees of Miss Jane Margaret Seymour, on 26th April 1927. I believe that there was another sale at the country house. At Sotheby's the 'vilana windisch' was knocked down to Mr Frank Sabin, but passed shortly afterwards into the collection of Mr H. E. Ten Cate, of Almelo, Holland, who lent the drawing in 1928 to the Dürer Exhibition at Nuremberg, where for the first time in the twentieth century it became known in the original to students of Dürer. It has now, happily, found a home in one of the leading collections of the master's work, and one of the most accessible.

There are splendid drawings of various kinds in the British Museum Dürer collection: landscapes, animals, portraits in silver-point and chalk and charcoal, these latter chiefly of the last decade of Dürer's life. But 'una vilana windisch' stands apart: there is nothing like it (by which I do not mean to assert that nothing else is so good) in the whole surviving work of Dürer, and the acquisition of such a drawing adds something entirely fresh, something in its kind incomparable, to the London Dürer collection.

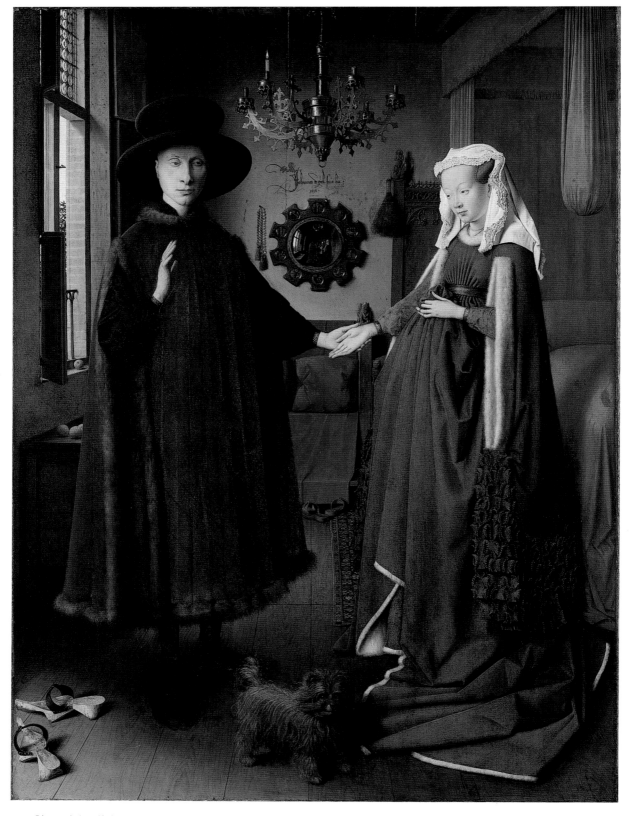

33. *Giovanni Arnolfini and his wife,* by Jan Van Eyck. 1434. Panel, 83 by 62 cm. (National Gallery, London).

1934

ERWIN PANOFSKY

Jan van Eyck's Arnolfini portrait

For about three quarters of a century Jan van Eyck's full-length portrait of a newly married couple (or, to speak more exactly, a man and a woman represented in the act of contracting matrimony)[1] has been almost unanimously acknowledged to be the portrait of Giovanni Arnolfini, a native of Lucca, who settled at Bruges before 1421 and later attained the rank of a '*Conseiller du Duc de Bourgogne*' and '*Général des Finances en Normandie*', and his wife Jeanne de Cename (or, in Italian, Cenami) whose father, Guillaume de Cename, also came from Lucca, but lived in Paris from the beginning of the fifteenth century until his death.[2] But owing to certain circumstances which require some investigation, this identification has been disputed from time to time.

The 'orthodox theory' is based on the assumption that the London portrait (Fig. 33) is identical with a picture acquired by Don Diego de Guevara, a Spanish grandee, and presented by him to Margaret of Austria, Governor of the Netherlands, by whom it was bequeathed to her successor, Queen Mary of Hungary. This picture is mentioned in two inventories of Lady Margaret's Collection (one made in 1516, the other in 1523), which give the name of the gentleman portrayed as 'Hernoul le fin' and 'Arnoult fin' respectively, as well as in the inventory of Queen Mary's property made after her death in 1558.[3] From this we must conclude that she brought it with her to Spain when she left the Netherlands in 1555, and in 1789 it is still mentioned among the works of art adorning the palace of Charles III, at Madrid.[4] As for the London portrait, we only know that it was discovered at Brussels in 1815 by an English Major-General called Hay and subsequently taken to England where it was purchased by the National Gallery in 1842.

As the subject-matter of the picture described in the inventories (a man and a woman standing in a room and joining hands) is absolutely unique in northern fifteenth-century panel-painting, its identity with the London portrait seems to be fairly well established; moreover, considering that the picture formerly belonging to the Hapsburg princesses disappeared after 1789, and the London portrait appeared in 1815, it seems safe to assume that the latter is identical with the former and was carried off during the Napoleonic wars. In addition, the London portrait corresponds to the descriptions in several respects, particularly the date (1434) and the mirror reflecting the couple from behind.[5]

There are only two circumstances which periodically give rise to discussion and recently led Monsieur Louis Dimier[6] to the conclusion that the picture in the National Gallery cannot be identical with the picture mentioned in the inventories: firstly, the enigmatical inscription on the London portrait: '*Johannes de Eyck fuit hic*'; secondly, the fact that, in Carel Vermander's [Karel van Mander] biography of Jan van Eyck (published in 1604), the 'Hapsburg picture' is described in the following manner: ' . . . *in een Tafereelken twee Conterfeytsels van Oly Verwe, van een Man en een Vrouwe, die malcander de rechter handt gaven als in Houwelijck vergaderende, en* worden ghetrouwt van Fides, die se t'samengaf.'[7] Translated into English, the passage reads: 'On a small panel two portraits in oils, of a man and woman taking each other by the right hand, [note that, in reality, the man grasps the woman's right hand with his *left*:] as if they were contracting a marriage; and *they were married by Fides who joined them to each other*.'

From this Monsieur Dimier infers that the 'Hapsburg picture' not only showed a bridal pair as in the London panel, but also a personification of Faith who fulfilled the same office as, for instance, the priest in the versions of the *Sposalizio*, and he confirms this conclusion by quoting Joachim von Sandrart who, in

1675, qualifies Vermander's description by adding the statement that '*Fides*' appeared as an actual female ('*Frau Fides*' as the German version puts it): '*Par quoddam novorum coniugum, quos* muliebri habitu adstans *desponsare videbatur Fides.*'[8]

Now, Monsieur Dimier is perfectly right in pointing out that Vermander's '*Fides*' cannot possibly be identified (as was conjectured by some scholars)[9] with the little griffin terrier or Bolognese dog seen in the foreground of the London picture. For although a dog occurs fairly often as an attribute or symbol of Faith,[10] the Flemish word '*tesamengeven*' is a technical term equivalent to what '*desponsare*' or '*copulare*' means in Latin – a term denoting the action of the person entitled to hand over the bride to the bridegroom. Thus it is beyond doubt that not only Sandrart, but also Vermander actually meant to say that the couple portrayed in the 'Hapsburg picture' were united by a human figure embodying Faith. The only question is whether or not Vermander is reliable. And this question must be answered in the negative.

Apart from the fact that a description as thorough as that in Queen Mary's inventory where even the mirror is mentioned would hardly omit a full-size figure, we must inquire from whom Vermander gleaned his information about a picture which, as mentioned above, he had never seen. Now it is a well-known fact (although entirely disregarded by Monsieur Dimier) that Vermander's statements as to the van Eycks are mostly derived from Marcus van Vaernewyck's *Spieghel der Nederlantscher Audtheyt* published in 1569, and (as *Historie van Belgis*) in 1574. This was also the case with Vermander's description of the 'Hapsburg picture', which is proved by the fact that he repeats Vaernewyck's absurd tale that Queen Mary had acquired the picture from a barber whom she had remunerated with an appointment worth a hundred florins a year – a tale which Sandrart took over from Vermander as credulously as the latter had taken it over from Vaernewyck. Thus Vaernewyck is the ultimate source from which both Vermander and Sandrart obtained their information, and his description of the 'Hapsburg picture' reads as follows: '*een cleen tafereelkin … waerin gheschildert was / een trauwinghe van eenen man ende vrauwe / die van Fides ghetraut worden*',[11] that is in English: 'a small panel on which was depicted the wedding of a man and a woman *who were married by Fides*'.

It is self-evident that Vermander's description is nothing but an amplification of this text, and we can easily see that he amplified it rather at haphazard.

Since he was familiar with the usual form of a wedding ceremony, he ventured the statement that the two people took each other by the *right* hand (whereas, in the London portrait, the man proffers his *left*); and since, in his opinion, Vaernewyck's sentence '*die van Fides ghetraut worden*' (who were married by Fides) was lacking in precision he arbitrarily added the adjectival clause '*die se t'samengaf*' (who joined them to each other). So this adjectival clause, so much emphasised by Monsieur Dimier, turns out to be a mere invention of Vermander's.

But what did Vaernewyck mean by his mysterious sentence? In my opinion he meant nothing at all, but simply repeated (or rather translated) information which in all probability puzzled him as much as his translation puzzles his readers. We should not forget that Vaernewyck had not seen the picture either, for it had been brought to Spain by Queen Mary, and it is a significant fact that, in his earlier writings, he does not mention it at all.[12] Thus his description must be based on information gleaned from an unknown source, most probably a letter from Spain; and when we retranslate his sentence into Latin (using the passage of Sandrart as a model) we can easily understand how the confusion arose. This hypothetical text might have read: '*Tabella, in qua depicta erant sponsalia viri cuiusdam et feminae* qui desponsari videbantur per fidem', and a sentence like this would have been an absolutely correct description of the London picture. Only, it could easily give rise to a misinterpretation because, to an uninitiated mind, the expression '*per fidem*' might easily suggest a personification – while, in reality, it was a law-term.

According to Catholic dogma, marriage is a sacrament which is immediately accomplished by the mutual consent of the persons to be married when this consent is expressed by words and actions: '*Actus exteriores et verba exprimentia consensum* directe faciunt *nexum quendam qui est sacramentum matrimonii*', as Thomas Aquinas puts it.[13] Even after the Council of Trent had prescribed the presence of two or three witnesses and the co-operation of a priest, the latter is not held to dispense the 'sacramental grace' as is the case in the baptism of a child or the ordination of a priest, but is regarded as a mere '*testis qualificatus*' whose co-operation has a mere formal value: ' . . . *sacerdotis benedictio non requiritur in matrimonio quasi de materia sacramenti*'. Thus, even now, the sacerdotal benediction and the presence of witnesses does not affect the sacramental validity of marriage, but is only required for its formal legalisation. Before the Council of Trent, however, even this principle was not yet

acknowledged. Although the Church did its very best to caution the Faithful against marrying secretly, there was no proper '*impedimentum clandestinitatis*' until 1563; that is to say, two people could contract a perfectly valid and legitimate marriage whenever and wherever they liked, without any witness and independently of any ecclesiastical rite, provided that the essential condition of a 'mutual consent expressed by words and actions' had been fulfilled. Consequently in those days the formal procedure of a wedding scarcely differed from that of a betrothal and both these ceremonies could be called by the same name '*sponsalia*', with the only difference that a marriage was called '*sponsalia de præsenti*' while a betrothal was called '*sponsalia de futuro*'.

Now, what were those 'words and actions' required for a legitimate marriage? Firstly an appropriate formula solemnly pronounced by the bride as well as by the bridegroom, which the latter confirmed by raising his hand. Secondly: the tradition of a pledge ('*arrha*'), generally a ring placed on the finger of the bride. Thirdly, which was most important: the 'joining of hands' which had always formed an integral part of Jewish marriage ceremonies as well as those of Greece and Rome ('*dextrarum iunctio*') (Fig. 34). Since all these 'words and actions' (comprehensively depicted in the London portrait) fundamentally meant nothing but a solemn promise of Faith, not only the whole procedure was called by a term derived from '*Treue*' in the Germanic languages ('*Trauung*' in German, '*Trouwinghe*' in Dutch and Flemish, whereby originally '*Trouwinghe*' could mean both '*sponsalia de præsenti*' and '*sponsalia de futuro*'), but also the various parts of the ceremony were called by expressions emphasising their relation to Faith. The forearm raised in confirmation of the matrimonial oath was called '*Fides levata*';[14] the wedding-ring is called '*la fede*' in Italy up to our own times; and the '*dextrarum iunctio*' was called '*fides manualis*' or even '*fides*' without further connotation,[15] because it was held to be the essential feature of the ritual. Also in heraldry a pair of joined hands is simply called '*une Foi*'.[16]

Thus in mediaeval Latin the word '*fides*' could be used as a synonym of 'Marital oath', more particularly '*dextrarum iunctio*.' Consequently Jan van Eyck's London portrait could not be described more briefly or more appropriately than by calling it the representation of a couple '*qui desponsari videbantur per fidem*', that is to say: 'who were contracting their marriage by a marital oath, more particularly by joining hands'.

It is both amusing and instructive to observe how, in the writings of sixteenth- and seventeenth-century

NVPTIÆ

SPONSVS, ac SPONSA *uicissim dexteras iĩgunt, maritali fidei argumentum.* PRONVBA IVNO *in medio stat, ac utrunque amplectens, coniugio iũgit.* AMORES GEMINI *hinc inde, uolitantes coronam altera manu tenent, altera flores et frondes effundas, quorum sertis postes ædium nouis Nuptis exornare consueverunt.*

34. A Roman marriage ceremony, from a Roman sarcophagus (Matz-Duhn II, 3098). (Palazzo Giustiniani, Rome, from P. S. BARTOLI: *Admiranda Roman. Antiquitatum ... Vestigia*, Rome [1693]).

biographers, this abstract law term gradually developed into a living, though allegorical, female figure. Vaernewyck opened the way to the misinterpretation by inserting the Latin word '*fides*' into his Flemish text and writing it with a capital F, but shrank from any further explanation. Vermander emphasised the personality of this rather enigmatical '*fides*' by adding the adjectival clause '*who joined them to each other*', and finally Sandrart explicitly asserted that she was present as an actual woman, '*habitu muliebri adstans*'. It is not difficult to understand the mental processes of those humanistic authors. To the contemporaries of Cesare Ripa, personifications and allegories were more familiar than to others, and they had in their minds all those Roman sarcophagi where the people to be married are united by a '*Juno pronuba*' (Fig. 34). But the case should be a

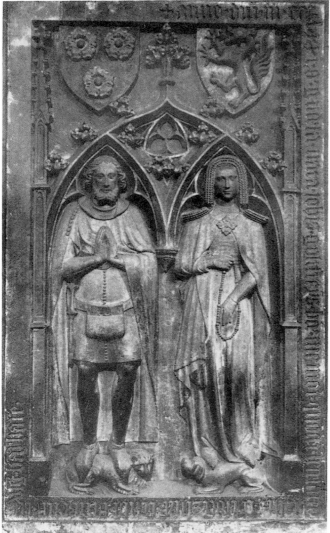

35. Johann von Holtzhausen (d. 1393) and his wife, Gudela (d. 1371). (The Cathedral, Frankfurt-am-Main).

the lack of any legal or ecclesiastical evidence was bound to lead to the most serious inconveniences and could cause actual tragedies. Mediaeval literature and papers dealing with law-suits are full of cases, partly tragic, partly rather burlesque, in which the validity of a marriage could be neither proved nor disproved for want of reliable witnesses,[17] so that people who honestly believed themselves to be married found out that they were not, and vice versa. The most preposterous things could happen when the depositions of the people concerned contradicted each other as they often did; for example, in the case of a young lady who was to become the mother of no less illustrious a person than Willibald Pirckheimer. This young lady was originally on fairly intimate terms with a young patrician of Nürnberg, called Sigmund Stromer, but wanted to get rid of him when she had made the acquaintance of Dr Hans Pirckheimer. Now the unfortunate lover asserted that she was his legitimate wife, owing to the fact that they had secretly performed the ceremony of 'joining hands'; but this was exactly what she denied. So the bishop of Bamberg, to whom the case was submitted, could not but decide that the marriage was not proved, and she was allowed to become the mother of Willibald Pirckheimer while poor Stromer remained a bachelor all his life.[18]

Now, this state of affairs perfectly explains the curious inscription on the London portrait '*Johannes de Eyck fuit hic. 1434*'. In Monsieur Dimier's opinion, this sentence which, according to the rules of Latin grammar, cannot but mean 'Jan van Eyck has been here', would make no sense if it was not translated by 'this was Jan van Eyck', thereby proving that the persons portrayed were the artist and his wife. Setting aside the grammatical problem, Monsieur Dimier's interpretation (which, by the way, was suggested by several other scholars, but was emphatically opposed by Mr Salomon Reinach some fourteen years ago)[19] is contradicted by the simple fact that a child of Jan van Eyck had been baptised before 30th June 1434. Thus, discarding suspicions which must be regarded as groundless by the fact that this child was held over the font by Pierre de Beffremont in the name of the Duke of Burgundy,[20] we must assume that Jan van Eyck and his wife were married in the autumn of 1433 at the very latest, so that they cannot be identical with the bridal pair represented in the London picture. Furthermore, the phrase 'Jan van Eyck was here' makes perfectly good sense when we consider the legal situation as described in the preceding paragraphs. Since the two people portrayed

lesson to us not to attempt to use literary sources for the interpretation of pictures, before we have interpreted the literary sources themselves.

To the modern mind it seems almost inconceivable that, up to the Council of Trent, the Catholic Church could acknowledge a marriage contracted in the absence of any priest or witness. Still this seeming laxity logically follows from the orthodox conception of matrimony – a conception according to which the binding force of a sacrament fulfilled by a spiritual '*coniunctio animarum*' did not depend upon any accessory circumstances. On the other hand, it is obvious that

were married merely '*per fidem*' the portrait meant no less than a 'pictorial marriage certificate' in which the statement that 'Jan van Eyck had been there' had the same importance and implied the same legal consequences as an 'affidavit' deposed by a witness at a modern registrar's office.

Thus there is no reason whatever to doubt the identity of the London portrait with the panel mentioned in the inventories: we can safely adopt the 'orthodox theory' according to which the two people portrayed are Giovanni Arnolfini and Jeanne de Cename,[21] all the more so because the circumstances of their marriage are peculiarly consistent with the unusual conception of the 'artistic marriage certificate'. Both of them had absolutely no relatives at Bruges (Arnolfini being an only child whose property finally went to a nephew of his wife, and Jeanne de Cename's family living in Paris),[22] so that we can understand the original idea of a picture which was a memorial portrait and a document at the same time, and in which a well-known gentleman-painter signed his name both as artist and as witness.

Dr Max J. Friedländer (who, by the way, already divined the meaning of the inscription without investigating the matter)[23] rightly points out that the Arnolfini portrait is almost a miracle of composition: 'In it a problem has been solved which no fifteenth-century painter was destined to take up again: two persons standing side by side, and portrayed full length within a richly furnished room . . . a glorious document of the sovereign power of genius.'[24] In fact, to find an analogous composition in northern painting, we must go forward to Holbein's *Ambassadors*. However, taking into consideration the fact that the London picture is both a portrait of two individual persons and a representation of a sacramental rite, we can explain its compositional scheme by comparing it not only with specimens of portrait-painting, but also with representations of marriage ceremonies to be found, for example, in the Bibles Moralisées[25] or, even more à propos, in a French Psalter of about 1323 (Munich, cod. gall. 16, fol. 35).[26] In it, the marriage of David and Michal, the daughter of Saul, is represented in a very similar way as that of Giovanni Arnolfini and Jeanne de Cename, only the bride does not act of her own accord, but is given away by her father who is accompanied by a courtier and carries a glove as a symbol of his tutelary authority (Fig. 36).

Apart from this difference, the two scenes resemble each other in that the ceremony takes place in absence of a priest and is accomplished by raising the forearm

36. *The Marriage of David and Michal*, from a French Psalter of c.1323. (Bayerische Staatsbibliothek, Munich).

and joining hands, '*fide levata*' and '*per fidem manualem.*' Thus the precocious apparition of a full-length double portrait can be explained by Jan van Eyck's adopting a compositional scheme not uncommon in the iconography of marriage pictures. But this adoption of a traditional scheme means anything but a lack of 'originality'. When the Arnolfini portrait is compared with the fourteenth-century miniature, we are struck by the amount of tender personal feeling with which the artist has invested the conventional gesture and, on the other hand, by the solemn rigidity of the figures, particularly that of the bridegroom. Van Eyck took the liberty of joining the *right hand* of the *bride* with the *left* of the *bridegroom*, contrary to ritual and contrary, also to all the other representations of a marriage ceremony. He endeavoured to avoid the overlapping of the right arm as well as the *contrapposto* movement automatically caused by the '*dextrarum iunctio*' in the true sense of the term (see Fig. 34). Thus he contrived to build up the group symmetrically and to subdue the actual movement in such a way that the '*fides levata*' gesture of the bridegroom seems to be invested with the confident humility of a pious prayer. In fact the position of Arnolfini's right arm would make a perfect attitude of prayer if the other arm moved with a corresponding gesture. There is something statuesque about these two figures, and I cannot help feeling that the whole arrangement is, to some extent, reminiscent of those

slab-tombs which show the full-length figures of a man and a woman in similar attitudes, and where the woman is usually made to stand upon a dog, here indubitably used as a symbol of marital faith (Fig. 35).[27] It would be an attractive idea to explain the peculiarly hieratic character of the Eyckian composition by an influence of those quiet devout portrayals of the deceased, such as may be seen on innumerable monuments of that period; all the more so because the inherent connection between the incunabula of early Flemish painting and sculpture is proved by many an instance.

In the London picture, however, these statuesque figures are placed in an interior suffused with a dim though coloured light, which shows up the peculiar tactual values of such materials as brass, velvet, wood and fur, so that they appear interwoven with each other within a homogeneous chiaroscuro atmosphere.

Small wonder then that the Arnolfini portrait has always been praised as a masterpiece of 'realistic' interior, or even genre, painting. But the question arises whether the patient enthusiasm bestowed upon this marvellous interior anticipates the modern principle of '*l'art pour l'art*', so to speak, or is still rooted to some extent in the mediaeval tendency of investing visible objects with an allegorical or symbolical meaning.

First of all we must bear in mind that what Mr Weale simply calls 'a Flemish interior' is by no means an ordinary living room, but a 'Nuptial Chamber' in the strict sense of the term, that is to say, a room hallowed by sacramental associations and which even used to be consecrated by a special '*Benedictio thalami*'.[28] This is proved by the fact that in the beautiful chandelier hanging from the ceiling, only one candle is burning. For since this candle cannot possibly serve for practical purposes (in view of the fact that the room is flooded with daylight), it must needs bear upon the marriage ceremony. In fact a burning candle – symbol of the all seeing wisdom of God – not only was and often is, required for the ceremony of taking an oath in general,[29] but also had a special reference to weddings. The 'marriage candle' — a substitute for the classical '*tæda*' which had been so essential a feature of Greek and Roman marriage ceremonies that the word became synonymous with 'wedding' – was either carried to church before the bridal procession, or solemnly given to the bride by the bridegroom, or lit in the home of the newly married couple; we even know of a custom according to which the friends of the couple called on them in the evening '*et petierunt*

Candelam per sponsum et sponsam . . . sibi dari'.[30] Thus we learn from the one burning candle that the 'Flemish interior' is to be interpreted as a '*thalamus*', to speak in mediaeval terms, and we comprehend at once its unusual features. It is not by chance that the scene takes place in a bedroom instead of a sitting-room (this applies also to a considerable number of fifteenth- and sixteenth-century *Annunciations* in which the interior is characterised as the '*Thalamus Virginis*', as a liturgical text puts it), nor is it by accident that the back of the armchair standing by the bed is crowned by a carved wooden figure of *St Margaret triumphing over the Dragon*, for this Saint was especially invoked by women in expectation of a child;[31] thus the small sculpture is connected with the bride in the same way as the burning candle is connected with the bridegroom.

Now the significance of these motives is an attributive, rather than a symbolical one, inasmuch as they actually 'belong' to a Nuptial Chamber and to a marriage ceremony in the same way that a club belongs to Hercules or a knife to St Bartholomew. Still, the very fact that these significant attributes are not emphasised as what they actually are, but are disguised, so to speak, as ordinary pieces of furniture (while, on the other hand, the general arrangement of the various objects has something solemn about it, placed as they are according to the rules of symmetry and in correct relationship with the statuesque figures) impresses the beholder with a kind of mystery and makes him inclined to suspect a hidden significance in all and every object, even when they are not immediately connected with the sacramental performance. And this applied in a much higher degree to the mediaeval spectator who was wont to conceive the whole of the visible world as a symbol. To him, the little griffin terrier as well as the candle were familiar as typical symbols of Faith,[32] and even the pattens of white wood so conspicuously placed in the foreground of the picture would probably impress him with a feeling of sacredness: '*Solve calceamentum de pedibus tuis, locus enim in quo stas terra sancta est.*'

Now, I would not dare to assert that the observer is expected to realise such notions consciously. On the contrary, the supreme charm of the picture – and this applies to the creations of Jan van Eyck in general – is essentially based on the fact that the spectator is not irritated by a mass of complicated hieroglyphs, but is allowed to abandon himself to the quiet fascination of what I might call a *transfigured reality*. Jan van Eyck's

landscapes and interiors are built up in such a way that what is possibly meant to be a mere realistic motive can, at the same time, be conceived as a symbol, or, to put it another way, his attributes and symbols are chosen and placed in such a way that what is possibly meant to express an allegorical meaning, at the same time perfectly 'fits' into a landscape or an interior apparently taken from life. In this respect the Arnolfini portrait is entirely analogous to Jan van Eyck's religious paintings, such as the marvellous *Virgin of Lucca* where many a symbol of virginity (the '*aquæ viventes*,' the candlestick, the glass carafe and even the 'throne of Solomon')[33] is 'disguised' in a similar way; or the image of St Barbara whose tower (characterised by the three windows alluding to the Holy Trinity) has been transformed into what seems to be a realistic Gothic church in course of erection;[34] but, thanks to the formal symmetry of the composition, this building impresses us as even more 'symbolical' than if the tower had been attached to the figure in the usual form of an attribute.

Thus our question whether or not the still-life-like accessories in our picture are invested with a symbolical meaning turns out to be no true alternative. In it, as in the other works by Jan van Eyck, mediaeval symbolism and modern realism are so perfectly reconciled that the former has become inherent in the latter. The symbolical significance is neither abolished nor does it contradict the naturalistic tendencies; it is so completely absorbed by reality, that reality itself gives rise to a flow of preternatural associations, the direction of which is secretly determined by the vital forces of mediaeval iconography.[35]

JOHN POPE-HENNESSY

'Reflections on British Painting'
by Roger Fry

The majority of the authors of the introductions to English painting by which the opening of the British Exhibition was anticipated worked on the premise that languages are most simply learned by reading dictionaries. Interest in painting for them was the result rather than the cause of interest in the painter. Mr Fry's lectures, written after study of the little new light that was thrown on his subject by the exhibition, form an agreeable contrast; their hundred and fifty odd pages consist entirely of mature judgements compressed with care and expressed with something very like perfection.

It is natural that a book published after the British Exhibition should convey a sense of disillusionment. Mr Fry succeeds in giving coherent, rational expression to what few visitors to the exhibition can have escaped feeling. 'I am not going to try to make out', he writes, 'what I believe would be an impossible case, though one which would give us all great satisfaction, namely, that Great Britain has been one of the great artistic centres of the world; that the British are by race and culture peculiarly gifted for creation in the visual arts . . . When I consider the greatness of British civilization as a whole . . . I have to admit sadly that British art is not altogether worthy of that civilization', and he goes on to make the interesting suggestion that the weaknesses of British painting, so far from having an inherent physiological cause, may be attributed to the fortuitous absence at the end of the seventeenth century, when England 'seemed to have been drawn into the current of the European tradition', of a painter with a personality comparable to Wren's, an absence which unreasoning admiration for Hogarth has hitherto concealed. It is from the standpoint of the European tradition that Mr Fry consistently criticises English painting, and his whole book forms a welcome protest against the tendency, more evident than ever recently, to vaunt as a national style the defects of provinciality. Hogarth, for all his genius, remains for Mr Fry an undeveloped painter, whose work is marred not so much by an innate feebleness of composition as by the deliberate sacrifice of pictorial and psychological to propagandist values, a dual criterion, imaginative as well as technical, which, whether or no it is a mere concession to his subject, while it enables Mr Fry to do full justice to Wilkie's formal and Morland's tonal sensibility, leaves Bonington as the greatest English illustrative painter.

Similarly, where he deals with landscape painting, Mr Fry criticises Gainsborough and Crome in terms of Ruisdael and takes up the challenge to Claude expressed in the case of Turner, implied in that of Wilson. His critique of Wilson runs on the same lines as his critique of Reynolds, painters both of them who made 'the mistake of thinking you can imitate a final result without understanding the underlying processes', a mistake to which Hazlitt in both instances first pointed an erratic finger. To Turner, Mr Fry will not even allow the debt acknowledged by impressionism, arguing as he does that the failure of Turner to formulate any consistent impressionist theory detracts from the importance of a practice that was in only a slightly more general sense of the word impressionist. However unattractive the romantic elements in Turner's make-up may appear today, it is surely impossible to reject his claim to technical innovation of a most important kind. Where Turner the artist is at a discount, Turner the painter is something it is impossible to ignore. In general, however, Mr Fry's criticism is sympathetic and appreciative and his book has an interest and importance quite disproportionate to its size; there can be no question that it is incomparably the soundest and most intelligent conspectus of English painting in print.

It seems possible, though the size of the reproduction precludes a definite decision, that the Wilkie discussed by Mr Fry as *William IV receiving the Keys of Edinburgh Castle*, no location being given, is in actual fact the sketch in the Scottish National Portrait Gallery for the large Holyrood House picture of *George IV entering Holyrood*.

DOUGLAS LORD

Les Peintres de la réalité en France au XVIIe siècle

Following the Le Nain Exhibition last summer at the Petit Palais, there was recently held in the Musée de l'Orangerie this second exhibition (*Les Peintres de la réalité en France au XVIIe siècle*) which placed them among their contemporaries. But when Champfleury referred to the three brothers as '*peintres de la réalité*' he was referring to their subject-matter rather than to their technique. In view of this, the title seemed singularly ill-chosen; for though between the work of the brothers Le Nain, Robert Tournier, Georges de La Tour, Philippe de Champaigne, Valentin and Vouet there is a certain technical unity due to the influence of Caravaggio, there is not the same unity of subject matter. But this exhibition also embraced landscapes by Claude Gellée, the Poussin self portrait (Musée du Louvre), as well as still-lifes by Linard, Moillon and Stoskopff which were in the style of Brueghel de Velours. Unfortunately the preface to the catalogue written by M. Charles Sterling offered no solution: '*Pour les esprits religieux du XVIIe siècle la mystique et la réalité sont étroitement liées . . . en France on spiritualise les choses de la plus simple, de la plus modeste réalité. Tel était l'art de Philippe de Champaigne, de Georges de La Tour, de Robert Tournier, des Le Nain.*' As a panorama of the art of the early seventeenth century, however, the exhibition was very interesting; but it showed, too, the general lack of concern with realism.

The centre of the exhibition was the work of the French '*tenebrosi*', the followers of Caravaggio; but, despite Caravaggio's obvious defects as a painter, his failure to observe the corporeal significance of objects, his neglect of tactile values and movement, and his acceptance of the ready-made aspect of figures, it was impossible not to feel the greater banality of his French disciples. In this respect it was interesting, for example, to compare *Les Tricheurs* by Valentin (Staatliche Gemäldegalerie, Dresden) and *Les Tricheurs* by Mathieu Le Nain (Coll. Vergnet-Ruiz, Paris), with the picture of the same subject by Caravaggio (Palazzo Sciarra-Colonna, Rome). On the other hand, one could not but be struck by the mastery of the altogether more intricate composition, *Le Tricheur* by La Tour (Musée du Louvre, Paris, formerly Coll. Pierre Landry), which was recently seen at Burlington House (no. 118, Exhibition of French Art, 1932), and which is of particular interest as it is one of the only daylight scenes painted by this artist.

La Tour, about whose life very little is known, was, in fact, the discovery of the exhibition. All his present known works, twelve in number, were collected here. One of these, however, *Le Joueur de Vielle* (Fig. 37; Musée des Beaux Arts, Nantes), hitherto variously attributed to Velázquez, Zurbarán, Maino and Juan Rizzi (whose signature it actually bears), but now for the first time exhibited as a La Tour, is almost certainly not a product of his brush. A moment's comparison with both *St Jérôme pénitent* (Nationalmuseum, Stockholm) and *St Jérôme dans sa cellule* (Musée du Louvre, Paris, formerly Coll. Louis Delcléve, Nice), served to emphasise its comparative compositional weakness and its completely different tonality. La Tour, though a follower of Caravaggio, was a more original artist. His work is not Baroque like that of most of the '*tenebrosi*', for there is a minimum of movement. His composition is lucid and based on clear geometric principles; and by simplifying his forms he simplifies his subjects. Most of his pictures are nocturnal scenes and concentrate on the chiaroscuro effects of candlelight, the source of light being invariably hidden by a protective outstretched arm in silhouette in the foreground. The two finest pictures of this type were *Le Reniement de St Pierre* (Musée des Beaux-Arts, Nantes) and *L'Adoration des bergers* (Musée du Louvre). La Tour is essentially a stylist, handling his canvases in a very firm and individual manner; but particularly noticeable are his sensibility to tactile values and his effective rendering of space and

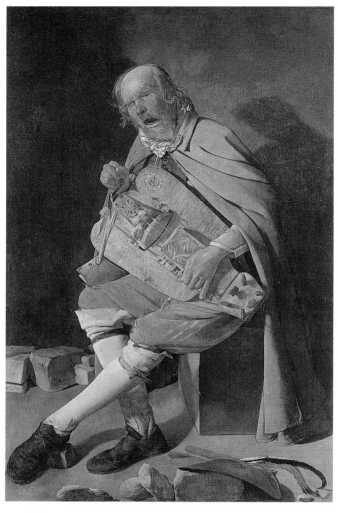

37. *Le Joueur de Vielle*, by Georges de La Tour. 1628–30. 162 by 105 cm. (Musée des Beaux-Arts, Nantes).

volume; his compositions are not arranged on the purely horizontal line of the brothers Le Nain.

After La Tour, perhaps the most memorable paintings were those of Philippe de Champaigne, four in all, amongst which were a fine *Portrait de femme* (Musée du Louvre), and his masterpiece *La Mère Catherine-Agnès Arnauld et Soeur Catherine de Ste Suzanne* (Musée du Louvre), both of which showed him to be a painter of considerable achievement.

The brothers Le Nain were represented by twenty pictures of which five were newly-discovered works. Most of the others, such as *Portraits dans un intérieur* (Musée du Louvre), by Antoine, and *Repas de Paysans* (Musée du Louvre), and *Vénus dans la Forge de Vulcain* (Musée des Beaux-Arts, Reims), by Louis and Mathieu, had already been seen at the Petit Palais and were fully discussed at that time by Mr E. K. Waterhouse (THE BURLINGTON MAGAZINE, LXV [September 1934], p. 132). Of those not shown this summer, the most interesting were *Réunion de famille*, by Antoine (Musée du Louvre), *Paysans dans la campagne*, by Louis (Wadsworth Athenæum, Hartford), *Le Jardinier*, by Mathieu (Coll. Dr Van Der Ven, Deventer), and *Le Cortège du bélier*, by both Mathieu and Louis (Coll. M.X, Paris [now Philadelphia Museum of Art]). This last picture is the counterpart to *La Fête du vin* (Coll. Simon, [now Louvre] Paris). Among the newly discovered pictures there was a *Vierge au verre de vin* (Musée de Rennes), claimed as a youthful work by Louis, but the canvas has suffered so badly both by cutting and by repainting that it is difficult to accept this attribution unreservedly. So, too, with the full-length *Portrait of the Marquis de Troisvilles* (Coll. Comtesse de Mont-Réal, Rueil), attributed to Antoine. In style it is certainly reminiscent of Antoine, but it is painted in, for him, unusual and discordant tones. Moreover, its size (230 by 140 cm) as well as its subject, a captain in the musketeers of Louis XIII, are for this artist most unusual.

The remainder of the exhibits, among which were several pictures by unknown artists, as well as portraits by Bourdon, Lefebure, Le Brun and Régnier, merely served to show the general lack of originality or of any sort of national school at that period.

1936

MARTIN DAVIES

A portrait by the aged Ingres

Les chefs-d'œuvre ne sont pas faits pour éblouir.
Ils sont faits pour persuader, pour convaincre, pour entrer en nous par les pores. (INGRES)

The Director and Trustees of the National Gallery have been fortunate in acquiring the *Portrait of Madame Moitessier seated*, by J.-A.-D. Ingres (Fig. 38).[1]

The gestation of this picture is largely documented.[2] We are told he refused to paint her; he met her, he agreed.[3] No portrait of Madame Moitessier is mentioned in a detailed letter of 7th June 1844, but he was painting her during the summers of 1845 and 1846, and on 24th June 1847, he wrote: '*j'ai à peine terminé Mme. de Rothschild, recommencée en mieux, et le portrait de Mme Moitessier.*'[4]

On 27th June of that year, Théophile Gautier published in *La Presse* an account of his visit to the studio of Ingres 'some weeks before'. He there writes of a portrait, from the description unquestionably the picture now in the National Gallery, beginning thus: '*bien que le peintre n'y ait encore consacré que trois séances . . .*'. The contradiction would be resolved if the letter of 24th June and the previous two of 1845 and 1846 (all without detail) refer to *Madame Moitessier standing* (Fig. 39); but this, we shall see, is unlikely. More probably Ingres erased all his work on *Madame Moitessier seated* in the early part of 1847, to begin again: and quickly reached a seeming completion far, for him, from the end. It is certain in this connection that the accessories were at one time different. A *charmante Catherine* stood at her mother's knee; then *l'insupportable Catherine* was erased, left only in a drawing at Montauban (Fig. 42).[5] The furniture, though of the same character, was different both in proportion and detail; a sketch of a very early design exists at Montauban (Fig. 43), and a corresponding strip, unfinished, and formerly preserved turned over the edge of the stretcher in the original, shows the frame of the mirror with similarly the table in front, and a part of the left hand about three inches to the right of its present position (Fig. 40).[6]

We do not know for how long Ingres continued at this canvas, working as usual painfully and with long interruptions; finally he gave up, perhaps at the terrible moment of his wife's death (1849). The sitter showed herself throughout quite charmingly adaptable, but even she complained of some delay in June 1851; Ingres probably decided then to paint an entirely new picture in a new design, possible to be terminated quickly. This new portrait of *Madame Moitessier standing* (Fig. 39) was completed in the last days of 1851.[7]

It is extremely impressive; but, '*bonne chance pour moi, les parents sont enchantés; et bien, vous croyez peut-être que je le suis moi, entièrement, non, mais je ne le dois dire qu'à mes discrets amis, etc.*'[8] A trifle more than an artist's disillusion before the fact? Ingres felt perhaps that this standing version was insufficiently *like*. It had been made his rule to devote the whole of a first sitting to the discovery and study of his sitter's characteristic pose; finger against head *was* Madame Moitessier.[9] He was again at work on the National Gallery picture within six months of having completed the other.[10]

In spite of the natural rapidity of his touch,[11] it was already twelve years after beginning that the painter wrote his signature: 'J. Ingres 1856 / AET LXXVI'.[12]

This portrait,[13] posed not simply and full of detail, demanded from Ingres his full constructive powers. The construction is naturalistic in the sense of being or rather seeming objectively possible; indeed Ingres demanded much more, that every detail (the more the better) should contribute to the character of the whole; her dress no drapery but her dress as she wore it, and so on. The elements of the complicated design were therefore very carefully thought out, in order that the picture should remain classically lucid.

The inner edge of the mirror-frame is the horizontal axis, the nose is on the vertical; but as the sitter is seen in a three-quarter view, these are but slight indica-

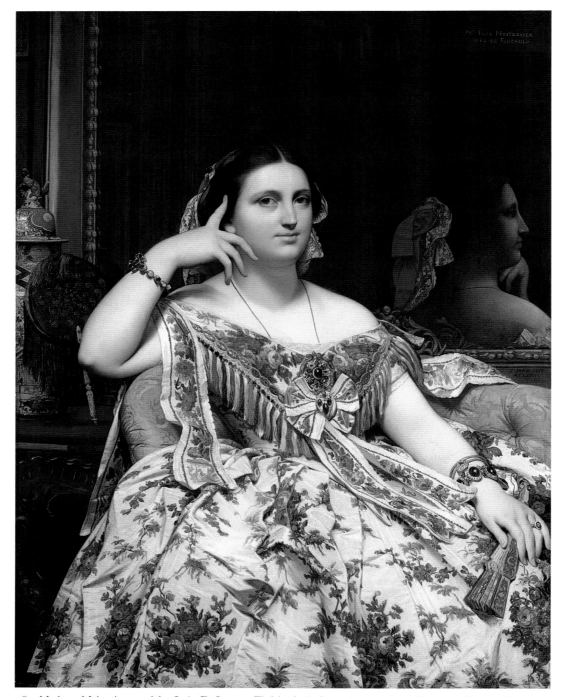

38. *Madame Moitessier seated*, by J.-A.-D. Ingres. Finished 1856. 120 by 92.1 cm. (National Gallery, London).

tions. The dominant line of the picture is, logically, the back of the sofa; it is repeated with variations by the line of the dress, doubled to the left; and the shoulders echo it above. Opposed to these is a series of falling curves. The lowest starts from her left little finger to cross the spaced pattern of the dress, emphasised above by the fan and the flittering bird-like shadow (marking the arm of the sofa), and by a quick repetition as the dress falls away; it is completed, in another plane, by the twirl of the table-leg. The second curve is the short line of the waist. The third (but from left to right, by a form of contrapposto giving stability to the

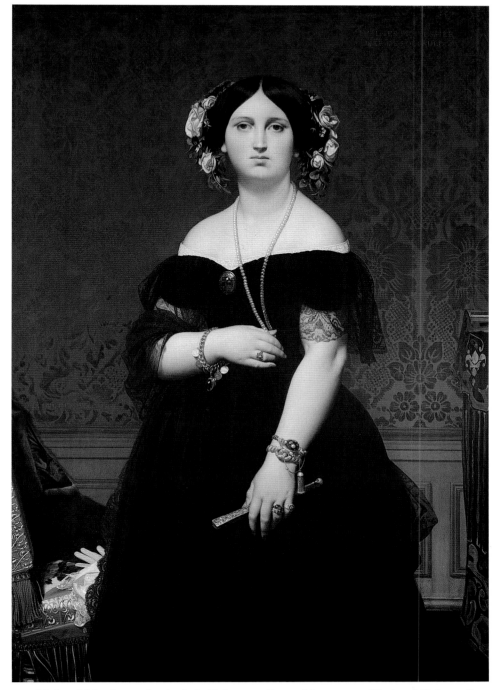

39. *Madame Moitessier standing*, by J.-A.-D. Ingres. 1851. 146 by 100 cm. (National Gallery of Art, Washington).

whole) is the upper line of the dress across the shoulders, continued behind to the forehead in the glass; the table's twirl being repeated (the strata earthquake-wrenched) by the right arm. These sets of curves are strongly bound together by two diverging lines, which frame the body; the hard outline of the dress to the left, emphasised at the break by the shoulder ribbon, and the more softly modulated line of the arm to the right. There are also two strengthening diagonals; the line from her right shoulder along the fringe, extending along the 'floating ceinture' almost to her left hand; and, more important, the axis of the body, beginning as the space between the

40. Fragment of an early version of *Madame Moitessier seated*, by J.-A.-D. Ingres. (?before 1847). (National Gallery, London).

41. Study of drapery, for *Madame Moitessier seated*, by J.-A.-D. Ingres. (?before 1847). Black chalk, 21 by 27 cm. (Musée Ingres, Montauban, no. 1848).

42. Study of the left arm for *Madame Moitessier Seated*, with the head of her daughter Catherine, by J.-A.-D. Ingres. c.1847. Black chalk, 16 by 12 cm. (Musée Ingres Montauban, no. 1847).

strings of the necklace, converging to a point, and spreading again to mark the legs in the fan-shaped folds on the dress, which by an exquisite emphasis have been brought to cross the fan held in the hand. Dominating this frame-work, and beginning at the enormous saucer-like bow on the chest, a rhomboid formed by the two fringes and the shoulders is slung above the skirt, thus subordinated; it rises asymmetrically in rapid perspective, but it is supported by the edge of the sofa, of, course, but also to the sight by the two strongly marked folds of the dress violently bent down at the waist. Its plane is made clear by the flat 'bertha' suppressing almost the breasts, and it is animated by the upper line of the dress diagonally streaking across. On this pedestal the neck and head are posed; to be held firmly in place by the vertical panel behind, whose lines continued would pass through her nose (the axis of the picture), her right eye, and the tip of the furthest extending finger of her right hand. The whole upper space, subordinated like the skirt to the chief parts of the figure, is crossed by these and other verticals, which construct the recession of the room in a plane balancing the sitter's, and at the same time hold together the mountainous horizon formed by the still-life and the two heads. The still-life and the reflected head have of course been painted dimly for the unity of the picture; the heavy *cache-peigne* cap helps to pull the reflection downwards. Above all the cande-

labrum has been carefully placed off the axis of the picture, to crown the whole.

Now, the emotional centre of the design is the hand supporting the head: '*une main d'une grande beauté s'appuie à la tempe et baigne dans les ondes de la chevelure un doigt violemment retroussé avec cette audace effrayante et simple du génie que rien n'alarme dans la nature.*'[14] A consistent effort has been made in the drawing to direct the attention first there; all the more necessary because the artist has dared to paint a dress almost as bright as the flesh, and the gilt frame of the mirror is not a strong enough colour to correct the consequent scatteration. Her left shoulder has therefore been tied down to the sofa by the shoulder-ribbon, and dies away in repetitions on the mirror-frame; her left arm is decidedly at rest; and her left hand is a closed form. Per contra, the line of this shoulder, the longest line in the picture unbroken on either side (except the far slighter verticals above), effects a violent but natural wrenching to the sitter's right of her head, tilted-only to meet that upraised finger! On her right side, I have already remarked the doubled fold of the dress, violent at the waist, and the hardness of its contour;[15] her right arm has been given an added upward drive by the false tangent of elbow and sofa, the rounding off of the angle made by the shoulder-ribbon near the arm-pit, and the rising 'line of beauty' of the arm's shadow on the shoulder.

Perhaps the amazing formal perfection of the design

and its resultant static plenitude can most easily be grasped by a comparison with the sketch above referred to (Fig. 43). She is there not peacefully and for ever seated; far slighter on the canvas, she has flung herself into a chair, legs (see Fig. 41) crossed. The chair fairly swallows her; her elbow hardly passes outside. The reflected profile, in itself of an exquisite purity, is in that place of a fussy and meagre contour; and the furnishings, so restrainedly suggestive in the final picture, are topheavily extended in height, and repeated in reflections to resemble rather a barber's shop than a lady's drawing-room. Although most of the elements of the final design are present in this sketch, the parts have not been brought together; and it may amuse the admirer of Ingres to count up the modifications he has introduced into the completed work, every one of which is an improvement.

The construction I have indicated, extremely elaborate in its system of stresses, was of course for Ingres only the grammar of picture-making; it is one expression of the pictorial Latin culture he stole from Raphael, and as many painters have used something of the sort for the organisation of their pictures, a direct

description suffices. But the style of this late portrait by Ingres will involve me in a more general treatment. The best English pictures, formative perhaps of our taste, were painted in a different manner, and to many people, even intelligently appreciative of the great masterpieces of Europe, *Madame Moitessier* may appear repulsive. In order unaffectedly to admire it, therefore, it is necessary that we should find out why he painted this picture as he did.

The logic of his aesthetics is classical and perfectly clear. For him, a portrait is primarily the expression, so far as the painter can see it, of the sitter's character; for the complete and undisturbed expression of this character it is necessary that every pictorial means should be subordinated to be absolutely coherent and natural-looking. For the coherent realisation of a three-dimensional object, form is important, colour subsidiary; for the coherent realisation of form, the contour is important, surface subsidiary. But even the contour (a pictorial invention) is licit only in so far as it expresses the form; no means of expression whatsoever may call attention insubordinately to itself. Not too much; enough.

43. Study for *Madame Moitessier Seated*, by J.-A.-D. Ingres. (?before 1847). Oil and graphite on canvas, 40 by 32 cm. (Musée Ingres, Montauban).

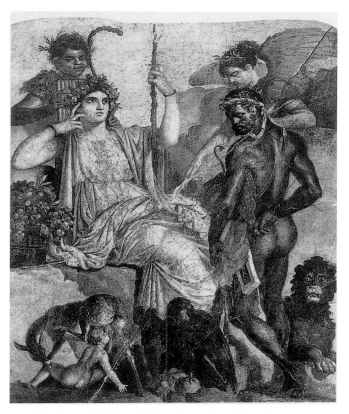

44. *Herakles and Telephus*. Wall-painting from Herculaneum. (Museo Nazionale, Naples).

We must bear in mind that this is only a method of expression; it is no more capable of producing from a second-rate man a first-rate work than of leading a first-rate man to the academic. But a comprehension of this method is extremely important; Ingres held it the one least likely to harm or impede the expression.

Ideally this is so. Like most logical systems, it takes no account of human facts; of frequent, the most frequent, talents, whose sensibility this method would simply stifle, whose expression is as complete as possible in their other more emotional or subconscious or coincidental way. We, the public, are of course always grateful for the presence of pictorial gifts, even impure or deformed, and Ingres himself was a passionate admirer of great talent, in *any* school; but these cases were not reasons against his choosing for his own work the ideally best *method* – restraint of style.

The result is unfortunate for us now; from an extremely superficial point of view, *Madame Moitessier* would seem a Winterhalter, considered (I believe) a nadir of European painting. If, therefore, we are to appreciate its serious merits, we must rid ourselves of our prejudices against the 'oleographic'; the picture will do it for the humbly sincere observer, with all the impolite persuasiveness of a work of art.

Habitually, the *line* of the young Ingres is admired; in the late portraits there is no loss but restraint of power. '*L'art*,' he says, '*ne réussit jamais mieux que quand il est mieux caché*';[16] the picture is no longer swamped by the style. *Madame Rivière* (1805) is in the execution a particularly intelligent Holbein; but the line, divine in itself, is so crudely and bombastically on the surface that it *maims* the form, itself still crude. In the late portraits there is no longer an abstract line, full of lusty life; the line has been tamed to do its duty, which is to express without disturbance the form. Every part of *Madame Moitessier* is thus convincingly in place. At her left shoulder, the line is twisted back like a spring to pass the neck; on the arm, the line bends under the weight. Only in his late portraits did Ingres thus fully and comprehendingly and with good sense *imprimer à son dessin le nerf et la rage*.[17]

That anyone should admire *brushwork* for having been prettily or cleverly or quickly done would have seemed to Ingres very superficial. He would, of course, have admitted that brushwork can be, and (I may add) often has been, the immediate expression of the brain or sensibility employing it; he has in this picture himself employed it (I shall mention one case) in a form reduced almost not to show. But brushwork was for him essentially messy and disturbing; for him the surface was a sheath through which the picture shines. '*Ce sont les résultats et non les moyens employés qui doivent paraître.*' '*Ce qu'on appelle "la touche" est un abus de l'exécution. Elle n'est que la qualité des faux talents, des faux artistes, qui s'éloignent de l'imitation de la nature pour montrer simplement leur adresse. La touche, si habile qu'elle soit, ne doit pas être apparente; sinon, elle empêche l'illusion et immobilise tout. Au lieu de l'objet représenté elle fait voir le procédé, au lieu de la pensée elle dénonce la main.*'[18] Without plunging into a discussion of the sense in which the contrary is true, I may here simply point out that lack of brushwork does not deaden; it has no effect. We shall in a moment see in what way this work of Ingres is freshly alive; but in any case he shares his quality with all the great masters before the Venetians and several after, that the only inexpressive thing about his picture is the outward manner in which the paint has been laid on.

For the *colour*, his primary aim was to colour without disturbance his forms, just as he made them flesh or velvet or china; '*le dessin comprend tout excepté la teinte*'.[19] This simplist, unfunctional and unemotional attitude enabled him to *see* the colour, which from the sincerity of its rendering is made extremely moving; thus the purple bonnet of *Madame Gonse* became under his brush a pictorial fact, and the strange harmonies of *Madame Moitessier* are sublime. It would be tedious to attempt here to prove what I believe to be true, that the aged Ingres was a great colourist; suffice it to point out that the picture, painted in an extraordinarily high key, stays exactly in place and in tone inside the frame – a sign of no mean coloristic gifts, even though it is the drawing that is the active participant in the construction. I need hardly add that Ingres was far too sensitive an artist to tie down in practice and in detail the elusive qualities of colour to a rule of 'tinting'. *Madame Moitessier* is full of coloristic inventions, such as the variations in the outlines of the fingers of her right hand, or the contour of her left hand invented not as black (dull) nor red nor blue (flesh shadows) but sage green; and it would be no exaggeration to say that in its colour, secondary though it is in his schema, Ingres looked after this picture with the loving care of a Cézanne.

In the treatment of *form*, portrait-painting was for the exasperated sensibility of the aged Ingres a passionate struggle, breaking sometimes into tears,[20] to fit what with his 'primitive' eye he saw into what his study and inclinations had taught him a picture should be. His 'idealising' tendency became from his isolation logical sincerity and lack of visual memory dryer and more rigorous as time went on; it dictated of course the superficial, the 'noble' style, and led him to suppress the acci-

dents of surface. But for the formal construction of his portraits, expressed almost entirely by the contour, he put what he saw first,[21] organising merely his vision. '*Vous tremblez devant la nature; tremblez, mais ne doutez pas!*' '*En matière de vrai, j'aime mieux qu'on soit un peu au delà, quelque risque que l'on coure.*' '*Prenez garde, vous y tournez. – Vous indiquez là une chose que je ne vois pas. – Pourquoi la faire sentir? parce que vous savez qu'elle y est. – Vous avez appris l'anatomie? – Ah! oui; – et bien! voilà où mène cette science affreuse, etc.*'[22] By applying this principle of 'truth' in his late portraits, Ingres preserved a beautiful freshness of impression. What one sees has to be seen to be believed; he frankly accepted (for his noble style!) the distortions of appearance, which his sincerity and comprehension realised as acceptable – right.

It is true that in minor places he allowed the demands of his picture to cause an invention. I need only cite the oblique scratch on the forehead of Madame Moitessier, reinforcing the action of her first finger; the ribbon on her right shoulder, originally curving down in the shadow of the lower arm, now straightened out and impossibly narrowed; and the 'bad drawing' of the egg-pattern along the 'bertha', modulated to avoid the mechanical. But instead of erecting these inventions into a dogma, the laws of some looking-glass country, Ingres limited them as much as possible; however individually necessary or (to us) fascinating, they were blemishes. *The deliberate subordination of his technical means made it essential that every functional line should be just right*; the passion he employed to this end has animated every one with an abiding but not insubordinate life.

Vision and coherence; or sincere sensibility to the formal appearance, ruthless restraint in the technical expression: these two principles of the art of Ingres were fully developed only in his late portraits. They are as little like 'pictures' as possible; no turning aside after some tricky or inessential lure to the eye, no unmannerly thrusting forward of the 'author.' This work, an intellectual feat in limpid French, is an extreme programme of aesthetics, in the classical tradition of Europe. Perhaps you do not admit the existence of any laws; '*il y en a qui se contentent, dans le dessin, du sentiment.*'[23] Ingres would point out that by no other means than his austere method of subordinations can any conscious feeling be completely or undisturbedly expressed. It is doubtful if many painters could with profit follow him far along this road; the plain man of culture will turn perhaps with relief from the only too painterly prowess of some other great artists to this *extremely* normal *Madame Moitessier*.

I have from time to time in the discussion of principles

45. Detail of Fig 38.

46. Detail of Fig 39.

glanced at some of the details; I may now return definitely to the picture, loosely and simply to indicate them. It is first to be remarked that Ingres has here included about as much as a single portrait can carry, two heads and three hands; but it has been so well organised (his ruthless method!) that it could flower in every part.

The head has been reduced to an elaborately geometrical shape, wrapped in exuberant flesh, on which a master-hand has carved the features. '*Les détails sont des petits importants qu'il faut mettre à la raison. La forme large et encore large!*'[24] Thus, the mouth is drawn with the rigour of an Antonello, but in feminine terms beyond that painter's powers; her cat-like eyes swim freely and in perfect modelling; and the bony construction between

cheek and temple has been understood. The face is framed: because it is caressing to touch a woman's cheek; and because the hair abstractly sweeping back helps keep the head in place; and then the pure line of the shoulder gains in emphasis, with further the effect I noted on the design!

The head in the mirror (a masterpiece of Picasso) has been severely subordinated to the unity of the picture; Ingres has taken the occasion to show in this demurer image that stripped of 'normal' surface (lustreless hair) and in an elementary form (the eye two triangles) her lines are good.

The hand at the head is posed heroically; only a lady would have dared. The fingers, seemingly of a sublime length, fall away in majesty; to rest at the indented contour of the little finger, which the reduction of the others renders powerful. Ingres has not even boggled at the thumb – nowhere, yet perfectly in place.

But in the left hand (Fig. 45) the contours grow and spread like fronds beneath the painter's trembling fingers; trembling – with age ? or with fear of shattering this precisely Mallarméan essence of femininity? I reproduce for comparison (the photograph in these subtleties is murder) the left hand of the standing picture (Fig. 46); miracle of sensibility, it contains half-developed the characters divided in the other between right and left. But the three rings disturb, and the heavy bangle is without meaning; see only the bracelet of amethysts in the other, confining the arm to its round, from under which wells up the wrist.

The left arm, easily attached to the shoulder, is modelled with a classical restraint; look closely and you will see a finely variegated brushwork, sufficient not to betray the subtle contour, sufficient gently to fit the arm within the circles of the bracelets. The right arm seems enormous, but has not lost its elegance; and over it as over the shoulders the skin is so electrically taut that it doesn't matter there is no blood beneath.

Without pausing over the marvellously rendered dress, under which (oh difficulty!) the body exists, I would finally call attention to the shapes between the forms, to rival Piero's spacing of beauty.

This rapid glance at the details brought me from time to time to note some aspect of the characterisation, which I may now more coherently indicate. It is possible that some of the works of the old masters are as completely realised in the form, though I fancy they never aimed at such complexity; it is of course true that several of them soared at times to sublimer heights of the imagination.

But the aged Ingres has for us now in his characterisation an interest the Ancients lack; his outlook on life is comprehensible, civilised. It happens to be in some respects undistinguished and unattractive; it is in its nature modern.

A lady. Woman was a saint, a princess or a harlot in the great age of painting: a lady appears sometimes in later works, often more charming or original, but nowhere so convincingly alive. Ingres by his method could take no snapshot of a character, and indeed his sensibility was perfectly obtuse to certain shades; but, a living lady.

And more than that: she is the Parisian, in the fashion, in her salon – a flower of civilisation! Do not deplore the character Ingres has discerned of a stupid, self-centred, well-fed, soulless, beautiful woman; she is a social phenomenon, peacefully alive. It is true that he was half in love with her;[25] his eye remained still passionately objective to discern her quality. A china-like surface is after all not inapt; and this sublime doll is no less than an historical document, *La Vie à Paris en* 1850, full of characteristic detail.

But there is very obviously something further, half unconscious.

Si mon air vous dit quelque chose,
Vous auriez tort de vous gêner.
Je ne la fais pas à la pose;
Je suis la Femme, on me connaît.

Not that the picture is loudly unchaste; the outrageous Madame de Senonnes shows her breasts, Madame Moitessier not. But Ingres adored the grossly feminine exuding from under a civilised surface; his taste was very normally and bourgeoisly impure. The heavy scent of this expression may perhaps lure you to study the austere work.

And his sincerity has informed the characterisation; the humourless painter discerned no reason to fear the possible ludicrous. A Goya, in the portrayal of this character, would have descended to some gorgeous caricature; Ingres remained, save in the sense indicated, objective. It is thus that his Monna Lisa, of the nineteenth century, is complete. Inadequate? No; and no one else could even have prepared the ground. A man of a fine nature is rare; that he should be also, and first, an artist, master, nay tyrant, of the bewildering possibilities of modern painting, is very unlikely. The aged Ingres here proved himself *the* draughtsman, objectively, profoundly sensitive to character; by far and away the most nearly *perfect* artist of our time.

JAMES MANN

Six armours of the fifteenth century

The interior of the church of the Sanctuary of the Madonna delle Grazie near Mantua presents an unusual, almost a fantastic, spectacle (Fig. 47). Ranged round the walls of the nave in elaborately ornamented galleries is a series of life-size dummies of persons, many in the act of undergoing execution or torture, who have been saved by the intercession of the Virgin. Several of these figures which are dressed in armour, are traditionally held to represent soldiers of the army which the Connétable de Bourbon led to the sack of Rome.

When writing of it in 1930 I stated that 'if the armour at Grazie were cleaned and well set up it would present a very different appearance from what it does at present, and would almost certainly reveal some interesting armourers' marks. Nine out of the seventeen suits include Gothic pieces, in some cases virtually complete'.[1]

When I first visited the Sanctuary in 1928 the authorities were quite unaware of the importance of the armour which clothes these tattered manikins. In fact, when I asked if I might borrow a ladder to look at them more closely, one of the brothers told me that the armour was only made of *carta pesta* and not worth the trouble. A first inspection soon made it evident that here was an unknown horde of armour of a type and period rarely found outside the great national collections.

I was kindly permitted to make notes and to have the figures photographed *in situ*. But without dismounting them it was not possible to make more than a preliminary examination, for the armour was coated with black paint and layers of the thickest dust that I have ever swallowed. The component parts of individual suits were distributed among different figures, and missing pieces were supplied by imitations in *papier mâché* (to this extent my informant was justified).

There the matter rested until a few years later when a new bishop was appointed to the See of Mantua. When he heard that I had published an account of the armour in the Sanctuary he took steps to have my indications confirmed. One of the figures was dismounted from the gallery and tests were made by scraping the paint on the armour in certain places. This revealed the presence of several armourers' marks. The Bishop at once got into touch with me, and at his invitation I paid another visit to the Sanctuary last September, when I was able to make a more thorough examination than had been possible on the two previous occasions.

From the first Monsignore Domenico Menna, Bishop of Mantua, has taken the keenest personal interest, and has provided every facility for dismounting the figures and removing from the armour the layers of disfiguring paint. With the help of the priests living in the monastery, and a smith and a saddler brought from Mantua, the armour was taken down, boiled and scrubbed, and then sorted out and reassembled in due order. Cramps, nails, and iron wire, which had been crudely used to fasten the various parts together were removed. Straps were repaired and missing rivets replaced where necessary. Much still remains to be done, for only the more urgent repairs were undertaken until more experienced help is available. Although the paint had helped to preserve the metal, many parts were affected to some extent by rust. No drastic cleaning was permitted that would injure the surface, and all parts were dressed with vaseline. There should be no difficulty at a later stage in restoring to the armour the well-groomed appearance that will enable its beauty to be appreciated. Finally, all the armour was photographed in detail piece by piece. As no model figures were available the suits were photographed upon living wearers.

As the work progressed numerous armourers' marks came to light (see Fig. 50). All were of the type associated with the workshops of Milan and its district during the fifteenth century. Attention was paid to these marks when reassembling the armours, so that as far as possible all parts bearing a similar mark should be put together. As a result six complete Gothic suits were assembled out of a total of seventeen armoured figures, and it is these which form the subject of this article. The remaining armour is mostly of the sixteenth century and contains some interesting examples. But I hope to publish in *Archæologia* a more detailed account of all the armour at Grazie than is possible here;[2] to amplify the descriptions by comparisons with existing armour elsewhere and to go more thoroughly into the marks, several of which are to be found in other collections.

Some idea of the importance of the armour in the Sanctuary can be gathered from the fact that when Sir

Guy Laking published his *Record* in 1920 he only listed six examples of cap-à-pie armours of this type (Vienna 3, Berne 1, New York 1, Turin 1).[3] Since then with the publication of the armoury at Churburg in 1929 four more have been added (nos. 19, 20, 21 and 22). No complete armour of this kind exists in a public collection in England. Without taking into account suits built up of separate parts gathered from widely different sources, it can be seen that the armour at S. Maria delle Grazie makes a very considerable accession to the material available for studying the great era of the armourer's craft. Milanese armour of the fifteenth century is probably best known to readers of THE BURLINGTON MAGAZINE from its frequent representation in Italian paintings of the Quattrocento. Paolo Uccello, Benozzo Gozzoli, Piero della Francesca and Mantegna have painted it with the most sympathetic attention to detail. For this reason a contemporary drawing by Squarcione (Fig. 52)

47. (*left*) Interior of the Sanctuary of the Madonna delle Grazie, Mantua, as it was in 1938.

48. (*right*) Suit of armour; Italy, fifteenth century (Museo Diocesano, Mantua, formerly S. Maria delle Grazie).

49. (*far right*) *St George*, by Andrea Mantegna. c.1460. Tempera on panel, 66 by 32 cm. (Accademia, Venice).

50. (*below*) Armourers' marks on the six fifteenth-century armours from the Sanctuary of the Madonna delle Grazie, Mantua.

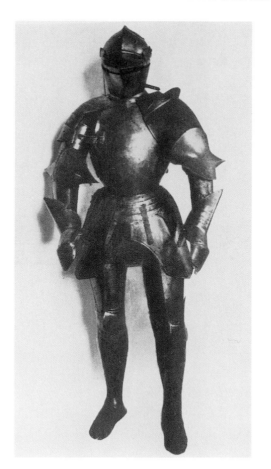

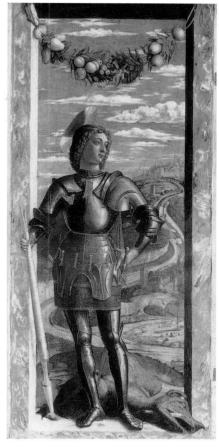

and Mantegna's *St George* have been introduced for comparison (Fig. 49).

Before being cleaned the first of these armours (Fig. 48) was lent last summer to the Mostra Iconografica Gonzaghesca, which was held in the Palazzo Ducale at Mantua. It alone remains virtually unaltered, for all its parts belonged to the fifteenth century and did not need reshuffling. When in its place in the church the figure that bore it used to be known as the Marquess Federigo II Gonzaga (1519–40). It was during his reign that the scheme of redecoration of the nave with the ornate galleries and dummies was undertaken by one of the friars, Francesco d'Aquanegra. Actually, the armour belongs to a previous generation and dates from before 1500.

It consists of a solidly built *armet à rondelle* which retains its buff or wrapper. This was found bent up and forced inside the bevor. It has now been straightened out and strapped in its proper position covering the lower part of the helmet in front. It consists of a face-guard, to which are riveted two gorget plates. The armet itself is solidly built, with a keeled ridge over the skull, cusped reinforcing plate on the brow and strongly turned-over

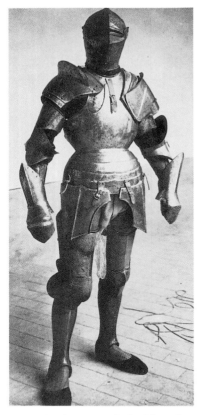

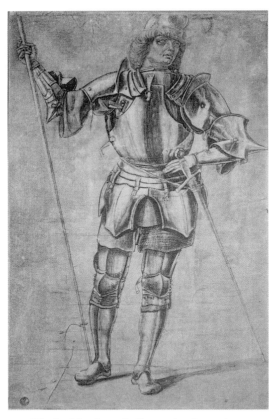

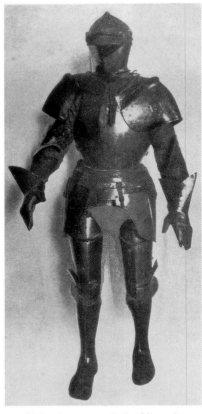

51. Suit of armour; Italy, fifteenth century (Museo Diocesano, Mantua, formerly S. Maria delle Grazie).

52. *Warrior*, Northern Italian artist, formerly ascribed to Francesco Squarcione. Brushpoint and greenish wash on greyish prepared paper, 40 by 26.5 cm. (Uffizi, Florence).

53. Suit of armour; Italy, fifteenth century (Museo Diocesano, Mantua, formerly S. Maria delle Grazie).

borders. The cheek-pieces are deep, concealing much of the lower part of the face and a U-shaped vent has been cut in front opposite the mouth. The rivet-heads of the hinges are flat and stamped with a rosette-pattern, which is frequently found on Milanese armour of this date and constantly recurs on the armour here.

The breastplate is forged in one piece, but stops short of the waist; the borders are turned strongly outwards. A lance-rest is bolted to the right side. Over it is a reinforcing breast of unusual size. It is of greater extent than the true breast-plate beneath it, as it reaches to the waist where the lower edge is bent outwards to carry the skirt of lames. It is really an exaggerated placate or lower breast-plate, while the other would be the upper part of a normally articulated Gothic breast. Just such a superimposed breast can be seen on the figure of St George in the painting of the Virgin and Child and Saints by Francesco Bonsignori in the Church of S. Bernardino at Verona dated 1488 and Ercole Grandi's [i.e. Ercole dei Roberti's] altar-piece in the National Gallery. It fits closely inside the turn-over of the neck and left armpit of

the breast proper and is cut out on the right side to accommodate the lance rest. Two buckles are placed one on each side for the straps to hold it in place and two other straps were riveted to the sides above the waist line. The reinforcing or lower breast carries four lames of a skirt, on the third of which are placed two pairs of flat rosette-headed rivets to hold the straps supporting the tassets. These last are of fine form, large and pointed, ridged in the centre and with the inner edges flanged. No marks are discernible on the armet, or the two breasts, but a well-known triple Milanese mark (no. 11) is stamped on either tasset. The backplate is built up of one large plate and three acutely pointed and cusped plates overlapping upwards. Two buckles are riveted on the shoulders and two at the sides. The pauldrons are of the ample Italian form, extending far behind over the shoulder blades. That on the left has a reinforcing plate in front with the upper edge upstanding. The pauldron proper is built up of three upper lames, a main plate and one lame for the arm. The right shoulder leaves the armpit free, and is built up of five lames, the lower two

with cusped upper borders behind and extending to the middle of the back. The right vambrace, by which is meant the whole arm below the shoulder as was the old meaning of the term, consists of an upper cannon nearly enclosing the arm; to this is attached a small articulated couter, with one upper and two lower lames, over which is riveted a large reinforcing elbow or garde-brace of fine form bearing a mark (no. 1). It is these large butterfly-like left elbows which give such character to Italian armours of this time. The well-modelled lower cannon of the vambrace is formed of two parts hinged together and fastened in the Italian manner by a buckle and strap near the wrist. The right arm consists of upper cannon, pointed articulated couter with a finely shaped tendon-protector with its upper half reinforced, and a lower cannon similar to the left arm. Both the gauntlets have long pointed cuffs, but apart from this are differently constructed; the back of the right hand is protected by a separate plate and the finger mitten is formed of two lames; while the left gauntlet is made in one piece except for a single separate plate; covering the fingers.

The cuisses bear a triple mark on the top lame (no. 2), and are distinguished by a diagonal *lisière d'arrêt* forged in a sweeping curve out of the upper edge of the main thigh-plate. The poleyns have rounded wings at the sides articulated by means of two lames above and below, and with the addition of an engrailed plate, to which is attached the wire intended to support the mail fringe. A number of links of the latter are still attached to it. The greaves are built in two halves in the usual way, with internal hinges on the outer side. The borders of the insteps are pierced for the attachment of mail shoes.

The second suit (Fig. 51) as now assembled has many interesting features. The armet retains its rondel and is of the same type as the last except that the cheek-pieces, although high, are not cut away where they overlap across the mouth. There are traces of a mark on the back of the skull. The breast is of specially fine form resembling the one at Berne and that in Squarcione's drawing (Fig. 52), being deep and rounded; the lower part coming well up the chest in front where it is held by a strap. Both upper and lower portions of the breast and back are hinged on the left side, and are fastened on the right by a strap and buckles and by a hook which engages in a slot. The lance-rest is missing. There is a skirt of four cusped lames from which depend two pointed tassets of elegant form. The upper breast and bottom lame of the skirt bear an interesting triple mark with a spurred O (no. 6). The tassets have the triple M mark (no. 11). The back consists of an upper and a lower

portion, the upper is built up of one main plate and three pointed lames overlapping upwards, to the centre one is riveted a buckle which receives the strap from the lower half. The latter consists of one pointed plate shaped to the waist and bearing a triple mark (no. 6). Buckles are riveted on the right side and hinges on the left to join it to the breast. The pauldrons are well built, both with upstanding guards, the reinforcing plate of the left is distinguished by the diagonal ridge often seen on English monumental brasses and tombs, and fastened by a staple and lynch pin. The left one has a triple mark including the cross-keys (no. 9), sometimes attributed to the Negroli. The arms are similar to the first suit with the large additional wing on the left elbow, and a tendon-protector on the right with the upper-part reinforced. The gauntlets have pointed cuffs, and are built similarly to the last two to be described, namely the right in four plates, the left in two.

As originally set up, two of the figures were fitted with two right and two left cuisses respectively. These had to be separated and properly paired off. In the present instance the cuisses are now a pair (as can be seen from the serrated edge of the cusped lame near the top and the pairs of marks (no. 10), but they are unequal in size since one lame of the left poleyn is missing. The right cuisse retains the vertical hinged plates enclosing the back of the thigh. There are holes in the extra plate of the poleyns for mail fringes and also on the bottom edge of the greaves. The wings of the poleyns are plain.

The third Gothic suit (Fig. 53) in many respects

54. Armet from suit no. 3 (Fig. 53).

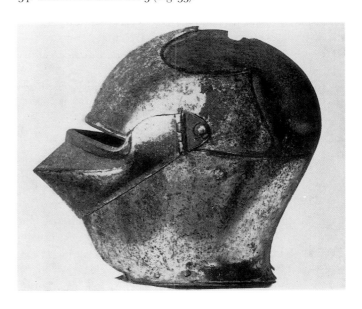

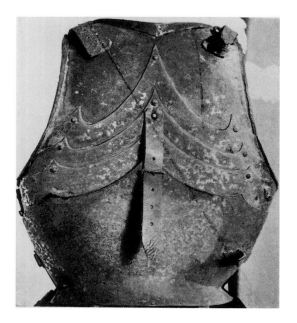

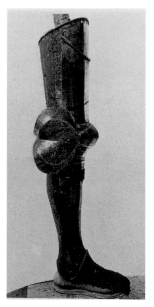

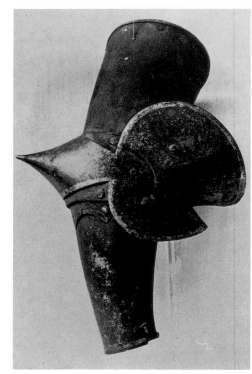

55. Backplate of suit no. 3 (Fig. 53).

56. Leg of suit no. 3 (Fig. 53), showing original mail fringes at knee and foot.

57. Right arm of suit no. 3 (Fig. 53). (Museo Diocesano, Mantua, formerly S. Maria delle Grazie).

reproduces the form of the preceding two. The armet (Fig. 54) is akin to the first described in that the cheek-pieces are cut out at the mouth and the visor is small, with the lower edge of the sight turned over to a strong angular section. There is a triple mark on the back of the skull. The rondel is missing. The fine breast, built in two separate parts with the lower one overlapping the other in a high point, together with the laminated back-plate, closely resemble those of the last suit, but bear a different mark (no. 11). The tassets are of the same form as the last but a little smaller and lighter. The back plate is built up of a series of pointed laminations like the last two (Fig. 55). The pauldrons are of large size. The left has a small shield-shaped patch on the front of the rein-forcing plate. Both arms have well-shaped couters (Fig. 56), the left having, like the last two, a large reinforcing piece or garde-brace attached by a staple and pin, and with its surface relieved by two moulded ridges or crest-ings. One gauntlet, the right, survives, and like the other right-hand gauntlets is built up of four plates. The other gauntlet here shown in the illustration has been already described and is only added for symmetry to conceal the hand of the wearer.

But a feature of unique importance in this case is the legs (Fig. 57). These possess their original mail fringes and shoes. The only other authentic examples of this feature, so often reproduced by the Old Masters, are on one of the Churburg armours (no. 20) which retains its mail shoes, and the legs of the so-called armour of Niccolò da Tolentino, formerly in the church of S. Niccolò at Tolentino (Richards Sale, Rome, 1899, lot 1673), which retains the mail fringes at the knees. All other instances of mail fringes at the knees known to the writer are modern restorations, often where no fringes originally existed. No other legs than these at S. Maria delle Grazie are known to possess *both* fringes and mail shoes. The cuisses are well constructed and are com-pleted with vertical hinged plates to enclose the back of the thighs. A triple mark (no. 11) is on the uppermost plate in each case. The poleyns have finely moulded wings.

The next suit to be described (Fig. 58) has a neat little armet of a different type from the last three. It is shaped at the neck and the cheek-pieces to leave more room for the face. Other distinctive features are the piercings of the left side of the visor, and the manner in which the lower edge of the sight is turned upwards and not dou-bled over. The articulated breast and back, large and

rounded, resemble the last two in build, but have a different mark, very distinctly impressed several times in all (no. 22). The tassets are missing, but flat rosette-headed rivets show where they were once attached by straps to the third of the four lames of the skirt. The line of rivets along the border of the lowest lame secured the lining. The pauldrons are of ample build with reinforcing plates attached in each case by a central bolt in front, and show triple M marks (no. 21). At the back they extend far beyond the shoulder blades, the left being built of four and the right of five lames, the lower ones cusped. A *lisière d'arrêt* for strengthening it is riveted along the top edge of the middle lame of the right shoulder. The arms are less well built than those hitherto described. The left elbow has an additional wing very little larger than the cop that it covers, which is articulated twice above and once below. The lower cannons of the vambraces are of the usual type, hinged on the outside, and fastened by a buckle and strap across the forearm. There are no gauntlets and those shown in the legs are incomplete and lack the backplates of both

cuisses and greaves. The illustration of this suit has already been described under another head. The cuisses are similar in form to those of the last suit, except that the bottom lames of the poleyns are longer. The front plates of the greaves are of poor form and material and though old are probably later additions.

The fifth and sixth Gothic suits (Fig. 59 and 60) present a somewhat later appearance than the others by reason of the form of their breast and back plates. These are forged in one piece without placates or articulation. The armet of the fifth is of good fifteenth century form with an interesting triple mark on the back (no. 16; cf. the castle mark on an armet in the Bargello). The breast which has strong turnovers at neck and armholes retains its lance-rest. There are three lames to the skirt and a triple M mark (no. 21) in the centre of the lowest. The left pauldron is fitted with a very large, enveloping reinforcement or grandguard, probably dating from very late in the century. It is affixed by a bolt to a pauldron of four plates of which the main plate has an outward turned flange which fits neatly within

58 Suit of armour; Italy, fifteenth century (Museo Diocesano, Mantua, formerly S. Maria delle Grazie).

59 Suit of armour; (Museo Diocesano, Mantua, formerly S. Maria delle Grazie).

60 Suit of armour; (Museo Diocesano, Mantua, formerly S. Maria delle Grazie).

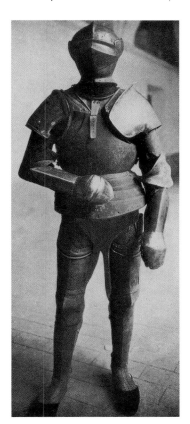
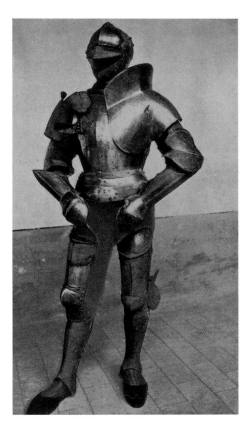
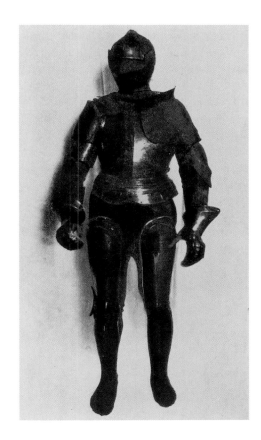

the high neck guard of the reinforcing plate. The right pauldron is similar to those already described with a reinforcing piece in front, affixed to six lames which extend far behind, the two lower being ingrailed along their upper edges. Instead of a *lisière d'arrêt* or stop-rib riveted to the main lame, it is strengthened by a corresponding ridge embossed along its upper edge. The arms are symmetrical and they too, are probably later in date than those previously described. They have large wings attached to the couters to protect the bend of the arm, and have no reinforcing plates. There are two lames above and two below the couter in each case. There are no gauntlets and a pair have been borrowed from one of the others. The legs are good examples of fifteenth century Italian armour. The cuisses as usual consist of a main thigh piece with a strong turnover to act as a *lisière d'arrêt* at the upper edge, above which is a narrow lame and then a larger topmost plate bearing the armourer's mark (nos. 17, 18). The right one retains the longitudinal hinged slats for the back of the thigh. The poleyns are articulated once above and twice below. The side-wings are of simple form. The lower edges of the greaves are perforated for the attachment of mail shoes.

The sixth and last of the Gothic armours carries an armet with small visor and low cheek pieces. There is a single mark of a split cross (no. 14) at the back of the skull. The breastplate, like the last, has no placate, but is fitted with gussets at the armpits, another late sign. It probably dates between 1490–1510 A.D. There are three lames to the skirt and no tassets. The left pauldron shows shell-like flutings, and two holes in front suggest that it possessed a large reinforcing plate similar to the last. The right one, which is not a pair to it, is earlier and more strictly gothic in form. It is built of five lames, the two lower ones on sliding rivets, with a *lisière d'arrêt* riveted along the upper edge of the main plate. The arms like the last are symmetrical. It so happens that the smith in removing the old nails which held them rigid has exchanged and reversed the couters, but it is a simple matter to put them right. The borders of the wings are sunk; their date is probably contemporary with the breast plate. Both the gauntlets have fluted mittens, but are not a pair as can be seen from the decoration of the cuffs. These, too, probably date from about 1500 and are on the threshold of the 'Maximilian' fashion. Compare similar gauntlets in the Royal Armoury at Madrid. The legs are well-built, but late, with deep hollow flanges as *lisière d'arrêt* to the cuisses, which retain their protection for the back of the thigh consisting in this case of a single hinged plate to each. The bottom edge of the greaves is cut off straight in the Italian fashion of the sixteenth century and is not shaped to the instep like the earlier examples previously described. The above brief descriptions will, I trust, suffice until the writer has the opportunity to discuss these armours in a more amplified form.

Being some distance outside Mantua, S. Maria delle Grazie is beyond the range of the normal tourist and is little known except to the pilgrims who flock to it every August. In 1555 an Englishman in the train of Queen Mary Tudor's envoys on their way to Rome, visited the Sanctuary, and in the very interesting account of his journey which has been published among the State Papers he tells how 'We passed through a town called Andalesco and by our Lady of Mantua, her chapel, where is the greatest offering in these parts of Italy. There they shew pictures (*sic*) of men, which she preserved (so they say) that were stricken into brains and hearts and in at their backs with swords and daggers; and where is also such wonderful works of wax, as I never saw the like again.' Gothic armour was commoner then than now, and he was more struck with the dramatic nature of the figures than the armour that clothed them. Otherwise he might have anticipated this account by some four hundred years.

NEIL MACLAREN

'Meindert Hobbema'
by Georges Broulhiet

This is a book which purports to give a full-length study of Hobbema, together with a complete illustrated catalogue of his paintings and drawings. It is arranged on the familiar lines of this type of monograph and might be supposed to be comparable, for example, with Rosenberg's *Jacob Ruisdael*. In the words of the preface (p. 11): '*L'étude qui suit est cartésienne, dans la tradition qui imprègne toute carrière scientifique. Les rectifications qu'elle contient à l'encontre des opinions admises sont nécessaires pour retablir la réalité*'; the result is, to say the least, disconcerting. It would be a thankless task to examine in detail the analysis of the artist which occupies the first hundred pages and which is written in a false rhetorical style little less confusing than its substance. '*Repoussant au deuxième plan et comme moyen auxiliaire la sensibilité de l'expert, devant la carence de l'histoire, la recherche suit le fil d'Ariane de l'iconographie; le contact direct avec l'œuvre du peintre en est la règle absolue*'; its chief purpose, however, seems to have been to extend the *œuvre* of Hobbema to include not only copies and pastiches, old and modern, but also a number of still-lifes and genre scenes as unrelated to each other as to Hobbema, here introduced without the burden of supporting evidence as either youthful or late works. For example:

'*Dans les documents d'un historiographe, nous avons trouvé la réproduction, extraite d'un catalogue de vente italien, d'un tableau symbolique représentant probablement* Saint Michel térassant un démon, *annoncé comme signé par Hobbema. Nous avions cru d'abord nous trouver devant une fantaisie de rédacteur de catalogue, et le document avait été enlevé des dossiers. Puis une personne digne de foi nous assure avoir vu un autre tableau représentant une bataille et portant le signature de Hobbema sur le harnachement d'un cheval*' (p. 94). It therefore does not come as a surprise to the reader who has undergone the previous ninety pages that the author mentions (p. 92) copies of Jan van Goyen, Cornelis Dusart, Wouwerman and others which he has no difficulty in identifying as by Hobbema. Indeed, the author draws on the following page the logical conclusion: '*Mais la vérité est probablement que, parmi les faux tableaux anciens imitations des maîtres du paysage du XVIIIe siècle qui embarassent les experts, beaucoup sont de la main de Hobbema qui les peignit par misère.*' The accompanying plates on this account certainly have a peculiar value in that they include reproductions of pictures it would be difficult to find elsewhere, and may constitute a convenient though not complete assemblage of Hobbema material.

The catalogue raisonné, which follows, it would be incorrect to call a compilation. Those few parts which are not additional to Hofstede de Groot's catalogue could be said to consist of a literal translation of it were they not in most cases a mistranslation. Despite word for word dependence on the earlier catalogue there is hardly a page on which there is not at least one error and frequently a dozen, not of scholarship or attribution but of mere transcription. The following examples chosen from hundreds of the same kind are quoted more for their Firbankian humour than in the hope that they will give any idea of the effect of the whole. A picture belonging to Lord Burlington is referred to (p. 402) as in the collection of the 'Duc de Burlington, Knoedler Hall, Londres'; the Earl of Crawford is mentioned variously as 'Duc de Crawford and Vaccarès' (p. 477), and 'Duc de Crawford and Balcarres-Katz Dieren' (p. 409); the Sackville Gallery becomes the 'Sockeville Gallery' (p. 95); 'in the possession of Woodburn at Hendon' appears as 'chez Wordbrun et Henden' (p. 438), and to show that these are not mere printing mistakes, amongst others of a similar nature, 'Holm Wood, Peterborough' is unkindly transferred to 'Holm Wood, Léningrad.' Apart from this a certain amount of information contained in Hofstede de Groot is omitted. It will be easily understood that on more important issues there are comparable aberrations, and throughout there is evident an astonishing artistry of inaccuracy.

HERBERT READ

'On art and connoisseurship'
by Max. J. Friedländer

It is generally recognised that the great connoisseur owes his greatness to the possession of a faculty which is distinct from both the learning of the scholar and the analytical powers of the scientist. We are not so sure that it is altogether different from the creative gift itself, for one explanation offered by the psychologist is that this special insight or 'flair' is only found in the repressed or frustrated artist. This is all the more likely if we accept the theory that 'the activity of the formative artist is essentially contained already in the act of seeing' – a theory for which there is more evidence than the author of the remark would find it congenial to present. For the author is himself a connoisseur – the greatest professional connoisseur of our time, and one who, in the full ripeness of his experience, and from the obscurity of exile, sends us his bright testament.[1] It has been sensitively translated 'from the author's manuscript' by Professor Borenius and is published by another exile, one who found a refuge, and recently, alas, a grave, in this country.

It is the most illuminating book of art criticism since Wölfflin's *Grundbegriffe*, and a certain organic vitality, such as is only found in books that have slowly grown out of a practical activity, makes the earlier classic seem, by comparison, artificially formal. Wölfflin's polarities still serve their purpose: they square the paper on which the student can most clearly plot his first historical graph; and Wölfflin is one of the few writers on the subject to whom Dr Friedländer pays a tribute – for he has hardly, he confesses, read any literature on the theory of art. But no connoisseur, however consistently he keeps his eye on the object, can move in the milieu of these objects (particularly if his language is German) without picking up a few philosophical habits ; and as a matter of fact, as a preliminary to his more practical

observations, Dr Friedländer handles some of the fundamental problems of aesthetics with precision and decisiveness – the problems of appearance and reality, of percept and image, of form and content, etc. These chapters contain no startling new theories, but they give concreteness to logical concepts, sensuous reality to abstractions. This is perhaps due to Dr Friedländer's clear realisation of the symbolic nature of art. 'All art', he writes, 'is symbolic, since the artist through image, word or note communicates to the spectator or listener by the material the transcendental, by the sign the thought or emotion, by the particular the general, by the example the category.' Criticism, in Dr Friedländer's hands, is a reversal of this process, proceeding from the category to the example, from the general to the particular, from the transcendental to the material.

Rewarding as these theoretical chapters are, they are excelled by those in which Dr Friedländer applies his pragmatic intelligence to the problems of connoisseurship – problems which may be historical (the objective criteria of authorship, for example) or practical (the analytical examination of pictures, the use of photographs, etc.) or technical (the detection of copies, forgeries, and restoration). Dr Friedländer withholds nothing: he pours out his secrets for the future use of students and the guidance of amateurs ; and there is no professional worker in the field of art, be he museum director, expert, dealer or restorer, who will not read these pages with great benefit. Particularly rich in observation and pertinent example is a chapter on 'Artistic Quality: Original and Copy', and a quotation from it will show how concretely Dr Friedländer will illustrate a point under discussion:

'I will try to illustrate by means of an example the kind of mistake a copyist is liable to make. Before me there lie two drawings, one the archetype, the other a

close imitation. In the foreground, out of the earth, there rises a stone across whose base there extends a wavy mass of sand. The copyist has erroneously taken the slight, undulating line for the lower edge of the stone, which now in the copy is not contained in the soil but, on the contrary, stands *on* the ground with an impossible jagged contour. The ensemble of forms seems in each case to be almost exactly the same, yet the total effect is completely different, since the copy has wiped out the special illusion caused by the position of the stone behind the wavy mass of sand.'

The first and the final test of a book as of a picture lies in the 'facture', and it is perhaps not necessary to praise a style which is already so famous, and which preserves all its animation in this translation. Dr Friedländer does not write a typical German style: he is elliptic, aphoristic, witty and objective. It is the style of a Good European, of a man who, in this field of art, has modelled himself on Goethe, Stendhal, Mérimée and Baudelaire rather than on the academicians. I will conclude by quoting a few of the hundreds of brilliant aphorisms which are merely the high lights on a consistently luminous canvas :–

Van Eyck's eye moved in front of a world at rest; Manet's eye rested in front of a world in motion.

To emphasise one's personal style means to make a virtue of necessity.

The artist never loses the feeling of standing before an insoluble task ... If he imagines that he has reached his goal, he has really come to the end and stands at that boundary where mannerism begins.

The concept of beauty suffers from an ominous generalness and painful vacuity.

The indifference with which the painters in the nineteenth century allowed their pictures to be framed produces a sense of distrustfulness.

The real theme of *genre* painting is condition, not event.

Woe to the master who looks at the human face with the eye of the still-life painter.

Works of art do not speak – they sing.

In front of art the thinkers are mostly blind and the practising artists mostly dumb.

It is in the nature of a work of art to speak ambiguously, like an oracle.

Intuitive judgement may be regarded as a necessary evil.

The works belonging to the old age of the greatest masters all share a sublime and transfigured timelessness.

Genius changes from inner necessity, talent for a reason.

There do not exist many authors whose literary capacity is on a level with their understanding of art.

These are enough to prove the self-application of a remark with which Dr Friedländer brings his book to an end: 'Descriptions or statements, elaborate and aiming at completeness, demand too much of the visual memory of the reader: it is the aphorisms, throwing light like flashes, which are above all effective.' But it should be added that Dr Friedländer has further aided the reader's visual memory by the choice of forty illustrations, excellently reproduced in half-tone.

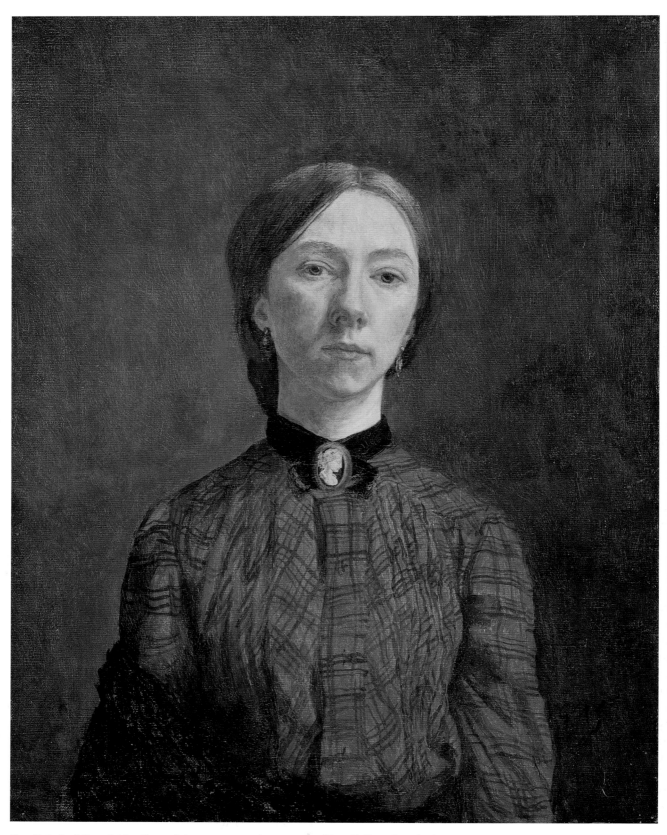

61. *Portrait of the artist*, by Gwen John. 1902. 44.5 by 34.3 cm. (Tate Gallery, London).

1943

AUGUSTUS JOHN

Gwendolen John

My sister's preference for slums and underground cellars never quite won my approval. I am attracted by both but not as a potential resident. The robust paganism of my outlook, intensified by the fact of consanguinity, resulted in a conflict in which fraternal jealousy was too often unable to repress its instinctive movements of impatience with what seemed to me a renegade and injurious philosophy, diametrically opposed to the system, perhaps more muscular than intellectual, which I then professed.

When soon after leaving the Slade she installed herself in a kind of dungeon near Fitzroy Street, into which no ray of sunlight could ever penetrate, I openly demurred. It was cheap, but was it truly economical? Would not her health suffer in this gloomy vault? Was the lighting, what there was of it, suitable for painting? It is true that the ordinary studio with its glaring top-light, is usually an unpleasant place, but this, I thought, was going too far. But no, Gwen was delighted with her new quarters and would not listen to my arguments. She never did. The same indifference to physical considerations characterised her throughout her life. The apartment at Meudon which she occupied for so many years was certainly not subterranean, being about six stories above ground, but it was inconvenient and situated in no enviable quarter; and later on, when she moved to Rue Babie, her new residence consisted of a mere shed, hardly weatherproof, erected in half-an-acre of waste ground. My objections to this policy of self-neglect, entirely motivated by my regard for her well-being, were met with ridicule. I was only betraying an absence of sensibility and a fundamentally 'bourgeois' state of mind. Besides she had her cats to consider. They came first. It was these animals prevented her coming to England on account of quarantine regulations, and *their* necessities which made an occasional visit to her father in Wales a matter of insuperable difficulty. Though she had acquired a cottage in Hampshire, after one short sojourn she never returned to it.

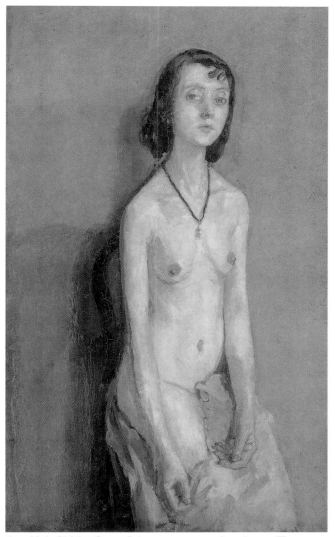

62. *Nude Girl*, by Gwen John. 1909–10. 44 by 28 cm. (Tate Gallery, London).

63. *Lady Reading*, by Gwen John. 1909–11. 40.3 by 25.4 cm. (Tate Gallery, London).

64. *The Nun*, by Gwen John. c.1915–21. 70.7 by 44.6 cm. (Tate Gallery, London).

With some talented student friends she passed some time in Paris under the tutelage of Whistler. It was thus she arrived at that careful methodicity, selective taste and subtlety of tone which she never abandoned. Though she owed much to this training, her power of drawing was entirely original as was her more than aesthetic sense of life. Her friendship with Rodin played an important part in her career. He recognised her gifts and acclaimed her as 'a fine artist'. It is not generally known that the statue commemorating Whistler which Rodin was commissioned to execute for this country, was modelled after my sister. This magnificent work, of which one arm is incomplete, takes the shape of a colossal female figure, slightly draped and holding a medallion with the Artist's

portrait thereon. It was not approved by the Committee, who decided to acquire a replica of the *Bourgeois de Calais* instead.

Gwen, though she became so much of a recluse, was by nature by no means lacking in *joie de vivre*. Her eye for character and her native humour enabled her to appreciate the gay as well as the tragic aspects of the *Comédie Humaine*.

Of an extreme timidity in a social sense, she was always capable of demonstrating a dauntless courage and a formidable strength of will. Her pride, honesty and devotion to what she took to be her duty, combined, under the compulsion of a sufficient motive, to transform her into an irresistible force. This gentle soul was then adamant in resolution and would stick at

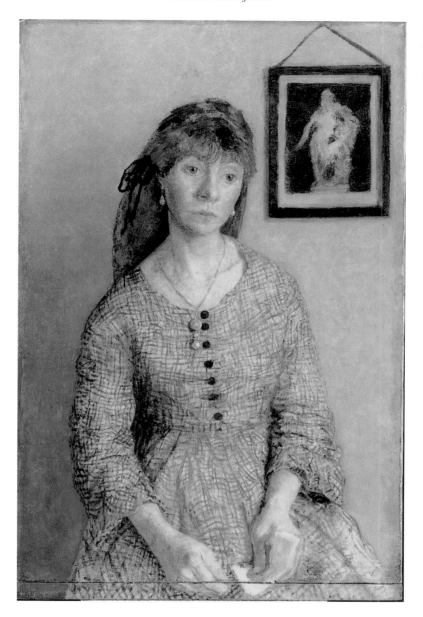

65. *Portrait of a woman seated*, by Gwen John. 1904–08. 58.4 by 38 cm. (Tate Gallery, London).

nothing. Having embraced the Catholic Faith she became, it might be said, more pious than the Pope. My Jesuit son, Elphin, used sometimes to attempt the conversion of his father and once, when he was arguing that I had nothing to lose but everything to gain by accepting the true Religion, Gwen happened to enter the room and, overhearing this line of reasoning instantly corrected the ardent young casuist. 'You are quite wrong', she said, 'one accepts the Truth because it is the Truth, and not for any advantage; indeed for the love of God one is prepared to lose everything, even life; as if that mattered!' The cold contempt of these words impressed me while it silenced my son . . .

In her later period my sister painted numerous por-traits of nuns; she also left some landscapes done chiefly in Brittany, besides many drawings of children, women, flowers and cats. Her coloured drawings are often repeated dozens of times, with slight variations. Few on meeting this retiring person in black, with her tiny hands and feet, a soft, almost inaudible voice, and delicate Pembrokeshire accept, would have guessed that here was the greatest woman artist of her age, or, as I think, of any other.

The end came when, feeling the need of a change of air, Gwen John took the train to Dieppe. She collapsed on arriving. She had brought no baggage whatever, but as it turned out had not forgotten to make in her will a suitable provision for the cats . . .

BRINSLEY FORD

Baron James Ensor

The death of Baron James Ensor, the Belgian artist, at the age of 82, which was announced in *The Times* of 19th December, is likely to pass unnoticed in this country, and it is a strange fact that a painter who was half English, and who held so unique a position in Belgium, should be so little known and appreciated on this side of the Channel. Ensor was born at Ostend on 13th April 1860, of an English father and a Flemish mother. In 1877 he went to the Brussels Academy, but in 1880 he returned to Ostend where he remained for the rest of his life, only leaving it to make an occasional visit to London or Paris. In his early work, such as *Le Salon Bourgeois* which seems sober enough to us, he experimented in a very individual yet restrained manner on the discoveries of Impressionism, sponsoring the movement in Belgium, and earning the derision of the critics. A few years later he broke the fetters which relate his early work to that of some of his contemporaries; and by 1890 he had already devoted himself to those chimerical subjects, to those weird and gesticulating puppets, to those lively skeletons and exotic masks, which he loved to paint, using their grotesque shapes for his subtle and ever varying experiments in harmony and tone. In 1929, after his fancy had been allowed free rein for nearly fifty years, when every capricious whim had been committed to canvas, and when the public could no longer be blamed for their bewilderment, his unusual gifts were officially recognised and he was created a Baron, an honour which he appreciated, even if he regarded it with a certain ironic amusement.

Ensor created a world of delicate and exquisite fantasy, working in gradations of colour so pale and opalescent that they seem inspired by his long and profound relationship with the sands and the sea. His touch was light as gossamer, and if he aimed at the suggestion rather than the substance of form it was to preserve that fragile, ethereal quality of paint which is characteristic of his best work. His compositions are sometimes disconnected, bizarre and wilful, but they are so by intention, not accident, and when the effects are not overdone they often yield an unexpected excitement. The Diableries and Buffooneries, which are the ever recurring themes in his canvases, recall his Flemish descent – the names of Bosch and Breughel suggest themselves as spiritual ancestors, but the resemblance is superficial. Ensor lacked the sting of their satire; and had he chosen to paint a pig in a nun's wimple it would have been the contrast which engaged his fancy, rather than any implied attack on a religious order.

The English visitor to Ensor could be assured of a warm welcome. The painter kept a small shell shop and lived above it. The shop itself, surely the last of its kind, was a veritable treasure house of Poseidon, where shells of every shape, size and variety were for sale, singly and in clusters, designed as earrings, necklaces, and indeed, for every decorative and purposeless object to which a shell can possibly be adapted. The room upstairs which served as sitting room and studio was not less extraordinary. The whole of one wall was dominated by his vast and impressive canvas *L'Entrée du Christ à Bruxelles*, masks and dolls, fans and brocades littered the chairs, a skull bedecked in a straw hat, gay with purple and green ostrich feathers, grinned menacingly from the top of a cabinet, while a huge ball of blue glass suspended from a chandelier reflected these and a thousand other curious objects. Ensor himself, a neat and distinguished figure, quietly dressed in black, with a small grey beard and a very courteous manner, would have passed as a Senator and been inconspicuous in any café. He spoke only French but took pleasure in recounting his English ancestry. It was however when he discussed his paintings that the visitor became aware of a rare and precious personality, and when Ensor, pausing in front of a delicate pastel, as though anxious to convey what he had striven for, murmured, blowing on the petal closed tips of his fingers till they burst apart, '*Voilà . . . un petit souffle et ça s'en va*', he caught in a phrase the essence of his art which will endure when many less nebulous creations have been forgotten.

1944

E. H. GOMBRICH

The subject of Poussin's Orion

This was the vision, or the allegory:
We heard the leaves shudder with no wind upon
 them
By the ford of the river, by the deep worn stones,
And a tread of thunder in the shadowed wood;
Then the hunter Orion came out through the
 trees,
A tree-top giant, with a man upon his shoulder,
Half in the clouds . . .

 Sacheverell Sitwell:
 'Landscape with the Giant Orion'.[1]

Bellori tells us that of two landscapes Poussin painted for M. Passart one represented 'the story of Orion, the blind giant, whose size can be gauged from that of a little man who stands on his shoulders and guides him, while another one gazes at him'. It is to Professor Tancred Borenius that we owe the identification and publication of this masterpiece which is now at the Metropolitan Museum at New York (Fig. 66).[2] The strange tale of how the gigantic huntsman Orion, who had been blinded for an attempt to violate the princess Merope at Chios, was healed by the rays of the rising sun, would appear to be a tempting subject for illustration. And yet Poussin seems to have been the first – if not the only – artist to paint it.

Perhaps the story did indeed appeal to him – as Mr Sacheverell Sitwell suggests – 'because of its poetical character, and because of the opportunity it afforded him to make a study of a giant figure, half on earth and half in the clouds, at the moment of sunrise', but the idea of making it the subject of a painting was nevertheless not his own. It was apparently first conceived not by a painter but by a man of letters, by that fertile journalist of late antiquity: Lucian.

In his rhetorical description of a Noble Hall, Lucian enumerates the frescoes which adorn its walls:

On this there follows another pre-historic picture: Orion who is blind is carrying Cedalion, and the latter, riding on his back, is showing him the way to the sunlight. The rising sun is healing the blindness of Orion, and Hephaestos views the incident from Lemnos.

There can be little doubt that this passage is the immediate source of Poussin's painting. Like Botticelli's *Calumny of Apelles* or Titian's *Bacchanal* it thus owes its origin to that curious literary fashion of classical antiquity, the 'ekphrasis', which fired the imagination of later centuries by the detailed description of real or imaginary works of classical art.

But though the passage from Lucian may serve to explain Poussin's choice of the subject matter it does not appear to have been the only literary source on which he relied when he began to reconstruct the classical fresco described by the Greek author. For in one point, at least, Poussin's picture does not exactly tally with Lucian's description: Hephaestos is not represented as 'watching the incident from Lemnos' – he is seen advising the guide he gave Orion and pointing the way towards the East where the sun is about to rise. Instead of him another divinity has taken over the role of a spectator: Diana, who is seen quietly looking down from a cloud. The same cloud on which she leans also forms a veil in front of Orion's eye and thus suggests some kind of connection between the presence of the goddess and the predicament of the giant. Félibien must have felt this connection when he described the picture as '*un grand paysage où est Orion, aveuglé par Diane*'[3] – quite oblivious of the fact that no classical version of the myth conforms to this description. It was not Diana who blinded Orion, however often the story of the hunting goddess may have been interwoven with that of the hunting giant who was said to have loved her in his youth, to have attempted to violate her, to have been slain by her for this crime (or

else for his boasts that he would kill all the animals in the world), and who was finally said to have been changed by her into that mighty constellation on the night sky in which his name lives on. No classical version of the tale, however, connects Diana with the episode of Orion's blindness. Indeed it is her intriguing appearance as 'a silent stone statue in the open sky' that inspired Mr Sacheverell Sitwell to his highly imaginative poetical interpretations of the painting which centre round the poet's impression that 'she will fade out of the sky as soon as Orion recovers his sight'. However, the presence of the goddess becomes perhaps less mysterious, if we turn from classical authors to the reference books Poussin may have consulted when trying to deepen his acquaintance with the myth to which Lucian alluded.

A few lines in a satirical verse by Marston give us a neat enumeration of some of the most popular reference books in vogue with the poets and artists:

> Reach me some poet's index, that will show
> 'Imagines Deorum', 'Book of Epithets',
> Natales Comes, thou, I know, recitest
> And makest anatomy of poesy[4]

The modern reader who turns to works like *Natalis Comitis Mythologiae* will find it difficult to associate this bewildering farrago of pedantic erudition and uncritical compilation with the serene Olympian world of Poussin.[5] The most apocryphical and outlandish versions of classical and pseudo-classical tales are here displayed and commented upon as the non plus ultra of esoteric wisdom. The very sub-title of Comes' book, *Explicationum fabularum libri decem; in quibus omnia prope Naturalis & Moralis Philosophiae dogmata contenta fuisse demonstratur*, shows it as part of that broad stream of tradition which, throughout the Middle Ages, kept alive the tenets of late classical philosophy, the belief that to the initiated the old fables reveal themselves as symbolical or allegorical representations of the 'arcana' of Natural History or Moral Philosophy.[6]

The principal method of this strange art of hermeneutics is a fanciful etymology which so stretches the sound and meaning of words and names that they are made to yield their pretended secrets. Weird and abstruse as these 'interpretations' read today, it can hardly be denied that they satisfy one, at least, of the principal requirements of any successful interpretation: the most disparate elements of a myth are, through this method, reduced to one common denominator and even the most contradictory episodes can be made to appear as different symbols and manifestations of one 'hidden truth'. If we turn to Natalis Comes's interpretation of the Orion myth we find that he chose to consider its various episodes in the light of a slightly repulsive apocryphal story which tells of the giant's joint procreation by Neptune, Jupiter and Apollo, a story, which to Natalis Comes clearly signifies that Orion stands for a product of water (Neptune), air (Jupiter) and sun (Apollo). Armed with this clue and a fanciful 'scientific' interpretation of meteorological phenomena he proceeds boldly to interpret the whole legend as a veiled symbol of the interaction of these elements in the origin and natural course of the storm-cloud:

. . . through the combined power of these three Gods arises the stuff of wind, rain and thunder that is called Orion. Since the subtler part of the water which is rarefied rests on the surface it is said that Orion had learned from his father how to walk on the water. When this rarefied matter spreads and diffuses into the air this is described as Orion having come to Chios which place derives its name from 'diffusion ' (for chéein means to diffuse). And that he further attempted to violate Aerope[7] [sic] and was expelled from that region and deprived of his lights – this is because this matter must pass right through the air and ascend to the highest spheres and when the matter is diffused throughout that sphere it somehow feels the power of fire languishing. For anything that is moved with a motion not of its own loses its power which diminishes as it proceeds.

Orion is kindly received by Vulcanus, approaches the sun, finds his former health restored and thence returns to Chios – this naturally signifies nothing e se but the cyclical and mutual generation and destruction of the elements.

They say that he was killed by Diana's arrows for having dared to touch her – because as soon as the vapours have ascended to the highest stratum of the air so that they appear to us as touching the moon or the sun, the power of the moon gathers them up and converts them into rains and storms thus overthrowing them with her arrows and sending them downwards; for the power of the moon works like the ferment that brings about these processes. Finally they say that Orion was killed and transformed into a celestial constellation – because under this sign storms, gales and thunders are frequent . . .

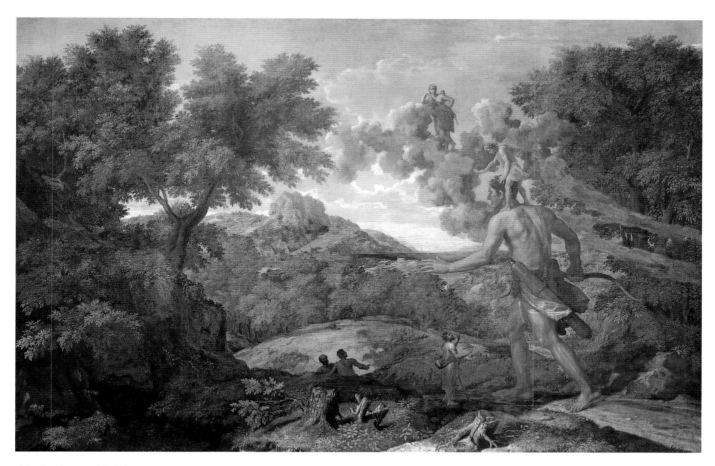

66. *Landscape with Orion*, by Nicolas Poussin. 1658. 108 by 183 cm. (Metropolitan Museum of Art, New York).

In this queer 'interpretation' Diana – the Moon and her power – forms indeed an integral part of the same process that is also symbolised in the episode of Chios: the drama of the circulation of water in nature.

But reading Natalis Comes's text in front of Poussin's picture it appears to explain more than the mere presence of Diana on the scene. The long-stretched stormcloud through which the giant is striding, the cloud that conspicuously rises from under the trees, expands through the valley, gathers up in the air and touches Diana's feet, this cloud is no other than Orion himself in his 'real' esoteric meaning. We cannot but admire the ingenuity with which Poussin has contrived to represent the exoteric and the esoteric aspect of the myth in one picture: To the uninitiated the stormcloud appears as a happy pictorial solution, as a rational trick which helps to illustrate Orion's blindness as a transitory phase which will be over when he has passed the mist and approached the rising sun.

To the circle of scholars who were wont to see 'the teachings of Natural and Moral Philosophy hidden in the fables of Antiquity' the cloud rising in the grandiose scenery represented the whole myth again on a higher plane the eternal drama of the 'mutual generation and destruction of the elements'.

Trained, as we are, in a predominantly visual approach to the arts, we may at first find little to commend in such an intellectual and even sophisticated trick of illustration that embodies a learned commentary into a representation of a classical myth. Indeed – had this trick remained purely on an anecdotal plane the connection with Natalis Comes's erudite compilation might just as well have remained forgotten. It constitutes the true achievement of Poussin's genius that he succeeded in turning a literary curiosity into a living vision, that his picture expresses in pictorial terms what it signifies in terms of allegory. Without the aid of any rational 'key' to its emblematic

language the picture has always imparted its inner meaning to sensitive observers. It was of this 'Landscape of Poussin' that Hazlitt wrote, with strange intuition, in his *Table Talks*: 'At his touch, words start up into images, thoughts become things'; and Professor Borenius, the rediscoverer of the painting: 'the use made of the terms of land, sea, and sky suggests the drama of nature of which the mythological terms are but symbols'.

Reading the passage from Natalis Comes there can be no doubt that this quite literally describes Poussin's approach to mythological landscape painting. An artist like Poussin can only have made use, in his reconstruction of Lucian's 'ekphrasis', of the humanist's allegorical reading of the myth because he accepted his approach as a whole, because he too conceived the ancient tale of violence and magic as a veiled and esoteric 'hieroglyph' of nature's changing course. Thus the landscape became more to him than the scene on which a strange and picturesque story was enacted. Its deeper significance lifted it beyond the sphere of realistic scenery or Arcadian dreams – it became fraught with the meaning of the myth; a vision *and* an allegory of nature herself.

KENNETH CLARK

Piero della Francesca's St Augustine altar-piece

In March 1941 Mr Millard Meiss published in the *Art Bulletin* an article on the figure of a saint by Piero della Francesca which had recently been acquired for the Frick Collection. With admirable learning and judgment he put forward the thesis that it was part of the altar-piece which Piero painted for the Church of S. Agostino in Borgo San Sepolcro. This altar-piece is mentioned in Vasari, and in two contemporary documents – a commission dated 1454, and a record of payment dated 1469. Mr Meiss suggested that it was a polyptych, consisting of a *Virgin and Child enthroned*, with two independent panels of saints on either side. The central panel is lost; the two saints to the right, now in the Poldi Pezzoli and Frick collections, represent *St Nicholas of Tolentino* and, probably, a *St John the Evangelist* (Figs. 69 and 70). Of the two saints to the left, one was the *St Michael*, now in the National Gallery, London (Fig. 68); the other, which Mr Meiss considered would probably represent St Augustine, was presumed lost. This panel is in the Museum of Antique Art of Lisbon (Fig. 67). It was bought in 1936 at the Count of Burnay's sale, together with a panel of a female Saint in the style of Brea. The two pictures were believed to be pendants, and were labelled 'School of Cima'. As Mr Meiss foresaw, it represents St Augustine. The height is the same as that of the St Michael (133 cm.), but it is a little wider than any of the other three panels (67 cm.) as a strip has been added to the left-hand side. This strip continues the balustrade which, owing to the spread of St Augustine's cope, is less in evidence than in the others of the series; and the pilaster is almost entirely a later addition. Since it is clearly of the same type as those in the *St Michael*, the restoration was probably executed before the panels were separated. The *St Augustine* is extremely dirty, but appears to be well preserved underneath. Those who remember the *St Michael* before 1920 will know what to expect if ever the

St Augustine is cleaned, although the latter seems to be in better condition.

That the Lisbon panel is part of the same series as the three other saints requires no proof: it remains to ask what this new discovery tells us about Piero. First, it confirms absolutely Mr Meiss's hypothesis that these pictures formed part of the S. Agostino altar-piece. Hitherto, this theory rested on only one piece of evidence, that the saint in the Poldi Pezzoli could probably be identified as St Nicholas of Tolentino; with the corollary that, as St Nicholas was an Augustinian saint, he and his companions must have been painted for S. Agostino. This is slight enough evidence (although no slighter than the flimsy foundations on which have rested half our histories of fifteenth-century art), but Mr Meiss's confidence in it has been justified. The *St Augustine* also supports nearly all that he says of the æsthetic scheme of the altar-piece – the firm outside buttress, contrasted with the cursive movement of the inner figures and the ascending diagonal relation of the hands. Most remarkable of all is the support which *St Augustine* gives to Mr Meiss's treatment of that important problem, Piero's relationship with Flemish painting, and in particular with Van Eyck. He points to the individualistic portraiture of the *St Nicholas* and compares it to Van Eyck's *Albergati*; and he parallels Piero's Brera altar-piece with Van Eyck's Van der Paele *Madonna*, pointing out that both take place in the apse of a church and both include a naturalistically painted, kneeling donor. These similarities alone are not entirely convincing: does not Masaccio's *Trinity* in Santa Maria Novella show the same setting of church and donor? But add to them a comparison between Piero's *St Augustine* and the Saint in the Van der Paele altar-piece, and Van Eyck's influence on Piero becomes very much more probable. The rich folds of St Augustine's cope, and his stole embroidered with scenes of the life of

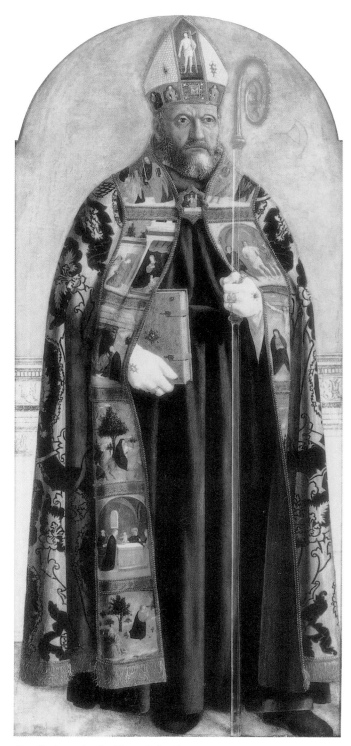

67. *St. Augustine*, by Piero della Francesca. 1460–70. Oil and tempera on panel, 133 by 56.5 cm. (Museu Nacional de Arte Antiga, Lisbon).

68. *St. Michael*, by Piero della Francesca. 1460–70. Oil and tempera on panel, 133 by 59.5 cm. (National Gallery, London).

69. *A Saint (St. John the Evangelist?)*, by Piero della Francesca. 1460–70. Oil and tempera on panel, 133 by 58.4 cm (The Frick Collection, New York).

70. *St. Nicholas of Tolentino*, by Piero della Francesca. 1460–70. Oil and tempera on panel, 136 by 59 cm. (Museo Poldi Pezzoli, Milan).

71. Detail of Fig. 67

72. Detail of Fig. 67

Christ are clearly inspired by some figure similar to the St Donatian. A pleasure in the texture of rich brocades does not, by itself, argue Eyckian inspiration, for it was common in the work of those painters influenced by the international gothic style, Gentile da Fabriano, Masolino and Domenico Veneziano, who were, from one point of view, the ancestors of Piero. But they used these brocades decoratively and, for the most part, as flat pattern, whereas in the *St Augustine* the folds are modelled in colour and achieve a degree of luminous plasticity hardly to be found in the tempera tinted vision of his Italian predecessors. For this reason the *St Augustine* is of all Piero's works that which most fore-shadows Bellini, for example, the Saints in the Frari Altar-piece, and so supports Longhi's thesis of Piero's influence in Venice.

So much in confirmation of Mr Meiss. The newly-discovered picture allows us to make a few further additions to our knowledge of Piero. In the first place, there is nothing else like it in Piero's surviving work. The type of the Frick Apostle can be paralleled in the Arezzo frescoes, and is remarkably close to that of the bearded apostle on the extreme right of the Brera altar-piece.

73. *The Annunciation*, by Piero della Francesca. c.1455. Fresco, 329 by 193 cm. (S. Francesco, Arezzo).

But the *St Augustine* displays a combination of intellect and will which is unusual. He is clearly a man of action, far more so than the *St Michael* or than the immobile warriors who appear in Piero's somnambulistic battles. That he felt this vigour and firmness to be the particular attribute of St Augustine is evident if we compare him to the two other mitred figures in Piero's work, the representations of *St Louis of Toulouse* in St Francesco and in the Museum of Borgo San Sepolcro.

But the great importance of the *St Augustine* is due to the small scenes from the New Testament which are depicted on his stole. How far the actual execution of these scenes is the work of an assistant will be discussed later, but assuming that they are studio work, they still give a valuable reflection of Piero's imagery. We can estimate their relationship to Piero's original compositions from two examples. The first is the *Annunciation* (Fig. 72) which is obviously derived from the fresco in the Church of S. Francesco, Arezzo (Fig. 73). The relationship of the figures to the architecture is exactly the same; but they are both in more conventional poses, the angel kneeling, the Virgin seated, and both have their arms folded across their breasts. The majestic aloofness

of Piero's standing figures has been sacrificed and would, in fact, have been inappropriate.

In the other example, the *Presentation in the Temple* (Fig. 75), Piero's original is lost, and we can only guess at it from a feeble school picture perhaps the work of Lorentino d'Arezzo, whose wretched frescoes in S. Francesco grow more and more incompetent as they become further removed from Piero's inspiration. This is the *Presentation in the Temple*, formerly in the Cook Collection (Fig. 74) which has always been recognised as a work of Piero's school. That it is probably a free copy of a lost Piero is suggested by the relics of grandeur in the design, by the beauty of the architecture and by certain reproducible details. This probability is now strengthened by the scene of the *Presentation* which appears on St Augustine's stole, and which clearly derives from the same design. We can see that rather the same process has taken place as in the *Annunciation*. The relation of figures to architecture and the main motive have been preserved, but the figures have become less impassive. The Virgin turns towards the Child, and does not preserve the aristocratic detachment which is discernible in the Cook replica. The

74. *The Presentation in the Temple*, school of Piero della Francesca. 180 by 135 cm. (Formerly Cook Collection).

75. Detail of Fig. 67

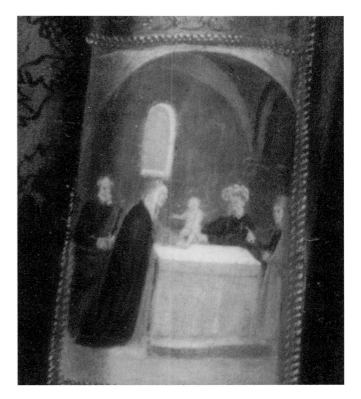

whole is conceived in a freer, more commonplace and more popular style.

Below the *Presentation* is an *Agony in the Garden* and, in the light of the foregoing similarities, we may see in it a simplified, popular version of one of Piero's most famous lost compositions, the *Agony in the Garden*, in S. Francesco of Sargiano, near Arezzo. But the other scenes on the stole cannot be associated with any lost originals. Two of these, the *Nativity* and *Flight into Egypt*, bear traces of Piero's style in the landscape and the tonality and may well derive from him. The *Flagellation* bears no relation to the picture at Urbino, although the Christ reminds us of Piero's *Baptism* in the National Gallery. The half covered *Crucifixion* is quite unlike Piero, as are the figures of Sts Peter, Paul and St John the Baptist. On the other hand, the risen Christ on St Augustine's mitre is worthy of Piero in tone and outline; and in fact the beautiful tone of the pearl-sewn ground must surely have engaged his personal attention.

Our survey of the scenes on the stole directs our attention to the unexplored subject of Piero's assistants. Piero's style is so entirely his own, and his mastery of it is so complete, that it is relatively easy to say when another hand has intervened; and from first to last he made full use of assistants. In his earliest work, the *Madonna of the Misericordia* at Borgo, where we may take as a standard of Piero's own work the *Madonna* herself, the *Crucifixion* and the damaged *Annunciation*, it is obvious that the predella and the small panels of saints are the work of another artist who has not even tried to assimilate Piero's style, though he has accepted some of his types. In the Arezzo frescoes, where many helpers were necessary, some of the minor episodes, such as the *Jew in the Well*, and figures such as the *St Louis*, are wooden and toneless in execution. In these cases the assistant was a local workman, and frescoes in other parts of S. Francesco show what such a workman could do without his master's guidance. No doubt there were also more skilful assistants, amongst them Bartolommeo della Gatta, whose two St Rochs in Arezzo suggest that in actual collaboration with Piero his hand would be almost impossible to detect. The Perugia altar-piece, mysterious and depressing from many points of view,

also shows evidence of shop-work in the lower part. The *Annunciation* above I believe to be largely the work of Signorelli.[1] It is here, rather than in the Christ Church and Villamarina *Madonnas*, that I would find evidence of his apprenticeship to Piero. Finally the Brera altar-piece has long been recognised as a studio work in which Piero has made use of at least two helpers.

It is therefore not surprising to find in the S. Agostino altar-piece evidence of very close collaboration between Piero and an assistant. We have a right to suppose that whereas Piero designed the figures and executed the heads, hands and chief passages of modelling, he left much of the ornament to his pupil: much, but not all, for the play of light on St Michael's shoulder plates or St Augustine's crozier seems to be beyond all but the finest powers of execution. The curious part is that this assistant is entirely different from the others, whose work has come down to us. He is not a mere duffer, like Lorentino; nor a faithful, but lifeless, disciple like the author of the Villamarina *Madonna*. Nor has he Bartolommeo della Gatta's precision of drawing. His rough, pictorial style suggests a different origin, and reminds us more of the paintings on majolica or cassoni, at a time when popular arts were often freer, and not more formalised, than the art of serious occasions.

It now remains to find the *Virgin Enthroned* which formed the centre of the altar-piece. She will not be hard to identify. As is well known, the step of her throne impinges on to the panels of the Frick Saint and the National Gallery *St Michael*, where it has been painted over. We can therefore guess that the marble balustrade which runs through the four lateral panels will be continued in the centre, and will form the basis of one of those magnificent architectural inventions which are such an important part of Piero's genius. We may imagine a throne more austere than that of the Perugia *Madonna*, perhaps such a one as inspired Bellini's *Coronation of the Virgin* at Pesaro. The Madonna herself, if she excels her surrounding saints as much as is usual in Piero's compositions, will be one of his greatest creations.

1948

A. D. B. SYLVESTER

The evolution of Henry Moore's sculpture: I

The creative process is like the Wimshurst machine. The artist's mind corresponds to the power that turns the wheel, the work of art to the spark flashing across the space between the two electrodes, the electrodes to the two poles in the physical world from which art springs – nature and the unshaped artistic material.

The artist's education consists in preparing those electrodes for work, that is to say, in finding out about appearances and in discovering the possibilities and limitations of his medium. Henry Moore separated these two domains of study. He learnt about his material without making any considerable effort to come to grips with nature, basing his early stone-carving on Precolumbian, and his early wood-carving on African, sculpture seen in the British Museum. Meanwhile he studied nature independently of the complications of carving by drawing and modelling the human figure from life, in an idiom influenced by the frescoes of S. Maria del Carmine – which he visited in 1925 at the age of twenty-seven – that adhered to natural proportions, somewhat thickened out to emphasise mass and eschew Praxitelean prettiness. (The separation was not, of course, complete, because while he was learning about nature he was also learning how to use clay and how to express the knowledge of three-dimensional form on a two-dimensional plane.)

Moore's use, at this stage, of two widely divergent approaches was clearly not the consequence of vacillation, of casting around for a style, because the variation of style always corresponded to the variation of medium, except in the case of one or two stone-carvings in a manner usually associated with his modelling. Nothing, indeed, could have indicated a greater decision and self-awareness. He had decided what artistic traditions of the past had most fully realised the potentialities of wood and stone and, in seeking what he has

called 'truth to material', was using their methods and discoveries in order to assimilate the methods and remake the discoveries for himself. As to nature, it had to be approached with less stylistic prejudice, and was most directly approachable through such highly flexible media as modelling and drawing. The rapidity with which they are executed permits working directly from the model, whereas carving does not. Modelling, moreover, could help him to grasp the tactile as well as the visual plasticity of forms because he could reconstruct them within his hands and thus attain a profounder sense of their volume.

Nevertheless, behind Moore's use of two different approaches there lay something more than recognition of the need for a dichotomous education. Common to all the naturalistic works was a mood of gentle contemplation, while more passionate feelings invariably found expression in the anti-naturalistic carvings. Even in his mature work, Moore tends to adhere more closely to nature when the content of a sculpture is tranquil than when it is more highly charged with drama. Never, indeed, has the duality been more apparent than in the two big reclining figures carved concurrently in 1945–46 – the elm *Reclining figure* and the stone *Dartington memorial figure*. Explanation of this will be possible at a later stage in this essay.

Moore's first effort to synthesise his naturalistic and Precolumbian styles was made in the relief *North wind*, of 1928, on the Underground Building, St James's,[1] a somewhat unhappy work which does not seem to have been conceived as a relief. The movement and solidity to which it tries to give conjoint expression are both present, but side by side, as it were. The attempt at a synthesis fails because the resultant style is neither Mexican nor naturalistic, but a rather commonplace Shell-Mexican geometrified realism. In spite of these shortcomings, it is alone

76. *Figure in Concrete*, by Henry Moore. 1929. ht 40.6 cm. (British Council).

among the Underground Building reliefs in exhibiting real sculptural power.

The sculptor can fulfil the three-dimensionality of a block of stone in two ways: either by emphasising its weight by means of broad masses, or by emphasising its depth by hollowing it or boring holes clean through it, and so letting in light. The latter method was first used to any extent by Moore in the *Reclining figure* in alabaster of 1929.[2] While a mercurial rhythm moulds the masses into repeated motifs, so that bent knee and upstanding shoulder echo each other to become mountains while the head and each breast assume the shape of a pear, between torso and akimbo arms is hollowed a space into which the breasts project to establish *internal* relations of mass.

In the dynamism of its linear rhythm and in its method of expressing three-dimensionality, this *Reclining figure* is not typical of the 1929 carvings. A work that is typical is the *Figure with clasped hands* in Travertine marble.[3] Here the shapes are more box-like and Mexican, and it is from this box-ness that its three-dimensionality

is derived. Every view expresses a different feeling, ranging from the stolid to the quick. The deeply moving plasticity of the head is tense to breaking point as the protruding stylisation of gathered hair at the back struggles to wrench round and touch the face. In *Figure in concrete* (Fig. 76),[4] fully three-dimensional form is achieved by emphasis on both weight (in the breasts and the head and hands built up in planes) and depth (in the carved-out belly). The realisation of both weight and depth reaches a monumental level in *Reclining figure in brown Hornton stone*,[5] the most ambitious carving of this fertile year and prototype of many later reclining figures. A quietly disturbing massiveness is the effect of its construction in a minimum of surfaces, of the squat dignity of the pose and, above all, of the narrow but deep, mysterious space between the huge, slightly parted, thighs.

It was in 1930 that the separate existence of two styles made way for a synthesis between the Precolumbian idiom and the less angular forms derived directly from nature. One imagines that Moore, now confident of his capacity to give solidity to form, no longer felt obliged to confine himself in carvings to those squat and squarish ones which attain this solidity by the easiest possible means. Modelling ceased and the carving absorbed the residue of its content, becoming more refined, more Italianate, more humanist – capable of achieving both the classical purity of the *Figure* in Armenian marble[6] and the baroque vitality of the *Reclining Woman* in carved reinforced concrete.[7] Humanism took him to the expression of character – a unique accomplishment among modern sculptors of comparable formal astringency. The reticence of expression which follows from that astringency is all the more telling than the over-emphasis of a Rodin: it implies passion never melodramatic, tenderness never cloying, sexuality never lascivious.

In all, Moore's second period (1930–32) can be epitomised as 'humanist'. Although the treatment is by no means as naturalistic as in the early terra-cotta and concrete sculptures, the human head and figure are simplified and modified rather than distorted. The feelings expressed, though not their expression, are essentially commonplace: the mother tenderly suckling her child[8] or fearfully protecting it from a menacing external world,[9] or holding it up as an offering to the sun (Fig. 77);[10] or, again, the freshness and virginal simplicity of a series of sculptures called *Girl*.[11]

Overtones of pantheistic mystery and an underlying rhythm of primeval power, present in the first period

but absent from the second, later became the predominant feeling-tone of the third. The last works of the second period formed a *cul-de-sac* at the end of a road from which the origin of the next line of development had already branched off in sculptures, untypical at the time, which departed radically from the proportions of nature. As early as 1930, Moore had made such a departure in the Cumberland alabaster *Figure*[12] and Corsehill stone *Reclining figure*.[13] But in these cases it was perhaps primarily with the intention of exploring new formal relations prior to incorporating them into humanist sculptures, namely the *Mother and child*[14] in Cumberland alabaster (1931) and *Reclining woman*[15] in green Hornton stone (1930). (The practice of exploring a sculptural idea first in the abstract and subsequently in a more human form has been recurrent throughout Moore's evolution.) On the other hand, a *Reclining figure* of 1930 in Ancaster stone,[16] in the same style as the *Figure* and *Reclining figure* just mentioned, did not proceed, as they did, back to the human figure, but to a still more radical departure from it in the octopoid *Composition* in Cumberland alabaster (1931),[17] with which a single contemporaneous work, the lead *Reclining figure*,[18] bears stylistic affinities. These two sculptures were the most crucial turning-point in Moore's development, and both were seeds of much that was later evolved: *Composition* of all his third period, *Reclining figure* of the lead sculptures of 1938–40 and the stringed figures of 1937–40. 1931, then, was the point at which the new road branched away,[19] although for another year Moore carried the old one to its conclusion. Finally, towards the end of 1932, he turned entirely to his new preoccupations and, for some years, never sculpted the human figure as such, except in. the carved reinforced concrete *Reclining figure* of 1933,[20] whose stylistic kinship, however, is with the lead *Reclining figure* of 1931, in which year the well-known study for it was drawn.

The works of the third period are fantasias composed of forms each of which represents or evokes various species of objects in some respect similar in shape. These objects are bones, shells, pebbles, rocks and caves, birds and fishes, and, above all, isolated organs or fragments of the human body. A number of different kinds of object are evoked by each shape in these fantasias because the sculptural shape is the highest common factor of the shapes of the objects it evokes. Hence, the sculptural forms are, so to speak, elemental, because they are common to objects of widely varied materials and sizes – raised knee and mountain; breast and fruit; vagina and cave – or else the analogy is

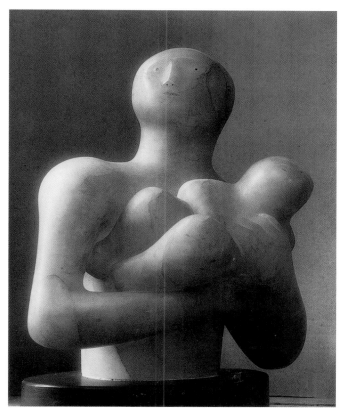

77. *Mother and child*, by Henry Moore. 1930. Alabaster, ht 25.4 cm. (current whereabouts unknown, formerly Herbert Marks collection).

merely between two or more different parts of the body: navel, nipple and eye. The elemental shapes are combined in the whole sculpture as if the human body had been dismantled and reassembled with the fragments in a new configuration capable of expressing a specific feeling or *conatus* better than it could be expressed by the mere modification of nature's configuration. At the same time, the constituent forms representing the rearranged fragments also evoke extra-human objects. Since they are *multi-evocative* in their reference to nature, these forms carry a rich variety of association, brought from the entire range of the species they evoke, and their emotive value is therefore complex, because of this richness, and mysterious, because they reveal analogies of structure between objects which superficially do not resemble one another, and also because their configuration in the whole fantasia shows how shapes unconnected in nature can be grafted together. Finally, an especial value appertains to those forms which evoke an object in stone and a part of the body because, when nature forms in the material

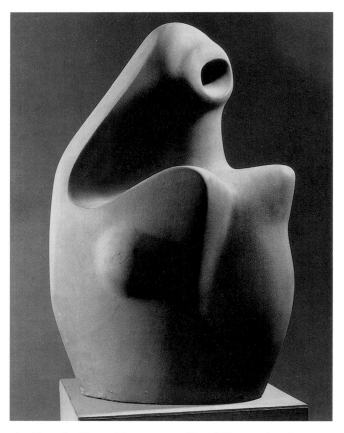

78. *Figure*, by Henry Moore. 1933. Corsehill stone, ht 76.2 cm. (Henry Moore Foundation).

used by the sculptor a shape that already resembles a part of the human body, such a shape is clearly the perfect model for the sculptor who wants to form that part of the body with a respect for the potentialities of his material.

The potentialities of his material, the fact that he was a sculptor and not a poet, were never forgotten by Moore, in whose abstract surrealism the surrealism never became literary, and the abstraction never empty. The juxtapositions of forms unconnected in nature, which arose in the fantastic configuration of the constituent parts, were never visually arbitrary because their *raison d'être* was always primarily plastic, not symbolic. Every new configuration was justified plastically by its capacity to give sculptural coherence to a block of stone.

Seldom has Moore created an image so mysterious and so rich in association as the Corsehill stone *Figure* of 1933 (Fig. 78).[21] The sinister orifice is the entrance to a cave, a navel, a sexual image, all-seeing eye and all-devouring mouth. The curved back is uterus and egg, symbols of fertility and eternity. The protrusions at the

front are breasts and wings. The sum of the parts is not human at all, but a boulder washed by the sea, a dinosaurian creature and a monstrous inhabitant of the moon. Inverted, however, it becomes a female torso, with unambiguous abdomen and breasts.

In a similar work carved the same year, the Travertine marble *Figure*,[22] Moore carried to its logical conclusion the method of asserting the third dimension through the emphasis of depth by carving clean through the block. 'Sculpture in air is possible, where the stone contains only the hole, which is the intended and considered form.'[23] Simultaneously almost, he found in the multiple-figure composition[24] another means of introducing space into the sculpture. The following year he began to subject the surface of the carving to a graphic treatment. This reached its climax in the green Hornton *Square form* of 1936[25] and thereafter diminished.

We need not labour to expound the value of such graphism when its function is purely abstract. But, where Moore has used it to indicate facial features, the effect is often disconcerting, for it tends less to give the head a greater expressiveness than to detract from its nobility by oversimplifying what is better wholly omitted. How much more expressive, how much richer in its evocation of facial forms, is the mere inflexion of a plane in the face of the left-hand figure of the *Three standing figures* – an inflexion which implies the jutting-out of both nose and chin. Again, the features are suggested in certain other works by a hole or a slot – so evocatively that a specific feeling is thereby communicated in spite of the rigid economy of means. We are led to infer that even the simplest plastic treatment of the facial features produces, with Moore, a more powerful expression of them than does a graphic treatment, although the latter is usually more representational.

Between 1934 and 1937, the fragments of the human figure became gradually less conspicuous in Moore's vocabulary of forms, which remained, nevertheless, far more dependent on nature than on geometry. The main sources of his sculpture in stone became – with exquisite logic – rocks, pebbles, shells and bones. At the time of the Corsehill *Figure* of 1933, the primary evocations had been human and the secondary ones inhuman. These roles were gradually reversed, the change reaching its consummation in the 1937 Hopton-wood stone *Sculpture*[26] and bird's eye marble *Sculpture*,[27] but even here the latent presence of human forms is indicated by the natural growth of the latter work into the *Recumbent Figure* of 1938[28] in green Hornton stone, and

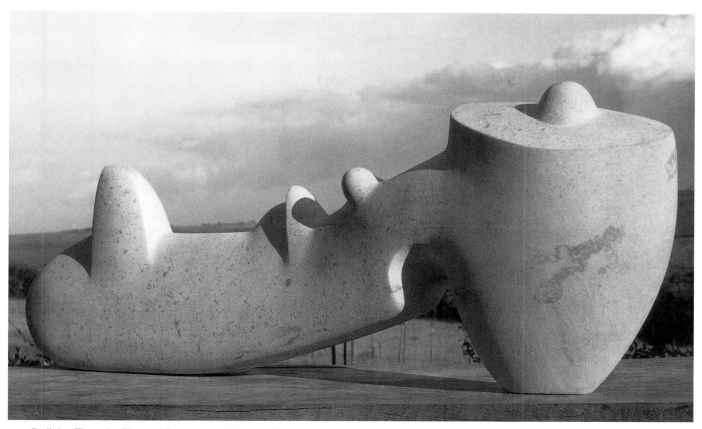

79. *Reclining Figure*, by Henry Moore. 1937. Hopton-Wood stone, length 83.8 cm. (Fogg Art Museum, Harvard University Art Museums, Cambridge, MA, gift of Lois Orswell, Narragansett).

by the creation, in 1936, of two elm sculptures[29] which fully anticipated this *Recumbent figure*. Moreover, the astonishing *Reclining figure* of 1937 in Hopton-wood stone (Fig. 79)[30] evokes not only a reclining human figure whose face stares at the sun, but – of all things! – a reclining human profile and a shoe. Apart from these considerations, even the works most dehumanised in form – e.g., *Two forms*[31] and the two *Square forms* of 1936[32] and the two *Sculptures* of 1937 – were not dehumanised in content. Shapes drawn from the inanimate world served to express human emotions by means of plastic analogies with psychological processes and constellations. In 1937, Moore wrote: 'My sculpture is becoming less representational, less an outward visual copy, and so what some people would call more abstract; but only because I believe that in this way I can present the human psychological content of my work with the greatest directness and intensity.'[33] The diminishing evidence of human shapes was neither intended to make, nor succeeded in making, his work any less a communication of human emotions. There *was* a fundamental change taking place at this time,

however, namely, in the precise method of communication, whether the shapes were human or inanimate. The multi-evocative method of communication, with its dependence on the recognition of associations, while by no means eliminated, ceased to be predominant. It became an adjunct to a more direct method, only secondarily dependent upon the interpretation of signs, i.e., evocation of objects, and not at all dependent upon symbolism, i.e., designation, in accordance with some convention, by an object or an idea. With the later works of the third period and their successors, the spectator's apprehension of the content derives mainly from his intuitive apprehension of an analogy between a shape and a mental event, the efficacy of which analogy depends on unconscious and preconscious awareness of past associations, but not on a conscious (verbal) remembering and recognition of them. Thus he is immediately aware, for example, in regarding a form most of whose weight is near the top, that the form has an upward action and expresses the emotional implications of such an action because the connection between such a form and such an action and such an emotion is

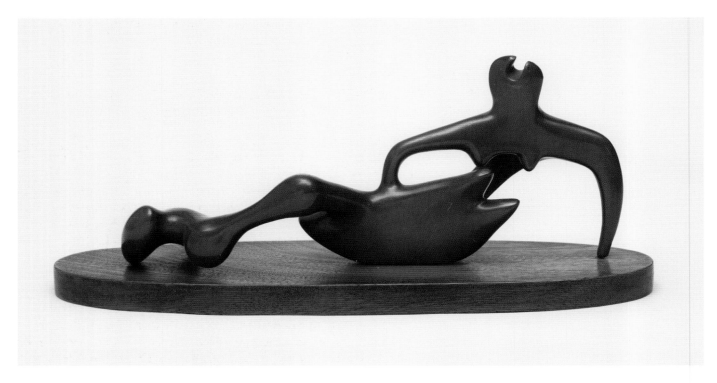

80. *Reclining Figure*, by Henry Moore. 1938. Lead, ht 35.6 cm. (Museum of Modern Art, New York).

firmly established in the memory (in this case preconscious rather than unconscious), since that connection has long been a habitual perception.

The close inter-relation of human, monstrous and inanimate forms in the third period gives rise to a pantheism in which a single life force is imposed on all the divers contents of the physical world. From its connection with the inanimate, the human form acquires endurance and eternity. From its connection with the human, the inanimate form acquires the animistic vitality of the totem. A sense of mystery follows from the supposition of unity between unlike things, from the protean character of a sculpture that can appear, at one moment, to be a fragment of the human form, and, at the next, a fragment of inanimate nature. The protean, metamorphic, forms, with their multiple evocations, here placate us by revealing that functionally similar objects are also physically similar – e.g., breast and fruit – there startle us by revealing that functionally different objects are physically similar, e.g., nipple and eye. We are led back to a primeval world in which the differences between classes of objects, highly evolved into particularity, are reduced into the primal substance of stone. This primeval world consists of forms which might have existed on some vast seashore before the coming of man. (There is some affinity with Tanguy, whose paintings, however, seem rather to be a *recollection* of such a world, whereas Moore creates that world in its reality – in his drawings no less than in his sculpture, so that this difference from Tanguy is not the product merely of difference of medium.) Some of these primordial forms are huge boulders. Others – though carved at an earlier date – have been evolved from those boulders into living things, dinosaurian monsters. But man is everywhere implied, and it was now Moore's task to evolve man from these primeval entities.

The process of evolution from the primeval to the human was rendered visible in a lead *Reclining figure* of 1938 (Fig. 80)[34] in which the upper half of the body grows from the form of a bone. The forearm is stretched and tapered to press upon the earth, while its inner edge forms one side of a nearly semicircular arch, twice hinting at angularity, which springs tensely upwards with the stress of Gothic vaulting.

In the humanist sculptures of the second period, Moore's representation of the human figure had not departed radically from the proportions and external

contours of the body. The *proportions* characteristic of the fourth period reverted to those of the human figure – away from the freely invented proportions of the third period – but the constituent forms were evolved less from those of the body than from the bone and pebble forms of the later third period. Moore was now more than ever preoccupied with the hole and with concave shapes in general. Since the external contours of the human figure are predominantly convex, emphasis on the concave implied seeking inspiration elsewhere: in the shapes of bones – often concave in one dimension, convex in another – such as the knuckle and the femur, in the internal shapes of shells, and in such architectural forms as the arch.

A convex surface encloses the sculptural mass, which withholds its energy from the space surrounding it, so that a sculpture composed mainly of convexes has a quality of repose. A concave surface lets space into the mass. Where the concave is a hollow between convex bulges, the space appears to push against the bulges so that they acquire an explosive vitality. Where the con-

cave is the internal wall of a hole piercing a convex mass, the space within the hole seems to push the pierced mass centrifugally outwards. A combination of convex and concave – whether the concave is hollow or hole – produces a conflict at the surface of the convexes between the force pushing outwards and the contour essaying to confine it. This tension between explosion and repose, producing an effect of held-in energy – 'an immense, pent-up energy', to quote Moore – is one of the factors that contribute to monumentality, because monumentality is not merely massiveness but an impression that the form contains tremendous energy, yet is strong enough and big enough to withhold that energy and prevent its escape. Hence, while monumentality can appertain to sculptures primarily dynamic or primarily static, it is necessarily excluded from a work which is the extreme expression of either quality.

Where convexes predominate, sculpture tends to be tranquil; where concaves predominate, to be vital. It is now clear why Moore's more tranquil representations of the human figure adhere more closely to its natural

81. *Reclining Figure*, by Henry Moore, 1939. Elm Wood, length 205.7 cm. Detroit Institute of Arts, Detroit, formerly Elizabeth Onslow-Ford Collection).

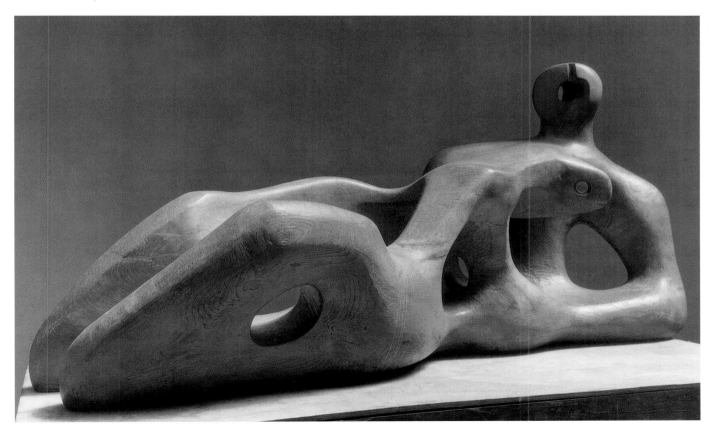

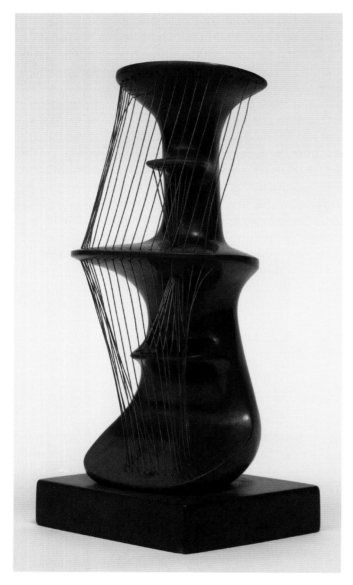

82. *The Bride*, by Henry Moore. 1940. Lead and wire, ht 30.5 cm. (Museum of Modern Art, New York).

Thus the beginning of the fourth period saw not only the evolution of man from the primeval forms of the fantasias, but the start of an extensive use of concave shapes, in Moore's phrase, 'opening-out the forms'. Between the advent of this period in the wood-sculpture and in the stone-sculpture, there was a gap of two years. In wood, it began as early as 1936, with the elm *Reclining figure* and *Figure*; in stone, with the green Hornton *Recumbent figure* of 1938 which, though akin in dimensions to the elm *Reclining figure* of 1939, is closer in shape to the *Figure* of 1936. Moore had long since ceased to sculpt in concrete, but 1938 saw his return to the use of lead – in a style related to that of the stone *Recumbent figure*. Thus, it can be said that the fourth period got under way in 1938, for the two elm carvings of 1936 were his only antecedent works in the style of the fourth period, since his stone-carvings right up to the end of 1937 retained that of the third. The reason for this time-lag was stated in a recent letter from Moore: 'The explanation why the 1936 elm figures are unlike any of the stonework of the same date lies, I think, in their material. I have always known and mentioned how much easier it is to open out wood forms than stone forms, so it was quite natural that the spatial opening-out idea of the reclining figure theme first appeared in wood, and it wasn't until two years later that my freedom with stone had got far enough to open it out to that extent without the stone losing its structural strength.' The stone sculpture of the third period had, indeed, evolved towards this opening-out, by means of a gradually increasing use of concave contours and holes. This was certainly one of the factors conducive to its dehumanisation, since natural precedent for the concave and the hole had to be sought elsewhere than in the human body.

That Moore did not hasten prematurely to open out stone forms indicates the respect he pays to the properties of the medium. Even when he did open them out, he did so less emphatically than in his treatment of wood and metal, and it is certain that his partiality to the concave will never be so fully expressed in stone as in these other materials. For stone in itself appears cold, strong and unyielding, and invites carving in those big convex masses which express repose. In contrast, wood of itself appears warmer and more flexible, and these qualities are best realised by carving holes, hollows and other concave shapes which give vitality to the mass. Again, lead has a mechanistic sleekness, and Moore has exploited this in sculptures possessing so much open space, and so little solid mass, that they are skeletons rather than

appearance than do his more vital representations, for, as I have just pointed out, most of the external contours of the human figure are convex, so that a statically-inclined representation of the human figure need only modify nature, whereas a dynamically-inclined representation, which has to emphasise the concave to become dynamic, must depart more radically from the human figure, not only hollowing out the mass, but carving large holes right through it, as in the big stone *Recumbent figure* of 1938 and elm *Reclining figure* of 1939 (Fig. 81),[35] so that space can circulate more freely.

bodies, scaffoldings rather than buildings. Hence, the eye pursues at speed their rhythms and their hard contrasts of light and shadow. Such a treatment makes the best, moreover, of their necessarily small scale, since the extremely dynamic character it gives them preserves them from a monumentality which would make them seem bigger than their dimensions, and cause them to seek the open air, like the stone and wood work, instead of resting at ease indoors. Bronze – in which the most recent metal sculptures have been cast – has not the same sleekness as lead, because of its patina. A surface green and matt, and not black and shining, is respected by a style which tends no less than that of the lead sculptures to perforate the mass with holes, but goes less far towards the condition of scaffolding by leaving unscathed somewhat broader areas of metal.

The opening-out of the mass is the constant factor in all the sculpture of the fourth period. The return to the human figure is not, because humanity was not the only species evolved from the forms of the third period. The second species was the stringed figure, whose seven manifestations in lead and wire, and six in wood and string, were constructed in the years 1937–40 (Fig. 82).[36] Their initial stimuli were presumably the parallel struts spanning a space in the lead *Reclining figure* of 1931, the carved reinforced concrete *Reclining figure* of 1933, and a non-extant stone *Carving* of 1934.[37] The struts recurred after the invention of the stringed figure in a lead *Reclining figure* of 1939,[38] as well as in various drawings of projects for sculpture which were never realised.

In the stringed figures, the struts are thinned out into lengths of string or wire, and multiplied into sets of numerous parallel or radiating lengths. These lengths traverse the hollow contained by a concave form; sometimes two sets traverse the same hollow in such a way that one set is seen through the other. The tautness of the string is opposed to the rounded contour of the mass. The fact that space is contained within the hollow is emphasised by the presence of the string within that space. The tenseness of the string inevitably causes the eye to move along its length, so that direction is given to the space it traverses. When one set of bars is seen through another, the conflict of directions makes the space within the hollow circulate. 'Sculpture in air'[39] becomes a reality because the hollow is no longer open and limitless, but is given shape on its open side: the space remains visible but its limits are now defined on all sides; it is a form in air.

A further means of opening out the form was discovered in the combination of internal and external forms. Moore explored the possibilities of the idea only once at this period – in the lead *Helmet* of 1940.[40] I understand that he intends to take it further in the immediate future.

Among the many works of 1938–40, two stand out as the finest produced by Moore before the war: the *Recumbent figure* of 1938 in green Hornton stone, and the *Reclining figure* of 1939 in elm wood. The vibrant elm carving, like its predecessors of 1936, has an essentially feminine character. The trunk, tunnelled all its length along, and corkscrewed within like the barrel of a gun, is no mere sexual *symbol* – for any such tunnel, though shaped with none of the subtlety and power of this, could be thus interpreted – but in every nuance a *rhythmic expression* of female sexuality. It is, moreover, cathedral and cave-like in its mysterious depth and yet again more than this, for we need impose no arbitrary associational limit on the life embraced by its mercurial sensual rhythms, its stress of mass against mass, its grandeur and weight, its play of light that now illumines, now gives way to shadow, now reappears, as the holes in the flanks and the dense masses between them serve as windows and wall. Beside its slender neck and supple grace, the powerful neck and shoulders and aloof head of its complement in stone, the green Hornton *Recumbent figure*, are distinctly male. But here sexuality is a minor factor, irrelevant and, so to speak, unremembered by the figure itself, a figure that has transcended the dynamic to settle into an eternal stillness and silence. It would not be absurd to call it 'older than the rocks'.

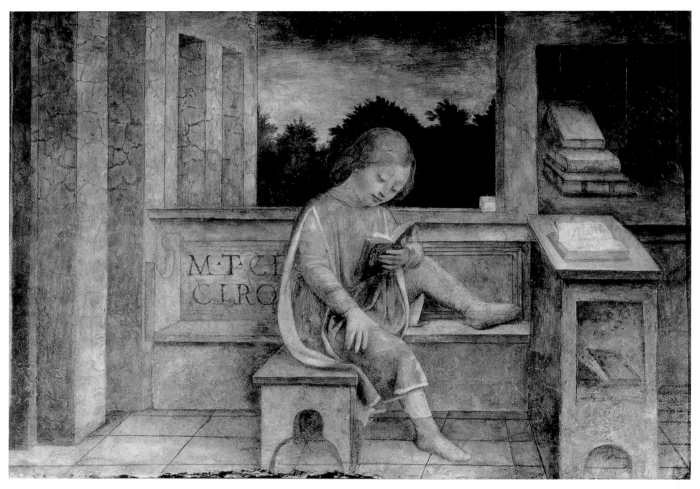

83. *The young Cicero reading*, by Vincenzo Foppa. c.1464. Fresco from the Palazzo Mediceo in Milan, 96 by 132 cm. (Wallace Collection, London).

85. *Pastorale*, by Gerrit van Honthorst. Signed and dated 1627. 109 by 100 cm. (Seattle Art Museum, Gift of the Samuel H. Kress Foundation, formerly Col. Waugh Collection).

84. Detail from *Joseph and his Brethren*, circle of Joachim van Wtewael. 134.6 by 205.7 cm. (Centraal Museum, Utrecht).

inclusion of a Bor of 1641 (20), for a Bronkhorst (24) of about the same time, for the Van Galen *Justice of Count William the Good*[8] of 1657 (35) or even for the Edinburgh Vermeer (92) of a few years before – and yet these pictures seemed entirely relevant, and attracted as much attention as any.

Various artists were present who belong in spirit to an earlier generation than the so-called Caravaggesques. Jan Woutersz Stap harks back to the world of Quentin Matsys. His *Heraclitus and Democritus* (63) was sensibly hung beside a Bylert (30) of the same subject. It was only unfortunate that the two Terbrugghens of 1628 in the Rijksmuseum, representing these two philosophers, could not have joined them. Vermeer's *Astronomer* of 1668 with his hand resting on the celestial globe, is the transposition of this theme into contemporary terms. The charming 'Monogrammist ISH' has clearly felt the impact of Baburen and Terbrugghen in his *Death of Ananias* (56) of 1624, but has been unable to digest them: he strings out his background figures like Scorel portrait-groups. Wtewael was represented by a masterpiece, *Joseph and his Brethren* (94), a surprising detail of which is here reproduced (Fig. 84), and by a much-rubbed version of his *Adoration of the Shepherds* of 1598 (93) which distantly echoes Jacopo Bassano and the Parmese. A signed replica of the latter is in my own collection. Abraham Bloemaert was shown as an elderly man falling temporarily a victim to Honthorst: with his *Flute-Player*[9] of 1621 (14) and a *Christ at Emmaus* of a year or two later (15). Although the figures are animated by Honthorst's dramatic lighting, the yellows and reds of their clothes still belong to the world of Mannerism. In fact, a few years later Bloemaert entirely renounces what he picked up from Honthorst, in his *Theagenes and Chariclea* of 1626 (16), to revert to a Mannerist-classicist style.

my chief criticism would be that certain artists were badly represented, or not at all. One disappointment was the neglect of the young Orazio Gentileschi, who forms a bridge between the monumental Southerners and the domestic Dutch, and of Saraceni who is important for Terbrugghen as well as for Pynas and Lastman. The authorship of certain pictures which hover between the North and the South, like the Corsham *Tobias*, which I have now no doubt is Dutch, and the small Berlin *St Christopher* (*Mostra del Caravaggio*, no. 105), might have been settled if permitted to appear in this company. It would have been instructive to have hung Caesar van Everdingen alongside Bor and Bronkhorst, and Jacob van Oost[6] and the still puzzling Finson alongside Seghers and Rombouts. Couwenbergh[7] could perhaps have been more impressively presented. A more suitable example of Rubens could surely have been procured than the *Christ at Emmaus* (112) from St Eustache in Paris, which cannot be an original. Wouter Crabeth II was represented by a derivation from the mature Honthorst (34) instead of by some Caravaggesque work such as the Rijksmuseum *Incredulity of St Thomas*. If it is objected that works by some of these artists lie outside the period chosen by the exhibition committee, then there is no justification either for the

Caravaggio himself was admirably shown with five[10] pictures from every period of his short, breathless career. Particularly instructive were the Uffizi *Sacrifice of Isaac* (2) hung in a much better light than last year at Milan, revealing further details of the 'North Italian' landscape, and the radiographs of the lateral canvases in S. Luigi, taken by the Istituto Centrale del Restauro, which demonstrate that Caravaggio changed his mind on more than one occasion about their compositions. These photographs, of the highest importance for the study of his early maturity, are still unpublished.

In the following room were grouped five Baburens, along with copies after him.[11] The earliest, dating from about 1618 before his return from Italy, closest in spirit

BENEDICT NICOLSON

Caravaggio and the Netherlands

The exhibition 'Caravaggio and the Netherlands' closed at the Centraal Museum at Utrecht on 3rd August and reopened a week later at the Musée Royal des Beaux-Arts, Antwerp, where it will continue until 28th September.[1] Rooms at Utrecht were set aside for precursors of Northern *tenebroso* painting, and for Flemings who felt for a time the impact of Caravaggio. But the core of the exhibition consisted of Dutch pictures of around 1615–30, which were grouped together in order to demonstrate how the Caravaggesque movement was kept going in the North, and how this tradition was transmitted in its new guise to the genre painters of Delft after the middle of the seventeenth century. This at any rate is what one assumes was the lesson to be carried away from the exhibition, judging by the august presence, at one end of Caravaggio himself, at the other of the young Vermeer. This is not the occasion to discuss at length the extent to which such a point of view is justified: it would involve too long a digression on too intricate a subject. I shall therefore confine myself to a few observations.

It is mistaken to suppose that every candle masked by a hand or a black back, every pencil of light creeping up a sleeve, must necessarily be due to Caravaggio's influence. The night scenes of Savoldo[2] and the Bassanos, and a Northern tradition of dramatic lighting effects going right back to Geertgen, were in a number of cases responsible for such features. The Mannerist Arnout Mytens, for example, who is sensibly represented in the exhibition by a copy on copper[3] of his Stockholm *Christ crowned with Thorns* (107) of just before 1600, and Otto Venius, whose night pieces of before 1613 might well have found a place alongside Honthorst and Bloemaert of the early 1620s, could have arrived at their 'Caravaggesque' solutions without ever having known of Caravaggio's existence.[4] Even the members of the *Schildersbent*, in touch with the

Caravaggesque movement when in Rome, drastically modified their styles on their return to the North. Baburen would I feel have developed along quite different lines, had he lived longer. Terbrugghen, who managed to hold his own in the exhibition with Caravaggio and Vermeer on either side of him, can only be described as Caravaggesque at several removes, in spite of his subject-matter. We should not allow ourselves to be beguiled into regarding him as a strict follower of the master on the evidence of a *Calling of St Matthew*, a lute-player or a *Musica di alcuni giovani*. Doubtless he had known Caravaggios in S. Luigi and in various private collections during his ten years' residence in Rome, and had been in touch with Saraceni and Gentileschi; doubtless his works before 1619 were conscientious essays in the latest Caravaggesque manner. But when we study his mature work, we find him making discoveries unheard of in the South – in technique, in his tender employment of light and colour, in the atmosphere of sad gaiety that he evokes. Perhaps a better case could be made out for the survival of Caravaggio in Honthorst and the Flemings, and the best case of all for Rembrandt, though one could not infer this from the two pictures catalogued under his name (nos. 59 and 60). But in what sense can Bor, Hals, Bronkhorst or De Grebber[5] (all represented in the exhibition) be said to participate in the movement?

I do not wish to imply that these are reasons for not holding an exhibition of this nature. On the contrary, the Utrecht show had a kind of unity of its own and made sense as a whole. But the impression of homogeneity was conveyed precisely because the artists were Netherlanders, asserting their Northern independence of spirit, expressing a new, Northern love of material things and everyday life – not because they were Caravaggesques.

Far from complaining of the scope of the exhibition,

1950

E.K. WATERHOUSE

The fresco by Foppa in the Wallace Collection

Among the less expected treasures of the Wallace Collection is the enchanting fresco of a young boy, who sits and reads a book on a kind of terrace-study which looks out on to a park. The parapet against which he sits is inscribed: M.T. CE/CIRO. (*sic*) and the latest book on Foppa by Dr Wittgens[1] calls it *Boy reading Cicero*. It is the sole fragment known to survive, not only of the decorative painting of the Palazzo Mediceo in Milan, but of Foppa's secular painting (Fig. 83).

The Hertford House Catalogue gives, with its usual admirable fullness, the evidence that it came from the Palazzo Mediceo and the various titles that have been given to it from time to time. Although it admits that it is 'most probably emblematic of education or eloquence' – since Filarete,[2] in the early 1460s, says of the part of the building from which it came: '*Nel parapetto dinanzi vogliono dipingniere le virtù cardinali*' – it still clings to the idea that the child may be one of the Sforzas reading Cicero. The usual suggestion is Gian Galeazzo, which would not only make it much later than the 1460s (which is the probable date on stylistic ground), but has the disadvantage that we know Gian Galeazzo to have been deliberately brought up to be more or less lacking in culture!

As a matter of fact there can be very little doubt who the boy is meant to represent. It is surely the young Cicero – a suggestion so obvious that it seems never to have been made! For the inscription on the seat must surely refer to the figure and cannot conceivably be meant to refer to the book he is reading. At the beginning of Plutarch's *Life of Cicero* we read, in Langhorne's translation: 'When he was of a proper age to go to school, his genius broke out with so much lustre, and he gained so distinguished a reputation among the boys, that the fathers of some of them repaired to the schools to see Cicero, and have specimens of his capacity for literature.' I would suggest that Foppa's fresco is intended to represent the young Cicero as the model of schoolboy industry, sitting on the bench inscribed with his name.

It is true that the figure (if Cicero) cannot be meant for one of the Cardinal Virtues, but it would be reasonable to suppose that these were accompanied by companion figures of the Seven Liberal Arts (as in such companion *Cassoni* as Schubring Nos 274/5 and 339/40). On these Cassoni an adult Cicero accompanies Rhetoric, but his appearance in Renaissance painting is so infrequent that an established iconography for him is lacking.

86. *Executioner with the Baptist's Head*, by Matthias Stomer. Before 1640. 109.2 by 155.6 cm. (National Gallery, London, collection of Sir Denis Mahon).

to Caravaggio, was the *Christ washing the Disciples' feet* (10a) once in the Giustiniani Collection and now at Wiesbaden. Following on this were two paintings of 1622: the Oslo *Christ among the Doctors* (8), exceptionally vigorous even for Baburen, and the Boston *Procuress* (9). The first has that strange pattern of hands, which originated with Caravaggio, was carried on most poetically by Terbrugghen, and became a popular feature of the Utrecht School: a curve of gnarled fingers confronting a pair of smooth, childish hands, a pattern which repeats the petulant grimaces threatening a bewildered boy's face. Hands are as eloquent in Utrecht painting as faces. It may be worth recalling in this connection that Caravaggio's *Madonna del Rosario*, with its striking pattern of hands, was at Antwerp soon after 1617, when the Netherlanders were on their way back to the North.

The second Baburen is supposed to have belonged to Vermeer, but I can find no justification for accepting

this fabulous provenance, any more than I can for the Jordaens *Crucifixion* (104).[12] I should place next in succession the badly damaged 'Votive offering' (91), the subject of which has not been identified, catalogued as 'attributed to Terbrugghen', but unquestionably a Baburen original, bearing a marked resemblance to the style of Jan Janssens,[13] whose beautiful *Annunciation* (100) was exhibited in another room; and finally the Weert *Christ crowned with thorns* (12) of about 1623–24. Although Baburen grew more homely and lightened his palette in the last years of his short life, he continued until the end to be haunted by the great themes that his Italian master had treated. The subdued yellow tone of the *Prometheus* of 1623 now hanging in the Rijksmuseum is due to dirt and varnish, and is therefore misleadingly 'Caravaggesque' in the conventional sense; but just as his *Deposition* had depended on Caravaggio's painting in the Vatican, so his *Prometheus* is a warm tribute to the

Conversion of St Paul in S. M. del Popolo, and would thus have been handsome addition to the exhibition.

Honthorst, to us a less sympathetic figure, developed along similar lines, lightening his palette and adopting a smoother technique as Rome began to fade from his memory. (Stomer, because he never came home, never grew tame.) The earliest Honthorst shown was a Caravaggesque *Mocking of Christ* (44) which I believe was painted during his Italian period. No doubt the first version of the *Liberation of St Peter*, a magnificent composition dating from this time but shown in an excellent later copy (43), was painted in the same coarse technique. Soon after his return to the North he popularised those set grins which remain such a characteristic feature of his subject-pictures until about 1630. His chronology is difficult to establish[14] since he possessed the faculty for painting in different styles concurrently, but presumably the Munich *Prodigal Son* (42) belongs to the bracket 1619–22, and the Borghese *Concert* (41) with points in common with contemporary Flemish painting, with its Caravaggesque still-life on the table, to a few years later. The *Death of Seneca* (48)[15] would therefore belong to the late 1620s. An exceptionally fine painting by Honthorst dated 1627,[16] in a private collection in London [now in the Seattle Art Museum], is here published for the first time (Fig. 85). It is close in spirit to his *Granida and Daifilo* in the Centraal Museum of two years earlier. On such pastoral scenes as these, Jan van Bylert based his style. His dependence on Honthorst was most obvious in two works at Utrecht: *The sutler* (31) and *Singing shepherds* (32), of 1630 onwards.

Bylert's *Five Senses* (25) from Hanover, perhaps just before 1630, sum up the carefree preoccupations of the Utrecht and Haarlem masters: their delight in music, easy love and a square meal. Here all the secular subjects of the school are crowded on to a single canvas. To a slightly earlier period may be assigned two curious Bylerts from Brunswick (26 and 27) which, as Denis Mahon has pointed out to me, have their origin in the Bolognese school: one is reminded of Domenichino's *Madonna della Rosa* recently rediscovered at Chatsworth. The Caravaggesque Bylert – I am thinking of such works as his Harrach *St Sebastian tended by women* of 1624 and the Boymans *Rachel and Laban* which are both close to Gentileschi – was not shown at all, and much space was wasted by monotonous paintings from his hand.[17]

The space could have been filled with more and better examples of Matthias Stomer, an important

artist who was poorly represented. I suppose the reason why he has been neglected (except by students with a truly international outlook) is largely that, like Lord Cowper, he never got back from the 'Grand Tour', and hence cannot be whole-heartedly claimed either as a Netherlander or an Italian. The Dutch Romanists have all shared the same fate. Of four pictures listed under Stomer's name in the catalogue, two are false (65 and 67);[18] a third, the Munich *Christ among the Doctors* (66) is already famous; and the fourth, of about the same date as the Munich picture, the *Liberation of St Peter* (64) in my own collection, at least has the merit of being unknown, but is not perfectly preserved in the background. It is based in reverse on the early Honthorst *Liberation* in the Kaiser-Friedrich. Voss[19] pointed out the influence of Caravaggio's *Calling of St Matthew* on the Berlin picture. The imperious gesture of the extended arm haunted the Dutch Caravaggesques. Terbrugghen in his two versions of the subject in Le Havre (71) and Utrecht (75) took pains to avoid the obvious: a subtle and a proud artist, he refused to make such allusions quite clear. A lesser man like Bylert (29)[20] took over the curve of the arm without criticism. But to return to Stomer: it was sad that the little-known *Executioner with the Baptist's head* (Fig. 86) from the Earl of Malmesbury's collection, now belonging to Denis Mahon, a copy of which by Dobson is the only known English Caravaggesque picture, did not become known in time for the exhibition, since it represents him in a different phase from the two that were on show.[21] It is difficult to establish a chronology for Stomer, since none of his early works is dated. One can only assume that his brush strokes grew more and more violent as time went on, ending in the South Italian style of the early 1640s. On this basis the smooth, more Honthorst-like *Executioner* would be among his earliest works, and the *Liberation of St Peter* and the Munich picture, in that order, which are more similar to Baburen than to Honthorst, would represent the style of his early maturity.

The personality of Paulus Bor has not been thoroughly investigated but the Utrecht exhibition helped to settle one or two questions, and to pose others. Like another Orlando, he kept on cropping up in different disguises. On his return to Amersfoort from Italy in the late 1620s, he fell under the sway of the young Rembrandt, whose influence is reflected in the *Adoration of the Magi* of 1634 (19), in the more or less contemporary *Finding of Moses* in the Rijksmuseum, and in the Utrecht *Deposition* (18) which may belong to a slightly

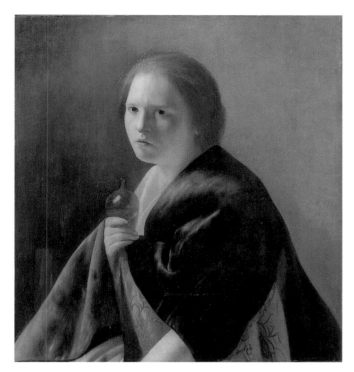

87. *Weeping Magdalen*, attributed to Paulus Bor. 1630s. Canvas, 64 by 59 cm. (Walker Art Gallery, Liverpool).

Centraal Museum, built up in a series of circles and crescents, as simple as his earlier pyramidical compositions, is dated 1641. Very shortly before this he must have painted the *Enchantress* (17) in the Andrea Busiri-Vici Collection in Rome, published by Longhi[22] as a work of Bor c. 1620–30. A companion piece in a private collection in Basle[23] has been cut down at the top.

Two other pictures, in the catalogue as 'attributed to Bor', present considerable difficulties. The *Shepherd and shepherdess asleep* (21) has tentatively been ascribed by Van Gelder and Gerson to Honthorst of about 1625, presumably on the basis of its undeniable similarity to the Honthorst *Granida and Daifilo* in the Centraal Museum, dated that year. The picture must surely be somewhat later, since it reflects the latest Terbrugghens: cf. the Borghese *Duet* (85) of 1629. I have not been able to make up my mind about its authorship, nor about that of the *Magdalen* (22) (Fig. 87), evidently of the mid-1630s, belonging to Leggatt's in St James's Street [now in the Walker Art Gallery, Liverpool]. For this picture, which one might have imagined outside the emotional range of the Utrecht masters, the names of De Grebber and the young Solomon de Bray have among others been proposed; but Bor in his Rembrandtesque phase still seems to me the most plausible suggestion.[24]

During the last week in July, the recently cleaned *Diana*[25] from the Mauritshuis was hung beside the Edinburgh Vermeer. The pictures bore little resemblance to one another in colour and technique. But here was a unique opportunity to observe a boy of genius, searching around in the past, near at hand and far away, for an attitude – for *his* attitude – towards life.

later period. Already in the latter he can be seen struggling to free himself of Rembrandt's influence, in the distortions of the background figures – strangely reminiscent of the first generation of Leiden Mannerists! – and in the swirling clouds which thread their way in and out of the crosses. By the early 1640s, Bor had found his true bent. The beautiful *Soothsayer* (20) in the

ENRIQUETA HARRIS

Spanish pictures from the Bowes Museum

The group of Spanish paintings from the Bowes Museum in the recent exhibition at the galleries of Messrs T. Agnew & Sons[1] was notable for the number of minor artists represented, though these were overshadowed by three masterpieces: El Greco's *St Peter Repentant*, Goya's portrait of *Juan Meléndez Valdés* and his *Scene in a prison*. It was, also, unusual to find no picture even attributed to Velázquez, Ribera, or Murillo. In these respects the character of the Bowes Museum's Spanish collection reflects to some extent the taste of the founder; but its origin is really to be discovered in the taste and circumstances of Francisco Xavier, Conde de Quinto, from whose widow John Bowes bought over sixty Spanish paintings in 1862 in Paris, where he was living at the time. Quinto, who had died in Paris in 1860, was a Spanish politician and writer, who was also concerned with the preservation of works of art and had held the posts of Dean of the Central Commission for Historical and Artistic Monuments and Director of the National Museum of Paintings.[2] This museum, which was installed in 1838 to house the works of art confiscated from the religious communities of Madrid, Toledo, Avila, and Segovia, was later incorporated in the Prado.[3] Whilst the most important works were taken over by the National Museum, a large number of paintings were sold both before and after the expropriation. And Quinto's collection, to judge from its catalogue and from the pictures which later found their way into the Bowes Museum, seems to have been formed from the leavings of the National Museum. Quinto's Catalogue[4] lists 217 paintings, of which more than three-quarters were Spanish, most of these being religious paintings by minor artists. There was little to attract the conventional English collector: only a handful of pictures ascribed to Velázquez, Ribera, and Murillo.[5] But there were no less than eighteen paintings described as El Grecos and eight as Goyas (the latter, all of secular subjects, must have come from private collections).

The pictures acquired by John Bowes formed one of the largest and earliest Spanish collections in this country;[6] it was only nine years since the sale of Louis Philippe's collection at Christie's had brought many artists' works here for the first time. Moreover, its size and range still makes it of special interest to students of Spanish painting, to whom the opportunity of seeing part of it in London was particularly welcome.[7]

Though the Greco and Goyas, which would have stood out in more distinguished company, may emphasise the somewhat provincial character of the rest of the Spanish pictures, it must be recalled that in Bowes's day neither artist was much better known or more highly valued (judging from the prices they fetched in the Louis Philippe sale) than others in his collection. If today they seem to prove his taste and foresight, it is quite probable that he chose them simply as examples of little-known masters and because two of them are signed, for he seems to have been specially interested in signatures.

The signed *St Peter repentant* by El Greco (no. 642), one of the earliest representations of this subject in painting,[8] is also one of the first of El Greco's many versions, close in style to the *Burial of Count Orgaz* (1586–8). It has all the exciting qualities of his developed Spanish style which is most admired today; but it was these qualities which, in the nineteenth century, earned him the reputation of being a madman.

The Goyas, on the other hand, are less surprising for the taste of the time. The signed portrait of' his friend, the poet Juan Meléndez Valdés (26), dated 1797, is one of his more intimate and sympathetic portraits; and the *Scene in a prison* (29), painted probably during the War of Independence or soon afterwards, is both delicate as a drawing and moving rather than horrifying.

88. *The Virgin of Montserrat, with donor,* by Fray Juan Rizi. 246.4 by 167.6 cm (Bowes Museum, Barnard Castle).

89. *A Hieronymite nun (St Eustochium?),* by Juan de Valdés Leal. 1657–58. 207 by 124.5 cm. (Bowes Museum, Barnard Castle).

The portrait of *The painter's brother* (14), attributed with the others to Goya in the Quinto *Catalogue* (44), has been doubted and is surely not by him.[9]

Of the minor paintings at Agnew's, several of the attributions in Quinto's *Catalogue* have since been changed.[10] Two early sixteenth-century panels, representing *Fathers of the Church* (8, 65), once attributed to Antonio del Rincón (Quinto, 128, 127), then to Alejo Fernández, are now ascribed by Angulo to the circle of Juan de Borgoña, who worked chiefly in Toledo, and by Post to the master himself.[11] The *Virgin of Montserrat* (824, Fig. 88), formerly ascribed to Alonso Cano (Quinto, 22) was identified by Mayer as a work by Juan Rizi, an artist who earned vicarious fame abroad when his signature was alleged to have been found on the once problem picture, the *Hurdy-gurdy player* by Georges

de la Tour, in the Nantes Museum (see Fig. 37, p. 52).[12] Rizi, a Benedictine monk, took the habit at Montserrat in 1627 and lived there with some interruptions till the Catalan rising of 1640, when he moved to Madrid and was for a time drawing master to Prince Baltasar Carlos. He was one of Velázquez's most distinguished Spanish contemporaries and invests his devotional paintings with a quality of realism akin to that of the master himself. The straggling rock roses in the foreground of the *Virgin of Montserrat*, like other elements in Rizi's pictures, remind one of El Greco and it is of interest that Rizi is said to have been a pupil of Maino, who was in Toledo during El Greco's last years; but the composition as a whole, and particularly the portrait of the kneeling ecclesiastic, are in the naturalistic language of the age of Velázquez. The miraculous black image

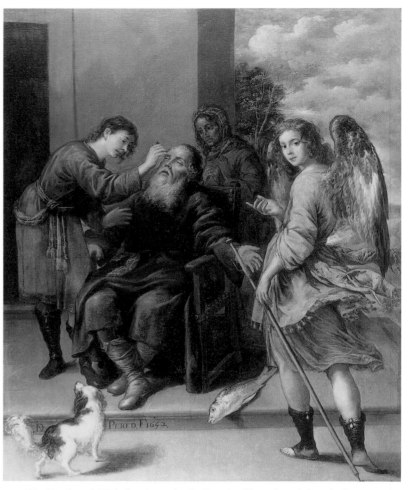

90. *Christ and the Virgin crowning St Juan de Dios with thorns*, by Francisco Camilo. Signed and dated 1650. 233.7 by 127 cm. (cut at sides). (Bowes Museum, Barnard Castle).

91. *The Healing of Tobit*, by Antonio de Pereda. Signed and dated 1652. 194.3 by 158.7 cm. (Bowes Museum, Barnard Castle).

of the Virgin and Child is seen on a high rock near the spot where, according to pious legend, it was found; and nearly every detail of the fantastic mountain in the background is recognisable as part of the actual scenery. The composition is a traditional one, derived perhaps from a devotional print, though it seems to differ from earlier versions in the realistic rendering of the image as well as of the scenery; and it may well be that Rizi's design was the model for a number of seventeenth- and eighteenth-century variants in painting, sculpture, and engraving.[13]

The *Hieronymite nun*, by Valdés Leal (10, Fig. 89), has a devotional air that relates it in a way to the *Virgin of Montserrat* and its naturalistic style, which survived long in Seville, explains perhaps why it was once attributed to Zurbarán.[14] Following Mayer, the *Nun* is generally

accepted as one of a series of pictures representing the founder and members of the 'Order' painted by Valdés Leal for the Monastery of St Jerome in Seville about 1657.[15] It is so similar in style to one of these, a *Hieronymite monk* in the Prado (2582), that they would appear to have been pendants. The fact that it is slightly smaller than other pictures of the series may indicate that it has been cut and this would also account for the absence of the plaque which appears at the bottom of the others. The *Nun*, the only female of the series that seems to have survived, has been credibly identified as St Eustochium, daughter of St Paula, who is seen in the background bending over her as she kneels before St Jerome.[16]

The authorship of three other seventeenth-century paintings at Agnew's is still in question. If the attribution

of the *Virgin of Montserrat* to Juan Rizi is accepted, as it certainly should be on internal as well as external evidence, the so-called *St Peter of Alcantara* (807) is surely not by the same hand, nor is it like any of Rizi's other known works. It must therefore be returned for the present to the list of *Tableaux dont les auteurs ne sont pas suffisament connues*, where it appeared in the Quinto *Catalogue* (198). The identification of the author might be helped by identification of the model of a church – not particularly Spanish in style – held by the sitter, a Carmelite, and not the Franciscan St Peter of Alcantara.[17]

The *St Ambrose* (2) and a pendant *St Gregory* (30), not shown at Agnew's, were called Herrera in the Quinto *Catalogue* (70, 185) but were rightly rejected from his *œuvre* by Thacher, who considers them to be probably Italian.[18] The curator of the Bowes Museum very kindly drew my attention to a pair of paintings representing visions of *St Ambrose* and *St Augustine* in the collection of Sir George Mounsey,[19] which are obviously by the same hand and which help to substantiate the view that the author was Italian and suggest that he was most probably a Neapolitan follower of Ribera.

The *St Francis in Ecstasy* (21), formerly ascribed to Murillo (Quinto 107), was given to Zurbarán by Mayer, who considered it to be a late work;[20] and this attribution has been accepted by most critics. Recently, however, Soria suggested that it was the relationship between Ribera and Zurbarán that tempted Mayer to give it to the latter and that it is in fact a work by Ribera or his circle.[21] These alternative attributions are an interesting reflection of the problem of the connection between Ribera and the painters of Seville. The attribution to Murillo was perhaps due to a general similarity to his early representations of the levitation of Franciscan Saints like, for example, the detail of St Diego in the *Angels' kitchen* (Louvre). But in style and in dramatic character the *St Francis* is closer to Zurbarán than to Murillo or Ribera and probably comes from his circle reflecting, it is true, the style of his early altar of *St Peter* (Seville Cathedral), in which Ribera's influence can actually be traced.

Later trends in seventeenth-century Spanish painting were illustrated at Agnew's by two religious subjects by contemporaries of Velázquez and by a portrait of Philip IV's widow, *Mariana of Austria*, by Carreño (32); but only in the portrait is Velázquez's influence at all marked. The religious paintings are interesting chiefly for being signed and dated: Francisco Camilo's *Christ and the Virgin crowning Juan de Dios with thorns* (810) in 1650 (Fig. 90); and Antonio Pereda's *Healing of Tobit* (34) in 1652 (Fig. 91). Both artists, according to Palomino, studied under the same master, who also taught Carreño, and both were primarily religious painters though they also worked at court. Here Pereda was deservedly the more successful of the two, for he gained some benefit from his collaboration with Velázquez in the Salón de Reinos in the Buen Retiro. Camilo, whose works reflect the evil influence of Van Dyck, is aptly described in the catalogue of the National Museum (where he was represented by thirteen works)[22] as 'one of the artists who contributed most to the decline of the School of Madrid'. The figures of the Virgin and Christ in the painting of *Juan de Dios* gives some credence to Palomino's story of Philip IV ridiculing Camilo's paintings of Ovid's *Metamorphoses* because he made Jupiter look like Christ and Juno like the Virgin, a story which he relates as an example of the King's good taste and discrimination.

C. R. DODWELL

'The Reconstructed Carmelite Missal'
by Margaret Rickert

It is impossible not to admire the skill and patience with which Miss Margaret Rickert has reconstructed this Carmelite Missal, which was cut up about 1826 and dispersed among five scrap-books. Two of these found a home in the British Museum, and a third was discovered as a result of Miss Rickert's work. In view of the complexity of assembling together again all these bits and pieces, it is not surprising to learn that the author was engaged on her work during periods extending over sixteen years, but the result has certainly been well worth the pains involved.

From the liturgical point of view the book offers, for the first time, reliable material on which to base a study of the Carmelite Missal in the late fourteenth century. From the point of view of art history, the reconstruction of the illuminations in a manuscript, which Miss Rickert has been able to date before 1391, means that we are provided with material which will be invaluable for any future work on English art of this period. Though several hands worked on the illuminations, the author has been able to divide them into three main stylistic groups. The first is in the traditional English style of the period, the second shows Bohemian influence, and the third is a foreign style executed by a foreigner, who Miss Rickert considers to be a Dutchman and who was also the master of the Gelder *Wapengedichten en Wapenboek* in Brussels. The stylistic comparisons which are made are very convincing. It is a pity that the quality of this stylistic analysis is not equalled by the quality of the reproductions, which are indifferent and sometimes too small for their purpose.

In her section on iconography, Miss Rickert points out the iconographical innovations of the illustrations, which are certainly of interest. She has not thought it necessary to analyse also the traditional aspects, elements of which go back to the twelfth century and even to Anglo-Saxon and Carolingian times, though this might have balanced the almost exclusive emphasis on what is original. It may be added that the suggestion that some of the illustrations show an association with the Wycliffite or Hussite heresies can hardly be sustained. It comes strangely after a statement of the traditional hostility between the Wycliffites and Carmelites, and one may ask whether Miss Rickert has not read too much into the five miniatures which led her to this conclusion. The 'lolling' posture of two Carmelite figures in a Carmelite Missal is probably due more to the dictates of the initial than to any desire to represent them in an impious position. The iconography of the other four illuminations is, perhaps, less unorthodox than is suggested. The absence of the Virgin from the Pentecost scene, for example, seems to be overstressed. It is not quite accurate to say that she is 'consistently present' in such scenes in the Middle Ages, since she is absent from Carolingian pictures of the Pentecost (as in the Stuttgart Psalter), from Sicilian mosaics (as at Monreale) and quite normally absent from Anglo-Saxon illuminations. The iconography of the lower scene of the *Three Marys at the Tomb* is a traditional one going back to early Christian art, and it may be further remarked that the scene described as the 'Supper at Emmaus' in this sequence, is, in fact, the *Mission to the Apostles*. All this is not to underestimate the important iconographical innovations of these five illustrations, but, even so, it would be unfortunate to assume that theological unorthodoxy were a necessary corollary of iconographical originality.

To dwell at such length on a single detail of the many new and rich things provided by the author may be rather misleading. Let it, therefore, be said at once that it behoves us only to be grateful to Miss Rickert for all she has done in providing us with a book which will be indispensable for any future work on English art at the end of the fourteenth century.

R. WITTKOWER

'Vincenzo Scamozzi'
by Franco Barbieri

Amodern biography of Vincenzo Scamozzi has long been overdue. Scamozzi is usually regarded as a follower of Palladio's conception of architecture; but apart from some fairly recent preliminary studies in Italy (Fausto Franco, Pallucchini), neither his particular idiom and his development nor his ideas on architecture have received the attention which they deserve.

Scamozzi is, of course, of particular importance in the history of English architecture, since it is he rather than Palladio who towers behind Inigo Jones's classicism (a fact not yet sufficiently appreciated), and Barbieri's book may help to correct some notions on that score.

The author of the present book has discharged his task with skill and critical discernment. He begins with an analysis of the academic atmosphere in the Accademia Olimpica at Vicenza, which had a formative influence on Scamozzi. He proceeds with a discussion of Giovanni Domenico Scamozzi, Vincenzo's father and teacher, who continued Serlio's academic Mannerism. After an apt analysis of the guiding ideas in Vincenzo Scamozzi's vast *Idea dell'architettura universale*, published in 1615, he turns to a fairly rapid but penetrating survey of Scamozzi's development as an architect and concludes with a painstakingly compiled 'regesto' which takes up a large part of the book (75 pages) and contains, apart from all the known biographical material, historical-critical notes on each building.

Barbieri sets out to sever the traditional bonds between Palladio and Scamozzi, and to reveal an unbridgeable gulf between Palladio's 'poetical', sculptural, and 'chromatic' conception of architecture, and Scamozzi's rational, linear, and decorative one; furthermore, to show Scamozzi as the heir to Serlio's ideas rather than to those of Palladio. All this is certainly true, and it is salutary to have it clearly defined. But I think the author, carried away by his discovery, overstates his case. There are, after all, buildings where he himself cannot define the precise contribution of the one or the other (e.g., the Palazzi Caldogno, Thiene-Bonin, and Porto-Breganze, Vicenza). Moreover, the theoretical bonds are also closer than the author would like to admit. Large sections of Scamozzi's *Idea* stem from Barbaro's commentary on Vitruvius (published 1556) to which Palladio contributed the plates – and not only the plates. Scamozzi noted in his own copy of the book '... *la prima volta che io il lessi, haverlo udito, la seconda ... haverlo goduto; e la terza che e questa, averlo giudicato ...*' (Cicognara, *Catalogo ragionato*, 1831, I, p. 134). Nobody can overlook the vital differences between Palladio's *Quattro libri* and Scamozzi's *Idea*, but it is surely going too far to contrast Palladio, '*capace com'è più di realizzazione poetica che non di pensiero*', with Scamozzi's rationalist intellectualism. I think I have shown in my *Architectural Principles* that Palladio was well equipped to condense a distinct set of ideas into simple and adequate language. However, such criticisms are of small account compared with the welcome and scholarly achievement of this book, in which for the first time Scamozzi is given his correct place as the intellectual father of neoclassicism.

JEAN ADHEMAR

'Art and architecture in France 1500–1700'

by Anthony Blunt

Mr Anthony Blunt's book* deserves praise. It is a work which does honour to the erudition and taste of this writer who is already known from so many excellent studies. Frenchmen in particular must pay their respects to this fine synthesis, which no single one of them could have achieved over such a wide field. Mr Blunt entitles his book *Art and Architecture*; he would perhaps have done better to have called it *Architecture and Art*, since the sections devoted to architecture are further developed than the remaining sections – no doubt rightly, because it is reasonable to hold the view that the architecture of the period under discussion is more important than other manifestations of art. However this may be, his plan is very simple and very ingenious: eight chapters carry us from 1494 to 1705, which hinge on, and are divided according to, the historical events (1525, 1540, 1560, 1598, 1630, 1661, 1685). We see the birth of the great movements, we see them developing; the great works are analysed intelligently, and numerous and substantial notes bear witness to a wide knowledge of the period covered, which is still so little known.

At every moment, moreover, with much modesty, Mr Blunt gives us his personal opinions, develops new points of view. He has a tremendous advantage over French art historians: a close familiarity with Italian art, which helps him at every stage to make comparisons, to draw parallels. His central idea – a perfectly just one – is that the two principal artists of the period under review are François Mansart and Nicolas Poussin. He knows Mansart well (*'le vrai, le grand Mansart, c'est l'oncle, c'est François'*, Montaiglon has said in one of his poems) and has devoted a book to him which is a model of its kind. He gives full weight to this great architect, whom he well characterises as a great classic: 'clarity combined with subtlety, restraint with richness, obedience to a strict code of rules coupled with flexibility within

them; and concentration by the elimination of inessentials'. He knows well how to 'read' the existing works, how to analyse his projects in which he listens to Mansart 'speaking aloud', and how to interpret the subtlety and richness of his conceptions. As for Poussin, whom he also knows intimately, he shows as clearly his different periods, and the revolution he brings about in the conception of painting, his taste for stoicism, for the central problem of the victory of the will over the passions. Thanks to Mr Blunt we see Poussin at work: first of all, reading a great deal, then making sketches, then making wax statuettes and starting them over again several times on a large scale; then painting, but refusing to paint from nature, an unusual method 'which explains many of the features of Poussin's style: its classicism, its marble-like detachment and also its coldness'.

This attitude leads him to pay less attention to the art of Jules Hardouin and that of Lebrun at Versailles, which is in any case well known, and to study above all in relation to Mansart and Poussin the whole range of art of the sixteenth and beginning of the seventeenth century, with the most interesting results. This gives us in fact a kind of perspective into which to fit, or not to fit, the numerous facts assembled by Mr Blunt. The result is excellent, and gives the key to the whole sixteenth century.

In this magnificent book, then, we witness the birth of the renaissance châteaux after the triumphant campaign of Charles VIII in Italy in 1494. We are made to understand that Frenchmen were much more struck by Lombard art, by that 'set piece' which is the façade of the Certosa of Pavia, still so close to Gothic exuberance, than by the fine severity of Florentine façades. And even when the architect of Blois decides to imitate the Loggie of Raphael, he fails to understand the drawing which is sent him from Rome, and simply makes recesses closed by glazed windows. Mr Blunt is quite

right to insist on the plan of Chambord, where for the first time in France can be seen the suite of apartments, which reappears throughout the sixteenth and seventeenth centuries. He is quite correct to note the influence exerted by Giuliano da San Gallo on this important innovation, through his pupil Domenico da Cortona, then at the court of Francis I. As for the painters, we realise that Bourdichon and Perréal knew Milanese paintings well, which accounts for their style. In this connexion, one would have welcomed a more precise definition of Leonardo's influence, since his project for the château of Romorantin, his paintings and drawings, are of capital importance.

Mr Blunt then turns to the middle years of Francis I. He studies in detail the château of Madrid, that of St Germain, and finally the Fontainebleau of Lebreton. He correctly accuses the kings of France of having all too seldom decided straight away to erect great monuments: this is particularly striking in the case of Fontainebleau where the absence of any general plan became extremely awkward later. Next he turns to the churches, notably St Eustache, where the combination of a Gothic structure and classical pilasters would have horrified a modern architect. He examines closely, but without admiring it particularly, the Gallery of Francis I in which he gives a more important place than usual to Primaticcio; especially interesting is his observation that the drawings of Jean Clouet, a Netherlandish artist, always considered in the France of his time as a foreigner, are, however, closer to those of Raphael than those of Holbein.

In the Classical period (1540–65) Mr Blunt has well defined the great architects, Serlio, the father of Mannerism, Lescot, and his researches in ornamental beauty, Delorme, the great Classic, an independent, national figure, the precursor of Mansart, who becomes a Mannerist at the end of his life, Primaticcio and the academism of his construction of the Aile de la Belle Cheminée at Fontainebleau, the learned Guillaume Philander, Nicolas Bachelier, more sculptor than architect. He tells us he does not know of any works by Vignola in France; however, in the Department of Paintings at Fontainebleau, there still existed in the seventeenth century a work by him: a *perspective* painted on wood, which could have exerted an influence in the sixteenth century. As for the painters, Primaticcio appears, in fact, around 1540 to have fallen under the influence of Parmigianino, but it has not

been sufficiently realised that drawings from the studio of Parmigianino were then being brought into France by his pupil Antonio da Trento who, under the name of Antonio Fantuzi, was the direct collaborator of Primaticcio. Mr Blunt points out, furthermore, that Primaticcio was very susceptible to influences, and that the 'illusionist' art of the Galerie d'Ulysse coincided with the arrival in Paris of Niccolò dell'Abate. He writes well about the strange figure of Chrétien, whom earlier he had studied in THE BURLINGTON MAGAZINE, about Noel Jallier, and François Clouet, an 'international Mannerist', more affected than his father had been by Flemish influence. He recalls the influence of Jean Duvet on the English school through the intermediary of his admirer William Blake. He pays tribute to the fine study of Du Colombier on Goujon, and studies the other sculptors over whom the shadow of Michelangelo always hovers. In one of his notes, as substantial as monographs, he mentions the interesting figure of Simon de Chalons, a painter at Avignon to whom we are devoting a study.

The wars of religion did not slow up the impetus of French art. This is the period of Bullant and Du Cerceau, Mannerist architects and megalomaniacs, of the great Germain Pilon to whom Mr Blunt quite rightly gives the famous *Diana* of Anet, of Antoine Caron whose 'popularity is exaggerated', of François Quesnel, the portrait painter notably of Marie-Anne Waltham.

Later, after the treaty of Vervins, Henry IV, who had pacified France, attempted to re-establish commerce and the arts. Then the great Parisian squares were designed: the Place Dauphine, the Place Royale, the Place de France, the *hôtels* on which M. Babelon has just written a very distinguished thesis at the Ecole de Chartes, the works of De Brosse, of Le Muet. Painters of talent abound: Bellange, Callot, Deruet, Vignon, the French Caravaggists, while Rubens (in Paris from 1622 to 1625) exerts no influence. Finally, with the very successful Baroque architect Le Vau, with Vouet, Champaigne, La Tour, the Anguiers and the Sarrazins, we are back again in the period of Mansart and of Poussin.

We abstain from concluding this review (as is too often done) with criticisms, which could be not help being captious; such criticisms as could be made would not detract from the considerable interest of this fine study.

FRANCIS HASKELL

Stefano Conti, patron of Canaletto and others

In 1923 Mr W. G. Constable gave news of four pictures by Canaletto which had been bought in the nineteenth century from Marchese Boccella in Lucca, and which, since his article was written, have ended up in Canada (Figs. 93-96) [now private collection, Italy].[1] He published Canaletto's own signed receipts and contracts which showed that the pictures were painted for Stefano Conti, '*nobile lucchese*'; the first two before November 1725, and the other two before June 1726. The negotiations were carried out by Alessandro Marchesini. As these are among the earliest works of Canaletto to have been identified, there has been much speculation as to who was Stefano Conti and how he got into touch with the artist. In Lucca recently I investigated material which solves these and other interesting problems.[2]

Stefano Conti came from a family of Milanese origin which settled in Lucca towards the end of the sixteenth century. His father, Giovanni, was accepted into the Lucchese nobility in 1630, and Stefano himself was born in 1654. From his lengthy will we learn that he carried on a flourishing trade in silk and cloth. He was a keen businessman and made anxious provision for the continuance of his trade after his death. This occurred in 1739 when he was aged eighty-five. He was buried in the Lucchese church of S. Maria Corteorlandini.[3]

In his will Conti devotes a paragraph to his collection of pictures, most of which had been painted specially for him '*tanto in Venezia, quanto a Bologna da i Primi Pittori del nostro secolo*'. In particular he was most anxious that they should not be dispersed after his death, but should be maintained '*in Casa per decoro della medesima*'. He himself, he tells his heirs, has been offered much

more than what he paid for them, but has always refused to sell.

Fortunately, although the advice was ignored and the pictures are mostly untraceable, full details have been preserved not only of the subjects and artists concerned, but frequently also of Conti's negotiations with them. The long correspondence was copied out, probably by a secretary, into a notebook which is now to be found in the Biblioteca Governativa in Lucca. All the following quotations and information come from this source.[4]

Conti's collecting activities began early in 1705 when he got into touch with Alessandro Marchesini and commissioned eleven pictures from him. Marchesini was a Veronese pupil of Carlo Cignani,[5] and henceforth he acted as Conti's agent in his dealings with the large number of other artists employed by him. So in the same letters in which Marchesini describes the progress of his own pictures, he also gives news of his dealings with Antonio Bellucci (four paintings), Gregorio Lazzarini (six paintings), Antonio Balestra (five paintings), and Marc' Antonio Franceschini (one painting). Marchesini himself was prepared to exert pressure on these artists. Thus he writes of a picture of Bellucci that '*a mio genio Lo vorrei veder mutato in qualche parte che gia me ne ha dato sicurezza di farlo*'. Perhaps for this reason some of the artists preferred to deal directly with Conti. Thus Balestra wrote from Venice in 1705 that he was not satisfied with the 100 ducats he had been offered for his first picture and threatened to stop working. Evidently the matter was settled satisfactorily, for two years later he wrote to congratulate Conti on the establishment of his gallery with its excellent lighting, and sent a certificate to guarantee the authenticity of the five pictures he had painted for it.

Certificates of this kind poured in throughout 1707 in answer to messages from Conti, who, as a shrewd

92. Detail of Fig. 94.

93 *The Rialto and the Palazzo dei Camerlenghi*, by Canaletto. 1725. 91.5 by 134.7 cm. (Private Collection, Italy, formerly Pillow Collection, Montreal).

95 *A View on the Grand Canal*, by Canaletto. 1725. 91.5 by 134. cm. (Private Collection, Italy, formerly Pillow Collection, Montreal).

94 *Church of SS. Giovanni e Paolo*, by Canaletto. 1726. 92.8 by 135.3 cm. (Private Collection, Italy, formerly Pillow Collection, Montreal).

96 *Church of the P.P. della Carità Rocchetini*, by Canaletto. 1726. Canvas, 92.8 by 135.3 cm. (Private Collection, Italy, formerly Pillow Collection, Montreal).

businessman, was determined to show that he had had his money's worth. By the end of the year the first phase of his collecting was over, and it is worth looking at it a little more closely. Besides those mentioned already, the most significant artists are Angiolo Trevisani, Giovanni Antonio Fumiani, Niccolo Cassana, Sebastiano Bombelli, Felice Torelli, and Gio. Giuseppe Del Sole – all working in Venice or Bologna. There were also two busts by Giuseppe Mazza.

Choice of subject was evidently left to the artists themselves, though the size required was nearly always given them. The themes are taken from the stock allegorical, mythological, and religious repertory of the period, besides a few specialities such as small battle scenes by Ferdinando Chiaro, and various animals by Gio. Agostino Cassana. Of greater importance for the future, as we will see, were three small landscapes by the Cremonese artist Francesco Bassi. As regards subject matter a number of letters from Franceschini are of interest. After some discussion he writes: '. . . *Il ritrovare Istoria, o favola di due figure con putti è un poco difficile, e quanto a me gradirei che cotesto Cav.re suggerisse a me il soggetto di suo genio.*' He goes on to suggest various possibilities, sacred and profane at random – Adam and Eve, Bacchus and Ariadne, etc. But, he continues, '. . . *Riuscirebbe però più di mio gusto una Pastorale capricciosa con un Pastore, Ninfa e due o tre putti in atto bizzaro e curioso . . .*'. This suggestion was accepted and, after some delay, due to illness and an urgent commission from the Pope, the picture was completed by December 1705.

To paint portraits of himself, his wife, and his heir, Conti chose Sebastiano Bombelli, the most fashionable portraitist of the day in Venice. These were probably painted on one of Stefano Conti's visits to Venice which are referred to from time to time in the correspondence. For those of his three daughters he chose the Lucchese painter Antonio Franchi.

So far all the artists mentioned were well known at the time they were commissioned by Conti, and, though of very varying merits, were in the direct tradition of late seventeenth-century Italian painting. They were, in fact, just the artists whom one might expect a rich 'provincial' to choose for his gallery. They do not include any of the painters who were to be of real significance to the eighteenth century. But there was one exception, and this was to prove of the greatest importance for the future. In July 1707 Luca Carlevarijs apologised for his delay in replying to Conti and explained that he had been away from Venice for a month. He was now enclosing the certificates asked for, and Conti

inserted copies of them under the heading:[6] '*Luca Carlevarijs Pittore commorante in Venezia mi ha fatto di mia commissione N.3 Quadri in tela di figurine piccole rappresentanti tre Prospettiva di d.a Venezia . . .*'.

For some years Conti now stopped buying altogether. Then in 1713 he bought a Guercino, *Rest on the flight into Egypt*, from the heirs of Sig. Bonviso Bonvisi, and a year later a *Christ in the garden*, '*universalmente giudicato*' to be by Correggio. In 1718 he commissioned a *Cain killing Abel* from a fellow Lucchese, Domenico Brugiore.

Then suddenly in July 1725 the correspondence with Marchesini is renewed. Marchesini's delight that Conti still remembers him and the fact that the note-book continues without interruption show that Conti had in fact stopped buying for several years and that no documents are missing. After effusive compliments to his patron, Marchesini writes:

> *Intesi il bisogno di che V.S. Ill.ma desidera per li due accennati quadri da accompagnare gli altri che tiene dipinti dal Sig.r Lucca Carlevari. Ma adesso veram. te vive il Soggetto, se non fosse superato di maggior stima dal Sig.r Ant. Canale, che fa in questo paese stordire universalmente ognuno che vede Le sue opere, che consiste sul ordine dl Carlevari ma vi si vede Lucer entro il Sole, sicchè questo è mio amico che appoggerò le due opere*

This extract gives a vivid illustration of Carlevarijs's eclipse by the young Canaletto with his startling light effects – an eclipse which is supposed to have caused the older artist such bitterness. But it also seems to indicate that Canaletto was never in fact his pupil, as has sometimes been supposed. Had this been the case, surely Marchesini would have been unable to resist adducing it as yet one more example of the favourite story of pupil outdistancing master. Marchesini adds that he will get in touch with Canaletto at once. Thereafter he writes weekly to report progress. The measurements are given, '*e mi creda che avera tutta l'ambizzione d'incontrar l'occasione di farsi conoscere frà tanti soggetti di pittura che nella galleria di V.S. Ill. ma sia raccolti*'. Like Owen McSwiney two years later Conti found Canaletto a difficult man as far as money was concerned.[7] He demanded thirty *zecchini* a picture, which he only reluctantly reduced to twenty, after Marchesini had assured him that this was more than he could expect from any other client and that if the pictures proved satisfactory further presents would be given.

As for the subject, '*ò Letto quelle che a fatte il S.Lucca [Carlevarijs] acciò non incontri Le simile, ma trovera vedute differente, e farà cose d'ammirazzione che assicuro sopravanza il S.Lucca Carlevari che adesso e vecchio*'. The views chosen are

discussed a week later on 4th August, when Marchesini informs Conti that work has begun on '*due delle più belle vedute che mai e state osservate, nel sito appunto dove alloggiava l'Ill.ma comitiva dell'Ill.mo S.Gio. Angelo.*'[8]

Conti was evidently so pleased by what he heard from Marchesini and from his son Gio. Angelo, who was on a visit to Venice, that he now ordered two further paintings from Canaletto, making four in all. On 11th August Marchesini reported that Canaletto would begin work on the first two at once, and would look around for suitable views for the others: '*cosa grandiosa come quelle a vedute qui l'Ill.mo S.Gio. Angelo da un P.re Mstro Pedoci Carmelitano, che ha sorpreso il molto dell'altra prima veduta in Ca dell'E.mo Sagredo, cavagliero di tanta intellegenza, e che tiene molte meravighose Cose ...*' A week later Marchesini wrote that Canaletto was about to begin work on the first, '*dipingendole sul Lido proprio dove stava di alloggio l'Ill.mo Sig. Gio. Angelo*'. He adds that: '*Il giorno di S.Rocco espose al Publico una sua veduta di S.Gio. e Paolo che fece meravigliare tutti. L'Ambasciadore dell'Imperatore se La Levò, e ne fece l'Acquisto avendone un altra di maggior grandezza, e le diè l'ordine d'accompagnarla, e pienissimo di commissioni ma non abbandonerà per qualsiasi questi due primi che deve a V.S. Ill.ma e poi li altri due non Le sara Lontano ma sollecito anco per questi ...*'[9]

A fortnight later Marchesini writes that Canaletto has begun, but will not let anyone see the pictures. Meanwhile trouble had arisen over the expense of buying colours: '*non è questi Pittori ordinari, e nelle Loro opere non può scansare L'Azzurro quale tutto il Suo principal colore, che adoperi, mentre deve servirsi anche nè verdi per resistere alla discrezione del Tempo*'.[10] The problem was settled and now that the pictures were at last under way Marchesini's next job was to attend to their framing: '*Per le cornici che si va facendo per li due Quadri che va operando il S. Canale o scelto qui il primo Maestro che so, quando vedra le opere sue, son sicuro che resteranno sovrano a tante che V.S. Ill.ma tiene nella Sua Galleria.*' Canaletto himself '*dice che ne suoi quadri non ricerca cose troppo grandiose, e che le Sagome non deve occupare La pittura ...*'

On 15th September Marchesini writes that the second two pictures are to be larger in size than the first;[11] and on the 29th he tells Conti that the artist has decided on the second lot of views to be painted, '*e credo che sara l'una che V.S. Ill.ma mentre teneva casa alla Croce che per Angolo si vede il Canal fino alli P.ri Scalzi, e la veduta nell'altro Angolo dalla parte delle monache di S.Chiara, che si vede da una parte e l'altra crederei forse restera bene a memoria di V.S. Ill.ma ...*'[12] A week later he writes: '*Il Sig.r Ant. Canale è attentissimo dietro al p.mo quadro fisso sulla locanda sù la veduta sta dipingendo non con l'immaginaria mente nelle solite stanze de Pittori stessi come practica il S.Lucca [Carlevarijs] ma questo va sempre sul loco, e forma tutto sul vero; veramente, e uno stupore ...*'. This is confirmed in the remarkably interesting letter of a few days later, 13th October:

et ho parlato col S.Canale che mi ordina riverire V.S. Ill.ma e l'Ill.mo S.Gio. Angelo onde mi disse che circa le due nuove vedute intende che quella della Croce a S.Chiara che si vede sin tutto il corso del Canale sino alli P.ri Scalzi anderà bene, ma l'altra the V.S. Ill.ma scrive del Canalazzo, e la Dogana che resta fra il Canal Grande e con tutte l'altre fabbriche, questo non lo può fare mentre esso dipinge sopra il loco e non a idea a Casa come fa il S.Lucca, e volendo far questa vi vorrebbe un Loco fisso, e stabile cosichè vede V.S. Ill.ma che non vi è caso, ma che però fara scelta di altra che accompagnerà in bella veduta ...

This, as far as I know, is the only direct proof we have that Canaletto actually painted in the open air – a practice that is usually regarded as having been begun by the landscape painters of the nineteenth century.[13] That this was looked upon as a startling novelty is shown by Marchesini's repeated comparison with the habits of Carlevarijs. Evidently Canaletto himself gave it up once the pressure of commissions became too heavy, though in 1760 Dr John Hinchcliffe found that the artist was still drawing in the open air.

Such pressure was already growing in intensity, and, as has already been seen, Marchesini constantly tried to reassure his patron that the artist had begun work, only to have to admit further delay in a subsequent letter. On 3rd November Conti was told that all would be well within ten days, though there was talk of Canaletto being employed by the French Ambassador.[14] Finally both pictures were completed – '*uniti assieme fa una comparsa stupendissima*' and on 1st December Marchesini wrote: '*. . . e spero che tutti li S.ri di Lucca resterà maravigliati di si grande opere del Canal, che attesto da Cristiano, che tutti chi li à veduti, e l'E.mo Sagredo, altri Cavalieri, e molti Pittori tutti conclude, che questi due quadri, e li piu belli che si sian veduti, e spero che anco l'altri due seguira di tal gusto ...*' Two more were still to be painted, and the correspondence continues much as before. On 8th December Marchesini writes that Canaletto '*à detto che spera negl'altri due avvenire sarà, e riuscirà assai vaghi, e di belle vedute imparticolare quella d.lle Monache alla Croce, che fra tanto s'anderà procurando il Loco ad una balconata della Casa Businelo, che fù Cavalier Grande giusto a tocco di quella che aveva V.S. Ill.ma come più volte scrittoli*'.

There were the usual delays due to other commissions,[15] but on 2nd February 1726 Marchesini was able to write that Canaletto was about to begin the

remaining two pictures, 'con vedute di Terra, e siti piu grandiosi come quello del Ponte di Rialto'. A fortnight later, however, Canaletto was complaining about the quality of the priming, which, he said, 'betrayed' him. Rather cautiously Marchesini pointed out that the artist's nature was 'un poco soffistico, e dilicato', and asked Conti to humour him so as not to discourage his future efforts. By 4th May Marchesini could report that the pictures were ready. One represents:

> la veduta della Chiesa di S.Gio. e Paolo, con la Chiesa, o sia Scuola di S.Marco, il Cameo tutto con la bella statua a cavallo del general C.leone, parte dl Rio con veduta delle Case, e Ponte, e Barche, che smonta alla riva, e molte figurine per il med. Campo; l'altro la veduta della Carità in veduta (come a veduta l'Ill.mo Sig. Gio. Angelo dl Quadro che vide a Cà Sagredo) avendo mutate tutte le figurine.[16]

Eventually by the end of May one of the pictures was ready and Canaletto was claiming a present, as the second two had caused him much more work, 'come per verita non si puo negare'. Ten zecchini were sent, and Marchesini was able to write: 'ho osservato in Lui un sommo contento'. On 22nd June the last picture was finally completed, and the remainder of the correspondence on the subject is concerned with details of framing, of packing, and transport – 'che le pongano piane, e piatte sopra le schiene degl'Animali' – and, above all, of the eternal problem of how to avoid the customs.[17]

The problem of customs was a familiar one to all collectors of the eighteenth century as it is to those of today, but there can have been few more ingenious solutions to it than the one provided by G. M. Crespi, 'lo Spagnuolo', the last artist to be employed by Conti.

Negotiations began in August 1728 when Crespi was aged sixty-three, and took place directly between the artist and Conti, whose gallery was now referred to as 'famosa'. Crespi began haughtily by saying that he wanted a proper written contract of the kind that he had always had 'con Sua Altez.a il Gran Prencipe Ferdinando Defonto, con Sua Santita Defonta, con il principe Eugenio di Savoja mio Prne, di cui sono attual serv. re ...' After this had been satisfactorily settled, he wrote to Conti a fortnight later, describing the subject he had chosen:

> con l'istoria di Cibele, quando partoriti ebbe Giove, e Giunone in un parto solo, mostrò solamente Giunone a Saturno, e diede nascossamente Giove alle Cureti, dette le coribanti, per nodrirlo. Queste dubitando, che li vagiti lo decollassero, come e solito dlli Bambini, e inventarono di marchiare con una certa cadenza, detta da essi Bactili, e cosi gli urtavano assieme, e percuotevano piccole targhe di bronzo, di modo che Li vagiti del Pargoletto Giove, non potevano giungere agl'orecchi di Saturno, che divorava gli suoi figli Maschi.

This excessively long title has been quoted at such length for a reason which will be apparent later. With his letter Crespi enclosed a sketch, 'ma questo non le deve servire, che per un Embrione'.

Some months afterwards, in April 1729, Crespi had finished the picture, and it is now that he writes of the 'inganno curioso' by which he has cheated the customs. Sacred pictures, he explains, pay less duty than profane ones, and so he has changed the title of the painting he is sending to Conti. In fact he has said that it represents 'la ritrovata di Moise nel fiumo Nilo dalla figlia di Faraone'![18] The plan worked admirably; Conti was pleased with his picture; Crespi was given a present, and in his last letter he warns Conti, in friendly terms, to be wary of dealers. It was their fakes, he writes, which were responsible for the Venetian collector Zaccharia Sagredo spending 7000 to 8000 zecchini on pictures that were not worth a single piastra and hence hastened his death.

To avoid confusion I have dealt with Conti's complicated negotiations with Canaletto separately and in some detail. But while these were in progress Conti was also engaged – through Marchesini – with other Venetian artists. In August 1725 Rosalba Carriera painted a portrait of his daughter-in-law, Emmanuella, and shortly before this, dealings began with Sebastiano and Marco Ricci. As with Conti's purchase of Canaletto's works, the impulse was almost casual. A companion picture was required for the landscapes of the Cremonese painter, Francesco Bassi, which Conti had bought twenty years earlier. The artist himself was now blind. Marchesini reported on the current situation:

> Qui vi sono un virtuoss.o Pittore Paesista, che le sue opere sono in grandiss.ma stima quì, e in Londra, che presentem.te opera per questi S.ri Inglesi ed è pittore di molto prezzo, ma una maniera assai terminata onde non sò cosa al presente dirle, ne risolvere se questo,[19] ò il Rizzi doverlo appoggiare perche questo eccellente Pittore è maraviglioso per far vedute, e bizzarri siti di fabbriche al gusto di Puscin con colorito spiritoso, e Lucido, che incanta il primo che divise disopra, è veramente Paesista, è questo Ricci è misto che sarebbe meglio averne due compagni di questo per esser La Sua galleria di un gusto non più veduto, come anch'esso è sempre occupato per qui è Londra, onde starò attendendo cosa decide sopra di questi V.S. Ill.ma mentre son due rari soggetti ...

A week later, on 21st July 1725, Marchesini writes that he has decided to choose Marco Ricci – 'lo conosco più capace e di maggior stima [dell'altro virtuoso Cingheroli]' – and

recommends Conti to buy two small pictures by him:

> *che in Londra ne viene assai ricercati, il suo prezzo è solo 5 cecchini per ogn'uno, e mi creda che son cose ammirabile con certi belliss.mi siti, e vedute, che pajono di Tiziano, e Pusino, questi quadrettini li tiene ricoperti col suo Cristallo, che costa otto in dieci Lire, poi la Sua soazzetta bella intagliata, e benissimo dorata che costerà 20 Lire incirca . . .*

They are equally suitable for a picture gallery, or for '*un gabinetto come qui moltissimi Cavaglieri ne possiede . . .*' The usual delays followed: Ricci's engagements with English patrons were particularly pressing. On 4th May 1726, however, Marchesini went to visit Marco Ricci, '*e vidi il sud. suo Zio* [Sebastiano] *che dipingeva sopra a Le figurine li quadri è bellissimi, che per verita è due opere stupendissime a meraviglia riuscite . . .*' Conti eventually bought five works by Marco Ricci.

Some months earlier Marchesini had been engaged in direct negotiations with Sebastiano, who agreed to paint '*due quadri istoriati di figure intiere a mez.o naturale . . . che deve essere istorie pien di Alessandro Magno, che deve star a fronte di altri due de bravi Mstri Bolognesi*'. Sebastiano insisted on forty '*doppie di Franza*' as his minimum price. Marchesini wrote that this was not unreasonable for an artist who had been paid 100 *zecchini* for a small picture in Vicenza and other similar prices. But Conti evidently thought differently. No more was heard of the pictures of Alexander the Great and Sebastiano's activities were confined to painting in the small figures on his nephew's landscapes.

Enough has been quoted to show the great interest of the correspondence; pressure of space has forbidden more than a few passing references to some of Conti's main concerns – details about prices, packing, framing, and so on. Moreover, by concentrating almost entirely on those artists who are of interest to us today, I have inevitably distorted Conti's true position in the history of taste. As a significant art patron he enters history almost by accident. A gap is found in the wall space of his gallery; a letter follows to Marchesini; and a young, and as yet little known, Canaletto makes an important appearance. But there are only four Canalettos out of ninety-seven pictures in all,[20] most of which, as I have already indicated, look back towards the late baroque rather than forward to the significant artists of the new century. Yet if Stefano Conti is not a particularly exciting patron, he is none the less eminently representative of the taste of the 'man in the street' – a species about whom we have singularly little information.[21]

1962

SVEND ERIKSEN

Marigny and 'le Goût Grec'

*L*e goût grec in French furniture and interior decoration attained such great influence that the Louis XVI style is hardly thinkable without it.[1] But it is almost impossible to show exactly when, how, and through whom the influence and the stylistic changes occurred, owing particularly to the great difficulty that attaches to the precise dating of most furniture. It is certain, however, that long after the appearance of the first *à la grecque* furniture – Lalive de Jully's from *c.*1756–57[2] – France continued to produce superb furniture in the purest rococo idiom. A single late example is Marie Antoinette's toilet-table in the Louvre, made by Joubert, dating from 1770.[3]

Le Marquis de Marigny, Mme de Pompadour's brother, is one of the persons whose attitude towards the relation between rococo and neo-classicism it would be interesting to have clearly defined, especially as regards the years around 1760. But strangely enough, we are far from well informed about the man who held such important posts as *Directeur et Ordonnateur des Bastiments, des Jardins, Arts, Académies et Manufactures Royales.*

His contemporaries have not made it easy for us to arrive at an understanding of Marigny's attitude. Two of them, Dufort de Cheverny and C. A. Guillaumot, have left us the following, hardly compatible, evaluations. Dufort, who had a considerable personal spite against Marigny says:

> *Vandières* [*i.e.*, Marigny], *ayant tous les arts à ses ordres, entouré de ses artistes, pouvait perpétuer ce mauvais genre* [*i.e.*, the rococo], *qui fatiguait les vrais connaisseurs. Madame Geoffrin fit toutes les avances pour l'introduire dans sa société. C'est là qu'il acquit un jugement sûr et que, malgré lui, il épura son goût. Que de peine tous ces habiles gens que j'ai connus m'ont dit avoir eue à lui inculquer le goût du vrai beau, qu'il sentait, mais dont son amour-propre l'éloignait.*[4]

Guillaumot, on the other hand, writes:

> *C'est par une suite de notre barbarie que le public ignore une partie des bienfaits que M. le Marquis de Marigny a répandus sur les Arts, & sur-tout sur l'Architecture, qui, à tous égards, avoit besoin qu'il les étendît jusqu'à elle. Il a le premier eu le courage d'introduire dans sa maison des meubles de bon goût, & de les décorer d'ornemens sages. Depuis ce temps la feuille d'acanthe a été substituée dans un grand nombre de maisons à celle de chicorée tant à la mode ci-devant.*[5]

Furthermore, Marigny himself had the misfortune to leave behind him a letter which, since it was picked up in the Archives Nationales by Jean Locquin,[6] has become widely known. It has been cited in a number of standard works on art to show that Marigny was vacillating in his attitude towards the neo-classic style. Marigny's letter which, according to Locquin, was written '*àpropos de sa maison du Roule*', contained the following rather compromising instructions to the architect Soufflot: '*Je ne veux point de la chicorée moderne, je ne veux point de l'austère ancien, Mezzo l'uno, Mezzo l'altro.*'

It may be true that Marigny had no very personal opinion about art, and that his taste was uncertain. But it is very unlikely that his high office and his daily attendance at Versailles should not have given him the necessary poise and aplomb in the exercise of his official duties in the world of art. It is therefore hardly credible that he – who, moreover, is recognised as a man who paid great attention to detail – should not have given clear instructions in artistic matters – as, for example, when an artist was about to begin an official portrait of him like the one the Swedish painter Alexander Roslin made in 1761 to be hung in the Académie d'Architecture in Paris (Fig. 97).[7]

This portrait is remarkable because it shows the director of the architectural academy in an ultra-modern setting. This would be comparable today to a portrait of the president of the Royal Academy sitting in stately posture in a glass-fibre house surrounded by furniture recently designed by Charles Eames. In

97 *Portrait of Le Marquis de Marigny*, by Alexander Roslin. 1761. 150 by 112 cm. (Château de Versailles).

98 *Sketch of Roslin's portrait of Le Marquis de Marigny*, by Gabriel de Saint-Aubin, in the artist's copy of the Catalogue to the Salon of 1761. (Bibliothèque Nationale, Paris).

Roslin's portrait of Marigny there is hardly a trace of the rococo style, in spite of the fact that it was painted in 1761, perhaps already begun in 1760, at a time when the major part of Parisian interiors and furniture was still pure rococo.

In the portrait Marigny is sitting at a writing-table close to the wall. The table is black, apparently meant to represent ebony. It is evidently rectangular, without a single curved line anywhere, and richly mounted with chased gilt bronze in classical design. The slightly tapering legs are fluted and the frieze is mounted with broad and narrow fillets of bronze surrounding large rosettes and ornamental leaves. The table top is edged with a classical bronze border. Behind Marigny on a high pedestal stands an 'antique' vase of red porphyry

embellished with gilt bronze mounts, likewise in classical design. Against the rear wall is seen the lower part of a broad, fluted pilaster and just to the right of Marigny's shoulder the wall panel is decorated with a heavy Greek fret. On the wall hangs a large painting of which only the lower, left-hand corner is visible. It is framed in a broad 'Louis XVI' frame decorated with a heavy, rope-like garland.

While the table is of a known type,[8] the gilt chair seems more unusual and fanciful. It is of a strange and awkwardly monumental design but unmistakably non-rococo with its flutes and scrolls and heavy acanthus leaves, though its curved arm-rests disclose a trace of the current style. Modern classification would call it a 'transition' chair.

It will, of course, usually remain an open question whether the furnishings in a portrait are the property of the sitter or of the artist, or whether their presence is due to a combination of the painter's imagination and the model's desire to be painted in prepossessing surroundings. Whether or not the question can be answered, however, it may be presumed that the furnishings in every official portrait always have a meaning, and possibly were included in the picture at the request of the sitter, or at any rate with his approval. The more modern the furnishings are, the more this is likely to be true. In a period when 'at-home days' once or twice a week were generally observed, a well-known man would, presumably, run great risk of being made to look ridiculous if he allowed himself to be portrayed in ultra-modern surroundings unless, in one way or other, there was some reality behind the portrait.

In this particular case, it is most likely that some, at least, of the furnishings belonged to the artist, inasmuch as very similar objects are found in other, later portraits by Roslin. Furthermore, it is most probable that the portrait was painted in Roslin's studio and not in Marigny's home. There exists, at any rate, a letter from Marigny to Soufllot in which he writes: '*Je seray demain a 3 h chez Mr Roslin pour achever mon portrait; Je vous y donne rendez-vous pour cette heure . . .*'.[9] Nevertheless, as already indicated, we cannot deny the sitter an important share in deciding the details of the portrait, although his share may have been mostly dictated by considerations of principle. The original frame for the Roslin portrait, chosen by Marigny, also seems to point in this direction – particularly when we consider that the portrait was to be hung in such an important place as the Académie d'Architecture.

The Salon of 1761 was visited by Gabriel de Saint-Aubin, who carefully sketched many of the exhibited works of art in his copy of the printed catalogue of the exhibition.[10] Among the paintings he found worthy of sketching was Roslin's portrait of Marigny (Fig. 98). His drawing is only two inches high, but still like enough for us to recognise it. Only in few cases did Saint-Aubin also include the frame of the picture in his sketch. But around his drawing of Marigny's portrait is seen a highly elaborate frame which, considering the date 1761, is worthy of notice, being completely foreign to the contemporary rococo. Its most marked feature is a thick garland hanging in heavy loops, as dominating as the garlands decorating Lalive de Jully's furniture. We can hardly be mistaken when we characterise this frame as typically *à la grecque*. But, of course, it might

have been wholly a creation of the artist's imagination, as was presumably often the case when engravers made plates from painted portraits and then surrounded the engraved portrait with a decorative, engraved frame. However, in this instance the frame is not fictitious. Though today Marigny's portrait is in an entirely different frame, there fortunately exists a contemporary, detailed description of the frame ordered by Marigny for the Roslin portrait before it was exhibited at the Salon of 1761, and this description corresponds as closely as could be desired with Saint-Aubin's drawing. The frame was made in 1760 by the wood-carver Honoré Guibert[11] whose *mémoire* for it is found in the Archives Nationales[12] among many other bills (cf., the Appendix to this article).

Guibert's bill is worded as follows:
Une bordure destinée pour le portrait de M. Le Directeur et Ordonnateur general des Batiments du Roi peint par le S. Roslin.

Cette bordure a 6 pieds 1/2 de haut y compris le couronnement; et 4 pieds 8 po. de large; et 6 pouces de profil.

Elle est ornée d'oves à l'antique, de graines de perles, de rets de coeurs et feuilles d'eau, surmonté d'une couronne de fleurs et pour support un Compas et Porte-Crayon liés avec des rubans: de la partent deux guirlandes agraffées par un cloud. Le bas est orné d'une seule et grande guirlande tenue par des clouds d'un angle à l'autre.

There can hardly be found a portrait and frame from the year 1761 better suited to show a break with *la chicorée*, as the rococo style was sometimes called at the time. In this instance, then, Marigny proves to have been far from uncertain in his approach to art but rather an avowed modernist.

It is, therefore, highly confusing to hear from Locquin that just a year earlier (18th March 1760) Marigny should have written the unfortunate letter about what he would and what he would not have in his house at Roule: ' … *Je ne veux point de la chicorée moderne, je ne veux point de l'austère ancien, Mezzo l'uno, mezzo l'altro.*'

It is true that on 18th March 1760, Marigny did write the above words to Soufflot, but when read in its context the passage is seen to refer to an entirely different matter. Marigny writes:[13]
Je joins icy la mesure d'un Quadre pour lequel vous ordonnerez au S^r Gibert de m'apporter deux ou trois desseins a choisir. Ma soeur fait faire ici plusieurs copies de son Portrait en petit d'apres Boucher, elle m'a demandé de lui faire faire des bordures; Je ne veux point de la chicorée moderne, je ne veux point de L'austere ancien, Mezo l'uno mezo l'altro. Basta che sia corniche di buon gusto.

As it will be seen, this passage has nothing to do with Marigny's house in the Faubourg du Roule but concerns frames for a certain number of replicas of a portrait of Mme de Pompadour. Nor would one expect Marigny to use such a tone with his friend Soufflot, for whom he had great respect and who undoubtedly had considerable influence on Marigny in matters of art. What reasons Marigny may have had for ordering frames of a neutral character we can only surmise. Possibly they were designed for portraits to be presented to persons with whose tastes the giver was unfamiliar.

Unless the whole thing is a mystification we must, then, apparently entirely dismiss Locquin's famous quotation and his interpretation of it. Thereafter we come again to the year 1761 when we find Marigny a fully-fledged modernist as regards furniture and interior decoration. This, however, is only the official Marigny; of Marigny in his private capacity, in that year, we still know nothing.

Not until 3rd July 1763 have we documentary proof that Marigny acquired furniture for his own use which must have been appreciably different from ordinary rococo furniture. On that date, according to a still-existing bill[14] from the upholsterer Antoine Godefroy, 12 chaises, 12 fauteuils, 4 fauteuils en bergère, and 5 canapés were delivered to Marigny. The furniture was made for a large, tent-shaped pavilion, designed by Soufflot, in Marigny's garden in Faubourg du Roule. The bill reveals only one thing which, in this connexion, is of interest, namely, that the legs were 'a gaines avec des plintes caré [sic]'. There is no doubt that a gaines means straight tapering legs and, likewise, that avec des plintes caré signifies that the legs had cubical blocks, either above the capitals at the top or above the feet at the bottom, but which it is not now possible to determine.[15]

About two-and-a-half years later Marigny himself comes to our aid with a letter to Soufflot, dated 18th January 1764.[16] The letter concerns changes to be made in the house Rue Saint-Thomas-du-Louvre, where Marigny had his private dwelling. Here, a dining-room is to be turned into a music room. About this Marigny writes: 'Je demande a Soufflot de me faire pour la boiserie de cette piece, un dessein de bon goust miparti grecquerie.'[17]

To judge the meaning of the expression 'miparti grecquerie' we should bear in mind that there is a difference between goût grec and that which a later generation has called the Louis XVI style. Neo-classicism manifested itself in several guises. One aspect of it is represented by Lalive de Jully's heavy and somewhat ornate furniture and its direct sequel, as seen, for example, in several pieces of Leleu's furniture and in ornamental prints by Neufforge and Delafosse. During the eighteenth century this was called, among other things, le style mâle. Another aspect is the better known, more subdued and lighter and more elegant version. An ébéniste like Riesener seems to have worked in both idioms.

There can hardly be any doubt that Marigny personally preferred the latter, moderate version, and that it was this he meant when he used the expression 'miparti grecquerie'. We should bear in mind that he wrote this to Soufflot, who was an exponent of the purest form of neo-classicism, and who, undoubtedly, never in his life designed anything that could be termed en rocaille. Marigny wrote this to the same Soufflot who, in 1768 (not 1760 as has often been claimed) designed Marigny's new, wholly Palladian villa in the Faubourg du Roule, which we know from the three drawings of it now in the collections of the Musée Carnavalet.[18] In a letter from the period, dated 12th June 1768,[19] Marigny writes to Soufflot regarding his new house at Roule: '. . . Quant a la decoration je m'en raporte entierement a vous; je vous la demande d'aussi bon gout que la facade que vous m'avez donné.' A clearer expression of Marigny's attitude can hardly be demanded. And here it is worth recalling that Marigny sent his instructions to Soufflot the same year that Guillaumot published his book in which the quotation already mentioned appeared: 'Il a le premier eu le courage d'introduire dans sa maison des meubles de bon goût, & de les décorer d'ornemens sages . . .' Moreover, it is certain that Guillaumot had finished the manuscript of his book at least two weeks before Marigny wrote his letter, dated 12th June, to Soufflot. Cochin's approbation at the end of Guillaumot's book is dated 27th May 1768. This gives another proof that the furnishing of the new house in Faubourg du Roule was not Marigny's first venture in the new style.

If, then, we can take it for granted that Marigny, in 1761 at any rate, officially supported neo-classicism, there still remains the question of when he began to do so.

Marigny's twenty-one months' study trip in Italy, 1749–51, accompanied by Cochin, Soufflot and l'Abbé le Blanc, has often been described, and it is well known that Cochin – rightly or wrongly – regarded this journey as epoch-making in many respects. '. . . la véritable époque décisive', he said, 'ç'a été le retour de M. de Marigny d'Italie et de sa compagnie. Nous avions vu et vu avec réflexion. Le ridicule [i.e., the rococo] nous parut à tous bien sensible et nous ne nous en tûmes point . . .'[20]

99 *Portrait of Le Marquis de Marigny*, by Louis Tocqué. Signed and dated 1755. 134.6 by 104.1 cm. (Château de Versailles).

Nevertheless, in the portrait painted by Tocqué in 1755 we find Marigny standing by a writing-table in pure rococo style (Fig. 99). This portrait,[21] also, was to be hung in an important place, *viz.* l'Académie de Peinture, where Cochin held the post of *secrétaire perpétuel*. We do not know what Cochin thought of the portrait, but inasmuch as a writing-table of this type was probably found at the time in every well-to-do home in Paris, there can have been nothing shocking to the current taste in the fact that a similar piece of furniture figured in Marigny's portrait, the more so as in 1755 there can hardly have existed a single example of neo-classic furniture in Paris; not even Lalive de Jully's furniture *à la grecque* could have been finished so early.

But already the following year the tune was about to change. On 18th May 1756 Marigny asked the Academy of Architecture whether, among the subjects of the competitions arranged by the Academy, there would be '*des décorations d'intérieur de palais pour corriger le mauvais goust d'ornemens qui subsiste aujourd'hui*'. Hautecœur,[22] who has called attention to this, is in no doubt that Soufflot and Cochin stood behind the inquiry. If this is true, it is not difficult to imagine what the two artists thought, and perhaps said, when they saw Tocqué's portrait of Marigny.

With the scant knowledge we as yet possess, therefore, we are forced to limit ourselves to saying that while it is well known that le Marquis de Marigny had for some time favoured neo-classicism in architecture, it was not until some time – which cannot yet be definitely deter-

mined – between 1755 and 1761 that he also advocated the new style for furniture and interior decoration.[23]

APPENDIX

It should be noted that Honoré Guibert's above-mentioned bill concerns sixteen frames made by him in 1760 and that, according to the descriptions, all sixteen were in neo-classic style. In the same folder are found bills (Nos. 18 and 18 *bis*) for frames '*faites et fourni . . . sous les Ordres de Monsieur Le Marquis De Marigny*' for two other portraits which also were shown at the Salon of 1761 a portrait of the King, painted by Louis-Michel Van Loo, and Greuze's portrait of the Dauphin. The frame for the King's portrait was very much like Marigny's but was much richer and cost more than five times as much. The description runs as follows:

. . . Elle est ornée d'oves à l'antique sur le carderon de feuilles d'eau et de perles en filées: le tout très recherché. Le couronnement est composé de l'Écu de france avec les Coliers des ordres de St Michel et du S. Esprit: et pour Supports des Drapeaux, trompettes, casques, faisceaux, Lances, haches, Epées, et des Boucliers historiés: le tout de grandeur naturelle: De ce couronnement partent des Guirlandes de Laurier en trois parties, agraffées par des rubans à une fleur de lys à chacun des angles superieurs faite de deux branches de Laurier agencé en couronnes soutenües par des noeds de ruban: des memes guirlandes tombent au milieu du profil et servent à attacher des trophées et ensuite font chûte sur les angles inferieurs où elles sont encore agraffées et enfin elles viennent au milieu du Soubassement se terminer en forme de couronne au dessus d'un Bouclier ovale sur lequel est tracé le Chiffre du Roi en Lettres formées de branches d'Olivier et de Rainceaux d'ornemens. La largeur du Cadre est grouppée de deux Palmes du Caducée et du miroir de la prudence: ces ornements, excepté les Oves Perles et Chapeles ont été appliqués sur le profil après avoir été aussi sculptées separement et appliquées sur la dorure.

In Saint-Aubin's catalogue (Fig. 100) this frame is also sketched and there is complete agreement between the sketch and the above description by Guibert. The same is true of the frame around Greuze's portrait of the Dauphin (Fig. 101). Guibert's description of the latter is as follows: '. . . *Le couronnement est orné de fleurs et deux branches de Laurier liées par un noeud de ruban d'où partent deux Guirlandes de fleurs agraffées aux deux angles du haut et retombent au milieu du cadre . . .*'.

Thus we have documentary evidence of eighteen neo-classical frames from 1760 to 1761, a fact which does not appear to be generally known in the history of picture frames. A few other frames are found in Saint-Aubin's catalogue, all of them neo-classical. He did not sketch a single rococo frame in his catalogue. Most of

100 *Sketch of L.-M. Van Loo's portrait of Louis XV*, by Gabriel de Saint-Aubin, in the artist's copy of the Catalogue to the Salon of 1761. (Bibliothèque Nationale, Paris).

101 *Sketch of Greuze's portrait of the Dauphin*, by Gabriel de Saint-Aubin, in the artist's copy of the Catalogue to the Salon of 1761. (Bibliothèque Nationale, Paris).

the paintings he drew without frames. The conclusion would therefore seem warranted that Saint-Aubin drew the neo-classical frames because they struck him as something entirely new and strange.

1968

OTTO KURZ

Hagenauer, Posch, and Mozart

It was only in recent years that the name of the sculptor Johann Hagenauer (1732–1810) became known outside his native Austria. The Museum of Art at Cleveland, Ohio,[1] and the Victoria and Albert Museum in London[2] acquired works from his hand, and in two international loan exhibitions (Munich 1958, Baltimore 1959) Hagenauer appeared among the representative artists of the 'Age of Rococo'.

Johann Hagenauer was born at Strass (Upper Bavaria) in 1732 as the son of poor peasants.[3] One day when as a child he was sent to Salzburg to sell firewood, a wealthy local merchant, Lorenz Hagenauer, became interested in the bright and gifted boy who bore the same family name; later he enabled him to study sculpture. The young sculptor could not have found a kinder protector than Lorenz Hagenauer who happened to be the landlord of the Mozart family. He owned the house which is now the Mozart Museum at Salzburg. When father Mozart toured the world with his two infant prodigies Wolfgang and Nannerl, he sent long reports of the daily happenings and successes to his landlord and friend who was always ready to help or to look after the interests of his protégés.

Hagenauer's first known work (1753), a spirited *Glorification of St Lawrence* in the best Bavaro-Austrian tradition, was evidently commissioned by his protector as it shows his coat-of-arms, and was made as a shrine for relics of his patron saint.[4] The flame-like rococo cartouche shows that the young artist followed the latest Parisian fashion which he knew presumably not directly, but from the ornamental engravings which were published at Augsburg and spread the new style all over Europe.[5]

Although already an accomplished artist, Hagenauer decided in 1754 to go to Vienna to study at the Academy there. After having finished his studies he went to Italy 'in order to reach greater perfection'. Our information about his stay in Italy comes from the summary of the *curriculum vitae* which Hagenauer wrote in 1774 when he applied for a professorship at the Vienna Academy.[6] He states there that he studied under distinguished Italian masters, won first prizes at academic competitions in Bologna, Florence, and Rome, and became an associate of the Bolognese Academy.

Hagenauer's modern biographers have lamented the complete lack of works and documents from the years 1759 to 1765. It is possible to fill this gap to a certain extent. One of Hagenauer's Italian works is still extant and belongs to the Accademia di Belle Arti at Bologna. A hundred years ago it was still exhibited, but later it was relegated to the cellars and forgotten until Dr Silla Zamboni rediscovered it a short while ago.[7]

The terra-cotta relief represents *Quintus Curtius leaping on horseback into the chasm which suddenly opened on the Roman Forum* (Fig. 102).[8] If it were a work of ancient art and came from an excavation, one would describe it as excellently preserved; but as it dates from 1763 one has to state that it is badly cracked and rather damaged. Both the forearms of the hero and the hoofs of the horse are now missing.

There were quite a few artists (like Altdorfer, Pordenone, Paolo Veronese, etc.) who depicted the death leap of Quintus Curtius in frontal foreshortening, but what looks exciting in a sketch, or on a façade or even on a ceiling, produces a strange and even slightly absurd effect in a three-dimensional work of art. This is not due to the fact that the onlooker has to imagine himself inside the chasm – this would equally apply to the painted versions – but to the artist's not very successful attempt to weld together a relief and a sculpture in the round.[9] It was a daring attempt which did not come off, and led to incongruities like the jumping hero planting his right foot firmly against something which suggests firm ground but is nothing but the surface of the relief.

102 *Quintus Curtius*, by Johann Hagenauer. Terra-cotta, 66 by 48 cm. (Accademia di Belle Arti, Bologna.)

When on 4th June 1763 a commission of the Bolognese Academy of Fine Arts met in order to award the first prize in sculpture, the three judges, the sculptors Domenico Piò (d.1799), Ercole Lelli (1703–1766) and Angelo Piò (1690–1770) gave it unanimously to the young artist from Salzburg for his *Quintus Curtius* relief.[10] True, he was the only candidate, but the judges were careful to point out that it was not the absence of other competitors, but the merit of the work which they took into consideration. It was presumably the unconventional and daring treatment of the scene which impressed them so much. The entry in the minutes reads:[11]

Alli 4 di Giugno 1763 adunaronsi in una delle camere della Scuola delle Statue li tre Giudici della Scultura Sig. Domenico Piò Principe, Sig. Lelli Viceprincipe, Sig. Angnolo (sic) Piò, col Vicesecretario Pesci. Non eravi che un solo Concorrente per la Prima Classe, ma pare di tanto merito l'opera di esso, che fu giudicato degno del Premio. Anzi fu giudicato che sarebbe stato difficile, anchorchè vi fussero stati altri Concorrenti, che alcuno glielo avesse potuto contrastare. Fu dunque destinato a Premi Marsigli Aldrovandi

Per la Prima Classe della Scoltura Giovanni Hagenaver di Salisburgo.

In Italy Hagenauer won not only academic prizes and brought together a collection of plaster casts after ancient sculptures,[12] he met there also his future wife, Rosa Barducci, who had a talent for painting and was apparently a 'character'.[13] The marriage was solem-

nised in Salzburg Cathedral on 26th November 1764. Father Mozart was then in London and had to send the bridegroom his congratulations by letter. Soon after his return Madame Rosa, as she was always referred to, her husband the archiepiscopal court *statuarius*, and the four Mozarts became intimate friends.

On 12th December 1769 Leopold Mozart and the 13-year-old Wolfgang Amadeus left Salzburg for their first Italian concert tour. Already on the following day, when they had stopped for the night at Wörgl in the Tyrol, Wolfgang sat down to write a letter to his sister Nannerl (in Italian as a language exercise) asking her to give '*un Complimento a tutti miei buoni amici al sig. Hagenauer (al mercante) alla sua moglie, ai suoi figli e figlie, alla Signora Rosa e al suo marito*'.[14] From Bologna, where Mozart father and son arrived in March 1770, Leopold was able to write home: 'What especially pleases me is that Wolfgang is admired here even more than he has been in all the other towns of Italy; the reason is that Bologna is the centre and dwelling-place of many masters, artists and scholars.' In those days of triumph, when they were busy playing and listening to music, being fêted and meeting people, they managed somehow to find time for sightseeing, and did not fail to pay a visit to the *Quintus Curtius* of their compatriot and friend. 'We have been to the Institute', wrote Leopold to his wife, 'and have admired the fine statue of our Court Statuarius'.[15] The Accademia Clementina was then a section of the Istituto delle Scienze. 'What I have seen in Bologna surpasses the British Museum. For here one can see not only the rarities of nature but everything that deserves the name of science preserved like a dictionary in beautiful rooms and in a clear and orderly fashion. Indeed you would be amazed.'

The sculptor Hagenauer was by no means forgotten in Bologna. 'Herr Brinsecchi and many persons have been asking for our Court Statuarius.' And in August, when the two Mozarts stayed again in Bologna on their way home from Naples and Rome, they met a Dominican from Bohemia called Pater Cantor, who told them that he had been Hagenauer's father confessor.[16] The least Mozart father and son could do was to follow the example of their friend. So they confessed to Pater Cantor, received communion, and attended his mass. Father Mozart wrote afterwards to his wife: 'You ought to have two fine gold haloes made for us in Salzburg; for we shall certainly return home as saints.'[17]

'Is it true that Hagenauer has been appointed Professor of Sculpture in Vienna?' Wolfgang Amadeus asked his sister from Munich on 30th December 1774.[18]

It was more than a polite interest in the career of a friend. Mozart was trying desperately to escape from the unbearable life at Salzburg and its constant humiliations. In a letter written a few weeks later father Mozart underlined the personal implication:[19] 'They rightly fear in Salzburg lest one bird after another may fly away; since Hagenauer Statuarius has also taken another appointment.'[20] A few years had to pass before Mozart could follow Hagenauer's lead by giving up the hated servitude under the Philistine archbishop for the freedom of Vienna. But while Hagenauer in his position had at least a regular income, for Mozart these Viennese years were an unending struggle against poverty and debts.

When in 1774 Hagenauer left Salzburg for Vienna, a faithful pupil went with him, the Tyrolese Leonhard Posch (1750–1831).[21] Posch worked in Vienna as Hagenauer's assistant, but when a serious illness forced him to give up stone carving for less strenuous work, he discovered his true vocation, the modelling of small portrait medallions in wax. Posch became a fashionable portraitist first of Austrian, and later in life, after he had moved to Berlin, of German society. Today he is best remembered for his fine portrait of Goethe, and above all for his wax relief of Mozart. Constanze Mozart regarded it and the painting by Lange as the two best likenesses of her late husband.[22] The original was apparently the relief which until the last war belonged to the Mozartmuseum at Salzburg and which is now lost.[23] Posch used to sell replicas of it in wax as well as in plaster.[24]

Posch's *oeuvre* consists almost entirely of these portrait medallions in which a typically neo-classical stress on outlines is happily blended with a rococo liveliness of modelling. His predilection for blue backgrounds shows the influence of the then fashionable Wedgwood ware. Only occasionally did Posch try his hand at some other task. In the autobiography which he wrote in old age, he says:[25]

> A Count Daben, who is better known under the assumed name Müller and as the owner of a waxwork cabinet, used my wax sculptures to give them a lifelike appearance by colouring them and providing them with real hair. In the 'nineties we produced together portraits of the Emperor, the Empress and their children, which were such a success that their Majesties decided to send them as gifts to Naples where the Empress was born. We were commanded to deliver them there. At the same time we were asked to model the whole royal family there; in

103 *King Ferdinand IV of Naples*, by Leonhard Posch and Count Josef Deym. Wax. (National Library, Vienna.)

104 Another view of the wax bust illustrated in Fig. 103.

addition I had to produce casts of the most outstanding works of ancient art. Thus I went to Naples in 1793, where I was very busy in my profession, and returned to Vienna only in 1795.

Of these portraits in wax made at Naples one is still in existence, the bust of King Ferdinand IV (Figs. 103 and 104), in which in Schlosser's words, 'realism becomes almost an indiscretion'.[26] As in Goya's royal portraits, which date from these same years, one is never quite sure whether one should speak of portraiture or *lèse-majesté*.[27] The portrait turns out to be the work of two artists: Leonhard Posch who modelled the head, and 'Müller or 'Count Daben' who imparted to it its frightening lifelike appearance by colouring it, dressing it with a real uniform, and providing it with the traditional characteristics of waxwork figures, glass eyes, and real hair.

In his masterly *History of Portrait Sculpture in Wax* Julius von Schlosser has traced this now despised branch of art back to its two venerable roots: the effigy of the deceased in classical funerary rites, and the votive figure. The coloured life-size wax figure with real hair, with its pretence to be life itself, has for long been the stock example by which all writers on aesthetics tried to prove that extremes of realism can never produce real art; and in spite of all theory, in spite of being banned to the wax-work cabinet or the fairground, from time to time great artists regarded coloured wax as a congenial medium.

In Austria the imperial collections contained such wax images at least since the sixteenth century. When Lady Mary Wortley Montagu was shown round the Imperial Treasury in Vienna in 1716, she remarked: 'The next Cabinet diverted me yet better, being nothing else but a panel of wax babies and toys in ivory,

very well worthy to be presented to children of 5 years old.'[28] The first public waxwork cabinet was opened in Paris under Louis XIV by Antoine Benoist (1632–1717). When Bernini first heard about it during his stay in Paris, he thought such wax figures were *cosa di donne*, but after having seen them he had to revise his hasty judgment.[29] Benoist was not the only artist of renown who did not despise coloured wax. Among other sculptors who produced such waxwork figures with real hair and dress one could quote the Bolognese Angelo Piò, whom we have met among the judges in the competition in which Johann Hagenauer won the first prize, or Carlo Bartolomeo Rastrelli (1670–1744).[30]

To come back to the bust of King Ferdinand IV. The count who dressed and coloured the neo-classical bust by Leonhard Posch is by no means an unknown personality. His real name was not Daben, as Posch called him, but Deym, to be exact Count Josef Deym von Stritetz (1750–1804). After having killed his adversary in a duel, he had to flee and assumed the truly inconspicuous name Joseph Müller. A gift for modelling suggested to him the opening of a waxwork show, the first one ever seen in Vienna.[31] It was an immediate success and became one of the main sights of Vienna. One day his exhibition was visited by the Countess Brunsvik with her two daughters Theresa and Josephine, two ladies well known from the biography of Beethoven, although neither was, as had been claimed, the composer's mysterious 'immortal love'. Josephine and 'Müller' at once fell in love, but in order to gain her hand the modest modeller of wax figures had to reveal his true identity.

Count Deym's exhibition must have been a remarkable sight. He certainly provided for every taste. One could listen to, and watch a 'mechanical canary bird', or study the anatomical figure of a pregnant woman. One could admire works by Georg Raphael Donner,[32] and the famous *Charakterköpfe* of Franz Xaver Messerschmidt.[33]

There was a life-size group of the family of the King of Naples made of a newly invented wax mixture which was said to imitate flesh to perfection.[34] The bust of King Ferdinand IV in the Library at Vienna (Figs. 103 and 104) served evidently as a study from life for this group portrait.

The two main attractions were, however, Laudon's Mausoleum and the 'Bedroom of the Graces'. The Mausoleum was a cenotaph with wax figures erected in honour of the Austrian field-marshal Laudon. A contemporary advertisement tells us: 'Each hour a suitable funeral music, especially written for the purpose by the unforgettable composer Mozart, is to be heard, which lasts eight minutes and in precision and purity surpasses anything that was ever attempted to be suitably applied to this kind of artistic work.'[35] Of a different, and certainly a wider, appeal was the 'Bedroom of the Graces'. Here one could gaze at a 'fair sleeper' (still in our days an attraction in similar exhibitions), 'illuminated in the evening by alabaster lamps', if one's attention were not too much distracted by the three Graces which gave the room its name and which consisted of a statue of the Venus Kallipygos reflected in three mirrors. The statue itself was one of the casts which Leonhard Posch had brought back from Naples. 'A glorious flute music, as though inspired by the breath of love, resounds without its being possible to tell whence the magic notes come. It is an Adagio by the unforgettable Mozart.'[36]

These compositions were written by Mozart specially for Count Deym's waxwork cabinet. In the catalogue of his own works Mozart entered three compositions for a musical automaton, or clock (*Uhr*) as he called it.[37] Of one of these we know that Mozart had to force himself to write it for the sake of earning some money. In a letter to his wife from Frankfurt on the Main (31st October 1790) he complained bitterly: 'I have now made up my mind to compose at once the Adagio for the clockmaker and then to slip a few ducats into the hands of my dear little wife. And this I have done, but as it is a kind of composition which I detest, I have unfortunately not been able to finish it. I compose a bit of it every day – but I have to break off now and then, as I get bored. And indeed I would give the whole thing up, if I had not such an important reason to go on with it. But I still hope that I shall be able to force myself gradually to finish it.' It was certainly not an aversion to mechanical music which made Mozart detest this commission.[38] He goes on: 'If it were for a large instrument and the work would sound like an organ piece, then I might get some fun out of it. But, as it is, the works consist solely of little pipes, which sound too high-pitched and too childish for my taste.'[39]

When Mozart died on 5th December 1791, it was Count Deym who took his death mask.[40] The manuscripts of two of the compositions which Mozart wrote for Deym's Gallery belonged later to Beethoven who received them, as has plausibly been suggested, from Countess Josephine Deym, *née* Brunsvik.[41] The wax figures which Posch and Deym produced in collaboration were certainly in good company. 'Mingle with the mighty', as the advertisements of a famous modern waxwork cabinet might say.

HUGH HONOUR

The Galleria d'Arte Moderna, Florence

High up on the top floor of Palazzo Pitti, the Galleria d'Arte Moderna used to be a place where, even at the height of the tourist season, one could be sure to escape the crowds jostling through every other Florentine museum. None but the most energetic and adventurous climbed the one-hundred-and-forty stone steps (I have counted them) leading up to its many dowdy rooms which had been little changed since 1924. And there were few if any protests when it was closed for a complete rearrangement. Now the first twelve rooms have been re-opened. They are a revelation. Thanks to the initiative of Dr Sandra Pinto the gallery has been transformed into the most immediately attractive museum of nineteenth-century art in Italy.

These twelve rooms are arranged as an exhibition (of indefinite duration) entitled *Cultura neoclassica e romantica nella Toscana Granducale* and provided with a fully illustrated and exceptionally well documented catalogue based on a great deal of original research in the archives and early nineteenth-century periodicals. Careful scholarship has also played a part in determining even the smallest details in the decoration of the galleries, from the terrazza floors to the wall-hangings, curtains and pelmets, from the design of pedestals for sculpture to the selection of furniture and such decorative objects as clocks and candelabra – all catalogued by Alvar Gonzalez-Palacios. Works of art and decorations thus combine to evoke the atmosphere of Florence in the Empire and Restoration periods.

The majority of the works of art have been in the possession of the Florentine Galleries since the expulsion of the last Grand Duke in 1859. But few of these had been on show in recent years. Some were in the store-rooms while others were lent to various public buildings including the law court of Florence and the Prefetture of Pistoia and La Spezia, whence they have

only now been retrieved. An endearingly absurd painting; of Dante on the beach at Ravenna by Domenico Petarlini, for instance, was placed in the Accademia di Belle Arti in 1867, lent to the Accademia della Crusca 1915–23, to the Casa del Fascio 1929–44, then to the Post Office from 1950 until last year. But some of the exhibits are recent acquisitions ('*acq. presso l'Ufficio Esportazione di Firenze*' to use the official jargon). A number come from other public collections in Florence – self-portraits from the Uffizi and Bartolini *gessi* from S. Salvi. And a few are on loan, notably the enchanting portrait group of the Niccolini family formerly ascribed to Bezzuoli but, as the catalogue shows, in fact by the very little known Giuseppe Colzi de' Cavalcanti.

It is more than a little difficult to select works for special mention from a collection which includes so much that is unfamiliar even to specialists and so little by artists whose names are known outside the company of Ottocento addicts. And almost inevitably several of the most striking works are those which have been exhibited and illustrated from time to time – Tommaso Minardi's exquisite self-portrait, the image of a hypersensitive young artist in his studio, Pietro Benvenuti's masterpiece '*Il giuramento dei Sassoni*' which almost ranks with the great Napoleonic machines of Gros, Francesco Hayez's *Sampson*, Giuseppe Sabatelli's *Farinata degli Uberti*, a resonant mediaeval battle-piece, and Giovanni Dupré's statues of *Cain* and *Abel*, outstanding mid-nineteenth-century works of sculpture.

Perhaps the major discovery is Canova's bust of the muse *Calliope* which has generally been ignored or dismissed as a copy though its quality is alone enough to reveal that it is an autograph work (Fig. 105). As Dr Pinto demonstrates it is, in fact, identical with the bust which Canova completed for Giovanni Rosini in 1812 in the same year as his somewhat similar *Helen* for Isabella Albrizzi Teotochi. Other notable pieces of

105 *Calliope* by Antonio Canova. 1812. Marble, ht 46 cm. (Galleria d'Arte Moderna, Florence).

106 *Alexander placing his seal on the mouth of Hephaestion*, attributed to Louis Gauffier. c.1789. 95 by 73 cm. (Galleria d'Arte Moderna, Florence).

sculpture include Bartolini's model for the Demidoff monument, Tenerani's *Psyche* which inspired a eulogy from Pietro Giordani, *gessi* by Francesco Pozzi and Luigi Pampaloni. There are also several busts by Giovanni Bastianini who is less well known as the sculptor of such original works than as an expert faker.

Walking through these rooms one's eye is caught again and again by Italian renderings of themes which were popular with artists of the same period in northern Europe – scenes from the lives of Dante and Tasso, of course, but also Christopher Columbus, Mary Queen of Scots and even the blind Milton (the latter by Enrico Fanfani). Monastic and church interiors seem to derive from the type originated in France by F.-M. Granet. There are scenes from the lives of artists similar to those which figured in the Paris *Salons* of the *Restauration* – Cimabue discovering Giotto,

Dante introducing a smooth-cheeked Giotto to Guido da Ravenna, Brunelleschi and his egg, Luca Pacioli presenting Leonardo to Lodovico il Moro, Benvenuto Cellini dictating his memoirs while working on his *Perseus*. There are some splendidly operatic mediaeval pieces which sometimes recall the melodies as well as the titles of early Verdi operas – *La battaglia di Legnano* complete with trumpeters in full bray by Amos Cassioli, and *I due Foscari* by Hayez. Mediaevalism is combined with necrophilia in Enrico Pollastrini's *Nello at the Grave of Pia*. A roomful of landscapes includes some remarkable scenes of natural destruction by Giovanni (father of the more famous Telemaco) Signorini. Middle-Eastern subjects – notably some sketches of Egyptian fellaheen – appear in a room devoted to the work of Stefano Ussi. Another room is hung with religious paintings mainly by the *Puristi* who

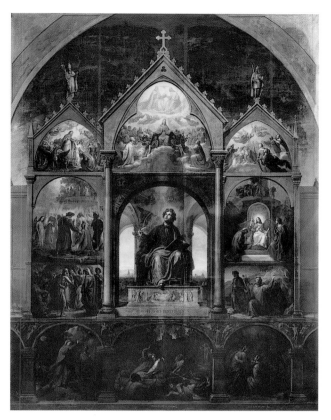

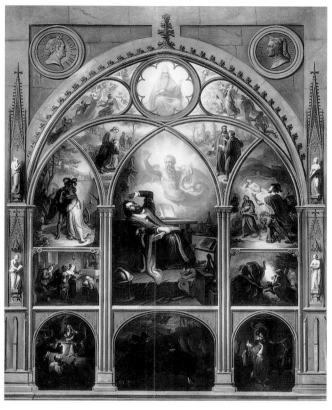

107 *The Divine Comedy*, by Carl Vogel von Vogelstein. 1842–44. Oil on paper, 232.5 by 176.5 cm (Galleria d'Arte Moderna, Florence).

108 *Faust*, by Carl Vogel von Vogelstein. 1854–55. Canvas, 232 by 179 cm. (Galleria d'Arte Moderna, Florence).

are now beginning to awaken the interest of scholars in Italy (selections from their theoretical writings are collected in Dr Paola Barocchi's excellent *Testimonianze e polemiche figurative in Italia* just issued by G. D'Anna, Messina-Florence).

But the collection is not confined to works by Italian artists. One of the most interesting of the earlier pictures, *Alexander placing his seal on the mouth of Hephaestion* is convincingly attributed to Louis Gauffier who is known to have exhibited a painting of this unusual subject at the *Salon* in 1789 (Fig. 106). There is a large classical landscape by Nicolas-Didier Boguet and there are portraits by F.-X. Fabre who spent so many years in Florence. A little shipwreck scene appears to be French though one may doubt the optimistic attribution to Géricault. A spirited equestrian portrait of Anatole Demidoff by the Russian painter Karl Pawlowitsch Brjuloff of 1828, and a sedate portrait of his wife, Princess Matilde Bonaparte by Ary Scheffer are both distinguished works in their very different ways. Ludwig Richter is represented by a poetic little landscape. But of non-Italian works the most interesting are those by Karl Vogel von Vogelstein – a striking self-portrait, a perhaps too sugary *Suffer the Little Children to Come unto Me*, and two vast pictures like stained-glass windows, devoted to the *Divine Comedy* and to *Faust*, which are notable examples of German late Romantic painting (Figs.107 and 108).

In short, these new rooms in the Galleria d'Arte Moderna will fascinate anyone interested in the wilder reaches of nineteenth-century art. And for those bent on investigating the Ottocento – as earlier generations of Italophiles 'discovered' the Seicento and the Settecento – they provide an ideal point of departure.

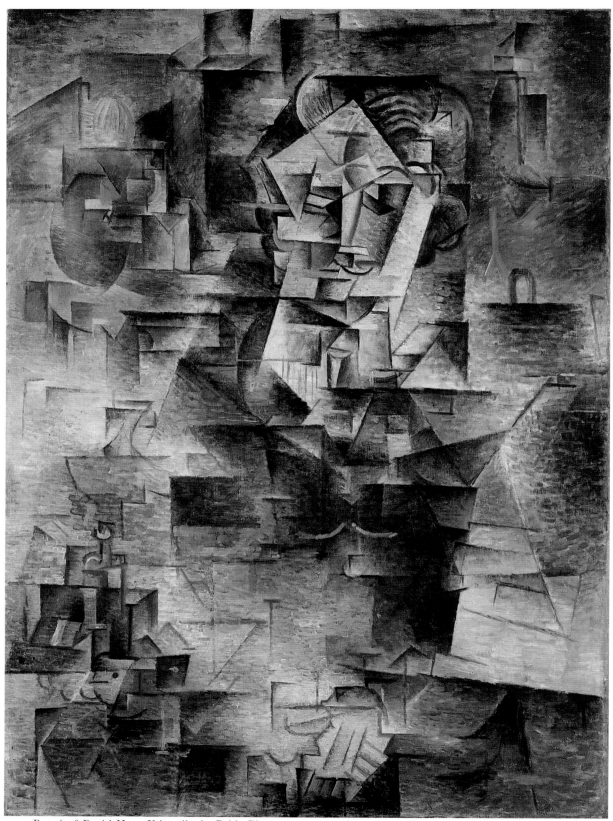

109. *Portrait of Daniel-Henry Kahnweiler*, by Pablo Picasso. 1910. 101.1 by 73.3 cm. (Art Institute of Chicago). Gift of Mrs Gilbert W. Chapman in memory of Charles B. Godspeed.

ROLAND PENROSE

Picasso's portrait of Kahnweiler

When I was asked by the Directors of the Burlington Magazine to follow on from Kenneth Clark's admirable lecture on the *Mona Lisa* with a lecture on a portrait painted by Picasso,* I decided to choose a painting which has caused a great deal of controversy and which marks the zenith of a movement which has been fundamental in the many revolutionary changes that have taken place in the art of this century. The portrait of Daniel-Henry Kahnweiler (Fig. 109) is for many reasons a unique and fascinating work. Kenneth Clark, in his introduction to his lecture said 'Some of the greatest pictures ever painted have been portraits . . . and yet the aesthetic theory of the last seventy years runs entirely counter to the fact of experience that a truthful likeness to an individual can be a great work of art.'

Picasso painted many portraits which were undoubtedly truthful likenesses but I have deliberately chosen one which cannot easily be qualified as a likeness to the sitter or even a likeness of the human form. It was, in fact, considered by many critics when it was painted to be an outrage to all that can be labelled serious art.

This painting therefore raises many urgent questions. First of all we may ask why a young artist who had shown his ability to paint convincing lifelike portraits since his early youth should produce, with great diligence, a portrait of a close friend which bears no obvious resemblance to his model. If indeed his motive was not portraiture in the usual sense but rather an exercise in the invention of a new style, why did he choose to have a model before him all the time he was painting it and insist that it was a serious attempt to create a realistic likeness of his friend? Was he naively perpetrating a mystification, insulting tradition and viciously mocking all serious belief in art? These were, in fact the motives that have frequently been attributed not only to this work but to the greater part of Picasso's production.

What I wish to consider is what in Picasso's career led up to this painting and whether it should be thought of as the beginning of a new conception of portraiture or as a brilliant attempt which failed.

Pablo Picasso, as we know, began life with a most unusual talent for expressing himself in drawing and painting. Encouraged by his father, who was himself a competent though uninspired painter (a badly paid art master who imposed on his son strictly academic rules), young Pablo took to painting as naturally as a bird learns to fly. Already, when he arrived in Paris in 1900 at the age of nineteen, he had outgrown all that art schools could teach him. He rapidly found the atmosphere he needed, not only among experienced painters and sculptors but also among poets such as Max Jacob, Alfred Jarry, André Salmon, Pierre Reverdy, Maurice Raynal and Guillaume Apollinaire.

The early years were not easy. He lived in great poverty but his personality, his eager searching black eyes and his talent found a response in collectors such as Gertrude Stein and her brothers who had settled in Paris, and from dealers. Within six years of his first arrival he had risen from a condition close to starvation to being the centre of a tumultuous group of artists and poets in Montmartre who came to be known as '*La Bande Picasso*' and to the position of a young painter recognised for the emotional power of his work. Pictures of these years known as the 'Blue Period' are now in high demand. They were followed by the even more seductive paintings of the 'Rose Period'.

The climacteric period began, however, in 1906. It centred, surprisingly, first around a portrait. Picasso had become intrigued by the originality of Gertrude Stein and appreciated her enthusiasm for *avant garde* activities. She had recently bought Cézanne's portrait of his wife and it was in her salon in the rue de Fleurus that he met many of the élite in the world of art and

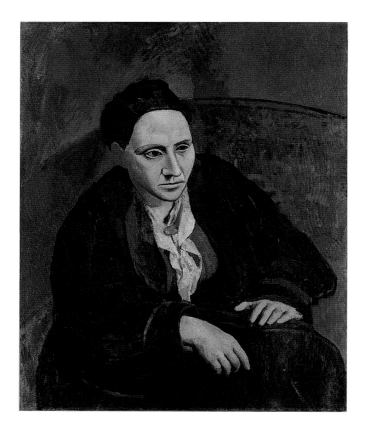

literature. Among her friends also were Matisse, Derain, Gris and Braque, Visits were returned by Gertrude and her brothers, Leo and Allan to Picasso in his bohemian quarters in the Montmartre studios known as the Bateau Lavoir.

With his ability to draw a likeness with incredible speed, Picasso made many drawings of his friends, often choosing those like Leo Stein whose long legs, gold-rimmed spectacles and bushy black beard made him easy prey for caricature. The Steins were among the first to buy Blue Period paintings. They were fascinated by the talent of Picasso just as they were captivated by his manner and the fire in the blackness of his eyes. Leo had made a collection of rare books of which he was particularly proud but told Picasso that he could not trust him to look at them because he felt sure his eyes would burn holes through the pages.

It came as a surprise, however, to Gertrude that she should be asked by Picasso to sit for her portrait since it was then well known that he had found the actual presence of a model no longer necessary. The circus folk, his favourite subjects at that time, lived nearby, but were never asked to come and pose for him in his studio. But on this occasion, reverting to his earlier more conventional habits, Picasso made heavy demands on his sitter.

Gertrude Stein claims that she sat more than eighty times for her portrait. She describes her ordeal thus: 'Picasso sat very tight on his chair and very close to his canvas, and on a very small palette which was of uniform brown grey colour, mixed some more brown grey and the painting began'.[1]

To relieve the monotony, Picasso's mistress, Fernande of the beautiful almond-shaped eyes, read aloud stories from La Fontaine. Gertrude was only able to account for his unexpected demands and persistence by presuming that there was a mystic attraction binding together Spaniards and Americans.

As the weeks went by the likeness that appeared on the canvas pleased her but it slowly became apparent that it did not satisfy Picasso. Something was going wrong and 'all of a sudden' she tells us, 'one day

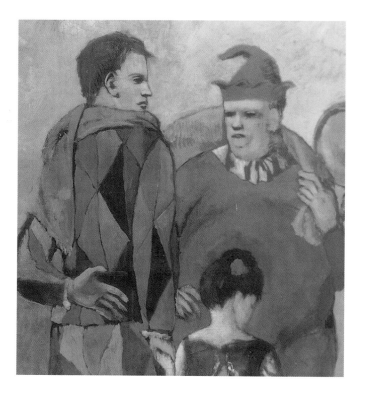

110. *Portrait of Gertrude Stein*, by Pablo Picasso. 1906. 100 by 81.3 cm. (The Metropolitan Museum of Art, New York, Fletcher Fund).

111. Detail from *Family of Saltimbanques or Les Bateliers*, by Pablo Picasso. 1905. (National Gallery of Art, Washington (D.C.), Chester Dale Collection)

Picasso painted out the whole head. "I can't see you any longer when I look", he said irritably. And so the picture was left like that' and he left for Spain. His journey this time lasted all summer. On his return, without seeing his model he painted in the head and presented the picture to Miss Stein. She accepted it graciously, but from others came severe criticism. They were shocked, they said, by the masklike severity of the face – to which Picasso replied with a cryptic remark, that has since become justified: 'Everybody thinks she is not at all like her portrait, but, never mind, in the end she will manage to look just like it'. Indeed, as it now hangs in the Metropolitan Museum in New York it is recognised by all as the most authentic portrait of that inventive and ebullient poet Gertrude Stein (Fig. 110).

There are several points in this story that are significant. The first is the doubt that grew in Picasso's attitude towards his own work. He endorsed instinctively Max Jacob's statement, 'Doubt, that is art', and owed his proverbial youthfulness throughout his life to the continuous questioning that he exerted on himself and his work.

With this in mind it is not surprising that he should have scrubbed out an unsatisfying likeness, but it is astonishing that after months abroad and without another glimpse of his sitter, his imagination and his visual memory should have been sufficient to allow him to paint a likeness so convincingly from memory.

We have ample proof that throughout his life Picasso enjoyed making portraits of his friends. In his early youth Pablo had been recognised as the family portrait painter. There are remarkably competent and expressive portraits of his parents, made when he was fourteen years old, and many excellent paintings and pastels of his aunt, his sister and friends of the family. But it is also evident that he found great interest in studying his own appearance. In innumerable drawings he proved that he was able to see himself not only full face but in profile. There are self-portraits in which he took pleasure in caricaturing himself among his friends or seeing himself dressed up in strange disguises, even as Pharaoh, although the most prevalent and significant was that of Harlequin (see Fig. 111). This desire to walk around himself and see himself from all points of view is obviously at the root of later discoveries in Cubism. By this time many changes had taken place and self-portraits became rare. When the romantic symbol of Harlequin in his diamond coat of many colours reappeared we find it incorporated into his work in a more abstract cubist form.

There is a dramatic self-portrait as early as 1901 in which we are given an expressive view of the privations he was suffering during his first year in Paris. By 1906 the early years of extreme poverty had changed to a more prosperous life, as may be seen from another self-portrait painted at about the same time as *Gertrude Stein* and with the same formal severity. His paintings were now selling well, not only to the Steins but also to buyers abroad such as the great Russian collector Shchukin.

The work of this period has qualities of classical perfection which make it seductive to all. Alfred Barr claims that these paintings 'have an unpretentious, natural nobility of order and gesture which makes the official guardians of the "Greek" tradition such as Ingres and Puvis de Chavannes seem vulgar and pallid.'

The optimism of the 'Rose Period' continued to show itself in paintings made during the following summer at Gosol, a village high in the Spanish Pyrenees. But before this visit began Picasso had been deeply impressed by some newly discovered pre-Roman Iberian bronzes (400–200 B.C.) which had been shown in the Louvre. As he passed through Barcelona he was again conscious of the strength of the Romanesque and the Gothic art of Catalonia and also his admiration of El Greco was rekindled. These influences first appeared in the final version of the portrait of Gertrude Stein and in the self-portrait painted on his return to Paris. Soon after, they were to burst out its that revolutionary painting which caused a great crisis; its Picasso's life and in the history of contemporary art, *Les Demoiselles d'Avignon*, painted in the winter and early spring of 1906–07.

In the autumn he had produced a series of nudes that show how his delight in classical charm had been dramatically sacrificed to a desire to represent forms with convincing solidity. He had emphasised their sculptural qualities to a point which was almost grotesque. These nudes showed a dissatisfaction with the past and a desire to discover new visions of reality. But again, doubt made him take abruptly a new direction. He adopted a style in which the forms were flattened, when he began to paint *Les Demoiselles*.

This painting which is now recognised as an event of major importance in the history of contemporary art is often called the first cubist painting and although it lacks that characteristic geometric stylisation which was to earn that movement its superficial title, it contains other basic cubist conceptions which are fundamentally more important. Without entering into a discourse on *Les Demoiselles* which has been liberally and very competently reviewed by many art historians, I would like to

112. *Portrait of Manuel Pallarés*, by Pablo Picasso. 1909. 67.9 by 49.5 cm. (Detroit Institute of Arts).

mention three characteristics which are relevant to the subject of this lecture.

The first is the multiple view-point implied in the lower figure on the right of the painting. It is portrayed from in front and behind as though we were moving around it.

The second is more basic in its implications. It is the fact that we are no longer presented with an imitation of what we consider to be reality but with an object, or rather the representation of objects on a flat surface which we are asked to consider in their own right rather than as a reminder of a something '*déjà vu*'. Picasso had introduced into painting the conception of an object as something that we *know*, instead of something we have only seen from a fixed point of view, limited in time and space. It can therefore claim to be an object, known and understood as we know objects in daily life which are subject to the element of time – objects which can move or which we can move around.

Finally, there is a third factor: the influence of tribal

art, chiefly from Africa. The recent discovery by a few painters, including Matisse and Derain, that there were powerful qualities both emotional and aesthetic, in objects that had formerly been dismissed as barbaric, was also welcomed by Picasso. Their first impulse was to enjoy them for their bizarre appearance. Picasso however saw, particularly in African sculpture, an attitude towards art and reality which since the renaissance had faded out of European art. He realised that its power was due, not to an attempt to imitate nature but to a creation of a new magical reality of its own. The idea came to him when *Les Demoiselles* was well advanced. The influence of Iberian sculpture is clearly visible in the eyes and faces of the three nude figures on the left of the painting, and he ruthlessly introduced his new conception of reality in the two figures on the right.

The outcry of horror when Picasso showed the picture to his friends was probably the most dramatic event in all his life . . . a life punctuated by the frequent scandals that his naturally rebellious spirit never ceased to provoke. Among the very few who were not outraged or sad that such a promising young painter should have gone mad was a young German who had settled in Paris as an art dealer . . . Daniel Henry Kahnweiler. He had recently become a friend of Picasso and was not only an admirer of his extraordinary talent but showed he was undeniably convinced by offering him his services as a dealer.

While Braque and Matisse looked at the new work, bewildered, Derain said sadly, 'one day we shall find Pablo has hanged himself behind his great canvas' and Leo Stein gave his verdict as 'Godalmighty Rubbish'. But Kahnweiler saw in it the birth of a new conception of art.

Picasso's forfeiture of his hard-won reputation was of no importance beside the internal struggle he went through as he realised 'that he could no longer be an artist who accepts without a challenge the dictates of his muse', said Apollinaire who was also a witness. The poet later discussed this drama in his book *The Cubist Painters*, stressing the difference between artists whose 'works do not pass through their intellect' and those who 'must draw everything from within themselves'. He added 'Never has there been so fantastic a spectacle as the metamorphosis he [Picasso] underwent in becoming an artist of the second kind.'

A self-portrait of 1907 reveals the change to a more introspective mood. In its deformations which emphasise the main features and simplify the structure of the head, it has affinities with the tribal masks of Africa.

With much enthusiasm and very good judgement,

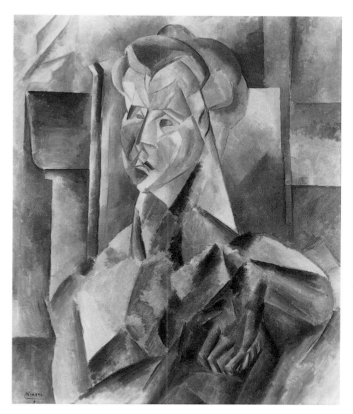

113. *Portrait of Clovis Sagot*, by Pablo Picasso. 1909. 82 by 66 cm. (Kunsthalle, Hamburg).

114. *La Femme en vert*, by Pablo Picasso. 1909. 100 by 81 cm. (Stedelijk Van Abbemuseum, Eindhoven).

Kahnweiler gave all the encouragement he could to Picasso and also to Braque, who rapidly recovered from the initial shock and saw the possibility of using this new conception of art as a means for the creation of a new style. The paintings he had made in the summer of 1908 were too revolutionary for the Salon d'Automne and were refused. But Kahnweiler had the courage and foresight to exhibit Braque's paintings in his gallery in the rue Vignon. From then until the outbreak of war in 1914 he was to be a close companion of both Picasso and Braque in those years of passionate discovering which challenged all conventional ideas of art and established Cubism as a style or rather as an attitude to our consciousness of the world around us.

These early paintings of Braque showed very clearly the influence of Cézanne in their colour and their simplification of form which was based on Cézanne's belief that nature should be treated by an analysis of its basic forms, the cylinder, the sphere and the cone, contained in a framework of linear perspective. It was the geometric shapes dominating the landscape that attracted the attention of the critic Vaucelles and suggested to

him that 'Cubism' should be the name of the new style.

By a strange coincidence, that same year Picasso returned from his summer spent north of Paris at La Rue des Bois with canvases that showed the same tendencies and in which the influence of Cézanne was also apparent. However it was in the following year that the cubist style began to crystallise.

With Fernande, Picasso had returned to the farm of his old friend Paillarés at Horta de Ebro (or more correctly Horta de San Juan). It was an atmosphere that had pleased Picasso during his first visit ten years before and he enjoyed the clear skies and sharp contrasts in the landscape. The well-cultivated plain with the compact angular shapes of villages and the arid crags of the mountains coincided with his love for the light and the drama of Spain.

There during the summer he painted many landscapes, single figures and heads, including a portrait of Pallarés (Fig. 112). This work is important because of its stylistic resemblance to a portrait he had painted earlier in the same year of a friendly dealer in Paris, Clovis Sagot (Fig. 113), and the influence of Cézanne that can

139

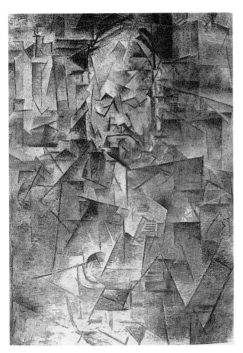

115. *Portrait of Ambroise Vollard*, by Pablo Picasso. 1909–10. 92 by 65 cm. (Pushkin Museum, Moscow).

paintings, 'It would have sufficed to cut them up . . . and then to assemble them according to the indications given by the colour in order to be confronted with a sculpture.' More recently, explaining his intentions in making this head, he told me, 'I thought at one moment that the curves you see on the surface should continue into the interior. I had the idea of making them in wire.' But feeling that this analysis in depth was becoming too much of an intellectual exercise, he decided on this compromise in which the head retained its solidarity and volume while the surface is broken into facets closely resembling the simplified shapes he had used in the paintings of Fernande.

By the winter of 1909–10, Braque and Picasso had evolved a very definite and personal style to which Juan Gris gave the name 'Analytical Cubism'. As they progressed it became increasingly complex so that for the layman it was difficult to relate it to the subject-matter from which it was derived. Both artists saw the danger of it becoming an abstract aesthetic exercise which would have been contrary to their intention of penetrating deeper into the reality of the world around them.

It was for this reason that Picasso continued to work with a model in front of him. A well-known instance of this is to be found in the method he used in painting *The girl with the mandoline* in 1910 with Fanny Tellier as his model. She returned time after time to pose for him until her patience gave out and she announced that she was indisposed. 'I realised', Picasso told me, 'that she meant not to come back and consequently I decided that I must leave the painting unfinished. But, who knows?' he added, 'it may be just as well I left it as it is'. It is significant that he abandoned the painting as soon as his model left him.

But there was another means of remaining in contact with reality which Braque never attempted: the portrait. In the spring of 1910 Picasso painted three portraits for each of which he demanded the patient participation of his model. In each case he picked on friends who were devoted to him, and, because they were all dealers, had a special interest in his work.

There is a painting of the winter of 1909 known as the portrait of Braque but Picasso denied that it should be taken seriously as a portrait. The first important work of this period was the portrait of Ambroise Vollard. He was the first dealer in Paris to promote the painting of Cézanne and gave Picasso an exhibition as early as 1901. The sittings began during the winter of 1909–10 in the well-lit studio to which Picasso had

be seen in both. In the portrait of Paillarés, however, the colour is reduced almost to monochrome and it is the construction of the surface of the head with bold geometric simplifications which is emphasised. It is, I think, worth recalling that, thanks to the enthusiasm of Roger Fry, the *Portrait of Sagot* was shown in London in the first Post-Impressionist exhibition, during the winter of 1910–11. It was greeted with scorn and angry protest.

A series of paintings (Fig. 114) which were based on Fernande, although she did not actually sit for them, are of interest for us in this study of the progress of portraiture in Cubism, which led to its climax in the *Portrait of Kahnweiler*. The analysis of the shape of the head and body has become increasingly structural and definite. Its surfaces are constructed by facets organised so that they meet and present a surface which is closely related to the background. In other ways, particularly in their colour, the paintings contain frequent references to Cézanne. Throughout, figures and landscapes received the same treatment.

Returning to Paris, Picasso went to the studio of his friend, the sculptor Gonzalez. There he modelled a woman's head which was clearly a three-dimensional version of the recent paintings of Fernande. It is an early example of the closeness between painting and sculpture characteristic throughout the work of Picasso. For him painting and sculpture were virtually interchangeable, as we can judge from a conversation with Gonzalez in which Picasso said that in the early cubist

moved recently in the Boulevard de Clichy. The result was, in this case, a compromise between imitation of nature and the cubist version of reality, for although the principle of keeping a continuous screen of facets in monochrome close to the picture plane was observed, the head itself was detached from the background by a local flesh colour. A comparison with a contemporary photo of Vollard can prove that the painting achieved its purpose of being remarkably realistic, recording not only an excellent likeness but also the circumstances – the heat of the stove and the length of the sittings – that caused the otherwise vivacious dealer to spend most of the time asleep. Vollard himself tells us that although many people failed at the time to recognise him, the four-year-old son of a friend said without hesitation on seeing the painting for the first time: 'That's Monsieur Vollard' (Fig. 115).

Wilhelm Uhde, the sitter for the second portrait, which was painted the following spring, was a German intellectual, who, like Kahnweiler, had been attracted to Paris by the progressive ideas that throve there. In character he was austere and reserved. This is eloquently conveyed by the consistency of the subdued tones of grey maintained throughout with no concessions to the colour of flesh. Here, there is an even more complete merging of the figure into the background, which is filled, appropriately, with a chimneypiece and books. The treatment throughout is admirably fitting. It expresses convincingly the dry, loyal personality of Picasso's scholarly friend, with his conventional style in clothes and his perceptive wide-awake eyes.

As can be seen from a contemporary photo, the likeness is extremely faithful; so much so that more than twenty years later, although I had never met Monsieur Uhde and knew only the portrait, I was able to recognise him sitting in a crowded café.

Having pursued to this point his cubist interpretation of the reality of his sitters, Picasso left Paris, accompanied by Fernande and André Derain to spend the summer of 1910 in the small Catalan port of Cadaqués at the invitation of his friend Ramón Pichot. Here, he continued to organise the analysis of form in his painting with even greater severity. According to Kahnweiler, who followed eagerly the development, it was during this summer that he arrived at the summit of Analytical Cubism. But he returned to Paris with a large number of unfinished canvases, still doubting and dissatisfied.

It was the portrait of his life-long friend Kahnweiler on which he then began to work. We can see clearly what had happened at Cadaqués if we compare it with the portrait of Uhde. In the earlier painting he is still concerned with arrangements of the surface, whereas now he treats the sitter as a three-dimensional structure, composed of disrupted elements plotted in space like a transparent honeycomb, viewed from many different angles and yet welded together into a comprehensive whole. To quote Kahnweiler, 'he had taken a great step – he had pierced the closed form'.

Let us now turn our attention to the portrait itself (Fig. 109). As he had done before with his former sitters, Picasso demanded the presence of Kahnweiler for some thirty sittings and set to work directly on the canvas without making any preliminary drawings. Again he accepted the existing background of his studio with objects lying around in disorder and an unconventional collection of pictures, drawings, musical instruments, draperies and tribal objects hung on the walls. In the portrait it is possible to decipher, on the left, one of a pair of wooden statues from New Caledonia that he had acquired two years before, and below it a group of medicine bottles which Kahnweiler remembers him keeping always beside him. On the right of the canvas, prominently in view, is a large staple driven into the top of a picture. The figure itself is seated and slightly displaced from the centre of the canvas to leave room for its companion, the New Caledonian statue. The head of the figure is on a level with Kahnweiler and facing towards him, but it is impossible to detach it entirely from the intricate pattern of the background. The group of bottles on the table below is more legible and has a resemblance to a landscape of houses at Horta, called the 'Reservoir', painted only a year before. The tight grouping, the geometric shapes and the composition are all similar but in the landscape certain clues, such as doors and the reflection of the houses in the water give it a much larger scale. In spite of the similarity of method, there can be no confusion.

The colour of the portrait, typical of paintings of this period, is subdued, almost monochrome, but the variations between brown, ochre and colder grey are far from meaningless. They subtly accentuate changes in the inclination of the planes in a way that is reminiscent of Cézanne. Although the contrasts are often strong, no black and no white is used.

In spite of the difficulty we may experience in understanding Picasso's analysis of his sitter we have the impression of the presence of a human form seen from the head to the hands clasped together at the bottom of

116. Daniel-Henry Kahnweiler, photographed by Picasso.

the painting. Above them are other recognisable features such as a watch chain and higher up an opening in the jacket that shows a striped shirt, stiff collar and a tie. These we recognise as signs or clues which, put together, allow us to see the painting as a portrait of Kahnweiler in his best suit rather than an aesthetic exercise in abstraction.

Naturally it is Kahnweiler's head that dominates and again, when set beside a photo of Kahnweiler, we discover as by a miracle that a mysterious likeness has been achieved, although it is impossible to discover any feature that corresponds literally with the photographic imitation of nature. The eyes which, in the case of Uhde are easily recognisable, are crystalline constructions. The nose emphasised on the left with deep shadow meets a cylindrical shape rounded off by shading which terminates abruptly in an area lighter in tone and geometric in shape which links with forehead, chin and the far side of the face so as to frame the essential features, eyes, nose and mouth, while the head is crowned with curved lines indicating hair (cf. Fig. 116).

Such a description, however, is sadly inadequate. It suggests that the structure is weak and arbitrary whereas in reality we are presented with an architecture in which each facet is constructed with conviction and a noble sense of proportion. As we examine each detail there is never a moment of uncertainty as to how the structure holds together. It is this assurance that prompted Picasso to say 'In the paintings of Raphael, it is not possible to measure the exact distance from nose to mouth: I want to paint pictures in which this can be done'. In order to make this possible he had denied himself any reference to the illusory depths of linear perspective and covered the whole canvas with facets close to the picture plane, joining them together without anywhere leaving a hole. Head and background are united in the same shallow plane and dovetail continuously into each other.

In spite of the convincing presence of anthropomorphic architecture there are deliberate ambiguities and often plurality of statement. This is to be found in the detail of the mouth which is drawn with two disconnected lines at different levels and completed by a curve and a vertical division. As a result of these surprisingly sparse indications we perceive a closed mouth spread across the face and strangely alive in its expression.

The body, from the shoulders to the hands, is again composed of planes which can be taken to protrude or retreat without finally destroying the total mass and allowing us the delight of letting the eye wander in and out of its successive crystalline passages. The organisation of the surface forms a pattern that recalls the intricate honeycomb design of the Moorish vaulting in the Alhambra. Here, although it floats in the vertical plane of the picture, it is like ripples on the surface of water. The imagination is stimulated to find in it scenes which though they are ambiguous appear undoubtedly to exist. It is excited by the rhythmic life of this new reality and devises with delight its own interpretation. The passages round the neck and shoulders can seem like a promenade among streets and houses, glowing with light and clearly defined in their spatial relations to each other, though we imagine them to be one inch in depth or a hundred yards. This new sense of reality, detached from representation, creates a new world of poetic associations. Again to quote Kahnweiler: 'The finished product is in the mind of the spectator'.

It is the creation of this phantasmagoria which has caused Edward Fry to say, when discussing the portrait of Vollard from which somewhat the same sensations

can be obtained: 'The real subject, however, is not Vollard but the formal language used by the artist to create a highly structured aesthetic object.' This could be true if we reverse the portrait and enjoy it in the same way upside down. We shall find that Kahnweiler is dissolved into dramatic effects resembling the prisons of Piranesi. But that was not, I believe, Picasso's intention. He never became interested in abstraction for its own sake. Analytical Cubism, his most hermetic period, was still for him a search for reality. Considering always that he was above all a realist and that the subject of this painting, was Kahnweiler, there is no doubt that he succeeded, in a most, triumphantly daring way, in establishing a likeness which is a composite of human characteristics and an organization of form which is both illusive and matter of fact, just as life is itself.

There is a question which follows which I find difficult to answer. Why, after the invention and realisation of a masterpiece such as this do we find no more cubist portraits? It is true that both Braque and Picasso were at this time in doubt about how much further they could continue in a style that, even when applied to portraits, was becoming increasingly hermetic. In their search for links with reality they turned, in the Synthetic Cubism that followed, to collage and the use of words and signs. But these methods were more appropriate in still life. In Analytical Cubism the link was in peril of dissolving into abstraction. In consequence, this form of expression was modified by Picasso.

There seems to be a parallel here with the reason he gave me for making the cubist *Head of a woman* in bronze rather than in wire. In this form it would have become excessively intellectual. For although Picasso was extremely well read and brilliantly intelligent he lived more intensely by his emotions than his intellect. It was this that diverted him from experiments that could lead away from an integration of art and life.

There has been speculation about the degree to which mathematics and a consciousness of the theories of modern atomic physics entered into Cubism. The idea that Picasso and Braque actually used mathematical calculations and applied them with geometric instruments is completely false but the knowledge that, according to the physicists, solid objects are composed almost entirely of empty space had undoubtedly some influence in prompting Picasso to analyse, in his own way, the reality of these objects and to relate apparently solid matter to empty space. This endeavour is to be found from the cubist period throughout his work.

The painting, when it left Picasso's studio, became the property of Kahnweiler and would have remained with him as a treasured possession had it not happened that at the end of the 1914–18 war all his property was sequestered by the French Government because of his German nationality. In the auction that followed the portrait was bought by a Swedish painter, Grunewald, who paid no more than 2,000 francs (say £100). Later it went to America and was added to the collection of Mrs Charles Goodspeed who later became Mrs Gilbert Chapman on her second marriage. Mrs Chapman, who is herself a skilled painter, made an extremely faithful copy of the portrait before giving it to the Art Institute of Chicago where it may now be seen.

Kahnweiler never ceased to be a close friend of Picasso and I am grateful to him for his excellent writings about Cubism in general as well as for the invaluable information he has been kind enough to give me about his portrait.

However, the ending of portraiture in the analytical cubist style did not mean that Picasso lost his desire to make portraits. There followed innumerable examples of portraits of his friends which are completely representational. A convincing example is to be found in a drawing and a series of three lithographs which he made of Kahnweiler in one day, 3rd June 1952. Here the influence of Cubism is absent as in most of the drawings he made of his friends, but this is not true of his paintings, in particular those of the women he loved and his own children. In the portraits of Dora Maar, the emotional content frequently removes all but a slight resemblance to his model and it was rare for him to paint her or his wife, Jacqueline, from life.

But if we examine the portrait of Picasso's daughter, Maïa, of 1937 we can find many references to Cubism, such as the two eyes and two nostrils placed on the same profile, implying movement in the subject or in the spectator and creating a contrast with the fixed stare of the doll she is holding. There are even more obvious associations in *The woman weeping*, of 1937, which can in some ways be considered as a portrait of Dora Maar. Here the simplification of form undoubtedly has its origin in Cubism. These are, however, only vestiges of the total dissection and reorganisation of form found in cubist portraits and nothing in the work of Picasso in portraiture after 1910 can claim to be the successor of the portrait of Kahnweiler.

One significant subsequent development should not be forgotten. During the transition from Analytical to Synthetic Cubism in 1911, Picasso fell in love with a girl

named Marcelle Humbert, whom he called Eva, and although there is no portrait, not even a drawing to show us her beauty, through his eyes, Picasso wrote to Kahnweiler on 12th June 1911 telling his discerning and reliable friend Heine: '. . . I love her very much and shall write her name on my pictures.' The name Eva which appears in some paintings became synonymous with '*Ma Jolie*' taken from a popular song of the time and her presence in his heart rather than in his eye was inscribed, like a lover's token on the bark of a tree, in several cubist paintings, a subterfuge for outright portraiture.

In trying to sum up the intrinsic value of this extraordinary work I find that apart from the fascination of its aesthetic value, the classical equilibrium of its composition in depth and the harmony in its subdued colours, it is the realisation of a new vision of reality that interests me most. André Breton described the necessity for grasping this vision in his prose-poem *Le Château Etoilé*.[2] After discussing paranoic interpretations of forms in the clouds or in stains on old walls, he wrote: 'There is there a source of profound communication between people which we have only to free from all that masks and troubles it. Objects in reality do not exist in the way they appear to. From a consideration of the lines on which the most ordinary among them is composed springs forth, without the effort of one wink of the eye, a remarkable '*image-devinette*' [a riddle-image] that is inseparable from it and which establishes for us, with no possible error, the only real object, present and for us desirable'.

It is the evocation of this 'riddle-image' by Picasso with its probe into reality, its widespread implications and its poetic power that makes the *Portrait of Kahnweiler* a unique and extraordinary work of genius.

1977

LETTER

DAVID RODGERS

Tintoretto's Golden Calf

Sir, With reference to your Editorial in the August issue on the restoration of the Madonna dell'Orto, at the risk of appearing either naive or pedantic, may I point out that Tintoretto's painting in this church commonly known as the 'Adoration of the golden calf', is in fact *The making of the Golden Calf.* Since cleaning it has become quite apparent that the calf is made of clay and that the jewels being laid before it are the raw material from which it will be either cast or gilded and encrusted. To the right of the calf, Aaron, holding calipers, is presumably discussing technical problems and the whole of the foreground is indicative of work and artistic interest rather than adoration of either the contemplative or frenzied variety. I hesitated to write to you on such a relatively simple point but the recent and excellent publication by Ashley Clarke and Philip Rylands about which you write with enthusiasm in your Editorial perpetuates and indeed strengthens the existing misconception by including in a caption the words – 'Detail of the Israelites bringing jewels to the ceremony' (p.70), whereas in fact, they are simply bringing raw material as is suggested in *Exodus* XXXII. 2. 3.

FRANCIS HASKELL

Benedict Nicolson (1914–1978)

A few lines in Benedict Nicolson's monograph on Terbrugghen (1958) will probably conjure him up vividly to those who were happy enough to know him and may also help to indicate some aspects of his attitude to art and to scholarship: 'I have walked up and down that stretch of the Oude Gracht, ridiculously imagining myself in the artist's shoes. But this section of the canal has been ruined by improvements and traffic; and no amount of historical melancholy could conjure up the atmosphere of the Snippevlucht in his time. And the house that might have given me a clue to his way of life has long since disappeared.' It is easy to visualise Ben's long strides and rather sloping gait; his shabby, patched clothes; the cigarette hanging from his mouth; the air of intense concentration on his brooding face which would surely have made him dangerously indifferent to the traffic that had ruined the canal . . . Ben, despite the reputation for austerity acquired by this journal under his editorship, did not despise a private, imaginative approach to those artists whom he studied. On the contrary. Biography was always his favourite reading, and his reviews of current exhibitions were freely sprinkled with the personal pronoun. It is not inappropriate to try and convey some impression of the man as well as the achievement.

The two cannot, of course, be separated, not only because the personality of any editor is directly relevant to the success of the journal for which he is responsible, but also because for the last thirty-one years the Burlington Magazine had constituted an intimate part of Ben's life. I can think of no other person I have ever known for whom a job was so intrinsically woven into the very fabric of his being: from the discovery of a new article ('Oh, Francis, there's *such* an interesting piece in the February number') to the minute correcting of page-proofs. And yet – to those who did not know him – it has to be stressed that, though his life did

indeed revolve round the magazine, he was never a bore about it. I can convey his feelings best if I suggest that the Burlington Magazine gave Ben something of the security that can be given by a really happy home – always there, but not to be inflicted on others unless they wanted to hear about it: in which case, whether or not they were his colleagues, he would love to explain its problems, its virtues, its weaknesses; never mysteriously or condescendingly, but just as one talks to friends who share common interests.

Ben really did have a genius for friendship. He retained his old friends, and he was always acquiring new ones, and he treated them all as if they were exactly the same age as he was. He loved social life of almost every kind whether in the acute discomfort of an undergraduate room or squalid restaurant or in the splendour of some grand, ceremonial dinner – for one of the most appealing sides to his character was that he never seemed to discriminate by category or on principle. Of course, he liked some people and some occasions and of course he disliked others, but – although he had decided opinions which he could express decisively – he was exhilaratingly unpredictable. How often I remember asking him, after he had been away to see some friend, or country, or museum, whether he had enjoyed himself: there would be a moment of hesitation before he answered, as if he was trying to get the nuance exactly right, and then he would begin: 'I thought it was *absolutely*' and here would follow a long pause during which I had no idea whether he was going to conclude '*terrible*' or '*wonderful*'. But it was usually the latter, for he had a great capacity for liking people and things.

He loved clubs, going regularly to Brooks's and to the Beefsteak and, with Philip Toynbee (one of his oldest and closest friends) he founded an informal lunch club which meets once a fortnight at Bertorelli's in

Charlotte Street – and he belonged to other institutions of the kind. And yet, despite so much social life (for being much loved, he was also much invited out by his friends), he was not always an easy companion. He could sit absent-minded and silent through a whole dinner, for no apparent reason and quite unaware of what must have appeared bad manners to an embarrassed neighbour, for afterwards he might well comment on how pleasant an evening he had passed. When concentrating on some issue he would become so absorbed that he would ignore everything that went on around him. He liked eating, but (as if defying the cliché that taste in cooking and art go together) he had little, if any, discrimination. 'The paté is simply *delicious*', he would say enthusiastically about some raw, indigestible mess and when, towards the end of his life, he took to making suppers for his friends in his own flat, the results were sinister – but somehow became palatable through the warmth of his advocacy and because it was almost impossible to be with him without enjoying what he enjoyed.

He loved reading, but music he actively disliked rather than found meaningless: almost the only time I have ever seen an expression of real misery (rather than boredom) on his face was when he was compelled to attend an – admittedly awful – evening of Irish folk songs at a splendid country house in County Cork. His appreciation of natural beauty was genuine, but it did not (I think) play a very important part in his life. Despite his mother's passion for the countryside he was essentially an urban man.

Ben could be extraordinarily perceptive (and sometimes sharp) about the people he met. This may come as a surprise, for what he said so often appeared to be ponderous, conventional, at times even banal. But then, when discussing some friends whose marriage might be in difficulties or some bizarre social occasion, he could suddenly, unexpectedly, analyse the situation with a finesse that truly was worthy of a Stendhal or a Proust. There were moments when he could seem so innocent of the ways of the world as to be ingenuous; others when he could surprise one with an oblique comment that revealed that he knew exactly what were the issues at stake.

This combination of directly contradictory qualities was, I believe, one of the secrets of his exceptional success as an editor. He could feel very strongly about issues affecting the arts, and readers of his editorials will know that he could express himself very vigorously (even harshly) about them; and yet, having done so, he had

117. Benedict Nicolson

the rare and enviable capacity of being able to separate his private and public personalities, and to adopt a resigned, if necessary calm, attitude to those very same issues. Similarly, he loved his friends, but he would never accept articles from them if he thought that they were not up to the standard that he expected and he would not interfere with their making venomous remarks about each other in the pages which he edited. He did this neither because he enjoyed goading his contributors so as to stimulate circulation nor because he was insensitive, but because he genuinely could not understand that people could carry over scholarly disputes into private relationships. In fact, people usually do just this, but Ben himself did not; he had a real streak of innocence about him which was constantly surprising and constantly delightful. And he had no sense of possessiveness about his researches which he freely communicated to others working in the same field.

Ben was an exacting scholar of the first order who really loved pictures: he was not, however, eloquent about them – except sometimes in print. Visiting an exhibition with him was exciting because of the intense feeling he generated (like an electric discharge) rather

than because of anything he specifically said: in this he was unlike his great friend and admirer, Vitale Bloch, who shared so many of his tastes and who was commemorated so recently by him in these pages. For years he refused to lecture, but quite recently he had taken to accepting invitations from undergraduate societies and similar bodies, and his casual, conversational, undogmatic approach was greatly appreciated by his audiences. And he too, very much enjoyed such occasions – because he was a man who genuinely loved communicating with people more than merely imparting information or showing off his personality.

Ben was born on 6th August 1914, the elder son of Harold Nicolson and Vita Sackville-West, and until the end of his life he remained devoutly attached to the memory of his father (in whose published diaries there are many references to him) and to those 'Bloomsbury' values which came to him at first hand from Virginia Woolf. He was not happy at Eton, but he enjoyed his time at Oxford (he was at Balliol), and he made lasting friendships there with Jeremy Hutchinson, Stuart Hampshire, Francis Graham-Harrison, Isaiah Berlin – the values of Beaumont Street, where he had lodgings, with its 'almost harsh demand for *emotional integrity*' are vividly recalled in Philip Toynbee's *Friends Apart*, and they remained with him to the end: he could, on occasions, be painfully frank – even tactless – when what one wanted from him was sentiment and consolation.

With some of these friends he helped to found the 'Florentine Club', which invited guest speakers such as Kenneth Clark, Herbert Read and Duncan Grant to talk about art. Ben's own tastes at this period were centred on the early Italian and the contemporary. He travelled quite widely in Europe and America, and – like many other English and American art historians of his generation – he 'graduated' with Berenson at I Tatti. Recalling his stay there, Nicky Mariano referred to his 'slow and halting reactions. B.B. used to say that Ben was like a deep well of crystal-clear water, and that it was worthwhile making the effort to draw it up.' While writing this brief memoir of Ben, I have tried to get in touch with as many of his friends from this period of his life (before I knew him) as possible, and – without exception – they have all told me that in all essentials he never changed: Berenson's comments did indeed remain extraordinarily apt.

Through the influence of Kenneth Clark he was appointed Deputy Surveyor of the King's Pictures in 1939, but the war intervened almost immediately. Ben served in the army in the Middle East and in Italy, where he was badly injured in an accident that had nothing to do with the fighting. In 1947, at the age of 32, he took up his appointment as Editor of the Burlington Magazine.

It is little more than a year ago that the Editorial Board of Directors tried, on the occasion of his thirtieth anniversary in the post, to record his achievements. There is obviously not much that can now be added to the editorial of April 1977, especially as many of the readers of that tribute will themselves have had personal experience of his direction of this magazine. To what was then said I would like to add only that Ben treated contributions from the most distinguished of veterans to the rawest of newcomers with exactly the same degree of critical attention: he was never overawed by celebrities and he was impossible to bluff. It will be up to others to gauge the true extent of his achievement, but they will have to realise that he was a stubborn as well as a kind editor and that, for better or for worse, the Burlington Magazine has, since 1947, been the creation of one man.

His books and articles too can only be adequately judged by the experts in the many fields in which he worked (it is to be hoped that a bibliography can be drawn up before too long to show his extraordinary range), but a few points can be made about them even in a personal memoir, for they offer so vivid a reflection of his own character. The son of a diplomat and man of the world, educated at Eton and Oxford, trained by Bernard Berenson (the last serious historian to be wholly convinced that real art came to an end with the end of the Italian Renaissance), Ben was drawn instinctively to the outcasts, the offbeat, the provincial: the painters of Ferrara (1950), Terbrugghen (1958), Wright of Derby (1968), the Treasures of the Foundling Hospital (1972), Courbet (1973), Georges de la Tour (1978; with Christopher Wright), the Followers of Caravaggio (to be published next year). How many art historians are there whose *œuvre* is at once so consistent in spirit and yet so varied in time and place, so personal and yet so absolutely scholarly? Nearly all these books make major contributions to the history of art, but though the *Wright* is his most ambitious and most important work, perhaps the *Terbrugghen* is the one to which Ben's friends will turn most often: the contrast he draws between the shy, introverted, sensitive Terbrugghen and the coarser, worldly-wise, successful Honthorst may perhaps be a little simplistic but it gives him a wonderful opportunity to proclaim the values that were always dear to him and that he could describe

with unrivalled sensitivity – for when on form he was surely one of the very best contemporary writers on art in the English language.

Over the past two or three years Ben's health had deteriorated noticeably. He had become a little deaf; he had had to spend some time in hospital after being knocked down by a taxi; and, above all, while staying with friends in the country during the Christmas holidays of 1976, he had suddenly been afflicted with a disturbance of the circulation which left him lame in one leg. He was (he had always been) an impossible invalid. His friends conspired to organise appointments with the doctor, tried to stop him smoking (which he had been told was particularly dangerous) and to drink more carefully. Such precautions – understandably – irritated him and brought accusations of nagging. Who can now tell whether they would, if pursued more systematically, have delayed the final outcome? It can only be said that while his death was a terrible shock, it was not entirely unexpected.

Yet these last years of his life were certainly among his happiest – for it was his friends, and not he, who worried about his health. In 1956 he had married the distinguished Italian art historian Luisa Vertova who was then working for Bernard Berenson. Six years later the marriage broke down, causing great grief to both of them: for some time Ben suffered a series of troublesome, absurd, and obviously psychosomatic illnesses – he could not, for instance, walk across bridges, and I well remember the infinite logistical complications during a visit to Pisa of trying to get him to cross the Arno in the absence of adequate public transport or accessible taxis. Yet time healed the wounds, and they became warm friends (Luisa arrived in London to stay with him on the day after his death). Their daughter Vanessa, after the inevitable reaction against two art-historical parents, herself took up the study of art history and this

gave Ben (who had always been a most loving parent as well as enchanting companion) the utmost pleasure. His phobias vanished, and – after a very long interval – he even began to relish air travel once again (he had first been taken into an aeroplane by Lindbergh) which enabled him to visit exhibitions far more frequently than he had been able to do for years. Honours came and he enjoyed them: membership of the Executive Committee of the National Art-Collections Fund, a CBE (1971), fellowship of the British Academy (belatedly, in 1977). In the same year, the Burlington Magazine celebrated the thirtieth anniversary of his editorship with a handsome party at Brooks's and, surrounded by colleagues and admirers, he heard his toast drunk in the splendid room hung with Reynolds's group portraits of the Society of Dilettanti of which he was a member (characteristically, he gave a tiny dinner afterwards for a few close friends in the upstairs room of a small Soho restaurant to which he had long been attached). Messages arrived from all over the world and he was obviously very pleased – but not (I think) wholly surprised. He was a genuinely modest man, but he knew that he was a remarkable editor.

On 22nd May the Chairman of the Editorial Committee of this journal wrote to tell him that by a unanimous decision of the Committee he was invited to stay on as editor despite the fact that he was about to reach normal retiring age. There is every reason to believe that Ben knew of this invitation, but he never received the letter. On the same day he dined at the Beefsteak, and the friends who were there all describe him as having been cheerful and on excellent form. He walked to Leicester Square underground station and there he collapsed and died instantaneously. The coronary thrombosis that killed him was so massive that he could neither have felt any pain nor even realised that he was ill.

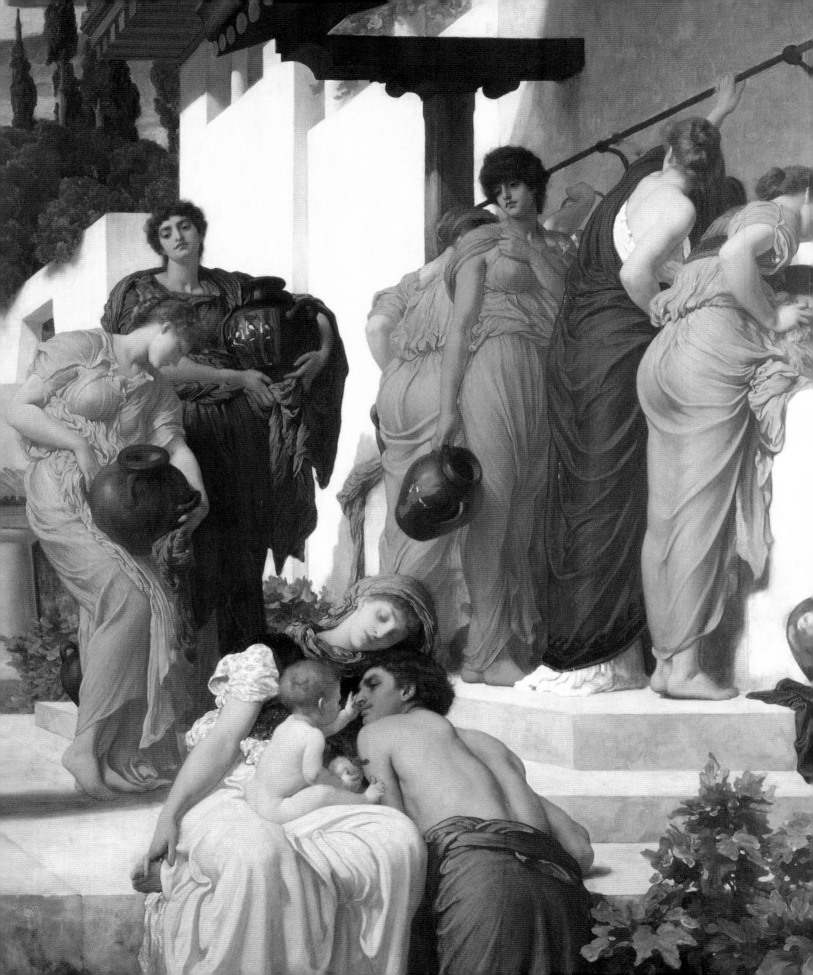

1983

IAN JENKINS

Frederic Lord Leighton and Greek vases

The British Museum provided a unique source of reference for the nineteenth-century painter of classical subjects.* Above all, it housed the Elgin Marbles, thought by many then, as now, to be the sublime manifestation of Greek artistic genius. There were, however, other objects to attract the painter's eye in the classical repository of Victorian Bloomsbury: since the eighteenth century, vase-paintings had been used by artists as sources of information about dress, armour, furniture and many other details of ancient life, and in the next century vases came to be featured increasingly in historical painting, as objects in their own right. In Leighton's monumental *Captive Andromache* (Fig. 119) the Homeric subject of Andromache enslaved in Argos fetching water for her captors demanded a profusion of such vessels. A detailed examination of the vases in this and other paintings by Leighton (the ancient models for which are mostly to be found in the British Museum) provides a telling insight into the painter's approach to his work, both as antiquarian and artist.

At first glance, the pots in the *Captive Andromache* appear to be mostly Attic vases of the sixth and fifth century B.C., but, as we shall see, no single vase exactly resembles its ancient prototype. The numbered tracing (Fig. 120) will help us to pursue them one at a time: vase no. 2 is a *hydria*, a three-handled jar which was used as a water-pitcher in antiquity, and is therefore appropriate to the subject here. There are two main types of *hydria*, both of which are shown in the *Captive Andromache*. No. 2 is the type sometimes called *kalpis* by archaeologists where the neck and shoulder form a continuous line, whereas the other has a more sharply angled shoulder from which the neck is offset. The latter is visible in the painting, sideways on the head of the woman on the left of the picture (no. 1). Vases of the second *hydria* type

118. Detail of Fig. 119.

were most commonly produced in the sixth century B.C., while the *kalpis* first appeared in the later sixth century, and continued into the fourth. Vase no. 2 is thus authentic in shape, but its decoration – though also Greek – is of a different period. A three-tier frieze of birds, floral motifs and lions is probably inspired by the earlier black-figured decoration of middle Corinthian vase-painting and is curiously out of place here.

The *kalpis* shape recurs in nos. 6 and 7, and although here the figured scenes are less obviously anachronistic, they are nevertheless alien to the vessels they decorate. The vase at Andromache's feet is partially obscured by the drapery, and although only one figure is visible, this identifies the scene as one borrowed from a specific Attic red-figured *hydria* of the angle-shouldered type dated to around 480–70 B.C.[1] The full scene has three figures: the two on the left are thought to represent Menelaus pursuing Helen, the identity of the third, that shown by Leighton, is uncertain. In his adaptation of this vase he has transferred the scene from one *hydria* to another and, less obviously, has translated the subject from red-figure to black-figure.

The subject of vase no. 7 is a black-figured fountain-house scene datable to around 510 B.C.,[2] depicting women fetching water from a fountain. Once again the scene has been borrowed from a *hydria* of the earlier type, but Leighton's rendering of it is in this case more true to the original vase-painting, or, at least, to its appearance in the 1880s; since here there is an added complication. It was common practice in black-figure vase-painting for the artist to distinguish the paler complexion of women by rendering their skin white, and to pick out ornamentation of dress and other details in the same colour. Shortly after its discovery, however, the areas of added white which had been applied to this vase in antiquity were accidentally erased by over-cleaning. They were subsequently restored and it was with the white newly added that the vase appeared in

151

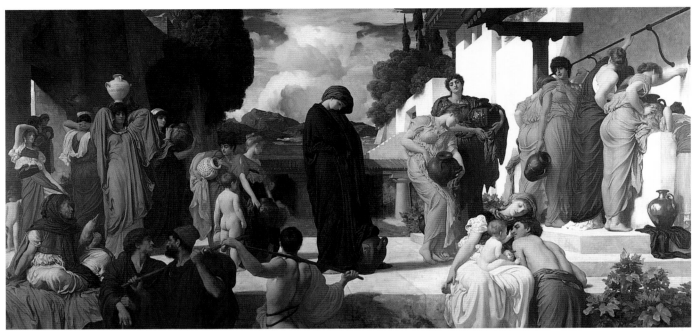

119. *Captive Andromache*, by Frederic Leighton. c. 1888. 193 by 407 cm. (City Art Gallery, Manchester).

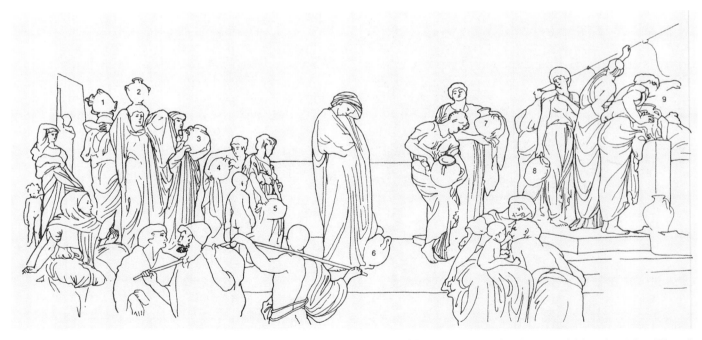

120. Numbered diagram of *Captive Andromache*, indicating the various vases depicted: 1: Hydria. 2: Kalpis with Corinthian-style decoration. 3: Non-Greek shape with scene from vase B668 (B.M. Catalogue). 4: Non-Greek shape with Non-Greek decoration. 5: Non-Greek shape with scene from vase B17 (B.M. Catalogue). 6: Kalpis with scene from vase E161 (B.M. Catalogue). 7: Kalpis with scene from vase B331 (B.M. Catalogue). 8: Non-Greek shape with scene from vase E179 (B.M. Catalogue). 9: Kalpis with unidentified scene.

the British Museum after its acquisition in 1868. Thus it was seen by Leighton, and we can see from his reproduction of part of the scene that he has recorded it faithfully. A modern reaction against repainting has since caused the restoration to be removed.[3]

We need not, on the other hand, assume that Leighton was working from the original vase. His use of the painting independent of the pot may indicate that he was working from secondary sources. In 1858, for

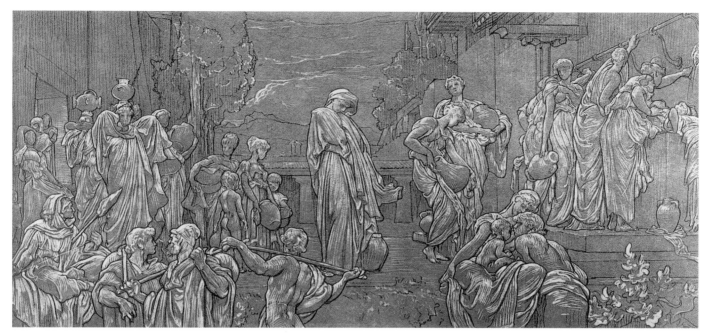

121. Photograph of final sketch for *Captive Andromache*. (British Museum, P. and D. 1897–11–26–24; present whereabouts of sketch unknown).

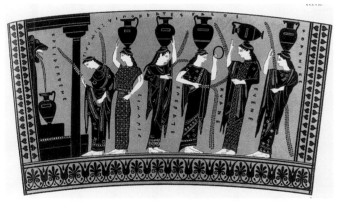

122. Scene from vase B331 (B.M. Catalogue). Engraving from E. Gerhard's *Griechische Vasenbilder*, 1858.

example, the scene was reproduced as a coloured engraving in Gerhard's *Griechische Vasenbilder* (Fig. 122).[4] This was the standard source for subsequent publication of the scene, which became famous because of its inscription, indicating that it depicted no ordinary fountain but *Kallirhoe*, the most famous of all the springs of ancient Athens.

In general, the vase-scenes in the *Captive Andromache* make no special reference to the subject of the painting. It would be stretching a point too far to suggest that the pursuit of Helen by Menelaus is particularly appropriate because, like the story of Andromache herself, it is drawn from the Trojan cycle of myths. The fountain-

house scene, on the other hand, may be thought to echo the theme of the painting, and it is possibly for this reason that the vase recommended itself to Leighton. More likely, however, it was not so much the subject of the vase-painting that appealed to him, as its static, frieze-like arrangement of figures. Leighton had a particular fondness for processional compositions, as can be seen clearly in a number of his earlier works, including the celebrated *Cimabue's Madonna* (1853–55), *The Syracusan Bride* (1865–66), and the *Daphnephoria* (1874–76).[5] The *Captive Andromache* clearly fits within this tradition.

Vessels 3, 4, 5 and 8, which all have a shallow, offset neck with twin handles and tapering body, are not borrowed from the Classical potters' repertoire of shapes; only the decoration – with the striking exception of no. 4 – is Greek. The scene painted on no. 3 has been adapted from a white-ground *alabastron* signed by Pasiades as potter around 500 B.C., and depicts two maenads on either side of a bird. The vase was acquired by the British Museum in 1887, and its subject was illustrated in a water-colour study published in the *Journal of Hellenic Studies* for the same year.[6] This was almost certainly Leighton's source for the scene, although he felt no compulsion to remain true to the original: his adaptation places the 'roll-out' of the scene on to an alien shape, and the original painting in polychrome on a white ground is reproduced by Leighton in black figure on a red ground.

Vase no. 5 owes its figured scene to a black-figured neck-amphora made in Athens around 540–20 B.C., and purchased for the British Museum in 1772 as part of Sir William Hamilton's first vase collection, which had been published earlier in four lavishly illustrated volumes. Leighton possessed a copy of this publication and he must have taken the scene from here.[7]

Finally no. 8 bears the figure of a winged Nike, holding a jug in one hand and a libation bowl in the other, from a red-figured *kalpis* dated to around 480 B.C.[8] Here Leighton's licence to reproduce the vase-scene according to his own taste has enabled him to make good the original. By the 1880s the vase had suffered severely from damage by fire, which had discoloured the figure of Nike from the normal pleasing tone of Attic red-figured pottery to a dull, greyish brown. The Victorian painter restored its reddish hue and picked out the skin surfaces of the figure with white paint.

From this survey of the pots in the *Captive Andromache* it is clear that Leighton was quite unconcerned with archaeological accuracy, freely adapting the vase-paintings he used and often working from secondary sources rather than originals. His studies for individual figures in the painting (Leighton House) further illuminate his methods: working in a studio without immediate access to models for his antique vases the artist posed his living models with whatever was to hand among the bric-à-brac of Leighton House. A later drawing (Fig. 121) shows the composition virtually finalised with only the details left to complete.[9] The semi-crouching figure immediately ahead of Andromache still carries a studio prop of the kind seen in the earlier studies; the eventual canvas, however, substituted a *kalpis*. The prop can be identified as a modern Egyptian water jar.[10] Coarse ware vessels of this shape with corded decoration were very common in Egypt in the nineteenth century, as now, and Leighton must have acquired one when he visited Egypt in the 1860s.[11]

Greek vases feature prominently in other paintings by Leighton. The fountain-house scene discussed earlier reappears appropriately in *At the fountain* (1892),[12] and in the picture entitled *Lachrymae* (1895).[13] In this last (Fig. 123) the mourning figure of a woman leans on a grave-stele in the form of a Doric Column. A *hydria* with the fountain-house scene rests on the column behind her, swathed in a funerary wreath. It is not the only vase in the painting: at the foot of the column resting on its side, Leighton has placed a red-figured *kylix* with a figure of Hermes in the tondo, which has been identified as a cup now in the Louvre.[14] A *kalpis* with its

back to us is seen further round the base of the column. The *Lachrymae* is also of interest because the composition itself may be inspired by vase-painting. Scenes of one or more figures seated or standing by a funerary monument are common on Attic vases of the fifth century B.C., and South Italian vases of the fourth century B.C. Such scenes became the standard motif for Attic white-ground *lekythoi*, which were intended to hold offerings of oil at the tomb.

There is, however, the possibility of a more immediate source. On the evenings of Thursday 13th and Saturday 15th May 1886 a performance was given at the Princes Hall, Piccadilly of G. C. Warr's abridged version of Aeschylus's *Oresteia* and, on the intervening Friday, of his adaptation of Homer entitled *The Tale of Troy*. Tableaux and scenery were designed by, among others, Frederic Leighton, G. F. Watts, E. J. Poynter, Henry Holiday and Walter Crane. Sir Charles Newton, recently retired as Keeper of Greek and Roman Antiquities at the British Museum, acted as archaeological advisor. At these performances Leighton watched his friend and protégée, Dorothy Dene, perform the rôles of Cassandra and Nausicaa. He subsequently acquired a souvenir copy of the text and music, which were reproduced in two handsome volumes with illustrations by Walter Crane.[15] Warr's preface to the second volume states that several of the illustrations were based, if loosely, on the 'scenic representations'; for in the story of Orestes, the mourning at the tomb of Agamemnon was illustrated with a tableau of Electra and her fellow libation-bearers arranged around a funerary stele (Fig. 124). There is much in this scene that reminds us of the *Lachrymae*, not least the figure of Electra herself. It seems fair to suppose that Leighton had this picture in mind, or perhaps even the memory of the original tableau, when he conceived the mourning woman of the *Lachrymae*.

The theme of the *Lachrymae* is similar to a much earlier painting, *Electra at the tomb of Agamemnon* (c.1869).[16] Here, however, the mourning figure is not the quiet, languid form of the anonymous woman in the earlier work but the vengeful daughter of Agamemnon, who stands at, rather than leans on, the tomb of her father: her hands are flung over her head in a ritual gesture of mourning, and her face expresses a mixture of pain and anger. At the foot of the column, and in a similar position to that in the *Lachrymae*, is what may pass for a *kylix*, despite its eccentric handles. The black-figure scene in the tondo represents a satyr and a maenad.

124. *Echoes of Hellas*, by Walter Crane, after G. C. Warr. Engraving.

123. *Lachrymae*, by Frederic Leighton. c.1895. 157 by 63 cm. (Wolfe Fund, Metropolitan Museum of Art, New York).

The design of these two figures – well fitted to the circular frame – suggests that Leighton had a specific model in mind. The shape of the large jug behind Electra is eccentric and we may doubt its having any ancient antecedents at all. The decoration, on the other hand, a frieze of grazing animals and floral ornament, is in the style of pottery painted in the proto-Attic phase of Athenian vase-painting and was perhaps inspired by the scene on a lid in the British Museum.[17]

One painting after another, therefore, tells the same story. We recognise in them stray elements borrowed from Greek vases, but rarely is one object reproduced entire, or faithfully. Leighton was no archaeologist and yet he had ample opportunity to check the authenticity of his archaeological accessories, had he so wished. We know, for example, from the catalogue of his library, which was sold up after his death, that he had immediate access to a number of standard works on

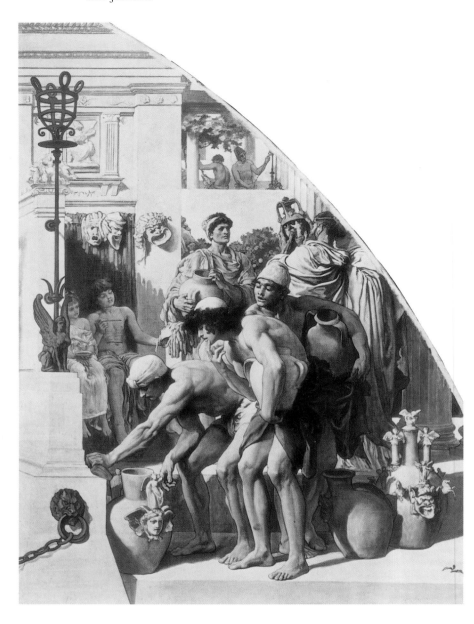

125. Two pages of studies of objects in the British Museum, by Frederic Leighton (sketchbook xv). *c.*1872. Pencil on white paper, each 21 by 7 cm (Royal Academy).

126. Detail from photograph of monochrome cartoon for *Arts of industry as applied to peace*, by Frederic Leighton. (British Museum, P. and D. 1947–2–11–17; actual cartoon in Victoria and Albert Museum).

archaeology. Furthermore, as President of the Royal Academy he became a Trustee of the British Museum and must have been a regular visitor there.[18] The facts were available to him but he evidently did not feel compelled to observe them.

This is confirmed by the testimony of two pages from a sketchbook now in the Library of the Royal Academy (Fig. 125).[19] They contain pencil sketches, more visual notes than drawings, of objects in the British Museum. Leighton's choice of objects shows a degree of discernment: they are all of Etruscan or South Italian workmanship, with the exception of a late

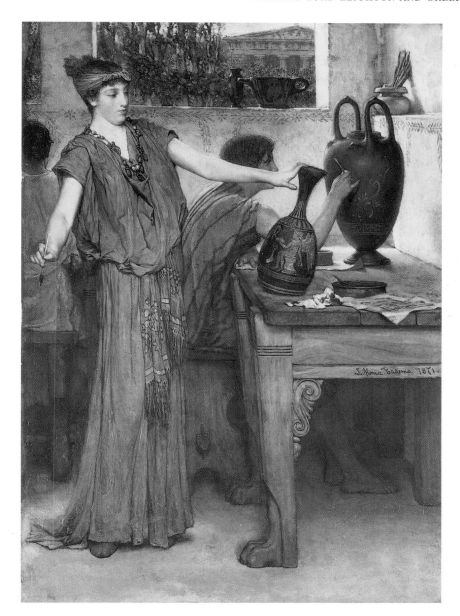

127. *Etruscan vase painters*, by Lawrence Alma-Tadema. 1871. Panel, 39.2 by 27.3 cm. (City Art Gallery, Manchester).

128. Eight studies of Greek and South Italian pottery (now in the Louvre). Unsigned. Water-colour, 37.6 by 26.5 cm. (Alma-Tadema Archive, 84/E2325–1915, University of Birmingham).

Attic head-vase.[20] These were to provide the basis for the archaeological accessories featured in his fresco entitled *Arts of industry as applied to peace*. This was the companion to another fresco, *Arts of industry as applied to war*,[21] both commissioned by the South Kensington Museum, later to become known as the Victoria and Albert. There they can be seen today, sadly much deteriorated and badly cramped by subsequent re-use of the space they originally commanded.

Both the *Arts of peace* and the *Arts of war* are painted within a lunette. In the *Arts of peace* the most fruitful area for archaeological investigation is the right hand side of the composition, where the potters and pot-sellers are grouped (Fig. 127). Most striking are the large vessels (*askoi*) standing in the foreground, clearly inspired by a type of Hellenistic pottery produced at Canosa in southern Italy in the third century B.C. Canosan pottery is distinctive for its polychrome painted decoration and applied figure ornament. Studies from Canosan pottery in the British Museum appear among the R.A. notebook sketches but, with the possible exception of the plainer *askoi*,[22] Leighton's Canosan pots do not have any exact ancient counterparts. The satyr's mask, for example, on the vessel

farthest to the right, does not seem to have been empl-oyed as an ornamental motif on this type of pottery, and indeed appears to have been borrowed from the late Attic head vase featured in the sketches.[23]

A South Italian red-figured *lebes gamikos*[24] (marriage-bowl) appears in the notebook sketches, and served as the model for the object being inspected by the discerning customer at the back of the group of figures in the fresco (Fig. 126). The shape is rendered accurately enough, but the scene underwent radical alter-ation: on the original a woman was shown leaning on a washstand, in Leighton's adaptation she was displaced by a free-standing figure of a man.

Other objects featured in the fresco are more loosely based on the notebook sketches. A terracotta lid from Centuripe in Sicily of the third century B.C. provided the inspiration for the elaborate invention carried on the head of a woman in the other corner of the fresco.[25] Similarly, details of an Etruscan bronze *cista*[26] formed the basis for the fantastic object standing on a podium in the centre of the painting, behind the figures of women dressing.

The objects featured in the notebook sketches were not notable for their artistic merit, but seem to have recommended themselves to the painter's eye as curiosi-ties, distinctive for their outlandish shapes and fanciful decoration. Later, in the studio, Leighton reworked what he had seen in the Museum into even more elabo-rate creations, no doubt supplementing his own obser-vations with ideas drawn from the resources of his library. Further, just as in the *Captive Andromache*, he was prepared to use whatever was to hand in the studio.

The *Arts of industry as applied to peace* affords the fullest insight into Leighton's tendency to deviate from his sources in his use of archaeological motif. The note-book sketches confirm our assumption that the painter did not begin from a position of ignorance, but that he freely modified what he knew to be academically cor-rect. Was his approach to the archaeological element in his painting, therefore, merely careless, or can some more positive explanation be found? The attempt at a final answer to that question may be helped by compar-ison with two other contemporary classical painters, one of whom cared a good deal about archaeological accuracy, the other of whom did not.

Lawrence Alma-Tadema has been applauded and ridiculed in turn for his attention to detail. In his *Etruscan vase-painters* (Opus XCIV, 1871), which has recently joined the *Captive Andromache* in the City Art Gallery, Manchester (Fig. 127), the principal figure

stands back from an Apulian red-figured *lekythos* to which she is applying the finishing touches. Behind her sits a male companion who applies his brush to the body of a large *lebes gamikos*. On the window sill there sits a red-figured drinking-cup (*glaux*), and beside it an *aryballos* (oil-bottle). The *lekythos* and *glaux*, at least, can be identified, and both are in the Louvre, although it was probably not there that Alma-Tadema saw them.[27] The University Library in Birmingham possesses the painter's vast reference collection of drawings, prints and photographs. In folio 84 is contained a page of water-colour studies seemingly prepared for publication (Fig. 128). All the objects are now in the Louvre,[28] but were once in the possession of one Joseph-François Tochon d'Annecy (1772–1820). I have not been able to discover how Alma-Tadema came to acquire this page of drawings but, clearly, they provided the source for the two identifiable vases in the painting, and although he has exaggerated the size of the *lekythos*, both are ren-dered accurately enough.

Tadema has deservedly earned himself the reputa-tion of an archaeologist among painters. On the other hand, there is a tendency to exaggerate the extent of his scholarly acumen. *The women of Amphissa*, (Opus CCLXXVIII, 1887, Sterling and Francine Clark Art Institute, Williamstown, MA), for example, depicts female devotees of the cult of Dionysos languishing after a night of bacchic excess. Among shrivelled cucumbers and swooning maenads the painter has placed a number of objects, carefully observed in them-selves, but strikingly anachronistic when taken all together. The figured vases include a black-figured *hydria* decorated with a fountain-house scene, and a ram's head *rhyton*; this last is in the British Museum and is dated to around 480 B.C.[29] There are, besides, an assortment of South Italian fishplates belonging to the fourth century B.C. In addition to ceramic vessels, under the awning on the left of the picture a woman holds a large silver wine-mixing bowl. This vessel is very similar in shape to that which had been discovered together with the rest of the so-called Hildesheim treasure near Hanover in 1868.[30] The inclusion of this silver *krater*, which probably dates to the early Roman Imperial period, demonstrates a desire on the part of the painter to be up-to-the-minute in his use of archaeological material; a desire which prevailed over considerations of archaeological integrity.

Alma-Tadema's approach was, nevertheless, self-consciously archaeological in a way that Leighton's was not. Leighton was first and foremost a painter; and the

objects he uses are included because of the demands of subject or composition, rather than to exhibit his own antiquarian virtuosity. Although his themes are frequently classical, Leighton's paintings often seem to evoke a timeless romance, and the non-Greek are as vital as the authentically classical elements to the picturesque setting of his subjects. In this respect his art exhibits that spirit of aesthetic eclecticism which is so evident in the works of Albert Moore.

The natural reaction in this age of archaeological sophistication when confronted with Moore's glaring anachronisms is to laugh and wonder how he could have got it so very wrong. But this is to do him an injustice. His case is put very well in a remarkable appraisal by a contemporary critic, Cosmo Monkhouse:

> . . . The (second) class of complaint which supposes that Albert Moore intends to give us pictures of Greek life, and fails, implies a total misconception of the aims of his art. He is no Alma-Tadema seeking to reproduce for us the life of extinct civilisations. In such reconstructions archaeology is important, an anachronism is a defect, but not in the art of Albert Moore, who seeks only after beauty, and employs the robes and draperies of Athens only because they are to his eyes far more beautiful than any costume which has been invented since. Remembering such criticism as applied to his work he has been known to utter the astonishing dictum that 'anachronism is the soul of art.'[31]

Leighton's anachronisms and archaeological aberrations must be regarded in the same vein. 'His knowledge of classical antiquity', wrote M. H. Spielmann in a posthumous appreciation, 'was hardly, less than that of Mr Alma-Tadema; but he had long laid it aside as an aid to painting, convinced that what is so charming a merit in Mr Tadema's art was only out of place in his own. He held that an anachronism in a work not definitely and deliberately historical and illustrative is no fault when it does not outrage the eye or outrage the sense by its impropriety.'[32] In the *Captive Andromache* itself, Spielmann claims that Leighton steered a 'middle course, with full knowledge of the concession he was making to art'. If we were able to confront Leighton with the archaeological shortcomings of his paintings he would, I think, admit them readily, but he might reasonably express surprise at our concern.

129. Large dish, blue and white, Iznik c.1480. (Haags
Gemeentemuseum, the Hague). Diameter 44.5 cm.

J.M. ROGERS

Iznik

Though it can hardly be claimed that the Ottoman pottery of Iznik is poorly known, its rarity in Turkish collections meant that it was under-represented in the Council of Europe *Anatolian Civilisations* exhibition of 1983, which did so much to revalue the status of the Ottoman arts of the classical period. But in fact, the present exhibition of 204 pieces, *Iznik: the pottery of Ottoman Turkey*, at the Ibrahim Paşa Palace, Istanbul (to 15th December) sponsored by the Türk Ekonomi Bankası, is the first exclusively devoted to Iznik pottery either inside or outside Turkey (although there are, of course, more numerous museum displays on view – notably the 530-odd pieces in the Musée de la Renaissance at Ecouen). A display of finds of 'Miletus' wares from Iznik (kilns have also been discovered at Miletus, as well as other sites in Western Turkey), to show the comparatively unimpressive beginnings of Ottoman pottery, leads on dramatically to the finest products of the first period of Iznik blue and white, a remarkable contrast of shapes, sizes and rich decoration. In the main hall of the Ibrahim Paşa Palace, its walls still hung with the monster Uşak carpets which are its permanent glory, come the greater part of the pieces arranged partly by theme and partly in chronological order. In the centre are a series of mosque lamps dating from c.1510 to c.1570 (Fig. 130), each in its individual case. The whole thing is a gorgeous spectacle, but at the time I visited the exhibition there was no hand-list. The exhibits and their sequence make sense only in the context of the major study by Julian Raby and Nurhan Atasoy (with a valuable summary of recent work on the chemistry and structure of Iznik ceramics from Julian Henderson) published in association with it.[1]

In the exhibition the traditional stylistic groupings, most of them by toponyms which have long been recognised to be misleading, have been followed, some

of them, however, renamed and one 'Tuğrakeş' for 'Golden Horn', arguably substituting one misleading description for another. All have been considerably refined and certain groups even attributed to individual potters – though the organisation of the potters remains largely a matter of conjecture and the minute 'Morellian' details on which Julian Raby partly bases his attributions often reappear on pieces of very different styles. However, for the early blue and white made from c.1470 to the 1520s, which has previously been lumped together as 'Abraham of Kütahya' wares, after the inscribed cruet in the British Museum (Godman Bequest, G. 1983, 1), he conclusively demonstrates that it is a misnomer. Instead, he postulates a sequence of distinct styles, associated with the reigns of three Ottoman Sultans, Mehmed II, Bayazid II and Selim I: dishes with heavily modelled arabesque designs and small bowls recalling the 'palace bowls' of the Yuan (c.1480–90); dishes with cloud-scroll compositions (c.1495–1510); a group of mosque lamps associated with the mosque/tomb of Bayazid II (d.1512) in Istanbul, with highly eclectic decoration but less heavily modelled motifs (c.1510); and vessels increasingly using blue on white and enhanced with turquoise details (1520s).

For the earliest group Raby has pulled off a great *coup*, the identification of the central design of a splendid basin (274; Paris, Musée du Monde Arabe, 5150) with drawings in a palace album (Istanbul University Library, F 1423),[2] mostly with material from the reign of Mehmed II but possibly compiled under Bayazid II and now associated with a certain 'Baba Nakkaş', addressed in a *temlikname* of Mehmed II dated Safer 880/June–July 1475 as '*al-ustād al-muʿazzam*', and evidently the head of the palace scriptorium. Raby has already ably exploited these designs, which may be traced on the bindings of dated manuscripts of the 1460s and 1470s for the library of Mehmed II and were

130. Mosque-lamp, blue and white, with traces of gold leaf, Iznik c.1522. Ht. 36.5 cm. (Çinili Köşk, Istanbul).

very rapid stylistic development over two generations or so. The widespread occurrence of blue and white sherd material in habitation areas in Western Turkey and all over the Ottoman provinces demonstrates that the potters, having once mastered the technique, were able to expand their production for a wider market, which stood them in good stead when the Court came to have enough Chinese porcelains for itself and commissions dried up. There is some evidence for the use of stencils, notably the virtually identical insides and outsides of two basins of c.1510 in the Victoria and Albert Museum and the Louvre: the master was designed for the V & A basin, which is 2.5 cm. less in diameter. Both show considerable use of dotted outlines, which may indicate transfer by pouncing, but dotted detail is highly characteristic of the treatment of motifs in early Iznik blue and white.

While the use of gilding seems to have been envisaged from the first as an enhancement and is associated to some degree with all the main stylistic groups, Raby argues for successive enlargements of the colour scheme, first turquoise (1520s), then a range of iron-greens from grey to leaf-green (1530s–40s), manganese purple (by 1550) and, as is well known, bole red (later 1550s) (Fig. 131). These are mostly *termini post quem*, for the later colours did not generally supersede the earlier; except for the curious way in which the 'Damascus' spectrum, the largest and the most sophisticated, was quite suddenly ousted by bole red and its associated spectrum, to the extent, Raby suggests, that in the last decade of Süleyman's reign the potters 'had a new colour scheme in search of a style'. There are transitional pieces. The rather orangey, painterly effects of early bole red tiles, like those of the mosque of Rüstem Paşa (c.1561) were evidently compatible with the degree of reduction in the kiln necessary for the iron greens of the 'Damascus' group but not with the bole red applied, as it soon came to be, as a thick impasto: the greens associated with these are quite different in tone. Manganese survived for a few years longer and last appears on the tiles of the tomb of Süleyman (1566), but the effect does not appear to have been welcome and in some cases, Raby remarks, red simply replaced purple in copies of earlier compositions. Interestingly the successive colour spectra are accompanied by markedly different patterns so that, very often, one can guess the colour-scheme from a black-and-white photograph of a piece.

Despite the considerable refinements in chronology of all the stylistic groups, Raby does not, I think, conclusively

then developed in the transformation of Uşak carpets from a cottage into a Court industry in the same period.[3] This gives his claim that the origins of Iznik blue and white were a direct Court initiative considerable force. On the Court side there was considerable unsatisfied demand for Yuan and early Ming porcelains; technically speaking the body and glaze are a radical innovation; the extreme rarity of finds outside Ottoman palace sites argues that they were, initially at least, made in small numbers and largely restricted to palace use; and the homogeneous designs of bindings, pottery and even carpets suggests that they were made for single patrons of well defined tastes.

The earliest blue and white wares were undoubtedly capital- and labour-intensive. As at Meissen, Raby remarks, the technical breakthrough was the spur to a

solve the problem of the Sünnet Odası tiles in the Topkapı Saray: if some of the tiles are to be associated with repairs to the palace in the first decade of Süleyman the Magnificent's reign, others are plainly as late as the 1560s, which does little to resolve the dating of the magnificent blue and turquoise panels.[4] He abandons the misleadingly discrete succession postulated by Lane in favour of a much more realistic sequence of overlapping groups, which also allows for revivals of older styles or, as in the case of the 'Golden Horn'/'Tuğrakeş' wares, production over several decades. Dated or dateable tiles provide important clues, though he properly recognises certain fundamental differences in tile and pottery production. He also uses evidence of provenance, where available, to date pieces. His chapter XXII on late blue and white (237–45) is an excellent illustration of the way pieces with secure provenances can be used to identify and date whole groups of pottery.

Raby makes two attempts, both hypothetical, to explain the decline in both Iznik pottery and tiles soon after 1600. First, a marked decline in demand from the market in general (to which the Court in the later sixteenth century also had recourse for large purchases of Iznik wares) in the face of greatly increased imports of later Ming Chinese export wares. Though the volume of imports may be gauged from these confiscated from the estates of deceased officials now in the Topkapı Saray there is not much evidence that the Iznik potters produced imitations of them. Secondly, a report by Evliya Çelebi, a notoriously inaccurate source, that the potters had suffered from oppression (*zülm*) under Ahmed I in the early seventeenth century. In the sporadic accounts and registers of just prices fixed for the markets, the price of Iznik tiles seems not to have reflected the general inflation of the late sixteenth and early seventeenth centuries but they provide no evidence that the potters were squeezed by inflation either in raw materials or in labour costs. That indeed would have been excellent grounds for appeal to the legal authorities since the Ottoman principle of the just price allowed for a ten percent profit (with an agreed higher percentage for crafts demanding particularly arduous or minute workmanship). Like others so far advanced Raby's thesis would explain a decline in the quantity, not the quality, of production. The lower quality of the tiles which continued to be produced in the 1620s and sold freely on the Istanbul market may have been a consequence of the withdrawal of centralised control; but the rôle of centralised control in

131. Dish, polychrome, Iznik c.1580. Diameter 44 cm. (British Museum, London, Godman Bequest).

maintaining standards even in the palmy days of the Iznik potteries remains highly debatable.

Nurhan Atasoy's first contribution addresses the contemporary evidence for Iznik pottery in the historical writings and archival documents. She convincingly accounts for the rarity of intact pieces of fine Iznik in Turkey in terms of the devastating fires and earthquakes which time and again ravaged the metropolis. Most notably, the Old Palace was so damaged by fire in 1540 as to be barely habitable thereafter, and the fire of 1574 in the kitchens of the Topkapı Saray could well explain the total disappearance of fine Iznik wares from that palace. The archival evidence for the distribution of Iznik wares, here valuably complemented by excavation material from sites in Istanbul, is not all helpful and the Edirne *tereke* defters of the seventeenth century do not, for example, substantiate the claim that Iznik was driven off the market by imports of later Chinese export wares. Here it may well be that Iznik is under-represented in household inventories because few of those surviving are of the sort of people who would have had it.[5]

Professor Atasoy also considers the types and forms of Iznik pottery, using extant shapes to interpret the sources. As she herself says, quite a lot of the interpre-

tation is a matter of conjecture: some terms remain obscure, while some shapes appear to have no specific terms, and it is quite probable that the vocabulary of both terms and shapes will need to be expanded with future discoveries. This historical lexicography (many of the terms in modern Turkish are used in markedly different senses, presenting further opportunities for confusion) is essential for estimating the degree to which production at Iznik became standardised and whether that was internal to the industry or, more probably, attuned to broader functional or marketing needs. In the useful typology of shapes it should be noted that the tankard (*maşrapa*) shape is certainly older than 1540, as witness fragmentary early blue and white vessels in the Çinili Köşk and the Aleppo museum (is the base of the latter mistakenly restored?).

The exhibition, like the volume reviewed here, is particularly noteworthy in illustrating pieces from private collections and from out of the way museums and in demonstrating that however well one may think one knows the material there are always oddities to surprise – such as the 'Damascus' dish with decoration on a ground of white spirals, which must have been a potter's aberration. Raby's numerous suggestions for identifying the products of individual kilns should also be followed up. The fine group, which he plausibly dates to c.1560–65, can, for example, be much expanded by two intact pieces in the British Museum (Henderson Bequest, 78–12–30–501–2), as well as by fragments from the Crimea, from Sofia and from Iaşi in Romania. It is probably not over-imaginative to see these as the work of a single hand. If other groups are similarly identified the result must certainly suggest particular patterns or strategies of marketing.

The authors never lose sight of the fact that, certainly from 1560 onwards, but quite possibly even earlier, the pottery of Iznik was treated by the authorities as a spin-off from the manufacture of tiles, and a new survey of the tile industry, which would not disdain the evidence of the pottery, is now also needed. It is almost certain that John Hayes's long awaited work on the pottery from the church of St Polyeuktos at Saraçhane and forthcoming publication of the rich sherd material in the Benaki Museum in Athens by John Carswell and Helen Philon will bring further revisions in both technology and typology. However, this volume is a milestone in the study of Iznik ceramics and in many respects definitively changes the picture given by the three classic studies on Iznik of Arthur Lane, Kurt Erdmann and Katharina Otto-Dorn.[6] It also brings the day appreciably nearer when something like Richard Goldthwaite's recent survey of the Italian renaissance maiolica industry[7] can properly be written for Iznik.

Two other exhibitions also deserve brief notice, a small survey of finds from excavated sites in Istanbul at the Çinili Köşk (a welcome opportunity also to view again this exquisite building which has been closed for many months), in which the material from St Polyeuktos figures prominently; and an exhibition of kiln finds at Iznik over the past fifteen years in the museum at Iznik,[8] which includes hitherto unparalleled fragments of great rounded pots with blowsy lotuses or sprigged motifs in blue on white, one with recessed handles for carrying. They are a salutary reminder of how much remains to be discovered about the Iznik potteries and of how soon our basic ideas may have to be revised.

ANDREW BUTTERFIELD

Verrocchio's Christ and St Thomas:
chronology, iconography and political context*

Andrea del Verrocchio's, *Christ and St Thomas* from the Mercanzia niche at Orsanmichele, Florence (currently under restoration) is widely acclaimed as one of the masterpieces of Florentine renaissance sculpture (Figs. 132 and 133). But, despite the praise it has elicited since the day of its unveiling,[1] it has received little serious scholarly investigation.[2] As a result, the aesthetic character of the monument has been imprecisely analysed and its iconography, patronage and political context have gone wholly uninvestigated. Indeed, even the summary of the archival documentation now widely repeated in print is incomplete and misleading. It is the purpose of this article to publish some recently discovered documents for the *Christ and St Thomas*, and to explicate their significance for the sculpture's history and iconography.

Present knowledge of the archival record is due primarily to Giovanni Gaye, who in 1839 published a highly summary account of the chronology of work on the sculpture.[3] Gaye cited few of his sources, squeezed much of his findings into one phrase,[4] published only short extracts from the original registers, and did not analyse their contents. Although a handful of documents have come to light since then, it is still essentially Gaye's summary – slightly amplified – that is repeated today.[5]

In fact the *Christ and St Thomas* is among the best documented sculptures of fifteenth-century Florence. The account books of the Università della Mercanzia, the sculpture's patron, survive from 1479 onwards and include nearly all the payments to Verrocchio, beginning in that year; these have been largely ignored as a source of information on the sculpture.[6] For documentation before 1479, it is necessary to turn to the records of the Mercanzia's chief executive body, the Sei della Mercanzia. The Mercanzia was the most important tri-

bunal for commercial law in Florence,[7] and the Deliberazioni dei Sei consist largely of legal decisions; only when the Sei had to order or approve payments to be made by the treasurer of the Mercanzia are they mentioned in the Deliberazioni. Thus the Deliberazioni record the decision to make a payment or to initiate a series of payments; normally, they do not record the actual disbursements.

The history of the commission begins on 26th March 1463 when the Parte Guelfa sold all rights to its niche at Orsanmichele to the Università della Mercanzia for 150 florins.[8] Three days later the Sei della Mercanzia appointed a board of five *operai* to plan and direct work on a '*statua et seu figura digna et venerabilis*' to fill the niche.[9] However, on 14th May 1466, in a *deliberazione* to replace a deceased *operaio*, it is stated that the statue had not yet been commissioned.[10] The next reference to the sculpture is in a newly discovered document of 19th December 1466,[11] which states, for the first time, that the sculpture will be of bronze. The contract with Verrocchio appears not to survive. But, as the document of December does not mention an artist by name, Verrocchio may have received the commission between that date and 15th January 1467 (modern style) when the Sei della Mercanzia authorised a payment to him of 300 florins for the sculpture.[12] The next document is from 24th April 1468 when the Sei and the *operai* agreed to pay Verrocchio a fee of 25 *lire* a month for his work on the sculpture.[13] This document speaks of '*figuras haeneas*' and is thus the first record we have of the intention to fill the niche with more than one figure. One of the monthly instalments of 25 *lire* is referred to in a *deliberazione* of 21st December 1469.[14] On 2nd August 1470 the Sei ordered that the bronze and other metals for one of the sculptures be reweighed in the presence of two of the Sei.[15] The sculpture is next mentioned in a newly

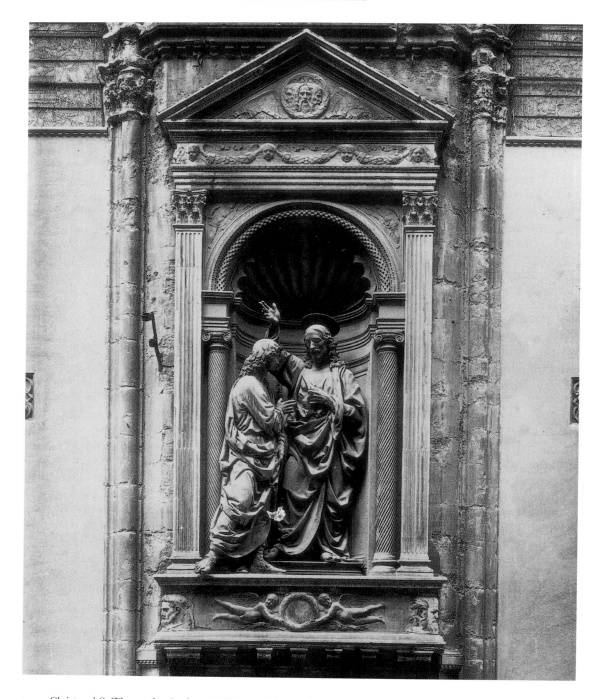

132. *Christ and St Thomas*, by Andrea del Verrocchio. 1476–83. Bronze, ht 200 cm. (Orsanmichele, Florence).

discovered *deliberazione* of 21st March 1476 in which Verrocchio is assigned 10 florins 'for part of the bronze figure to be placed in the tabernacle'. Since the bronze for one figure is mentioned in 1470 and one figure of bronze is recorded in 1476 there can be no doubt that the figure was cast sometime between these two dates. Moreover, we know from a later document that this must have been the statue of Christ. The group is next documented in another newly discovered *deliberazione* of 22nd June 1476 when a series of payments to

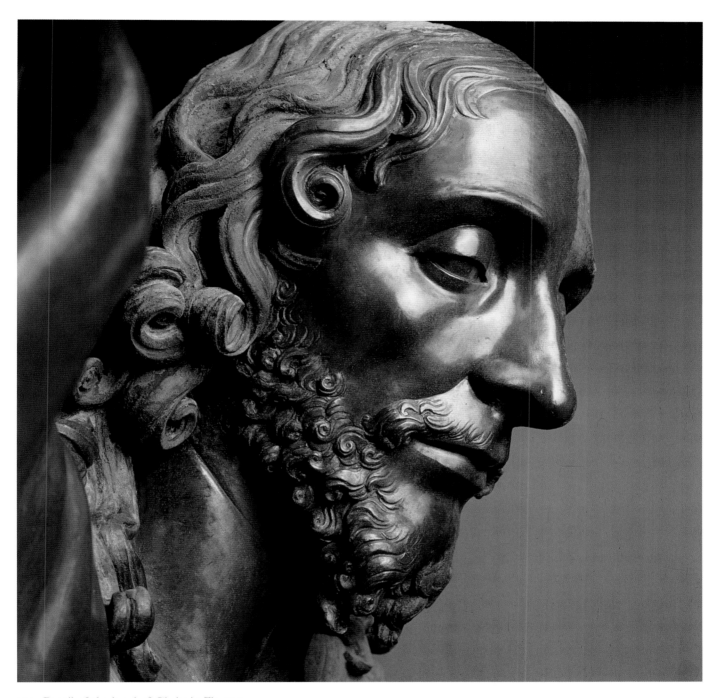

133. Detail of the head of Christ in Fig. 132.

Verrocchio was authorised for work on both figures;[16] the dates and amounts of the payments are recorded in the margin of the document. On 13th January 1477 (modern style), the Sei authorised that another 120 florins be paid Verrocchio in 10 florin instalments.[17] The margin records five payments between February and November 1477, four between January and September 1478, one in 1479, and two in July and August of 1480.

The first entry for the *Christ and St Thomas* in the Libro di Debitori e Creditori della Mercanzia dates

from early 1479. This key document records a payment to Verrocchio of 148 florins and 317 *lire*, and states that the figure of Christ is almost finished and the statue of St Thomas ready to be cast.[18] The entry specifies that the bronze for the St Thomas weighs 3981 Florentine pounds. The account book next records four payments to Verrocchio between May 1479 and August 1480, the dates and sums of which do not correspond with those for the same period listed in the *Deliberazione*.

Some time between August 1480 and March 1481 a dispute arose over a payment to Verrocchio of 40 florins and 200 *lire*. There are no more payments to Verrocchio in this period and all work on the sculpture appears to have stopped. Concerned to see the sculpture finished, the Signoria intervened, and on 26th March 1481 a *provvisione* was passed ordering the payment to be released to Verrocchio.[19] In a *deliberazione* of 12th April 1481, the Sei stated their intention to make the payment, and the disbursement was entered in the account on 2nd May.[20] According to the text of the *provvisione*, the dispute was over the right of the *operai* to make the payment to Verrocchio 'senza la dispensatione de' consigli'. In every other appearance of the word 'consigli' in the documents for the *Christ and St Thomas*, it refers to the Three Major Councils of the Florentine government, and that must be the case here as well.

There is no clear evidence, however, as to why the *consigli* in 1480–81 could claim control over Mercanzia payments to Verrocchio, a right they had not previously held. Nor is it clear why consent had initially been refused for this payment. Most likely, the dispute was due in some fashion to the financial crisis of 1480–81, which had been brought on by the Pazzi War.[21] Faced with the possible collapse of the Monte Comune, the Florentine funded debt, the government had in June 1480 granted the Three Major Councils, together with the new Council of Seventy, increased control over both the Monte and taxation. It is probable that the power of the *consigli* over Mercanzia payments to Verrochio – temporary though it may have been – was due to their partial authority for either taxation or the Monte. This is all the more likely since it appears that on some occasions around 1480 the Mercanzia paid Verrocchio directly from the Monte.[22] Unfortunately, we cannot know the answer to this problem until the finances of the Mercanzia are investigated in a systematic fashion.[23] Whatever the nature of the dispute, the *provvisione* failed to restart work on the sculpture. There are no more payments to Verrocchio until the Spring of 1483. We do not know if the long interruption was due

to problems in the Mercanzia's finances, Verrocchio's involvement in other projects or a combination of both factors. On 22nd April 1483 the Florentine government made another *provvisione* regarding the *Christ and St Thomas*.[24] More than once the document expresses concern about how little time is left for the completion of the sculpture. This suggests that the immediate cause for the Signoria's intervention may have been the imminence of Verrocchio's departure for Venice to work on the Colleoni Monument.[25] The *provvisione* attempts to resolve all of the problems which might obstruct completion of the group. In brief, it states that the sculptor understands that financial difficulties prevent the Mercanzia from paying him what he rightfully should receive. Nevertheless, Verrocchio, who to date has already been paid 306 florins for his '*magistero*', agrees to finish the sculpture on condition that he is paid 94 florins by the time of its completion, and another 400 florins afterwards in four yearly instalments of 100 florins each. The document also reasserts the authority of the Sei and the *operai* to pay Verrocchio.

The *provvisione* set the Feast of St John the Baptist (24th June) as the target date for the completion of the sculpture and Verrocchio appears to have returned to work immediately. There are eight payments to him and to his assistants, Giuliano d'Andrea and Pagolo, between 5th and 30th May 1483 for a total of 53 florins.[26] In June Verrocchio and his co-workers were paid 5 florins at the end of each of the first two weeks of the month, and then 24 florins on 21st June 1483, the day of the unveiling of the sculpture.

Once the sculpture was in place, the Mercanzia stopped paying Verrocchio altogether. Finally, at the end of 1487 Andrea petitioned the Signoria to intercede, and on 19th December 1487 a *provvisione* ordered the Mercanzia to pay Verrocchio.[27] But instead of the 400 gold florins he had been promised in 1483, the Mercanzia now agreed only to deposit, on his behalf, 200 sealed florins over a two-year period in his nieces' accounts in the Monte di Dote, the dowry fund. At the same time, the Signoria ordered that certain minor additions and repairs be made to the niche.[28] On 2nd January 1488 the Mercanzia acknowledged its debt to Verrocchio and also asked his brother Tommaso and his pupil Lorenzo di Credi to '*fare le lettere da pie a dette fighure a nostro oro*'. While this might conceivably refer to the gilded inscriptions along the hems of the figures' robes, it is more likely that it refers to an inscription on the base of the statue of Christ. No payment records

for any of this work survive, however, and it is possible that neither the inscription nor the other additions were executed.[29] In his testament of 25th June 1488 Andrea left the money owed him to his brother Tommaso.[30] The last recorded payment for the sculpture is on 26th November 1488 when Tommaso received half of the money due for his daughters' dowries. A document in 1490 acknowledges the Mercanzia's debt of another 100 sealed florins, but there is no record of an actual disbursement.[31] A final entry in 1490 states that the Mercanzia still owes the Arte di Calimala 400 sealed florins for bronze purchased for the casting of the *Christ and St Thomas*.

To summarise, Verrocchio was commissioned to make a bronze statue in the fall or winter of 1466. By the spring of 1468 it had been decided that two figures, not just one, be made. Work continued through 1469 and 1470 and was sufficiently advanced by August 1470 for the figure of Christ to be ready for casting. This was done sometime between 1470 and 1476, and it was chased between 1476 and 1479. The model for the St Thomas, on the other hand, appears to have been worked up to a final state only between 1476 and 1479. It was cast in 1479 and chased between 1479 and the autumn or winter 1480, and then again between 22nd April 1483 and 21st June 1483.

The loss of the Mercanzia account books from before 1479 makes it impossible to determine accurately both how much Verrocchio was paid and what the total cost of the sculpture was. Moreover, it is impossible to tell from the wording of the *deliberazioni* which disbursements were for materials and expenses and which for Verrocchio's workmanship. In April 1483 Verrocchio stated he had been paid to date 306 florins for his '*magistero*'. After that date there are documented payments to Verrocchio and his heirs for 173 florins, making a total of 479 florins.[32] Including this sum, the total documented expenses for the sculpture are just over 957 florins, 545 *lire*. The actual total must have been a good deal higher as one can see by comparison with Ghiberti's *St Matthew*, the most thoroughly documented bronze for Orsanmichele, which cost a total of 1750 florins.[33]

The documents help to establish more than just the basic chronology of the *Christ and St Thomas*. They also provide the foundation for reconstructing both the political context of the commission and the iconography of the sculpture. This is immediately apparent when considering the *operai*, the men who planned and directed the work. Like most executive and deliberative bodies of the Mercanzia, the initial board of *operai* in 1463 consisted of one member from each of five major guilds, the Calimala, the Cambio, the Lana, the Por S. Maria, and the Speziali. The men on the board in 1463 were Piero de' Medici, Leonardo di Bartolomeo Bartolini, Dietisalvi Neroni, Pandolfo Pandolfini and Matteo Palmieri.[34] In 1466, however, the board's composition changed: in May, Girolamo di Matteo Morelli replaced the deceased Pandolfini;[35] in September, Neroni was exiled for his part in the anti-Medicean conspiracy; and, finally, in December, Lorenzo de' Medici replaced his father, Piero, who, in the wake of the conspiracy, was too busy and too infirm to continue to serve on the board. We do not hear again of *operai* by name until June 1483, when Bongiano Gianfigliazzi and Antonio Pucci are mentioned. Gianfigliazzi replaced Morelli in his offices in the Mercanzia in August 1480,[36] presumably including that of *operai*. Pucci, on the other hand, was a member of the Arte di Speziali,[37] and probably replaced Palmieri after the latter's death in 1475.

All these men were members of the inner circle of the Medici *stato*. (This is even true of Neroni until the conspiracy of 1465/66.) Of the original board, all, with the exception of Pandolfo, served as *Accoppiatori*,[38] the *officials* who determined which names were placed in the sortition bags for the Three Major Councils and often even selected the Signori *a mano* – in short, the primary agents of Medicean political control.[39] Moreover, the *operai* held year after year the most important offices of the Florentine government. For example, the Medici rewrote the constitution and restructured the government in a series of *Balìe* in 1466, 1471, and 1480.[40] The names of the *operai* always figure among the leaders in these *Balìe*. The ties between Piero and Lorenzo de' Medici and the other *operai* apart from Neroni were strong and lasting. Palmieri was a loyal lieutenant of the Medici throughout his life.[41] Antonio Pucci stands immediately to Lorenzo de' Medici's right in Ghirlandaio's fresco of the *Confirmation of the rule* in the Sassetti chapel, which was painted between c.1482 and 1486.[42] His family had been allies of the Medici for several generations and owed their rise in social status to Cosimo's patronage. Indeed, the bonds between the two families were so strong that the *amici* of the Medici in the 1420s and 1430s were known as the *puccini*.[43] Girolamo Morelli lent money and men to Piero de' Medici during the crisis of 1466[44] and was described in the 1470s as one of Lorenzo's most trusted advisors '*circa le chose de' importantia*'.[45] And Bongiano

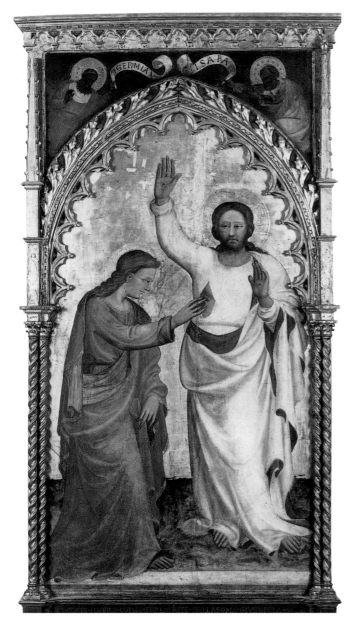

134. *Christ and St Thomas*, by Giovanni Toscani. 1419–20. Panel, 240 by 112 cm. (Galleria dell'Accademia, Florence).

the Sei della Mercanzia.[47] Indeed, in 1471 Lorenzo de' Medici, assisted by Bongiano Gianfigliazzi, Matteo Palmieri and two others, directed a new scrutiny for the Sei.[48] With the new lists for the Sei packed with Medici partisans, Lorenzo could use the court both to aid friends and to punish enemies, as he did, for instance, against Giuliano Gondi in 1472.[49] What is more, in the 1470s Lorenzo reorganised the judical system of Florence. Reform was necessary because Florence had a multitude of courts whose areas of juridicial competence both overlapped and changed, causing legal chaos. Lorenzo planned reforms for the Mercanzia as early as 1471,[50] but did not carry any out until 1477.[51] In that year, he delimited and defined the scope of the Mercanzia's competence, added to it some of the powers formerly held by the Captain of the People, and made it a court of appeal for the lesser guild courts. What is more, the Mercanzia was at the centre of a shift in the theoretical foundation of law. The reforms of 1477 and 1478 generally diminished the powers of the medieval, professionally trained judiciary and gave these powers instead to laymen whose judgments were founded on common sense, not law.[52] In the words of Bartolomeo Scala, the Sei della Mercanzia were 'chosen not as experts in law but because they are naturally shrewd and good men'.[53] Laurentian judicial reform is characterised, therefore, by a shift from statutory law to executive law, from *ragione* to *arbitrio*.

Now that it is clear who the *operai* were and what their interest in the Mercanzia was, one can ask why these men chose the doubting of St Thomas as the subject of the sculpture. There are two main reasons. First, the doubting of Thomas was commonly associated with justice in fifteenth-century Tuscany. For instance, images of Christ and St Thomas appeared in courtrooms and *sale dell'udienza* in Siena, Certaldo, Scarperia and Pistoia.[54] What is more, there was a Trecento painting of the doubting of St Thomas over the entrance to the Sala dell'Udienza in the Palazzo Vecchio in Florence itself.[55] The Mercanzia, moreover, commissioned a panel of the scene for decoration of its Palazzo around 1420 (Fig. 134).[56] One key factor in the subject's appeal was that Christ and St Thomas were thought to personify two essential aspects of a just magistrate: clemency,[57] and the desire for truth.[58]

Secondly, St Thomas was a favoured saint of the Medici. The Medici were the principal patrons of the church of S. Tommaso Apostolo in the Mercato Vecchio in Florence.[59] A member of the family (presumably Cosimo) commissioned from Uccello a fresco

Gianfigliazzi was knighted by Lorenzo himself in 1470.[46] In other words, the men who planned and directed work on the sculpture were Lorenzo de' Medici and his closest political allies.

It is important to note, moreover, that Lorenzo was especially interested in the Mercanzia. Guicciardini stated that Lorenzo sought to control appointments to

of the doubting of St Thomas for its façade, and in 1460 Cosimo ordered a new high altar and altar-piece. Furthermore, in January 1435 as Gonfaloniere di Giustizia Cosimo had the Feast of St Thomas declared a communal holiday.[60] (It should be noted that one of the *operai*, Leonardo Bartolini, was part of the same Signoria in January 1435.)[61] Every year on the 21st December the Sei della Mercanzia and the Captains of the twenty-one Guilds processed to S. Tommaso Apostolo and made a donation at the altar.

Given these associations, it would not be surprising to find that Lorenzo and his friends saw the *Christ and St Thomas* as the perfect emblem of Medicean justice (and of the justice of Medicean rule).[62] Indeed, there is evidence that this may have been their intention. In the spring of 1478 Lorenzo ordered the reform of another principal organ of the judical system of Florence, the Otto di Guardia.[63] New statutes for this magistracy were written in 1478 and a presentation copy ordered the following year.[64] The front cover of this book makes clear the extent of Medici pretensions to identify themselves with the state, for it is decorated with the Medici *stemma*; the arms of the Commune are on the back of the book. More importantly, the illuminated frontispiece shows Christ and St Thomas, set in a tabernacle (Fig. 135). On the base of the tabernacle is the Medici *stemma*, surmounted by a crown.

Mercanzia documents cast light on the religious iconography of the sculpture as well. From Irenaeus on, the exegetical literature on the Doubting of St Thomas cited John 20:24–29 primarily as a proof text of the bodily resurrection of Christ and of all Christians.[65] In St Augustine's famous formulation, 'The scars of the wounds in His flesh healed the wounds of unbelief (in physical resurrection)'.[66] There can be little doubt that this tradition was fundamental to the iconography of Verrocchio's group. Both *provvisioni* stress the usefulness of the sculpture in the promotion of Christian faith,[67] and the inscriptions on the hems of the figure's robes – DOMINUS MEUS ET DEUS MEUS ET SALVATOR GENTIUM on Thomas's mantle, and QUIA VIDISTI ME THOMA CREDIDISTI BEATI QUI NON VIDERUNT ET CREDIDERUNT on Christ's – are taken from John 20:28–29 and constitute Thomas's declaration of faith and Christ's reproof.

But the documents suggest an additional aspect of the iconography. To judge from annual payments of up to 164 *lire* in the 1460s and 1470s,[68] the Mercanzia was a chief patron in Florence of Corpus Christi, a major eucharistic feast of the liturgical calendar.[69] A sacramental interpretation of Verrocchio's sculpture[70] is

135. *Christ and St Thomas*, by Mariano del Buono. Frontispiece of the illuminated statutes for the Otto di Guardia, Florence. 1479. (Archivio di Stato, Florence).

perhaps indicated as well by the appearance of Isaiah in the right spandrel of the Giovanni Toscano panel.[71] His presence is most likely due to Isaiah 12, a passage which was associated with the Doubting of St Thomas because of its emphasis on the charity of God.[72] The passage ends with the eucharistic imagine, '*Haurietis acquas in gaudio de fontibus salvatoris*' ('in joy you will draw water from the fountains of the saviour'). The illuminated frontispiece of the Statuti degli Otto di Guardia also alludes to the sacramental significance of Christ and St Thomas: the frieze of the tabernacle which houses the figures is decorated with bunches of grapes in fictive porphyry. Interest in this iconography, which is

unmentioned in homiletic and exegetical literature in the Latin West,[73] may have been stimulated in Florence by the study of the two Greek patristic authorities for the symbolism, St Cyril of Alexandria[74] and St John Chrysostom.[75]

Finally, we must consider what the archival records do not say. It has often been claimed that the documents mention the existence of a large scale terracotta model of St Thomas which the Mercanzia purchased to place in the Palazzo della Mercanzia. This idea is due to Fabriczy's reading of the first sentence of the *provvisione* of 26th March 1481, which states in part '. . . *per dar perfectione ad una figura di Sancta Thomaso in bella statua di bronzo per porla in Orto san Michele . . . et per non lasciare guastarsi e perire la boza e principio di sì bella cosa'*. Fabriczy's interpretation of the sentence was plausible: the use of *et*, of course, appeared to indicate that the *provvisione* was authorising payment for two things, not one; *guastarsi* and *perire* seemed to imply something frangible, and one of the meanings of the word *boza* is 'model'. Nevertheless, this interpretation must be wrong. To begin with, as we have already seen, the main concern of the *provvisione* was the contested legality of an unreleased payment. Moreover, the second half of the document, which specifies what the *provvisione* actually authorises, makes no mention of a model, nor does the notarial description of the contents of *provvisione* in the margin of the register. Three additional documents record the actual disbursement of this payment to Verrocchio and none of them mentions a model either. Finally, the primary meaning of *boza* is not 'model', but 'unfinished work'; this must be the meaning of the word in the *provvisione*.

Although we now know a great deal more about the history, the context and the iconography of Verrocchio's *Christ and St Thomas*, much remains to be studied. Above all, one would like to determine Verrocchio's artistic intentions. The relationship of the figures to the niche, the classical dress and pose of St Thomas,[76] the planning of the sculpture in terms of light and shade, and many other aspects need to be examined. It is to be hoped that its present cleaning at the Opificio delle Pietre Dure in Florence will stimulate further investigation.

1993

ALEXANDRA SHATSKIKH

Malevich and film

Kazimir Malevich's venture into questions of cinematography dates from the mid-1920s, and was prompted both by events in his own life and by the expansion of Suprematism into other art forms at the end of the previous decade. The decisive event was Malevich's first meeting with the great Russian film director, Sergei Eisenstein in 1925. Since the early 1910s Malevich had spent the summer months at the village of Nemchinovka, just outside Moscow, which he considered to be the finest place on earth, even specifying in his will that he wished to be buried there. In the summer of 1925, Eisenstein was working with Nina Agadjanava at her dacha in Nemchinovka on the script for the film *The Year 1905*. Later, in the biographical essay 'Nuney' (as Nina was called by her friends in Georgian), he recalled: 'It is enough to remember, that it was here, at Nuney's … that I first met (and grew very fond of) Kazimir Malevich, such an indefatigable, stubborn, and principled fighter, at the time of his aggressively conducted battle for the direction of the Institute [GINKhUK]'.[1]

Malevich is mentioned repeatedly as a man of high 'pictorial culture' in Eisenstein's diaries and articles. In May 1939 he dedicated an essay to the painter, and the theme of his short story 'Nemchinov Post' was based on an episode from Malevich's youth: beaten unconscious by village hooligans, Malevich single-handedly managed to avenge himself on them all, becoming in the process a fearless fighter.[2]

It was not only Malevich's personal qualities that Eisenstein found sympathetic. They were attracted to each other by their profoundly different views on art, which made for lively debate between them. The first result of this was Malevich's article on film posters prompted by an exhibition organised at the State Academy of Art (later called GAKhN, the State Academy of Artistic Sciences) in 1925. Malevich's piece 'On Exposures', with the sub-heading 'Posters' appeared in the summer issue of *Film Journal ARK*, a magazine recently founded by the Association of Revolutionary Cinematography, which brought together Eisenstein, Lev Kuleshov, Mikhail Koltsov and other well-known filmmakers and literary figures.[3] Friendship with the futurist-poets, especially with Velimir Khlebnikov, played an important rôle in Malevich's artistic development;[4] following their practice of creating new words to accompany new concepts, he coined the word 'exposure', meaning that the function of a poster or placard was visually to 'expose' the content of the film.

The exhibition at GAKhN, organised as an academic display of easel paintings, was not generally regarded as a success, but a year later 'The Second Exhibition of Film Posters' (1926), held in the foyer of the Moscow Kamerny Theatre, received much greater acclaim, and included bold Constructivist examples. During the 1925 exhibition, Malevich severely criticised the posters as insufficiently expressive of the character of the films they advertised. He also pointed to the clumsy and arbitrary way in which they had been attached to the walls and squares of the town, asserting that this had destroyed their promotional, informational and decorative function. Obsessed by his desire to find a theoretically solid platform for artistic creativity, Malevich carried out a lot of experimental work at the Leningrad State Institute of Artistic Culture (GINKhUK). In his opinion, the newly emerging Soviet film poster should be guided by artistic precepts as well as the psychology of perception and the laws of information science.

The only known film poster by Malevich himself is that for 'Doctor Mabuso', now in the State Tretyakov Gallery (Fig. 136). This work, while far from typical of the genre as a whole, is extremely revealing about

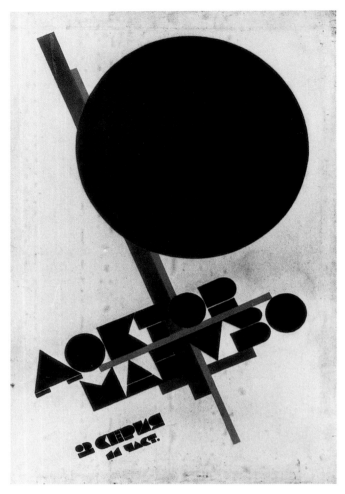

136 *Doctor Mabuso*, by Kazimir Malevich. 1925. Poster, 106 by 70.6 cm. (State Tretyakov Gallery, Moscow).

Malevich's idiosyncratic approach. To begin with, there was no single film called 'Doctor Mabuso'. The well-known German film director, Fritz Lang, made a long, two-part detective drama entitled 'Doctor Mabuse – the Gambler', screened in 1922 ('Mabuso' in Russian documentation of the 1920s). In March 1924, Eisenstein participated in re-editing the film, as a way of acquiring studio skills. The Lang film was shown, under the title 'Doctor Mabuso' in Russian movie theatres from 1925 (when Malevich made his poster), alongside the Eisenstein variant. Malevich concentrates on the 'black villain', whose transformation into a positive hero parallels that of Dr Caligari.

The black circle was an important element of Suprematist language, and in this poster it plays an allegorical and symbolic rôle, emphasising one of the visual leitmotifs of the film. In his analysis of Lang's film, Siegfried Kracauer remarked:

> As vividly shown on screen, the world finds itself in the power of brutal lust and depravity …Anarchy, ruling the world, clearly announces itself …And the circular motif becomes apparent. The floor in the new gambling house is ingeniously viewed to show a circle of closed hands during a spiritual séance filmed from above to give the impression of an exclusive circle. Here, as in Caligari, the circle symbolises chaos.[5]

For the inscription Malevich devised a type of 'blind' print. The letters consist of precise geometrical shapes saturated with colour – circles, semi-circles, triangles, trapeziums, and rectangles (which were to have a life in typography long after Malevich's original invention). The impeccably controlled flatness of the 'Doctor Mabuso' poster, emphasising the two-dimensional surface ('the impenetrable scheme' as Malevich called it), was to be broken, in the hands of other designers, by the addition of representational film stills. This led to collage compositions which Malevich considered to be an intolerable infringement of the principles of the film poster, and he condemned the Constructivists for using photographs in their 'exposures'. The ascetic restriction of colour and the magnificent, dynamic rhythm of Malevich's work also contribute to the memorability of the 'Doctor Mabuso' image, in which the 'black' circle of the sun and the ominous, pitch blackness of the letters are redolent of the dark figure of the film's hero.

In this refined and elegiac work, Malevich developed the Suprematist film poster using Suprematist methods and forms to bring out the essential content of the drama. This was, of course, only one in a series of Malevich's projects to introduce Suprematism into 'utilitarian life' – encompassing designs for fabrics, porcelain, and even architecture. Malevich's use of the 'eternal' medium of oil paint on canvas for 'Doctor Mabuso' emphasised the durability of the image, whereas normally posters in front of cinemas were painted directly onto canvas with glue paints which were easily wiped off to make way for successive images. It is appropriate that Malevich's poster, because of its medium and support, was later catalogued as a 'painting' by the Tretyakov Gallery.[7]

The expressive simplicity of Malevich's 'exposure' shows that Suprematism had the potential to be as effective in poster design as Constructivism, even though fewer examples exist. One of Malevich's pupils, Mikhail Veksler (1898–1959), a member of the Vitebsk

UNOVIS (Champions of the New Art), who later moved to St Petersburg, dedicated himself exclusively to this genre, producing a large number of Suprematist film posters in the 1920s (Fig. 137), but unfortunately few have survived.[8]

In his discussion of the cinema poster as a branch of graphic art, Malevich was initially unable to overcome the problem of a new artistic language. Many avant-garde painters saw film as extending the possibilities of the plastic arts and regarded the screen as a surface on which they could paint rays of light. Photography, 'mother' of the cinema, was respected only as a technical means to an end, and 'photographic' was synonymous with naturalistic. Malevich asserted that the cinema lacked its own content in the first article of his small series:

> Until now there has been no poster-exposure. In particular – no 'exposure' specifically for film. However, perhaps there has been no specific 'film exposure' for the simple reason that there has been no film? There have only been film cameras, turning themselves into pencils, paintbrushes, and a multicoloured palette, as a new method of communicating those pictures the old painters toiled over. Film, at present, is only a new, technical means in the field of communicating most completely what is real in art, and film directors are the new artists of IZO [Fine Art Department of the People's Commissariat Enlightenment], whose works remind us of static art.[9]

Malevich considered the laws of the development of painting 'from Impressionism to Suprematism', which he had formulated, to be universal for art in general. In his view, art had to move away from depicting reality to expressing a reality perceived by the mind, lying beyond superficial, material appearances. Malevich called for the realisation of 'pure sensation', which not only required no 'subject' or visible likeness but actually excluded such concepts. For him material appearances were 'alien' and to use them for the 'sensation of art' was unacceptable, as they would only destroy the meaning of art – the equal of nature and God in its creation and evolution. Cinematography also had to reject all the old 'alien' forms and find its own content through 'non-objectivity'.

These views were developed in Malevich's next article in '*Film Journal ARK*' three months later. Its title 'And images triumph on the screen' seems at first glance to contradict the sense of the text.[10] The word 'to triumph' in Russian has connotations of 'to be happy, to celebrate, to have a good time'. To suit his purpose, Malevich invested the word with the pejorative theatrical sense of acting and putting on airs. Calling it 'Kinetic art', Malevich accused film of all the sins of traditional figurative painting, condemning it for choosing to display 'the ugly face of life in the form of art' instead of its own content.

For the Suprematist Master, the language of film was to evolve from fine art, as opposed to the traditional sources, photography and theatre. In Malevich's opinion, the artist's work in film was always connected in one way or another to painting, which influenced the style of the production, the composition of the film frame and the expressive nature of the props. In his last article of the series, entitled 'The Artist and Film',[11] he once more reproached film-makers for being technically limited by conventional artistic notions, whereas the 'dynamic' artist developed new techniques but was 'reactionary' in his treatment 'of light and subject'.

At first Malevich could find no-one among makers of contemporary Soviet films capable of sharing his conception of a new cinema. Initially he made exceptions of Sergei Eisenstein and Dziga Vertov,[12] recognising the value of their experiments with a new representation of objects in cinematography which could become a step towards the final dethronement or 'pulverisation' of 'objects'. According to Malevich this would prepare the ground for the transformation of late Cubism into non-objectivity.

By the time he became acquainted with Malevich, Eisenstein had already made *Strike*, and Malevich's articles on cinema coincided with the production period of *Battleship Potemkin*, which had grown out of *The Year 1905*, the film the director was working on in Nemchinovka in 1925. Although he recognised a great talent in his friend and opponent, Malevich differed sharply from Eisenstein in his concept of cinematography. For Malevich 'literature that was not made by letters but by people' was unacceptable.[13] In his turn, Eisenstein, who believed in the revolutionary effect of film on the people, found Malevich's concept of the new artistic language of film both foreign and 'frivolous'.

Contemporary film theorists had long established that even before the cinema, forms already existed from which the language of film developed. Perhaps the most significant of these was montage. Eisenstein asserted that a film language would evolve from associative montage and that generally montage, in the broad sense of the word, would serve as the expression

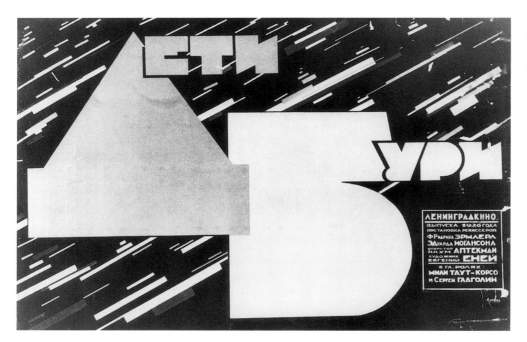

137. *Deti buri (Children of the storm)*, by Mikhail Veksler. 1926. Poster, 70 by 106 cm. (Museum für Gestaltung, Zürich).

of the fundamental principles of graphic thought. In the second half of the 1920s, developing and elaborating his views on the possibilities of associative montage, Eisenstein created the theory of the 'intellectual film'.

The director defined montage as an arena of conflict, the same conflict that Malevich first designated as the 'moment of struggle', and later as the 'law of contrasts'. For Malevich this was the basic law of artistic creation which had evolved during his Cubo-Futurist period: 'It transpired that there was one further concept to be found in objects in order to reveal new beauty. The intuitive feeling found in objects is the energy of dissonance created by the meeting of two opposite forms.'[14] From the purely plastic field the law of contrasts quickly widened to embrace the whole sphere of artistic thought and Malevich saw it as instrumental in destroying the ossified dogmas of old art. The clearest illustration of his law of contrasts is found in the painting *Cow and violin* (1913; Fig. 138). This has the following inscription on the back: 'the alogical confrontation of two forms – "cow and violin" – is a moment of struggle against logic, the natural order, narrow-minded meaning and prejudice. K. Malevich.' Another description, was given by Malevich to the future UNOVIS students in Vitebsk: 'Logic always stood as an obstacle to new intuitive movements and in order to become free from prejudice, it was necessary to create Alogism. The picture shown represents a moment of struggle through the confrontation of two forms, of a cow and a violin in a Cubist construction.'[15]

The depictions of the violin and cow, in differing scales, planes and styles, through their irrational interaction and juxtaposition on the picture plane, were intended to subvert reason which fetters the artist's will by a rigid division of 'subject' and 'form', dictated by a restrictive hierarchical structure. The principle of artistic expression in this picture reduces representation to basic visual units. Almost all Malevich's transrational canvases are constructed to a greater or lesser degree according to the methods of associative montage and supported by the 'law of contrasts'.

Malevich's famous Alogical canvases such as *An Englishman in Moscow* (1914, Stedelijk Museum, Amsterdam; Fig. 139) and *The Aviator* (1914, Tretyakov Gallery, Moscow; Fig. 140) are directly related to one of the central events of the artist's creative development, the production of the opera *Victory over the Sun* (1913), his first sortie into another field of art.[16] Music, literature and painting were fused in a *Gesamtkunstwerk*, a spectacle which closely corresponded to the concepts of the World of Art, most magnificently displayed in Diaghilev's productions of the Ballets Russes in Paris. Of particular interest in the production of the opera was Malevich's innovatory use of 'pictorial light' or rays of light, which made a great impression on his contemporaries. The opera began in total darkness broken by a flash of light from a projector which in

turn illuminated individual objects and parts of the *mise-en-scène* – bits of scenery, figures of actors, and so on.[17] Thus, the first non-objective 'film' was presented to the viewer, as the spotlight on the 'stage-screen' randomly picked out real-life episodes and fragments unmotivated by any narrative, but directed by the will and intuition of the artist-creator. The cinematic quality of *Victory over the Sun* is also indirectly demonstrated by the fact that the opera's dramaturgical outline is more accurately described as a 'scenario' than as a 'libretto'. The production of the opera anticipated by a decade the theory of 'Montage of Attractions',[18] which was the springboard for Eisenstein's 'leap' from theatre to film in 1923.

Victory over the Sun represented the peak of Malevich's Alogism, from which 'the desert of non-objecting and formlessness' was already visible. The conscious move into the latter was completed in spring 1915, when he was preparing sketches for the second (unperformed) production of the opera, which later served as illustrations for the proposed publication of the opera's text. Malevich went even further, 'pulverising' objects and forms into fragments and plastic elements, then recomposing them in a kaleidoscopic new picture. Although the ashes of earthly materiality are not completely shaken off, fragments of reality are variously and heterogeneously interpreted.

Malevich's transition from the Alogist phase of Cubo-Futurism to Suprematism marked the end of 'associative montage', which had acted as a stepping stone to the speculative realm of the pure essence of painting. Suprematist compositions invoked correspondences with the fundamental laws of the universe – dynamics and statics, tension and stillness, pulsating rhythm: the 'law of contrasts' took on an ontological rôle. Suprematist painting was the first stage of experimental investigation into new principles and methods, the stage at which a comprehensive, utopian project for the 'new reality' was created. Once this was achieved, Suprematism could then extend into all spheres of man's activity, including film.

Malevich called on all film directors to strive towards non-objectivity.[19] From those of Eisenstein's films he had seen, he thought that this director already displayed the potential for such a move: 'Eisenstein has one advantage over other directors – a certain understanding of the "law of contrasts", an intensification of which should later lead him to non-objectivity by purifying the screen of natural and agitational forms . . . Eisenstein has also turned his attention to the law of

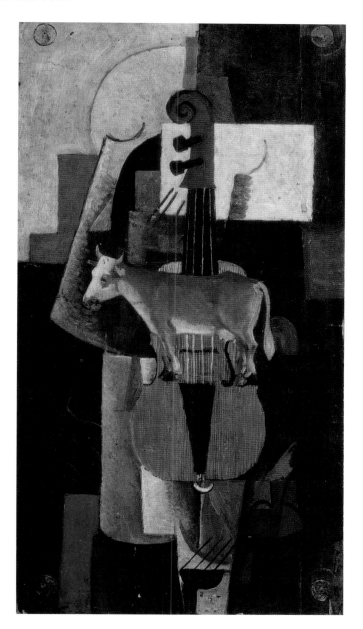

138. *Cow and violin*, by Kazimir Malevich. 1913. Panel, 48.8 by 25.8 cm. (State Russian Museum, St Petersburg).

contrasts which made his film production brilliant [here he has in mind the film *Strike*]. But he must also realise that surrounding the idea with extraneous contrasts should be done only to realise "contrasts as such", and not to produce gratuitous effects. If he understands this law as laid down by Cubism (the only school concerned with the law of contrasts), then he will find himself at the summit, from which silhouettes of the future of film culture and art in general will be visible.'[20]

139. *An Englishman in Moscow*, by Kazimir Malevich. 1914. 88 by 57 cm. (Stedelijk Museum, Amsterdam).

It is understandable that for Eisenstein, completely bound up in his own art, such instructions from Malevich seemed feeble interference from a painter outside his artistic sphere: 'To discuss cinematography in terms of easel painting is naïve. It may be accessible to people of good pictorial culture, but it is absolutely meaningless to the cinematographer. For example, although it is possible for people to discuss and analyse film using Kazimir Malevich's statements, not even an incompetent film student would venture to examine "film frames" from the point of view of easel painting.'[21]

At the same time, the creator of Suprematism, angered by efforts to place art at the service of some idea or other, whether of social welfare, the class struggle, the aesthetic shaping of life or whatever, saw the

gulf which separated him from artists who believed in the value of serving the political and social needs of the Soviet state. Malevich fought his battle on two fronts: caustically arguing with the Leftist Constructivists who, he believed, were turning art into the 'slave of production', and no less violently fulminating against the right, whose representatives closed ranks when the AKhRR (Association of Artists of Revolutionary Russia) was gaining strength in its aim to use art as an agitational and propagandist tool.

Eisenstein argued that the full effectiveness of art could be seen in its social influence on the masses. He was firmly convinced that the film language he had so brilliantly devised was meant to confirm the ideology of Soviet totalitarian society, and to be the vehicle of the 'party-line' in art. In such sentiments lay the roots of the tragic fate of the great film director, and the source of his spiritual separation from Malevich. Preserved in the Eisenstein archive is a letter from Malevich which essentially rebukes the director, and indicates the degree to which their friendship had deteriorated:

Dear Sergei Mikhailovich,

I have received and studied your letter. It is true, the letter is not completely clear to me when you mention the quarrel you picked with Gastev. It's obvious that the culprit is the monistic system, which first gave expression to the movement, but this expression will not serve as water in AKhRR's mill and my endeavours will not add a single drop of water to increase the movement of the millwheel.

You took Mayakovsky's AKhRR leftist line and I do not agree with that line and therefore decline to give you material.

I will be in Moscow from the 20th–25th August, I will be at K.I.S.h. We will talk in more detail. I shake your hand. K. Malevich, 13th August 1928. Tarasovka.[22]

The 'monistic system' mentioned in the letter was a theory much discussed in Eisenstein's circle at that time. For Eisenstein it was most fully represented by the performances of the Japanese Kabuki theatre which caused a furore in Moscow in the summer of 1928, at a time when he was engaged in the problems of changing from silent to talking films. The 'monistic ensemble', 'the monistic sensation of a theatrical tempest', meant the fusion of sound, movement and space, including the actors' gestures and voices, that would effect a single impression, acting on the viewer's perception as an

140. *The aviator*, by Kazimir Malevich. 1914. 125 by 65 cm. (State Tretyakov Gallery, Moscow)

integral whole.[23] From Malevich's letter it is clear that for him the 'monistic system' was the creation of an image, and symbolised all that was hateful in the exploitation of art by the state and by society.

According to Malevich the cinema's most important task was to create experimental films. Only by going through this experimental phase would it be possible to create a 'film logic and a special treatment, without

141. *Supremus no. 50*, by Kazimir Malevich. 1915. 97 by 66 cm. (Stedelijk Museum, Amsterdam).

which the organism of film would contract catarrh'.[24] This last statement corresponded directly to the theory of the 'additional' element in painting, based on Malevich's research in the mid-1920s. This explored the development of an artistic system through the 'addition' of primary plastic elements, original 'genes' which formed the whole 'body' of a new tendency, as, for example, in Suprematism where the 'gene' was the straight line. Malevich compared this 'additional element' in art with the cumulative effect of small doses of medicine.[25] The work of the artist and his companions in GINKhUK was devoted to revealing the additional elements to be found in Cézannism, Cubism and Suprematism.

Malevich knew a certain amount about the progress of cinema in Europe. 'In the West, major painters are gradually beginning to work in film, starting from a purely abstract element from which they will achieve new forms in the future.'[26] Native experimental cinema opened up completely different directions for a new artistic language. As before, various modifications of montage, which the Suprematist Malevich now defined as an 'intellectual scrap-heap', played a leading rôle.[27] He was pursuing the same lines of thought as other theorists and founders of 'pure film', 'integral film' and 'abstract film', and it is notable that such harmony of ideas was coincidental and arrived at independently, as if springing from a similar vision of 'film culture'. The theoretical work published by Germaine Dulac and his associate Louis Delluc in 1927, declared that film had already progressed from the 'realistic stage' (with all the trappings of 'authenticity'), had passed through the 'impressionistic stage' (where objects, landscape, light and shade served to reflect inner feelings), and had reached the phase of 'pure film', understood as a 'visual symphony'.[28] The emergence of a 'feeling for the cinema' – analogous to literary feeling, a musical ear, and sensibility to painting – of which Dulac wrote would undoubtedly have evoked a sympathetic response from Malevich, the leader of the new movement for 'sensation in art'.

Malevich found no supporters on Soviet soil for his research into 'non-objective' cinematography. New hopes and possibilities opened up for him, however, during his visit to Berlin in 1927 (from 29th March to 5th June). At his own request, Malevich was introduced by Alexander von Riesen, his escort in Berlin, to Hans Richter (1888–1976) who was already recognised as the founder of European abstract film. Richter had begun his career as an artist in the Blaue Reiter group (the Blaue Reiter Exhibition of 1912 was the first time Malevich showed outside Russia), and was then a participant in the Dadaist movement, in many ways similar to the slightly earlier Alogism. Together with the Swedish artist Viking Eggeling (1880–1925), Richter became absorbed in studying the alterations of painted and graphic forms in space, producing a transformation of successive images in long rolls.[29] As a result of this collaboration, films by Eggeling appeared – *Diagonal Symphony* (1920–23),[30] *Horizontal Symphony* (1924), *Parallel Symphony* (1924) – and Richter made a series of abstract films called *Rhythm* (1921–25), in which geometric figures and lines underwent a plastic metamorphosis on screen, rhythmically organised into visual music.

In the mid-1960s, while writing his memoirs, Hans Richter recalled his acquaintance with the exotic

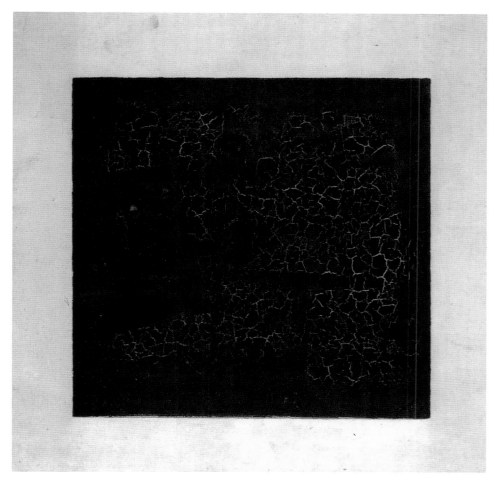

142. *The black square*, by Kazimir Malevich. 1914–15. 79.6 by 79.5 cm. (State Tretyakov Gallery, Moscow).

Russian artist, remarking that 'the main circumstance that drew us to Malevich was the Suprematist picture of the world, expressed through spatial continuity and dynamics'.[31] Apparently Malevich asked to see all Richter's abstract films and, as a result of these viewings and their conversations, decided to carry out a long cherished project of his own. A three-page script for 'An artistic and scientific film: painting and the problems of the architectural approach to the new classical architectural system' was discovered by Werner Haftmann in the Malevich archive in the 1950s.[32] The script, which bears the note 'For Hans Richter', is in three parts: the first, through a succession of episodes, aimed 'to show the development of the Suprematist square' and the other two were to be concerned with 'Architectonisation as a problem' and 'Architecture in

life'. Only a sketch for the entire first part was completed with some preliminary drafts of the rest. Clearly because of this the unfinished script was not shown to Richter and remained among Malevich's papers.

In the first part Malevich transported his theory concerning the emergence of Suprematism into the language of film and brought it up to date. The black square was the first form, the original Suprematist element. From it, as if from a nucleus, all subsequent compositions evolved through a process of transformation and division, to form the totality of the Suprematist world he was creating. In the first episode of the film, the square changed from black to red, then white (Malevich was confident that colour would soon be introduced into film). Every element of this Suprematist scheme passed through three consecutive

stages: black and white, coloured (best illustrated by the colour red which acted as a symbol of colour in general), attaining the ultimate white stage, signifying 'absolute non-objectivity'.[33] In the schematic pictures of the film script, conveying Malevich's thesis, the square, revolving on its axis, became a circle, the next basic Suprematist form, then, in the process of further division and displacement, became a 'form resembling a cross'. In the sixteenth episode the script abruptly ends.

The most important plastic idea of Malevich's scenario is the dynamic integrity of 'Supra-elements' in the unity of space-time. The transformation of geometric forms was both the meaning and the expression of a pictorial event. This, in turn, comprised a range of natural and self-sufficient phenomena, equal in value to all other phenomena in the universe.

The proposed film possessed a close genetic relationship with Malevich's canvases. A bare white space always formed the ground of Suprematist compositions. The depth and volume of the space were elusive and ambiguous but distinct. For the artist and many of his adherents the closest analogy to the unusual space of pictorial Suprematism was found in the mystical space of Russian icons, which was not subject to everyday physical laws. However, unlike icons, Suprematist compositions represented nothing and nobody, and were born of a free creative will, expressing their own miracle and nothing more: 'Thus the plane of pictorial colour suspended on the sheet of white canvas immediately conveys a strong sensation of space. It transports me to a fathomless wilderness, where I can feel the points of the universe creatively around me.'[34] The immaterial geometric elements hovered in a colourless and weightless cosmic space. The similarity between the white cinema screen and the white ground of a Suprematist picture ('a sheet of white canvas') is clear – both possess the same qualities, both are exponents of spatial relativity, and both are simultaneously flat and fathomless, seen as either receding away from or coming towards the viewer (the opposite, in fact, of an icon which only 'opens out' in one direction).

Being originally a plastic artist, Malevich considered space his basic element, and even once called himself the 'Chairman of Space', emulating Velimir Khlebnikov's designation as 'Chairman of the Terrestrial Globe'. In retrospect, however, it is clear that for Malevich the conquest of time was just as consuming an idea. From his early impressionist phase, Malevich had always worked in series, hanging his canvases in a straight line along the wall. This idea was particularly clear in his arrangement of his Suprematist paintings, at the 'Last Futurist Exhibition "0:10"' (Zero-Ten) of 1915. In St Petersburg (then known as Petrograd) thirty-nine paintings were shown together: they already encompassed the first two stages of Suprematism and even the departure into volume (see Fig. 141). In 1916, at the 'Knave of Diamonds' exhibition in Moscow, the artist showed sixty Suprematist works, numbered from one to sixty. Number one was *The black square* (Fig. 142), probably followed by *Black cruciform planes* and *The black circle*. Undoubtedly the Suprematist masterpieces *Supremus no. 50* (1915, Stedelijk Museum, Amsterdam; Fig. 141), *Supremus no. 56* (1916, State Russian Museum, St Petersburg), *Supremus no. 58* (1916, State Russian Museum, St Petersburg) completed this magnificent series.[35] Actually, Malevich re-hung the exhibited canvases into a linear progression, grouped in 'episodes' illustrating the process of development from work to work.

Malevich's continuing desire to demonstrate the movement of plastic ideas in time also informed the publication *Suprematism. 34 drawings*, completed at UNOVIS in Vitebsk in 1920. Here lithographic reproductions of fundamental Suprematist subjects were organised in succession, subject to the logic of the dynamic transformation of Supra-elements, with time as the conditioning factor of the arrangement.

Malevich constructed his theory concerning the development of new trends in art on evolutionary principles but as he elaborated his views he moved successively backwards in time to find Suprematism's origins. Initially he saw the movement towards objectlessness as deriving from Cubism (his first booklet was called *From Cubism to Suprematism*, 1915). Then he extended the roots of Suprematism further back, making Cézanne the starting point (*From Cézannism to Suprematism*, 1920). In the last variant he took a further step back in time, tracing Suprematism 'directly' from Impressionism (the title of his first one-man Exhibition was *Kazimir Malevich. His path from Impressionism to Suprematism*, 1919–20). In the last twenty years of his life, however, he constructed an 'authentic' history of the development of the newest art, crowned by Suprematism, arranging objects and events in an invented sequence which bears no relation to history or his own biography. He declared that the black square was the prototype from which all the other Suprematist works sprang, ignoring earlier abstract compositions with geometric shapes. Thus Malevich created his own concept of time, which he

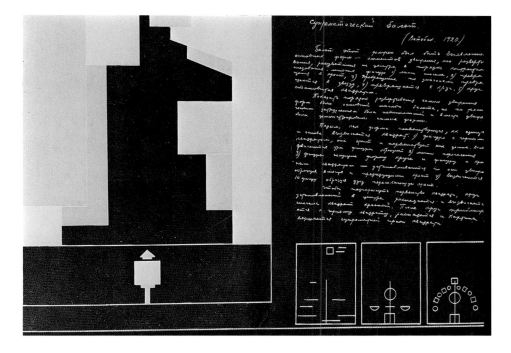

143. Designs for *Suprematist ballet*, by Nina Kogan. 1920. Gouache and ink, 22 by 31.5 cm. (Museum of Theatre Art, St Petersburg).

commanded just as easily and freely as the weightless, colourless space of his non-objective pictures. Suprematist easel painting paralleled the new perception of the cosmos as developed in Einstein's physics.[36] The logical conclusion of Suprematism would therefore have been to capture movement itself, fusing space and time into an indissoluble whole. The script Malevich wrote for Richter shows that a 'film culture' would have allowed him to realise this new concept of time and space. He saw the emergence of a new type of spiritual artist, a 'film-painter of dynamic pictures', as the inevitable result of the introduction of non-objectivity into cinematographic language.

The potential that abstract geometrical painting held for film was grasped by several of Malevich's followers. Particularly significant was an experiment carried out in Vitebsk by the artist Nina Kogan (1889–1942) at the beginning of 1920 (Fig. 143). She aimed to create an unprecedented spectacle, using the old definition of 'ballet' for want of a more accurate term. Her 'Suprematist Ballet', based on the transformation of geometrical elements in space and time, was intended 'to show an unfolding sequence of shapes' as 'the principal meaning of the ballet', but because of technical difficulties this proved impossible, and the forms alone were shown, without movement.[37]

As with Malevich's projects, the future visual realisa-tion of Nina Kogan's scenario was to be the animated film. In Vitebsk, the UNOVIS students wore shields containing representations of geometric shapes and moved around in the dark in the required formation; projected lights picked up the resulting *mise-en-scène*. The technique carried echoes of Malevich's designs for the production of *Victory over the Sun*. Also conceived in 1920 in Vitebsk, El Lissitzky's book *A Suprematist Tale of Two Squares*, represents another presentiment of the cinematographic potential of non-objective forms.[38] Its pages are like a sequence of stills from a silent cartoon film that have been supplied with the relevant titles.

For Malevich, the possibilities of putting into practice a new language of film were never fulfilled. Hans Richter, engaged in his own projects, did not heed the call of the Russian artist. In old age, as Richter recalled in his memoirs, he was extremely distressed at this missed opportunity for, as it later became clear, the development of abstract film suffered as a consequence.[39]

Urgently recalled to the Soviet Union from Berlin, Malevich was soon faced with the problems of surviving in a totalitarian society. Richter, arriving in Leningrad to shoot the film *Metal* in 1933 met him there and found the Russian master a subdued man. Two years later, in 1935, Malevich died and was buried, in accordance with his wishes, at Nemchinovka.

ROBERT ENGGASS

Ludovisi's tomb for a Colonna prince

Bernardino Ludovisi's lavish memorial for Filippo Colonna, which today stands in the church of S. Andrea in Paliano, was described in detail by Giovanni Francesco Chracas some two and a half centuries ago, but since that time has dropped completely out of the literature both on Ludovisi and on baroque sculpture in general.* It is a handsome monument (Figs. 144 and 145), and Chracas's admiration for it, expressed at much greater length than was his custom for works of art in an entry in his *Diario* Ordinario for 24th April 1745, is well worth repeating (the annotations in square brackets are mine; for his complete text, see the Appendix below):

We have received word from Paliano, which is located in the province of Campagna, one of the most important feudal possessions of the Colonna family in the papal states, that they have just finished putting in place a sumptuous tomb. It was made here in Rome, on the orders of the High Constable Don Fabrizio Colonna, to commemorate the memory of Don Filippo Colonna, his most worthy father, he too a High Constable of the Kingdom of Naples. The tomb is in the Collegiate church of S. Andrea, within which are buried all the ancestors of that eminent house. The tomb has a large plinth of coral-colored brescia antica on which rests the splendid sarcophagus which is made of alabaster set against a blue ground, and on it in gold letters is an inscription which was composed by Giuseppe Bianchini, a member of the Order of the Filippini at the Chiesa Nuova [i.e. S. Maria in Vallicella in Rome] . . .

The urn is decorated with gilded metal [a narrow ornamental band that frames the central panel] as is the cover or lid of the sarcophagus, on which are placed two well carved cartouches of giallo [antico] which sustain a great oval frame made of pavonazzo [a white marble with purple or bluish veining], it

too adorned with gilded metal [a large floral swag of gilt bronze]. Against this enframement, sustained by an elegantly carved console of giallo [antico] is a [white Carrara] marble bust depicting the defunct prince clad in heroic vestments. At the sides are two life-size marble putti, one of which holds a [flaming] torch above the sarcophagus, directing the eye of the viewer to the bust portrait, and the other, charmingly posed, is in the act of quenching the other torch, thus signifying the end of human life. There is in addition a large pyramid made of verde antico, which rests on the top of the plinth and provides a background for all the other elements. Above the pyramid, carved in [white Carrara] marble, is the coat of arms of that illustrious house, surrounded by military trophies which serve to remind us of the famous soldiers who were born of that noble stock. All of this [monument] was designed and executed by Bernardino Ludovisi, a member of the Colonna household.

Of Filippo Colonna, who is commemorated in Ludovisi's tomb, we know little.[1] He was born on 7th April 1663 of the union of Don Lorenzo Onofrio Colonna, Duke of Tagliacozzo and Prince of both Paliano and Castiglione, and Maria Mancini the niece of Cardinal Mazarin (or Mazzirini), the prime minister of Louis XIV. The Colonna had for centuries been supporters of the Spanish crown, and for generations had held hereditary title to one or another of the highest offices in the kingdom. Don Onofrio had been Viceroy of Aragon. In 1687, following the death of the Viceroy of Naples and during the interregnum, Don Onofrio served as head of the ruling council. On his arrival in Naples he immediately appointed his sixteen-year-old son Filippo to the position of commander of the company of lancers. This seems to have been one of the high points of Filippo's public career, though we do

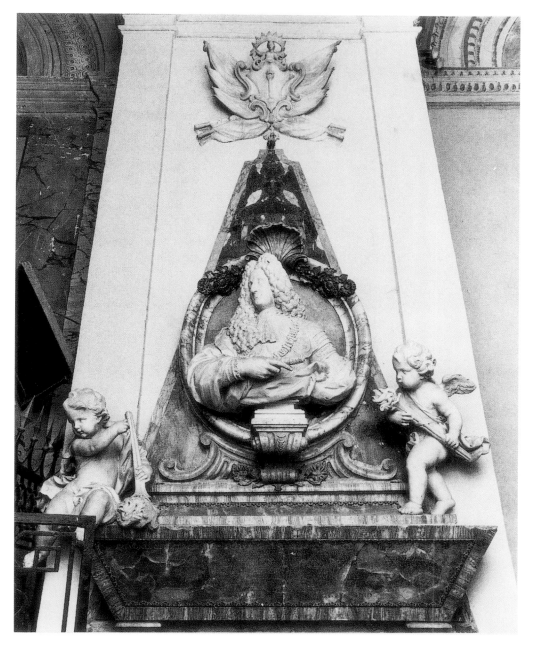

144. *Tomb of Filippo Colonna*, by Bernardino Ludovisi. 1745. White and coloured marbles with gilt bronze. (S. Andrea, Paliano).

know that in 1689 he succeeded his father as High Constable of Naples. On his eighteenth birthday he married Lorenza de Cedra, but she died without issue in 1697 and he remarried, this time Olimpia Pamphilj, by whom he had seven children. In 1679 King Charles II made him a member of the Order of the Golden Fleece. He died, as the inscription on his tomb indicates, on 8th November 1714.

Bernardino Ludovisi, who created Filippo Colonna's tomb, was one of the most active and far from the least successful among the sculptors of mid-eighteenth century Rome, though he is almost completely forgotten, quite undeservedly, today.[2] His sculpture tends to be tucked away in seldom visited churches or high up on the tops of façades. His activity was by no means confined exclusively to the service of the Colonna, as

145. Detail of Fig. 144.

right hand, so that this high honour can be identified only by cognoscenti who recognise the distinctive links of the chain – a sophisticated touch that must surely have been suggested by the prince himself. The surrounds of the Colonna crest – captured banners and what appear to be oars draped with sails – must allude to the Battle of Lepanto, the famous naval victory of the Catholic forces over the Moslem Turks, in which Marcantonio Colonna commanded the papal fleet.[4]

Now in the full flood of the mid-eighteenth century there is no longer any interest in profound expressive content, as in Bernini's bust of Gabriele Fonseca or the bust of Giulia Albani by Camillo Rusconi. Instead there is grace and charm and the quality is high. The curly-headed putto on the left (Fig. 145) is an absolute delight. His body, filled with movement and in sharp tension, forms an arc that is set off by his fluttering drapery and the flames of his torch.

Above all, Ludovisi is one of those rare birds among sculptors, a true colourist, as is demonstrated not only here but even more effectively in the Spinola Tomb at the Copelle. It is not just a matter of the richness of the materials, though that is certainly part of it. But it is also the way the precious marbles and gilt bronze are combined so as to create the most pleasing colour harmonies, and to set off the figures, which are always in white Carrara marble.

For the grand millennial tradition of Roman tomb sculpture this is almost the final chapter. It would flourish again with Canova, but only briefly. In our own century, almost without exception, the Roman tomb figures seem almost as lifeless as the deceased whom they commemorate.

Chracas seems to suggest. His finest sculpture is the Tomb of Giorgio Spinola in S. Salvatore alle Coppelle in Rome, a very small church which has been almost continuously closed to the general public during the last fifty years.[3]

With his bust portrait of Filippo Colonna, Ludovisi stresses social position and military glory. The prince wears a lavish wig, arranged casually so as to drop down over his chest on one side and over his back on the other. He is clad in embossed armour and holds what appears to be a field marshal's baton, but there is also a bunch of lace at his throat. He wears a thin cloak which is enlivened with many complex baroque folds, and is skilfully drawn across his waist so as to provide a natural termination for the bust, in the way that was invented by Bernini for the bust of Francesco d'Este. Colonna also wears the gold chain of the Order of the Golden Fleece, but its most distinguishing feature, the suspended lamb, is concealed beneath his

APPENDIX

Giovanni Francesco Chracas's description of Filippo Colonna's tomb, 24th April 1745 (Reprinted from *Diario Ordinario*, no. 4329 [24th April 1745, pp. 2–5].

24 aprile 1745 . . . Si è avuta notizia da Palliano Terra nella Provincia di Campagna, uno dei più cospicui feudi che abbia l'Ecc.ma Casa Colonna in questo Stato Ecclesiastico, di essere già del tutto terminata l'erezione del sontuoso Deposito fatto lavorare qui in Roma dall'Ecc.mo Sig. Contestabile D. Fabrizio Colonna per la Ch. Mem. del fu Ecc.mo D. Filippo Colonna, pari-

mente Gran Conestabile del Regno di Napoli, suo degnissimo Padre, nella insegna chiesa Collegiata di S. Andrea di detta Terra, ove sono sepoliti tutti gl'Antenati della stessa Ecc.ma Casa. Consiste questo in un gran Zoccolo di Breccia Corallina antica, su di cui posa un nobile Urna d'Alabastro, con fondo azzuro, e quivi à Caratteri d'oro vi è scolpita la sequente Iscrizione fatta dal Padre Giuseppe Bianchini della Congregazione di S. Filippo Neri in Chiesa Nuova

MEMORIAE. PERPETUAE/ FILIPPI. COLUMNAE/ LAURENTII. MARSORUM. DUCIS/ FILII/ PRINCIPIS. PALIANI/ QUI. CUNTIS. CIVIUM, QUIRITUM/ ORDINIBUS. CARUS/ DIEM. SUUM. OBIIT/ VIII. IDUS. NOVEMBRIS/ ANNO. SALUTIS. MDCCXIIII/ VIXIT. ANNOS, L. MENSES. VI/ DIES. XXIX/ EUM. OLYMPIADE. VERO. PAMPHILIA/ CONJUGE. PIISIMA. SUAVISSIMAQUE/ ANNOS. XVII/ SINE. ULLA. QUERELA/ & CONTROVERSIA/ DE. EO. ROMA. NIHIL. VIUD. DOLUIT/ NISI. MORTEM/ FABRICIUS. COLUMNA/ FILIUS. MAESTISSIMUS/ PATRI. OPTIMO/ & DE. SE. BENEMERITENTI/ AD. SUI/ & MATRIS. VIDUAE. SUPERSTITIS/ SOLATIUM/ CONTRA. VOTUM/ MONUMENTUM. POSUIT. EX. ANIMO

Resta la medesema tutta ornata dei metali dorati come è anche il Coperchio della sopradetta Urna, ove sono posate due bene intagliate Cartelle di giallo, che reggono un grande Ovato di pavonazzo antico similmente ornato di metalli dorati, e sotto di esso, sostenuto da una mensola di giallo di finissimo intaglio, si vede in marmo il Ritratto del difonto Principe in busto all'eroica vestito. Vi sono ai lati due Putti al naturale scolpite in marmo, l'uno dei quali tiene una face rivolta sopra l'Urna in atto di additare a riguardanti il sudetto Ritratto, e l'altro in vago atteggiamento figura smorsare l'altra face, denotando con ciò il fine dell'umana vita. Vi è in oltre un gran Piramide di Verde antico, che fà fondo a tutto il menzionato lavoro, posando sopra l'antedetto Zoccolo con ornamenti vaghissimi di metallo dorato, e sopra essa Piramide e collocata l'Arma intagliata in marmo dell'Ecc.ma Casa sudetta con attorno una quantità di Trofei bellici, quali rammemorano l'Illustri Guerrieri di tal nobilissima Prosapia, il tutto inventato e scolpito dal Sig. Bernardino Ludovisi, e Familiare della detta Ecc.ma Casa Colonna.

1998

EDITORIAL

Upon a peak in Brentwood

The hydra-headed Getty is much more than a museum, and the move to its new Center at Brentwood, Los Angeles, inaugurated on 16th December, has meant the unification in a campus-like setting of its seven programmes, which have also been re-named (if not yet 're-branded') for the occasion.[1] The Research Centre for Art History and the Humanities houses in its new circular home – perhaps the most interesting single building on the site – very extensive special collections of manuscripts, sketchbooks and documents, a selection of which will be illustrated in a future issue of the Magazine. Relations between the Museum in Malibu and the old Research Center in Santa Monica with its 'innovative' art-historical brief have not always been easy, but there are welcome signs that these unnecessary and unproductive divisions (reflecting wider dissensions between university-based and museum-based art history) are now breaking down.

As an architectural event, the opening of the Getty Center has been somewhat upstaged by the Guggenheim Museum at Bilbao which has immediately taken its place as one of the key buildings of the age. With hindsight, we may wonder why the Getty trustees passed over Frank Gehry, the Californian architect of poetic sculptural form, to select Richard Meier, the East Coast, European-minded geometrical minimalist. But, at least as far as the Museum and its historical collections are concerned (with a terminal date for acquisitions of 1900), there is much to be said for Euclidean spaces and, although there have been the usual tussles about interior decor, curatorial considerations have been seen to prevail.

Fifteen years have passed and a reputed billion dollars been spent since the site for the Getty Center was first purchased in 1982 (English critics might reflect that the British Library, a much smaller complex, has cost almost as much). The building history has been punctuated by the Los Angeles riots and the earthquake of 1994. If the latter served perforce to strengthen foundations, the former have left the Getty Center and its mission with more lasting shivers of uncertainty. Was it wise for a hyper-rich institution such as this to climb a hill, turn its back on the city, and devote itself to the study and accumulation of western high art? Although this question will be long and legitimately debated, one of the more convincing defences for the Center's lofty position is that it makes this spectacular hill-top site, with its unrivalled views of city and ocean, available for the cost of a bus ride or parking ticket. Staring at the Pacific – and at the extraordinary urban sprawl at its edge – is not the least pleasure afforded upon this peak.

Viewed from afar (Fig. 146), the new landmark looks odd rather than beautiful: a close-packed, flat-topped battery of giant food mixers, roll-topped desks and waving ocean-liner decks girdles the hill, flanked at either edge by two low round bastions with scarped flanks, one a reservoir-cum-helicopter-pad, the other a cactus garden. The form of these last consciously recalls the fortification of Tuscan hill-towns, a referential leitmotif reinforced by the use throughout the Center of 'cleft' blocks of Italian travertine (300,000 of them) as a facing material, their honey-coloured surfaces resembling squares of Parmesan cheese.

Ascending from the car park below by the little tram that winds its way round the hill, one arrives at the plaza from which the complex of buildings unfolds. It is clear from the ground-plan (less so from the ground itself) that the overall layout is governed by two axes – one aligning with the San Diego expressway, the other with the grid of the city streets. All the buildings are oriented to one or other of these axes, creating purposeful contrasts of angle. The use of unworked travertine adds a rustic touch to Meier's standard

146. The J. Paul Getty Center, by Richard Meier & Partners. 1997; Los Angeles.

neo-modernist repertoire of stove-enamelled surfaces, cylindrical columns, areas of square-paned glass, blocky forms and pipe-railed edges. But the further employment of smooth travertine for paving and steps creates a harshly reflective glare: it is this uncompromising stoniness and lack of shade that has brought the Athenian Acropolis to the minds of some observers.

At the core of the complex, the museum itself is not a single structure but a series of interconnecting two-storey pavilions of varying shapes and sizes, grouped around an internal piazza and crossed by the two governing axes of Meier's master plan. Paintings are hung in the twenty top-lit galleries at the upper level, and sculpture, decorative arts, drawings, manuscripts and photographs are installed in the darker rooms below. Visitors can choose to follow chronological sequences through horizontal suites of galleries, to move up and down within each block, or to wander in and out of pavilions at the piazza level. If the sense of high, fortified galleries with stunningly framed vistas again recalls Italian examples such as the Vatican museums, here there is of course a much smaller scale and a deliberate avoidance of the forced, one-way itinerary in favour of constant opportunities to pause and return. The opportunity to move in and out consciously evokes some of the enjoyments of the Roman villa at Malibu, but it also underlines the abrupt contrasts between Meier's clinical architecture and the more historicising gallery interiors (Fig. 148). Early on it became clear that the two aesthetics were irreconcilable.

However, there are also striking divergencies of decorative approach between the departments of the museum. The paintings galleries are on the sober side, with wooden floors, skirtings and door surrounds, walls mostly covered with plain fabrics. The effect is of no-frills neutrality. But – and this is undoubtedly the most important thing – the lighting is as close to the ideal as could be imagined. The natural Californian daylight

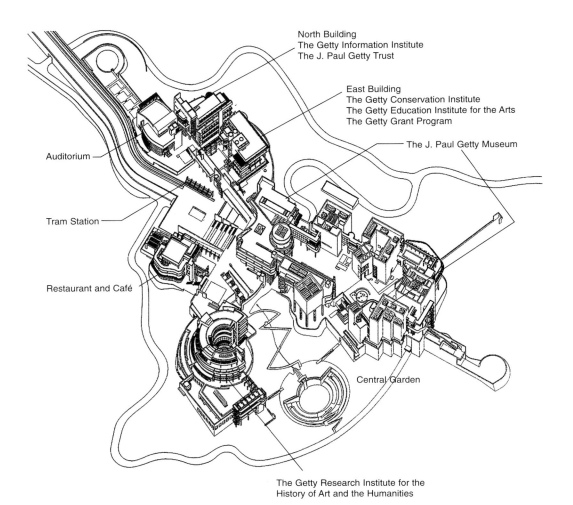

North Building
The Getty Information Institute
The J. Paul Getty Trust

East Building
The Getty Conservation Institute
The Getty Education Institute for the Arts
The Getty Grant Program

The J. Paul Getty Museum

Auditorium

Tram Station

Restaurant and Café

Central Garden

The Getty Research Institute for the
History of Art and the Humanities

147. Axonometric of the J. Paul Getty Center.

screened through louvres, together with the now canonical Dulwich-inspired coved ceilings, creates limpid, studio-like conditions in which there is no barrier between painting and viewer.

It was always clear that special treatment would be required for the superb French decorative arts collections – the richest and deepest of the museums's holdings, including four 'complete' panelled rooms of which two had not been shown at Malibu. The effects here are shamelessly opulent, with bracket cornices, complex mouldings and handwoven silks blurring the contours of old and new. The sculpture and non-French applied arts galleries provide a startling contrast: bronzes are set up on forests of grey plinths against tinted intonaco walls, with smooth varnished travertine floors and detailing. Here there is most

kinship to the architecture and least concession to context, although in one room an eighteenth-century atelier is pleasingly evoked with terracottas grouped on a trestle table. Thus the hybrid but selective character of the collecting policy is directly reflected in the decor. But the museum seems a little young to have such definite departmental boundaries, and, for example, an integrated Italian renaissance room, with tondi, cassoni, sculpture, bronzes, maiolica and glass, could easily be created from the existing holdings.

Perhaps the greatest surprise about the new Getty Museum is that, even without the antiquities (which will be kept at the Malibu villa, due to re-open as a Center for Comparative Archaeology after refurbishment in 2001), it has apparently been built without expansion in mind. Although about a dozen pictures have been

148. South pavilion of the J. Paul Getty Museum, with a view of one of the period rooms.

borrowed to enhance the representation of European painting (the illuminating juxtaposition of the *Lady in red* from Frankfurt with Pontormo's *Halberdier* confirms that the former is by Bronzino), space is by no means unlimited here or in the downstairs galleries. What happens if a decision is made to expand the collecting policy some way into the twentieth century – which would go well with the fine Futurist, Constructivist and Bauhaus material in the Research centre? Are we likely, as is hinted in one of the new publications accompanying the opening, to see the construction of yet a third museum in some less remote quarter of the city?[2]

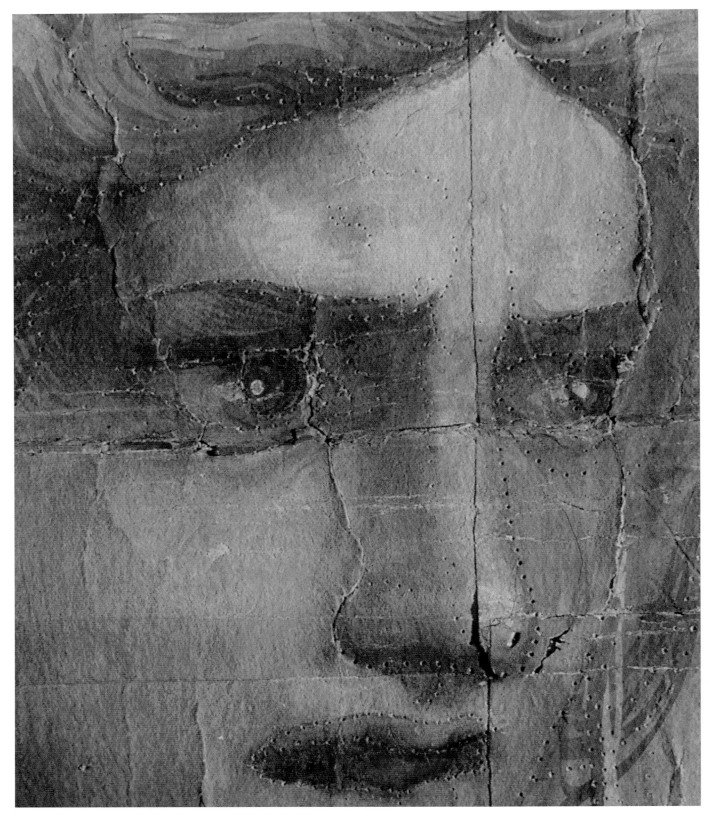

149. Detail of the head of a woman in Raphael's *Death of Ananias* cartoon, showing pricking.

SHARON FERMOR AND ALAN DERBYSHIRE

The Raphael tapestry cartoons re-examined

In Spring 1992, the seven Raphael tapestry cartoons on loan from the Royal Collection to the Victoria and Albert Museum were taken down from display for the restoration and redecoration of the gallery. This provided an opportunity to re-examine them, using techniques that had either not been available or were less well-developed when the cartoons were last conserved in the mid-1960s. This article outlines the main findings of the examination, the data from which will be stored as a permanent resource in the Museum's Print Room.*

CONSERVATION

It was decided to limit conservation to preventative treatment. The cartoons had been cleaned in the 1960s using powdered vinyl eraser, and were then retouched in pastel.[1] Since then, they have remained relatively free from surface dirt, and further cleaning was felt to be unnecessary and inadvisable. Their structure is highly complex and still imperfectly understood, while the paint layer is complicated by retouchings of various periods. Highly interventionist treatment would therefore have been both difficult and risky. Treatment was thus restricted to the following procedures. First, loose areas of paper were reattached to the canvas backings, using methyl cellulose.[2] Secondly, the stretchers and the back of the canvases were surface cleaned with a soft brush, soft cloth and a low-powered vacuum cleaner. Thirdly, areas of the canvas supports that had become attached to the stretcher bars during previous restorations were freed, using a steam generator. Finally, the damaged edges of the cartoons were reinforced with Japanese kozo paper and wheat-starch paste, the paper being toned to blend in unobtrusively with the canvas backing.

HISTORY AND DOCUMENTATION

The history of the cartoons is well known, but a brief resumé may serve to provide a context for the recent re-examination.[3] They were commissioned by Pope Leo X in 1515 as designs for a set of tapestries to hang on the lower walls of the Sistine Chapel. Ten tapestries from this set are extant (in the Pinacoteca Vaticana), but only seven cartoons survive. Completed in 1516 by Raphael and his workshop, the cartoons were sent to Brussels to be woven in the workshop of Pieter van Aelst. There, we discovered, a set of copies was made by pricking around the outlines of the designs (see Fig. 149). The original cartoons were then cut into vertical sections to be used directly on the looms, as was customary for the low-warp method of tapestry weaving.

The recent examination has demonstrated that the pricked copies were made before the cartoons were cut up, for, wherever the sections were misaligned when they were glued to the backing canvas in the late seventeenth century, the rows of pricking are misaligned to exactly the same degree. With this knowledge, the pricking can be used to reconstruct parts of the design that have since been lost or distorted by clumsy retouchings. In the *Death of Ananias*, for example, two rows of prick-marks in the distant landscape indicate the outlines of buildings which originally embellished the vista but have since been lost as the blue pigment, probably azurite, has flaked off.

After the first weaving, the cartoons appear to have been sold to another Brussels workshop, possibly that of Willem Dermoyen.[4] Two further sets of tapestries were made in Brussels, one for Henry VIII in an unknown workshop, before the cartoons entered the Brussels atelier of Jan Van Tiegen who made at least two more sets from them (or from copies of them). Still in Brussels in 1573, by 1623 they had found their way to Genoa, whence they were acquired, still cut into sections, by

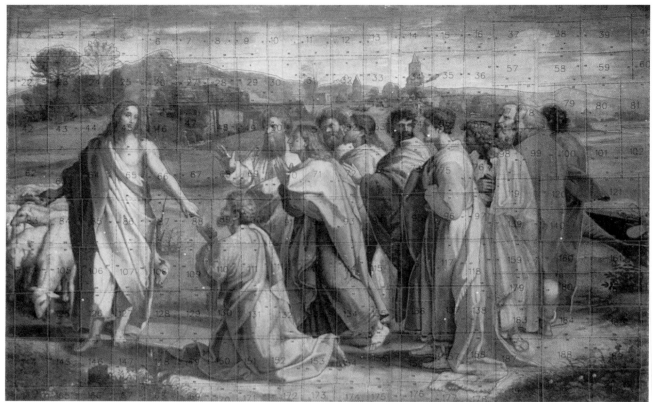

150. Photogrammetry of *Christ's charge to Peter* (Fig. 170), with individual sheets of paper numbered.

151. Transmitted-light photograph of *Christ's charge to Peter* (see Fig. 170).

Charles I when Prince of Wales, for use in the tapestry factory at Mortlake. The sections themselves were not used at Mortlake, probably because they were too damaged; instead, copies were made by the artist Francis Cleyn for use on the looms.[5]

The recognition of the cartoons as independent works of art is usually associated with William III who, around 1697, ordered that the sections be re-united and mounted onto the canvas which still supports them. The reconstituted paintings were installed two years later in the King's Gallery at Hampton Court, re-modelled for the purpose by Sir Christopher Wren. In 1865 the cartoons were given by Queen Victoria on long-term loan to the South Kensington Museum, now the V&A, an arrangement which has been confirmed by successive monarchs.

152. Detail of Fig. 151.

THE STRUCTURE OF THE CARTOONS

The recent re-examination focused initially on the physical structure of the cartoons and how they had been made in Raphael's workshop. This first involved measuring each individual piece of paper – each cartoon contains around two hundred sheets – and looking at the way in which they were put together. Here pioneering use was made of the technique of photogrammetry – so far little used in Britain for documenting works of art (Fig. 150)[6] – which made it possible to plot the dimensions and position of each sheet without making physical contact with the fragile surface of the cartoons. It emerged that the sheets, almost without exception, measure 27.9 by 40.6 cm. (11 by 16 in.), and are put together in a very orderly and systematic way, in groups of around thirty at a time, rather than in rows. The overlaps between the sheets are likewise very similar in width, around 1.3 to 1.9 cm. (0.5 to 7.5 in.).

Both photogrammetric diagrams (Fig. 150) and transmitted-light photographs (Fig. 151) show the pattern of the sheets, the overlaps showing up in the latter as a regular, almost geometric grid of dark lines.[7] It is particularly significant that only one grid appears, confirming conclusively that the cartoons are made up of a single layer of paper sheets, a question on which there had previously been some uncertainty. In the light of the 1960s examination, for example, the late Joyce Plesters concluded: 'The joined sheets of original paper are stuck down onto a similar composite sheet, the paper of which seems to be old, if not contemporary, and in places where glimpses of the underlayer of paper were seen during repairs to damages in the upper layer, it seemed that some of the sheets had previously been used for drawing and writing.'[8] However, while in some areas a second rectangular pattern seems to be visible in transmitted light, it does not show up in either raking or natural light. Furthermore, any secondary layer of sheets would have to be of much finer paper with overlaps too narrow to provide the effective support that would presumably have been their intended function. In fact, in most cases where such lines appear they correlate with other features detectable in natural or raking light, such as heavy creases, seams in the canvas, tears or patches. In cases of surface loss where a second layer of paper is visible from the front of the cartoon, this can be identified as a patch applied from behind, rather than an overall layer. Many such patches are visible in transmitted-light photographs as dark areas of irregular size and shape, testifying to the care that was taken at certain times to repair even the smallest of tears.

Transmitted-light photographs also reveal clusters of pinholes, visible as points of bright light, often around heads. These are presumably traces of the nineteenth-century practice of allowing students to take tracings of details, pinning sheets of paper onto the surface of the cartoons, as described by Richard Redgrave,[9] although it is possible that they may relate to the set of exact full-sized copies made much earlier by Sir James Thornhill, and now in the Royal Academy.[10]

The cartoons are made of medium-thick rag paper. Handmade paper such as this was hung over hair ropes to dry, leaving an impression of tiny wrinkles in the centre of the sheet. Down the long edges of the sheets

153. Detail from *Christ's charge to Peter* (Fig. 170), showing an area of the cartoon which was cut out and reinserted.

in the cartoons, rope marks (see Fig. 152) are often visible to the naked eye and, especially, in X-radiographs, since paint accumulated in the indentations. The fact that these marks occur near the edges shows that the present pieces of paper were obtained by cutting in half sheets of double the width, and we can infer that the original sheets corresponded to the common *foglio reale bolognese* size (56 by 40.5 cm, 22 by 16 in.) used, for example, by Michelangelo both in the huge Battle of Cascina cartoon and in that for the Cappella Paolina *Crucifixion of St Peter*, a fragment of which survives in the Museo di Capodimonte, Naples.[11] The direction of the laid lines in the paper, visible where there is little pigment, also confirms that we are dealing with bisected royal folios, as the lines run at right angles to the longer edge. Unfortunately, canvas backing makes the cartoons opaque and this, together with the relative thickness of the pigment, has made it impossible to locate any watermarks.

Why did Raphael and his assistants halve the sheets, making a demanding commission undertaken at a very busy time in the artist's career even more labour-intensive? The answer is almost certainly that, by doubling

the number of overlaps, Raphael provided himself with a stronger skeleton on which to paint, an important factor for such large surfaces (the cartoons average seventeen by eleven feet in size), especially as they were to be painted in body-colour rather than drawn in a dry medium such as chalk or charcoal, which would place an additional strain on the paper surface. Vasari describes cartoons for frescoes as being executed while secured to a wall with an outer rim of paste and we can probably assume that Raphael and his team worked in a similar way here.[12] The cartoons were certainly painted in a vertical position as the X-radiographs show paint drips running downwards.

It is a tribute to the craftsmanship of Raphael's workshop that there is only one clear instance in all seven cartoons of a paper patch, very small in size, applied to the front surface, presumably to cover a tear. This is certainly a contemporary repair, as the paint on the patch is continuous with that on the surrounding paper. The workshop thus succeeded in constructing vast paper surfaces, of a single layer, in such a way that they supported their own weight and that of the paint without tearing. The trimming of the deckle edges from

the sheets also helped, providing straight edges which were easier to align one with another and smoother surfaces on which to paint.

Raphael was undoubtedly a careful and meticulous worker by nature. At the same time, his approach to other commissions appears to have been quite pragmatic and he was not given to creating unnecessary labour. It may therefore seem surprising that he worked so meticulously and with such a concern for durability, or at least soundness of construction, on works destined to be cut up by the weavers and then likely to be disposed of or dismembered for particularly attractive motifs. (There are indeed several examples in the cartoons of the cutting out of individual motifs, presumably to allow them to be copied or used elsewhere. The charming detail of two figures in the landscape background of *Christ's charge to Peter* is a case in point [Fig. 153], the figures having been cut out and reattached.) Unless patrons re-purchased them (as Leo X may have intended to do), tapestry cartoons normally became the property of the weavers, who could do with them as they wished.

INFRA-RED REFLECTOGRAPHY AND UNDERDRAWING

The underdrawing found with the aid of infra-red reflectography proved to be extremely interesting for the questions it raised about how Raphael worked and how the designs were prepared. There is no trace on the cartoons of squaring up, or of any other means by which the small *modelli* made by Raphael and his assistants were translated to this very large scale.[13] Nor can Raphael have used as a guide the grid provided by the paper sheets, since the direction of the latter periodically changes from portrait to landscape format (Fig. 150), altering the dimensions of the 'squares'. It is just conceivable that he may have used other full-size drawings – cartoons for cartoons – for the transferral of the designs or of individual motifs. He could have done this using *spolvero*, or by blackening the back of a preliminary drawing and tracing it through onto the cartoon. In either case, the process might no longer be detectable. It is, however, hard to imagine him making full-size preliminary drawings as this would have been extremely labour-intensive, although it is conceivable that he used 'preliminary cartoons' or auxiliary cartoons for some individual heads, since these are remarkably free from pentiments. At least one of the known *modelli*, that for *Christ's charge to Peter*, in the Louvre,[14] is itself squared up, suggesting that transfer to

154. X-radiograph of the head of St John in the *Healing of the lame man* (Fig. 169), showing hatched brush strokes.

155. Infra-red reflectograph of the head of the man with the ox in the *Sacrifice at Lystra*, showing the edges of shadow.

a larger, perhaps intermediate-sized compositional drawing was envisaged. It seems inconceivable that Raphael and his collaborators worked from small *modelli* of this type to such enormous cartoons with no intermediate stages, especially since both the drawing and the painting on the cartoons are bold and assured, with very few alterations. Nor are there any pentiments created by the insertion or application of new sections of paper, a practice which is relatively common in large cartoons.

The underdrawing as it appears in the reflectographs (Figs. 155, 157, 159–62) is quite simple and economical, largely confined to the outlines of figures, drapery and buildings. It is carried out in charcoal, although in some

156. Detail of the *Healing of the lame man*, showing the woman and her child.

157. Infra-red reflectograph of the face of the woman in Fig. 156.

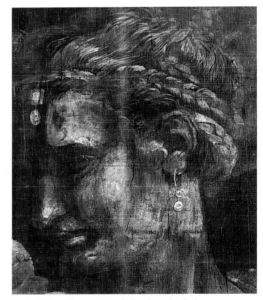

158. X-radiograph of the head of the woman in Fig. 156.

places lines have been drawn or reinforced with a brush, causing localised flaking of the paint layer. The charcoal layer is also identifiable in cross sections, between the paper fibres and the paint. No modelling seems to have been carried out at the drawing stage, and the shading that is visible in some of the reflectograms appears most likely to result from carbon black used in suspension in the paint layer. It needs to be said that the appearance of the reflectograms can be deceptive and they also vary according to the lighting and position from which the image was taken. Given the vast size of the cartoons it was impossible to replicate exactly the same conditions

for every image. Equally, it was impossible to take paint samples from every area where some suggestion of underdrawing is visible in reflectograms, so that it cannot be ruled out conclusively that charcoal or black chalk shading may be present in some areas. Overall, however, the shading visible in the reflectograms appears even and diffuse, with a smooth and wash-like quality suggestive of modelling in paint, rather than stumped or smudged charcoal or black chalk. There are few variations in density or texture in these shadows, and no sign at all of any hatching. Where hatching does appear, it is carried out in the paint layer and shows up

clearly in the X-radiographs, as in the head of St John in the *Healing of the lame man* (Fig. 154). It is not visible in the reflectograms, suggesting that the paint used contained little carbon black. The shading in the reflectograms also occurs in areas that have crisp, clearly defined limits, as might be achieved with the point or the edge of a brush (Fig. 155).

What seems to emerge from the reflectograms, then, is that charcoal drawing was used primarily to sketch the outlines of the main forms. The modelling was then carried out quite broadly in the body-colour, rather than in highly finished or detailed underdrawing. Cross-sections confirm that carbon-black, usually with vermilion, was used to render the darker shadows as well as to reinforce the outlines.

The head of the woman with a baby, certainly painted by Raphael, in the *Healing of the lame man* (Fig. 156) can be used as an example to show the various stages of the drawing and painting The reflectogram shows the drawing of the profile – here made quite thick and blunt as the area to the left of the woman's face is in deep shadow – which has been reinforced with a paint line containing carbon black (Fig. 157). It also shows some wash-like shading on the cheek. The drawing is quite simplified, however, and not as expressive as the finished head, which acquires real structure only in the painting, as visible in the X-radiograph (Fig. 158). Here, the projections and hollows are modelled with supreme confidence, and the defining highlights in the jewellery perfectly placed as the head is brought fully to life.

Most of the drawing in the cartoons functions in this way, as a basic indication of forms that are then fully modelled in body-colour. This is what one might expect, given the scale of the project and the undoubted pressure of time. A notable exception is the *Miraculous draught of fishes* (Fig. 172), almost certainly the only cartoon to be executed entirely in Raphael's hand and probably the first in the series.[15] It is also the only cartoon of the seven for which no fully finished *modello* survives.[16] Here, the drawing is much freer and more spontaneous and does not give the impression of having been transcribed from an earlier study. The drawing on the shoulders of the apostle hauling in fish, for example, is fluid and dynamic, giving the impression that the artist was searching for the definitive form (Fig. 159). In other areas, too, Raphael appears to be working out solutions to the figures on the cartoon itself, and there are numerous small pentiments in the legs, hands (Fig. 160) and drapery.

159. Infra-red reflectograph of the shoulder of the apostle hauling in fish in the *Miraculous draught of fishes* (Fig. 172).

160. Infra-red reflectograph of the hand of St Andrew in the *Miraculous draught of fishes* (Fig. 172), showing pentiment.

161. Infra-red reflectograph of one of the putti from the right column in the *Healing of the lame man* (Fig. 169).

162. Infra-red reflectograph of part of the head of St Andrew in the *Miraculous draught of fishes* (Fig. 172).

163. X-radiograph of the head of the cripple at the left in the *Healing of the lame man* (Fig. 169).

Given this, it is just conceivable that in the *Miraculous draught* Raphael worked directly onto the cartoon, without detailed studies: it is nonetheless noteworthy that there are no significant pentiments in the heads, beyond a slight adjustment to the nose of St Andrew (Fig. 162), and for these Raphael must surely have made preparatory drawings. The only other areas in which we find drawing of such freedom and spontaneity are in the background on the right of *Christ's charge to Peter*, and in the exquisite drawing of the putti on the columns in the *Healing of the lame man* (Fig. 169), probably attributable to Giulio Romano; the putto in profile on the left edge of the right-hand column provides a good example (Fig. 161).

The sculpted motifs on the columns appear to have been composed directly onto the cartoon, and not a single detail is repeated. Their beauty and inventiveness appear to have been recognised early on, for the upper part of the first column on the left shows two lines of pricking, one of only two areas on the cartoons to have been pricked twice. A weaver or painter may have made a copy of this part of the cartoon alone, for use in another context. The other double-pricked area is the inscription below the proconsul's throne in the *Conversion of the proconsul*. This is the only element not reversed for the convenience of the weavers, who would therefore have had to take a copy of the lettering and reverse it for themselves.

Reflectograms can be difficult to interpret, especially as a measure of the quality of underdrawing. As we have seen, the outline of a face was sometimes reinforced with a brush and paint containing carbon black, especially where the surrounding areas were to be in shadow: this can give the contour a heaviness which may not have been present in the underdrawing. Fainter images, such as those seen against a light background, can at first glance appear weak and lacking in conviction although in other cases, such as the head of St Andrew in the *Miraculous draught*, the skill and delicacy of the drawing are immediately apparent (Fig. 162). Similarly, where a face is brightly lit and therefore lacks many modulations or shadows, the reflectogram can appear formless, while X-radiographs of faces in shadow, where little lead white is used and the paint layer barely registers, can seem amorphous. Thus, the head of Barnabas in the *Sacrifice at Lystra*, certainly by Raphael, appears more vigorous and well-defined in the reflectogram than in the X-radiograph, even though the quality still comes through in the latter, thanks to a few judiciously placed highlights and the surrounding aureole of the halo. The head of the cripple in the *Healing of the lame man*, again by Raphael, provides another example of the way in which he could create modulations of light and shade using paint containing very little white (Fig. 163).

X-RADIOGRAPHY

During the conservation campaign of the 1960s, some sixty X-radiographs were taken of selected areas – mainly heads – by resting X-ray sensitive film on the front of the cartoons, which were supported horizontally on trestles. In the recent programme, it was decided to X-ray two complete cartoons – *Christ's charge*

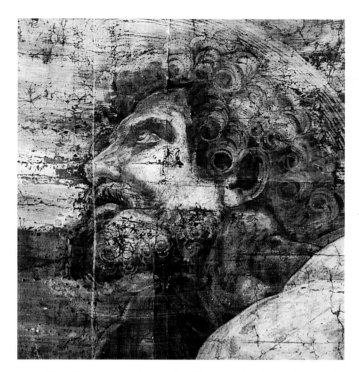

164. X-radiograph of the head of Peter in the *Miraculous draught of fishes* (Fig. 172).

165. X-radiograph of the head of Paul in *Paul preaching at Athens*, showing the pentiment in the ear.

to Peter and the *Healing of the lame man* – as well as details of others. The cartoons were placed vertically on a metal easel, and surface contact was avoided by placing the film against the back, using the stretcher bars and the bars of the easel as supports.[17] The resulting X-radiographs provide invaluable information about the cartoons' structure and reassembly, the areas of damage, craquelure, paint loss and retouching, as well as contributing to questions of authorship and painting technique. They suggest that the paint was applied in a single broad layer, and with great confidence and assurance. Remarkably few pentiments are visible, and those that do appear tend to be minor, such as the changes to St Paul's ear in the *Paul preaching at Athens* (Fig. 165).

There is no doubt that the X-radiographs can help us to distinguish between work by Raphael and that by other members of the workshop, even if we cannot always name or identify the assistants concerned. If we compare the head of St Peter from the *Miraculous draught*, certainly by Raphael (Fig. 164), with two heads of apostles from the *Death of Ananias*, for example, the differences are striking. Raphael has an absolute grasp of the structure of the face and renders it in its entirety: light and shade are placed with great precision to

model the different planes, catch the fall of light and convey the saint's intense expression. Many of Raphael's heads have hatched modelling and all reveal subtle gradations and modulations of light as well as an unerring attention to details such as the tiny highlights in the eyes and ears. By contrast, the heads of the apostles in the *Death of Ananias* are crudely and summarily rendered, and formulaic in their use of chiaroscuro. They lack definition and structure and are divided starkly into light and shade with no gradations of tone. The light areas are too bright and too isolated to be wholly convincing, and it seems inconceivable that these heads are by Raphael himself.

Thus X-rays gradually reveal where and why Raphael himself intervened in the cartoons. Initially it may strike us as rather odd that he should not have painted any of the apostles in the *Death of Ananias* (Fig. 171), although he certainly painted the figure of Ananias and the recoiling woman to the left – if not the horror-stricken man who is of a different physiognomic type and quite differently achieved. It appears that Raphael generally intervened in those figures that were thematically most important, such as Ananias, but also in those with particular compositional significance, making sure that the reading of these complex

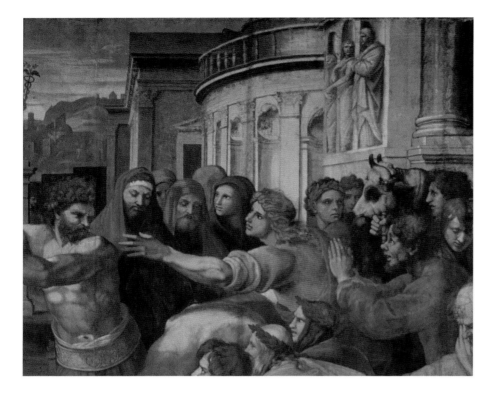

166. Detail of the *Sacrifice at Lystra*.

167. X-radiograph of the man with a wreath in the *Sacrifice at Lystra* (Fig. 166).

narratives was absolutely clear. Otherwise he seems to have been quite pragmatic in restricting his direct involvement at the painting stage.

One such example occurs in the *Sacrifice at Lystra* where the group of heads on the right is remarkably uneven in quality (Fig. 166). This area is badly water-damaged and therefore hard to judge. Yet, looking at these heads with the naked eye and with the aid of X-rays, the key figure of the cripple and the two heads

peering down appear immeasurably superior to those around them, a contrast particularly evident in the wreathed male head to the left, where the paint is applied in poorly differentiated strokes, giving the face a flat and inexpressive appearance (Fig. 167). The two peering figures, much stronger in conception and execution, are also crucial to the reading of this simultaneous narrative for, as they look down, they draw attention to the leg and discarded crutches of the newly cured cripple whose miraculous recovery was the catalyst for the impending sacrifice. The angle of their heads, and their ability to command attention by their innate strength, govern the proper understanding of the narrative and it therefore makes sense that Raphael would himself paint what could otherwise seem like incidental figures. The drawing and painting of the other figures in the background seems weak by comparison, the faces insipid and ill-defined.

Even in *Christ's charge to Peter* (Fig. 170), Raphael appears to have delegated some of the heads that were not crucial from an iconographic or compositional point of view. Thus, the apostle with the tilted face, who breaks up the two profiles at the front and engages the spectator, is beautifully rendered in terms of light and shade and seems to be by Raphael, while the profile behind him is weaker and less well characterised (Fig. 168). In the *Conversion of the proconsul*, only the heads

168. X-radiograph of two apostles' heads in *Christ's charge to Peter* (Fig.170).

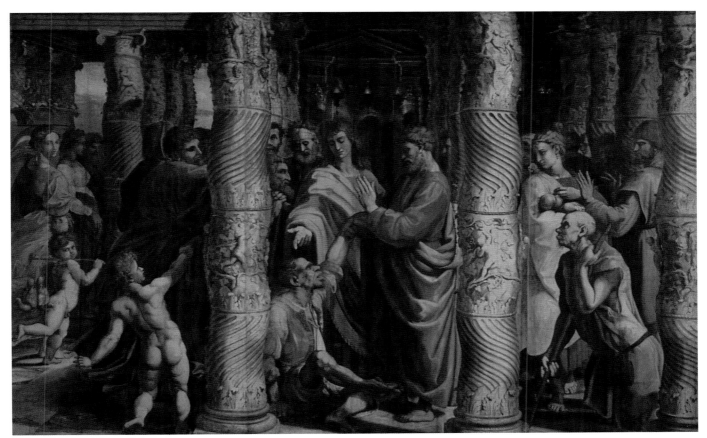

169. *Healing of the lame man*, by Raphael and assistants. Bodycolour on paper, 340 by 540 cm. (Royal Collection, on loan to the Victoria and Albert Museum, London).

of Paul and Barnabas appear to be by Raphael. Even the head of Elymas, which is nonetheless a fine one, and the seated proconsul (clearly identified by the inscription below his throne) seem to be by other hands.

In a set of works as large and complex as this, one has to assume that a range of different procedures were employed. There are many heads and motifs taken from other works by Raphael, but these could easily have been copied, as with any other preparatory drawings, onto the cartoons by other members of the workshop. In some cases a weak and mechanical drawing is transformed into a powerful head by Raphael's intervention in the painting; in other cases, such as the head of the woman in the *Healing of the lame man*, the drawing and painting appear as one. Lastly, a drawing by Raphael might possibly be painted by another artist. The divergence of quality and style in the cartoons cannot simply be put down to the intervention of different artists in the most straightforward way, but may also reflect the use of different working procedures.

X-rays have also proved extremely useful in revealing areas of damage, many of which were covered up by the pastel retouchings in the 1960s. Often, these retouchings are visible to the naked eye but, given the cartoons' size, it would not have been possible for us to record each one in words. X-rays, as they pass through the pastel to reveal the damaged areas, document the exact extent of the damage and retouchings. The head of St Peter in the *Healing of the lame man* (Fig. 169), for example, can be seen to have sustained loss, signified by the dark areas with irregular edges. This helps explain the rather crude appearance of the head in the finished cartoon, which at first glance does not appear to be by Raphael. However, in the X-radiograph, the areas of damage are clearly shown in the nose and brow, while the original straight profile of Peter's nose can also be discerned. In the cartoon, the nose has been retouched in a slightly curved shape, following the line of the damage, giving it a rather retroussé appearance – while the brow has been repainted with dark furrows. Together, these retouches give the head a semblance of caricature which is not apparent in the X-radiographs.

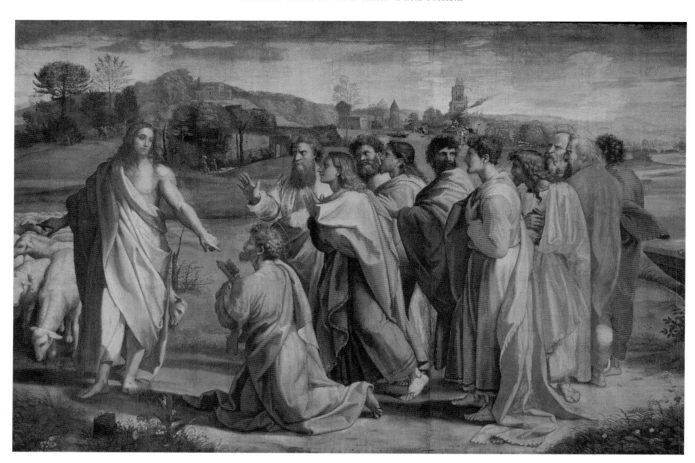

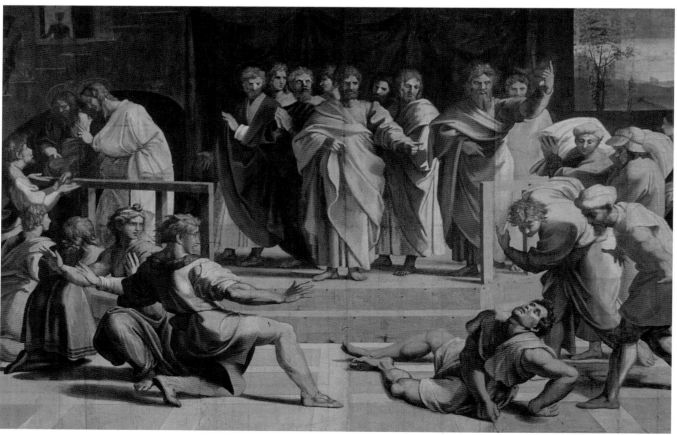

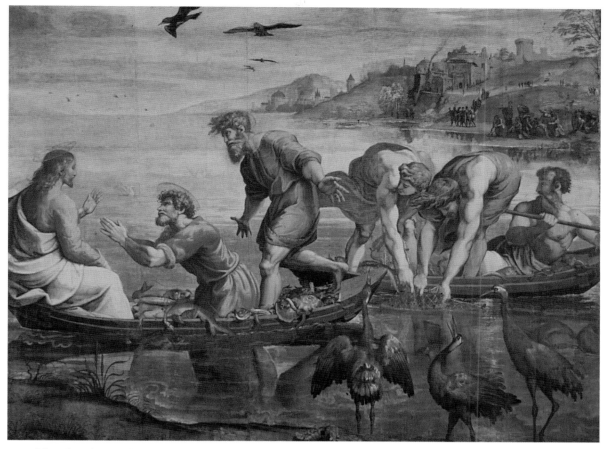

172. *Miraculous draught of fishes*, by Raphael. Bodycolour on paper, 320 by 390 cm. (Royal Collection, on loan to the Victoria and Albert Museum, London).

PIGMENT SAMPLES

Some pigment samples were taken from the cartoons in the mid-1960s by Joyce Plesters, who published some of the results about twenty years later in the papers of the Princeton Raphael Symposium.[18] Pigment analysis carried out in the recent campaign has arrived at similar results to hers, but has also been able to expand on these, partly as a result of improved microscopical techniques and partly by taking samples from different areas – specifically those where evident fading and discolouration have taken place.

170. *Christ's charge to Peter*, by Raphael and assistants. Bodycolour on paper. 340 by 530 cm. (Royal Collection, on loan to the Victoria and Albert Museum, London).

171. *Death of Ananias*, by Raphael and assistants. Bodycolour on paper, 340 by 530 cm. (Royal Collection, on loan to the Victoria and Albert Museum, London).

To the list of pigments that Plesters identified as present in the cartoons, it has been possible to add others, particularly orpiment and indigo, while pigments used in successive retouchings have also been identified. It has become apparent that considerably more fading and discolouration have occurred in the cartoons than was previously thought, explaining some chromatic discrepancies between the cartoons and the tapestries.

The pigment mixtures in the cartoons are sometimes quite complex. However, cross-sections confirm that, as suggested above, in most areas the paint was applied as a single, thickish layer of body-colour (pigment, water and animal glue, with the addition of significant amounts of lead white to render the paint opaque). Of course there are exceptions – cases where more than one layer of paint is visible. These can be divided into two categories: areas where one form is painted over another, as for example the hair of the apostle fifth from right in *Christ's charge to Peter* (Fig. 170),[19] and those areas where shadows or highlights have been applied

over the main body of colour, as in the shading of the same figure's yellow gown.[20] Both these instances show Raphael's concern to achieve exactly the right tone in each part: that is, he was providing the weavers not simply with colour guides in the form of thin washes of colour, but with fully coloured and carefully calculated designs.

The question of fading and discolouration is especially significant in considering some puzzling passages of off-white, grey and beige, which also disrupt the balance of the compositions. Most of the fading relates to the use of madder lakes, indigo or orpiment. Madder lakes were fugitive pigments produced in a variety of shades from pink to red and purple to brown. So badly have these faded in the cartoons that it is not possible to distinguish each different shade, but they are found in many pinks and reds, mixed with azurite to give a wide range of violet to purple colours, and added to vermilion to enhance and intensify the colour.

Thus the overall colour range of the cartoons would have been richer, warmer and more varied than it now appears. In the *Death of Ananias* (Fig. 171), for example, the maroon garment of Ananias is composed of madder lake and has probably faded considerably, while the very pale pink and obviously discoloured garment of the apostle distributing alms on the left is of madder lake and lead-white and would probably once have been a purplish, dusty pink, providing an effective balance to the deep red garment of the apostle on the far right. The presence of madder in Christ's robe in the *Miraculous draught* suggests that it was originally a deep pink, indicated also by its reflection in the water, painted with vermilion (Fig. 172). His gown, too, has some madder and was probably a pale lilac, more clearly distinguished from Peter's blue robe. Traces of madder lake also appear in Christ's now white robe in *Christ's charge to Peter* (it appears lilac on the back of the tapestry, where the colours are well-preserved), and in the badly faded gown of the exquisite female figure with the baby in the *Healing of the lame man* (Fig. 169); originally she must have worn a clear lilac cloak, with some areas of blue, creating an ornamental effect in keeping with her compositional and thematic importance.

Indigo (dark blue) and orpiment (bright gold-yellow), often used together in the cartoons to create a dark green, both change in water-based pigments. In *Christ's charge*, the disciple behind Peter now wears a dirty grey garment which reveals traces of indigo, orpiment, lead white, azurite and vermilion, and would originally have been dark green with purple in the shadowed areas, making the apostle a more effective foil for Peter and a stronger termination for the figural group. The equivalent figure in the tapestry wears a green garment with a blueish tinge, perhaps due to the loss of the fugitive yellow dye.

CONCLUSION: THE STATUS OF THE CARTOONS

Most of what we have found in the cartoons, from the making of the paper surfaces to the mixing and deployment of colour, suggests that Raphael thought of them as more than simply tapestry designs, to be used once and then discarded. Their making reveals a high degree of care and preparation, and each cartoon is finished to the smallest detail of form and colour. This does not necessarily mean that Raphael would have considered them to be independent works of art, although he may well have done so. By this time the collecting of cartoons was well established and, although the size and consequent fragility of these examples might seem to rule them out as collectors' items, one, at least, had been bought by Cardinal Domenico Grimani for his private collection in Venice by 1521.[21] Furthermore, as John Shearman pointed out in his monograph, the fact that Raphael did not reverse the inscription on the *Conversion of the Proconsul* would seem to suggest that he wanted the cartoon to remain legible as an independent entity, and that this took precedence over the weavers' convenience.[22]

The care Raphael took over the cartoons also indicates the importance of the commission and his awareness that the tapestries would be directly compared with the Sistine Ceiling. Many aspects of the cartoons – the muscularity and monumental scale of the figures, the exquisite landscapes and the widespread use of *colori cangianti* – reveal Raphael's sense of dialogue with Michelangelo's recently completed frescoes. In both design and execution Raphael made sure that nothing was left to chance – or to the weavers' imagination.[23]

In some respects this caused problems in Brussels. It has long been observed that the weavers altered the formation of the background landscape in *Christ's charge to Peter*, inserting a plain grassy strip between the heads of the figures and the dense areas of foliage and buildings. This was almost certainly necessitated by the weaving process, which required specialists in heads and landscape to work side by side on the looms. The recent examination has provided physical evidence of this

alteration: like the two small figures in the background (Fig. 153), the main figural group has been entirely cut around, enabling the weavers to separate the figures completely from their surroundings. The cartoon has also been cut between Christ and St Peter, suggesting perhaps that further alterations to the composition may have been considered. The parts were then rejoined with extraordinary care and precision, using repair strips applied to the back, which are visible in transmitted light. So careful was the reassembly that at some points it is difficult to detect whether the parts were actually detached. Detailed examination also reveals that the background landscape has not been pricked round, the only such instance in the cartoons. The rest of the cartoon has been pricked very closely, including the foreground foliage. This may suggest that the weavers intended to improvise the landscape or that they found the sfumato effects impossible to reproduce with prickmarks. While the landscape in the *Miraculous draught*, in which buildings dominate, has been meticulously pricked, that in *Christ's charge to Peter* appears to have been beyond the weavers' experience.

As we have seen, the cartoons were patched, copied and repaired from early in their history, and care was taken with their reassembly when individual motifs had been cut out. While this may simply have been out of a desire to extend their usefulness as tapestry designs, and thus their market value, it also suggests that they were highly esteemed. If the Mortlake weavers worked from Cleyn's copies, this may be not only because the strips were too damaged to be used, but also because Charles wanted to preserve them. He had his monogram stamped on the back of each strip of the *Conversion of the Proconsul* – a detail which has also become visible under transmitted light. While the cartoons' financial value was low, at a mere £300, their cultural value as original works by Raphael may well have been very much higher.

It may also have been during Charles's ownership that the canvas strip-linings discovered during the recent campaign were applied. Ribbons of fine canvas between 5 and 10 cm. wide were laid down all the edges of each section into which the cartoons had been cut, visible in outline in raking light (Fig. 173) and as opaque bands in transmitted light. In most cases the canvas strip applied to the right-hand edge of each section extends beyond the edge, while that on the left coincides exactly with it. On *Paul preaching at Athens*, one of these vertical strips is an uncut selvedge, indicating that it has not been tampered with, and that this differential

173. Detail of *Christ's charge to Peter*, photographed in raking light.

positioning was intentional. There are also pinholes down the left edge of each piece, suggesting that the strips were on occasion butted together and pinned through to unite the cartoons. Radiocarbon dating of this fine canvas gives it a span of 1390–1640, making it plausibly locatable within Charles's reign.[24]

Initially these canvas strips may have been applied to allow Francis Cleyn to copy the cartoons while they were supported in a vertical position, but they could subsequently have been used to enable the works to be exhibited as whole compositions, as they were in the reign of William III.[25] William's reunification of the sections onto backing canvases secured the cartoons' status as works of fine art although, as we have seen, that did not mean that they were always treated with reverence.

Given the difficulty of moving the cartoons, there is unlikely to be an opportunity to examine them again for some considerable time. In this article we have given an overview of the data we have gathered, and have hinted at the possibilities it offers for future research. In some cases the findings have confirmed episodes in the cartoons' history that are known from written sources. In others, as with the infra-red reflectography, X-rays and pigment samples, it has provided material that is largely new. Of course, even such scientific material can be interpreted in different ways, and it is our hope that this examination may prompt further debate about some of the complex issues that surround these extraordinary works of art.

OLIVER MILLAR

Frederik Hendrik of Orange and Amalia van Solms

It is impossible to praise too highly the two recent exhibitions at the Mauritshuis and the Historisch Museum in The Hague (closed 29th March) which, one hundred yards apart, combined to present a wonderfully rich and broadly based account of the achievements of the Stadhouder Frederik Hendrik and his wife Amalia van Solms and to set their activities as patrons and collectors within a wider historical and cultural framework. As we have come to expect of exhibitions on the banks of the Vijver, the whole project was, like the main wall of the Oranjezaal, a triumph. In both locations the exhibits were displayed lucidly and with impeccable taste. The labels, Dutch and English, provided a note on the original location, in the prince's or princess's apartments, of the picture (or other object) and an excellent booklet, written for the benefit of the general public, was distributed gratis. Between the two catalogues,[1] which are companion volumes, there is some inevitable overlapping. They are both beautifully produced and provide, for the English reader, invaluable material on the historical background and the varied themes which the exhibitions set out to demonstrate (much of the material is the fruit of recent research and is published for the first time). The catalogue of the Historisch Museum's show, *Princely Display*, is a volume devoted to those themes, illustrated in colour and black and white with a large number of supplementary plates. The book is essential for anyone wishing to see the princely couple's interest in the fine arts within a wider framework, but a number of very interesting pieces in the exhibition are regrettably not reproduced.

The catalogue has excellent chapters on the court (by Willem Frijhoff), on the quasi-monarchical nature of the Orange family which attained briefly 'an almost European authority thanks to the ambitions of the Stadhouder and his personal qualities'; on the genesis of the court (by Marie-Ange Delen), particularly interesting for its account of the court and influence of Louise de Coligny; an exceptionally good chapter by Jori Zijlmans on life at court in The Hague with useful information on the central figure of Constantijn Huygens. Marika Keblusek writes on the court of the exiled Bohemian royal family, their status and influence, the rivalry with the Prince of Orange, the furnishing of their palaces in The Hague and at Rhenen, and the education of the children (glimpses therein of Lievens) at Leyden; and Olaf Mörke discusses the Orange court as the centre of political and social life during the republic. In a chapter by Koen Ottenheym on the prince's building activities, the work on his different residences is described in great detail and illustrated, both in the catalogue and in the exhibition, with very good topographical material, ranging from examples of Dutch topographical engraving (for example, by Van Berckenrode, Milheusser or Allard) to some enchantingly evocative wash drawings by Jan de Bisschop (Fig. 174). Particularly interesting is the material on Honslaarsdijk and the Huis ten Bosch, the creation of Amalia van Solms. In an equally good complementary chapter on the prince's gardens Vanessa Brezmer Sellers stresses the crucial part played by the prince in ushering in the golden age of Dutch gardening, his gardens coming to represent the 'bulwark of a new, idyllic Bohemia – the "Garden of Holland" protected by the Princes of Orange'. In the final chapter Irene Groeneweg produces some very interesting information on dress in the age of Frederik Hendrik and his wife; but her conclusions on, for example, the relation between Van Dyck's and Mytens's royal portraits are misleading.

Marieke Tiethoff-Spliethoff writes at length on the portrait painters in the service of the prince, notably on the contrast between the work of Van Mierevelt and Van Honthorst. She stresses in Van Mierevelt's case the

174. *Hercules and Cacus*, by Jan de Bisschop. 9.7 by 15.8 cm. (City Archives, The Hague; exh. Historisch Museum, The Hague).

problems, discernible in the exhibition, involved in an extensive studio practice from the time of his fine first portrait of the prince, c.1610, of which an early variant was painted for Sir Ralph Winwood. It was very good to see Van Mierevelt's distinguished, but severely damaged, 1641 portrait of Huygens from the Huygensmuseum Hofwijck at Voorburg. Honthorst, coming to the service of the prince after he had been employed by Charles I and the Queen of Bohemia, presents the same problem. At his best, in, for instance, the profile portrait of the prince painted in 1631, the touch is light, almost feathery, and the atmosphere and characterisation extremely sensitive. In the display of (chiefly) small portraits of members of the prince's and princess's circles, cleverly arranged but sadly not reproduced in the volume, the quality varied from the very good (especially when painted on panel) to the perfunctory. The big royal full-lengths are consistently well-arranged, though the handling can be rather smooth and unfeeling. One question is raised by relating (p. 181) the letter, in which the painter informs Huygens that he has prepared the canvas for the painting of the Stadhouder with his wife, to the double portrait (1637) in the Mauritshuis. This is, in fact, made up of two single full-lengths subsequently stitched together. Nor, surely, is it correct to say (p. 182) that the prince did not sit for his likeness to Honthorst after c.1640. Honthorst produced a later – a sadder, care-worn – image which is seen in the big family group of 1647 in the Rijksmuseum (A874) and in a number of small portraits, one of them

actually held by his widow in the portrait in Berlin.[2] Of the big royal full-lengths in the exhibition the most interesting is the portrait (c.1654) from the Breda Museum of the widowed Princess of Orange, the Princess Royal, with the young William III. The author discusses Honthorst's crucial rôle in initiating the tradition of pastoral and historical portrait painting in The Hague, beginning with the full-length of 1629 of the princess as Flora with her two eldest children, including the fascinating group of her son with three of his sisters in pastoral vein (lost, but reproduced as fig. 156) and proliferating in innumerable heads and shoulders of the Palatine princesses and the ladies and children in Amalia van Solms's circle.

In the exceptionally good catalogue of the exhibition in The Mauritshuis the entries on the individual items are preceded by chapters describing in much detail the earlier history of the collections of the House of Orange; the growth and quality of the collections of the prince and princess and the stamp on it of their different personalities and tastes; the significance of the collections in the status of the royal couple among other European rulers; the choice of artists from the North and the South; their admiration for Rubens, Van Dyck, Willeboirts Bosschaert and Seghers and their special liking for the painters of Haarlem and Utrecht; and the obvious limitations of their interests. A great deal of information can now be provided on the hanging of pictures (and of different classes of pictures) in the individual houses of resort, thanks principally to the

175. *Amaryllis and Mirtillo*, by Anthony van Dyck. 123 by 137 cm. (Graf von Schönborn, Pommersfelden; exh. Mauritshuis, The Hague).

magisterial publication of the Orange inventories under the guidance of T. H. Lunsingh Scheurleer between 1974 and 1976 (a selection of the inventories is included in the exhibition). Particularly useful is a long account of the subsequent history of the collection and its dispersal, which was in the end so unfortunate for the House of Orange and for the Netherlands but so enriching for Germany: this account builds on the pioneering article of 1967 by Börsch-Supan and demands from readers today a tight grasp of genealogical detail (Fig. 2 is surely the young Frederick the Great and not his grandfather).

An essential aspect, and perhaps the special charm of the collection, was Amalia's taste for pastoral subjects and love stories. It is well analysed in the chapter by Van der Ploeg and Vermeeren and was immediately apparent in the first room of the exhibition, where we were confronted with Van Dyck's exquisite *Amaryllis and Mirtillo* (Fig. 175). It is as hard to avoid platitudes when writing about this lovely picture, as it is to overestimate its significance in Van Dyck's career, and indeed in the context of early baroque painting; but in its scale, its mood, the rare beauty of its colour and the sustained brilliance with which it is painted,[3] the extraordinary

176. *Theagenes receives the palm of honour from Charicleia*, by
Abraham Bloemart. 1626. 157.2 by 157.7 cm. (Mauritshuis,
The Hague).

177. *Artemisia*, by Gerard von Honthorst. 170 by 150 cm. (Art
Museum, Princeton University; exh. Mauritshuis, The Hague).

lightness of touch and feeling in, for example, the
foliage in the upper left area, Van Dyck is distilling on a
small, essentially decorative scale so many of the quali-
ties he venerated in Titian; and he is, above all, evolv-
ing for a particular patron a court style of unusual
refinement which he must have hoped he was going to
be able to deploy further when he crossed the North
Sea – bringing with him versions of his portraits of the
Prince and Princess of Orange and their little son. The
last, a touching example of Van Dyck's unfailing skill in
investing his portraits of grand children with a rare
mixture of fragility and authority, is very damaged.
The portraits of the parents, lent from Madrid, are
thoroughly competent, but the male portrait, though
good in the head, has a rather unattractive coarse
bravado in the painting of the rest: a quality noticeable
in the painting of the curtain in the pendant. The ver-
sion in Baltimore of the male portrait is, by contrast,
rather subdued in the way it is painted.

In the same room were two pictures from the gift to
the princess by the States of Utrecht in 1627: the *Garden
of Eden*, painted in the previous year by Savery and a
veritable *tour de force* by an admired painter, and
Cornelis van Poelenborch's *Banquet of the gods* of 1625,

one of the many pictures to find their way through the
genealogical maze to the Anhaltische Gemäldegalerie
in Schloss Georgium and particularly fine in the treat-
ment of the shadowed heads around the figure of
Bacchus. In the next room the quality and subject-mat-
ter of the pictures Frederik Hendrik and Amalia most
liked were strikingly displayed. The pictures, originally
hanging in Honslaarsdijk (now also in Germany) and
illustrating the story of *Il Pastor Fido*, are outstanding for
the high key in which they are painted and for the
extraordinary refinement of their handling. The scene
by Van Poelenburch has a beautiful, ebullient dancing
rhythm and is slightly softer and more atmospheric
than the almost (for this artist) monumental *Mercury and
Herse* from Het Loo. Dirck van der Lisse's *Blindman's buff*
is a little less lively and the figures taller and thinner, as
they are in Bloemart's *Marriage of Amaryllis and Mirtillo*.
Silvio and Dorinda by Hendrick Bloemart and Saftleven is
interesting for its quieter atmosphere and rich land-
scape background. The two long panels by Van der
Lisse and Gijsbert Gillisz. d'Hondecoeter are of out-
standing quality, the first with a good deal of Van
Poelenborch's soft, rich atmosphere. In the same room
a different, startlingly old-fashioned note is struck by

the two scenes (Fig. 176) by Abraham Bloemart, both commissioned by the prince, from the story of Theagenes and Charicleia. Again, the quality is of the very highest, brilliant in colour, dramatic, carefully worked out into very complex compositions; and the pictures in this room, taken with the Van Dyck, give a truly remarkable impression of the brilliant quality of the pictures the couple were assembling. If they were designed to be set into chimney pieces the effect on a visitor must have been spectacular.

Some of the larger pictures were less distinguished. The figures, for example, in the *Crowning of Diana* do not seem to have been painted by Rubens himself, though the work would have made a fine impression over the fireplace in the banqueting hall at Honslaarsdijk, part of a decorative scheme devoted to the chase. Van Honthorst's chimney-piece, the *Meleager and Atalanta* of 1632, is awkwardly composed, but his pair of pictures of young women playing musical instruments, recorded in 1632 in the Stadhouder's quarters, are very good examples of his work in this genre, particularly with that lovely Utrecht yellow. His *Artemisia* (Fig. 177), apparently painted later and recorded as an overmantel for Huis ten Bosch, is suffused in a softened atmosphere and has an unexpectedly tender mood. The extensive patronage of Willeboirts Bosschaert by the Oranges is illustrated by one large canvas, commissioned in 1647. He was, perhaps, the best that could be found after the passing of Rubens and Van Dyck: only reasonably accomplished, decorative, essentially superficial. On the other hand he collaborated in Daniel Seghers's flower-pieces, '*cartelles*' on a big scale, of extraordinary brilliance, one of which, painted in 1645, is in the exhibition, hanging above copies of the gold palette, brushholders and maulstick, made by Van Brechtel, which he received in payment.

A small room was hung with the set of little copies, probably correctly attributed to Remigius van Leemput (one of the set is displayed in the Historisch Museum and one [no. 161] strikes a rather discordant note): an excellent example of this type of record of distinguished prototypes. They are framed in very fine, crisply carved small variants of the auricular frame. Earlier in the exhibition a most interesting juxtaposition was made. Honthorst's portrait of the prince in profile, painted (on canvas) in 1631, faced his portrait of the princess which is of different quality, and is painted on panel in a pattern used also, for example, for the Queen of Bohemia.[4] Rembrandt's portrait of the princess in profile (1632) hung more congenially with

the portrait of the prince, even it seems, down to the form of the painted oval. The two portraits, moreover, were hanging almost next to each other in the Stadhouder's quarters in 1632. Near the end of the exhibition Constantijn Huygens, seated with his clerk in the evocative portrait from London, presided over a room in which the prince's links with Rembrandt and Lievens were illustrated by *Samson and Delilah*, from Berlin, painted in the year after de Keyser painted Huygens and recorded in the Stadhouder's quarters in 1632 with the miraculously painted *Simeon's hymn of praise*, attributed then to Rembrandt or Lievens; and by two from the seven paintings of scenes from the life of Christ assembled by the prince. One of the famous letters (the third) from the artist to Huygens hung alongside, within a few inches of the clerk who could have opened the letter for his master. In the same room was the large *Gypsy fortune teller* by Lievens, recorded in the Nordeinde inventory of 1632, in which two of the principal figures are painted from the same models as appear in a lost panel of the same period. It would perhaps be difficult to find at this date so strange and original a composition, or on so large a scale, by Rembrandt. The last painting in the exhibition was the most moving *Allegory* by Flinck on the memory of the prince: painted in 1654 to hang in the large East cabinet of Huis ten Bosch and a melancholy contrast with Honthorst's pastoral group of 1629.

The exhibitions were enriched with other works of art: musical instruments, furniture, some items of dress and some very good low-relief plaques and medals, by Lutma and Dadler, for instance, in the Historisch Museum; and, in both exhibitions, important pieces of sculpture by Dieussart, including the oval reliefs in marble of the Great Elector and his wife (the male portrait dated 1647) from Huis Doorn and the handsome, uncomplicated busts of the Prince and his son from Schloss Würlitz. Of the specimens of plate on show the finest were the ewer set with cameos and gems from the princess's collection; Adam van Vianen's ewer from the Rijksmuseum; and the gold goblet and cover of 1610 by Paul van Vianen, lent by the Fürst zu Wied, a piece of outstanding beauty. It shone even in the context of these two truly memorable exhibitions.

They have done for the Prince and Princess of Orange what was achieved for Christian IV in the Council of Europe exhibition in Denmark in 1988. In any future survey of royal patronage and connoisseurship in early seventeenth-century Europe, the achievements of these Northern figures must be included.

LORNE CAMPBELL

Edward Bonkil and Hugo van der Goes

Edward Bonkil, Provost of the Collegiate Church of the Holy Trinity in Edinburgh, is the donor who appears on the reverse side of the second of the 'Trinity Panels' lent from the Royal Collection to the National Gallery of Scotland (Fig. 178). The two panels are believed to be the wings of a large triptych commissioned by Bonkil for his church. Painted in the 1470s, they are attributed to Hugo van der Goes. As Bonkil's portrait seems to have been taken from life, he and van der Goes must have been in direct contact, presumably in the Low Countries.[1]

An investigation of the Scottish sources has shown that Edward was the son of Robert Bonkil, an Edinburgh merchant who had traded with Flanders, and the brother of Alexander Bonkil, a burgess of both Bruges and Edinburgh who was also active in the trade between Scotland and the Low Countries.[2] A closer study of the Bruges sources now reveals that links between the Bonkils and Bruges were extremely close and that Edward may have been brought up there.

Edward's father Robert Bonkil, who died between 1447 and 1456, owned a house in the 'Bogaerstraat' (the present Boomgaardstraat) in Bruges. After Robert's death, his son-in-law John Todd claimed that, according to the custom of Flanders, he was entitled, in the right of his wife Mary Bonkil, to a share in the property. Alexander Bonkil, Robert's, eldest son, opposed the claim and asserted that, according to the custom of Scotland, he had inherited the entire house. On 26th October 1456 the burgomaster, aldermen and consuls of Bruges referred the dispute to the Edinburgh authorities.[3] As no record of their decision has been found, it is not known whether the house in the Boomgaardstraat remained in Alexander's possession or whether it was divided between him and his siblings. The house was conveniently situated in the Scottish quarter of the town, for the Boomgaardstraat ran between the Hoogstraat and the Schottenplaats (now the Sint Maartensplein) and was close to the Schottendijk (now the Sint Annarei).[4]

Various members of the Bonkil family continued to live in Bruges, where two of them were members of the Confraternity of Our Lady of the Snow. To this large confraternity belonged many of the most prominent people in Bruges, foreign merchants established there and artists such as Petrus Christus, Hans Memling (who joined in 1473–74), the court painter Pierre Coustain (who joined in 1475–76) and the illuminator Willem Vrelant.[5] By 1467–68, the first year for which records have survived, Alexander Bonkil was a member of the confraternity.[6] He may have joined several years earlier, though he did not renew his membership in 1468–69. Meanwhile an Adam Bonkil, Scotsman, and his (unnamed) wife were members between 1468–69 and 1470–71. Adam died in 1471.[7] He was probably a brother of Edward and Alexander and may have taken over the Bruges house and the running of the family business in Flanders when Alexander became more closely involved in Scottish affairs.[8]

Edward Bonkil may have been born in the 1420s. If he was brought up in his father's house in Bruges, he would have spoken Dutch and could have known a great deal about contemporary artists in Flanders. His connections with the Low Countries would have recommended him to Mary of Guelders, Queen of Scots, who was the daughter of Arnold, Duke of Guelders, and Catherine of Cleves, went from the Burgundian court in 1449 to marry James II,[9] and was the foundress of the Collegiate Church of the Holy Trinity. She was buried there in December 1463. Bonkil, with whom she might have conversed in Dutch, French or Scots, must have been her protégé. Three years after her marriage, he was at the Scottish court: on 25th June 1452 he witnessed a deed in the 'King's Chamber' in Edinburgh

178. *Edward Bonkil with two angels*, by Hugo van der Goes. c.1475–80. Panel, 202 by 100.5 cm. (National Gallery of Scotland, Edinburgh, lent by Her Majesty The Queen). Reproduced by Gracious Permission of Her Majesty The Queen.

Castle.[10] He was, of course, the first Provost of the Queen's church and the Master of the conjoined Trinity Hospital, also founded by her.[11] When Edward Bonkil commissioned his triptych from Hugo van der Goes and had his portrait taken, he might have stayed in the family house in Bruges and would have encountered in Flanders Scottish relations and perhaps also Flemish friends. They might have advised him in his choice of painter. Bonkil was not an obscure provincial cleric who, by singular good fortune, happened to come upon Hugo, the greatest painter of his day. He was in fact a cosmopolitan who had had every opportunity to indulge an interest in Netherlandish art and whose friends and relatives in Bruges may have urged or encouraged him to move on from there to Ghent, to ignore Christus and Memling and to employ Van der Goes.

J. B. BULLEN

Sara Losh: architect, romantic, mythologist

In 1869, Dante Gabriel Rossetti wrote with enthusiasm both to his mother and to Jane Morris about the 'extraordinary architectural works' by Sara Losh, 'a church of a byzantine style and other things', which he had just visited in the village of Wreay, outside Carlisle. Her designs were, he said, 'full of beauty and imaginative detail, though extremely severe and simple', much more original 'than the things done by the young architects now'. Losh, he added, 'must have been a really great genius, and should be better known'. He thought her buildings so advanced that he expressed the wish that Philip Webb, the designer of William Morris's Red House, could come to Wreay and see them for himself. Losh, he wrote, was 'entirely without systematic study as an architect, but her practical as well as inventive powers were extraordinary'.[1]

The group of buildings to which Rossetti referred are all still standing in the village of Wreay: they include a school and school house, a monumental obelisk in memory of Losh's parents, a mortuary chapel based on the ancient church of St Piran on the north Cornish coast, a mausoleum for her sister and the 'Byzantine' St Mary's Church (Fig. 179). Losh has not wanted for occasional admirers since Rossetti: Nikolaus Pevsner found her choice of style 'remarkable', although there were many aspects of the design of St Mary's which he described as 'bewildering'.[2]

Sara Losh was born in 1786 and brought up in a radical, intellectual, progressive, and free-thinking circle. Her father came from an old Cumbrian family (Arlosh) and had been educated at Sedbergh and Trinity College, Cambridge, where he developed a love of science. According to Henry Lonsdale,[3] the only authority we have on the Loshes, both John and his third brother William were, as he put it, 'directed to political progress, and the securing of religious freedom untrammelled by creeds and other human credentials'.[4] John

Losh founded an alkali works for the manufacture of soda at Walker near Newcastle and in 1809 established the Walker Iron Works. On John's death in 1814, his brother William continued to run the business which had been inherited by Sara. Sara's mother, Isabella, died in 1799 when Sara was only twelve years old and she and her sister Katherine were brought up by her aunt Margaret. It was her uncle James Losh (d.1833), however, who seems to have provided for her a window on the larger world. A lawyer, who became Recorder of Liverpool, he was an outstanding public figure, a Unitarian, a champion of the new railway, a campaigner for the abolition of slavery and a supporter of Catholic emancipation. His diaries make it clear that he was well-read in contemporary literature and drama. He had been friendly with Sarah Siddons and had a passion for politics both British and European. He was a close friend of many leading republican figures, knew Wordsworth and Southey and brought many of his visitors to meet Sara and Katherine in the family home of Woodside near Wreay.[6]

According to Lonsdale, Sara Losh was a witty, intelligent, good-looking woman who, when young, loved social gatherings and fine clothes. According to her classics teacher, she was a scholar of outstanding ability: she was fluent in Italian and French, read Greek and could translate from Latin *in extempore*. She also excelled in music and mathematics. Lonsdale, who was thirty years her junior, was clearly a great admirer, though he hints at an obstinate temper that would not tolerate fools, and a singular desire to have her own way combined with a certain lack of self-confidence. She was, he says, 'educated far beyond the reach of her own sex, and, indeed of most men'.[7] James Losh endorsed this opinion of her abilities, confiding to his diary in 1825 that Sara 'has great powers of mind', but, he added, 'a languid constitution and an over delicacy of

179. St Mary's, Wreay, by Sara Losh. 1842.

feeling have prevented her from taking that rank in society to which she is, in all respects, justly entitled'.[8] The rank in which Lonsdale places her is alongside the critical rationalists Mme de Staël and George Eliot (whom he claimed to know personally) and he speaks of how her 'active and ardent mind' drew to her 'superior-minded company in various walks of life'. Above all he stresses her theoretical ecumenicalism, recording that he had 'seen around her social board Unitarians and Episcopalians, Catholics and Christians unattached'.[9] Among these would have been her Unitarian uncle and the fervent Catholic antiquarian Henry Howard and his son P.H. Howard who became MP for Carlisle in 1830, while Anglican friends included William Paley, a fellow of Christ's, Cambridge, and Archdeacon of Carlisle best known for his book *Evidences of Christianity*

(1794), Isaac Milner who had twice been Vice Chancellor of Cambridge and who frequently preached in Carlisle, as well as Edmund Law, Bishop of Carlisle. Also members of the circle were the physicist Sir John Leslie and the orientalist Joseph Carlyle who became professor of Arabic languages in Cambridge in 1795 and explored the libraries of Hagia Sophia and the Seraglio.[10] In 1833 James Losh, recording one of his numerous visits to his nieces at Woodside, mentions the fact that 'my old friend Wordsworth, the Poet, dines with us . . .'[11]

1817 was the *annus mirabilis* in Sara Losh's life. She was thirty-one, and went with her uncle William and her sister Katherine on a Continental tour. The full extent of their journey is uncertain, but we know that they travelled through France to Italy, travelling as far

as Spoleto, Naples, Pompeii, and Terracina. From there they went on to Paestum and returned via Rome. To record her travels Losh wrote seven volumes of energetic prose which were evidently packed with details of society, paintings, landscape, and architecture.[12] The sheer bulk of these journals, which have unfortunately been lost, suggests a very extensive tour, encompassing much more than the few places mentioned by Lonsdale. Her uncle James, who was a severe critic, even of Wordsworth, was impressed by these writings. Her attention to art and architecture was, he said, 'indefatigable' and if published, he claimed, the diaries would form 'one of the most amusing and instructive works on Italy' to appear in recent years.[13]

This tour undoubtedly laid the foundations for Losh's extensive architectural knowledge and probably gave her her first sight of Continental romanesque building which was still something of an unusual taste in 1817.[14] The fragments extracted by Lonsdale, though they do not specifically mention romanesque monuments, provide a fascinating insight into her temperament and interests. In France she was intrigued by the Christianised fertility rites in a Rogation Day procession at Pont l'Echelle, noticing that a 'remnant of such observances may still be traced in England', and while in Rome she was saddened by the departure of a belief in myth from modern painting.[15] In the Sistine Chapel she was positively iconoclastic, finding it 'gloomy', 'horrible' and verging on the 'ludicrous',[16] and after a talk on *The Last Judgment* by a Signor Magrini she outraged the lecturer by suggesting that the devils had the most satisfactory part in the whole work.[17] Pompeii seems to have had a profound effect on her. 'The view from the upper ranges of the amphitheatre', she wrote, 'exceeded in beauty, grandeur, and fascination all that we had ever seen or could have imagined.'[18] When she returned home she constructed a 'Pompeian court' as part of the garden at Woodside,[19] and in 1830 a cottage, now destroyed, 'on the model of one discovered in the ruins of Pompeii' for the master of an infants' school which she endowed.[20]

Architecture and architectural history seem to have fascinated both Sara and her uncle. In 1827 James Losh was so enthusiastic about a lecture given in Newcastle by a Mr Woods entitled 'Architecture as illustrating history and the state of society in different nations' that he persuaded Woods to stay for four days.[21] Knowing Sara's interests, her uncle must surely have introduced them. Lonsdale confirms that architecture was important to Sara as a means to historical and cultural understanding. 'Archaeology had many attractions for her', he wrote, 'not only as a study *per se*, illustrating the curiosities of ancient and modern structures, but as, viewed with an historic or architectural meaning, realising to modern eyes the life of the past.'[22] By the time that Sara came to build at Wreay she was realising the fruits of a carefully considered view of architecture and its relationship with society and religion.

In 1835 Sara Losh's sister Katherine died. Sara had been extremely close to her and, in the words of her biographer, she suffered 'almost inconsolable grief'.[23] Sara was then forty-nine, without husband or children, and had already undergone more than her fair share of bereavements. Surrounded by death, she seems to have become fascinated with philosophical and religious ideas which involved the generation of life, the migration of the soul and the continuity of life after death. The first hint of these preoccupations was a memorial obelisk dedicated to her parents and modelled closely on the famous seventh-century cross at Bewcastle.[24] This she designed in collaboration with Katherine but completed it after her sister's death. Later Sara designed in memory of Katherine a primitive Cyclopean mausoleum, which must have been completed by 1847 when it is mentioned in a local guide book.[25] A box-like structure with a square copper-covered oak door, it stands in the churchyard of St Mary's looking as if it had been built by a pre-Christian race of giants using large elementary blocks held up only by their own weight. Inside it contains a pale marble statue of Katherine by a local sculptor, Dunbar, done from a sketch which Sara made when the two women were in Naples in 1817.

Losh's work at St Mary's was prefaced by a smaller architectural project which in its turn was stimulated by an important archaeological discovery. In 1836 a small oratory church emerged out of the shifting sand-dunes near Peranzabuloe in north Cornwall, where it had been buried for more than seven hundred years.[26] The antiquity of the church of St Piran caught the imagination of antiquarians because it demonstrated, as one of them wrote, 'the similarity of St Piran's to the structures of the early Christians, especially in the East – at Byzantium and Antioch'.[27] Here, on British soil, was what appeared to be a piece of Byzantium, and as the oratory was excavated at one end of the country, it came to the notice of Sara Losh at the other.

In the early 1830s before her sister died Losh had donated some land half a mile from the village of Wreay for use as an interdenominational burial ground.

In 1836 her imagination was fired by the story of St Piran's, by its antiquity, and by its links backwards to the earliest Christian buildings. In addition to this the discoverer of St Piran's, the amateur archaeologist William Michell, reported that it was surrounded with the bones of an ancient cemetery.[28] Sara Losh decided to build a replica mortuary chapel for resting coffins before burial which would exactly duplicate the Cornish oratory in shape and size. She obtained details – plan and elevation – of the extremely simple, plainly decorated structure, and she carefully reproduced the two sculpted heads which serve as imposts to the door, the leonine animal which serves as the keystone, and the double chevron which surrounds both window and door.[29] Inside she copied the altar and stone side seats, and incorporated a sculpted palm as her only personal contribution.

By 1832 the parish church of St Mary's, Wreay, had fallen into a dilapidated state.[30] In a long and detailed survey of the old church, Losh stated that attempts at preserving the structure would be in vain, but that where possible the materials should be reused in a new building.[31] In her own words, Sara 'offered to furnish a new site . . . and to defray all the expenses of its re-erection, on condition that I should be left unrestricted as to the mode of building it'.[32] In 1836 the township of Wreay donated a plot of land from the common which she had cleared, levelled and drained. Her involvement was highly professional. In the course of the work, she supervised everything from the draining of the land, through the use of building materials and the choice of design to the elaborate construction of the decorative detail. Characteristic of her record is the account of the foundations of the church. 'To secure the dryness of the chapel floor', she wrote, 'the flags are raised on dwarf walls, with the exception of the platform at the entrance, which is raised on dry stone chippings.'[33] The whole project rests on Losh's command of technical detail, her observations of ancient work in France and Italy, her study of the contemporary revival of early architectural styles, and her personal interest in religious myth and symbolism.

The building is unique. Rossetti's friend, the artist and writer William Bell Scott, pointed out that 'before the revival of church architecture in connection with ritual and reactionary theology, her little Byzantine church . . . was a notable performance'.[34] He was right. Not only was St Mary's one of the first of an important series of British 'Early Christian' buildings which looked more to Continental than English models, it also challenged the growing sense that gothic alone was suitable for ecclesiastical building and decoration. Losh chose a part romanesque, part basilican style which had few parallels in Britain, and she adopted a recondite and unorthodox decorative scheme based on myth and legend, some of it pre-Christian.

Both Rossetti and William Bell Scott identified St Mary's as 'Byzantine', while Losh herself called it 'early Saxon or modified Lombard'.[35] A writer in a contemporary journal suggests that the term 'Byzantine' was used generically at the time for 'pre-Gothic' architecture. 'Byzantine', he declared, 'might be its most accurate general name; but as in passing into different countries it became more or less modified, so it has in each received a different denomination: in Italy it is called Lombard, in England, Norman; and to the German churches of the same style, Mr Whewell has affixed the term Romanesque.'[36] Losh does not use the term 'Romanesque' but her own choice of terms suggests that her inspiration was partly English and partly Continental.

English antiquarian opinion since John Aubrey in the seventeenth century and Thomas Warton and Thomas Gray in the eighteenth had long cherished an affection for round-arched buildings.[37] The great romanesque monuments were justifiably celebrated – Christ Church Cathedral, Oxford, and parts of Winchester, Gloucester and Exeter Cathedrals – and, though many romanesque buildings had been destroyed during the eighteenth century (parts of Hereford Cathedral), others were carefully restored (Ely Cathedral). Humbler local churches also received their fair share of attention. The 1792 restoration of the mid-twelfth-century church of Tickencote by S.P. Cockerell, 'the most remarkable church in Rutland',[38] is a mixture of restoration and creation, and almost certainly inspired the Rev. Richard Lucas to build the nearby All Saints Church at Pickworth in a simple round-arched Norman style.[39]

Very few neo-Norman churches were built in Britain in the early part of the nineteenth century, and P. F. Robinson's Christ Church, Leamington Spa (1825) and James Picton's Holy Trinity, Hoylake near Chester (1835) seem to be the only new foundations that predate Losh's St Mary's, which she began to plan around 1836.[40] Embarking on her project, Losh would undoubtedly have consulted Loudon's *Architectural Magazine* where, in the first volume, she would have found some encouragement for adopting an English pre-gothic style in an article by Picton in which

Tickencote is mentioned with approval and Picton's own church at Hoylake presented as a possible model for future development. He admits that the style had been neglected because it was too 'rude in its details' but (and this might have caught Sara Losh's attention) its simplicity made it cheap (Hoylake cost only £1,900) and the mouldings were, Picton said, 'such as any country mason might easily execute'.[41]

For distinctive and unusual features of St Mary's such as its strongly defined semi-circular apse, Sara Losh may well have drawn on knowledge of the nearby church of St Leonard in Warwick, Cumberland or the famous church of St Mary and St David at Kilpeck, in Herefordshire, described by Pevsner as 'one of the most perfect Norman village churches in England'.[42] Like the Wreay church, Kilpeck is round-arched, has a prominent apse and is extensively decorated with carving. But Losh herself suggests that the inspiration for St Mary's was as much Continental as English: it is, as she put it, 'modified Lombard'. For reasons which are not entirely clear Lombard architecture was taken up in a number of outstanding churches in the early 1840s. James Wild's Christ Church, Streatham, and Sidney Herbert's St Mary and St Nicholas, Wilton, are examples of this type.[43] Wild might have known about the developments in Bavarian *Rundbogenstil* in Munich and its apologist Hübsch:[44] Klenze at the Allerheiligenhofkirche (1826–29) and Gärtner at the Ludwigskirche (1829–40) were both building in a version of the romanesque. These churches later became the talk of the architectural profession but it is unlikely that in 1836 Sara Losh, who understood little German, would have heard of them. It is also unlikely that she was familiar with the debate going on in France about pre-gothic architecture led by Ludovic Vitet.[45] Charles Questel's Saint-Paul-de-Nîmes (1836–48), one of the earliest neo-romanesque buildings in France, was started at about the same time as St Mary's.

Instead, Losh's understanding of continental romanesque must have come from her study of English writings. By 1836 most of these focused on German Rhenish,[46] but there was one writer whose enthusiasm for the Italianate 'Lombard' was considerable – Thomas Hope. Hope came to England from Amsterdam in 1796, creating a substantial collection of paintings, sculpture and antiques and acquiring considerable influence in the early nineteenth-century world of connoisseurs and artists.[47] Four years after his death in 1831, his eldest son, Henry Thomas Hope published *An Historical Essay on Architecture by the late Thomas Hope,*

180. 'San Michele Pavia', from THOMAS HOPE: *An Historical Essay on Architecture*, London [1836], pl.32.

illustrated from Drawings made by him in Italy and Germany (1835), the fruit of a lifetime of travelling and observing buildings. Half of its breezy and compendious text is devoted to Lombard architecture, which Hope believed to be an amalgam of Roman and Byzantine elements and central to an understanding of the development of Western architecture.[48] Hope provides a gazetteer of Lombard churches in Italy, France, Germany, and England but warns his reader that since Lombard was so widespread it became 'modified' (the same term that Losh uses) and mixed with other styles at different points in Europe. In Hope's volume of some ninety-seven plates, seventy are romanesque. In his account of the west front of St Mary's, Lonsdale makes a comparison with 'Lombard and Rhenish churches' particularly 'San Michele in Pavia, and the Duomo of Parma' while the doorway, he says, recalls 'that of Santa Maria della Piazza, Ancona'.[49] Each of his examples is illustrated in Hope's *Essay*,[50] and it seems probable that when Losh came to design St Mary's, Hope's words and illustrations triggered memories of her Italian tour that had been lying dormant in her memory for nineteen years (Fig. 180).

The church is deliberately primitive in style. 'The unpolished mode of building adhered to in the new chapel', wrote Losh, 'most approximates to early Saxon or modified Lombard, which was preferred to a more improved style, as less expensive and elaborate.'[51] The

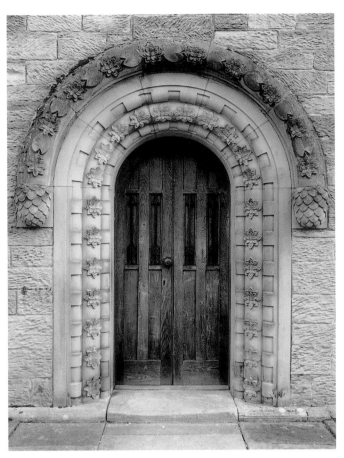

181. Door in west front of St Mary's, Wreay.

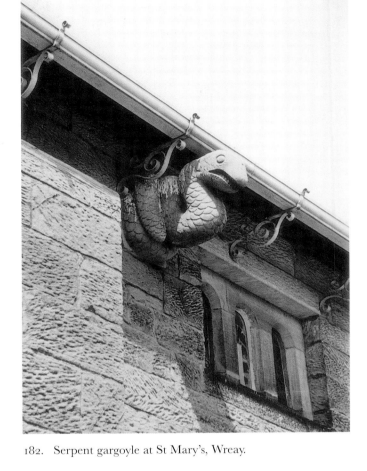

182. Serpent gargoyle at St Mary's, Wreay.

gable on the west front, decorated with rising blank arches, bears a close resemblance to a number of Hope's illustrations. On the exterior the windows are notable for their repetitive simplicity and for the absence of imposts, but those on the west end are encrusted with the most unusual decoration in a style unmatched in the 1830s. According to Lonsdale, Losh employed only local craftsmen, including a Mr Hindson who 'had never shown the slightest feeling for art', and instructed them by first making mouldings in clay and then getting the men to copy them. The sympathetic relationship between designer and craftsman, as Rosemary Hill has pointed out, anticipates the theories of both Ruskin and Lethaby, whereas the curiously flattened and stylised decoration, as Pevsner noticed, looks forward to the work of the Arts and Crafts movement of the end of the century.[52] It is not surprising that Rossetti wanted Philip Webb to see the building.

The decorative motifs make up a cornucopia of flora and fauna. Fir-cones, moths, owls, scarab beetles, ears of barley, butterflies, and ammonites crowd around the inside of the three windows at the west end (Fig. 183), and the door (again with no imposts) is decorated with a double row of lotus flowers and leaves, while its hood moulding is ornamented with the leaf and flower of the water-lily and the bosses on the end are in the shape of pine-cones (Fig. 181). Huge gargoyle beasts – 'emblematical monsters' as Losh called them[53] – seem to burst from the four corners of the building. From one comes a serpent (Fig. 182), from another a tortoise, and the west end is crowned by a small bell tower surmounted by an eagle. The dragon on the north side, according to Losh, was to serve as a flue for the wood-stove inside the building, while 'the iron bar inserted in its jaw', she said, 'is to prevent the starlings from making nests in it'.[54]

The style and decoration of St Mary's suggest that Sara Losh was well aware of the rituals of the early

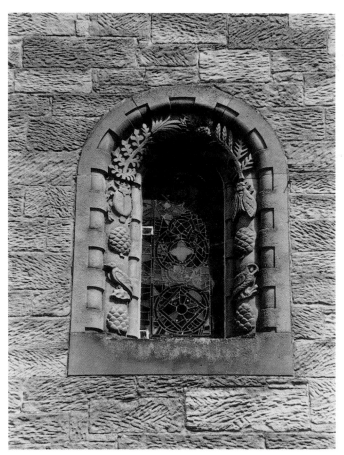

183. Window in west front of St Mary's, Wreay.

Church and the growing controversies around church design. The late 1830s saw the founding of the Cambridge Camden Society and the Oxford Architectural Society whose aims were to keep a careful watch over the plans and fittings of new churches, to supervise the restoration of old churches and to reintroduce the spirit of Catholic worship into the Anglican liturgy. One of the current issues involved the mythographic connexion between ancient religions and Christianity. 'Philosophy, religion, history and poetry, are the component parts of mythology', wrote the anonymous reviewer of Creuzer's influential *Symbolism and Mythology* in 1829, following Creuzer's definition of the latter as 'the knowledge of the universal language of nature, as expressed by certain symbols'.[55] Creuzer had been preceded in his study of the symbolic basis of religion by several mythographers to whose work Sara Losh would have had access, including Alessandro Maffei, Pierre d'Hancarville,'[56]

Stanislas Famin, and above all Richard Payne Knight. Payne Knight investigated the connexion between natural symbol, myth and religion in his book *An Inquiry into the Symbolical Language of Ancient Art and Mythology* (1818) which was reissued in 1836, at precisely the moment when Losh must have been contemplating the design of St Mary's, and almost every one of the symbols that she uses in the decoration of her church has a place in his work. The guardians of the chapel are all there – the snake ('symbols of health and immortality'), the tortoise ('immortality'), and the eagle ('creation, preservation, and destruction'). The caterpillar, chrysalis and butterfly, all of which appear on the windows of the west front, are related by Payne Knight to 'an emblem of man in his earthly form', 'a natural image of death' and 'the celestial or ethereal soul'.[57] In other words, they are representative of the passage from birth, life, through death to immortality.[58] Payne Knight was essentially a pantheist for whom Christianity was just one religion among others.[59] His ideas were revolutionary and Rousseauistic. Sara Losh may have been less sceptical in her view of Christianity, but St Mary's is filled with imagery that suggests the continuity of religious belief and the recognition that much pagan symbolism had been taken up by Christianity.

The majority of Losh's chosen forms both outside and inside the church are connected with fertility, the generation of life, and the male and female principles. The lotus flower, the pomegranate and the barley corn, emblems distributed throughout the church, are representative, says Payne Knight, of 'the passive generative power' of the female, while a ubiquitous motif at St Mary's is the pine- or fir-cone, identified by him with phallic mysteries and as fundamental to many religious beliefs.[60] Cones are attached to the window openings and the west door, are sculpted in wood over the locks on the interior of the door, and hang from the centre of each of the large roof beams. Most prominently they stand sculpted in stone between the 'baptistery' and the nave (Fig. 184). And, most significantly the motif also occurs in the mausoleum dedicated to Katherine Losh, whose classically posed figure is shown in rapt contemplation of a fir-cone.

As Payne Knight points out, the pine-cone appears on the end of Bacchus's thyrsus and 'therefore holds the place of the male, or active generative attribute'.[61] But, as Sara Losh well knew, the pine-cone had been adopted by Christianity as a symbol of resurrection and immortality. When she was in Rome we know that she

184. Sculpted pine-cone, baptistery, St Mary's, Wreay.

as a key element in the symbolic narrative about generation and the passage of the soul through life into death while presiding over the realm of the living and the dead. This is particularly evident when we move inside the church. Even on a bright day it is mysteriously crepuscular (the Bishop wanted more Anglican light in it),[65] with small windows carefully calculated to produce the effect of sombre intensity. There are no aisles, no presbytery and no organ loft. The main west door opens into the small rectangular baptistery which is separated from the nave by a low wall terminated by the two fir-cones. The baptismal font in local alabaster was carved by Sara and her cousin William Losh. Between the Norman zig-zag motif that encircles the top and the Greek fluting at the base are a series of low-relief representations of lilies, butterflies, vines, pomegranates, birds, and beetles. Both the subject and the style are strongly reminiscent of some fine Byzantine work in S. Apollinare in Classe at Ravenna. There, however, they appear on magnificent ninth-century sarcophagi or ciboria for the benefit of the dead rather than the new-born.[66]

The area of initiation and the creation of life leads by means of a low step down into the nave which is about thirty-four feet long (Fig. 185). The approach to the sanctuary is guarded by a single round arch at whose base are male and female figures, ultimately derived from the oratory of St Piran. They had also been copied at the mortuary chapel at Wreay where, as in the original, they look outwards but here in the church they are turned inwards to look at each other across the altar on which are placed two large, open, candlesticks in alabaster carved in the form of the lotus flower, 'the emblem' as Lonsdale points out, 'of receptivity and reproduction'.[67]

Lord Lindsay, writing about the symbolic meaning of the arch in basilican churches, described it as 'the Triumphal Arch, introducing from the central nave into the sanctuary, and thus figurative of the transition, through death, from the Church Militant on earth, to the Church Triumphant in heaven'.[68] The impression of triumphant ascension is enhanced in St Mary's by the upward-straining flap of the wings of a giant eagle on one side of the nave and of a pelican on the other and the movement is taken up by the two winged angels above and echoed yet again by the seven musical angels ranged between eight palm trees.[69] This area beneath the apse is much darker than the nave, the light hardly penetrating the high narrow windows. In the last phase the communicating worshipper has to ascend six high

visited the Vatican, where she would have seen the colossal pine-cone forming part of the fountain in the Cortile della Pigna. Three and a half metres high, it was made about 1 A.D., and for the Romans was a symbol of generation, while for the early Christians who had originally placed it in the forecourt of Old St Peter's it symbolised the promise of eternal life, the fruit of the *arbor vitae*.[62]

The transformation of pagan symbols into Christian ones was one of the issues discussed by Thomas Hope in his *Essay*.[63] He does not specifically mention the pine-cone but he might have noticed an example in a Christian context in the Lateran Baptistery or the duomo of Torcello.[64] At St Mary's, Wreay, the cone acts

185. Nave of St Mary's, Wreay.

steps to approach the altar, behind which are clustered fourteen heavy romanesque pillars whose capitals are decorated with bats, water-birds, leaves, grasses and serpents. Each of the openings between the pillars creates a sedilia, with each space allotted to one of the apostles and bearing his monogram. Christ is seated in the centre to welcome the pilgrim through life. In a basilica this position behind the altar was occupied by the Bishop and his clergy, as for example at the duomo of Torcello. Above and behind the pillars seven coloured jars or lamps are placed in the small window openings letting through pale and mysterious yellow, red, and orange light. Lonsdale tells us that they are 'symbolic of the seven works of the Spirit of God' and in his discussion of Losh's use of the form of ancient ferns which decorate the higher windows of the apse he says that she 'mingles the antediluvian world and that of external nature with the adornments of the churches of the East, in which Paganism and Deism, the Law and the Prophets, prefigure the forms, the affinities, and the antagonisms of the newer developments of our race'.[70]

Once again, Lonsdale was fully alive to the potentially heterodox religious views being expressed here, and what he calls Losh's 'spacious conception of human worship'.[71] Sara's faith was clearly an unusual one. After the death of her father, James Losh recorded in his diary a conversation in which she voiced 'doubts and anxieties which are but too common to minds of much sensibility and deep research'.[72] Her own research had taken her into a religious world whose springs were pre-Christian and pantheistic. Lonsdale cautiously historicises his explanation of the church but betrays his own recognition of the symbolism when in a brief moment of irony he says that 'there is unity of purpose throughout the work, showing the development of the different Cults, from the time of Osiris and his Nilotic nymphs, through the days of the wise King, bright in his polygamy and home virtues, down to the monogamic non-virtuous Anglo-Saxon, accredited with representing the latest phase of civilization'.[73] It is hardly surprising that Bishop Percy of Carlisle was puzzled by the church when he came to consecrate it in 1842.[74] What Lonsdale fails to mention, but the Bishop cannot have failed to notice, is that both interior and exterior are almost bereft of specifically Christian symbolism. There are few images connected with Christ, his teachings or his works, and there are no details recording the history of the Church. Instead, the building pulsates with details of primitive organic, vegetable and pagan life. Losh herself was keen that no funerary monuments would be introduced to clutter its 'simplicity and uniformity'.[75]

In a sense the whole chapel is a funerary monument, which does not so much memorialise death as celebrate the whole life process. Its inspiration was undoubtedly personal, triggered by the deaths in Sara's family and that of her sister in particular, but it is ultimately a monument to humankind caught up in the cycle of generation. Losh's achievement is a considerable one. In his autobiography, William Bell Scott wrote that Losh's 'Byzantine chapel at Wreay' was the result of 'taste and power of intelligent design altogether unusual among women' and felt that she was 'entitled to a place in artistic dictionaries'.[76]

DAVID BOMFORD

'Secret Knowledge:
Rediscovering the lost techniques of the Old Masters'
by David Hockney

In 1948, Jacques Maroger, formerly Technical Director of the Laboratory of the Louvre and President of the Restorers of France, published an eagerly awaited book, *The Secret Formulas and Techniques of the Masters*. Its tantalising opening words were, 'Ever since the knowledge of the great painting techniques of the Renaissance was so mysteriously lost, about the end of the seventeenth century, artists have been trying vainly to discover the methods of such masters as Titian, Rubens, Rembrandt and Velázquez' Maroger's method was to concoct complicated recipes of oils and waxes based on pure guesswork and his own misguided notions of how the painters of the past worked; his book, a blend of error and unfounded conjecture, threatened to be influential until a cutting review by Ralph Mayer in the *Magazine of Art* cogently exposed its absurdities.

Fifty years on, artists are still trying vainly to discover the methods of the masters. David Hockney's lavish book, its title ominously echoing Maroger's, has been greeted with acclaim by art historians and critics who should have known better – and, while it may not share the ignominious fate of its predecessor (now almost unknown), it is, alas, based on the same false premises.

Hockney's thesis is a simple and an admittedly intriguing one: he is convinced that the painters and draughtsmen of the past used optical aids – mirrors, lenses, prisms – to a hitherto unsuspected degree. Hockney is not the first person – and will certainly not be the last – to speculate on the interaction of drawing and optics, but he argues for a radical shift in our view of how artists worked. Indeed, he suggests that the use of these devices was so widespread that the very development of the realistic tradition of European painting can be attributed to them.

The event that opened Hockney's eyes to this idea was the exhibition of Ingres portraits at the National Gallery in 1999. He was struck by the sureness of line and lack of hesitation in some of the drawings Ingres made of his sitters and how they differed from others which appeared more freehand. Hockney makes a distinction between the two styles. The freer drawings are 'eyeballed' – that is, drawn directly from the subject. But he became convinced that, for the others, the artist had used a *camera lucida* – a device based on a prism, patented at the beginning of the nineteenth century, that superimposed the images of objects in front of the user on a sheet of paper and enabled them to be traced.

There is, of course, no historical evidence that Ingres ever used such a device for portraits – no documentary record, no remark made by one of his many sitters, no equipment found in the studio. There is only the author's hunch. A series of Hockney's own portrait drawings done through a *camera lucida* and placed alongside drawings by Ingres does not offer convincing proof of his theory. It certainly seems reasonable to conclude that Ingres was simply a stupendous draughtsman and had no need of artificial aids. Why would one think otherwise – unless one is a contemporary artist who finds the business of drawing more and more difficult? Or a critic happy to cut the great draughtsmen of the past down to size – to impose the constraints of the ordinary upon the extraordinary? As for the differing styles of Ingres drawings, no mention is made of the importance of the medium (pencil, charcoal) or of the function (preparatory sketch, finished drawing) which would determine the way that outlines were set down and the final effect that the artist desired.

The book is in three parts. The first is a visual essay,

sumptuously illustrated, with a commentary developing Hockney's argument; the second brings together largely familiar written sources connecting optics and art; the third consists of the lengthy correspondence by fax that Hockney had with artists, art historians and scientists during his enquiries.

The first section moves rapidly on from drawings by Ingres to his painted portrait of Mme Leblanc in the Metropolitan Museum. Hockney is unable to believe that the rich cloth draped over the chair could have been painted 'without some optical help'. He goes on: 'it would have taken observational and painting skills of the highest order to do this freehand. It would also have taken a vast amount of time …' Some might think that Ingres had such skills in abundance – and, indeed, might remember that a painting like *Madame Moitessier seated* did take twelve years to paint. But, for Hockney, it is but a short step to conclude that the painter must have used 'some form of *camera obscura* for the meticulous detail in the paintings. This seems to me the only explanation.'

A *camera obscura* used how exactly? There is widespread misunderstanding of what is actually possible using a *camera obscura*. People seem to think that the appealing, slightly hazy images produced by such devices (images that are not only upsidedown but also reversed left to right – but which, it is generally agreed, did influence the look of Vermeer's art) can somehow be magically transformed into paintings. At best, broad outlines can be traced, but capturing detail or painting directly on the projected image in a darkened space – where the colours on the palette cannot be seen and where hand and brush block the projection – is practically impossible.

Ignoring inconvenient practicalities, Hockney gets into his stride. No artist was apparently capable of painting gorgeous fabrics or shining armour without recourse to optical aids: Moroni, Bronzino, Giorgione, Mor and Van Dyck are all swiftly disposed of. Caravaggio appears with the Berlin *Amor* and the Hermitage *Lute player*. We learn that feathered wings and foreshortened musical instruments were equally impossible to paint unaided: 'was it just divine skill, or could he have used optics?' Most of us would settle for divine skill.

The level of reasoning throughout the book never rises above fervent conjecture. No sooner has a guess been made, a hunch been hazarded, than it becomes established fact. As Martin Kemp rightly warns in one of his letters published in the final section, Hockney's arguments are circular: the means are inferred from the pictures and then made to account for effects. Unfounded speculations pile on each other until a dizzying edifice of wishful thinking totters before our eyes. One reads the first part of the book with mounting incredulity. By p. 65, the skewed perspective of a Memling carpet has proved that 'artists were using optics as early as the end of the fifteenth century'. Three pages later, the use of 'oil paint is not enough to explain' the realism of a Campin portrait: 'something else is in play.' It is, of course, optics: 'what other explanation could there be?'

We are almost at the moment of revelation, vouchsafed by a professor of optics at the University of Arizona, who almost outdoes Hockney in his balletic leaps of faith. With absolutely no evidence at all (other than 'it works'), we are told that Campin, Van Eyck and the rest used concave mirrors, which act like lenses, to project images on to a flat surface to be traced. This is 'proved' by setting up a shaving mirror in Hockney's California studio; the fuzzy upside-down image of a model sitting outside the window in the sunshine appears on the wall where the artist traces it. Q.E.D. Never mind that the image is blurred and that Van Eyck's are pin-sharp and full of detail, or that the light levels in northern Europe for much of the year simply would not permit this sort of projection. Never mind that concave mirror technology was nowhere near as advanced as convex mirror technology in the fifteenth century – and certainly would have been far inferior to a modern shaving mirror (and, incidentally, you cannot flip a convex mirror to make a concave one). Never mind that no single historical source has ever mentioned this method of capturing images. At least this last is easy enough to explain: we are told that artists were secretive and concealed their methods even from their sitters. According to Hockney, the set-up with the sitter outside the window and the artist inside with his mirror happily preserved the secret – and also explains why so many renaissance portraits appear as if through window openings.

The mirror-lens theory gathers pace. The chandelier in Van Eyck's Arnolfini double portrait was apparently painted directly on its projection with the panel 'hung . . . upside down next to the viewing hole'. Now, of course, we know a great deal about this painting and the extensive underdrawing with its multiple pentiments is the absolute antithesis of a traced image. It is true that the chandelier (along with the dog) is not underdrawn, but why propose such a com-

plicated (and, as we saw above, almost impossible) method of painting this passage when the most obvious explanation is that the artist simply painted it directly? Presumably modern artists, increasingly dependent on photographs, find such skills too baffling to comprehend.

Large, complex figure groups were constructed piecemeal: 'each element in the painting – each face, each object – was drawn separately with a mirror-lens and the hole-in-the-wall method . . . and then pieced together on the panel. In effect, it's a collage.' Helpfully, Hockney juxtaposes Van Eyck's *Mystic Lamb* with his own photocollage *Pearblossom Highway* to demonstrate the method. The notion that artists such as Van Eyck could actually draw and make studies for paintings without optical aids is not even considered. We are in the grip of an obsession so profound that rational thought is suspended. Muddled thinking abounds: for example, the perspectival analysis of objects in Holbein's *Ambassadors* on p. 100 is completely misunderstood. Plotting 'vanishing points' for randomly placed books is meaningless: to go on and conclude from this that Holbein was abandoning Albertian perspective in favour of a mirror-lens collage is ludicrous.

Caravaggio gets a special mention. It is documented that he owned mirrors, although there is nothing to suggest that they were in any way unusual. Hockney, though, immediately assumes that they must have been mirror-lenses and tries to demonstrate how the Borghese *Bacchus* is constructed as a collage, with the head, back, shoulder and arm of the figure all being recorded separately and pieced together. Is it remotely likely that an artist of Caravaggio's skill would laboriously focus and refocus his mirror on individual limbs and join individual sections together to make his Bacchus? Of course not: he would want to set down the figure all of a piece – and the freely brushed underdrawings that have been observed in his paintings tell us this is exactly what he did.

Out of nowhere, we are told that 'in the mid-1590s Caravaggio came into the possession of a lens'. Again, there is absolutely no historical evidence for this, but the left-handed Uffizi *Bacchus*, apparently reversed by the lens, is cited as proof. We might ask, why shouldn't a Bacchus be left-handed? – but two more left-handed drinkers (by Annibale Carracci and Frans Hals) are brought in to clinch the argument. Actually, there is a perfectly sound reason why drinkers might be shown left-handed. With the light coming from the painter's left (as it nearly always does) a right-handed drinker would cast a shadow over his own face; also the fact that the light does indeed come from the left is a pretty sure indication that the image has not been reversed. However, a prosaic explanation like this is clearly not as interesting as the idea that artists all over Europe were secretly making their paintings with the help of lenses.

The argument rambles on. Every theatrical effect, every realistic form, every skilful passage of painting, every unexplained distortion, every tricky bit of perspective, every approach to, or retreat from, the picture plane – all are attributed to the painter's use of optics. Half a millennium of artistic imagination, workshop tradition, draughtsmanship, painterly skill and academic practice – and half a century of research into European painting methods – are all ignored in pursuit of the 'lost' technique. The narrowness of intellectual focus is truly dispiriting.

It is with some relief that we turn to the third section of the book that reproduces Hockney's extensive correspondence with his collaborators and others. It is by turns revealing, touching and (often unintentionally) funny. Hockney clearly has much charm and it is intriguing to watch him deploy it in his faxed pages to a whole range of correspondents flattered by his attention. It is also riveting to witness how people negotiate the quicksand of his obsession. Some retreat immediately and we never hear from them again; some tiptoe around it, not quite sure whether they should be taking it seriously; others are wary, but inexorably drawn in; a few willingly throw themselves in and are rewarded by the full beam of approval and David's characteristic signing-off, 'love life'.

So is this book merely amiable nonsense? Nonsense it certainly is but, unfortunately, it is more of a problem than that. Unlike Maroger's 1948 book, this one will he widely read and believed because Hockney has been a significant artist and is still a popular figure held in great affection. The problem is that, despite Hockney's protestations to the contrary and with no evidence at all other than his own conviction, his book actually sets out to devalue the art of the past – to reduce the astonishing complexity and brilliance of European painting to a series of optical tricks. Whether he likes it or not, present-day art-students will take its central message to be that great draughtsmanship doesn't matter, perhaps never existed – that the right mirrors, lenses or prisms are the secret key to great art. And that does a disservice to us all.

NOTES

Dante Rossetti and Elizabeth Siddal

Republished (with a few cuts) from THE BURLINGTON MAGAZINE, I [March–May 1903], pp. 273–95. Only four of the five drawings then in the possession of Harold Hartley (a member of the Consultative Committe of the newly founded Magazine) are reproduced here. For the work of Rossetti, see V. SURTEES: *Dante Gabriel Rossetti: The Paintings and Drawings*, 2 vols., Oxford [1971]; and, for Elizabeth Siddal, J. MARSH: *Pre-Raphaelite Sisterhood*, London [1985].

Clifford's Inn and the Protection of Ancient Buildings

This was the first of two Editorials in the June 1903 issue (THE BURLINGTON MAGAZINE, II [June–August 1903], pp. 3–5), this one following up on an earlier article, P. NORMAN: 'Clifford's Inn', with drawings by F. L. Griggs, THE BURLINGTON MAGAZINE, I [March–May 1903], pp. 239–55. Clifford's Inn was bought by the builder William Willett in 1903, but his plans for the site came to nothing: the buildings were finally demolished in 1935 (H. HOBHOUSE: *Lost London. A Century of Demolition and Decay*, London [1971], p. 120). The Royal Commission on Historical Monuments (now part of English Heritage) was established in 1908 (with similar bodies in Scotland and Wales).

1. 'Reports from Her Majesty's representatives abroad as to the statutory provisions existing in foreign countries for the preservation of historical buildings.' – Miscellaneous, no. 2 (1897).

Cézanne

XVI [October 1909–March 1910], pp. 207–19.

Part II of Denis's piece was published in the same volume, pp. 275–53. His original French version was reprinted in M. DENIS: *Théories, 1890–1910. Du symbolisme et de Gauguin vers un nouvel ordre classique*, Paris [1912]. For a discussion of Cézanne's *fortune critique* putting the Denis essay in context, see 'A Century of Cézanne Criticism'; F. CACHIN: 'From 1865 to 1906'; J.J. RISHEL: 'From 1907 to the present', in F. CACHIN *et al.*: *Cézanne*, exh. cat., (Grand Palais, Paris, Tate Gallery, London, Philadelphia Museum of Art), Philadelphia [1996], pp. 23–75.

1. Translated by Roger E. Fry.
2. Published in *L'Occident* [July 1904].

The Munich Exhibition of Mohammedan Art

XVII [April–September 1910], pp. 283–90. Part II of the article was published *ibid.*, pp. 327–33.

Fry himself republished it in R. FRY: *Vision and Design*, London [1920], and subsequent editions. For the catalogue of the Munich exhibition, see F. SAARE and F. MARTIN: *Die Ausstellung von Meisterwerken muhammedanischer Kunst in München 1910*, Munich [1912]. Some of the pieces discussed by Fry were exhibited in the Hermitage's travelling exhibition of 2000 and published in the catalogue, *Earthly Art – Heavenly Beauty. Art of Islam*, St Petersburg [2000]. We are most grateful to Michael Rogers for supplying us with the latest scholarly views on the dating and location of the objects.

1. [Michael Rogers kindly informs us that the piece is probably (as captioned here) South Indian, seventeenth century.]
2. G. MIGEON: in *Gazette des Beaux-Arts* [June 1905], and *Manuel d'Art Musulman*, Paris [1907] p. 226.
3. I cannot help calling attention, though without any attempt at explaining it, to the striking similarity to these Sassanid and early Mohammedan water jugs shown by an example of Sung pottery lent by Mr Eumorfopoulos to the recent exhibition at the Burlington Fine Arts Club, Case A, no. 43, Here a very similar form of spout is modelled into a phoenix's head.

Sir Hugh Lane

XXVII [April–September 1915], p. 128.

In 1959, and in subsequent years, agreements have been reached between London and Dublin. Under the current arrangements the majority of the pictures bequeathed by Hugh Lane are permanently displayed at the Hugh Lane Memorial Gallery of Modern Art, Dublin, and six great paintings are successively shown for six years in Dublin and six years at the National Gallery, London.

The Literature of Chinese Pottery

XXX [January–June 1917], pp. 45–52.

1. R. L. HOBSON: *Chinese pottery and*

porcelain: an account of the potter's art in China from primitive times to the present day, London [1915].

2. It would be unfair to make no mention of the excellent report by Mrs Williams prefixed to the catalogue of the exhibition held by the Japan Society of New York in 1914, to which Mr Hobson makes suitable acknowledgment for information obtained direct by her from Chinese connoisseurs. Though restricted to the consideration of the Sung dynasty wares, this essay does something less than justice to the T'ang period by asserting that it was during the time of the Sung emperors 'that the Chinese potter rose from the rank of artisan to that of artist'.

3. Mr Hobson seems to imply that white kaolinic material was already in use in 536 A.D. for the manufacture of porcelain; a careful reading of his references, however, appears to show that, whilst the material was known at that date, its use for ceramic purposes is not conclusively established before the date of the compilation of the T'ang Pharmacopoeia (about 650 A.D.).

4. The true nature of late Ming dynasty enamelled porcelain is well represented by the two bowls in the plate reproduced herewith (Figs. 17, 18).

Negro art

XXXVI [January–June 1920], pp. 164–72.

The exhibition discussed here was held at Paul Guillaume's gallery, 108 Faubourg St Honoré, Paris, where 'Negro art' was regularly shown, along with the work of Derain, Modigliani, Picasso, Matisse, etc. Paul Guillaume (1891–1934) had begun dealing in African sculpture c.1911 before opening his gallery in Paris. The Walter-Guillaume collection of French art was bequeathed to French nation and is now in the Orangerie, but his personal collection of African art was dispersed. See M. GEE: entry in *Dictionary of Art,*. ed. J. Turner, London [1996], s.v.

Translated by D. Brinton

1. The rooms in the Louvre that have recently been reopened are better arranged.

2 We owe this word, I believe, to M. Guillaume Apollinaire.

Una Vilana Windisch

LVI [January–June 1930], pp. 237–38.

For recent bibliography on the Dürer drawing, see J. ROWLANDS with G. BARTRUM: *Drawings by German Artists and Artists from the German-Speaking Regions of Europe in the Department of Prints and Drawings in the British Museum: the fifteenth century and sixteenth century by artists born before 1530*, London [1993].

1. According to a letter to *The Times* of 4th April, 'una vilana' is good mediaeval Latin. This is true, but perhaps it is still better Italian, the indefinite article being in that language normal, in Latin exceptional. And why should Dürer write Latin? The writer goes on to suggest that 'windisch' suggests an abbreviated Latinised form of the German, the full form being presumably 'windischana'. This is very far-fetched, and there is no full stop indicating an abbreviation. Why not leave the German word alone, as it stands?

Jan van Eyck's Arnolfini Portrait

LXIV [January–June 1934], pp. 117–27.

For a recent (and contrary) view of the painting, see L. CAMPBELL: *National Gallery Catalogues. The Fifteenth Century Netherlandish Schools*, London [1998], pp. 174–211.

1. W. H. JAMES WEALE: Hubert and John van Eyck, London [1908] (hereafter cited as WEALE I), pp. 69 ff; W. H. JAMES WEALE and M. W. BROCKWELL: *The van Eycks and their Art*, London [1912] (WEALE II), pp. 114 ff. Both with bibliography.

2. For the Cename family and the personality of Giovanni Arnolfini, see L. MIROT: 'Etudes Lucquoises', *Bibliothèque de l'Ecole des Chartes*, XCI

[1930], pp. 100 ff, esp. p. 114.

3. These inventories are reprinted in WEALE I, p. 70 and WEALE II, p. 114. In WEALE II a third inventory of Lady Margaret's Collection, made in 1524, is also quoted. This is said to contain a similar description of the picture. As for Queen Mary's inventory, see R. BEER, in *Jahrbuch der Kunsthistorischen Sammlungen des Allerhöchsten Kaiserhauses*, XII [1891], p. CLVIII, No. 85.

4. K. JUSTI, in *Zeitschrift für bildende Kunst*, XXII [1887], p. 179: 'Otra pintura vara de alto y tres quartos de ancho; Hombre y muger agarrados de las manos. Juan de Encina, Imbentor de la pintura al oleo.'

5. The fact that the picture is called a large one in the inventories (while, in reality, it is not larger than 84.5 by 62.4 cm.) is no obstacle. Mr Weale is obviously right in pointing out that 'large' and 'small' are relative terms, and that the panel is set down as 'large' in comparison with those preceding it in the inventory of 1516. In addition a picture which was 'small' for a late sixteenth-century writer like Vermander, was 'large' when judged by the standards of about 1400. As for the inventory of 1555/58 it is obviously based on an earlier on.

6. *Revue de l'Art*, XXXVI [1932], pp. 187 ff. see also letter [November 1932]. Monsieur Dimier's statements were already contradicted, though not properly disproved, by M. JIRMOUNSKY, in *Gazette des Beaux-Arts*, LXIV, 6 [1932], p. 423, and also 7, [December 1932], p. 316.

7. CAREL VERMANDER: *Het Leven der doorluchtighe Nederlandtsche en Hooghduytsche Schilders*, ed. H. FLOERKE [1906], I, p. 44.

8. JOACHIM VON SANDRART: *Acad. Germ.* [1683], p. 203. In the German edition (*Teutsche Akademie* [1675], ed. R. PELTZER [1926], p. 55) the passage reads as follows: '*Ein Mann und Weibsbild, so sich durch Darreichung der rechten Hand verheurathen und von der darbey stehenden Frau Fides vermählet werden.*'

9. See, for instance, W.H. JAMES WEALE: *Notes sur les van Eyck*, London and Brussels [1861], p. 26 ff., and FLOERKE,

ed. cit. at note 7 above, p. 408.

10. See X. BARBIER DE MONTAULT: *Traité d'Iconographie Chrétienne*, Paris [1890], p. 196 or CESARE RIPA: *Iconologia*, s.v. 'Fedeltà'. In the *Repertorium Morale*, by PETRUS BERCHORIUS (middle of the fourteenth century, printed Nürnberg [1489]) the dog is interpreted as 'vir fidelis' (s.v. 'canis').

11. WEALE I, p. lxxxv. In the *Historie van Belgis* of 1574 the passage is to be found on fol. 119v.

12. See WEALE I, pp. lxxvi ff.

13. As for the theory of matrimony in Catholic theology, see H.J. WETZER and B. WELTE: *Kirchenlexikon*, s.v. 'Ehe', 'Eheverlöbnis', 'Ehehindernis'. Also F. CABROL and H. LECLERCQ: *Dictionnaire d'Archéologie Chrétienne et de Liturgie*, Paris [1907–53] s.v. 'Mariage'; same authors: *Dictionnaire de Théologie Catholique*, s.v. 'Mariage' (very thorough).

14. DU CANGE: *Glossarium mediae et infimae latinitatis*, s.v. 'Fides'.

15. CABROL AND LECLERCQ, *op. cit* at note 13 above, col. 1895. DU CANGE, *loc. cit.* above.

16. DIDRON: *Annales Archéologiques*, XX [1860], p. 245. See also Andrea Alciati's famous *Emblemata*, no. ix ('*Fidei symbolum*').

17. Plenty of literature may be found in CABROL AND LECLERCQ, *op. cit* at note 13 above, col. 2223.

18. E. REICKE: *Willibald Pirckheimer*, Jena [1930], pp. 10 ff.

19. S. REINACH, in *Bulletin archéologique du Comité des travaux historiques et scientifiques* [1918], p. 85.

20. WEALE I, p. xl; WEALE II, p. xxxvi.

21. As for the apparent family likeness between Jeanne de Cename and the wife of Jan van Eyck as portrayed by her husband in the famous picture of 1439 (a family likeness from which Monsieur Dimier concludes that the two portraits represent the same person, while Mr Weale rather believes Jeanne de Cename to be the sister of Margaret van Eyck), we must bear in mind that in Jan van Eyck's pictures the women are much less 'individualised' than the men, adapted as they are to a typical ideal of loveliness. As far as we can learn from documents, Jeanne de Cename had only one sister named 'Acarde' (MIROT, *loc. cit.* at note 2 above p. 107 and stemma, p. 168).

22. MIROT, *ibid.*, p. 114.

23. M. J. FRIEDLÄNDER: *Die Altniederländischer Malerei*, Berlin, I [1924], p. 18.

24. M. J. FRIEDLÄNDER: *Van Eyck bis Breughel*, second ed. Berlin [1921], p. 18.

25. A. DE LABORDE: *La Bible Moralisée*, Paris [1911], pl. 86 and 154.

26. Published by HANS FEHR: *Das Recht im Bilde*, Munich [1923], fig. 191.

27. This type of medieval slab-tomb is the result of an interesting process which can be observed in a good many instances. This bible is full of what we may call 'involuntary descriptions' of ancient oriental images, such as, for instance, the scape-goat tied to the Holy Tree as recently discovered in the royal tombs of Ur which was the model of Abraham's ram caught in the bush, or the Babylonian astral divinity resuscitated as the 'apocalyptic woman'. Now the thirteenth verse of the 90th Psalm says '*super aspidem et basiliscum ambulabis et conculcabis leonem et draconem*', thus describing the Babylonian type of a god or hero triumphing over an animal or a couple of animals (a type which also gave rise to the representations of St Michael fighting the Dragon, the Virtues conquering Evil and so forth). We can observe how this motive which originally was used exclusively for the representations of Christ was gradually transferred to the Virgin, the Saints and finally to the slab-tombs, such as the monument of Bishop Siegfried von Epstein in Mainz Cathedral or that of Heinrich von Sayn in the Germanisches Museum, Nuremberg. From this we must conclude that the animals forming the 'foot-rest' of the knights and princes portrayed on great mediaeval slab-tombs were originally not attributers denoting the praiseworthy qualities of the deceased but symbols of Evil conquered by the immortal soul. Later on, however, the Lion which originally was meant to be the '*leo conculcatus*' described in the 90th Psalm was interpreted as a symbol of Fortitute, and when the statues of a married couple were to be placed on the same monument (so that the women, too, had to be provided with an animal) she was usually made to stand upon a Dog, conceived as a symbol of marital Faith (cf. note 10).

28. Cf. I. HERWEGHEN: *Germanische Rechtssymbolik in der römischen Liturgie* (Deutschrechtliche Beiträge VIII, 4) [1913], pp. 312 ff.

29. 'Jurare super Candelam', 'Testimonium in Cereo'. See WETZER and WELTE, *op. cit.* at note 13 above, s.v. '*Eid*' and J. GRIMM: *Deutsche Rechtsaltertümer*, fourth ed., Leipzig, [1899], II, p. 546.

30. DU CANGE, *op. cit.* at note 14 above, s.v. 'Candela'. Cf. WETZER and WELTE: s.v. '*Hochzeit*' and '*Brautkerze.*'

31. WEALE I, p. 20 and WEALE II, p 17. This belief has even led some scholars to suppose that St Margaret is to be regarded as a substitute for the classical Lucina (F. SOLEIL: *La vierge Marguérite substituée à la Lucine antique*, Paris [1885]).

32. With regard to the dog, see notes 10 and 27; with regard to the candle, see DIDRON, *loc. cit.* at note 16 above, pp. 206 ff, and plate facing p. 237. Also E. MÂLE: *L'Art religieux de la fin du moyen-âge in France*, second ed., Paris [1922], p. 334, and RIPA: s.v. '*Fede Cattolica*', where the motive is explained by a passage of St Augustine which says '*Caecitas est infidelitas et illuminatio fides*'. Needless to say, '*Fides*' could always mean both 'True Belief' and 'Faithfulness', especially of wife and husband. Fides conceived as a theological virtue explicitly prescribes '*serva fidem coniugum*' (DIDRON, *loc. cit.* at note 16 above, p. 244).

33. As for the '*aquae viventes,*' see W. MOLSDORF: *Führer durch den symbolischen und typologischen Bilderkreis der christliche Kunst des Mittelalters*, Leipzig [1920], no. 795. The comparison of the Virgin with a 'candelabrum' is to be found in the *Speculum Humanae Salvationis* (quoted in E. BEITZ: *Grünewalds Isenheimer*

Menschwerdungsbild und seine Quellen, Cologne [1924], p. 25; in Berchorius's *Repertorium morale* the 'candelabrum' is adduced as a symbol of Virtue and, quite logically, as 'basis fidei', because the candle itself stands for Faith as mentioned in the preceding note). As for the carafe, which also occurs in Grünewald's Isenheim altar, see BEITZ, *op. cit.*, p. 47.

34. This is the reason why the picture was sometimes described as St Agnes (WEALE I, p. 89; WEALE II, p. 129).

35. Thus, it is not surprising that a little dog, very similar to that in the Arnolfini portrait, occurred also in the famous picture of a naked woman taking her bath described by Bartholomaeus Facius and apparently analogous to a painting which was formerly in the collection of Cornelius van der Geest (WEALE I, pp. 175 ff, WEALE II, pp. 196 ff), where the motive has obviously nothing to do with marital Faith. Iconographical symbols, especially in mediaeval art, are almost always 'ambivalent' (the snake can mean Evil as well as Prudence, and golden sandals can be an attribute of Luxury as well as Magnanimity, cf. E. PANOFSKY, in *Münchner Jahrbuch der Bildende Kunst,* N.F., IX [1932], pp. 285 ff. Thus, the equation Dog–Faith does not preclude the equation Dog–Animality, as shown on the reverse of the well-known Constantine-medal, where a little dog characterises the personification of Nature in contradistinction to Grace. Consequently the griffin terrier 'fits' into the bathroom picture as well as into the Arnolfini portrait, whether we regard it as a 'symbol' or as a mere 'genre-motif'. When this article was in print, K. VON TOLNAI published a paper (*Münchner Jahrbuch,* as above, pp. 320 ff) in which, I am glad to say, the problem of symbolism in Early Flemish art is approached in a similar way.

Reflections on British Painting

LXV [July–December 1934], pp. 45–46. By Roger Fry. 148 pp. + 66 reproductions. (Faber and Faber.) 7s. 6d.

Les Peintres de la réalité en France au XVIIe siècle

LXVI [January–June 1935], pp. 138–45.

Douglas Lord was an occasional *nom de plume* of Douglas Cooper. The view that the *Hurdy gurdy player* in Nantes was not by Georges de la Tour, based on the alleged signature on it of the Spanish artist Juan Rizi, has been abandoned (see, in this volume, E. HARRIS: 'Spanish pictures from the Bowes Museum', p. 105). For recent literature on the picture, see P. CONISBEE: *Georges de la Tour and his world,* exh. cat. (National Gallery of Art., Washington, and Kimbell Art Museum, Fort Worth), New Haven and London, 1996, cat. no. 11; J. CUZIN et al.; *Georges de la Tour,* exh. cat., Grand Palais, Paris [1997], cat. no. 23.

A Portrait by the Aged Ingres

LXVIII [January–June 1936], pp. 257–68.

For Mme Moitessier, see, most recently, G. TINTEROW and P. CONISBEE: *Portraits by Ingres: Images of an Epoch,* exh. cat. (National Gallery, London, National Gallery of Art, Washington, and Metropolitan Museum of Art, New York), New York [1999], pp. 426–46.

1. Purchased (at a low price) from the sitter's family, through the mediation of Messrs. Jacques Seligmann.

2. See LE VICOMTE HENRI DELABORDE: *Ingres, sa vie, ses travaux, sa doctrine,* Paris [1870]; A. BOYER D'AGEN: *Ingres d'après une correspondance inédite,* Paris [1909]; H. LAPAUZE: *Ingres, sa vie et son œuvre,* Paris [1911]. My 'text' is quoted by Delaborde on p. 115.

3. Marcotte's evidence: DELABORDE, *op. cit.* above, p. 255.

4. BOYER D'AGEN: *op. cit.* at note 2 above, pp. 370–71, 379, 387 and 388. In four letters of June 1851, December 1851 and January 1852, Ingres speaks of the seven years he has been painting her (DELABORDE *op. cit.*, p. 256; LAPAUZE: *op. cit.*, pp. 456–57 – both cited at note 2 above); so he began probably in the latter part of 1844.

5. '*Un portrait de femme assise sur un canapé, et dont la main joue avec une tête*

d'enfant penché à ses genoux' (T. GAUTIER, in *La Presse* [1847]). See LAPAUZE, *op. cit.* at note 2 above, pp. 441–42 for the adjectives.

6. In the sketch, she is seated, not on a sofa but on a chair, so it is probably anterior to Gautier's visit to the studio in 1847: unless it be assumed that Ingres tried a sofa, then a chair, then a sofa again for the final picture.

Lapauze (p. 491) reproduces it the wrong way round: M. Félix Bouisset, Keeper of the Musée Ingres, most courteously permitted me to have photographs made of this and of several other drawings in his charge. M. Bouisset also very kindly sent me the following observations. '*L'esquisse peinte sur toile mesure: Haut. 0 m. 40 – Larg. – 0 m. 32. A mon avis, c'est un travail fait sur la demande d'Ingres, par un élève. Le même cas s'est produit plusieurs fois. Seul, le fond est peint, gris clair; ornements et bordures des glaces, ton vieil or. Le portrait est légèrement silhouetté à la mine de plomb. Mais il est certain qu'Ingres a rectifié lui-même certains traits et il a notamment modifié, en accentuant le trait, le mouvement du bras gauche et de la main. Il a même tracé une verticale et une horizontale en vue de la mise en place du portrait. L'Esquisse n'est pas renversée, comme dans le livre de Lapauze.*'

The strip in the original has now been removed from the stretcher: the inner edge of the mirror frame was at the same level as in the final picture. The red table (a dark band in the photograph) and the position of the hand, implying a flatter angle of the arm, correspond with the design of the sketch, except that the hand must have been higher up, on the arm of the chair. There was also a small patch of red carpet (now destroyed) turned over the stretcher along the bottom to the left: the rest had been cut away, undoubtedly by Ingres himself.

Several *pentimenti* are visible in the final picture, for example, at the tangent of the right arm and sofa, in the shoulder-ribbon under the right forearm, in the sofa to the spectator's right.

7. Completed between 15th December 1851 and 7th January 1852 (LAPAUZE, *op. cit.* at note 2 above, pp. 456–57): the date on the picture is 1851. It is apparently true that Ingres painted this second picture quickly. LAPAUZE (p. 442) seems to assume that it was begun soon after 1847. But he then says that the dress was done in a few sittings: in June [1851] the arms and hands, then the head (no documents quoted). The accessories were painted in October, then again the head; and the signature was added before the year was out.

There is no evidence that Ingres began the picture before the summer of 1851, and his other occupations before his wife's death and his prostration after make it unlikely. Gautier in 1847 saw the National Gallery version, no other. The four letters (see note 4) in which the artist says 'this' portrait has been occupying him for seven years, and the letter (LAPAUZE, p. 442) on 'this' portrait his wife and M. de Foucauld did not live to see, signify in all probability merely 'a' portrait (but not more than one at a time). The probable occasion of the standing version was the sitter's impatience: 'notre belle avec toute sa bonté, n'a pu s'empêcher de me rappeler qu'il y a sept ans qu'elle est commencée' (June 1851): an impatience stirred by the rapidity with which *Madame de Broglie* had been sketched in (see Blanc's longer text of the letter, *Gazette des Beaux-Arts* [1868], i, pp. 536–37). The next letter (about June 1851) is according to Blanc's text (*ibid.*) decisive 'malgré les brillantes expressions dont s'est servi notre belle et bonne Mme. Moitessier, il n'est pas moins vrai que la partie n'est pas gagnée encore, ce qui se décide cependant à partir d'aujourd'hui, première séance de cette terrible et belle tête.' But Delaborde (*ibid.*, quotes the letter as follows: '… il n'en est pas moins vrai que la partie n'est pas gagnée encore, ce qui va se décider cependant par une séance de cette terrible et belle tête.' Pending a scholarly edition of the letters we may believe either or neither. My suggestion that Ingres in this more simply designed portrait was working to time is partially confirmed by a letter to

Madame Gonse, written it is true to put *her* off, of December 15th, 1851: 'je ne parlerai pas des droits . . qu'elle (Moitessier) a de passer la première, chose résolue et impossible d'éluder.' Cf. also the obscure sentence quoted at the top of LAPAUZE p. 446 (1st October 1851).

It is at least certain that the standing version, very great masterpiece as it is, shows some signs of haste. The style of Ingres is so severe that even he cannot always completely realise a form (see *Madame de Broglie*), but there is not merely incoherence in the shoulders; the face, though staggeringly superior to what most painters could have done, is somewhat hard and poor – eyes together, adenoidal neck! – in comparison with the sublime features of the National Gallery portrait. This lack of comprehension is hard to detect in the original – one is blinded by the splendour of the head-dress, dominating the head like some halo in perspective: in a detailed photograph (not here reproduced) it is clear enough.

8. 7th January 1852: LAPAUZE, *op. cit.* at note 2 above, p. 457.

9. Cf. the principle quoted by DELABORDE (p. 153): 'pour bien réussir dans un portrait, il faut se pénétrer d'abord du visage que l'on veut peindre, le considérer longtemps, attentivement et de tous les côtés, et même consacrer à cela la première séance.' Cf. also a letter of October 1851 to Madame Gonse (LAPAUZE, *op. cit.* at note 2 above, p. 454) 'cette séance de demain est seulement pour vous poser et bien examiner: après-demain, le pinceau sera dans ma main.'

BLANC (*Gazette des Beaux-Arts* [1868], i, 539) obscurely says the pose is imitated from 'la Flore pompéienne.' Mr Pryce of the British Museum very kindly identified the reference to a figure in the painting *Herakles and Telephus* from Herculaneum, now at Naples [Fig 44]. The reminiscence is extremely probable, especially as Ingres often borrowed poses in his subject-pieces (and he did visit Naples), but it is not very important: Ingres would not have forced a classical pose on

his sitter if she had not naturally taken to it.

10. June 1852, LAPAUZE, *op. cit.* at note 2 above, p. 448. The complete letter is given by Lapauze, in *Le Roman d'Amour de M. Ingres*, Paris [1910], pp. 325 ff. Though there is no description, the reference is certainly to the National Gallery picture: the other was finished.

11. Cf. Horace Vernet's remark: 'on prétend que je peins vite: si vous aviez vu, comme moi, Ingres …! Je ne suis qu'une tortue.' (AMAURY-DUVAL: *L'Atelier d'Ingres*, Paris [1878], p. 47). Mottez wrote 'il est capable de peindre une figure entière en un jour' (R. GIARD: *Le Peintre Victor Mottez*, Paris [1934], 125).

12. Finally removed from his studio in January 1857: letter of 10th–28th January, LAPAUZE, *op. cit.* at note 2 above, p. 498. Lapauze (p. 450) quotes a letter of 9th March, 1853, in which Ingres with melancholy renounces painting this portrait: Mr Cunnington, and Mr Nevinson of the Victoria and Albert Museum, have very kindly informed me that the costume she wears in the final picture (Ingres was continually making her change: LAPAUZE, *op. cit.*, p. 451) dates from not before 1854, probably 1855–56. The *Madame Moitessier* (no description) shown in the studio about December 1854 (DELÉCLUZE in *Journal des Débats*, [8th December 1854]: letter of Mottez, December 18th, in GIARD, *op. cit.* at note 11 above, p. 190) was certainly the standing picture, borrowed with several others for the first public exhibition of the *Jeanne d'Arc*.

13. I have discussed this picture with my colleagues at the National Gallery and others: I here thank them. I have read at one time or another most of what has been written on Ingres, and many of my judgments on the painter are derived of course from my reading.

14. GAUTIER, *loc. cit.* at note 5 above.

15. The outermost fold was added to reinforce the effect: it descends to the level of the original frame, not to the bottom of the picture, an inch of which was formerly hidden.

16. Quoted by DELABORDE, *op. cit.* at note 2 above, p, 117.

17. *Ibid.*, p. 126.

18. *Ibid.*, pp. 125 and 150.

19. *Ibid.*, p. 123.

20. Cf LAPAUZE, *op. cit.* at note 2 above, p. 384: AMAURY-DUVAL, *op. cit.* at note 11 above, p. 47.

21. The distortions of Ingres are a popular subject of exegesis: in his portraits they bear a near relation to the fact. In his subjects, they are more directly caused by the expressionistic needs of the picture: *'si vous peignez non d'après la nature déjà copiée par vous, mais directement d'après le modèle, vous serez toujours esclave, et votre tableau sentira la servitude.'* (Quoted by DELABORDE, *op. cit.* at note 2 above, p. 131.) But his portraits were invariably painted to a large extent from life.

22. Quoted by DELABORDE, *op. cit.*, pp. 116–117 and AMAURY-DUVAL, *op. cit.* at note 11 above, p. 58.

23. Quoted by DELABORDE, *op. cit.*, p. 126.

24. *Ibid.*, p. 124.

25. See the letter referred to in note 10 above.

Six Armours of the Fifteenth Century

LXXII [January–June 1938], pp. 121–32. The armours are now in the Museo Diocesano, Mantua.

1. J. G. MANN: 'The Sanctuary of the Madonna delle Grazie with Notes on the Evolution of Italian Armour during the Fifteenth Century', *Archaeologia*, LXXX [1930], pp. 117–142.

2. [This was published shortly after the article reprinted here: J. G. MANN: 'A further Account of the Armour Preserved in the Sanctuary of the Madonna delle Grazie near Mantua', *Archaeologia*, LXXXVII [1938], pp. 311–51.]

3. [G. F. LAKING: *A record of European armour and arms through seven centuries*, 5 vols., London [1920–22]].

Meindert Hobbema

LXXIV [January–June 1939], pp. 43–44.
By Georges Broulheit. 210 pp. + 271 pl. (600 ill.) Paris (Firmin-Didot.) Frs. 500.

On Art and Connoisseurship

LXXX [January–June 1942], pp. 134–35. *On Art and Connoisseurship.* By Max J. Friedländer. London (Bruno Cassirer). 21s.

Gwendolen John

LXXXI [July–December 1942], pp. 237–40.
This short piece, published three years after Gwen John's death, was reprinted in A. JOHN: *Chiaroscuro: Fragments of an autobiography*, London [1952]. For an up-to-date account of Gwen John's work, see C. LANGDALE: *Gwen John*, New Haven and London [1987], and, for her life, S. ROE, *Gwen John*, London [2001].

Baron James Ensor

LXXXII [January–June 1943], pp. 50–51.
Ensor did not in fact die until 19th November 1949. His great painting, *Christ's entry into Brussels*, mentioned in this notice, is now in the J. Paul Getty Museum, Los Angeles; see P.G. BERMAN: *James Ensor: Christ's Entry into Brussels in 1889*, Los Angeles [2002].

The Subject of Poussin's Orion

LXXXIV [January–June 1944], pp. 37–41.
This classic article has been reprinted several times in English, notably in *Symbolic Images*, London and New York [1972], pp. 119–23, and in *The Essential Gombrich*, ed. R. Woodfield, London [1996], pp. 515–19, as well as in French and Hungarian. For recent bibliography on the painting, see P. ROSENBERG: *Nicolas Poussin 1594–1665*, exh. cat., Grand Palais, Paris [1994], cat. no. 234.

1. S. SITWELL: *Canons Of Giant Art; Twenty Torsos in Heroic Landscapes*, [1933]. (The volume contains two poems and notes on Poussin's Orion).

2. T. BORENIUS: 'A Great Poussin in the Metropolitan Museum,' THE BURLINGTON MAGAZINE, LIX [1931], p. 207.

3. *Entretien* VIII.

4. Quoted by DOUGLAS BUSH: 'Mythology and the Renaissance Tradition' in *English Poetry*, Minneapolis [1932].

5. C. MITCHELL: 'Poussin's Flight into Egypt', *Journal of the Warburg Institute*, I [1937/38], p. 342 first drew attention to Poussin's use of this author.

6. J. SEZNEC: *La Survivance des Dieux Antiques, Studies of the Warburg Institute*, XI, London [1940].

7. Comes uses the form Aerope instead of Merope because it fits into his context to interpret the name as meaning 'Air'.

Piero della Francesca's St Augustine Altarpiece

LXXXIX [1947], pp. 205–09.
For Clark's account of Piero's whole career, see K. CLARK: *Piero della Francesca*, Oxford [1951], revised ed. [1981]; and, for recent research on the S. Agostino altar-piece (of which the central panel has never come to light), see J. R. BANKER: 'Piero della Francesca's S. Agostino altar-piece: Some new documents', THE BURLINGTON MAGAZINE, CXXIX [1987], pp. 642–51.

1. Compare the modelling of the Virgin's head and the placing of the ear with the Signorelli angels in the sacristy at Loreto; and her hands with any of those in early Signorellis, e.g., the *Virgin and Child* in the Brera.

The Evolution of Henry Moore's Sculpture

XC [1948], pp. 158–64.

Part II of the article (not republished here) was *ibid.*, pp. 189–95. For David Sylvester's views on Henry Moore, see also D. SYLVESTER: *Henry Moore*, exh. cat., Arts Council of Great Britain [1968], and the later revised editions of the *Complete Sculpture*, I, which retain only Herbert Read's introduction from the early editions referred to in this article; see *Henry Moore Complete Sculpture, I: Sculpture 1921–48*, ed. D. SYLVESTER, fifth ed., London [1988].

1. H. READ : *Henry Moore: Sculpture and Drawings*, 1st and 2nd eds., [1944] and [1946], pl. 11.
2. *Ibid.*, pl. 12b, 13a.
3. *Ibid.*, pl. 15b.
4. For different view, see *ibid.*, pl. 62.
5. *Ibid.*, pl. 16.
6. *Ibid.*, pl. 31b, 32.
7. *Ibid.*, pl. 67.
8. *e.g.*, *Ibid.*, pl. 28a.
9. *e.g.*, *Ibid.*, pl. 30.
10. This *Mother and Child* of 1930 is here reproduced for the first time.
11. *e.g.*, *Ibid.*, pl. 29a, and in wood, pl. 78.
12. *Ibid.*, pl. 20.
13. *Ibid.*, pl. 25a.
14. *Ibid.*, pl. 21.
15. *Ibid.*, pl. 26.
16. *Ibid.*, pl. 27a.
17. *Ibid.*, pl. 27b.
18. *Ibid.*, pl. 100. For the study for this, mentioned subsequently, see *ibid.*, pl. 118a.
19. Alternatively, the date could be given as 1930, if the Ancaster stone *Reclining figure*, Cumberland alabaster *Figure*, and Corsehill stone *Reclining figure* are accepted as the beginning of the 'new road'. In turn, these could be related back to the alabaster *Reclining figure* of 1929. Some measure of arbitrary division is inevitable when the continuous process of an artist's evolution is compartmented into periods. Thus, an alternative interpretation of the years 1930–32 would have separated out two styles – the 'humanist' and the more abstract, from which my 'third period' would be the exten-

sion. Thus, the more abstract works would form a group spreading over the years 1930–7 and growing from the alabaster *Reclining figure* of 1929. Such an interpretation would be validated by the African Wonderstone *Composition* of 1932 (READ, pl. 33), certain wood carvings of 1932 (READ, pl. 74, 77, 79a) and two almost geometric *Reliefs* of 1931 and 1932 (*Ibid.*, pls 64 and 65). My own division makes for greater coherence, however; and coherence is, after all, the whole purpose of compartmentation. Moreover, the best works, the most completely realised works, of 1930–32 are the humanist ones. The others, besides forming a numerically smaller proportion of the output of these years, are important primarily as preliminary explorations of possibilities only later brought to fruition.

20. *Ibid.*, pl. 68, 69a.
21. For different view, see *ibid.*, pl. 34a.
22. *Ibid.*, pl. 34b.
23. H. MOORE: 'The Sculptor Speaks', *The Listener*, XVIII, no. 449 [18th August 1937], pp. 339. Reprinted in READ, p. xli, and elsewhere.
24. *e.g.*, READ, pls 36, 37, 41a, 43, 45, 69b and 81.
25. *Ibid.*, pl. 50.
26. *Ibid.*, pl. 53b and 54.
27. *Ibid.*, pl. 55.
28. *Ibid.*, pl. 56. Cf. also with the abstract *Sculpture* of 1937 the *Three standing figures* of 1947–48.
29. *Reclining figure*, READ, pl. 83; *Figure*, *ibid.*, pl. 84, 85 and 86.
30. Also *ibid.*, pl. 51,
31. *Ibid.*, pl. 45.
32. *Ibid.*, pl. 47a and 50.
33. MOORE: *loc. cit.* at note 23 above, p. 340; in READ; p.xlii.
34. Also *ibid.*, pl. 101.
35. For different views, see *ibid.*, pl. 87.
36. *Ibid.*, pls 89–96, including different view of *The bride* (Fig. 5). Two of the thirteen figures are not reproduced.
37. *Ibid.*, pl. 39a.
38. *Ibid.*, pl. 103a.
39. *Cf. ibid.*, quotation on p. 160.
40. *Ibid.*, pl. 105 and 106.

The Fresco by Foppa in the Wallace Collection

XCII [1950], p. 177.

For the most recent catalogue of the Wallace Collection, see J. INGAMELLS: *The Wallace Collection. Catalogue of Pictures. I*, London [1985], pp. 279–80 (where the spelling CECIRO is said to be due to restoration).

1. F. WITTGENS: *Vincenzo Foppa*, Milan [1949], pl. XXI and p. 93 where she dates it 1462/64.
2. *Antonio Averlino Filarete's Tractat über die Baukunst*, ed. W. VON OETTINGEN, in *Quellenschriften fur Kunstgeschichte und Kunsttechnik*, Neue Folge, III, Vienna [1890] p. 685 (Book 25).

Caravaggio and the Netherlands

XCIV [1952], pp. 247–52.

This was the first publication by Benedict Nicolson on Northern Caravaggism. For his monograph on Terbrugghen, mentioned here as in preparation, see B. NICOLSON, *Terbrugghen*, London [1958]; and see also *idem*: *The International Caravaggesque movement: lists of pictures by Caravaggio and his followers throughout Europe from 1590 to 1650*, Oxford [1979] and second revised and enlarged edition, *Caravaggism in Europe*, edited by Luisa Vertova, Turin [1990].

1. This review (if it is to appear before the Antwerp exhibition closes) has to be based on the pictures at Utrecht. According to information received up to 14th August, the following works were neither at Utrecht nor Antwerp: 23, 39, 102 of original catalogue; 22 of Supplement I. The following were at Utrecht but not at Antwerp: 10, 11, 28, 29, 38, 45. Nos. 95 and 101 were in original catalogue and at Antwerp but not at Utrecht; 6a and 56a were in Supplement II but not at Antwerp. Throughout this article, the numbers in parentheses are catalogue numbers. I am much indebted to Dr M. Elizabeth

Houtzager of the Centraal Museum for her assistance in a number of ways, and to Mr Denis Mahon for the generous contribution of his opinions. I have much profited from countless arguments with him in front of the pictures. I do not propose to discuss here the works of Terbrugghen in the exhibition, since I am engaged on a more detailed study of this artist, to appear at a later date, except to say that 73 and 74 are modern forgeries, 88 has nothing to do with Terbrugghen and 86 and 89 are copies.

2. W. SUIDA (*The Art Quarterly* [Summer 1952], pp. 165–70) has noted the similarity between Savoldo's *Nativity* recently acquired by the National Gallery, Washington, and the Honthorst *Nativity* lent to Utrecht from the Uffizi (in lieu of 40, which describes an *Adoration of the Shepherds* in the same gallery). This comparison confirmed an opinion I had already formed independently.

3. Sold Christie's 6th October 1950 (lot 108), see O. BENESCH, in THE BURLINGTON MAGAZINE, XCIII [November 1951], p. 352, note 2.

4. Another similar artist whom it would have been interesting to see in this company, Adam Elsheimer, was only represented by engravings after his works (Supplement Nos. 34–41). No. 41, the only one not identified in the catalogue, is after a picture which exists in more than one version: probably the finest belongs to Count Seilern (see H. WEIZSAECKER: *Adam Elsheimer . . .* , Berlin [1936] I, p. 237).

5. The *Scribe* (36) of 1625 is certainly by De Grebber although the reading of the signature is doubtful: cf. his *Works of charity* at Haarlem, of three years later.

6. For the Bruges Caravaggist Jacob van Oost the Elder, see R.-A. D'HULST in *Gentse Bijdragen*, XIII [1951], pp. 169–91. However, a work by him (107a) was at Antwerp.

7. The *Man with glass and pipe* (33) dated 1627, with its Hals-like still-life, has the same form of signature ('CBF') as a Couwenbergh *Bacchic Scene* of the previous year at the Arcade Gallery, London (Fig. 4, [now Rheinisches Landesmuseum, Bonn]), published by J. G. VAN GELDER in *Nederlandsch Kunsthistorisch Jaarboek* [1948–49], p. 161, as a *Bacchus and Ceres*. The latter is, of course, a descendant of Titian (cf. Titian, *Klassiker der Kunst*, 26 and 191).

8. This picture, the only known work by Nicolaes van Galen, is as remarkable in style as in iconography. At first sight, one cannot believe such a phenomenon possible before the middle years of the nineteenth century. It tells the story of a fourteenth-century bailiff who defrauded a peasant by stealing one of his cows and replacing it by another, less magnificent. For this crime Count William had the bailiff executed. No doubt it was painted for propaganda purposes.

9. The picture is in poor condition, with extensive repaints in the face. Another 'Caravaggesque' Bloemaert dating from the early 'twenties is the Brunswick *Nativity*.

10. *The ecstasy of St Francis* (6) in a Roman private collection, catalogued as 'ascribed to Caravaggio', is a typical Baglione. An inferior replica, damaged, was in Christie's (Anon.) Sale, 29th May 1952 (lot 46).

11. The Utrecht *Deposition* (7) is a good copy of the S. Pietro in Montorio altar-piece. Another copy is at Goodwood. A reduced copy of the Berlin-Wiesbaden picture (10a) was also exhibited (10). The small Utrecht *Procuress* (11) derives from a Baburen composition known from a large version in the Residenz at Würzburg. The signature and date on the copy exhibited are spurious. A replica of the wretched Utrecht *David saluted by women* (13) is at Hermannstadt, dated 1623. The composition and types are related to Terbrugghen – their association was close at this stage when they were both back in the North – and R. LONGHI (*Proporzioni*, I, p. 57, note 79) even goes so far as to describe the Hermannstadt picture as a copy of a youthful work by Terbrugghen.

12. Vermeer's Metropolitan *Allegory* in which the Jordaens appears was exhibited at the Prinsenhof, Delft during the summer of this year (cat. no. 324). Vermeer either copied another version, or took liberties with this one by cutting off a wide strip from the bottom. L. GOWING (*Vermeer*, London [1952], pp. 47–55) correctly stresses the importance to Vermeer of the subject-matter of pictures he introduced into his interiors. But can he really have owned these as is generally supposed? The Jordaens would have been a bulky possession. Is it not more likely that he borrowed them for specific purposes? He must have had them at least temporarily on his walls because the accidental play of light over them was just as important to him as their moral lesson.

13. The two artists were in close touch in the early 1620s. Cf. the style of the 'Votive Offering' with the Janssens *Roman Charity* in the Academia de San Fernando (illus. in H. VOSS: *Die Malerei des Barock in Rom*, Berlin [1925], p. 136) a replica of which, significantly ascribed to Baburen, is in the F. C. Lycett Green Collection on loan to the Cape Town National Gallery (illus. D. BAX: *Hollandse en Vlaamse Schilderkunst in Zuid-Afrika* [1952], p. 112). Dr Bax suggests that the latter may be by David de Haen, but Janssens seems to me a more likely candidate. The roses in the 'Votive offering' are painted by a different, inferior hand.

14. Some other Honthorsts in the exhibition that I have not referred to are as follows. The Cologne *Adoration of the Shepherds* (46) on which the date '1622' is still faintly visible, is similar in style to the scene of drawing a tooth, in Dresden, dated that year. The ceiling decoration (45) of the same year is based on North Italian renaissance illusionism. (Honthorst's links with North Italy were always just as strong as with Rome, especially with the Bolognese and Venetian Schools.) The date '1623' on the Rijksmuseum *Merry musician* (47) has been tampered with, and though probably correct must be treated with reserve. The Utrecht *Procuress* (49) dated 1625 is not very

helpful in establishing a chronology since it is painted on panel. The *Lute-player* (50) has points in common with Terbrugghen *c.* 1626–28 – indeed, a version as Terbrugghen was in the Gallery Tamm Sale, Stockholm, 15th–17th September 1931 (lot 130) and the Bukowski Sale, Stockholm, 7th–9th May 1941 (lot 131). It was unfortunate that no. 39 was never sent from S. M. della Concezione. I do not understand why A. VON SCHNEIDER ('Gerard Honthorst and Judith Leyster', in *Oud Holland* [1922], p. 169) should wish to take away from Honthorst the *Laughing youth* (53) and give it to Leyster. The lighting of the face and sleeve, and the masking of the light by the glass, are typical of Honthorst in the years 1622–26: see his Uffizi no.148. No. 53 is damaged in the lower part and heavily repainted in the sleeve.

15. A fine drawing for this picture (illus. in the Centraal Museum Catalogue [1952], pl. 118) was also exhibited (supplement, no. 11). VOSS (*op. cit.* at note 13 above, p. 138) illustrates a Joachim von Sandrart apparently (though it is not legible) dated 1635, based on Honthorst's picture. A poor version (with changes) of the *Death of Seneca* was in the Ernst Museum Sale, Budapest, 21st February 1921 (lot 247).

16. The picture was formerly at Brownsea Castle, Dorset (sold 1857) and in the collections of Robert Kerley, Bournemouth (sold 24th April 1885 (166)) and Colonel Waugh.

17. The signature and date (1631) on a painting in the Brom Collection, Utrecht (29a) are false. This is a poor Mannerist picture which has nothing to do with Bylert.

18. No. 65 is a good copy of the Prado *Incredulity of St Thomas* (published by A. VON SCHNEIDER in *Oud Holland* [1924], p. 230; Prado No. 2094, catalogued [1949] as Honthorst); No. 67, a *Christ at Emmaus* in the Ed. de Vigny Sale, Amsterdam, 20th June 1933 (29) is a caricature of no artistic quality, of a painting of this subject in Grenoble (as Honthorst, but an original Stomer). The *Supper at Emmaus* (67a, at Antwerp only) is hardly good enough for the master.

19. VOSS, *op. cit.* at note 13 above, p. 469.

20. The replica in Budapest of Bylert's *Calling of St Matthew* exhibited here (A. VON SCHNEIDER: *Caravaggio und die Niederländer*, Marburg [1933], pl. 23b) is cut at the bottom.

21. The Mahon *Executioner* was on show in Colnaghi's galleries after cleaning in August 1952 (catalogue No. 14). It has been ascribed to Stomer by both Longhi and Voss. The copy which was formerly at Wilton and is now in the collection of Sir Thomas Barlow was in the Dobson exhibition at the Tate Gallery in 1951 (26). Vertue's theory that the head of the Saint was drawn from Prince Rupert will now have to be treated with the utmost suspicion. The lighting of the executioner is similar to a figure holding a torch in Honthorst's *Decapitation of the Baptist* in S. M. della Scala (A. VON SCHNEIDER: *Caravaggio und die Niederländer*, Marburg [1933] pl. 1). The two pictures, strangely enough, passed through the sale rooms within six months of one another: the Dobson copy was sold at Christie's, 22nd June 1951 (34), the original, 23rd November 1951 (81).

22. In *Proporzioni*, 1, pl. 66.

23. Published by VITALE BLOCH in *Oud Holland* [1949], pp. 104–08. Bloch expressed doubts about whether the date on the *Soothsayer* should be read '1641' or '1645' but it is certainly 1641.

24. The picture appears to have been cut at the bottom.

25. The signature has re-emerged rather battered since the picture was cleaned.

Spanish Pictures from the Bowes Museum

XCV [1953], pp. 22–24.

1. 29th October–24th December 1952. I am much indebted to Mr Thomas Wake, curator of the Bowes Museum, for answering all kinds of questions about the collection. I am also grateful to Messrs Agnew & Sons for supplying me with photographs of the paintings. The pictures are referred to in this article by the numbers in the Bowes Museum catalogue, which are also given in the exhibition catalogue.

2. *Enciclopedia Universal Ilustrada Europeo–Americana*, Bilbao, Madrid and Barcelona [1922], XLVIII, p. 1400.

3. *Cf.* P. MADOZ: *Diccionario Geográfico*, X [1850], p. 859. The only catalogue of the Museo Nacional, better known as the Museo de la Trinidad, is CRUZADA VILLAAMIL: *Catálogo Provisional* [1865].

4. *Catalogue d'une riche collection de tableaux*, Paris [1862]. The pictures were sold through M. Gogué and Quinto's name does not appear in the catalogue. I am very grateful to Mr Neil MacLaren for first drawing my attention to this catalogue and for the loan of his typescript made from a printed copy in the possession of the Bowes Museum.

5. Bowes bought one of each: a 'Velázquez' *Bodegón*, now attributed to the school of Meléndez; a 'Ribera' *St Jerome*, closely related to a painting ascribed to Ribera in the Uffizi, which proved to be signed and dated by Antonio Puga; and the 'Murillo' *St Francis in ecstasy* at Agnew's, now attributed to Zurbarán.

6. His most famous predecessor was, of course, Sir William Stirling Maxwell, many of whose pictures came from the Louis Philippe Collection.

7. Though the Greco and Goyas have often been seen in London, most recently at the Arts Council Exhibition of Spanish Paintings at the National Gallery (1947), the last time that a large selection from the Bowes Museum was shown here was at the Spanish Exhibition at the Grafton Galleries (1913–14).

8. See E. MÂLE: *L'art religieux après le Concile de Trente*, Paris [1932], p. 66; LOPEZ-REY: 'Spanish baroque: a vision of repentance in El Greco's *St Peter*'; *Art in America* [1947], pp. 313 ff. For a description of other versions, *cf.* N. MACLAREN: *National Galley*

9. It may be useful to record the confusion regarding the Quinto Goyas that occurs in the latest *catalogue raisonné* of his paintings: X. DESPARMET FITZ-GERALD: *L'œuvre peint de Goya*, Paris [1950]. The portrait of *Meléndez Valdés* is recorded (no. 378) as coming from the collection of Francisco Azebal y Arratia but not from Quinto's (A. L. MAYER: *Francisco de Goya*, English edition, London [1924], no. 345 also gives this as the provenance; but the museum has no record of it having come from any but the Quinto Collection). Moreover, it is illustrated by a plate (301) that in fact reproduces another version (apparently the picture from the Rosado Gil Collection, now belonging to the Banco de Crédito, Madrid). The *Scene in a prison* is catalogued (no. 207) but without provenance; and the so-called portrait of *The painter's brother* is not mentioned but a portrait in the Zuloaga Collection (no. 321, MAYER, 316) is wrongly identified as the Quinto portrait.

10. A. L. MAYER first published most of the museum's Spanish paintings and gave many of them their present attributions: 'Die Gemälde Sammlung des Bowes Museum zu Barnard Castle', *Zeitschrift für bildende Kunst*, XXIII [1912].

11. D.I. ANGULO: 'Alejo Fernández', *Archivo Español de Arte* [1930], pp. 246–47; C. R. POST: *A history of Spanish Painting*, IX, Cambridge Mass. [1947], p. 232.

12. E. TORMO, P.C. GUSI and E. LAFUENTE: *La vida y la obra de fray Juan Ricci*, I, Madrid [1930], p. 10, etc.

13. *Ibid.*, II, nos. 53 and 53a–c for variants; *cf.* also M. TRENS: *María, Iconografía de la Virgen*, Madrid [1946], p. 528 ff.

14. Not in the Quinto *Catalogue* but bought a few years later from his widow as a Zurbarán.

15. For the fullest information about the series, see J. GESTOSO: *Valdés Leal*, Seville [1916], pp. 47 ff.

16. *Ibid.*, p. 234. The palm and crown, the usual attributes of a martyr, could be symbols of victory (chastity) and beatitude.

17. Cf. E. BECK: 'Ecclesiological notes on a catalogue of Spanish Old Masters'. THE BURLINGTON MAGAZINE XXIV [1913–14], p. 170 ('presumably St Berthold').

18. J. S. THACHER: The paintings of Francisco de Herrera, the Elder'; *Art Bulletin*, XIX [1937], p. 373.

19. Bought in Rome in 1918 from a Spanish artist who attributed them to Zurbarán. The same model is used for the two paintings of *St Ambrose*.

20. MAYER, *loc. cit.* at note 10 above, p. 103.

21. M. S. SORIA: 'Francisco Zurbarán', *Gazette des Beaux-Arts* [1944], p. 158.

22. Only one is now exhibited in the Prado.

The Reconstructed Carmelite Missal

XCV [1953], p. 171.

1. *The Reconstructed Carmelite Missal. An English manuscript of the late fourteenth century in the British Museum. (Additional 29704–5, 44892).* By Margaret Rickert. 150 pp. + 4 col. pls. + 5 b&w ills. (Faber & Faber, London, 1952), £3 10s.

Vincenzo Scamozzi

XCV [1953], p. 171.

Vincenzo Scamozzi. By Franco Barbieri. 226 pp + 59 b&w ills. (Cassa di Risparmio, Verona and Vicenza, 1952).

Art and architecture in France

XCVI [1954], pp. 215–16.

The fifth edition of *Art and Architecture in France 1500–1700* (Pelican History of Art), revised by R. BERESFORD, was published by Yale University Press, New Haven and London [1999].

Stefano Conti, Patron of Canaletto and others

XCVIII [1956], pp. 296–300.

For a recent account of early Canaletto, see *Canaletto. Prima Maniera*, ed. A. BETTAGNO, exh. cat. (Fondazione Cini, Venice), Milan [2001].

1. W. G. CONSTABLE: 'Some Unpublished Canalettos', THE BURLINGTON MAGAZINE, XLII [1923], p. 278. These four pictures are now in the Pillow Collection, Montreal [now private collection, Italy].

2. Lucca, Biblioteca Governativa: 26 MS. 1110 – *Notizie genealogiche delle famiglie lucchesi*; and MS.1695 – *Notizie genealogiche riguardanti la famiglia Conti*. I am most grateful to the staff of this library for their kind help during my researches.

3. Lucca, Archivio Notarile: *Testamento segreto II Aprile 1739 pubblicato dal notaio Marc'Antonio Rinaldi, con verbale 8 Novembre 1739, foglio 1867.* This will makes it quite clear that Stefano Conti was not the naval architect employed on the last Bucintoro as reported by G. MARIACHER (*Le Tre Venezie* [January 1943], p. 34) and repeated by F. J. B. WATSON (*Canaletto*, 2nd edition [1954]) and VITTORIO MOSCHINI (*Canaletto* [1954]).

4. Lucca, Biblioteca Governativa: MS. 3299. I am extremely grateful to Dr Alessandro Marabotti of Rome for pointing out the existence of this correspondence to me.

5. MORETTI: *Notizie de'professori del disegno* – quoted in S. VITELLI-BUSCAROLI: *Carlo Cignani*, Bologna [1953], p. 33

6. Carlevarijs's descriptions of these paintings, which I have been unable to trace, are as follows:

> *Attesto io Luca Carlevarijs Pittore, di haver fatto all'Ill.mo Sig.r Stef. o Conti un quadro di qu.te 8 in largezza è qu.te 5 in altezza nell'quale vi è rapresentata la parte della Piazza di S.Marco, che stà frà il Palazzo Publico et la Ceccha, nel'qualle si vede parte del med.mo Palazzo e Ceccha, con la Chiesa di S.Marco, e Torre dell'Orologio; nel Principale del detto quadro vi è parte del Gran Canale, con quantità di Banche alla riva, d'ogni Genere, Ornato con quantità di figurine, le maggiori delle quali, sonno poco più di tre Once; è questo gli lo*

consegnai il Mese d'Agosto 1706.

Attesto io Luca Carlevarijs Pittore, di haver fatto all'Ill.mo Sig.r Stefano Conti, due quadri di qu.te 6 in largezza e 4 in altezza null'uno de quali vi è rappresentata la pescaria di Venetia, con la Frabrica della Ceccha, e granari Plublichi, con una parte del Canal Grande, oltre il qualle si vede la Chiesa di S.ta Maria della Salute, et la Dogana di Mare, con Barche d'ogni sorte, è quantità di figurine le maggiore delle quali saranno pocha meno di once 3.

Nell'altro vi è rappresentata la Veduta di S.Giorgio Magiore oltre il Canal Grande, con varij Bastimenti e Barche piccole è molte figurine come nell'altro e questi gle li Consegnai il Mese d'Aprile 1706.

7. HILDA F. FINBERG: 'Canaletto in England', *The Walpole Society*, IX [1920–21].

8. Gio. Angelo, Stefano's heir, died at the age of thirty-seven, in 1733, four years before his father. He had married and left a son, Giovan Stefano, who was later to become a very well-known physicist. Stefano also had three daughters all of whom married. The Conti family owned what is now the Palazzo Boccella in Via Fillungo.

9. It seems reasonable to assume that these were bought for the Prince of Liechtenstein who began buying Canalettos at about this period. But I can find no trace of a view of S. Giovanni e Paolo in the catalogue of the collection.

10. Marchesini is referring to Marco Ricci also.

11. On 10th November Conti changed his mind about this, and eventually all four pictures were the same size.

12. Here and elsewhere it will be seen that Canaletto often changed his mind about the views to be painted.

13. See A. MORASSI: 'Problems in chronology and perspective in the work of Canaletto', THE BURLINGTON MAGAZINE, XCVII [1955], pp. 349–53.

14. The two pictures concerned must be those now in the Hermitage: *Reception of the Ambassador* and *Feast of the Ascension*. Though, according to BRUNETTI (quoted in V. MOSCHINI: *Canaletto*, Milan [1954]), the Ambassador, Conte de Gergy, only presented his credentials in October

1726, he was in fact appointed to the post in 1723 (*Repertorium der diplomatischen Vertreter aller Länden*, II, Zürich [1950], p. 132) and presumably got in touch with Canaletto before his official entry into Venice.

15. The two pictures for the French Ambassador caused most trouble. But Marchesini also reports a most curious commission to paint a view of Corfu for 'Marscial Salenbug'. This almost certainly must refer to General Schulenberg who had defended the island some years previously. Canaletto was presumably expected to do the painting from a print; but in view of his scruples about working on the spot, it seems most unlikely that he would have agreed to such a task at this stage in his career. In any case I can find no mention of the existence of such a picture, and as Marchesini mentions it only once (3rd March 1726) the arrangements may have come to nothing.

16. I have been unable, as yet, to trace the present whereabouts of this picture.

17. Besides the documents quoted, all the contracts and receipts quoted by W. G. Constable have also been copied into the note-book.

18. This picture appears to have been lost.

19. This painter, later referred to as Cingheroli, is almost certainly Cimaroli.

20. Besides those mentioned in the text, artists included in the collection are Lodovico Lamberti, Tommaso Formenti, Giovanni Segala, Felice Torelli, Mario de'Fiori, Pietro Paolini, and Luca Cambiaso.

21. I am grateful to Mr Francis Watson for much useful help and advice.

Marigny and 'le Goût Grec'

CIV [1962], pp. 96–101.

For recent publications on Marigny, see A. R. GORDON, in the *Dictionary of Art*, ed. J. Turner, London [1966], s.v., and A. R. GORDON and M. DÉCHERY: 'The Marquis de Marigny's Purchases of

English Furniture and Objects', *Furniture History*, XXV [1989], pp. 86–108.

1. For a recent study of the period, see F. J. B. WATSON: *Louis XVI Furniture*, London [1960], pp. 7–11. Also by the same author: *Wallace Collection Catalogues, Furniture*, London [1956], pp.XXXVIII–XL. An introduction to the period is found in E. DACIER; *Le Style Louis XVI*, Paris [1946], pp. 16–18. A lecture on French furniture and interior decoration à la grecque, was given by Pierre Verlet at the Ecole du Louvre in 1959. The activities of the architect Victor Louis in the mid-1760's is dealt with by F. G. PARISET and S. LORENTZ in the catalogue of the exhibition *Victor Louis et Varsovie*, Musée Jacquemart-André, Paris [1958]. I am indebted to M. Verlet for calling my attention to this highly important study.

2. The late Fiske Kimball was the first to point out that a visual impression of this furniture could be obtained from Greuze's portrait of Lalive de Jully which had been exhibited at the Salon of 1759. See F. KIMBALL; 'The Beginning of the Style Pompadour 1751–9', *Gazette des Beaux-Arts*, 6th ser., XLIV [1954], pp. 57–64. After having been lost track of since the eighteenth century, some pieces of Lalive de Jully's furniture have recently been traced by the present author to the Musée Condé at Chantilly; cf. THE BURLINGTON MAGAZINE, CIII [1961], pp. 340–47.

3. Reproduced in P. VERLET: *Les meubles français du XVIIIe siècle*, II, *ébénisterie*, Paris [1956], pl.XII.

4. D. DE CHEVERNY: *Mémoires*, ed. Paris [1886], I, p. 117.

5. GUILLAUMOT: *Remarques sur un livre intitulé: Observations sur l'architecture…*, Paris [1768], p. 75; quoted by LOUIS HAUTECŒUR in his book *Histoire de l'architecture classique en France IV, seconde moitié du XVIIIe siècle, le style Louis XVI 1750–92*, Paris [1952], p. 2.

6. J. LOCQUIN: *La peinture d'histoire en France de 1747 à 1785*, Paris [1912], p. 16, n.16.

7. G. W. LUNDBERG: *Roslin*, III, Malmö [1957], p. 29. I am indebted to Mr

Lundberg, Director of the Institut Tessin in Paris, for the photograph of Roslin's painting reproduced in the present article.

8. Notably some writing-tables by Pierre Garnier who became master in 1742 and who later on delivered a large quantity of furniture to Marigny when the latter moved in 1778 to his house at Place des Victoires. See H. VIAL, A. MARCEL, and A. GIRODIE: *Les artistes décorateurs du bois*, I, Paris [1912], p. 205.

9. Paris Archives Nationales o¹ 1541–448.

10. Now in the Bibliothèque Nationale, Cabinet d'Estampes.

11. Honoré Guibert, born in Avignon, c.1720, died in Paris 1791. He was often employed by A.–J. Gabriel. He executed work in the Petit Trianon, Château de Bellevue, Opéra de Versailles, Château de Menars, etc.

12. Paris Archives Nationales o¹ 1922 A (Dossier Guibert, No.19).

13. Paris Archives Nationales o¹ 1541–444 *bis*.

14. Bibliothèque historique de la Ville de Paris, N.A. M.S. 106 *bis*, fols.165–76. Godefroy was upholsterer to Mme de Pompadour 1762–64.

15. Cf. A. J. ROUBO: *L'Art du Menuisier en Meubles*, Paris [1772], pp. 620 and 672 where two different uses of the word *plinthe* are found. I am indebted to M Pierre Verlet for both oral and written discussion of this problem. To illustrate the word *caré* we bring the following quotation from Roubo in connexion with the *bombée*-form of commodes: 'elle n'est plus guere à la mode depuis qu'on a adopté les formes quarrées pour tout ce qui s'appelle ouvrages fait à la grecque' (pp. 755–56).

16. Paris Archives Nationales o¹ 1252–35.

17. In all probability these wood carvings were executed by the above-mentioned Honoré Guibert who, later, in 1778–90, again executed work for Marigny at Place des Victoires. See VIAL, MARCEL, and GIRODIE, *op. cit.*, p. 231.

18. Reproduced in L. HAUTECŒUR, *op. cit.* at note 8 above, p. 199.

19. Archives Nationales o¹ 1252–149. See also J. MONVAL: *Soufflot*, Paris [1918], p. 398.

20. C. N. COCHIN: *Mémoires inédits*, ed. Paris [1880], p. 142.

21. Now at Versailles.

22. L. HAUTECŒUR: *Histoire de l'architecture classique en France IV, première moitié du XVIIIᵉ siècle, le style Louis XV*, Paris [1950], p. 473.

23. Mr Francis Watson has kindly called my attention to L. M. Van Loo's double portrait of Marigny and his wife (Digby sale, Sotheby's, 20th June 1951, lot 19, now in a private collection), exhibited at the Salon of 1769, in which the newly married couple are seen in a room entirely furnished in the Louis XV style. Marigny is standing beside his young wife who is sitting on a Louis XV chair alongside a flounced toilet table on which stands a fine Louis XV silver toilet service. This picture, which is of a definitely private character, is mentioned here for the sake of completeness. The painting undoubtedly depicts an actual interior – possibly a room in the Château de Menars which Marigny inherited, fully furnished, after Mme de Pompadour's death in 1764. The place, however, is of no great importance. The fact that Marigny advocated the nascent neo-classicism did not mean that he immediately stripped all his various houses of their furniture and redecorated them in the new style. Even a professed modernist like Lalive was satisfied with a single room decorated and furnished *à la grecque* while the remaining rooms, ten at least, were undoubtedly furnished in the current style. It is, also, well known that Marigny, as late as the 1770s, still had a weakness for *le goût chinois* – to the great disgust of Soufflot. The essential point is that, at an early date, Marigny actually came out strongly for the new style. It is of less importance that at the same time he preserved a liking for the Louis style.

Hagenauer, Posch, and Mozart

CX [1968], pp. 325–28.

The literature on Hagenauer and Posch is still scanty; see entries by M. PÖTZL-MALIKOVA and H. MAUÉ, in *The Dictionary of Art*, ed. J. TURNER, London [1996], s.v.

1. W. M. MILLIKEN: 'Christ at the Column by Hagenauer', *The Bulletin of the Cleveland Museum of Art*, XLI [1954], pp. 48–53. This bronze statuette was also shown in the exhibition *Age of Elegance, The Rococo and its Effect*, The Baltimore Museum of Art (1959), no. 285. J. MONTAGU : *Bronzes* [1963], p. 105, Fig.113.

2. *The Lamentation over the dead Christ*, lead (A.40–1954); a replica of the group in the Vienna Museum.

3. There exists a very thorough monographic study of Hagenauer by G. SOBOTKA and E. TIETZE-CONRAT: 'Johann Baptist Hagenauer', *Jahrbuch des Kunsthistorischen Institutes*, XIV [1920], pp. 1–56. For additions see I. HÖFER-WEGLEITER: 'J. B. Hagenauer', *Neue Deutsche Biographie*, VII [1966], p. 483.

4. Originally in St Peter's, Salzburg; now in the Barockmuseum, Vienna. *Österreichische Kunsttopographie*, XII [1913], p. 118; SOBOTKA and TIETZE-CONRAT, *loc. cit.*, p. 2.

5. It was a short-lived fashion. Already in 1766, when Johann Hagenauer and his brother, the architect Wolfgang Hagenauer, had to judge the sketch for an altar at Köstendorf, the latter condemned it for its use of rocaille ornament (*Muschelwerk*); cf. *Österreichische Kunsttopographie*, X [1913], p. 81 ; SOBOTKA and TIETZE-CONRAT, *loc. cit.* at note 3 above, p. 10.

6. The summary of the lost document is quoted in SOBOTKA and TIETZE-CONRAT, *loc. cit.*, pp. 10 and 40.

7. The relief was then on loan to the Museum in S. Michele in Bosco. L. ARZE: *Indicazione storico-artistica delle cose spettanti alla Villa Legatizia di S. Michele in Bosco*, Bologna [1850], app.VI. This reference was the starting-point for my search for the missing relief. In the end Dr S. Zamboni found it and provided me with the

photograph here reproduced. To him and to Professoressa Adriana Arfelli I owe my knowledge of the minutes of the meeting of the Accademia Clementina on 4th June 1763.

8. The size of the relief is 66 by 48 cm.

9. The figure of the horse protrudes about 17 cm. from the surface of the relief.

10. On these sculptors see now E. RICCOMINI: *Mostra della scultura bolognese del Settecento*, Museo Civico, Bologna [1966].

11. Manuscript in the Archives of the Accademia di Belle Arti, Bologna (Atti dell'Accademia Clementina, Vol.I, Zanotti-Casali 1710–1764).

12. On this collection see SOBOTKA and TIETZE-CONRAT, *loc. cit.*, pp. 28, 40 and 53, and M. POCH-KALLOUS: *Johann Martin Fischer* [1949], p. 76.

13. An entertaining biographical sketch of her has been provided by O. E. DEUTSCH: 'Rosa Hagenaeur', *Mitteilungen der Österreichischen Galerie*, VIII [1964], pp. 18–22. Little is known about her paintings; her love life and unconventional behaviour provided the Mozarts with gossip and anecdotes.

14. EMILY ANDERSON: *The letters of Mozart and his family*, second edition prepared by A. Hyatt King and M. Carolan, I, London [1966], p. 100. WILHELM A. BAUER and O. E. DEUTSCH: *Mozart, Briefe und Aufzeichnungen, Gesamtausgabe*, I, Kassel [1962], p. 293.

15. 27th March 1770. ANDERSON, *loc. cit.*, I, p. 123 f. (in the translation the plural 'statues' is a slip). BAUER and DEUTSCH, *loc. cit.*, I, p. 328.

16. Mozart to his mother and sister, 21st August 1770. ANDERSON, *loc. cit.*, I, p. 157. BAUER and DEUTSCH, *loc. cit.*, I, p. 382.

17. 25th August 1770. ANDERSON, *loc. cit.*, I, p. 157. BAUER and DEUTSCH, *loc. cit.*, I, p. 383.

18. ANDERSON, *loc. cit.*, I, p. 256. BAUER and DEUTSCH, *loc. cit.*, I, p. 514.

19. Letter to his wife, Munich, 21st January 1775. ANDERSON, *loc. cit.*, I, p. 262. BAUER and DEUTSCH, *loc. cit.*, I, p. 519

20. ANDERSON, *loc. cit.*, I, p. 437 ; BAUER and DEUTSCH, *loc. cit.*, II, pp. 209–10. In a letter, dated 29th December 1777, Leopold Mozart reported a rumour that Hagenauer might leave Salzburg, and in a later one of 16th March 1778 he informed his wife and son that 'Hagenauer the architect' had entered the service of the bishop of Gurk, because 'the Archbishop (of Salzburg) has treated him disgracefully' (ANDERSON, *loc. cit.*, p. 156 ; BAUER and DEUTSCH, *loc. cit.*, II, p. 325). This is not our sculptor (as wrongly identified in the index to Anderson), but one of his brothers, the architect Georg Hagenauer. For his works for the bishop of Gurk see K. GINHART: *Die Kunstdenkmäler Kärntens*, VI, Pt. I [1930], p. 104.

21. On L. Posch see L. FORRER: *Biographical dictionary of medallists*, IV [1909], pp. 669–73; VIII [1930], p. 194; and especially L. FREDE: 'Leonhard Posch, ein Reliefbildner der Goethezeit', *Zeitschrift für Kunstwissenschaft*, XII [1958], pp. 179–210.

22. From the travel diaries of Vincent and Mary Novello (1829); quoted in O. E. DEUTSCH: *Mozart, a documentary biography* [1965], pp. 538 and 541.

23. According to Schurig it was signed and dated at the back 'Posch 1788'. Posch himself presented it in 1820 to Mozart's younger son Franz Xaver Wolfgang with a dedicatory inscription (on the back of the frame) in which he refers to himself as the composer's boyhood friend (*Jugendfreund*). For these details see A. SCHURIG: *Leopold Mozart Reiseaufzeichnungen. Mit... einer Mozart-Ikonographie* [1920], p. 89. The relief is reproduced in O. E. DEUTSCH: *Mozart and his world in contemporary pictures* [1961], Fig. 17.

24. GEORG NICOLAUS VON NISSEN: *Biographie W. A. Mozart's*, herausgegeben von Constanze, Wittwe von Nissen, früher Wittwe Mozart [1828], *Anhang*, p. 181.

25. The autobiography was first published by G. LENZ in *Kunst und Kunsthandwerk*, XXI [1918], pp. 1–19; and reprinted by E. HINTZE: *Gleiwitzer Eisenkunstguss* [1928], pp. 11–12.

26. The bust has been published by JULIUS VON SCHLOSSER: 'Geschichte der Porträtbildnerei in Wachs', *Jahrbuch der kunsthistorischen Sammlungen*, XXIX [1911], p. 228. Schlosser connected the bust already with Deym. The autobiography of Leonhard Posch was then still unknown. A passing reference to the bust can be found in MARIO PRAZ: *Bellezza e bizzarria*, Milan [1960], p. 453.

27. King Ferdinand has been described by his brother-in-law, the Emperor Joseph II: 'Although an ugly Prince, he is not absolutely repulsive: his skin is fairly smooth and firm, of a yellowish pallor; he is clean except for his hands; and at least he does not stink. So far he shows no trace of a beard. But he is very oddly dressed: his hair smoothed back behind the head and gathered in a net; he wears a large white collar', etc. (quoted in H. ACTON: *The Bourbons of Naples* [1956], p. 138).

28. LADY MARY WORTLEY MONTAGU: *The complete letters*, ed. by R. Halsband, I [1965], p. 279.

29. CHANTELOU: *Tagebuch*, ed. H. Rose [1919], pp. 144 f., 319.

30. On Rastrelli's wax portraits of Peter the Great see N. M. SHARAYA: *Voskovaya persona* [1963].

31. T. FRIMMEL: 'Ein altes Wiener Wachsfigurenkabinett (Die Sammlung Müller-Deym)', *Alt-Wiener Kalander für das Jahr 1922*, pp. 128–35. O. E. DEUTSCH: 'Count Deym and his mechanical organs', *Music and Letters*, XXIX [1948], pp. 140–45.

32. C.M.A.: *Beschreibung der kaiserl. königl. privilegirten Kunstgallerie zu Wien am rothen Thurme* [1814], p. 49.

33. SCHLOSSER, *loc. cit.*, p. 237. On these heads see E. KRIS: 'Die Charakterköpfe des Franz Xaver Messerschmidt', *Jahrbuch der kunsthistorischen Sammlungen in Wien*, N.F. VI [1931], pp. 169–228; and the same: *Psychoanalytic explorations in art*, New York [1952], pp. 169–228.

34. FRIMMEL, *loc. cit.*, p. 130.

35. DEUTSCH: *Count Deym*, etc., p. 143. DEUTSCH has also reproduced a contemporary engraving of the

Mausoleum (*Mozart and his world in contemporary pictures* [1961], Fig.516).

36. Quoted from contemporary advertisements in DEUTSCH: *Count Deym*, etc., p. 144.

37. They are the numbers 594, 608, and 616 in Köchel's *Verzeichnis*. On these compositions see the paper by DEUTSCH quoted in note 31; the chapter on 'Mozart's compositions for the mechanical organ' in A. HYATT KING: *Mozart in retrospect*, London [1956], pp. 198–215; also ALFRED EINSTEIN: *Mozart, his character, his work*, Oxford [1957], pp. 153, 268–9. It has always been assumed that K.594 (Adagio and Allegro) is the music for Laudon's Mausoleum, and at the same time the *Adagio* mentioned in Mozart's letter of 3rd October 1790 (see note 39). The advertisements stress that the mechanical organ in the Mausoleum played a 'funeral music' (*Trauermusik*) specially composed for it (O. E. DEUTSCH: *Mozart, a documentary biography*, Lonson [1965], pp. 389, 394, 400–1). Does an Allegro answer this description? The 'Fantasia for Mechanical Organ' (K.608), played by Helmuth Rilling, can now be heard on a record (Turnabout Vox Production).

38. Already his father wrote music for the mechanical *Hornwerk* on Hohensalzburg; cf. DEUTSCH, *op. cit.* at note 37 above, p. 12.

39. ANDERSON, *loc. cit.*, II, p. 943 f. BAUER and DEUTSCH, *loc. cit.*, IV [1963], p. 115 f.

40. Letter from Sophie Haibel, Mozart's sister-in-law, to his biographer Nissen (7th April 1825). ANDERSON, *loc. cit.*, II p. 977. NISSEN, *loc. cit.*, Anhang, p. 181. O. E. Deutsch thinks that 'the mask was probably made by Posch' (in *The Mozart Companion*, edited by H. C. Robbins Landon and Donald Mitchell [1956], p. 7) but this seems unlikely. Deym was no great artist, but he was certainly technically proficient and able to make a death mask without help.

41. Köchel Nos.594 and 608. DEUTSCH, *op.cit.* at note 31 above.

Picasso's portrait of Kahnweiler

CXVI [1974], pp. 124–33.

For Kahnweiler and Picasso's portraiture, see *Daniel-Henry Kahnweiler. Marchand, editeur, ecrivain*, exh. cat., Centre Georges Pompidou, Paris [1984]; *Picasso and Portraiture*, ed. W. RUBIN, exh. cat. (Museum of Modern Art, New York, and Grand Palais, Paris), London and New York [1966], esp. pp. 280–84.

* Roland Penrose's lecture was delivered on 16th January 1974 in the Lecture Theatre at the Victoria and Albert Museum, and is here published without change – Ed.

1. [G. STEIN]: *The Autobiography of Alice B. Toklas*, London [1933].

2. ANDRÉ BRETON: *L'Amour Fou*, Paris [1937].

Tintoretto's Golden Calf

CXIX [1977], p. 715.

Benedict Nicolson

CXX [1978], pp. 429–31.

For corrections to Francis Haskell's obituary and for additional memories of Benedict Nicolson, see *ibid.*, pp. 602 and 850.

Frederic Lord Leighton and Greek vases

CXXV [1983], pp. 597–605.

A number of the illustrations used there have been cut in this republication, and the reader interested in identifying more of the vases is referred to the original article. For a recent account of Leighton, see *Leighton, eminent Victorian artist*, exh. cat., Royal Academy, London [1966], where *Captive Andromache* is no. 95. The *Arts of Peace* and *Arts of War* in the Victoria and Albert Museum have been splendidly restored since the article was published.

* Besides a number of colleagues in the British Museum from whom I have received much help and advice, and in addition to those mentioned below, I should like to thank the following: Richard Ormond, Julian Treuherz, Stephen Jones, and Prof. Dr Adolf Greifenhagen (Berlin), who has himself published articles on the theme of pots in pictures and has also brought to my attention an article by KARL KILINSKI II: 'Classical Klimtomania: Gustav Klimt and Archaic Greek Art', *Arts Magazine* [April 1979], pp. 96ff.

1. British Museum Catalogue of Vases (hereafter B.M., etc.) E 161; J. D. BEAZLEY: *Attic Red-Figure Vase-Painters*, second edition, Oxford [1963], 262, 41: the Syriskos Painter; L. B. GHALI-KAHIL: *Les Enlèvements et le Retour d'Hélène*, Paris [1975], pl.50.

2. B.M. B 331; J.D. BEAZLEY: *Attic Black-Figure Vase-Painters*, (Oxford [1956], 261, 41; by, or in the manner of, the Lysippides Painter; E. GERHARD: *Griechische Vasenbilder*, Part IV, Berlin [1858], pl. 307.

3. The damage is reported in P. O. BRÖNSTED: *Thirty-Two Ancient Greek Vases*, London [1832], p. 56. The restoration appears to have been carried out before the vase was acquired by the B.M. The overpainting was removed some time between 1942 and 1956.

4. *loc. cit.* (see note 2)

5. L. and R. ORMOND: *Lord Leighton*, New Haven and London [1975], cat. nos. 23, 121 and 237.

6. B.M. B 668; BEAZLEY, *op. cit.* at note 1 above, 98, 1; *Journal of Hellenic Studies*, VIII [1887], pl.82.

7. B.M. B 17; P. F. HUGUES (called D'HANCARVILLE): *Collection of Etruscan, Greek and Roman Antiquities from the Cabinet of the Hon. W. Hamilton* etc., I, Naples [1766], pl.93.

8. B.M. E 179; BEAZLEY, *op. cit.* at note 1 above, 307, 7: The Dutuit Painter, *Journal of Hellenic Studies*, XXXIII [1913], pl. 12.

9. *Drawings and Studies by the Late Lord Leighton P.R.A.*, Fine Arts Society [1898], pl.XXIV.

10. An example has recently been transferred to the British Museum from the Victoria and Albert: G.R.

unregistered V & A Material, Circ. 268–1939. I am grateful to Donald Bailey for bringing this object to my attention and for much invaluable assistance throughout the preparation of this article.

11. ORMOND, *op. cit.* at note 5 above, p. 96.

12. *Ibid.*, cat. 370.

13. *Ibid.*, cat. 390.

14. Louvre G, 471; BEAZLEY, *op. cit.* at note 1 above, 798, 1: in the 'manner of the Euaion Painter; E. POTTIER: *Vases Antiques du Louvre*, 3me Série, Paris [1922], pl. 151. The *kylix* was identified by Dr Dietrich von Bothmer for the catalogue to the exhibition, *Treasures from the Metropolitan Museum of Art New York*, National Pinakothiki, Alexander Soutzos Museum, Athens [1979], p. 260, 105.

15. G. C. WARR and W. CRANE: *Echoes of Hellas*, London [1887].

16. ORMOND, *op. cit.* at note 5 above, cat. 188.

17. GR 1977.12–11.9.; *Annual of the British School at Athens*, XXXV [1934–5], pl.42a.

18. On 28th May 1881 he was elected a member of the Standing Committee of Trustees and he attended meetings regularly until his death in 1896.

19. Sketchbook XV.

20. GR 1873.8–20.28. The head-vase enables us to date the sketches to within a couple of years: it had come into the British Museum with part of the so-called Castellani Collection, which arrived in England on approval in the Spring of 1871. Leighton exhibited the monochrome cartoon for the *Arts of industry* at the Royal Academy in Spring 1873. The Sketches were executed, therefore, at some time between Spring 1871 and Spring 1873.

21. This and its companion piece *Arts of industry as applied to war* are illustrated and discussed in R. ORMOND: *Leighton's Frescoes*, Victoria and Albert Museum Brochure, 6, London [1975].

22. I am grateful to Katrien Van Wonterghem-Maes for confirming

the eccentricity of Leighton's 'Canosan' pots. Cf. F. VAN DER WIELEN-VAN OMMEREN: 'Vases with Polychrome and Plastic Decoration from Canosa', *Proceedings of the British Museum Italic Seminar*, 1982 (publication forthcoming).

23. An observation made by Colin Wiggins of the National Gallery, London.

24. GR 1756.1–1.482.

25. B.M. Catalogue of Terracottas D 1; C.V.A. IV Da, pl. 20, 4.

26. B.M. Catalogue of Bronzes 744.

27. Louvre K 214; G 619.

28. Louvre K 193 (top); K 339 (top left); K 59 (top right); K 386 (centre); K 215 (bottom right); K 339 (bottom). I am grateful to Prof. A. D. Trendall and M. Alain Pasquier for kindly providing information about these vases.

29. The *hydria* is possibly B.M. B 329; BEAZLEY, *op. cit.* at note 2 above, 334, l: the Syriskos Painter; E. PFUHL: *Malerei und Zeichnung der Griechen*, Munich [1923], pl. 79 and 296. The *rhyton* is B.M. E 795; see BEAZLEY, *op. cit.* at note 1 above, 265, 75; *Ant. Kunst*, 4, pl. 12, 2.

30. E. PERNICE and E. WINTER: *Der Hildesheimer Silberfund*, Berlin [1901], pl. 33. This same *krater* appears in other works by Alma-Tadema with its fine relief decoration clearly visible, e.g. *A dedication to Bacchus* (Opus CCLXXVIII, 1887); *A favourite custom* (Opus CCCXCI, 1909). Pieces of the Hildesheim Treasure appear frequently in other paintings, e.g. PERNICE and WINTER, *op. cit.* above pl. l in *A silent greeting* (Opus CCXCIX, 1889); pl. 39, in *Calling the worshippers* (Opus CCCXIII, 1892) and *Vain courtship* (Opus CCCLXII, 1900). The painter possessed replicas of two of the pieces including the *krater*, see W. MEYNELL in *Magazine of Art*, IV [1881], p. 187. These may have provided the models for the vessels featured in the paintings.

31. *Magazine of Art*, VIII [1885], p. 195.

32. 'The Late Lord Leighton, P.R.A., D.C.L., L.L.b.P', *Magazine of Art* [1896], p. 208. I am indebted to Hilary Morgan for this reference.

Iznik

CXXXI [1989], pp. 881–83.

1. *Iznik: The Pottery of Ottoman Turkey*. 384 pp. + 991 ills. in b & w and col. Published under the auspices of the Institute of Social Sciences of Istanbul University for the Türk Ekonomi Bankası (Alexandria Press, Thames and Hudson, London, 1989), £120. ISBN 0–500–97374–1. The *pottery* of the title refers to a place of manufacture, not a product. Unglazed wares are not treated; and the rôle of Kütahya, which contributed skilled labour for the initial development and which must have continued to produce throughout the sixteenth century, is underplayed.

2. S. ÜNVER: *Fatih devri saray nakışhanesi ve Baba Nakkaş çalışmaları* Istanbul [1958]. I was able to consult this through the kindness of Julian Raby.

3. J. RABY: 'Court and export: Part 2. The Uşak carpets', in *Carpets of the Mediterranean countries 1400–1600*, ed. R. PINNER and W.B. DENNY, London [1986], pp. 177–87.

4. Building works at the palace must have been virtually continuous. Among major constructions of the latter part of Süleyman's reign, however, must have been a pavilion for the roof for which 300 quintals of lead were urgently required (order dated 22 Zilka'de 957/2nd December 1550: see Ö.L. BARKAN: *Süleymaniye camii ve imareti inşaatı*, II, Ankara [1979], p. 152, no.358).

5. Not surprisingly, blue and white figures prominently in the trousseau of a lady, Sitti bint Ahmed, dated 1500 (see H. ÖZDEĞER: *1453–1640 yılları Bursa şehri tereke defterleri*, Istanbul [1988], p. 221), who had chinawares valued at 580 akçe, including two *çanak* (? sherbet bowls) valued at 300 akçe alone; and in the stock of a perfumer or apothecary, Sarrac 'Abdi, dated February 1500 (*ibid*, p.240). His estate, with a total value of 106,002 akçe, contained chinawares, *alaca*, *zeytuni* (olive green, probably celadons or their imitations) and *kâşi*, valued at 885 akçe. If *alaca* and *zeytuni* relate, as Raby has

argued elsewhere, to Chinese porcelains, the *kâşi*, 7 dishes at 350 akçe, was valued the most highly.

6. One mistake should be noted. The Ottoman Turkish verses at the rim of the British Museum jug (Henderson Bequest, 78 12–30 468) with the rhyme *vār* from which Franks first conjectured that Iznik wares were actually manufactured in Turkey (page 71, note 5) are not those by Revani on the base of a covered bowl (British Museum, Godman Bequest, G. 1983. 139): the entry in the exhibition catalogue, *Türkische Kunst und Kultur aus osmanischer Zeit* (Frankfurt and Essen [1985], 2/27) which is the source of the error, should accordingly be corrected. It is regrettable that space was not found to give the full inscriptions of the relatively few inscribed pieces. There are also occasional confusions in the footnotes which, in such a luxuriously produced volume surely need not have been relegated to the back of the volume. On page 79, notes 20 and 21 refer, respectively, to notes 21 and 20 on page 373. And on page 89 there is a block of footnotes which is out by two; note 48 refers to note 46 on page 373, note 49 to note 47, note 50 to note 49, note 51 to note 49, note 52 to note 50 and note 53 to note 51. Confusingly, the text of this chapter (IX) contains 53 notes but only 51 are given on page 373.

7. R. GOLDTHWAITE: 'The economic and social world of Italian Renaissance maiolica', *Renaissance Quarterly*, XLII/2 [1989], pp. 1–32.

8. O. ASLANAPA, ŞERARE YETKIN and A. ALTUN: *The Iznik tile kiln excavations (The Second round; 1981–1988)*, Istanbul [1989], TL150,000.

Verrocchio's Christ and St Thomas: chronology, iconography and political context

CXXXIV [1992], pp. 225–38. The documentary appendix has not been reprinted here

See, now, A. BUTTERFIELD: *The Sculptures of Andrea del Verrocchio*, New Haven and London [1997], ch. 3 and cat. no. 8; *Il Maestro di Leonardo: Il restauro dell' 'Incredulità di San Tommaso' di Andrea del Verrocchio*, ed. L. DOLCINI et al., Milan [1992]; and D. COVI: 'Two new documents concerning Luca della Robbia and Andrea del Verrocchio at Orsanmichele', THE BURLINGTON MAGAZINE, CXLI [1999], p. 752.

In memory of Peter von Blanckenhagen

* Research for this article was funded by a Samuel H. Kress Dissertation Fellowship. I would like to thank the Kress Foundation for its generous support. For help during the preparation of this article, I would like to thank Rolf Bagemihl, Alison Brown, Gino Corti, Michael Rocke and Nicolai Rubinstein.

1. L. LANDUCCI (*Diario fiorentino dal 1450 al 1516*, ed. I. DEL BADIA, Florence [1883], entry for 21st June 1483) called the sculpture '*la più bella cosa che si truovi, e la più bella testa del Salvatore ch'ancora si sia fatta*'.

2. In the bibliography on Verrocchio there are only two separate titles dedicated to the *Christ and St Thomas*: C. SACHS: *Das Tabernakel mit Andreas del Verrocchio Thomasgruppe an Or San Michele zu Florenz*, Strassburg [1904] and D. COVI 'The Date of the Commission of Verrocchio's 'Christ and St Thomas'', THE BURLINGTON MAGAZINE, C [1968], p. 37. Now see also K. VAN AUSDALL: The *Corpus Verum*: Orsanmichele, Tabernacles and Verrocchio's *Incredulity of Thomas*', in S. BULE, A. DARR and F. SUPERBI GIOFFREDI, eds.: *Andrea del Verrocchio and Late Quattrocento Italian Sculpture*, Florence [1992].

3. G. GAYE: *Carteggio inedito d'artisti dei secoli XIV, XV, XVI*, Florence [1839], I, pp. 370–72.

4. *Ibid.*, p. 370: '*i pagamenti che seguono poi, diventano frequenti nel 1476 [e] nel 1480*'. All subsequent analyses of the chronology of work on the sculpture have relied on this phrase, rather than on the documents themselves.

5. For the most recent summaries of the documents see G. PASSAVANT: *Andrea del Verrocchio*, London [1969], pp. 176–77; C. SEYMOUR: *The Sculpture of Verrocchio*, Greenwich, Conn.

[1971], pp. 163–64; and J. POPE-HENNESSY: *Italian Renaissance Sculpture*, 3rd ed., New York [1985], pp. 296–97.

6. One document from the account book was cited by Milanesi in G. VASARI, *Le vite de'più eccellenti pittori, scultori e architettori*, ed. G. MILANESI, Florence [1878–85], Vol.III, p. 363, note, and later checked by PASSAVANT, *op. cit.* at note 5 above, p. 177. For further information see note 18 below.

7. In addition to commercial law, the Mercanzia was responsible for a broad range of issues in the promotion and protection of Florentine business and trade. See G. BONOLIS: *La giurisdizione della Mercanzia in Firenze nel secolo XIV*, Florence [1901]. Moreover, according to J. NAJEMY (*Corporatism and Consensus in Florentine Electoral Politics, 1280–1400*, Chapel Hill, N.C. [1982], p. 11): '[The] sense of belonging to an interguild elite was, in fact, institutionalised in the Mercanzia… Although the Mercanzia was itself a corporation, it was never integrated into the guild federation. In fact, it was later used by the oligarchs as an instrument for imposing electoral and political controls over the guilds themselves'. The Mercanzia in the fifteenth century is largely unstudied. See, however, L. MARTINES: *Lawyers and Statecraft in Renaissance Florence*, Princeton [1968], pp. 133–35, 361–62 and 465; and A. ZORZI: *L'amministrazione della giustizia nella repubblica fiorentina*, Florence [1988].

8. Archivio di Stato, Florence (hereafter ASF), Mercanzia, 295, fols.117v–18r. This document was discovered and published by C. VON FABRICZY: 'Donatellos Hl. Ludwig und sein Tabernakel an Or San Michele', *Jahrbuch der königlich preussischen Kunstsammlungen*, XXI [1900], pp. 254–55. Negotiations for the sale had begun in December 1459, but had not gone through because of the Mercanzia's lack of adequate funds. For the history of the tabernacle before the *Christ and St Thomas*, see D. ZERVAS: *The Parte Guelfa, Brunelleschi and Donatello*, Locust Valley, N.Y. [1987], pp. 99–151.

9. ASF, Mercanzia, 295, fols.120r–20v. First discovered and published by FABRICZY, *loc. cit.* above, pp. 255–56.

10. ASF, Mercanzia, 299, fols.104v–05r. Discovered and published by COVI, *loc. cit.* at note 2 above.

11. I would like to thank Gino Corti for his help in the transcription of this document. [For the document, see the original publication of the article, Appendix, p.233, document I.]

12. ASF, Mercanzia, 300, fol.104r. The document was discovered by GAYE, *op. cit.* at note 3 above, p. 370, but is unpublished.

13. ASF, Mercanzia, 302, fols.101r–01v. Discovered by GAYE, *op. cit.* at note 3 above, p. 370, but unpublished.

14. ASF, Mercanzia, 305, fol.165v. First discovered and published by J. MESNIL: 'Les figures de Vertus de la Mercanzia', *Miscellanea d'arte*, I [1903], p. 45. The relevance of this document for the *Christ and St Thomas* has not been previously noted.

15. ASF, Mercanzia, 307, fol.30r. First discovered by GAYE, *op. cit.* at note 3 above, p. 370, but unpublished.

16. I would like to thank Michael Rocke for his help with this document. [For the two documents of 1476, see the Appendix to the original article, p. 233 documents 2 and 3, Mercanzia 316, fols. 52v and 110v.]

17. I would again like to thank Michael Rocke for his help in the transcription of this document [Appendix, document 4, Mercanzia 317, fol. 71r].

18. I am indebted to Rolf Bagemihl for his help in the transcription of the documents from this page of the account book [Appendix, document 5, Mercanzia 14103, fols. 131–33r]. The existence of the first entry, at the top of the page, was first noted by MILANESI, *op. cit.* at note 6 above. Milanesi, however, did not report most of the contents of the document and cited it with the incorrect date of 1476. PASSAVANT (*op. cit.* at note 6 above, p. 177), corrected the date but also related only a portion of the information. Neither Milanesi nor Passavant noticed the other entries on the page concerning Verrocchio.

19. ASF, Consigli della Repubblica, Registri delle Provvisioni (henceforth, Rep., Provv.), 172, fols.2r–3v. This document was first discovered and published by FABRICZY, *loc. cit.* at note 8 above, pp. 256–57, who gave it the incorrect date of 26th March 1482, and, more importantly, misinterpreted it to be the authorisation for the Mercanzia to purchase from Verrocchio a terracotta model of St Thomas to be placed in the Palazzo della Mercanzia. For more information on this, see the penultimate paragraph of this article.

20. [For the *deliberazione* of 12th April 1481] ASF, Mercanzia, 321, folio numbers missing [and, for the disbursement of 2nd May, Appendix, document 5, Libro di Debitori e Creditori, filza 14103, Libro B Rosso, fols. 131–33].

21. On the financial crisis of 1480–81, see L. F. MARKS: 'The Financial Oligarchy in Florence under Lorenzo', in E. F. JACOB, ed.: *Italian Renaissance Studies*, London [1960], pp. 123–47.

22. ASF, Rep., Provv., 174, fols.7v–8v, 22nd April 1483, states that one cannot '*di nuovo grauere el monte*' or '*tornare al monte*' to fund work on the sculpture. Some form of direct payments from the Monte might also explain why the dates and sums of the payments for 1479 and 1480 in the *deliberazione* of 13th January 1477 (modern style) do not agree with those of the Libro di Creditori e Debitori for the same period.

23. It is not clear whether the dispute was simply a disagreement about fiscal responsibility and the division of governmental authority or whether party politics were involved as well. The provvisione, which was introduced with the approval of the Seventy by a hand-picked Signoria, passed in all three Councils by overwhelming majorities. The Councils were still capable of resisting Medici policies, and presumably would have fought against this provvisione had they wanted to.

24. ASF, Rep., Provv., 174, fols.7v–8v. This document was previously published in a highly abbreviated form by GAYE, *op. cit.* at note 3 above, p. 371.

25. Nevertheless, it appears that Verrocchio did not move permanently to Venice until May 1486. See D. COVI, 'Four New Documents Concerning Andrea del Verrocchio', *Art Bulletin*, XXXXVIII [1966], p. 99.

26. ASF, Mercanzia, 14103, fol.13L [Appendix, document 5]. See also the cross-indexed entries referred to on this page, especially ASF, Mercanzia, 14103, fol.108R. Giuliano was clearly the more important assistant since he was entrusted with greater legal and financial authority than Pagolo. Certainly Giuliano is the same man who was identified as '*Giuliano d'Andrea scharpellatore del popolo di San Piero Maggiore di Firenze*' in a suit against Lorenzo di Credi in 1490. For this document, see COVI, *loc. cit.* at note 25 above, p. 102.

27. ASF, Rep., Provv., 179, fol.152v. First published by FABRICZY, *loc. cit.* at note 8 above, p. 258.

28. ASF, Rep., Provv., 179, fol.140v. First published by FABRICZY, *loc. cit.* at note 8 above, p. 259.

29. It is important to note that documents for Verrocchio in the Libro di Debitori e Creditori of fols.13L–13R change in nature in 1487. Up to that point, 13L serves as a cross-indexed, summary account of payments made to Verrocchio by the different treasures of the Mercanzia. After 1487, 13L and 13R are a double-entry account of disbursements related to the sculpture. Hence, the fact that the entry for the inscription appears only on the left side implies that the payment was never actually made. The base of the figure of Christ appears not to have an inscription, but a final conclusion must be postponed until the base is cleaned.

30. For the text of the testament, see GAYE, *op. cit.* at note 3 above, pp. 367–70.

31. [Appendix, document 6, 14103, fol. 13r, for the 26th November 1488

document, and Appendix, document 7, 14104, fol. 26L, for the 1490 one] I would like to thank Gino Corti for his transcription of this latter document.

32. ASF, Mercanzia, 14104, fol.26L [Appendix, document 7] states that the Mercanzia has paid Verrocchio a total of 395 large florins, 520 *lire*, 18 *soldi*, and 8 *denari*. But this figure was derived merely by totalling all of the expenses listed in ASF, Mercanzia, 14103, fols.13L–13R [Appendix, documents 5 and 6], which is by no means a complete record of the expenses on the sculpture. Hence this sum has less authority than a figure based on Verrocchio's statement of how much he had received up to April 1483 plus the payments to him and his heirs after that date.

33. R. KRAUTHEIMER: *Lorenzo Ghiberti*, Princeton [1956], p. 73, states that the costs of the St Matthew of 1419–23 were 1,100 florins for materials and other expenses and 650 florins for Ghiberti's fee. For further information, see A. DOREN: *Das Aktenbuch für Ghiberti's Matthäusstatue an Or San Michele zu Florenz (Kunsthistorisches Institut in Florenz, Italienische Forschungen I)*, Berlin [1906].

34. Again see ASF, Mercanzia, 295, fols.120r–20v, published in FABRICZY, *loc. cit.* at note 8 above, pp. 255–56.

35. ASF, Mercanzia, 299, fols.104r–05v, published in COVI, *loc. cit.* at note 2 above, p. 37.

36. ASF, Mercanzia, 321, fol.1r.

37. ASF, Mercanzia, 131, fol.24r.

38. The names of the *Accoppiatori* in 1463 appear in N. RUBINSTEIN: *The Government of Florence under the Medici (1434 to 1494)*, Oxford [1966], p. 126, note 6.

39. *Ibid.*, esp. pp. 30–52, on the importance of the Accopiatori.

40. For the *Balìe*, *ibid.*, pp. 136–228.

41. See A. MESSERI: 'Matteo Palmieri, cittadino di Firenze del secolo XV', *Archivio storico italiano* XIII [1894], pp. 256–340.

42. On Pucci's appearance in this fresco, see E. BORSOOK and J. OFFERHAUS: *Francesco Sassetti and Ghirlandaio at Santa Trinita, Florence*, Doornspijk, Holland [1981]. pp. 36–37.

43. On the ties between the Pucci and the Medici, see D. KENT: *The Rise of the Medici*, Oxford [1978], pp. 122–23.

44. I. DI SAN LUIGI, ed.: *Croniche di Giovanni di Jacopo e Lionardo di Lorenzo Morelli*, in *Delizie degli eruditi toscani*, Florence [1785], Vol.XIX, p.xviii.

45. C. SIMONETTA: *I diari di Cicco Simonetta*, ed. A.R. NATALE, Milan [1962], p. 136. It should also be observed that Morelli was one of the three Commissari of Pistoia who reassigned the commission for the Forteguerri Monument to Verrocchio sometime between 23rd January and 11th March 1477. This can be determined by comparing Lorenzo di Credi's 1488 contract to finish the monument (published by COVI, *loc. cit.* at note 25 above, p. 101, document II) with a letter by the Pistoiese *operai* of the monument to Lorenzo de' Medici written 11th March 1477 and published by E. WILDER: *The Unfinished Monument by Andrea del Verrocchio to the Cardinal Niccolò Forteguerri at Pistoia*, Northampton, Mass. [1932], p. 78.

46. A. BROWN: *Bartolomeo Scala*, Princeton [1979], p. 155.

47. F. GUICCIARDINI: *Dialogo e discorsi del Reggimento di Firenze*, ed. R. PALMAROCCHI, Bari [1932], pp. 26–27, 57. I am deeply indebted to Alison Brown for generously sharing with me her knowledge of the connections between Lorenzo de' Medici and the Mercanzia.

48. ASF, Mercanzia, 309, fol.38v, 7th August 1471, is the first reference to this scrutiny.

49. See L. DE' MEDICI: *Le lettere*, Vol. I, ed. R. FUBINI, Florence [1977], pp. 451–52.

50. See BROWN, *op. cit.* at note 46 above, p. 68.

51. On the judicial reforms in 1477–78, see A. DOREN: *Le arti fiorentine*, Florence [1940], Vol.II, p. 70; BROWN, *op. cit.* at note 46 above, pp. 79, 290; and ZORZI, *op. cit.* at note 7 above, esp. pp. 76–78. The legislation authorising the reform of the Mercanzia is preserved in ASF, Cento Deliberazioni, 2, fols.10r, 24v–27v, June–July 1477.

52. On this shift in law at Florence in the second half of the Quattrocento, see, G. ANTONELLI: 'La magistura degli Otto di Guardia, Firenze', *Archivio storico italiano*, CXII [1954], pp. 3–39; ZORZI, *op. cit.* at note 7 above; BROWN, *op. cit.* at note 46 above, esp. pp. 335–39; and A. BROWN: 'Platonism in Fifteenth Century Florence and its Contribution to Early Modern Political Thought', *Journal of Modern History*, L [1986], pp. 383–413.

53. As quoted by BROWN, *op. cit.* at note 46 above, p. 291 from Bartolomeo Scala's 'On Laws and Legal judgments'.

54. For the basic information on these works, see E. SOUTHARD: *The Frescoes in Siena Palazzo Pubblico, 1289–1539*, doctoral dissertation, University of Indiana (1978), Garland, New York [1979], pp. 100–01, 460. It should be pointed out that the fresco in Certaldo was commissioned in 1490 by Tommaso Morelli, Girolamo di Matteo Morelli's first cousin.

55. A painting of the doubting of St Thomas above the door to the Sala dell'Udienza is mentioned in one of Franco Sacchetti's *Rime* written c.1385. I would like to thank Nicolai Rubinstein for calling my attention to this poem. For further information, see below, note 58.

56. Giovanni Toscani, Galleria dell'Accademia, Florence, no.457. That the painting was made for the Mercanzia was first demonstrated by L. BELLOSI: 'Il Maestro della Crocifissione Griggs: Giovanni Toscani', *Paragone*, 17, no. 193 [1966], n.22.

57. The clemency or charity of Jesus towards St Thomas is a *locus communis* of biblical commentaries on the doubting of St Thomas (John 20:26–30). For example, see C. CORNELIUS: *Commentarii in evangelia*, Rome [1638], Vol II, p. 540. The importance of clemency in mediaeval and renaissance definitions of justice is demonstrated by Q. SKINNER: 'Political Philosophy', in C. SCHMITT and Q. SKINNER: *The Cambridge History of Renaissance*

Philosophy, Cambridge [1988], pp. 387–452, esp. pp. 415–16 and 425. In this context, it should be remembered that the commission for the Seven Virtues by Pollaiuolo and Botticelli grew from the Mercanzia's desire to replace a Trecento image of Charity in their Sala dell' Udienza. See ASF, Mercanzia, 305, fol.44, 18th August 1469, which was first published to MESNIL, *op. cit.* at note 14 above, p. 43. The connection between charity and justice is also emphasised by ST AUGUSTINE: *Confessions*, XII, xviii: 'Ad aedificationem autem bona est lex . . . quia finis eius est caritas'.

58. Thomas's second name, Didymus, was thought to connote doubt and scepticism. This etymology was popularised in the West by St Jerome in *Liber de nominibus hebraicis*. On this point, see U. PFLUGK: *Die Geschichte vom unglaubigen Thomas in der Auslegung der Kirche von den Anfangen bis zur Mitte des sechzehten Jahrhunderts*, doctoral dissertation, Hamburg University [1967], p. 106 and *passim*. While in religious terms Thomas's doubt was considered deeply sinful, in the context of justice and government it could be glossed as the desire for truth. This is vividly illustrated by Franco Sacchetti's poem (see note 55 above), which reads: *Toccate il vero com'io, e crederete/nella somma Iustizia in tre persone,/che sempre essalta ognun che fa ragione./ /La mano al vero e gli occhi al sommo cielo,/la lingua intera, ed ogni vostro effetto/raguardi al ben comune sanza diffetto./ /Cercate il vero, iustizia conseguendo;/al ben comune la mente intera e franca,/perch'ogni regno sanza questo manca*. See L. BATTAGLIA RICCI: *Palazzo Vecchio. Studio su Franco Sacchetti e le fabbriche di Firenze*, Rome [1990], pp. 50–52, 54, 89, 92, and 136; and M. MONACA DONATO: 'Un ciclo pittorico ad Asciano', *Annali della Scuola Normale Superiore di Pisa*, Classe di lettere e filosofia, ser.III, Vol.XVIII [1988], pp. 1198–1200. Furthermore, it must be pointed out that the first terza of Sacchetti's poem appears as an inscription on two Quattrocento images of Christ and St Thomas, Giovanni Toscano's panel painted for the Mercanzia around 1420, and the fresco in

Certaldo from 1490.

59. For further information about S. Tommaso Apostolo and the art works commissioned for the church, see F.L. DEL MIGLIORE: *Firenze, città nobilissima illustrata*, Florence [1684], pp. 485–89; G. RICHA: *Notizie istoriche delle chiese fiorentine*, Florence, Vol.V [1758], pp. 227–34; and W. and E. PAATZ: *Die Kirchen von Florenz*, Frankfurt-am-Main, Vol.V [1953], pp. 241–47.

60. ASF, Rep., Provv., 125, fols.210v-11r. This document was first discovered and analyzed by U. DORINI: 'Il culto delle memorie patrie nella Repubblica di Firenze', *Rassegna Nazionale*, CLXXIX [1911], pp. 3–25. I was led to this material by R. TREXLER: *Public Life in Renaissance Florence*, New York [1980], pp. 422–23. It is not known how long the saint's day was celebrated as a communal feast, but it certainly was not celebrated after 1460 when the festival calendar of Florence was reorganised (see DORINI).

61. G. CAMBI: Istorie di Giovanni Cambi, in I. DI SAN LUIGI, ed.: *Delizie degli eruditi toscani*, Florence [1789], XX, p. 135. According to DEL MIGLIORE, *op. cit.* at note 59 above, p. 485, it was Dietisalvi Neroni who persuaded Cosimo to suspend the communal celebration of the Feast of St Thomas.

62. In late mediaeval and renaissance Europe, the virtue of Justice was commonly defined as the habit of action directed towards the common good (CICERO: *De Officiis*, *passim*, (esp. 1.7.20, 1.10.31, 1.19.63; and ST THOMAS AQUINAS: *Summa Theologica*, II-II, Q58). One of the operai for the Orsanmichele group, MATTEO PALMIERI, gives the same definition of justice in his *Della Vita Civile* (ed., Florence [1982], pp. 8–9, and 131–38, 199). It is this association of justice and the common good that lies behind Sacchetti's poem cited at note 58 above. Furthermore, it was widely believed, e.g. by Coluccio Salutati, that Justice, in the sense of action directed to the common weal, makes any government, whatever its constitutional form, good and legitimate (see SKINNER, *op. cit.* at note 57

above, p. 419). As demonstrated by BROWN, *op. cit.* at note 52 above, throughout the 1470s and 1480s Scala, Landino, and others endeavoured to show that Lorenzo de' Medici was a wise philosopher-ruler who administered the state for the common good. The point was to demonstrate that Lorenzo's rule, despite its anti-republican tendencies, was still just and legitimate. Verrocchio's *Christ and St Thomas* would have served readily as a part of this campaign.

63. *See* ANTONELLI, *loc. cit.* at note 52 above, esp. pp. 26–39.

64. This book, with illuminations by Mariano del Buono, was commissioned on 27th February 1479. See M. LEVI D'ANCONA: *Miniatura e miniatori a Firenze dal XIV al XVI secolo*, Florence [1962], p. 180.

65. See PFLUGK, *op. cit.* at note 58 above.

66. ST AUGUSTINE: *Sermons on the Liturgical Seasons*, tr. M. MULDOWNEY, New York [1959], p. 266.

67. The provvisione of 26th March 1481 says the sculpture will stimulate '*reverentia et dilecto negli animi de vedenti*', while that of 21st April 1483, states that the *operai* desire '*chome zelosi della religione cristiana che tale degna opera non rimangha più oculta*'.

68. See ASF, Mercanzia, 308, not paginated, 22nd June 1471 for the authorisation of this sum for expenses for the Feast of Corpus Christi.

69. For the feast of Corpus Christi in Florence, see E. BORSOOK: 'Cults and Imagery at Sant'Ambrogio', *Mitteilungen des Kunsthistorischen Institutes in Florenz*, XXV [1981], pp. 147–202.

70. VAN AUSDELL, *loc. cit.* at note 2 above, also discusses the eucharistic symbolism of Verrocchio's *Christ and St Thomas*.

71. The other spandrel houses Jeremiah, probably alluding to Lamentations 1:12, which was often used as an inscription on images of the Passion in renaissance Tuscany. See H. BELTING: *The Image and Its Public in the Middle Ages*, tr. M. BERTUSIS and R. MEYER, New Rochelle, New York [1990], pp. 197–98.

72. F. BÜTTNER: *Imitatio Pietatis*, Berlin [1983], p. 182.

73. PFLUGK, *op. cit.* at note 58 above. It should be noted, however, that eucharistic images of Christ and St Thomas before Verrocchio's do exist. The examples I have found are: Netherlandish, late thirteenth century, Hannover, Landesgalerie; Circle of Dieric Bouts, Stuttgart, Staatsgalerie; Circle of Konrad Witz, Basel, Kunstmuseum.

74. On St Cyril's eucharistic interpretation of the doubting of St Thomas, see PFLUGK, *op. cit.* at note 58 above, pp. 54–56. St Cyril's writings were fundamental to the successful resolution of the Council of Florence; and his *In Joannis Evangelium*, which includes his commentary on the sacramental nature of the doubting of St Thomas, was translated into Latin in 1449 by order of Nicholas V. See J. GILL: *The Council of Florence*, Cambridge [1961], esp. pp. 219–21, 249–50; and C. STINGER: *Humanism and the Church Fathers*, Albany, New York [1977], pp. 223–34. For the text of *In Joannis*, see J. P. MIGNE: *Patrologiae Graecae*, Paris, Vol. VII [1863], pp. 725ff.

75. See PFLUGK, *op. cit.* at note 58 above, pp. 45–46 for the sermon attributed to St John Chrysostom on the eucharistic significance of the Doubting of St Thomas. The sermon is reproduced in MIGNE, *PG*, LIX, pp. 681–88. St John Chrysostom was praised and studied in Florence by Poggio Bracciolini, Ambrogio Traversari and others. Moreover, the new humanist Latin translation of his *Homilies on St John the Evangelist*, which was considered to be a classic in the exegetical tradition of the Doubting of St Thomas, was dedicated to Cosimo de' Medici in 1459. See STINGER, *op. cit.* at note 74 above, esp. pp. 104 and 157.

76. Seen from the side St Thomas's robe has the two distinguishing folds, the *sinus* and *ombo*, of a toga; Verrocchio also clearly modelled Thomas's sandals after examples in Greco-Roman statuary. The pose of Thomas is extremely close to that of a figure in the Arch of Trajan at Benevento.

Malevich and film

CXXXV [1993], pp. 470–78.

The author has made a small correction to the article, concerning the *Dr Mabuso* films.

1. S. EISENSTEIN: *Nuney* (Autobiographical sketches) in his collected works in six volumes, Moscow [1964], p. 314. GINKhUK was the Petrograd Institute of Artistic Culture.

2. S. EISENSTEIN: 'Nemchinov Post', ed. I.A. VAKAR, in *Nove rubezhi*, Odintsov [28th January 1988], p. 7.

3. K. MALEVICH: 'On Exposures. Posters', *Kinozhurnal ARK*, nos.6–7, Moscow [1925], pp. 6–8.

4. For the relationship between the work of Velimir Khlebnikov and Kazimir Malevich, see R. CRONE and D. MOOS: *Kazimir Malevich: The Climax of Disclosure*, London [1991], pp. 81–110.

5. S. KRAGAUER: *From Caligari to Hitler. A Psychological History of the German Film*, London and New York [1947], ch.6.

6. In the light of the above evidence the most likely date for the production of Malevich's film poster 'Doctor Mabuso' is 1925, rather than 1922–27, as given by the Tretyakov Gallery.

7. See act of acceptance of Malevich's 'Doctor Mabuso' poster in the Tretyakov Gallery, TsGALI, Archive of Principal Art, fol. 645, op.I, ed. kr.473, 1. 19.

8. Veksler's poster, for the film *Children of the storm* (*Deti buri*, 1926, Museum für Gestaltung, Zürich; fig. 28) was exhibited in *The Great Utopia* exhibition Frankfurt, Amsterdam and New York (1992). It is similar to Malevich's in its typeface and displays a similar use of Suprematist elements.

9. MALEVICH, *loc. cit.* at note 3 above.

10. K. MALEVICH: 'And images triumph on the screen', *Kinozhurnal ARK*, no. 10, Moscow [1925], pp. 7–9. Considerable editorial correction is evident when checked against the original manuscript, preserved in the Malevich archive in the Stedelijk Museum, Amsterdam (Malevich archive, inventory no.32, Notebook III, 1920s). For the published text see T. ANDERSEN, ed.: *K. Malevich: Essays on Art*, 2 vols. Copenhagen [1968].

11. K. MALEVICH: 'The Artist and Film', *Kinozhurnal ARK*, no.2, Moscow [1926]. Published in ANDERSEN, *op. cit.* above, 1.

12. Dziga Vertov (real name Denis Avkad'evich Kaufman; 1896–1954) was one of the founders of international and Soviet documentary film, in which he was the first director to use montage.

13. These words from 'And images triumph on the screen' are not found in the published version.

14. K. MALEVICH: *Ot kubizma i futurizma k suprematizmu*, Moscow [1916], p. 22.

15. The lithograph of *Cow and violin*, with a handwritten text by Malevich, was one of the illustrations in his book *O novykh sistemakh v iskusstve*, Vitebsk [1919].

16. The production of the opera *Victory over the Sun* (with music by M.V. Matiushin, libretto by A.E. Khruchenykh, prologue by Velimir Khlebnikov, scenery and costumes by K. Malevich) was performed in St Petersburg on the 3rd and 5th December 1913. The work on the scenery and costumes for this production was subsequently seen by Malevich as the beginnings of Suprematism. Malevich also designed the cover for the opera's libretto, published in St Petersburg the same year.

17. A detailed description of the production of the opera is found in the memoirs of BENEDIKT LIVSHITS: 'Polutoraglaziyi strelets' [1989], pp. 448–50. For an English translation see 'The One and a Half Eyed Archer', trans. and ed. JOHN E. BOWLT, Newtonville, Mass. [1977].

18. S. EISENSTEIN: 'Montage of Attractions', *LEF*, no.3, Moscow [1923], pp. 70–75.

19. 'Eisenstein and Vertov are really first-class artists with leftist tendencies, for the first inclines to contrast, the second to the 'display of things', but there still remains a large

section of the path to Cézannism, Cubism, Futurism and Non-objective Suprematism for them to cover, and the further course of the development of their artistic culture can only be predetermined from the understanding of the principles of school. (MALEVICH, *loc. cit.* at note 10 above, p. 8.)

20. Quoted from Malevich's original MS for 'And images triumph on the screen', *loc. cit.* at note 10 above. The published version softens and omits some of the original wording.

21. S. EISENSTEIN: 'The fourth dimension in film', in his collected works in six volumes, II, Moscow [1964], p. 57.

22. Letter from Malevich in Tarasovka to Sergei Eisenstein in Moscow (Eisenstein archives, TsGALI, folio I, op.I, ed. Khr, 1943).

23. S. EISENSTEIN: 'An Unexpected Junction', *Zhizn' isskustva*, no.34, Leningrad [1928], pp. 6–9.

24. MS version of 'And images triumph on the screen', cited at note 10 above.

25. On Malevich's theory of additional elements see MOJIMIR GRYGAR: 'The theory of Kazimir Malevich's 'additional element'', *Russian Literature* (special issue: 'The Russian Avant-Garde XXI. Kazimir Malevich'), Amsterdam [1989], pp. 313–34.

26. K. MALEVICH: 'The Artist and Film', *Kinozhurnal ARK*, no.2, Moscow [1926], p. 17.

27. MS version of 'And images triumph on the screen', cited at note 10 above.

28. G. DULAC: '*Les esthétiques. Les entraves. Le cinématographe intégral, L'Art Cinématographique II*, Paris [1927], p. 33.

29. H. RICHTER: 'Viking Eggeling', *Studio International*, Vol. 183, no.972 [March 1972], pp. 97–99.

30. Malevich undoubtedly knew the issue of *Veshch'*, no.3, Berlin [May 1922], edited by El Lissitzky and Ilya Ehrenburg, which included the articles 'The Non-Objective Cinematographer' and 'Delluc. On Photogenius', as well as a reproduction of the still-sequence from Eggeling's film *Diagonal Symphony*.

31. H. RICHTER: *Köpfe und Hinterköpfe*, Zürich [1967], p. 102.

32. Malevich's scenario with the note 'For Hans Richter' was found in the Malevich archive originally held by the Von Riesen family, Bremen. It was reproduced in full in W. HAFTMANN, ed. and H. VON RIESEN, trans.: *Kazimir Malevich. Suprematismus. – Die Gegenstandlose Welt*, Cologne [1962], new ed. [1989].

33. On Malevich's philosophy concerning the colour white see M. LAMAČ and J. PADTRA: '*Pradrta J. Zum Begriff des Suprematismus*', in *Malewitsch*, exh.cat., Gallery Gmurzynska, Cologne [1978], pp. 167–72.

34. Malevich to M.V. Matiushin, June 1916, in E.F. KOVTUN, ed.: *K.S. Malevich. Pis'ma k M. V. Matiushinu, Ezhegodnik rukopisnogo otdela Pushkinskogo doma na 1974 god*, Leningrad [1976], p. 192.

35. On the reverse sides of the paintings *The black square, The black cross, The black circle*, painted in c.1923, are written the numbers l, 2, 3. On the back of *black circle* there is an elucidating inscription: 'the basic plane (form of circle) 1913'. The Suprematist sequence, represented in the *Knave of Diamonds* exhibition, undoubtedly originated from these basic Suprematist forms; in Malevich's publication *Suprematizm. 34 risunok* the visual sequence also originated from black squares, circles and crosses.

36. For the influence of twentieth-century scientific discoveries on the world view and work of Malevich see P. RAILING: *From Science to Systems in Art. On Russian Abstract Art and Language 1910/1920*, London [1989] and *eadem: Suprematism. 34 Drawings*, London [1990].

37. *Suprematicheskiyi balet* by Nina Kogan. 1920. Gouache and ink (The Museum of Theatre Art, St Petersburg).

38. EL LISSITSZKY: *Suprematicheskii skaz pro dva kvadrata*, Berlin [1922].

39. RICHTER, *loc. cit.* at note 31 above.

Ludovisi's tomb for a Colonna prince

CXXV [1993], pp. 822–24.

I am much indebted to Dott. Maria Giulia Barberini of the Soprintendenza ai Beni Artistici di Roma, in Palazzo Venezia, for her considerable assistance in securing photographs of this tomb, notwithstanding its relatively inaccessible location.

1. For Filippo II Colonna (1663–1714) Prince of Paliano, see P. COLONNA: *I Colonna dalle origini all'inizio del secolo XIX*, Rome [1927], pp. 278–84; and G. GALASSO, in *Storia di Napoli*, VI, Naples [1970], pp. 299–300.

2. See R. ENGGASS: 'Bernardino Ludovisi', THE BURLINGTON MAGAZINE, CX [1968], pp. 438–44; 494–500; and 613–18.

3. See ENGGASS, *loc. cit.* above, p. 497 and figs. 10, 12, 13 and 14.

4. The Colonna, whose most famous ancestor is Pope Martin V (1417–31) had a long history of military exploits dating back to the late Middle Ages. In their vast palace in the centre of Rome, the enormous fresco (1675–78) by Giovanni Coli and Filippo Gherardi on the vault of the Grand Gallery represents the victory of Marcantonio Colonna over the Turkish fleet at Lepanto. The fresco on the vault of the Sala della Colonna Bellica depicts Marcantonio Colonna borne up to heaven by Hercules.

Upon a peak in Brentwood

CXL [1998], pp. 3–4.

The supplement on the special collections of the Getty Research Institute mentioned here was published in the same volume of the Magazine, pp. 425–32. Since the publication of this Editorial, two of the Getty's programmes, the Information Institute and the Education Institute for the Arts, have been terminated. The re-opening of the Malibu villa is still in the future.

1. In addition to the Museum, these are: the Research Institute for the

History of Art and the Humanities, the Conservation Institute, the Education Institute for the Arts, the Information Institute, the Grant Program, and the Leadership Institute for Museum Management.

2. *The J. Paul Getty Museum and Its Collections. A Museum for the New Century*. By John Walsh and Deborah Gribbon. 288 pp. incl. 200 col. pls. and 50 b. & w. ills. (The J. Paul Getty Museum, Los Angeles, 1997). £$65, ISBN 0–89236–475–0 (HB); $40, ISBN 0–89236–476–9 (PB). A somewhat sanitised account of the building is given in *Making Architecture. The Getty Center*. By Harold Williams, Ada Louise Huxtable, Stephen D. Rountree and Richard Meier. 165 pp. incl. 75 col. pls. and 75 b. & w. ills (The J. Paul Getty Trust, Los Angeles, 1997), $50, ISBN 0–89236–463–7. Of the many publications accompanying the opening, mention should be made of the updated Summary Catalogues of the various departments, and of the second volume of the *Catalogue of Drawings*, by Nicholas Turner and Carol Plazzotta.

The Raphael tapestry cartoons re-examined

CXL [1998], pp. 236–50.

The reader is referred to the original article for the full complement of illustrations.

This article is based on research carried out jointly by Sharon Fermor, Alan Derbyshire and Josephine Darrah of the Victoria and Albert Museum. Some of the material was presented by Sharon Fermor at the conference 'Raphael, the cartoons and the decorative arts', held at the Museum on 7th and 8th February 1997. The authors would like to thank Paul Joannides, Ashok Roy, John Shearman, Pauline Webber and Aidan Weston-Lewis for discussing aspects of the material with them. Photography of the cartoons was carried out by Paul

Robins, Mike Kitcat and Sara Hodges. We are grateful to PCA (Plowan Craven & Associates) and LH Systems Ltd (suppliers of Leica systems) for supporting this article.

1. There are few written records of the 1965–66 campaign. A summary appears in J. PLESTERS: 'Raphael's Cartoons for the Vatican Tapestries: A Brief Report of the Materials, Techniques and Condition', in *The Princeton Raphael Symposium. Science in the Service of Art History*, ed. J. SHEARMAN and M. HALL. Princeton [1990], pp. 111–24.

2. This involved two conservators: one working at the front of the cartoon applied adhesive and pressed the loose areas into place using hand pressure against resistance prodded by the other, holding a piece of Plastazote at the back.

3. See J. SHEARMAN: *Raphael's Cartoons in the collection of Her Majesty the Queen and the tapestries for the Sistine Chapel*, London [1972], pp. 138–65, and, for the most recent summary S. FERMOR: *The Raphael Tapestry Cartoons. Narrative, Decoration and Design*, London [1996], pp. 9–45.

4. For this part of the cartoons' history see T. CAMPBELL: 'School of Raphael tapestries in the collection of Henry VIII', THE BURLINGTON MAGAZINE, CXXXVIII [1996], pp. 69–79.

5. The cartoons were described as too damaged to be used in 1573, on which see SHEARMAN, *op. cit.* at note 3 above, p. 145; on the making of Cleyn's copies, *ibid.*, p. 147.

6. The photogrammetry was carried out by Plowman Craven and Associates, using Leica photographic equipment. Five to six overlapping pairs of photographs were taken for each cartoon: each pair was then put into a stereo plotting machine, enabling the operator to see a three-dimensional image of the cartoon which could be used to take computer-aided measurements of any variations in relief – mainly those caused by the overlapping of two sheets of paper, which causes a lip of around one mm. in depth. These variations could then be scaled precisely using previously

determined reference points.

7. These photographs, which effectively provide a view through the cartoons, were taken with the gallery in blackout, with flashlight, using four Bowers soft boxes (flash units) behind the cartoons to provide the light source.

8. PLESTERS, *loc. cit.* at note 1 above, p. 112.

9. 'The cartoons, during the last half century . . . had been taken from the stretchers, rolled up and sent to various palaces, to the British institution to be exhibited, and to the Royal Academy for students to copy . . . Tracing was also allowed, and I have seen large sheets of tracing paper pinned on to the cartoons, and a hard pencil used to trace the lines – to the great injury of these precious works, the more so that the outlines have all been pricked through for pouncing, and any following by the point over the outlines must press into these holes and cause them to break together' (R. REDGRAVE: 'Report on the state of the Raffaelle cartoons on their Removal from Hampton Court Palace in April 1865, and the Nature of their Accommodation at Hampton Court and South Kensington respectively', 18th May 1865, V. & A. Nominal File, Raphael Cartoons Part 1, 1858–1892).

10. See SHEARMAN, *op. cit.* at note 3 above, pp. 148–49, 153 and 155.

11. See M. HIRST: 'I disegni di Michelangelo per la Battaglia di Cascina', in *Tecnica e stile: esempi di pittura murale del Rinascimento italiano*, ed. E. BORSOOK and F. SUPERBI GIOFFREDI, Milan [1986], I, pp. 43–58. On the Naples fragment, see C. BAMBACH: 'Michelangelo's Cartoon for the Crucifixion of St Peter Reconsidered', *Master Drawings*, XXV [March 1988], pp. 131–41.

12. G. VASARI: *Le Vite de' più eccellenti Pittori, Scultori ed Architettori*, ed. G. MILANESI, Florence [1878–85], I, p. 175.

13. For the *modelli*, see SHEARMAN, *op. cit.* at note 3 above, ch. IV, pp. 91–96.

14. See the entry by C. MONBEIG

GOGUEL, in *Raphaël dans les collections françaises*, exh. cat., Grand Palais, Paris [1983], pp. 283–84, no.100. This *modello* measures 22.3 by 35.5 cm. and the others are of similar dimensions.

15. For a discussion of the probable sequence, with earlier opinions, see SHEARMAN, *op. cit.* at note 3 above, pp. 101–09.

16. There is, however, a drawing in Windsor of modello-like character, not quite recording the final composition and lacking the foreground fish; it is usually attributed to G.F. Penni; see SHEARMAN, *op. cit.* at note 3 above, pp. 94–96.

17. Each cartoon used 180 separate radiographs, identified by attaching lead letters and numbers to each piece of film. Positioning of the X-ray source was facilitated by the regular pattern of the recently refurbished mosaic floor in the gallery After a number of tests it was found that the best results were obtained when the X-radiographs were exposed at 22 kilovolts for 30 seconds, with a source to object distance of 100 cm. The X-radiography was carried out by Howard Pearson of Roffey Ltd., using Agfa Structurix D7 film. We are very grateful to Ted Newton of Agfa-Gevaert Ltd. for donating the film.

18. PLESTERS, *loc. cit.* at note 1 above. The recent pigment analysis has been carried out by Josephine Darrah, whose findings are summarised here.

19. Five or six layers of paint are present overall, leading to crazing or cracking on the surface. The background landscape was first painted with a mixture of azurite (blue) and lead white, in one or two layers; the grass and tree were then laid in using azurite and lead-tin yellow, a second layer of malachite (green), lead-tin yellow, golden ochre and carbon black in varying proportions, and finally with golden ochre and lead-tin yellow for the yellow detail of the tree. The apostle's hair was then applied, first with an almost black layer, then with a brown made up of vermilion, yellow ochre and carbon black.

20. The gown consists of a mixture of vermilion, madder lakes, ochre and lead white, with the shaded areas applied in carbon black with vermilion and yellow ochre.

21. See T. FRIMMEL: *Der Anonimo Morelliano*, Vienna [1888], p. 104.

22. SHEARMAN, *op. cit.* at note 3 above, p. 137.

23. As perceptively observed in G. WAAGEN: *Treasures of Art in Great Britain*, London [1854], II, pp. 372–73: 'In order, also, that nothing might be left to the arbitrary discretion of the workmen in the simply mechanical manufacture of the tapestries, all the parts, contours, colours, lights and shades, are given with the greatest precision.'

24. A date under Cromwell or Charles II seems in any case less likely. Cromwell kept the cartoons without apparently making use of them, while Charles II pawned them to raise the money for other tapestry sets to be made; see PRO 52/8 King's Warrant Book VIII (pp. 218–21 and 222).

25. SHEARMAN, *op. cit.* at note 3 above, p. 148.

Frederik Hendrik of Orange and Amalia van Solms

CXL [1998], pp. 281–84.

1. *Vorstelijk Vertoon* (English ed. as *Princely Display*). Compiled and edited by Marike Keblusek and Jori Zijlmans; with contributions by numerous authors. 254 pp. incl. 69 col. pls. and 131 b. & w. ills. (Historisch Museum, The Hague and Waanders Publishers, Zwolle, 1998); £79.50, ISBN 90–400–9989–8 (HB); £55, 90–400–91951 (PB). *Vorstelijk Verzameld* (English ed. as *Princely Patrons*). By Peter van der Ploeg and Carola Vermeeren, with contributions by other authors. 276 pp. incl. 59 col. pls. and numerous b. & w. ills. (Mauritshuis, The Hague and Waanders Publishers, Zwolle, 1998), £79.50, ISBN 90–400–9987–1 (HB); £55, 90–400–9193–5 (PB).

2. Reproduced as fig.184 in the book. A small point: the pendant to Honthorst's full-length, at Windsor, of the prince, reproduced as fig. 178 in the volume, is not the portrait reproduced as fig. 173, but is another in a private collection in England. On the contemporary *cartellino* is inscribed: '*Amalia Princip* [] /*Aº163*[]'. The princess stands to the left front, in black, a fan in her left hand and her right resting on a red table-cloth.

3. As long ago as 1955, when it was shown at Genoa (*100 Opere di Van Dyck*, no.88), it was obvious that the version in the Galleria Sabauda was only a very good, probably contemporary, copy.

4. An example, signed and dated 1632, was in the Craven collection, sold at Phillips, 18th December 1984 (lot 43); another is on display in the Historisch Museum. A good version of the profile portrait of the princess, wrongly inscribed as the Queen of Bohemia, was also formerly in the Craven collection.

Edward Bonkil and Hugo van der Goes

CXLIII [2001], pp. 157–58.

1. C. THOMPSON and L. CAMPBELL: *Hugo van der Goes and the Trinity Panels in Edinburgh*, Edinburgh [1974]; L. CAMPBELL: 'Edward Bonkil: a Scottish Patron of Hugo van der Goes', THE BURLINGTON MAGAZINE, CXXVI [1984], pp. 265–74 (hereafter cited as CAMPBELL [1984]); *idem*: *The Early Flemish Pictures in the Collection of Her Majesty The Queen*, Cambridge [1985], pp. 42–47; E. DHANENS: *Hugo van der Goes*, Antwerp [1998], pp. 302–24.

2. CAMPBELL [1984], pp. 269–70.

3. Bruges, Stadsarchief, Oud Archief, Stadscartularia, Groenenboek A, fol.240 no.3, published in L. GILLIODTS-VAN SEVEREN: *Coutumes des Pays et Comté de Flandre, Quartier de Bruges, II. Coutume de la ville de Bruges* (Recueil des anciennes coutumes de la Belgique), II, Brussels [1875],

p. 117: '*Cum certa questionis materia mota fuerit coram nobis inter Alexandrum Abonkel filium Roberti, ex una parte, et Johannem Tod tanquam maritum Marie filie predicti Roberti et sororis dicti Alexandri, ex alia parte, ratione et occasione cuiusdam domus situate in predicta villa Brugensi in vico appellato Bogaerstrate, predicto quondam Roberto dum decessit spectantis; predicto Alexandro asserente eandem domum ad se tanquam primogenitum dicti Roberti debere spectare juxta consuetudinem legitime observatam in regno Scotie; supradicto Johanne Tod contrarium asserente signanter quod in eodem domo juxta consuetudinem patrie Flandrie participare debebat. Hinc est quod dictis partibus hinc inde auditis et consideratis huius cause meritis et aliis consideratis, dictas partes et quamlibet earum remisimus et remittimus per presentes ad cognitionem baillivi et justiciariorum ville Edimburgensis in Scotia, ubi predictus Robertus tempore sui decessus civis et oppidanus fuit, ut causam predictam ipsorum judices decidant sine debito juxta jura et consuetudines regni Scotie, et precipue dicte ville Edimburgensis aut alias prout ipsis visum fuerit judicii et rationis.*' Robert Bonkil was still alive on 15th June 1447 (D. LAING: *Registrum Cartarum Ecclesie Sancti Egidii de Edimburgh* [Bannatyne Club publication], Edinburgh [1859], p. 75). Robert's wife may have been the Christian Bonkil who had rights over the lands of Mosshouses near Penicuik in Midlothian (CAMPBELL [1984], p. 269, note 26). John Todd was presumably the Leith merchant of that name who on 30th March 1456 had hides and cloth freighted on a ship of Veere (H.J. SMIT: *Bronnen tot de geschiedenis van den handel met Engeland, Schotland en Ierland*, I, *1150–1485*, The Hague [1928], II, p. 926 [no.1448]). He and Mary Bonkil may have been the parents of Peter Todd, the fourth of seven witnesses to a deed drawn up for Edward Bonkil on 21st May 1496 (St Andrews Charters: see CAMPBELL [1984], p. 266). The first witness John Lindsay was the husband of Edward's niece and heiress, his brother Alexander's daughter, Marion Bonkil; the second was William Bonkil, vicar of Ormiston; the fifth was John Lethane, whose wife was Elizabeth Bonkil (J. DURKAN, ed.: *Protocol Book of John Foular 1528–1534* [Scottish Record Society publication, n.s. 10], Edinburgh [1985], pp. 159-60 [493]). Peter Todd appears to have been related to Agnes Todd, wife of Archibald Forrester of Corstorphine ('Patrick' [= Peter] Todd was her procurator on 8th October 1522 when, on her behalf, a sasine was broken. A witness to this transaction was Master James Haliburton, whose wife was Margaret Bonkil: see W. MACLEOD and M. WOOD, eds.: *Protocol Book of John Foular* [Scottish Record Society publication], Edinburgh [1930–53], III, pp. 112 [316] and 92 [231]).

4. A. VERHULST and J.-M. DUVOSQUEL: *Historische Stedenatlas van België, Brugge*, Brussels [1991], p. 107.

5. On the confraternity, see R. STROHM: *Music in Late Medieval Bruges*, revised ed., Oxford [1990], pp. 47–48; Stefaan Van de Cappelle, who is working on the history of the confraternity, kindly sent information and photocopies of extracts from the accounts. For Christus, see M.W. AINSWORTH and M.P.J. MARTENS: *Petrus Christus, Renaissance Master of Bruges*, exh. cat., Metropolitan Museum of Art, New York [1994], pp. 198–209; for Memling, see A. SCHOUTEET: 'Nieuwe teksten betreffende Hans Memling', *Revue belge d'archéologie et d'histoire de l'art*, XXIV [1955], pp. 81–84; D. DE VOS: *Hans Memling, The Complete Works*, London [1994], pp. 408–13; for Vrelant, see B. BOUSMANNE: 'Item a Guillaume Wyelant aussi enlumineur', exh. cat. (Bibliothèque Royale, Brussels), Brussels and Turnhout [1997], pp. 51–52; for Coustain, see A. SCHOUTEET: *De Vlaamse primitieven te Brugge, Bronnen voor de schilderkunst te Brugge tot de dood van Gerard David*, I (Fontes historiae artis neerlandicae, II), Brussels [1989], p. 155.

6. Bruges, Rijksarchief, Oud Archief Onze-Lieve-Vrouwekerk, no.1531, Algemene Rekeningen 1467–1499, fol.6v: '*alexander bonckel ij g*' (STROHM, *op. cit.* above, p. 47).

7. Algemene Rekeningen 1467–1499 (cited in the previous note), fols.38: '*Adam bonckel & vxor iiij g*' (under payments in arrears for the year 1468–69); 43v: '*Adam bonckel & vxor iiij g*' (under payments 1469–70); 67: '*Adam bonckel & vxor iiij g*' (under payments 1470–71); 92v: '*Item van adam bonkel scote v s. g.*' (payments 1471–72, '*doodghelde*' for deceased members, second entry); 94: '*Item van adam bonkel*' (payments 1471–72 for masses for the dead, first entry).

8. CAMPBELL [1984], p. 269; for the letter of 7th September 1469, see N. GEIRNAERT: *Het archief van de familie Adornes en de Jeruzalemstichting te Brugge* (Brugse geschiedbronnen, XIX–XX), Bruges [1987–89], II, pp. 73–74 (no.192).

9. M. SOMME: 'La jeunesse de Charles le Téméraire d'après les comptes de la cour de Bourgogne', *Revue du Nord*, LXIV [1982], pp. 731–50 (esp. pp. 735–36); H. VAN DER VELDEN: 'Defrocking St Eloy: Petrus Christus's 'Vocational portrait of a goldsmith'', *Simiolus*, XXVI [1998], pp. 242–76 (esp. pp. 254–57).

10. W. FRASER: *The Scotts of Buccleuch*, Edinburgh [1878], II, p. 46; CAMPBELL [1984], p. 270.

11. CAMPBELL [1984], pp. 270–71.

Sara Losh: architect, romantic, mythologist

CXLIII [2001], pp. 173–74.

1. Letter to his mother, 1869 (*Letters of Dante Gabriel Rossetti*, ed. O. DOUGHTY and J.R. WAHL, London [1967–], II, 716); letter of 23rd August 1869 to Jane Morris (*Dante Gabriel Rossetti and Jane Morris: their Correspondence*, ed. J. BRYSON, Oxford [1976], p. 24). Rossetti had met Sarah Losh's cousin Margaret Losh in Ayrshire in 1868, and stayed with her in Wreay the following year. Losh lent Rossetti money and corresponded with him until her death in 1872.

2. N. PEVSNER: *The Buildings of England: Cumberland and Westmorland*, Harmondsworth [1967], p. 40 and *idem*: 'Sara Losh's Church', *Architectural Review*, CXLII [1967], p. 67. Both J. Mordaunt-Crook and

Gavin Stamp have also (in conversation) expressed admiration for St Mary's and Sara Losh.

3. Henry Lonsdale (1816–76) was a doctor, born in Carlisle, who practised first in Edinburgh then in 1844 returned to his native city. He published widely on medical matters and in 1851 gave up medicine to pursue his interests in Italian art and write his six-volume *Worthies of Cumberland*. A political radical, he was a friend Mazzini and Garibaldi and a strong supporter of Italian unity. He was also friends with a medical mythographer, Thomas Inman, whose two-volume *Ancient Faiths Embodied in Ancient Names*, London [1869], expresses a belief in a phallic basis for the religious impulse.

4. H. LONSDALE: *The Worthies of Cumberland*, London [1873], IV, p. 147.

5. *The Diaries and Correspondence of James Losh*, ed. E. HUGHES, Surtees Society, Durham [1963]. Much remains unpublished (see note 8 below).

6. An engraving of 1794 shows this as an unexceptional building in Palladian style but it was much extended first by Losh herself and then by other members of the family: See L. KEMP: *Woodside*, Wreay [1997], p. 14. I am very grateful for additional information supplied by Mr Kemp.

7. LONSDALE, *vol. cit.* at note 4 above, p. 201.

8. J. LOSH: *Diaries 1798–1833*, MS, Carlisle Public Library, entry dated 30th September 1825.

9. LONSDALE, *vol. cit.* at note 4 above, p. 236.

10. For Carlyle, see R. CORMACK: 'Curzon's 'Gentleman's Book'', in R. CORMACK and E. JEFFREYS: *Through the Looking Glass: Byzantium through British Eyes*, Aldershot [2000], p. 154.

11. LOSH, MS cited at note 8 above, entry for 7th August 1833.

12. Passages are quoted in LONSDALE, *vol. cit.* at note 4 above, pp. 209–13.

13. LOSH, MS cited at note 8 above, entry for 28th March 1823. Dr Jeffrey Smith pointed this out to me.

14. In Germany, Friedrich von Gärtner,

the future *Rundbogenstil* architect, showed an interest in Italian mediaeval architecture during his first visit to Italy in 1815–17. In France, ALEXANDRE LABORDE's *Les Monumens de la France* which first appeared in 1816 dismissed romanesque as *'l'architecture dégénérée'*. When the term romanesque was introduced into English by William Gunn in 1813 (though not published until 1819) he used it somewhat pejoratively, and similarly its early employment by Charles de Gerville in 1818 as *'architecture roman'* was to denote a style which was 'heavy, crude … [and] degraded by our uncouth ancestors' (see T. WALDEIER BIZZARRO: *Romanesque Architectural Criticism: A Prehistory*, Cambridge [1992], p. 143).

15. LONSDALE, *vol. cit.* at note 4 above, pp. 208 and 212.

16. *Ibid.*, p. 212.

17. *Ibid.*, p. 213

18. Quoted *ibid.*, p. 201.

19. *Ibid.*, p. 216. Lonsdale gives no date for this.

20. *Ibid.*, p. 223, and MANNIX and W. WHELLAN: *History, Gazetteer and Directory of Cumberland*, Beverley [1847], p. 74.

21. LOSH, MS cited at note 8 above, entries for 4th, 6th, and 7th April 1827. This may have been the architect Joseph Woods whose *Letters of an Architect from France, Italy, and Greece* were published in the following year. Woods, whom Ruskin later ridiculed in *The Seven Lamps of Architecture* for his remarks on Venice, was a convinced neo-classicist. His letters, however, betray some affection for romanesque: he wrote, for example, that 'the most interesting example at Verona to the antiquary as a specimen of the architecture of the depth of the middle ages, is the church of S. Zeno' (J. WOODS: *Letters*, London [1828], p. 229).

22. LONSDALE, *vol. cit.* at note 4 above, p. 206.

23. *Ibid.*, p. 220.

24. For this obelisk she used the drawings by Henry Howard published in H. HOWARD: 'On the Runic Column at Bewcastle in Cumberland',

Archaeologia, XIV [1803], pp. 113–18.

25. 'In the church yard adjoining the chapel, is a chaste piece of sculpture, from the chisel of Dunbar, in polished marble – the figure of the late Miss Catherine [sic] Losh – for which a cell in the Druidical fashion has been built' (MANNIX and WHELLAN, *op. cit.* at note 20 above, p. 172).

26. The dating of this oratory is a matter of some debate and varies from the sixth century (Pevsner) to the ninth century (Thomas); it is discussed in E.W.F. TOMLIN: *In Search of St Piran*, Padstow [1982], pp. 7–8. Material about the church which, after various phases of excavation, has once again been covered by sand, is kept in Truro museum.

27. W. HASLAM: *Perran-Zabuloe*, London [1844], p. 89.

28. W. MICHELL: letter to *The West Briton* [1835], quoted to TOMLIN, *op. cit.* at note 26 above, p. 8. Losh may have first read about St Piran's in the *Gentleman's Magazine* in 1835 which quoted Michell, gave the precise dimensions of the building, and connected its extreme antiquity with its rôle as a mortuary (ANON.: 'Church of Peranzabulo, Cornwall', *Gentleman's Magazine*, n.s. IV [1835], pp. 539–40).

29. These were removed to the museum of the Royal Institution of Cornwall, Truro. It is now very difficult to determine their sex, so worn are they, but William Michell, whose detailed notes are also held in the museum, says that they are 'the head of a man and that of a woman rudely sculpted of stone … of very remote antiquity'.

30. LOSH, MS cited at note 8 above, entry for 11th November 1832.

31. Carlisle Record Office, PR118/30, MS transcript by the Rev. Richard Jackson (first incumbent of St Mary's, Wreay) of an account by Sara Losh of the building of St Mary's. I am extremely grateful for the assistance of Stephen White and Susan Dench of Carlisle Public Library and Record Office.

32. MS cited at note 31 above, p. 4.

33. *Ibid.*, pp. 18–20.

34. W. BELL SCOTT: *Autobiographical Notes*,

ed. w. MINTO, London [1892], I, p. 221.

35. MS cited at note 31 above, p. 28.

36. ANON.: 'On the Romanesque Style for Churches in London and Large Towns', *Christian Remembrancer*, III [1842], p. 576. William Whewell was the author of *Architectural Notes of German Churches*, London [1830].

37. See T. COCKE: 'Rediscovery of the Romanesque', in *English Romanesque Art 1066–1200*, ed. T. HOLLAND, J. HOLT, and G. ZARNECKI, exh. cat., Hayward Gallery, London [1984], p. 362. The words are those of Thomas Warton.

38. G. DICKINSON: *Rutland Churches Before Restoration*, London [1983], p. 107.

39. *Ibid.*, p. 86.

40. T. MOWL: *The Norman Revival in British Architecture, 1790–1870*, unpublished D.Phil thesis, Oxford, 1982 (MS D.Phil.c.3937).

41. J.A. PICTON: 'A few observations on the Anglo-Norman Style of Architecture, and its Applicability to Modern Ecclesiastical Edifices', *Architectural Magazine*, I [1834], p. 290.

42. N. PEVSNER: *The Buildings of England: Herefordshire*, Harmondsworth [1963], p. 201.

43. St Mary's, Wreay, just predates James Wild's Christ Church, Streatham, which was begun in 1840 and completed in 1842 (N. JACKSON: 'Christ Church, Streatham, and the Rise of Constructional Polychrome', *Architectural History*, XLIII [2000], pp. 218–52) and it significantly predates another 'modified Lombard' church, Sidney Herbert's St Mary and St Nicholas at Wilton near Salisbury, which was begun in 1841 and consecrated in 1845. Though Wild had never been abroad when he built the Streatham church, he had acquaintances who travelled widely in the East and in Italy. Herbert was a High Anglican Italophile who, having failed in his intention to bring back 'portions of an old Lombard church near Florence' (see G. GODWIN: 'Early Christian Building and their Decorations; illustrated by Wilton Church, near Salisbury', *The Builder*,

XVI [1858], p. 526), engaged Wyatt and Brandon to combine details from two romanesque churches, S. Pietro and S. Maria in Tuscania, near Viterbo. Christ Church cost £7,000, whereas all the notices of Herbert's church spoke of how 'the magnificent Byzantine church at Wilton cast him over £30,000'. (ANON: *Obituary Sidney Herbert First Baron of Lea, reprinted from 'Fraser's Magazine'*, London [1862], p. 36). Sara Losh built St Mary's for £1,200.

44. See H. HUBSCH: *In welchen Style sollen wir bauen?*, Karlsruhe [1828].

45. In the 1830s Ludovic Vitet, as Inspecteur Général des Monuments Historiques, urged the reappraisal of French romanesque; see L. VITET: 'De l'architecture Lombarde'. *Revue française*, XV [1830], pp. 151–73. He was succeeded by Prosper Merimée who suggested that French gothic was indebted to romanesque models and wrote admiringly of the 'Byzantine' elements in Saint-Maurice d'Angers, Saint-Gilles-du-Gard and even the lower portions of Saint Germain-des-Prés in Paris (P. MERIMÉE: 'Essai sur l'architecture religieuse du moyen âge', *Annuaire historique pour l'année 1838*, Paris [1837], pp. 283–327. In 1835 LABORDE substantially revised his *Les Monumens de la France* (*op. cit.* at note 14 above) with a new section on romanesque.

46. Notably G. MOLLER: *An Essay on the Origin and Progress of Gothic Architecture Traced in and Deduced from the Ancient Edifices of German . . . from the Eighth to the Sixteenth Centuries*, London [1824]; and W. WHEWELL: *Architectural Notes of German Churches*, London [1830].

47. For Hope, see D. WATKIN: *Thomas Hope and the Neo-Classical Idea*, London [1968].

48. T. HOPE: *An Historical Essay on Architecture*, London [1835], I, p. 250: 'Lombardy was the first after the decline of the Roman empire, to endow architecture with a complete and connected system of forms, which soon prevailed wherever the Latin church spread its influence from the shores of the Baltic to

those of the Mediterranean.'

49. LONSDALE, *vol. cit.* at note 4 above, p. 224.

50. HOPE, *op. cit.* at note 48 above: S. Michele in Pavia, pl. 32; Duomo of Parma, pl. 30; S. Maria della Piazza, pl. 10. However, Lonsdale does not mention Hope's book.

51. MS cited at note 31 above, p. 28.

52. See R. HILL: 'Romantic Affinities', *Crafts*, no.166 [2000], pp. 35–39, esp. p. 37 and PEVSNER, *loc. cit.* at note 2 above. I am very grateful to Rosemary Hill for sharing her knowledge of Sara Losh with me.

53. MS cited at note 31 above p. 20.

54. *Ibid.*

55. ANON: 'Symbolism and Mythology', *Foreign Review*, III [1829], pp. 325, 326 and 333.

56. For Payne Knight's debt to d'Hancarville, see *The Arrogant Connoisseur: Richard Payne Knight 1751–1824*, exh. cat., ed. M. CLARKE and N. PENNY, Manchester [1982], pp. 50ff.

57. R. PAYNE KNIGHT: *An Inquiry into the Symbolical Language of Ancient Art*, London [1818], pp. 19, 40, 82 and 136.

58. See, e.g., P.A. MAFFEI: *Gemme antiche figurate*, Rome [1708], III, pls.23 and 24, illustrating a number of figures of psyche, i.e. the soul, as a butterfly or accompanied by a moth.

59. Payne Knight believed in what he called a 'System of emanations … the fundamental principle of the religions of a large majority of the human race … though not now acknowledged by any established sect of Christians' (R. PAYNE KNIGHT: Preface to *Alfred, a Romance in Rhyme*, London [1823], p.vii). For a discussion of this in Payne Knight's work, see A. BALLANTYNE: *Architecture Landscape and Liberty: Richard Payne Knight and the picturesque*, Cambridge [1997], pp. 96ff.

60. For the female symbolism, see PAYNE KNIGHT, *op. cit.* at note 57 above, p. 32. He had explored phallic symbolism in his first book: R. PAYNE KNIGHT: *An Account of the Remains of the Worship of Priapus*, London [1786], and this theme is continued in the *Inquiry*.

NOTES TO PAGES 221–27

61. PAYNE KNIGHT, *op. cit.* at note 57 above, p. 124.

62. P.P. BOBER and R.O. RUBINSTEIN: *Renaissance Artists and Antique Sculpture*, London [1986], cat. no.187; G. HEINZ-MOHR: *Lessico di iconografia cristiana*, Milan [1984], pp. 286–87. The *pigna* was moved in 1605 to the Cortile del Belvedere where it still stands today.

63. HOPE, *op. cit.* at note 48 above, I, p. 184: 'At Ravenna … the vine, the palm-tree, the dove, the paschal lamb, or the peacock, are seen intermixed with the sacred monograms and the cross, on almost every one of those tombs of the fourth and fifth century … and the whole menagerie of sacred animals – the lamb, the dove, the deer, the goose, the peacock, and the fish . . . appears . . . still inserted in the walls of the modern cathedral.'

64. This is discussed in E. GOBELET D'ALVIELLA: *La migration des symboles*, Paris [1892], p. 113. In her *Apotheosis and After Life*, London [1915], pp. 195–96, A. STRONG points out that the pine-cone appears 'almost as constantly' on Roman tombstones as the cross on pagan graves. 'It has been suggested', she says, 'that the pine-cone is so frequently used to adorn graves because of its likeness to the grave *conus*, which is itself derived from the omphalus-shaped tombs or *tholos*. Further, it has been argued that the conical stone placed over the tumulus is simply the phallic emblem of life . . .'

65. In conformity to this primitive manner of building, large windows could not have been properly made in the absis, but the Bishop fearing a want of light, gave only a conditional assent to the plan as it now stands, desiring it should be so contrived that larger windows might be opened if found desirable. This however he afterwards dispensed with' (MS cited at note 31 above, pp. 29–30).

66. The grape and vine leaf motif was taken up by a number of Arts and Crafts designers most notably in Lethaby's font at All Saints', Brockhampton (1901–02).

67. LONSDALE, *vol. cit.* at note 4 above, p.

231. Knight associates the lotus with the legend of Isis and Osiris and 'the passive generative power' of the female.

68. A.W. LINDSAY: *Sketches of the History of Christian Art*, London [1847], I, p. 17.

69. The palm tree is another symbol of resurrection and spiritual triumph (HEINZ-MOHR, *op. cit.* at note 62 above, pp. 259–60).

70. LONSDALE, *vol. cit.* at note 4 above, p. 231.

71. *Ibid.*, pp. 233–34.

72. LOSH, MS cited at note 8 above, entry for 30th March 1814.

73. LONSDALE, *vol. cit.* at note 4 above, p. 234.

74. The significance of the symbolism, said Lonsdale, was 'hardly comprehended by Bishop Percy and his episcopate supporters' (*ibid.*, p. 230).

75. MS cited at note 31 above, pp. 22–24. Referring to monumental and funerary sculpture, Losh said: 'These I would earnestly hope may not be introduced into this rustic chapel, the simplicity and uniformity of which, would be totally destroyed, by the glaring aspect of black, white or coloured marble, with the usual decorations either heraldic or mortuary.' 'Indeed', she added, 'I would hope the time is not distant, when Christians will have too much reverence for their places of worship, to fill them with the memorials of their dead, and that the pernicious practice of interment within these sacred buildings will soon be entirely abandoned.'

76. BELL SCOTT, *loc. cit.* at note 34 above.

Secret Knowledge: Rediscovering the Lost Techniques of the Old Masters

CXLIV [2002], pp. 173–4.

By David Hockney. 296 pp. incl. 402 col. pls. + 58 b. & w. ills. (Thames and Hudson, London, 2001), £35. ISBN 0–500–237859

PHOTOGRAPHIC ACKNOWLEDGEMENTS

111. *Family of Saltimbanques or Les Bateliers*, by Pablo Picasso. 1905. (National Gallery of Art, Washington (D.C.), Chester Dale Collection)